Pre-Raphaelites
Victorian Art and Design

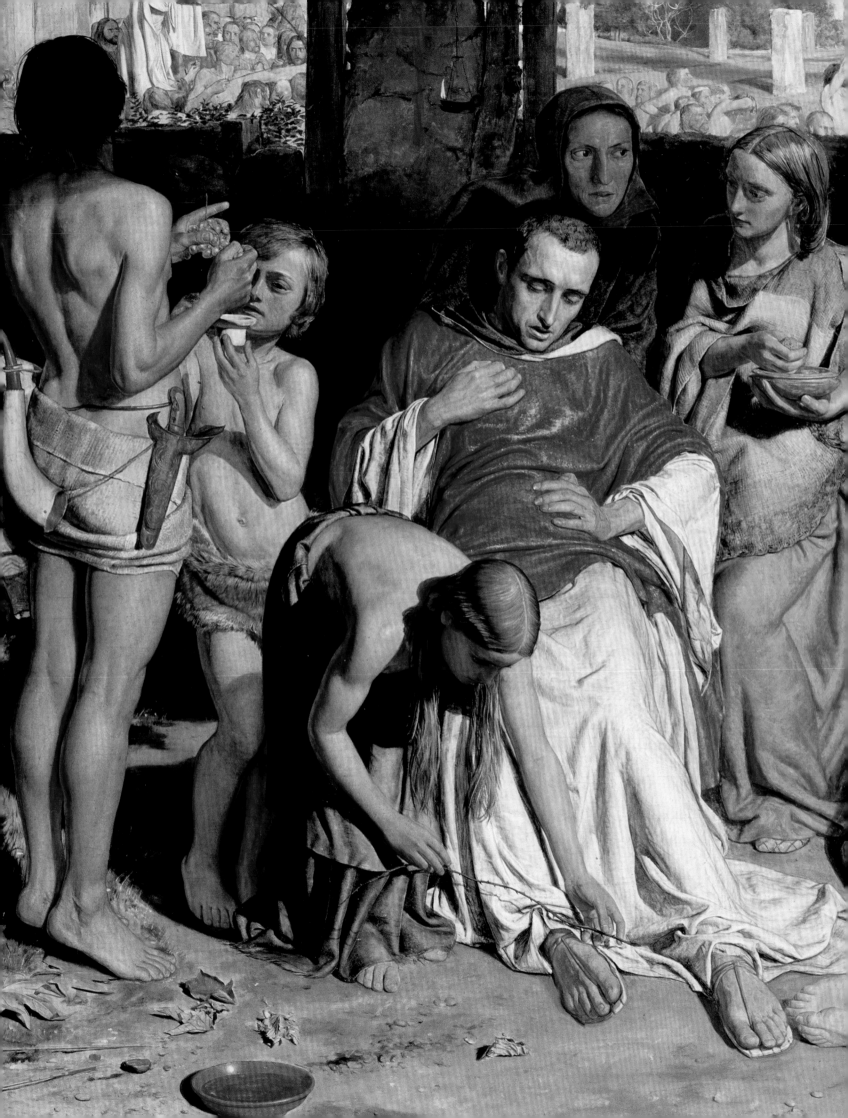

Pre-Raphaelites
Victorian Art and Design

Tim Barringer
Jason Rosenfeld
Alison Smith

With contributions by
Elizabeth Prettejohn
and Diane Waggoner

YALE UNIVERSITY PRESS
NEW HAVEN AND LONDON

Published in North America by
Yale University Press
P.O. Box 209040
New Haven, CT 06520-9040
www.yalebooks.com/art

First published 2012 by order of
the Tate Trustees by Tate Publishing,
a division of Tate Enterprises Ltd,
Millbank, London SW1P 4RG
www.tate.org.uk/publishing

This book was published in conjunction with the exhibition
Pre-Raphaelites: Victorian Avant-Garde
Tate Britain, London, 12 September 2012 – 13 January 2013
National Gallery of Art, Washington, 17 February – 19 May 2013
State Pushkin Museum of Fine Arts, Moscow, 10 June – 30 September 2013

Library of Congress Control Number: 2012951912

ISBN 978-0-300-19444-9

Designed by Libanus Press Ltd
Colour reproduction by DL Imaging Ltd, London
Printed in Italy by Conti Tipicolor

Front cover: John Everett Millais, *Mariana* 1850–1 (no.35)
Back cover: Edward Burne-Jones, *The Doom Fulfilled* 1885–8 (no.173)
Frontispiece: William Holman Hunt, *A Converted Christian British Family Sheltering a Christian Missionary from the Persecution of the Druids* 1849–50 (detail of no.86)

Measurements of artworks are given in centimeters, height before width, before depth.

CONTENTS

FOREWORD
LONDON

The Pre-Raphaelite Brotherhood lasted only five years, but the Pre-Raphaelite artists worked on for another half century. This then is an exhibition that is both very specific – examining the relationship between the key founder members and their close associates – and also more general, expanding into a much wider frame of reference over fifty years. It is an exhibition about the group but also about the individual, about youth and old age, and about how art projects change over time. It is an exhibition that, like the Brotherhood, looks back – retrospective and introspective in nature, examining its own precedents – but also looks forward and suggests alternative futures.

It is the work of three curators, each a specialist in the period. Two work in the United States and one in Britain; all were deeply impressed by the last major Pre-Raphaelite exhibition, held at the Tate a generation ago. If that exhibition, as they argue, was primarily biographical, premised on individual careers, it was also determinedly chronological and ended in the early 1880s. This one sets out to examine the group ethos and then to situate its trajectory, joint and individual, within the much wider understanding of Victorian society that has resulted from scholarly work of the last twenty-five years. This allows it to pull out themes and range more fluidly across a longer period of time.

We are pleased to host this exhibition in its first manifestation, but just as pleased to know that it will develop range and meaning as it travels to the United States and Russia, and, in a smaller version, to Japan. Alison Smith, our lead curator for the nineteenth century, has put an enormous amount of work into the partnership involved in this project, both with the partner galleries, represented notably by Diane Waggoner, and with the curators, Tim Barringer and Jason Rosenfeld. We should like to thank our partners, listed in greater detail in the acknowledgements as well as our supporters: The Anson Charitable Trust, The Ahmanson Foundation, Christopher J Gridley, the American Patrons of Tate and Tate Patrons, as well as those who prefer to remain anonymous. We are also grateful for the support of The Charlotte Bonham-Carter Charitable Trust, The Hintze Family Charitable Foundation, The Finnis Scott Foundation and The PHG Cadbury Charitable Trust, which have additionally helped us conserve a number of our works for the exhibition.

The Pre-Raphaelites, of any British art movement, best represent the strength of Britain's non-metropolitan galleries, and of the private collections that led to their creation. Tate might be seen as simply one example of this collecting trend, and of Henry Tate's collection, two key paintings by Millais are on any roll-call of Pre-Raphaelitism. Those industrial magnates and professional entrepreneurs must have recognised in these works something of their own interest in combining old and new: medieval and Renaissance techniques allied to the new photography; natural pigments with the artificial effects made possible by chemical advances; the unique with the reproductive; plain truths with something more poetic.

These were artists living in a time of profound change, and they sought old truths as much as they embraced new possibilities. Their religious belief was tested by Darwinism, the notion of progress was thrown into question by the relentless march of capitalism. This exhibition seeks now to recast these paintings within the mores of the age as well as to assert their aesthetic qualities. It suggests that we understand their use of almost archaeologically based empirical evidence as part of a larger quest for truth and certainty.

We know that these artworks have enduring effect and appeal, but now we want to understand more accurately why and how they were made. We show how their authors worked and reworked certain key themes; we show how these were the answers sought by those who questioned, almost obsessively. By situating the paintings within a wider material world, peopled more variously by those who shared the lives and aims of the few original members of the Brotherhood, this project intends to open up Pre-Raphaelitism to those for whom it has become something of a cliché, as well as to those who have always loved its richness and ambition.

Penelope Curtis
Director, Tate Britain

FOREWORD
WASHINGTON

In late 1857 and early 1858 a group of Pre-Raphaelite pictures traveled from Britain to the United States for the first time in an exhibition of "English Art" slated to be shown in New York, Philadelphia, Boston, and Washington. Among the paintings were works by William Holman Hunt, Ford Madox Brown, and John Brett. Missing were works by Dante Gabriel Rossetti and John Everett Millais, an absence lamented by American critics. The exhibition, taking place during a sudden financial crisis, was canceled before it got to Washington.

The National Gallery of Art is pleased to remedy this history in presenting the first full retrospective of the Pre-Raphaelite movement shown in the United States. Organized by Tate Britain, the exhibition is also the first substantial reconsideration of the movement since Tate's landmark 1984 retrospective. The exhibition reveals Pre-Raphaelitism to be the first avant-garde movement in Britain, and the first modern movement in which the artists worked across a range of mediums – from painting, sculpture, and drawing to the applied arts, including stained glass, textiles, wallpaper, tapestry, and books. It traces Pre-Raphaelitism from its origins in 1848 through its influence on the rise of the aesthetic movement, the arts and crafts movement, and European symbolism. Establishing a new ground for thinking about modern art, this exhibition and its themes prompt a reconsideration of a broad range of nineteenth-century art in both America and Europe and its impact on art of the early twentieth century.

Pre-Raphaelitism arose in Britain during a time of profound technological invention and social and economic transformation. Inspired by the clarity of art from before the time of Raphael, proponents of the movement distilled the art of the past while reinventing the art of the present, absorbing the lessons of empirical observation and the new medium of photography to observe nature closely. The aesthetic vibrancy of their art rivals that of their nineteenth-century contemporaries, and their works retain their remarkable power today.

The Gallery is pleased to continue its commitment to exhibiting British art, from the 1997 survey *The Victorians: British Painting in the Age of Queen Victoria*, to a series of monographic exhibitions on Turner, Constable, and Gainsborough presented in the past ten years, to the 2010 exhibition *The Pre-Raphaelite Lens: British Photography and Painting, 1848-1875*.

We wish to thank the three curatorial voices of the exhibition: Alison Smith at Tate Britain and guest curators Tim Barringer, Yale University, and Jason Rosenfeld, Marymount Manhattan College. We are also grateful to Diane Waggoner, associate curator of photography at the National Gallery of Art, who worked in close collaboration with the aforementioned curators to shepherd the exhibition in Washington.

We thank the many lenders who graciously parted with their works for a time so we could share them with our visitors. We are grateful to Sally Engelhard Pingree and The Charles Engelhard Foundation for their generous support of the exhibition.

Earl A. Powell III
Director, National Gallery of Art

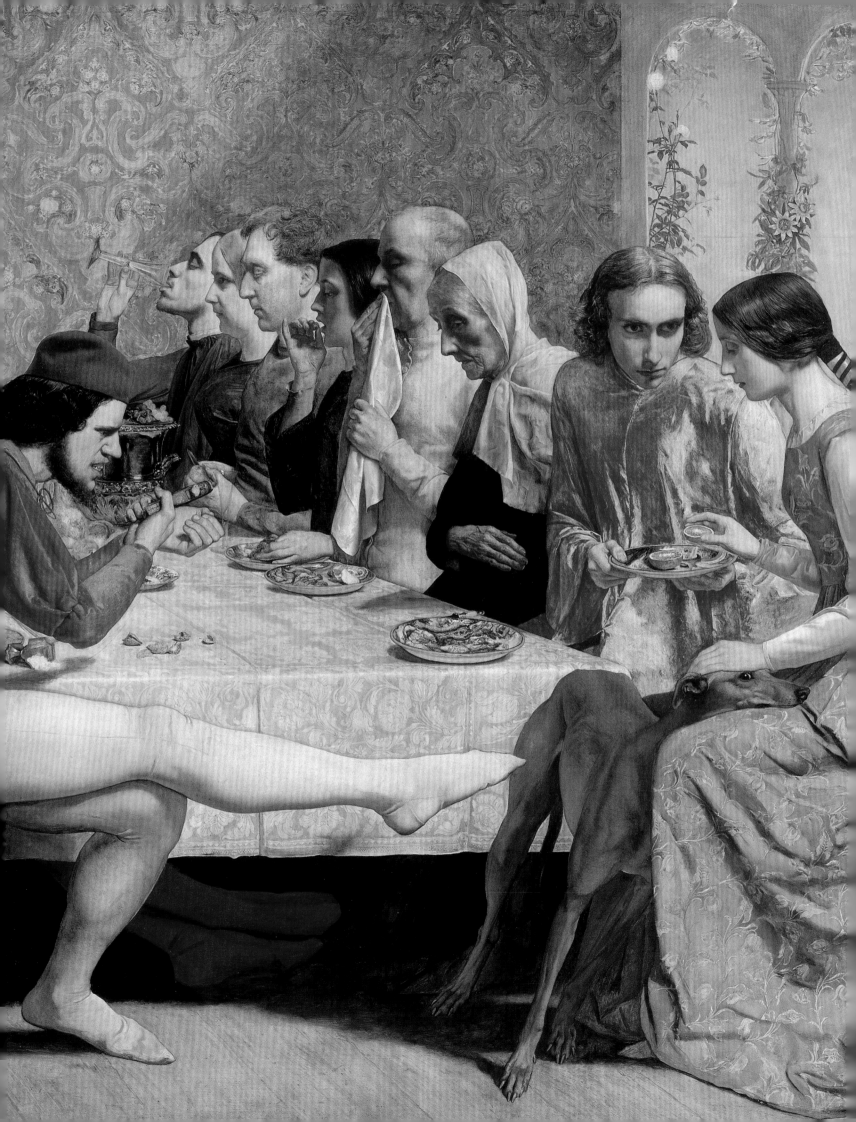

VICTORIAN AVANT-GARDE

Tim Barringer and Jason Rosenfeld

This book and exhibition present the art of the Pre-Raphaelites as an avant-garde movement whose achievements across many media – painting, drawing, sculpture, photography and the applied arts, as well as literature and political theory – constitute a major contribution to the history of modern art.[1] The term 'avant-garde' describes an organised grouping with a self-conscious, radical, collective project of overturning current orthodoxies in art and replacing them with new, critical practices often directly engaged with the contemporary world.[2] It has usually been associated with movements such as Impressionism, Cubism, Dadaism and Surrealism.[3] Pre-Raphaelitism belongs among the very earliest of the historical avant-gardes. The Pre-Raphaelite Brotherhood was founded in 1848 in a world that was recognisably modern: it was marked by dramatic technological and social change, the globalisation of communications, rapid industrialisation, turbulent financial markets and the unchecked expansion of cities at the growing expense of the natural world. London was the centre of the world economic system and of an empire of unprecedented size and complexity. Every aspect of life was changing quickly. Traditional social relationships, beliefs and patterns of behaviour were challenged as never before, while evolving into those familiar to the world today. Early Victorian painting had barely registered these seismic shifts. By contrast, the paintings, drawings and material objects in this exhibition are vivid cultural manifestations of the seething energy of the world's first industrial society.

The Pre-Raphaelite Brotherhood (PRB) was founded in London in September 1848. Its leading members were the young painters John Everett Millais (1829–96), Dante Gabriel Rossetti (1828–82) and William Holman Hunt (1827–1910), and their slightly older friend and mentor Ford Madox Brown (1821–93), who never formally joined the group but shared many of its aims. From its origins Pre-Raphaelitism was characterised by innovative stylistic choices and reformist aesthetic, social, political and religious thinking. The radicalism of the Pre-Raphaelites lay in a refusal to accept the conventions revered by their teachers and society at large; in their insistence on getting to the root or origin of artistic, and sometimes also social and political, problems; and in their commitment to fundamental change. Despite its familiarity through colour reproduction today, when looked at afresh, Pre-Raphaelite art remains as difficult, unruly and distinctive as it was at the time of its creation. Its sharp lines and 'shrill colours', as Ernst Gombrich

called them, sound a note of dissidence, as do its revolutionary approach to history painting, exploration of the profusion and brilliance of the natural world, challenging engagement with the contemporary social and religious life of Victorian England, and distinctive portrayal of beauty and sexuality.[4]

As the title of *The Germ* (no.23), the group's short-lived periodical, implies, the Pre-Raphaelite Brotherhood intended to sow the seeds of a widespread reform of society through advanced art and design. And so it did: the British Aesthetic movement, which first flowered in the 1860s, and the international Arts and Crafts movement of the late nineteenth century both have their roots in Pre-Raphaelitism. In the later 1850s a new group converged around Rossetti, including the young poet and designer William Morris (1834–96) and the painters Edward Burne-Jones (1833–98), Elizabeth Siddall (1829–62) and Simeon Solomon (1840–1905). They explored the relationships between art and poetry, and art and music. Most strikingly, they moved beyond the traditional fine-art media of painting, drawing and sculpture to embrace the design and production of furniture, textiles, ceramics, wallpapers and stained glass, and the design and illustration of books.

By the last decade of the nineteenth century the second generation of Pre-Raphaelites, led by Burne-Jones, had created new forms of history painting in a mythic visual language appropriate to the changing psychological and social conditions of the *fin de siècle*. The hitherto underestimated late works of Millais, Hunt and Brown, all of whom lived for half a century after the founding of the PRB, also explored new and often difficult subject matter, and each artist evolved his own highly original, even idiosyncratic, visual language. In the 1880s and 1890s, Morris and Walter Crane (1845–1915) transformed the latent political radicalism of the Pre-Raphaelite movement into an explicit socialist affiliation, developing an iconography for the British left.

Historical and *modern*

Faced by a startling rapidity of technological change and social upheaval, Victorian culture consistently turned to the past for solutions to the intractable political, moral and aesthetic problems inherent in the condition of modernity. In *Past and Present*, published in 1843, Thomas Carlyle, a social commentator much admired by the Pre-Raphaelites, contrasted the strong

John Everett Millais, *Isabella* 1848–9 (detail of no.26)

leadership and social cohesion of the medieval world with the chaotic present.[5] Theorists of the gothic revival, including the architect A.W.N. Pugin, believed that the beauty and spirituality of medieval life revealed the hideous debasement of existence in the industrial city. Meanwhile, at the very moment that he lent his support to the Pre-Raphaelites in 1851, John Ruskin (1819–1900) was writing *The Stones of Venice*. His chapter 'The Nature of Gothic' found in medieval sculpture 'signs of the life and liberty of every workman who struck the stone', in contrast to the 'slavery in our England', the wage slavery of industrial labour and its soulless and ugly products.[6] Some imaginative early-Victorian artists, such as William Dyce (1806–64), later a friend and follower of the Pre-Raphaelites, had already begun to look to early periods in the history of art for alternatives to what they saw as conventional and crass in the art of the nineteenth century (no.4).

The brazenly unconventional Pre-Raphaelites paralleled these radically revivalist strains in writing and design by producing pictures that scandalised the Victorian art world for several years after their debut in 1849. *Isabella* (no.26), Millais's first Pre-Raphaelite painting, was a frank declaration of the young artists' shared belief that paramount examples of pure and sincere art-making could be found in Italian and Northern European art of the fifteenth century, from before the era of the Italian painter Raphael (1483–1520) and his followers, the 'Raphaelites'. Turning their backs on the models proposed for emulation by the Royal Academy Schools, they contended that early Renaissance painting contained the seeds of a new art for the modern world of Victorian Britain. In *Isabella* Millais responded specifically to the side panels of the *San Benedetto Altarpiece* of 1407–9, now attributed to Lorenzo Monaco (no.27). In July 1848 they were acquired and placed on view in the National Gallery, which at that time shared its Trafalgar Square premises with the Royal Academy. Resonances of the Italian panels can be detected in Millais's deliberate compression of pictorial space, crisply etched faces piled one on another and representative of everyday people rather than professional models, brilliant patches of decorative colour, and individuated forms collaged into unity. Lorenzo's and Millais's works are seen together for the first time in the current exhibition.[7]

While the Brotherhood's very name declared an affiliation with the distant past, the group also argued that art should make a direct and critical engagement with contemporary society. In apparent contrast with their historicist leanings, they forged an entirely original realist idiom – precise, vivid and uncompromising. This early Pre-Raphaelite style emerged in part as a response to the revelatory new technology of photography, announced to the world in fixed and presentable form in 1839, less than a decade before the founding of the PRB. The daguerreotype, produced on a metal plate, and the paper negative process, products of recent scientific research, would seem to be the very antithesis of the passionate, poetic revivalism of the medievalist Pre-Raphaelite Brotherhood. Yet, the Pre-Raphaelites responded particularly to the uncanny precision of the daguerreotype, such as that of the National Gallery from 1839 by Michel de St Croix (no.22), whose luminous silvery image mirrored the world with a fidelity seemingly unprecedented in human endeavour. Inspired in part by photography, the Pre-Raphaelites portrayed the environments of Victorian Britain with ardent, sometimes painful, clarity. For example, in *The Awakening Conscience* (no.98), a searing indictment of the modern sex industry in which a 'kept woman' sees the error of her ways, Hunt revealed every detail of the interior with forensic precision. This was not mere pointless virtuosity, as Ruskin explained in a letter to *The Times*: 'That furniture, so carefully painted, even to the last vein of the rosewood – is there nothing to be learned from that terrible lustre of it, from its fatal newness?'[8] Pre-Raphaelite realism therefore inaugurated a new register of pictorial meaning.

Some of the most striking Pre-Raphaelite paintings bring together the historical and the contemporary in a single image. Thus Millais's *Christ in the House of His Parents* (no.85) presents the carpenter's shop with vivid immediacy, every woodchip enumerated with absolute fidelity. Yet Millais also connected present and future events through a complex typological symbolism that alludes to the subsequent life and suffering of Christ within the context of a believable narrative of his childhood: drops of blood from a scratch foreshadow stigmata, and tools suggest the instruments of the Passion. The imagery of labour, replete with dirty fingernails and imperfect, everyday bodies, forged unmistakable connections between the members of the Holy Family and modern working-class people. This caused consternation among Victorian viewers seeing the work for the first time. One disgruntled academic painter decried its 'pictorial blasphemy' perpetrated through a 'circumstantial Art-language from which we recoil with loathing and disgust'.[9] Charles Dickens was particularly affronted by the central figure of the Virgin Mary, who appeared 'so horrible in her ugliness, that (supposing it were possible for any human creature to exist for a moment with that dislocated throat) she would stand out from the rest of the company as a Monster, in the vilest cabaret in France, or the lowest ginshop in England'.[10] As with many later avant-gardes, the Pre-Raphaelites were subjected to a sustained barrage of critical abuse before finally finding a group of progressive writers, led by Ruskin, willing to champion their work.

In this exhibition religious history paintings and images of modern life hang side by side, indicating the interpenetration of Protestant faith and morality in Victorian Britain. The resulting ideas often chafed against the conventions of the time. Hunt submitted to the same exhibition *The Awakening Conscience* and *The Light of the World* (no.92). The latter was perhaps the most important and widely reproduced religious image of the nineteenth century, and an unforgettably vivid representation of

Christ.[11] Ruskin described it as 'one of the very noblest works of sacred art of this, or any other age'.[12] Hunt's juxtaposition of the two paintings was no accident. Perhaps the young woman turns to the path of righteousness precisely because she hears Christ knocking on the door of the human soul. It was a bold move indeed to suggest that an outcast figure such as a kept woman, considered by mainstream opinion to be a social deviant, was in direct dialogue with Christ.[13] By the time these works were on the walls of the Royal Academy in 1854, Hunt had set sail for Palestine. There, pursuing his mission as self-declared 'painter of the Christ', he would create a series of works that moved beyond the realism of Millais's *Christ in the House of His Parents* by observing actual biblical sites and offering a purportedly archaeological reconstruction of the life of Jesus. *The Finding of the Saviour in the Temple* (no.101) is a spectacular result of this project, a painting that adroitly reprises some of the formal elements in Millais's earlier, ground-breaking work, while binding together Hunt's deep Evangelical faith with an essentially imperial form of ethnography, in which Jewish 'types' of the present day were made to stand in for their historical forebears.[14] Recognised as a 'thoroughly English and Protestant' account of the scene in which the young Christ argues with the rabbis in the temple, it is replete with historical detail and absolute in its rejection of established artistic conventions.[15]

The juxtaposition of other pictures is equally suggestive. In *Work*, one of the most ambitious realist paintings of the nineteenth century, Brown presented a panorama of social types, but paid special homage to the powerful manual labourers digging a trench for new waterpipes (no.95). By depicting *Jesus Washing Peter's Feet* (no.93) with a similar hard-muscled physical type – a portrayal echoed in Hunt's later epic canvas *The Shadow of Death* (no.112) – Brown asserted that redemption can be achieved through manual labour. The workman's connection to Christ is more direct than that of the bourgeois. To find 'perennial nobleness, and even sacredness' in the activities of the working classes, as Carlyle and Brown both did, was to up-end Victorian social hierarchies, a manifestly radical proposition.[16] It is no surprise to find that Rossetti and Brown, as well as Ruskin himself, dedicated themselves to teaching art classes at the Working Men's College, a Christian Socialist philanthropic venture led by Frederic Denison Maurice, the pensive clergymen who can be seen with Carlyle in the right foreground of *Work*.

Encouraged by the fervent support of Ruskin, the pre-eminent art critic of the period, the Pre-Raphaelites turned their attention to the representation of nature with the same intensity of detail and with a consistent desire to unlock secrets of the past to comprehend the present. This development in their art coincided with a widespread enthusiasm, both professional and amateur, for natural history, especially geology and botany. In the 1850s Millais, Hunt and their young Ruskinian followers, such as John William Inchbold (1830–88) and John Brett (1831–1902),

dedicated untold hours of laborious care to the precise rendering of landscapes, from familiar vistas of southern England to Alpine scenery of the utmost grandeur, paying close attention to underlying geological structures as well as to minuscule details of flora and fauna. Even familiar scenery could provide a landscape of revelation. Dyce's *Pegwell Bay* (no.82) forms a profound meditation on humankind's place in time and space as understood through geology and astronomy: members of the painter's family collect fossils and shells in the foreground, while above the cliffs, in the pale dusk sky, is Donati's comet.

Pre-Raphaelitism's apparently contradictory status as both a revivalist and a realist movement dates from its very inception. This unexpected combination of the historical and the modern is one facet of the unorthodox and original character of Pre-Raphaelite art, and its continued power to perplex, provoke and delight more than a century and a half after its contentious debut.

Pre-Raphaelite 'otherhood'

Like all avant-gardes, the PRB cultivated a mystique, emphasising the group's foundation and the conspiratorial intimacy of its members. It originated as an act of rebellion by seven very young men dissatisfied with what they saw as the degenerate and rule-bound art of the day.[17] The three leaders of the group had been students at the Royal Academy Schools but had lost faith in its traditions and their teachers. They deliberately positioned themselves as 'other' to the Academy and its doctrines, as laid down in the *Discourses* of the founding president, Sir Joshua Reynolds (1723–92). The Pre-Raphaelites reviled Reynolds's own tenebrous and ungainly painterly style, created in emulation of the old masters, referring to him as 'Sir Sloshua'.[18]

Millais had distinguished himself as a prodigiously gifted and prize-winning student, precocious in his mastery of drawing and painting techniques. Rossetti, the scion of a family of

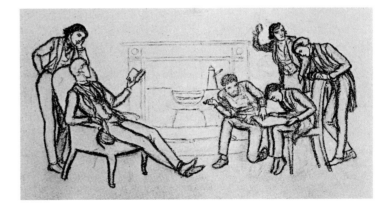

Fig.1 Arthur Hughes after a sketch by William Holman Hunt, *The Pre-Raphaelite Meeting*, 1848, present whereabouts unknown, reproduced from Hunt 1905, I, p.140.

intellectual Italian immigrants, was already, at twenty, an accomplished poet richly endowed with visual and literary creativity. Hunt, a Londoner from a more modest background, showed signs of the uncompromising originality and constant striving for truth in representation that would mark out his mature work. They were joined by the sculptor Thomas Woolner (1825–92) and two painters of lesser talent, James Collinson (1825–81) and Frederic George Stephens (1828–1907). Stephens, along with the seventh member of the group, Rossetti's younger brother William Michael (1829–1919), would turn to writing and become a critic and chronicler of Pre-Raphaelitism. Brown, a struggling artist with a comprehensive training in the European academic tradition, briefly taught both Hunt and Rossetti. He was well versed in the latest continental art, and especially familiar with the early-nineteenth-century German Nazarene group (no.1), whose religious revivalism foreshadowed aspects of Pre-Raphaelite practice. Brown was both leader and follower, simultaneously teaching and learning from the PRB.

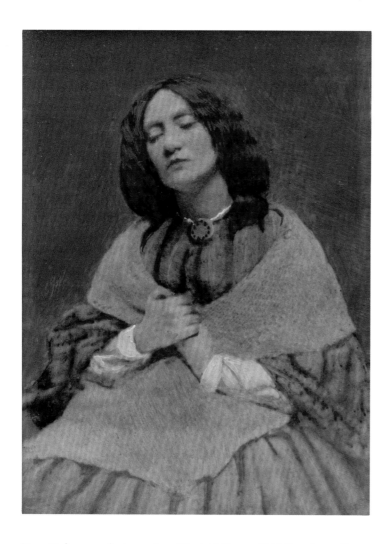

Fig.2 Unknown photographer, *Elizabeth Eleanor Siddall*, c.1850s, albumen print with hand colouring possibly by D. G. Rossetti, 5.1 x 7.6. The Walters Art Museum; gift of the A. Jay Fink Foundation, Inc., in memory of Abraham Jay Fink, 1963 [Washington only]

In its early days the Brotherhood expressed itself as a single artistic entity, adopting a shared gothic style of draughtsmanship (nos.28, 29). Tight, linear and shadowless, these early drawings referenced an eclectic range of sources, modern and medieval.[19] This linear style also gave early Pre-Raphaelite paintings a distinctive quality of precision and equal focus throughout, which was heightened by the use of unusual techniques, discussed in Alison Smith's essay below (pp.18–23). It was a remarkable achievement of the sculptor Alexander Munro (1825–71), a friend of the Pre-Raphaelites, to find a three-dimensional analogy to this style. Munro's *Paolo e Francesca* (no.38), viewed from any angle, presents pointed outlines, precisely rendered detail and the atmosphere of youthful ardour familiar from early Pre-Raphaelite drawing and painting.

For a handful of years after 1848 there was an intense artistic exchange among the Pre-Raphaelites, as commemorated in the portraits they made of each other as tokens of friendship. The PRB was notable for the homosocial bonding of its members, as an exclusive club of young men who provided each other with comradeship and emotional solidarity as well as artistic and critical expertise and professional contacts (fig.1). Yet the individual style and inclinations of each artist were never fully subsumed into a collective identity. Indeed, the art of the Pre-Raphaelites is more notable for its multiplicity and variety than for a singularity of style or approach. The sphere of Pre-Raphaelite influence was extremely wide, encompassing two generations of British artists, but as this exhibition aims to provide full exposition of the work of a core group of figures, it does not include work by many artists who adopted a Pre-Raphaelite idiom, such as the Liverpool painters James Campbell (c.1825/8–1903) and William Lindsay Windus (1822–1907), or associates of the PRB, such as George Price Boyce (1826–97) and Joanna Boyce Wells (1831–61).

The Pre-Raphaelites' variety of method and style contrasts with the unified approach of later avant-garde groups such as the Cubists, Vorticists and Italian Futurists, but the impact of their intervention was both immediate and long lasting. Pre-Raphaelitism was an attempt to make change from within. By showing their work at the Royal Academy's annual exhibitions, the highlight of the artistic calendar in Britain, under the scrutiny of a burgeoning art press, they issued a very public challenge. It is a testament to the quality of their work that the Pre-Raphaelites succeeded in changing the nature of the curriculum in the Royal Academy Schools and rapidly influenced the productions that would hang in future shows. Within just a few years established academicians of an earlier generation, such as Dyce (no.82), Richard Redgrave (1804–88) and Daniel Maclise (1806–70), adopted aspects of Pre-Raphaelite practice and style.

Pre-Raphaelite sisterhood

The Brotherhood was, by definition and rather unimaginatively, initially premised on the exclusion of women. There were, however, many influential female figures in the wider Pre-Raphaelite circle, and their numbers grew over time. The poet Christina Rossetti (1830–94), younger sister of Dante and William, developed a distinctive Pre-Raphaelite idiom in her literary work, marked by acute visual observation and deep religious conviction. The most significant female artist, however, was Elizabeth Siddall, whose work has emerged to deserved prominence in recent decades through the work of feminist scholars.[20] Siddall's physical features became well known after she modelled for Millais's *Ophelia* (no.69), one of the pictures that established his popularity with a mass audience. Her luxuriant red hair, pallid skin and striking physiognomy (fig.2) ran counter to widely held Victorian ideals of beauty, which more closely resembled the demure countenance of a Raphael Madonna or the young Queen Victoria herself. Siddall, who was the daughter of a Sheffield ironmonger, sustained herself by working in a London milliner's shop. She probably agreed to model as a way of entering the Pre-Raphaelite circle, and to pursue her own ambitions as an artist – ambitions that her sex and her class position placed beyond her reach. She became Dante Gabriel Rossetti's model, muse, lover and, eventually, wife. Rossetti created an obsessive series of drawings and paintings of Siddall, culminating in the posthumous tribute *Beata Beatrix* (no.124), in which his own conflicted love for her is conflated with that of Dante Alighieri for Beatrice Portinari.

The dialogue with Rossetti, followed by patronage from Ruskin, allowed Siddall some limited freedom to develop her own distinctive artistic style. Although relatively little work has survived, *Lady Clare* (no.50) demonstrates her characteristic willingness to push further against academic norms than her male colleagues. She adopted a self-conscious flattening of figures and a bold palette of colours, in emulation of medieval stained glass and illuminated manuscripts, with subject matter that either drew attention to the restrictions on women's freedoms or placed women in a position of power, however briefly. Siddall's death, aged thirty-two, of an overdose of laudanum, perhaps a suicide, deprived Pre-Raphaelitism of one of its most distinctive talents.

Many other women would contribute to the Pre-Raphaelite movement. Most were sisters or daughters of male artists: in addition to Christina Rossetti, Rosa Brett (1829–82), the sister of John Brett, created a small corpus of works of hypnotic intensity (nos.79–80) but abandoned her art when expected to fulfil a domestic role within her family. By contrast, the life of Jane Burden (1839–1914) was closer to that of Siddall. Born the daughter of an Oxford stableman, she was discovered as what they

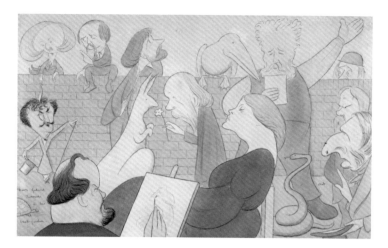

Fig.3 Max Beerbohm, *Dante Gabriel Rossetti in his Back Garden*, c.1904, published in Max Beerbohm, *Rossetti and his Circle*, London 1922.

called a 'stunner', or distinctive beauty, by the group of young men whom Rossetti had gathered to work collaboratively on a mural scheme for the Oxford Union building. She soon married Morris, who had painted her as *La Belle Iseult* (no.53), and, in collaboration with her sister Elizabeth 'Bessie' Burden, developed an artistic identity as the creator of subtle and ambitious works of embroidery (no.140). Women played a key role in the revival of the applied arts and crafts in the Morris circle, working both as designers and as expert practitioners of many craft skills. William and Jane Morris's younger daughter, May (1862–1938), became a leading exponent of revivalist needlecraft, the author of important publications, such as the illustrated *Decorative Needlework* (1893), and an active socialist.[21]

In addition to her own work as an artist, Jane Morris deserves credit for collaborating in the creation of the images in which she appears as a sitter, notably the series of drawings and paintings by Rossetti and a group of photographs by John Robert Parsons. Another significant figure in the Pre-Raphaelite circle, Fanny Cornforth, can be credited with the fabrication of an entire persona. Born Sarah Cox in a rural corner of Sussex, 'Fanny Cornforth' became emblematic of sensuous womanhood in Rossetti's works, including *Bocca Baciata* (no.119) and *The Blue Bower* (no.126).[22] Like an actress creating a role, she 'played' Fanny Cornforth, both in Rossetti's paintings and in a memorable photographic portrait (no.127). She also took the part of housekeeper in the bohemian ménage at Tudor House, Chelsea, where Rossetti and Algernon Charles Swinburne lived during the 1860s, accompanied by a veritable menagerie, human and animal, which included at various times a wombat and a Canadian woodchuck – a scene affectionately caricatured years later by Max Beerbohm (fig.3).

From a different part of the social spectrum was the photographer Julia Margaret Cameron (1815–79), a highly respectable, though hard-up, member of an imperial family newly returned

from Dimbola, their tea plantation in Ceylon (now Dimbula, Sri Lanka). She knew many of the Pre-Raphaelite circle and photographed some of them. She corresponded with Rossetti, of whom she was a fervent admirer. Cameron's response to Pre-Raphaelite imagery rejected the all-over razor-sharp clarity of daguerreotypes. In her hands the wet collodion negative and albumen print, the primary photographic process in use by the mid-1850s, became a subtly textured medium, allowing the smudges, blots and imperfections of her method to play a role analogous to the rich, painterly style adopted by Rossetti in the 1860s. Many of Cameron's finest works (nos.128–9) are exquisitely lit and modelled single heads, offering a photographic response to paintings such as Rossetti's *Bocca Baciata* and *Blue Bower*, and substituting female agency for the dominant male gaze. Cameron's distinctive refashioning of Rossetti's idiom defied convention in two important ways. Her work asserted both that photography belonged among the fine arts and that women could succeed as creative artists.

Capital of the nineteenth century

Pre-Raphaelitism was the distinctive product of a particular place and time. London was, in many ways, the capital of the nineteenth century. The city lay at the heart of an unprecedented global web of trade and communications, and of an empire that covered a quarter of the world. The census of 1851 recorded that the population of the London area was 2,650,939; in the same year over six million people, from all over the world, visited the Great Exhibition of the Works of Industry of All Nations at the Crystal Palace in Hyde Park, many of them also seeing Pre-Raphaelite paintings on the walls of the concurrent Royal Academy exhibition and reproduced in the pages of the *Illustrated London News*.[23] The railways formed great arteries for the movement of people and goods into and out of the capital. London's docks saw a massive volume of trade, while the stock exchange was the epicentre of the world economy. The visual sphere, too, was undergoing a revolution. The speed of production and distribution of mass-produced images via the steam press was only one aspect of an expanding image economy.

The most formidable manifestation of steam power was found in the large-scale manufacturing industries based in the midlands and the north. The mill owners, 'Captains of Industry', who for Carlyle were 'virtually Captains of the World', provided a key patron-group for the Pre-Raphaelites.[24] Whereas in France ambitious painters could seek support from the state, the Pre-Raphaelites looked for patronage from the newly prosperous and confident industrial middle class of mid-Victorian England, often more progressive in outlook than the aristocratic and professional collectors of earlier generations. Rossetti developed a network of private patrons and rarely exhibited his work

after the mid-1850s. Many Pre-Raphaelite paintings, however, were sold on the open market and purchased off the walls of exhibitions like that of the Royal Academy.

One of the earliest Pre-Raphaelite patrons was Thomas Combe, printer at the Clarendon Press in Oxford, who had become wealthy largely through the sale of Bibles to a worldwide public. With a hint of condescension, Stephens compared him to 'the class of merchant princes, as in Florence of old, aiding their own native art, and with characteristic common sense, [who] inquired the sterling *meaning* of a picture before he bought one'.[25] Among the most prescient Pre-Raphaelite patrons was Thomas Plint, the Evangelical stockbroker of Leeds who assembled a lustrous collection of Pre-Raphaelite works before his untimely death in 1861. He bought or commissioned Millais's *Christ in the House of His Parents*, Hunt's *Finding of the Saviour in the Temple*, and Brown's *Jesus Washing Peter's Feet* and *Work* – paintings brought together again in the section titled 'Salvation' in the present exhibition. These images seemed to enact Plint's proselytising belief in 'the *moral* religious element *at work*'.[26]

Perhaps the most influential of all Pre-Raphaelite patrons was Thomas Fairbairn, the very personification of the ambitious Victorian industrialist, who purchased *The Awakening Conscience* and commissioned from Hunt portraits of himself (no.110) and his wife and children (no.109). Fairbairn, who inherited from his father a thriving engineering business, was also a pioneer of the design reform movement and a key figure in the transformation of Manchester into a cultural as well as an industrial and commercial centre. He was centrally involved in a bitter industrial dispute, a direct test of strength between capital and organised labour, in which a cartel of Manchester employers united to overcome the fledgling union, the Amalgamated Society of Engineers.[27] Under Fairbairn's leadership the union was defeated after a lock-out of four months, which reduced the workforce to starvation. It seems unlikely that Fairbairn would have sympathised with Ruskin's radical analysis of industrial 'slavery' or with the 'certain socialistic twinge' experienced by Brown, who was later involved in setting up an employment bureau in Manchester.[28] The patrons of Morris & Co. – mostly oblivious of William Morris's increasingly radical beliefs – were also largely drawn from the suburban and provincial bourgeoisie.

Mid-Victorian prosperity supported a boom in the art world with vastly increased sales. Individual works sold for unprecedented sums: Hunt was able to secure £5,500 for *The Finding of the Saviour in the Temple*. The popular market for reproductive engravings and photographs, too, offered rich rewards. Millais achieved great wealth and high social status not only from the sale of original oils but also from smaller-scale watercolours after their compositions, copyright payments from engraved reproductions and unceasing portrait commissions. Other Pre-Raphaelites were less successful: the uncompromising and

often tactless Brown, in particular, struggled to make ends meet for much of his career.

Pre-Raphaelite paintings became prominent through various forms of reproduction and through public exhibitions. The short-lived Hogarth Club (1858–61), an independent society of artists, held semi-public exhibitions that included much Pre-Raphaelite work. Millais remained largely loyal to the RA, where even his most provocative early paintings had been prominently shown. He quickly rose to the rank of Associate (1853) and Academician (1863), and after being awarded a baronetcy in 1885, became President shortly before his death in 1896; his ascent from PRB to 'PRA' – President of the Royal Academy – was widely noted. Hunt preferred to exhibit major works as single pictures in well-publicised exhibitions such as that for *The Finding of the Saviour* in 1860. In 1865 Brown organised a private one-man retrospective with *Work* as its centrepiece. Advertisements were placed in railway stations, and the show garnered excellent critical attention but few sales.

In addition to the RA, there were many large public exhibitions outside London that followed on the heels of each other, with the transport of works to the north, to Edinburgh or abroad made possible, and secure and fast, by the spread of the railways. The Pre-Raphaelites were admired and purchased at exhibitions of the Liverpool Academy and in other regional venues. Although there was no display of paintings at the Great Exhibition, the Art Treasures of Great Britain exhibition at Manchester in 1857, spearheaded by Thomas Fairbairn, included a significant selection of Pre-Raphaelite works, many of them (including *The Awakening Conscience* and *Autumn Leaves*, no.117) lent by local collectors. In 1862 the International Exhibition at South Kensington included a display of the newly formed Morris, Marshall, Faulkner & Co.'s productions in the decorative arts, bringing them before a large public. Burne-Jones and Rossetti both shunned the large popular exhibitions, but when the Grosvenor Gallery opened on Bond Street in London in 1877 – an exquisitely appointed, aristocratic palace of art to counter the RA's department-store atmosphere – Burne-Jones's works took pride of place, along with select portraits submitted by Millais. The new museums of the industrial cities – Liverpool (opened in 1877), Manchester (1882), Birmingham (1885) and Newcastle (1901), in addition to the National Gallery of British Art established by Henry Tate in London (1897) – quickly assembled the best collections of Pre-Raphaelite work. These galleries are the major lenders to the present exhibition. As with other avant-garde groupings, the Pre-Raphaelites relied on a small cadre of sophisticated and sympathetic patrons, but ultimately their work circulated within the larger art market, whose success was predicated on the economic prosperity of Victorian Britain.

The Pre-Raphaelites also participated in the emerging global art scene through the presence of their works at international exhibitions, ranging from Paris in 1855, 1867, 1878 and 1889 to Chicago in 1893. In the United States, where a touring exhibition of Pre-Raphaelite paintings had been displayed in Boston and New York as early as 1857, the example of Pre-Raphaelitism gave rise to a new school of painting with its own journal, *The New Path*.[29] Familiar and influential across Europe, Pre-Raphaelitism seems to have had a particularly strong following in Poland, Central Europe and Russia, but more research is needed on such international responses to the movement.[30]

Pre-Raphaelite Aesthetes

The PRB disintegrated by 1853, and its members followed independent careers. With the exhibition of *Autumn Leaves* in 1856, Millais, the group's most prodigiously talented painter, established a benchmark for modern images of a subjectless nature, lacking a clear narrative or concise meaning. It was the initial step towards a further rethinking of the aesthetic potential of art, and it was accompanied by a loosening of the precise painting techniques of early Pre-Raphaelitism. W.M. Rossetti wrote at the time that with this picture, 'Millais is confirming himself in the tendency to paint with greater breadth, and more for distant effect; but, if he keeps up the standard of the *Autumn Leaves*, I conceive this to be still Praeraphaelitism, and perfectly legitimate.'[31] For Millais it was a natural evolution, and maturation, into a new mode of imaginative realism in his art, which would deeply influence later Victorian painters as various as John William Waterhouse (1849–1917; figs.27–8) and John Singer Sargent (1856–1925).

At the same time Rossetti, increasingly reclusive, became the centre of another unorthodox grouping of artists and poets. During this period he created a series of intimate oil paintings in which he pursued 'beauty for beauty's sake'. He embraced a range of historical exemplars, notably the painterly style of Venetian art from *after* Raphael; he became interested in Japanese ceramics; and, above all, beginning with *Bocca Baciata* in 1859, his work pursued a fleshly and eroticised ideal of beauty. This marked departure from the chaste ideals of early Pre-Raphaelitism shocked Hunt, who detected in it 'gross sensuality of a revolting kind, peculiar to foreign prints' – a reference to pornography.[32] Rossetti's works became a keystone of the British Aesthetic movement, passionately collected by a circle of devotees and, especially after the posthumous retrospective exhibition of his works at the Royal Academy in 1883, widely influential on British and European painting.

Rossetti and Brown joined the young poet and designer, Morris, and the painter Burne-Jones in an inventive scheme to reform the decorative arts through newly simplified designs inspired by medieval European and, later, Islamic examples, many of which were available in the new South Kensington Museum. The group rejected mechanical production and revived

traditional craft techniques in a radical move paralleling that of early Pre-Raphaelite paintings that emulated the processes of early Renaissance art. Morris, Marshall, Faulkner & Co., formed in 1861, was based on the ideal of a workshop organised along medieval lines. All the artists contributed designs, as did the architect Philip Webb, and the Pre-Raphaelite project of reforming the present with reference to the past took on a new life. Rossetti, Morris and Burne-Jones had already begun painting elaborate designs on the surfaces of furniture, after the manner of Renaissance *cassoni* (marriage chests). *The Prioress's Tale Wardrobe* (no.54), made by Burne-Jones as a wedding present for William and Jane Morris, eliminates the boundaries between fine and decorative art, creating an object that is avant-garde and medievalist at the same time, as well as aesthetic and functional. Morris, meanwhile, pioneered the revival of embroidery, tapestry, block-printed textiles and hand-printed books, and carried Victorian stained-glass making to new heights. Some of the idealism of the project had to be sacrificed in order to make 'the Firm' financially viable, and by the late 1870s Morris had become convinced that the radical analysis of society found in Ruskin's *Stones of Venice*, and shared by Brown since the 1850s, could only take effect through major political change. Well versed in the ideas of the French theorist Charles Fourier (among the first to use the term 'avant-garde' in his political writings of the 1830s) and Karl Marx, by 1882 Morris had become a committed socialist, who saw his literary, aesthetic and political activities to be inextricably intertwined. His prose work, *News from Nowhere* (no.151) is a utopian fantasy in which the post-revolutionary, egalitarian Britain of the twenty-second century (it is set in the year 2102) revives the bright colours, communal institutions and hand technologies of the Middle Ages – a Pre-Raphaelite vision of the future. In Morris's invention Ruskin's industrial 'slavery' of Victorian Britain is a thing of the past.

Perspectives on the Pre-Raphaelites

Each generation has reinvented the Pre-Raphaelites in its own image. The early history of Pre-Raphaelitism is remarkable for having largely been written by its members.[33] Towards the end of the nineteenth century Hunt began to write memoirs, which he eventually published in 1905 as *Pre-Raphaelitism and the Pre-Raphaelite Brotherhood* and intended as a definitive history of the movement. The text is filled with detail available only to a protagonist, but Hunt was determined to emphasise his own and Millais's achievements at the expense of Rossetti, Brown, Burne-Jones and Morris. William Michael Rossetti, by contrast, produced a large corpus of memoirs and edited documents, emphasising his elder brother's pre-eminence, an argument largely supported by the other writer who had been a member of the

PRB, F.G. Stephens. The old struggle between realism and revivalism resurfaced in controversies over Pre-Raphaelite legacy. As late as 1895, Hunt wrote to Millais just before the latter's death:

> You may have more or less noticed that the press whenever it talks of Preraphaelitism attaches the word to what Rossetti did with his extreme mannerism of his last days, and to what Burne Jones does now, which is treated as tho' it were ultra refined P-Rism ... [Stephens] never did understand what PR-ism meant, but believed that instead of being a real attempt to go back to healthy nature, as you and I did in all our pictures, it was an attempt to revive gothicism as Herbert, Dyce, and others, including Brown, were doing, and as Rossetti in his own sensuous not to say sensual manner did, as far as he was able, for he was at the end only an amateur ... You probably care as little about the mere credit of having begun this attempt with me to reform art, but you will have at least my amount of interest to prevent the world from thinking that our philosophy was on a level with Pusey's, and that of other revivalists.[34]

This exhibition aims to demonstrate that in the creative tension between the idiosyncratic realism of Hunt, Millais and Brown and the poetic freedom of Rossetti and Burne-Jones lies the dynamic force of Pre-Raphaelitism as an avant-garde movement.

Elizabeth Prettejohn charts the twentieth century's response to the Pre-Raphaelites in her essay in this volume, noting, against received opinion, that Pre-Raphaelitism never really disappeared from sight during the twentieth century. The modern exhibition history of the movement began with a revelatory reassessment of Brown mounted by Mary Bennett at Manchester in 1964, followed by full-scale retrospectives of Millais (1967), Hunt (1969), Rossetti (1973) and Burne-Jones (1975). These exhibitions won popular and critical acclaim in the 'swinging '60s' and psychedelic early 1970s: audiences found resonances with the Rossettian avant-garde, with even the clothing and hair in works by Rossetti and Burne-Jones seeming to mirror Carnaby Street. These exhibitions culminated with the Tate Gallery's magnificent and encyclopedic *The Pre-Raphaelites* in 1984, an exhibition of paintings, drawings and sculpture, excluding photography and the decorative arts and with a very limited number of works from after 1860. It charted, in more detail than ever before, the interaction between a broad range of artists in the movement and the chronological development of Pre-Raphaelitism. But it was circumspect, even timid, in the claims it made. History, moreover, had moved on. By 1984 Britain had endured a painful recession and race riots, and was in the middle of the miners' strike, a power struggle perhaps recalling Fairbairn's campaign against the Amalgamated Society of Engineers in 1851. The government was openly advocating a return to 'Victorian values' as a rejection of the 'permissive society' of the 1960s, while

commercial companies like Laura Ashley co-opted Morris-like designs as suburban lifestyle choices rather than expressions of countercultural rebellion. In particular, the presence of the Prime Minister, Margaret Thatcher, at the opening of the exhibition on 28 March 1984 seemed to symbolise a newly conservative reading of the Pre-Raphaelites (fig.4).[35] A contrasting account of the movement was offered by a wide-ranging exhibition titled *William Morris Today*, on display at the Institute of Contemporary Art in London at the same time. With contributions by leading thinkers of the left, such as E.P. Thompson and Raymond Williams, it celebrated Morris as a father of English socialism.[36]

The Tate exhibition in 1984 turned out to be a beginning rather than an end, just as the Thatcher era was a formative moment for contemporary art in London: *Freeze*, the breakthrough exhibition of the 'young British artists', took place in July 1988. By placing an unprecedented wealth of Pre-Raphaelite art on show with a thorough and informative catalogue, *The Pre-Raphaelites* made a major contribution. For a new generation of museum visitors – including the authors of this book – the exhibition and related publications were revelatory, opening up the potential for new analysis and interpretation. In a significant review the feminist art historians Deborah Cherry and Griselda Pollock took issue with the curators' biographical, rather than thematic, approach to art history and the patriarchal account of gender relations they appeared to endorse.[37] A collection of essays edited by Marcia Pointon in 1989, *Pre-Raphaelites Re-Viewed*, noted the exhibition's reluctance to address 'cultural politics' – particularly issues of class, gender and religion, but also questions of technique, which have recently returned to the centre of scholarship in the field – and turned a refreshing, deconstructive gaze on the mythologies surrounding the Pre-Raphaelites.[38]

Since 1984 there has been a dramatic expansion of critically engaged Pre-Raphaelite scholarship. New studies of Millais (Barlow, Goldman, Rosenfeld), Hunt (Bronkhurst, Jacobi), Brown (Bennett, Bendiner), Rossetti (Prettejohn, Marsh, McGann, Bullen), Morris (MacCarthy, Arscott) and Crane (O'Neill) have emerged in parallel with thematic publications, including new accounts of painting techniques (Townsend, Hackney and Ridge), Pre-Raphaelite religious painting (Giebelhausen), questions of labour and class (Barringer), and Aestheticism (Prettejohn, Staley). There has been a new generation of important monographic exhibitions: Siddall (1991), Morris (1996), Burne-Jones (1998 and 2009), Rossetti (2003), Solomon (2005), Dyce (2006), Millais (2007), Hunt (2008) and Brown (2011). And in addition to publishing important catalogues of the major Pre-Raphaelite collections, museums have explored significant related themes, including the influence of Pre-Raphaelitism on American art (1985); Pre-Raphaelite patrons (1989); Pre-Raphaelite sculpture (1991); the Grosvenor Gallery (1996); Pre-Raphaelite women artists (1997); Pre-Raphaelitism within

Fig.4 Margaret Thatcher visiting *The Pre-Raphaelites* exhibition at the Tate Gallery, 1984, accompanied by Leslie Parris and Peter Palumbo. Tate Archive

Victorian art (1997); Rossetti, Burne-Jones and Watts, and British Symbolism (1997); Millais's portraits (1999); Turner, Ruskin and the Pre-Raphaelites (2000); Pre-Raphaelite landscape (2004); the Pre-Raphaelites and Italy (2010); Pre-Raphaelite photography (2010); the Aesthetic movement (2011); and Pre-Raphaelite drawing (2011). A well-conceived Pre-Raphaelite survey, including the fine arts, photography and decorative arts, was mounted in Stockholm in 2009.

A thematic survey of Pre-Raphaelite creativity in multiple media over five decades, this exhibition and publication intend to produce a new account of the whole movement, drawing together the revisionist ideas of recent decades. The organisation is thematic within a broadly chronological framework, allowing focus to be placed on the formal qualities and the meaning of works in the context for which they were produced, rather than on the development of the style or career of the individual artist.

The aim in placing as comprehensive a collection as possible of Pre-Raphaelite art before the public in London, Washington DC, Moscow and Tokyo is to engage a wide audience, stimulate new research from scholars and perhaps spark further responses from artists, who are well placed to interpret the disrespectful, vibrant productions of the youthful rebels of 1848. Certainly, Pre-Raphaelite art-making resonates vividly with the art and culture of the present day. The emphasis on complex and unresolved narrative, on social commentary, on aspects of gender, sexuality and desire, and on race, empire and travel; the dialogue with photography and mechanical image-making; the questioning of conventional values, accepted concepts and canons of beauty; the relationship of current art-making to the art of the past; and issues of appropriation and synthesis: all these are preoccupations in the art and culture of our own turbulent times that were vividly explored by the Pre-Raphaelites, the Victorian avant-garde, at the moment of the inception of modern society.

MEDIUM AND METHOD IN PRE-RAPHAELITE PAINTING

Alison Smith

For the Pre-Raphaelites, artists' materials and the expectations that went with them became a way of constructing meaning in their work. Looking back to earlier art was central to their avant-garde project, and the adoption of historical technical processes accordingly became an important means through which they set about asserting their identity in the present. As students, they found the methods taught by the Royal Academy to be debased and irrelevant for what they wanted to achieve. Thus they rejected the more traditional and academic methods of 'dead-colouring', or underpainting in earth tones to establish the darker areas of a composition, and chiaroscuro, used to define broad areas of light and shadow and to establish key and subsidiary areas within a picture. Also abandoned were the academic technique of 'facture', or conspicuous brushwork, to convey texture, and the merging of tone to harmonise the disparate elements of a design. Instead, they took inspiration from the emerging and more marginal practices of the time: the most striking of these was the novel daguerreotype process resulting in sharp photographic images with glassy luminosity. Another important influence was the watercolourist's technique of applying local colour in small touches, like pixels on a white prepared ground, used by the established Victorian artists William Henry Hunt and J.F. Lewis.

Above all, the Pre-Raphaelites deferred to pre-Renaissance art, taking inspiration from miniaturist techniques employed in medieval manuscript illumination, the smooth clear colours found in Italian and Flemish quattrocento tempera and oil painting, and the reflective brilliance of early stained glass. They saw these methods as formally pure and, consequently, thematically moral: essentially clean when compared to the mucky medium of oil, as practised by European Baroque masters such as Annibale Carracci, Rembrandt van Rijn and Peter Paul Rubens, and upheld within the Royal Academy. In looking to art forms that thrived beyond the RA's influence and approval, they produced works of astonishing visual originality and effect, each distinguished by a sharp focus, the use of pure, unmixed colours, and attention to detail across the surface.

In its revolutionary use of colour Pre-Raphaelitism did not, however, represent a complete break with mainstream practice. The artists took advantage of certain developments within contemporary art, in particular the idea of preparing a canvas with a white ground to heighten colour. This was a method adopted extensively by artists such as J.M.W. Turner and the ambitious Irish genre painter William Mulready, as well as by William Dyce and the fresco revivalists working on the new decorations of the Palace of Westminster in the 1840s. Significant support for the use of white ground was found in Sir Charles Eastlake's translation of Goethe's *Theory of Colours* published in 1840.[1] More generally, the interest in the techniques used by early Renaissance painters was encouraged by publications such as Mary Philadelphia Merrifield's 1844 translation of Cennino Cennini's fourteenth-century *Il Libro dell' Arte* and her *Original Treatises ... on the Arts of Painting* of 1849. In the former Merrifield recommended the purity and permanence of the pigments manufactured by the theorist and artists' colourman George Field as the closest approximation to those used by early Italian painters, a point that would not have been lost on the Pre-Raphaelites who were regular users of Field's pigments.[2]

However, the Pre-Raphaelites went further than their contemporaries in their use of brilliant colour. This had a dramatic effect at public exhibition, where the Pre-Raphaelite paintings were accused of 'killing' all surrounding works with their jarring strident hues, an accusation earlier levelled at Turner. The assault on the eye presented by their paintings has not diminished much over time despite fading of small numbers of the pigments employed. In Millais's *Ophelia* (no.69), for instance, the chromatic pitch would have been even higher when the picture was first exhibited, due to the yellow gamboge used in the sunlit, nearer riverbank and to the mixing of that pigment with blue for the background leaves, which faded during the course of the artist's lifetime. The more obvious result is that these background leaves now appear much bluer than they originally would have been.

In achieving their brilliant iridescent effects, the Pre-Raphaelites evolved a particular way of working. Panels were sometimes used, as with Millais's *Mariana* and Brown's '*Pretty Baa-Lambs*' (nos.35, 67), but more often a canvas support on a stout stretcher, as for Rossetti's *Girlhood of Mary Virgin* (no.24), which is on a fine-weave canvas so smooth that the work was wrongly described by William Michael Rossetti as being 'Painted on panel'.[3] Although the Pre-Raphaelites often purchased canvases from suppliers or colourmen such as Roberson or Brown of High Holborn, firms that had a reputation for high-quality supports, it was not unknown for them to customise their supports with an additional white *imprimatura* layer, often of zinc white, so that the ground took on what Hunt called a 'stone-like hardness', as well as a fresh, white and grime-free appearance.[4] Rossetti was in fact the first to apply his own

additional ground of lead white for *The Girlhood of Mary Virgin*, but Hunt and Millais soon took up the practice using zinc white in oil as an extra priming layer for *Valentine Rescuing Sylvia from Proteus* (no.34), *The Hireling Shepherd* (no.70) and *Ophelia*. Whereas lead white was known to turn yellow over time, zinc white (an industrial product that first became widely available from the later 1840s) offered a bluer, more intense white. It allowed the Pre-Raphaelites to exploit the brightness of the ground by maintaining transparency in the application of subosequent layers of paint.[5] At all costs they wanted to avoid the soft effect caused by painting into a mid-toned ground but aimed to establish evenness of colour and tone across the picture surface to achieve an advantage in the display of dazzling colour at public exhibition. Brown thus advised the portrait painter Lowes Cato Dickenson in 1851: 'As to the pure white ground, you had better adopt it at once … for Hunt and Millais, whose works already kill everything in the exhibition for brilliancy, will in a few years force everyone … to use their methods.'[6]

The absence of dead-colouring explains why the Pre-Raphaelites would have had to draw directly on the white-primed canvas in graphite pencil to map out their compositions. They would then apply paint in mosaic patches as a single thin layer

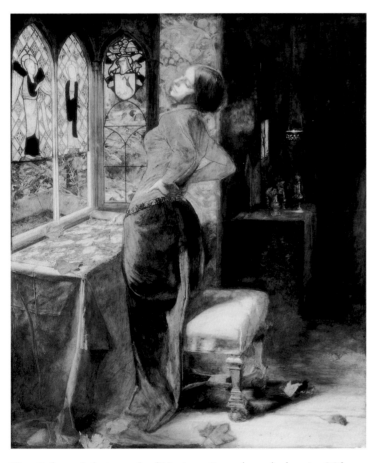

Fig.5 Infra-red photograph of *Mariana* 1850–1 (no.35), showing Millais's confident drawing with no hesitation or alterations.

of pure, mainly unmixed colour, with no glazing and the minimum of facture. This method accentuated luminosity by allowing the ground to remain visible through the thick yet transparent paint layers, for which the artists employed sable brushes typical of watercolour, not the squirrel or hogshair customarily used for oil. Their emulation of watercolour techniques is further evidenced by the tendency to leave the white ground untouched or reserved in places so it could assume a particular shape, as with the distant white horse in Hunt's *Valentine Rescuing Sylvia from Proteus*. The artists also adopted the miniaturist practice of hatching in fine strokes for flesh, Millais being particularly adept in this technique, as seen in the faces in *The Order of Release, 1746* (no.40), a composition for which he also exploited the angle of the brushstrokes to create the twill weave in the man's kilt and the child's tartan smock.[7] Although time consuming, the methods used were not particularly complicated, but pure and simple in keeping with Pre-Raphaelite ideology, the aim being to respect the material nature of each object represented, as seen in the sewing thread in both *The Girlhood of Mary Virgin* and *Ecce Ancilla Domini!* (no.87), formed through the application of gold over green underpaint with hatched lines to lend texture.

In making their pictures, the Pre-Raphaelites favoured transparent pigments such as emerald green and cobalt blue, both relatively new colours, as well as the more traditional rose madder, ultramarine and gamboge (a transparent yellow). It was not the newness of the pigments that mattered: in fact the artists prided themselves in being traditional in their use of materials and methods, continuing to use oil paint bladders, rather than immediately opting for the collapsible metal tubes patented in 1841, and frequently combining ultramarine with madder to make purple (as seen in Arthur Hughes's *April Love*, no.43). Even after 1859 they did not use the newly available cobalt violet. What was different, however, was their concern to maintain the pitch of colour throughout a composition, and to achieve this goal, they sometimes used white porcelain palettes for preparing their paints to emulate the white grounds on which they laid them. The artists also regularly adopted copal-based vehicles for binding their pigments in preference to a thinned oil one. They found copal, a tree resin used for high-quality durable varnish, to be glossier on drying and capable of forming a thick layer in one application of the brush, thus giving an intense coloured glaze in just one layer, rather like stained glass. It was also good for using out of doors since it formed thick, tacky paint that was easier to transport wet than drippy, thinned oil paint.[8]

An important innovation was the practice of painting with transparent colour onto discrete areas of wet ground to heighten luminosity. According to Hunt, this method was first utilised by himself and Millais for sunlight effects, enabling them to move beyond the linearity of their early work and to repair and repaint

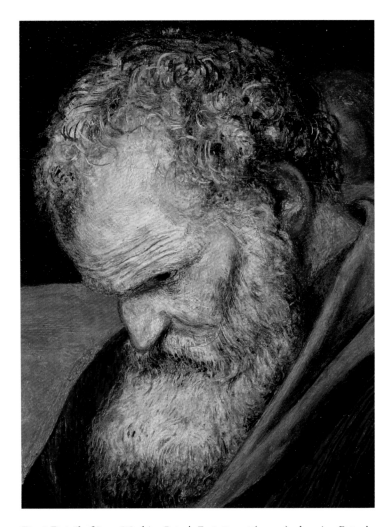

Fig.6 Detail of *Jesus Washing Peter's Feet* 1852–6 (no.93), showing Peter's head, purported to be painted on a wet white ground.

scraped areas without the loss of luminosity.[9] Hunt describes the method in great detail in his memoir in relation to the heads of Valentine and Proteus in *Valentine Rescuing Sylvia from Proteus*, making clear the analogy with fresco painting where the fresh plaster (*intonaco*) is applied at the onset of each day's work (*giornata*) and worked into with pigments when still wet.[10] Unlike the Impressionists who aimed at dissolving form through the rapid application of pure and regulated touches of colour, the Pre-Raphaelites worked slowly to establish form, according equal weight to both illuminated and shadowed recessed areas. Although the practice of building up a composition in sections like a jigsaw puzzle was clearly an acknowledgement of pre-Raphaelite or early Italian methods, it was a risky, somewhat perverse strategy in that it introduced the possibility of colours acquiring a pastel appearance by mixing with the wet white, or muddy if they became grimy by attracting dirt. Such was the case with Brown when he tried the technique 'on Millais's lying instigation' for the principal figures and the crimson cloth on which Christ kneels in *Jesus Washing Peter's Feet* (fig.6), a not altogether successful attempt, as seen in the rather streaky

application of paint in these areas.[11] Despite its risks, the method was capable of achieving brilliant results if the artist got it right – as, for example, in the red reflections and effect of sunlight streaming though the loose threads of Proteus's hair in no.34.

Although the wet-ground technique was limited in that it dictated how much work an artist could complete in a session, its great advantage was in maximising the optical impact of a white ground. Rather than the painted object possessing a fixed local colour, different areas of colour would be placed close to one another on the surface so that they would fuse on the retina once the spectator stepped back from the picture, as later seen in avant-garde paintings by the Neo-Impressionists in France, led by Georges Seurat. Hunt and Brown were probably the greatest experimenters when it came to representing the optical effects of simultaneous contrast, as seen in the use of complementary colours for the wool of the sheep in *Our English Coasts, 1852* (no.71), where blue and lilac are placed next to orange and yellow, and in the mauve shadows on the faces of the mother and child in 'The Pretty Baa-Lambs', where the illuminated areas are literally bleached by the sun. In the latter work Brown set out to represent the optical illusion of an after-image, using the unconventional juxtaposition of an emerald green glaze for the cavity of the woman's mouth against the madder of her lips and cheeks. This startling contrast is only noticeable on close inspection; from a distance the effect appears natural and correct, suggesting an intuitive understanding on Brown's part of the laws of simultaneous contrast being advanced by the pioneering French chemist Michel Eugène Chevreul around the same time.[12]

The Pre-Raphaelites' original aim of subsuming individual identity within an overarching artistic goal began to collapse around the late 1850s as each artist evolved a more personal and what might be termed post-Raphaelite working procedure.

This change was accompanied by a shift towards opacity in the way the artists used their pigments. *Autumn Leaves* (no.117) marked a turning point for Millais in this respect, with soft gradated, *sfumato* modelling used to suggest ambiguity in facial expression. The more painterly execution and uneven areas of focus in this work anticipate Millais's mature productions, which are drawn in less detail on canvas and grander in scale, the paint applied with larger brushes and interlaced with varnish to create an active surface that matched the vitality and energy that Millais wanted to express in his sitters and landscapes (see no.162). The act of painting itself became more physical. Instead of crouching close to the canvas, Millais would move back and forwards, checking each stroke of the brush against the subject in hand.

Of all the artists associated with the PRB, Hunt remained most committed to the early principles of the movement, becoming increasingly obsessed with the permanence and stability of his pigments, the sturdiness of his supports (for which he sometimes used blind stretchers with panels slotted in between the stretcher parts to protect the back of the canvas, as with *The Triumph of the Innocents*, no.169) and perfecting his compositions through endless scrapings and revisions. There had been an element of risk in the early paintings of the PRB in that the youthful, confident artists had no guarantee that their methods would endure with the passing of time. Hunt made it his mission to ensure that they would: he inscribed notes about his original painting methods and materials, and any subsequent restoration, on the unpainted spandrels of the pictures he later came to rework, such as *The Awakening Conscience* (no.98), and engaged in long and bitter disputes with colourmen over manufactured pigments that he believed were inferior to those used in early PRB productions, particularly the vermilion colours that had been made by Field.[13] Hunt also recommended that his works be covered with glass to protect what the art historian Carol Jacobi calls the 'smooth unbroken skin of his aesthetic'.[14] This practice echoed his idea that a painting should appear like a mirror or a window onto the world. As with Millais, Hunt veered towards opacity in his mature works, as seen in the denser application of paint in *Il Dolce far Niente* (no.121) and in the background of the *The Triumph of the Innocents*. Working on a large scale militated against the continued use of the wet-white ground technique, which would have been too time consuming. Instead, Hunt encouraged the process of using a stone-coloured ground and, in an inversion of early Pre-Raphaelite procedure, would also lay figures in first before working up the background with large brushes. W.M. Rossetti described how Hunt employed brushes of great length for *The Shadow of Death* (no.112), which allowed him to stand back from the canvas as he synthesised each mark into the general design.[15] In Hunt's case the quest for strength and durability relates to the steadfastness of his

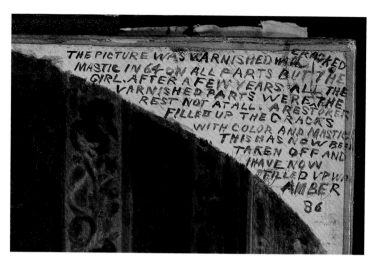

Fig.8 Right spandrel of *The Awakening Conscience* 1853–4 (no.98) with Hunt's notes about its restoration.

religious beliefs and his determination to fix meaning in the material substance of paint itself.

Rossetti had been unique among the PRB in abjuring oil paint, after his initial experimental works in the early phase of the Brotherhood. Instead, throughout the 1850s he opted to use watercolour, finding it less intractable than oil and better suited for a smaller scale. His decision to work almost exclusively on paper was also prompted by his practice as a writer, encouraging a close reading of details and symbols as if they represented poetic form in paint. Rossetti's unique watercolour system can be seen at its finest in his chivalric paintings of 1857 (see nos. 46–8). Bought by William Morris, they present an imaginative vision of the past with their rich decorative surface patterns and vibrant prismatic colours influenced by the medieval illuminated manuscripts Rossetti so admired. Although Rossetti used the favourite Pre-Raphaelite pigments – blue ultramarine, emerald green and rose madder – he added to these his own gum solutions and varnish to deepen tone in selected areas with the aim of modifying the aqueous properties of the watercolour medium. *The Tune of Seven Towers* (no.47) is typical of his practice in being conceived as a solid object. To strengthen the support, the medium-wove paper was sized with glue to withstand vigorous working with the brush and then lined on to a similar paper, before being attached to unprimed canvas and wrapped around a stretcher. Two extra strips of paper were added to the sides after Rossetti had begun the central figure when the composition outgrew the support, an additive process he often used in his watercolours, most works disclosing similar butt joins at the edges. Technical examination of this work carried out in 1993 revealed how the artist applied paint in a counter-intuitive way, rubbing in dry colour first and then building up forms with tiny strokes.[16] Rossetti used a range of techniques to create whites: the yellow hatching on the seated woman's red gown is

counterbalanced by scraping through or reverse-hatching in other areas, notably the wall hanging on the right, to lend detail and vibrancy to the surface. Rather than using scratching-out to register white, in this instance Rossetti applied lead white for the veil, sleeve and skirt trimming of the central woman in red. This has since discoloured, probably due to atmospheric pollution from coal-burning, thereby undermining the original role of white in accentuating the flickering patterns of colour across the composition. It seems that Rossetti, in comparison with Hunt, cared little about the permanence of his colours, delighting rather in their immediate brilliance.

Rossetti also differed from the other Pre-Raphaelites in that he used the colour and texture of his paint to direct the viewer's attention away from any purported external world. Instead, colour, line and pattern were exploited to evoke texture and sound in a form of synaesthesia, as if the artist were making a direct appeal to the viewer's aural imagination. This helps explain why *The Tune of Seven Towers* and *The Blue Closet* (no.48) inspired Morris to write sonnets, thereby extending the idea of correspondence across media, which was reinforced by these pictures' relation to the heavy furniture, decorative ceramic tiles and embroidered wall hangings produced by Morris and his associates at Red Lion Square around the same time (see nos.54, 135, 136).

Towards the end of the 1850s Rossetti started to venture beyond watercolour as he, like the other Pre-Raphaelites, sought a more monumental dimension in his art. He did not forsake all aspects of his earlier practice, retaining for instance a tendency to expand his canvases in a piecemeal fashion. The oil painting *Beata Beatrix* (no.124) thus comprises six pieces of canvas to allow space around Beatrice's hands as well as for the distant background. Recent analysis of the paint surface reveals that Rossetti was not so meticulous a craftsman as his peers, being more interested in the idea behind a work than its actual execution; Holman Hunt described him as 'at the end only an amateur'.[17] This explains the unfilled gaps in the white preparatory layer of *Beata Beatrix* and the bits of studio debris and brush hairs trapped within the paint surface. In his memoir of 1931, *Time Was*, the painter and connoisseur W.G. Robertson, like Hunt, recalled the self-conscious 'amateur' aspect of Rossetti's technique, describing his horror on encountering a painting by the artist at public exhibition that struck him as marred by 'distorted drawing' and 'tortured "gormy" paint'. Yet Robertson also goes on to say how the image returned to haunt him with its beautiful presence, a revelation that led him to conclude that the essence of a picture lay in its idea, not its final appearance: '[T]he mental photograph, taken during that momentary stance, should be that of the picture that might have been instead of the picture that was.'[18]

Rossetti's opaque and hermetic form of watercolour painting,

and even the avowedly 'amateur' aspects of his practice, became the inspiration for a number of untrained artists within the Pre-Raphaelite circle, such as Elizabeth Siddall and Edward Burne-Jones. However, while Rossetti composed in colour, in keeping with Pre-Raphaelite principles, Burne-Jones was (as Ruskin put it) 'a chiaroscurist': in his early works dark and sinister forms emerge from 'the dimness and coruscation of ominous light'.[19] Burne-Jones's radical use of the watercolour medium can be seen in early paintings such as *Sidonia von Bork* (no.56). For this he utilised two pieces of heavy cartridge paper wrapped around a stretcher in keeping with the Pre-Raphaelite emphasis on robust three-dimensional supports. The paint surface consists of watercolour and gouache interlaced with thin layers of gum arabic. As with Rossetti's watercolours, the application of gum at an early stage of painting rather than as a finish was unusual for the time and reminiscent of the syrupy texture that distinguished the works in tempera by William Blake, such as *The Ghost of a Flea* (c.1819–20; Tate), which together with *Sidonia* was once owned by W.G. Robertson. *Sidonia* is distinctive for its sharp contrasts of black and white. For lighter areas Burne-Jones used zinc white but restricted it to the hatching at the bottom of the witch's dress. For other areas of the coiled fabric he marked in the pattern first and then scratched heavily into the painted surface, almost as if making an engraving, the idea being to expose the underlying white paper before layering in darker lines on top in order that the snake-like configurations should writhe menacingly across the surface of the design.[20] It was later said that even so discerning a connoisseur as Laurence Binyon (Keeper of the Department of Prints and Drawings at the British Museum) was not entirely convinced that *Sidonia* was actually a watercolour, so intent had the artist been on disguising his materials to create a dark and unsettling work in keeping with the disturbing nature of the subject, the murderess Sidonia, taken from the gothic romance, *Sidonia the Sorceress*, by the Pomeranian poet Johann Wilhelm Meinhold.[21]

It is important to note that Burne-Jones was not alone in using complex mixed-media techniques at this time. For instance, Samuel Palmer, who had been influenced by William Blake's idiosyncratic techniques in printing and painting, ignored successive bans imposed by the watercolour societies on gum and varnish. But whereas Palmer's materials functioned to convey atmosphere and distance, Burne-Jones's served to reinforce the flatness and texture of paint itself. It is thus hardly surprising that Burne-Jones's early exhibits at the Old Water-Colour Society consequently met with a hostile reception from critics complaining about the artist's disregard for the specificities of the watercolour medium and the sullied nature of his surfaces. As he branched out in the 1870s to work on a larger scale in oil, he continued to adopt an experimental approach, flaunting conventional expectations of how oil paint should look as

he pursued a synergy of method across media. Robertson described how he would wilfully ignore the intrinsic nature of his medium by putting it to uses for which it was never intended: 'In water colour he would take no advantage of its transparency, but load on body colour and paint thickly in gouache; when he turned to oil he would shun the richness of impasto, drawing thin glazes over careful drawings in raw umber heightened with white; if he used pastel, it was to imitate oil.'[22]

Burne-Jones's paintings in oil thus incorporate characteristics of his earlier practice despite being conceived on a grander scale. Not only did he use dainty sable brushes for details, but he deliberately set out to deny the viscosity of the oil medium by employing dry, granular paint, to which he may have added chalk for the preparatory layer. He also rejected copal as a means to lend transparency and refused to take advantage of the white ground, painting into the still-wet *imprimatura* layer to obtain the 'muddy' effect Hunt, Millais and Brown had been so anxious to avoid. Moreover, in contrast to the smooth supports found in early Pre-Raphaelite productions, Burne-Jones used coarse canvases, which he accentuated with broken effects of scumbling – the practice of dragging paint across the surface so as to disclose the influence of the colour beneath it. Not being especially interested in natural translucent effects, Burne-Jones made it his purpose to imbue his works with a sense of solidity or hardness as if they were formed of metal. His art, as Robertson affirmed, was close to that of a jeweller's, to which end he would incise lines into the pigment, use gold mordant and fill up the spaces of his designs with various hues to make a beautiful pattern: 'Some of his pictures, the "Laus Veneris" [no.165] for instance, were like clusters of many-coloured gems or stained windows through which shone the evening sun.'[23]

Although Burne-Jones's mature work in many respects represents the antithesis of early Pre-Raphaelite practice, it should also be seen as its culmination, given that his aim was also to realise on canvas the material quality of the objects depicted, be it the gilded staircase in *The Golden Stairs* or the shot-colour draperies and heavy metal shield and crown in *King Cophetua and the Beggar Maid* (nos.168, 170). And like Hunt, Burne-Jones aspired to permanence, the durability and stability of his materials having been proven by the fact that very little treatment of these two works has been required since the time they entered the Tate collection, other than a surface clean. By using his pigments to create a sense of solidity, Burne-Jones took the lead from the Pre-Raphaelites in refuting the idea that

Fig.9 Detail of the shield and crown in *King Cophetua and the Beggar Maid* 1880–4 (no.170).

a given medium possesses intrinsic qualities to be adhered to and enhanced by the artist. Instead, he sought to determine new possibilities for his materials in close dialogue with the interiorised subjects he elected to represent. The controversy that surrounded the Pre-Raphaelites at all stages of their careers thus reveals something about the challenge their art presented at a time when the boundaries of media did matter and to reject them was both an aesthetic and an ideological commitment.

1. ORIGINS

The Pre-Raphaelite Brotherhood was founded in September 1848, towards the end of one of the most turbulent decades in British history during which ruptures in the new industrial society became clearly visible. The early works of the Pre-Raphaelites shared the rebellious, anti-establishment energy of these years. The biggest challenge to the political status quo came from Chartism, a mass working-class movement. The 'People's Charter' demanded reforms including votes for all men over twenty-one and the secret ballot.[1] On 10 April 1848 a huge Chartist demonstration gathered on Kennington Common. The authorities feared that Britain would become engulfed in a revolution like those that had spread across France, Germany and much of the continent in March 1848. Present that day at Kennington were William Holman Hunt and John Everett Millais, who would found the Pre-Raphaelite Brotherhood five months later. They witnessed modern history in the making. Hunt recalled: 'We did not venture on to the grass with the agitators, but standing up on the cross rails outside the enclosure, we could see the gesticulations of the orators as they came forward on the van drawn up in the centre of the green.'[2]

The scene was recorded by William Kilburn in a daguerreotype that captures the spectacle of the modern, urban crowd, respectably dressed and orderly, but massive and seething (fig.10). Behind is an uncompromising industrial landscape, in which a vertiginous chimney dominates vast, featureless manufactories. Kilburn's image, a stark emblem of modernity, is itself significant. Photography, announced in 1839, was already widespread by 1848, changing profoundly mankind's way of looking, and transforming the visual arts by providing a direct, permanent registration of the visible world.

At the same time intellectuals and critics had begun to question the dominant narrative of economic and social progress. Perhaps the pre-industrial world had been healthier, more peaceful, spiritual and beautiful? Had the increase in material wealth in the machine age been won at too high a cost? One of the most fervid exponents of this critique was the Catholic architect Augustus Welby Northmore Pugin, who espoused a return to the ideal of the Middle Ages – not merely its architecture but its cultural and social forms rooted in religion. In 1836 he published *Contrasts*, a wholesale critique of modern urban life, judged against the organic unity and aesthetic beauty of the medieval city. Pugin's own buildings in the gothic-revival style offered only a partial solution. Far more radical ideas emanated from John Ruskin, whose critical writings in support of Turner in *Modern Painters* were a key influence on the Pre-Raphaelites. Ruskin argued forcibly in 'The Nature of Gothic' (1853) that medieval society and its creative, pre-industrial forms of work were preferable to the 'slavery' in 'our England', where 'the animation of her multitudes is sent like fuel to feed the factory smoke'.[3] Factories, smoke and the multitude can, of course, all be seen in Kilburn's daguerreotype of the Chartist meeting. Ruskin would become the Pre-Raphaelites' most articulate and influential supporter, and their campaign to regenerate British art by reference to medieval and Renaissance precedents shared much with the gothic revival.

Discontent was also brewing in the art world. The Royal Academy, founded in 1768, had been successful in providing art education, organising annual exhibitions of work for sale and raising the status of artists in society. Portraiture and, to a lesser extent, landscape, had prospered. But the Academy had not produced a school of historical painters worthy of the British empire, as its founder Joshua Reynolds had hoped. At the beginning of the nineteenth century the radical printmaker and poet, William Blake – who became an inspiration for the Pre-Raphaelites years after his death in 1827 – had bitterly opposed Reynolds's scheme with its cultivation of rich patrons and the 'slavery' of learning by copying. The curriculum of the Academy Schools was based on drawing from casts of classical sculpture and from the nude model. Colour was learned by imitating the old masters, above all the pre-eminent Italian painter of the High Renaissance, Raphael, whose work could be seen in the recently founded National Gallery. The Gallery shared its new building on Trafalgar Square with the RA (no.22).[4] Some Academicians, such as Charles Eastlake and William Etty, worked happily within this established painterly tradition; others, such as the intellectual Scottish painter William Dyce (see no.4), the master of genre painting William Mulready and the ambitious Irish history painter Daniel Maclise, had for years been pushing at the boundaries of academic orthodoxy.

The arrival of 'primitive' works in the National Gallery's collections, such as Jan van Eyck's *Arnolfini Portrait* (1434, acquired in 1842; fig.13) and panels from Lorenzo Monaco's *San Benedetto Altarpiece* (1407–9, acquired in 1848; no.27), came as a revelation to a group of young students at the Royal Academy Schools – the future members of the Pre-Raphaelite Brotherhood. They imagined a gothic revival of painting practice, a renewal based on the purity and truth of fifteenth-century examples. Lacking the opportunity to travel to Italy, they made a close study of

published engravings of early Italian frescoes and especially prized the precise, linear representations of the late-fifteenth-century scheme by Benozzo Gozzoli from the Campo Santo (or monumental cemetery) in Pisa by Carlo and Giovanni Lasinio (fig.12). Traces of the Lasinio engravings can be seen in the early drawings of the Pre-Raphaelites – sharply inscribed with jerky gothic lines – but they were also influenced by the vibrant engravings of the nineteenth-century German printmaker Moritz Retzsch, whose idiosyncratic illustrations to Goethe and Shakespeare looked back to the German Renaissance.

A great opportunity beckoned for British artists when, following the destruction of the old Palace of Westminster by fire in 1834, it was decided to decorate with frescoes the interior of the new, neo-gothic building designed by Charles Barry and Pugin, the great polemicist of the gothic revival. A Royal Commission was headed by Prince Albert, the intellectually ambitious and idealistic consort of Queen Victoria, who had grown up in Germany admiring the extensive royal patronage of the arts in Berlin, Munich and Vienna. Albert was keen to use the opportunity to promote history painting in Britain. Regular competitions were held from 1843 onwards, and William Dyce was soon awarded a major commission.

Dyce met in Rome with a group of German artists who had seceded from academic training and who form the most significant precedent for the Pre-Raphaelite Brotherhood. Nicknamed the 'Nazarenes', they had formed a quasi-monastic brotherhood, the Lukasbrüder or Guild of St Luke, in Vienna in 1809 and moved to Rome, where they lived in a disused convent and concentrated on frescoes of religious subjects in a style derived from Raphael and other, earlier masters. Their distinctive self-presentation can be seen in Johann Friedrich Overbeck's historicising portrait of another of the Nazarenes, *The Painter Franz Pforr*, which draws elements from both Northern and Italian Renaissance panel painting (no.1).

The Westminster competitions brought back to London Ford Madox Brown, a painter who was a few years older than the Pre-Raphaelites and who, though of British origin, had been born in France and rigorously trained as a painter in Ghent and Antwerp. Brown, like Dyce, had extensive connections with the Nazarenes, whose influence is felt in his early works. Brown's key works of the late 1840s anticipate aspects of early Pre-Raphaelitism. *Seeds and Fruits of English Poetry* (no.7) began as a design for a Westminster fresco, its three main panels wrought into a whole by Puginesque *trompe-l'oeil* traceries. But when he

reworked the central panel as *Chaucer at the Court of Edward III* (Art Gallery of New South Wales, Sydney), he painted it as if from life, with the fresh colours of outdoor sunshine and a sparkling landscape setting. He would repeat this practice in his peerless modern-life paintings of the 1850s, *Work* and *The Last of England* (nos.94–5).

Brown was admired by the future Pre-Raphaelites and Rossetti was briefly his student, but Brown never joined the Pre-Raphaelite Brotherhood. Was the older painter the pioneer, even the sole inventor, of the distinctive Pre-Raphaelite style? It is impossible to say, since *Chaucer*, designed in 1845 and begun on the large canvas in 1847, was completed only in 1851, after the major early works of Rossetti, Millais and Hunt had been publicly exhibited, to a storm of critical protest.[5] TB

Fig.10 The Chartist Meeting on Kennington Common, 10 April 1848, daguerreotype by William Edward Kilburn, 10.7 x 14.7. Royal Collection Trust/© HM Queen Elizabeth II 2012

1

JOHANN FRIEDRICH OVERBECK 1789–1869

The Painter Franz Pforr (Der Maler Franz Pforr) c.1810

Oil on canvas 62 x 47
Staatliche Museen zu Berlin, Nationalgalerie

Overbeck and Pforr were leading members of the Lukasbund, or Brotherhood of St Luke, which formed as a secessionist group against the authority of the Vienna Academy in 1809.[6] They moved to Rome in 1810, where they established a quasi-monastic style of life and dress, even occupying the disused monastery of Sant'Isidoro, where this work was painted. They adopted flowing gowns, which gained them the nickname 'Nazarenes' because of their Christ-like appearance. Mutual affection and loyalty between members of the group were enshrined in 'friendship pictures' such as this.

Rather than a modern setting, Overbeck's portrait places the young Franz Pforr in *altdeutsch*, or old German, dress of the sixteenth century. He sits in a gothic loggia, with a German town seen in vertiginous perspective behind him, as in panel paintings by Northern Renaissance masters such as Petrus Christus. Strangely, however, a Mediterranean coastline rises behind. This emphasises the combination of German and Italian Renaissance art, exemplified by Dürer and Raphael respectively, which provided the Nazarenes with their ideal. Overbeck has provided for his friend an imaginary ideal wife, who reads a devotional text while undertaking domestic labour; her purity is indicated by lilies, symbolic of the Virgin Mary (see no.24). Overbeck's style deliberately rejected the painterliness admired in the Vienna Academy, based on the study of artists such as Titian, Rubens and Rembrandt. Instead, he uses here a careful, thinly painted technique built on meticulous pencil sketches. Pforr died in 1812, and his reciprocal sketch of Overbeck never became a painting, but remained in Overbeck's possession throughout his life.

Ford Madox Brown and William Dyce both met Overbeck in Rome, and the young Pre-Raphaelites were aware of the German artists, with their 'permanent striving for Truth' and return to early art,[7] as an important precedent for their own rebellion against the Royal Academy. The PRB also made friendship portraits that bear comparison with the earlier German works. By the 1840s, however, Overbeck and another of the Nazarenes, Peter Cornelius, had become artistic celebrities much admired in academies across Europe. Hunt was suspicious of 'the sickliness of character' of Overbeck's designs and Cornelius's 'German revivalism' in creating nationalistic fresco cycles in Munich and Berlin, which were widely reported in the British art press.[8] TB

WILLIAM BLAKE 1757–1827

Job and his Daughters, from *Illustrations of the Book of Job,* pub. 1826, reprinted 1874

Line engraving on paper 19.9 x 15.1
Tate. Purchased with the assistance of a special grant from the National Gallery and donations from the Art Fund, Lord Duveen and others, and presented through the Art Fund 1919

The visionary artist William Blake was an important formative influence on the PRB through his hard-edged linear style and disregard for academic conventions. For Blake, line possessed a moral and spiritual dimension, signalling the clear articulation of a concept, whereas he found oil paint ambiguous and lax by comparison, merely serving to manipulate the emotions of the spectator, a distinction that was central to the early work of the Brotherhood. Rossetti's enthusiasm for Blake first manifested itself in 1847 when he purchased a small notebook packed with the artist's sketches and writings, which he subsequently lent to the art critic Alexander Gilchrist to help him complete his biography of Blake. Following Gilchrist's premature death in 1861, the Rossetti brothers assisted the author's widow Anne in completing this book, William Michael producing the annotated catalogue and Dante Gabriel providing introductory remarks for each section, plus the Supplementary Chapter on Blake's art that concludes the first volume.

Blake's engravings for *The Book of Job* had been commissioned in 1823 by the painter John Linnell, later himself a supporter of the Pre-Raphaelites, and were published as a set in 1826. As the most widely circulated examples of the artist's work, these were to be crucial for his reappraisal during the nineteenth century. Ruskin, who was not alone in finding Blake's images disturbing and grotesque, nevertheless admired the imaginative power of the series, declaring: 'In expressing conditions of glaring and flickering light, Blake is greater than Rembrandt.'[9] In Gilchrist's *Life of Blake* Rossetti singled out plate 20, *Job and his Daughters,* for particular attention. Derived from Job 42: 13–15 and the apocryphal Testament of Job, the engraving shows the patriarch's three daughters leaning against his sturdy tree-like form as he points towards the scenes of his afflictions illustrated on the two roundels that encircle the group. As the writer Irene Langridge first suggested, this was a work that held a special appeal for Rossetti, encouraging the 'hidden mysterious richness and the wonderful painted interiors in which he [Rossetti] set his women'.[10] It was probably through Rossetti that Hunt similarly came to admire the image, his various designs for *The Lady of Shalott* (no.171) displaying clear affinities with it both in the whirling linearity of their composition and the echoing patterns of roundels enclosing further pictorial images.

More generally, the iridescent light effects of Blake's densely worked black-line engraving technique influenced the taut linearity and luminosity of the engravings produced by the Pre-Raphaelites for the Moxon Tennyson of 1857, as well as the later illustrative work of Morris and Burne-Jones (nos.151–2).　　AS

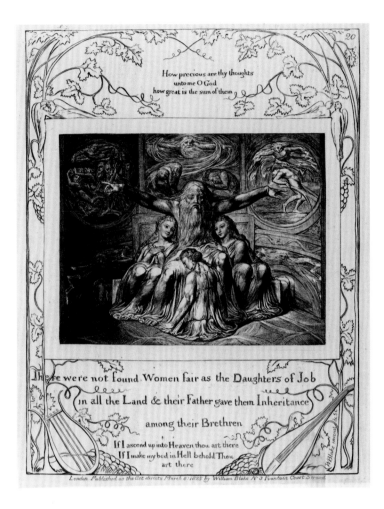

3

THEODOR VON HOLST 1810–44

The Bride 1842

Oil on canvas 92.3 x 71.3
Tate. Lent from a private collector 2011

The London-born painter Theodor von Holst was an important link between earlier Romantic artists, such as his teacher Henry Fuseli, and the Pre-Raphaelites. Holst's influence on the group only began after his premature death in 1844. Soon afterwards William Bell Scott, Rossetti, Munro and Millais all became fascinated with the painter's lurid gothic imagination. Rossetti shared Holst's passion for writers such as Goethe and Dante, and Rossetti's early pen and ink drawings are strikingly similar to Holst's in terms of both their emphatic use of line and their supernatural motifs. Millais would have seen Holst's works in the collection of his first patron, the dealer Ralph Thomas, while Munro owned a sketchbook crammed with the artist's dark imaginings.[11]

The Bride, Holst's most influential painting, was based on Percy Bysshe Shelley's poem 'Ginevra' of 1821, in which a Florentine girl is forced to marry an elderly nobleman and dies on her wedding night. Against a brilliant gold background the reluctant bride is shown idly toying with a lock of hair as she leans dejectedly against the ledge of a window, mocked by a bas-relief cupid with bat wings lurking in the bottom-left corner. The casement format recalls early Italian and Netherlandish painting as well as the revivalist portraiture of the Nazarenes (see no.1). Rossetti first saw *The Bride* at Stafford House in London and remembered it in his Supplementary Chapter to Alexander Gilchrist's *Life of William Blake* of 1863 as 'a most beautiful work by him'.[12] The deep impact this work made on Rossetti was subsequently revealed in his iconic half-figure portraits of sensuous women in decorative interiors from *Bocca Baciata* (no.119) onwards.

Holst made two other versions of *The Bride*, one of them for Lord Lansdowne, which hung in the breakfast-room of his house in Berkeley Square where Millais was a regular visitor. It is likely that this version inspired Millais's *The Bridesmaid* of 1851 (Fitzwilliam Museum, Cambridge) and maybe also influenced his enigmatic female portraits of the mid-1850s (see no.118). AS

4

WILLIAM DYCE 1806–64

King Joash Shooting 'the Arrow of Deliverance' 1844

Oil on canvas 76.3 x 109.5
Hamburger Kunsthalle

Dyce, a prominent figure in British history painting and art education, was a significant influence on the young Pre-Raphaelites. Born in Scotland in 1806, he began his studies at the Royal Academy Schools in 1825 but, disenchanted, left abruptly to complete his education in Rome. There he encountered the Nazarene painter J.F. Overbeck, with whom he shared a determination to create a modern Christian art rooted in Renaissance practice (see no.1). Exceeding the Nazarenes in daring, Dyce turned his attention to earlier Italian painting than they, and seems in particular to have absorbed a new firmness of outline and bold, schematic handling of drapery from the study of the panel paintings of Giovanni Bellini. He began to work (according to his friend C.W. Cope) 'in the Bellini or Perugino manner'.[13]

King Joash Shooting 'the Arrow of Deliverance', Dyce's only entry to the Royal Academy in 1844, exemplifies his distinctive new form of religious painting, informed by his deep commitment to High Anglicanism, his knowledge of Nazarene practice and his exposure to Italian quattrocento painting. In the Book of Kings the Prophet Elisha instructs the young King of Israel, Joash, to shoot arrows through the east window as a symbol of the victory God intended

for the Israelites over their Syrian foe: 'The arrow of the Lord's deliverance and the arrow of deliverance from Syria; for you must strike the Syrians at Aphek till you have destroyed them' (2 Kings 13). Despite Elisha's exhortations, Joash, lacking faith, faltered after shooting only three arrows, arousing the prophet's ire, and the possible victory over the Syrians did not take place. Dyce's dramatic composition focuses solely on the moral and spiritual dilemma facing Joash, who is held in the balance and found wanting.

Dyce's strikingly angular and pared-down composition reaches to the heart of the narrative: the young king's response to the words of the prophet. Though it displays authoritative draughtsmanship and fine command of anatomy, this is not a typical academic painting of the period. The hard, enamelled finish, Elisha's stiff and stylised draperies, and the sharp burst of orientalist colour in the king's garments and bow all contrast sharply with the lush, painterly effects influenced by sixteenth-century Venetian art and practised by contemporary painters such as Charles Eastlake and William Etty. During the 1850s Dyce was deeply influenced by the Pre-Raphaelites, effecting a transformation in his style (see nos.82, 108). TB

THOMAS WOOLNER 1825–92
Puck c.1847

Plaster, painted black 49.5 x 35.5 x 28
Tate. Presented by the Patrons of British Art through the Friends of the Tate Gallery 1991

Puck, the 'shrewd and knavish sprite' from Shakespeare's *Mid-summer Night's Dream*, was a subject much in vogue during the 1840s and one that allowed artists considerable licence in interpreting the character. At the RA Henry Howard, the Professor of Painting, championed the representation of fairy subjects, and the prominence accorded Shakespeare in the competition surrounding the decoration of the Houses of Parliament encouraged a generation of aspiring young artists to take up imaginary themes from literature.

F.G. Stephens recalled seeing the statuette standing high on a pedestal in Woolner's studio following its exhibition at the British Institution in 1847.[14] According to the catalogue that accompanied this exhibition, the incident portrayed came from an 'Imaginary Biography of Puck', which describes how the fairy chanced on a snake and mischievously denied it the satisfaction of seizing a sleeping toad as its prey. In order to capture the random nature of the encounter and the swiftness of Puck's reflexes in saving the toad, his stocky homuncular figure is presented momentarily thrown off balance as he raises his right foot to prod the amphibian. The poet Coventry Patmore, who was presented with a cast of the figure by Woolner, thought it displayed 'a grotesque fancy in harmony with the modern world, instead of being an attempt at that kind of beauty in which … we can scarcely hope to compare with the Greeks'.[15] Such 'grotesque' qualities can be seen in details such as the leaves and mottled texture of the snake as well as the pointed tips of Puck's beard, ears and bat-like wings. A similar combination of vegetable and human characteristics resurfaces in Millais's *Ferdinand Lured by Ariel* (no.33), which at some point before 1875 came into Woolner's possession.

Woolner's interest in using natural detail to dramatise a struggle for existence also lent his work a topical scientific dimension. He later told the naturalist Charles Darwin that he had modelled Puck's fawn-like ears after observing the vestigial tips that appeared on some human ears. Darwin subsequently acknowledged the 'Woolnerian tip' in his seminal publication, *The Descent of Man* of 1871.[16] AS

JOHN ROGERS HERBERT 1810–90

Our Saviour, Subject to His Parents at Nazareth (The Youth of Our Lord) 1847–56

Oil on canvas 81.3 x 129.5
Guildhall Art Gallery, Corporation of London

John Rogers Herbert was a close friend of the gothic-revival architect A.W.N. Pugin and was influenced by Pugin's visionary Catholicism. After his conversion in 1836 Herbert turned increasingly to religious subjects, and his style, inspired by the Nazarenes, was considered 'vicious' and 'German' by the history painter Benjamin Robert Haydon.[17] Like the Nazarenes, he had 'a mediaeval look both in appearance and dress'.[18] Also a friend of Dyce, Herbert was commissioned to paint murals, including the massive *Moses' Descent from Mount Sinai*, for the new Palace of Westminster. As Michaela Giebelhausen has noted, Nicholas Wiseman, then about to be Catholic Archbishop of Westminster, hoped for a new 'Catholic School of Art'. Wiseman admired the wide appeal of Herbert's work and noted 'how completely it addressed itself at once to the minds and hearts of the people'.[19]

When *Our Saviour, Subject to His Parents at Nazareth* was exhibited at the RA in 1847, Herbert included in the RA catalogue a text from *The Christian Year* by the Oxford Movement divine, John Keble:

Perhaps the cross, which chance would oft design
Upon the floor of Joseph's homely shed,
Across Thy brow serene and heart divine
A passing cloud of Golgotha would spread![20]

The painting's subject prefigures that of two major Pre-Raphaelite religious works: Millais's *Christ in the House of His Parents* (no.85), depicting an episode in the childhood of Christ, and Hunt's *Shadow of Death* (no.112), where the Crucifixion is foretold through a visual sign. In Herbert's pioneering conception Mary's look of sudden anxiety is caused by the two wooden planks in the foreground forming a cross, which Victorian typological interpretation would immediately connect with the Crucifixion. The same connection between a cross shape and the future Crucifixion lies at the heart of Hunt's *Shadow of Death*.

Although Herbert claimed that 'the background is painted from a very careful drawing made at Nazareth', the garments, familiar from any number of old-master images, and the reassuring softness of Herbert's technique and sweetness of his colouring contrast dramatically with the harsh realism of Millais's, Hunt's and Rossetti's early Pre-Raphaelite works. In *Christ in the House of his Parents*, 1850, Millais returned to the same subject as Herbert's painting but approached it with a far more radical and uncompromising visual language. The present work, made by Herbert in 1856, is a smaller replica of *Our Saviour, Subject to His Parents at Nazareth*, which is sometimes titled *The Youth of Our Lord*. TB

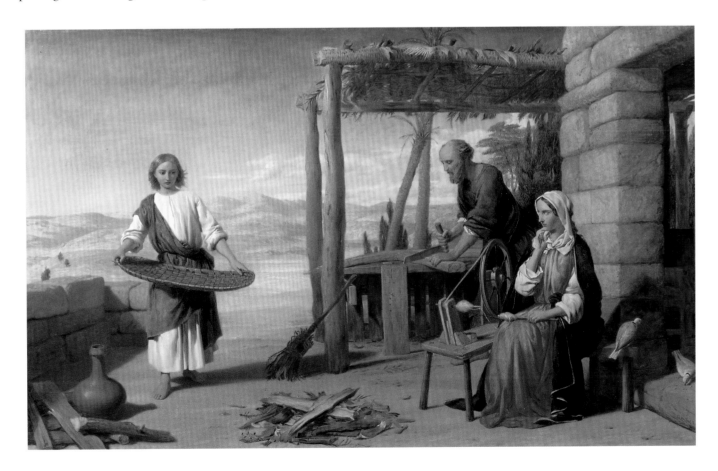

7
FORD MADOX BROWN 1821–93
The Seeds and Fruits of English Poetry 1845–53

Oil on canvas 36 x 46
The Ashmolean Museum, Oxford. Presented by Mrs W.F.R. Weldon, 1920

8
FORD MADOX BROWN

Geoffrey Chaucer Reading the 'Legend of Custance' to Edward III and his Court, at the Palace of Sheen, on the Anniversary of the Black Prince's Forty-Fifth Birthday (Chaucer at the Court of Edward III) 1850–68

Oil on canvas, arched top 123.2 x 99
Tate. Purchased 1906
[Washington only]

In 1841 a Royal Commission of Fine Arts, chaired by Prince Albert, was charged with commissioning large history paintings for the walls of the new Palace of Westminster, designed by Charles Barry and A.W.N. Pugin. From 1843 regular competitions were held in Westminster Hall of cartoons (large-scale monochrome designs) on subjects from British history, Spenser, Shakespeare or Milton. Encouraged by the prospect of patronage from the state, Ford Madox Brown returned in 1844 to London from Paris where he had been eking out a precarious living. His submission for the 1844 competition, *The Body of Harold Brought before William the Conqueror* (South London Gallery), is a powerful and dramatic composition influenced by Brown's education in Belgium, in which extreme, theatrical gestures and extreme emotions mark out the figures in a complex, tangled grouping. The elongated body of Harold, the Saxon king killed at the Battle of Hastings, is posed like the figure of Christ in a deposition scene. Harold's profile catches the evening sunlight, while a dark shadow falls across the harsh, swarthy features of William the Conqueror at the top of a contorted pyramid of figures. Brown gave visual form to the idea of the 'Norman yolk', an interpretation of English history in which an era of ideal 'Saxon liberties' was ended by the Norman Conquest.[21] Thomas Babington Macaulay's famous and surprisingly intemperate account portrays the Battle of Hastings as giving up 'the whole population of England to the tyranny of the Norman race'.[22] The cartoon's simple title was supplemented by a quotation from the first volume of David Hume's *History of England*, originally published in 1754. Hume emphasised the heroism of Harold, 'slain by an arrow, while he was combating with great bravery at the head of his men'. Brown quoted the phrase, 'The dead body of Harold was brought to William', but omitted the rest of Hume's sentence, 'and was generously restored without ransom to his mother', which presents a more humane impression of William.[23]

Although the composition of *The Body of Harold* shares its dramatic structure with Eugène Delacroix's celebrated *Taking of Constantinople by the Crusaders* (1841; Louvre, Paris), the exaggeration of facial expressions and contorted postures were entirely the artist's own. The taut, Michelangelesque musculature of the figures – such as those clasped together in a 'death-grapple' at the left – may reflect the influence of the German painter Peter Cornelius.[24] *The Body of Harold* was altogether too unconventional for the Royal

Commission, and Brown failed to secure patronage for his work.

Following a further failure in the 1845 competition, Brown began research in the library of the British Museum into yet another cartoon subject. He alighted upon Sir James Mackintosh's *History of England* (1830–40).[25] As he recalled in his diary, a passage on Geoffrey Chaucer 'at once fixed me, I immediately saw visions of Chaucer reading his poems to knights & Ladyes fair, to the king & court amid air & sun shine'.[26] Chaucer, for Brown, represented not only the origin of English literature but a remarkably vibrant and accessible figure.[27]

Not content with merely evoking a scene in the life of Chaucer, Brown wished to address the poet's influence: the subject of his first design was nothing less than the birth and flowering of the English language and its literature. Worried about there being 'no space left' for the prose writers, he soon limited the subject to *The Seeds and Fruits of English Poetry*. The composition incorporates three scenes, separated by painted Puginesque architectural elements and foliage, which can be seen in a small study begun while Brown was in Rome in 1845, the time at which he sought out the Nazarene painters Overbeck and Cornelius. Mimicking the panels of a triptych in an elaborate frame, *Seeds and Fruits* exemplifies Romantic medievalism, with vivid heraldic colours and gilding resembling the spectacular, emerging interiors of the new Parliament.

The iconography was a complex one, providing a trans-historical 'who's who' of English literature, linking the medieval with the modern in a typological manner typical of the Victorian era. In the outer panels are the fruit of Chaucer's seed: Milton, Spenser and Shakespeare on the left; Byron, Pope and Burns to the right. These choices – a fairly conventional early nineteenth-century canon of literary masters – were scornfully criticised by Brown's young friend and protégé, Dante Gabriel Rossetti, already a published poet as well as a painter, when he saw the three large canvases of the full-scale *Seeds and Fruits* in Brown's London studio.[28] In a typically unorthodox gesture Brown added beneath these outer panels a line of real children (including a sulky, blond-haired urchin girl on the right), rather than the conventional Renaissance winged putti, bearing cartouches with the names of modern poets. Among them is the now forgotten Kirke White, whose inclusion was, for Rossetti, 'ridiculous'.[29]

A stark contrast to the busy, anti-naturalistic and decorative

outer panels of *Seeds and Fruits* is presented by the central tableau. Here, viewed through a framing arch, is a brightly lit scene filled with historical detail, as carefully illusionistic as the other elements are schematic. As a complex, vertical arrangement with numerous figures, it relates to the successful Westminster cartoons of Daniel Maclise and to the work of the Nazarenes, yet with far greater lifelike vividness.

Probably in 1847 Brown decided to abandon the idea of a large triptych and to give up on the Westminster scheme, in favour of a single, monumental version of this central scene. The result was a vast oil painting, now in the Art Gallery of New South Wales, Sydney. The version shown here is a smaller replica, possibly begun by Thomas Seddon, who was working in Brown's studio in about 1850, but largely painted by Brown himself and finished in 1868.

Chaucer at the Court of Edward III is a Pre-Raphaelite masterpiece, bathed in real sunlight and set against a precisely rendered naturalistic landscape. The clarity, individual definition and local colour of each object give the painting's surface a kaleidoscopic dizziness, as fabrics and features compete for the viewer's attention. The careful individualisation of each face confirms that each was painted directly onto the canvas from a specific model. Many of Brown's friends sat for the painting, and Rossetti was chosen for the figure of Chaucer.

In addition to the extremely specific title, *Geoffrey Chaucer Reading the 'Legend of Custance' to Edward III and his Court, at the Palace of Sheen, on the Anniversary of the Black Prince's Forty-Fifth Birthday*, Brown recorded the tender lines from the early poem, 'Legend of Custance', that Chaucer is seen reciting:

Hire litel child lay weeping on hire arm,
　And, kneling piteously to him she said,
Pees litel sone, I wol do thee no harm!
　With that hire couverchied of hire hed she braid
And over his litel eyen she it laid,
　And in hire arme she luleth it ful fast,
And unto the hevens hire eyen up she cast.[30]

The faces of the gathered courtiers register none of the pathos of this text. Moving from figure to figure we see trivial, bored and gossiping fools: the vain and the stupid. The old king stares blankly with his mistress Alice Perrers on his arm; the Black Prince lounges

on his wife's lap, ill or bored; 'a cardinal priest' (according to Brown's catalogue entry) is 'on good terms with the ladies'; the jester is chatting idly; adolescent lovers are whispering in the foreground. The painting not only enshrines the great strengths of early English literature – sturdy, vernacular verse, alert to the innermost feelings of humble individuals – but also clearly records the indifference of the public. With this note of Hogarthian satire, Brown might have been reflecting sardonically on his personal position as an ambitious young artist, lacking patrons and struggling for recognition.

The future history of the large version of *Geoffrey Chaucer* exemplifies this: badly hung at the Royal Academy in 1851, it did not sell, though one friendly critic recognised it as embodying 'that clear-sightedness which can still look forward'.[31] Brown received only £25 for it in 1854 and bought it back in 1863 in order to prevent his own dealer, D.T. White, from cutting it up. However, its sale to the new 'Municipal Art Gallery' at Sydney in 1876, for £500, was a triumph and marked the first purchase of Brown's work by a public collection.

It is a crucial question as to whether Brown adopted the 'Pre-Raphaelite manner' visible in *Chaucer* after seeing the works of Millais, Hunt and Rossetti, or whether, as he argued in his later catalogue, *Chaucer* was 'the first [painting] in which I endeavoured to carry out the notion, *long before conceived*, of treating light and shade absolutely, as it exists at any one moment, instead of approximately, or in generalised style'.[32] The question can never be answered, since although *Chaucer* was begun before the Pre-Raphaelite style had been conceived, the work was completed, then altered again, long after paintings by Millais, Hunt and Rossetti had been exhibited publicly.　　　　　　　　　　　　TB

7　　　　　　　　　　　8

FORD MADOX BROWN 1821–93

The First Translation of the Bible into English: Wycliffe Reading his Translation of the New Testament to his Protector, John of Gaunt, Duke of Lancaster, in the Presence of Chaucer and Gower, his Retainers 1847–8, reworked 1859–60

Oil on canvas 119.4 x 153.7
Bradford Museums and Galleries

It was widely believed in Victorian England that John Wycliffe (1328–84), the controversial fourteenth-century theologian associated with challenges to papal authority, was responsible for the first English translation of the Bible, giving him special status as a precursor of the Protestant Reformation. Brown's choice of subject, at a moment of political ferment, found favour with the radical *People's Journal*, which claimed that 'the translation of the Bible into the English language may be regarded as the greatest preliminary effort to instruct "the people"'.[33]

Scholars have not identified a literary source for this scene of public reading, but Wycliffe and his radical anti-clerical followers, the Lollards, appear as heroic precursors of modern Protestants in most Victorian histories of England. John Lingard, for example, referred in 1823 to 'Wycliffe's new translation' as 'an engine of wonderful power … a spirit of enquiry was generated: and the seeds were sown of that revolution, which in little more than a century astonished and convulsed the nations of Europe.'[34] A later Victorian commentator insisted that 'true Englishmen will always number [Wycliffe] among the foremost upholders of our national independence, and the pioneer of those brave men who … were able to overthrow entirely an intolerable and alien oppression [the Roman Catholic Church]'.[35]

For Brown, Wycliffe was no distant medieval figure but a Carlylean hero with profound resonances for the present day – something of a Pre-Raphaelite, perhaps. Brown's sympathies were always radical and antipathetic to the status quo in both politics and aesthetics, and in Wycliffe he found a difficult man of unflinching principle with whom he surely identified. Brown remained preoccupied with Wycliffe throughout his career: one of his final works was a mural of *The Trial of Wyclif* in Manchester town hall (1885–6), in which Wycliffe's dignity contrasts with the chaotic and decadent scenes around him.

Brown certainly shared the fierce opposition to 'the poison of the Pope's doctrines and false religion' voiced in the most famous life of Wycliffe in *Foxe's Book of Martyrs* (published in Latin in 1554 and English in 1563).[36] *The First Translation of the Bible* directly engaged with the sectarian politics of the day and with rising popular antagonism towards the proposed re-establishment of Catholic bishoprics in Britain.[37] Two roundels, originally set in a *trompe-l'oeil* architectural design above the main tableau, now appear in circular niches in the gold frame slip. In one a sinister monk holding a locked book, his face in shadow, represents Catholicism, while in the other a blond maiden, symbolising the Protestant future, and bearing lilies of purity, holds Wycliffe's English Bible open to the viewer.

The main composition is designed in a bold, symmetrical and hieratic style clearly demonstrating the influence of the German Nazarenes and 'obviously designed', according to the *Athenaeum*, 'with a view to its execution in fresco'.[38] In the centre is the ascetic, dignified figure of Wycliffe who reads in his native tongue from his own Bible. Brown wrote approvingly that Wycliffe 'used to inculcate contempt of mundane cares and vanities, going barefoot and in cassock of the coarsest material'.[39] In a contrasting group to the right, clad in finery, are John of Gaunt – the younger brother of Edward, the Black Prince (who appears in Brown's *Chaucer*, no.8) – his duchess and their sleeping child. The adults listen, rapt, but there is an element of satire in Brown's depiction of these haughty figures. A pageboy holds volumes by Chaucer and John Gower to the left, and those two poets stand together, Chaucer in brilliant red headgear. The composition emphasises the centrality of the vernacular Bible to the development of English prose, and stands as a Protestant riposte to Overbeck's equally symmetrical and static, but militantly Catholic, allegory, *The Triumph of Religion in the Arts* (1840; Städel Museum, Frankfurt), which places a Raphaelesque Virgin Mary at the centre of the composition.

Brown was assiduous in his research for the painting, consulting recent scholarship on Chaucer, making a copy of a medieval alphabet in the British Museum library and taking great pains to represent furniture, architecture and costume appropriate to the period. The figure of Chaucer, he noted in 1865, was 'taken from the small portrait existing of him, in illumination, by his pupil, the poet Ocleve'.[40] While developing the composition, he followed the standard artistic regimen taught to him at the academies in Ghent and Antwerp, preparing an oil sketch for composition and colour (now in Bradford) and a systematic group of studies of figures and costumes in pencil. He used professional models (with the exception of his cousin Elizabeth, who appears as the duchess). His diary for 17 March 1848 records that he 'painted in the ground afresh for the jupon … Nothing like a good coating of White to get bright sunny colour', indicating that the Pre-Raphaelites' predilection for bright white grounds may have derived from Brown.[41]

The work was exhibited in the spring of 1848 not at the Royal Academy but at the National Institution's Free Exhibition, where Rossetti would send *The Girlhood of Mary Virgin* (no.24) the following year. The *Art Union* found it to be 'a beautiful and valuable production, brought forward in the manner of fresco, with a marked feeling for the style of the early Florentine school'.[42]

Seeing it again in 1855, Brown remarked that 'My Wickliff looks quite faded', but acknowledged 'I suppose it is I who have brightened', perhaps in response to the brilliance of Pre-Raphaelite colour.[43] The painting was purchased in 1859 by the Leeds stockbroker Thomas Plint, who asked Brown to rework it. The colour was strengthened and many details changed; the brilliant landscape in the right background was transformed, and the Saxon tower of Sompting Church, Sussex, added. A new gold frame flat was added to cover the extensive and, by 1859, outdated *trompe-l'oeil* Puginian tracery of the original version. Like *Chaucer*, the work, as we see it today, is both pre- and post-Pre-Raphaelite.

TB

2. MANIFESTO

The PRB was formed in September 1848 by artists well aware of the tradition of artistic groups in the recent past, especially the Nazarenes in Germany (no.1).[1] It was customary for artistic societies in England to coalesce outside the walls of the Royal Academy, as had happened most recently with 'the Clique', active from around 1837 to 1841 and including RA students William Powell Frith, Henry Nelson O'Neil, Augustus Leopold Egg, Richard Dadd and John Phillip. More social than radical, the Clique had no rebellious stylistic or political agenda and, with the exception of Dadd, all became Academicians. Their linkage was not secret. By contrast, the PRB revelled in the clandestine status of their group.

Although keenly aware of the momentous political and social changes taking place around them, in Britain and abroad, the PRB initially focused on reviving art itself, which they felt was in decline. They contended that in general it had become too conventionalised through a dependence on the evolution of a repetitive and insular practice as taught in academies since the late Renaissance. They desired to engender a new aesthetic for British art from the roots up, one distinctly different from the grandiose nationalist history paintings that were favoured in the Westminster competitions (which Brown and Millais had unsuccessfully entered) and were receiving the stamp of governmental approval on the walls of the new Houses of Parliament.[2]

At issue is how they constructed themselves as an avant-garde group, and the initial public nature of their intervention in art. While the members of the PRB and its circle recorded each other's likenesses in many friendship portraits (nos.10–21), no defining, collective portrait was ever made, unlike later avant-garde associations such as the Impressionists, Italian Futurists or the Brücke in Germany, who sat for painted or photographic group portraits. In addition, the PRB never developed a formal manifesto, although the members' first submissions to exhibitions and the aggregate content in their publication, *The Germ*, of which W.M. Rossetti became editor in late 1849, functioned as statements of its aims.[3] Rossetti also served as PRB secretary, although there were no other leadership positions. From 15 May 1849, just after the opening of the first Academy to include PRB pictures, he kept a journal of the group's activities.[4]

While the PRB formed as a result of its members meeting at the Royal Academy Schools and in private sketching clubs, it intended to introduce its revolutionary ideas through public exhibitions. In the spring of 1848, before the group's formation in the autumn, Hunt exhibited at the Academy *The Flight of Madeline and Porphyro during the Drunkenness Attending the Revelry* (see pp.246–7), a subject drawn from John Keats's 'The Eve of St Agnes'. Millais and Brown showed nothing that year, Rossetti never exhibited at the RA and Woolner submitted three modest sculptures: a portrait medallion, *The Rainbow* ('the airy child of vapour and the sun'), and *Eros and Euphrosyne*. Collinson showed one picture, *The Rivals*. Yet in the following year, the first of directed PRB activity, the Brotherhood introduced their ideas and began to engage both their peers and the wider public while maintaining the secret of their new union. Rossetti showed *The Girlhood of Mary Virgin* (no.24) at the rival Free Exhibition, as did Brown his *King Lear* (Tate). Woolner did not exhibit publicly but produced medallions of Coventry Patmore and Alfred Tennyson, poets who would inspire Pre-Raphaelite pictures (nos.35, 66). Hunt, Millais and Collinson each sent one picture to the Academy in 1849, having only given themselves a few months to paint them between establishing the PRB and the opening in early May. Hunt's *Rienzi* (no.25), Millais's *Isabella* (no.26) and Collinson's *Italian Image-Boys at a Roadside Alehouse* (fig.11) fortuitously hung together in the Academy's Middle Room, forming a fusillade directed at the complacency of the institution and its members who had accepted the works for display. All three featured Italian subjects, but Collinson's picture, inscribed with the initials 'PRB' like those of his Brothers, was the only one that dealt with modern life, later a major Pre-Raphaelite preoccupation. Collinson's genre painting was seemingly conventional in organisation and conception, derived from works such as David Wilkie's *Blind Fiddler* (1806; Tate). Hawkers sell Parian-ware

Fig.11 James Collinson, *Italian Image-Boys at a Roadside Alehouse*, 1849, oil on panel, 79 x 109. Private collection

bric-a-brac: cheap unglazed white ceramic portraits of Pope Pius IX and Napoleon, and religious subjects. Collinson contrasted these pallid and lifeless statues with close observation of a cluster of local people arranged in a standard semicircular composition (as opposed to the dynamic and diagonal arrangement of figures in *Isabella*).[5] It is a commentary on the dichotomy between the real and the artificial in art, and it is also an essay in the crafting of a Pre-Raphaelite realism, meticulous in style and based on painstaking depictions of features. The picture demonstrated how early Pre-Raphaelite technique could be divorced from the Middle Ages and confront the modern world with unparalleled directness, becoming part of the construction of meaning in their pictures.

These PRB works of 1849, recalled W.M. Rossetti, 'stood out conspicuously from amid their surroundings', which was certainly one of the Brotherhood's aims in submitting them to the RA. Yet, as Rossetti continued: 'In 1850 the serene auroral horizon of Pre-Raphaelitism was overcast. Well-established painters and routine critics had by this time found out that the young artists had resolute intentions of their own, and a concerted plan of action.'[6] In the *Illustrated London News* of 4 May 1850 Angus Reach revealed the meaning of the initials 'PRB', and criticism of the artists' work, initially curious and encouraging, turned to caustic and enraged.[7] The PRB's secretiveness incensed establishment forces, and they were consequently lambasted by conservative mouthpieces in the press. The main targets were Hunt and Millais, the two Pre-Raphaelites who took the biggest risks with their submissions to the Academy and were most insistent on trying to establish themselves in that prime forum. Yet, following the model of other British institutions that succeeded in staving off revolution by making limited concessions to radical demands, the RA commendably continued to accept Pre-Raphaelite works for exhibition from 1849 onwards and would take Millais into their ranks as an Associate as soon as he became eligible in 1853.

The conspicuous PRB style and extreme nature of their artistic critique in these first exhibited pictures were based on an approach gestated in their drawings (nos.28–9) and then transferred to their oils. And it is in the medium of drawing that the PRB's works most closely resembled each other. Visible in these initial Pre-Raphaelite works are the artistic influences traced in the 'Origins' section above: early Renaissance pictures (no.27)[8], illuminated manuscripts, Lasinio's line engravings (fig.12), contemporary German prints, traditions of medieval revivalism in the art of the Nazarenes (no.1), contemporary gothic-revival design and photography (no.31). The last, in particular, with its ability to fix a monochromatic image on metal plates or paper, would revolutionise two-dimensional artistic media. And unlike van Eyck in works such as the *Arnolfini Portrait* (fig.13), with its idealised bride, the Pre-Raphaelites produced individual likenesses of both men and women that would be a basic aspect in the construction of

their pictures. The approach to portraiture was one of the most original elements in their works (no.30), and the features of models were treated with a portrait-like verisimilitude. Authenticity began, for the PRB, with the face. It was in the visages of *The Girlhood of Mary Virgin*, *Rienzi*, *Isabella* and *Italian Image-Makers*, that the radical denial of *sfumato*, the hazy style of depiction without harsh outlines or contrasts of light and dark found in the work of Leonardo da Vinci and his followers, was most glaring.

This resulted in images that were different from the artificially slick surfaces, or *fini*, of French Neoclassical artists such as Jacques-Louis David, and established a new idea of earnest realism in English art. Ruskin articulated this most clearly in his letters to *The Times* in May 1851. The Pre-Raphaelites, he wrote, 'will draw either what they see, or what they suppose might have been the actual facts of the scene they desire to represent, irrespective of any conventional rules of picture-making'.[9] They would derive the form of their paintings not from the imagination, in the spirit of divine manifestation, or from earlier art, but from observation, historical research and unidealised faces taken from everyday models. The Pre-Raphaelites rejected the misty depiction of idealised form, consistent from Leonardo to Sir Joshua Reynolds, in favour of precision of outline and the brightness of local colour. As Ruskin put it: 'They have chosen their unfortunate though not inaccurate name because all artists did this before Raphael's time, and after Raphael's time did *not* this, but sought to paint fair pictures rather than represent stern facts.'[10] Stern facts, across various genres in art, became the formative basis of radical Pre-Raphaelitism.

For an avant-garde movement whose members were barely twenty years of age, it is remarkable that early PRB productions were so well conceived and finely executed. The first Pre-Raphaelite pictures of Millais, Hunt and Rossetti have stood up exceptionally well over time. Few artistic movements can claim such seminal works as their first essays in a new style. JR

Fig.12 Giovanni Paolo Lasinio after Benozzo Gozzoli or Giuseppe Rossi, *Noah and his Family, and the Drunkenness of Noah*, from *Pitture a Fresco del Campo Santo di Pisa*, Florence 1832. Victoria and Albert Museum; Dyce bequest [London only]

10

DANTE GABRIEL ROSSETTI 1828–82

Self-Portrait 1847

Pencil and white chalk on paper 19.7 x 17.8
National Portrait Gallery, London

11

DANTE GABRIEL ROSSETTI

Ford Madox Brown 1852

Pencil 17.1 x 11.4
National Portrait Gallery, London

12

WILLIAM HOLMAN HUNT 1827–1910

John Everett Millais 1853

Pastel and coloured chalks 32.7 x 24.8
National Portrait Gallery, London

13

JOHN EVERETT MILLAIS 1829–96

William Holman Hunt 1853

Pencil with some wash 23.5 x 18.9
National Portrait Gallery, London

14

DANTE GABRIEL ROSSETTI

Thomas Woolner 1852

Pencil 15.5 x 14.6 (hexagonal)
National Portrait Gallery, London

15

DANTE GABRIEL ROSSETTI

William Michael Rossetti 1853

Pencil and wash 28.2 x 21 (oval)
National Portrait Gallery, London

16

JOHN EVERETT MILLAIS

Frederic George Stephens 1853

Pencil 21.6 x 15.2
National Portrait Gallery, London

17

ALEXANDER MUNRO 1825–71

John Everett Millais, Esq., A.R.A. c.1853

Medallion relief in plaster of Paris 56.5 x 45.7
The Ashmolean Museum, Oxford. Presented by Sir Henry Acland, 1856

18

JOHN BRETT 1831–1902

Christina Rossetti 1857

Oil on panel 13.3 x 10.2 (framed)
Private collection

19

DANTE GABRIEL ROSSETTI

Elizabeth Siddall Plaiting her Hair (undated)

Pencil on paper 17.1 x 12.7
Tate. Bequeathed by H.F. Stephens, 1932

20

WILLIAM MORRIS 1834–96

Self-Portrait c.1856

Pencil 18.1 x 18.4
Victoria and Albert Museum, given by Dr R. Campbell Thompson

21

SIMEON SOLOMON 1840–1905

Self-Portrait 1859

Pencil on paper 16.5 x 14.6
Tate. Presented anonymously, 1919

The practice of making 'friendship portraits' was an important ritual in the formation of the Pre-Raphaelite Brotherhood as an avant-garde grouping, as well as being a central aspect of the artistic education of its members. The founders of the Brotherhood, dissatisfied with their education at the Royal Academy Schools, had belonged to various drawing and sketching societies, such as the Cyclographic Society, active in the first half of 1848. The mutual drawing of portraits between young artists was popular in part because no paid model was needed, and indeed friends and family sat for many of the figures in Pre-Raphaelite paintings. The creation and exchange of portraits within the group, however, carried a distinctive significance.

All the future Pre-Raphaelites had experimented with self-portraiture before the group came into being; Rossetti's flamboyant self-image with flowing hair, made while still a teenager, places him firmly in the Romantic tradition, with soulful eyes and urbane clothing. The flattering, fluent articulation of the drawing, in pencil heightened with splashes of white chalk, is that of a fashionable portraitist of the day, with little hint of the sharply radical, histori-cist graphic style that the Pre-Raphaelites would adopt in 1848–9.

The Nazarenes, the group of German artists whose anti-academic rebellion after 1809 in many ways prefigured that of the Pre-Raphaelites, prepared highly finished portraits of each other as a gesture of mutual affection and affinity (see no.1). It was in this spirit that the Pre-Raphaelite Brothers recorded each others' appearance and that of their circle of friends and mentors such as Brown, who casts a characteristically sceptical glance at Rossetti as the young artist carefully drew his former teacher in one of his most disciplined performances.

The Pre-Raphaelite Brotherhood was undoubtedly led by Hunt, Millais and Rossetti. Of its four other members, James Collinson, a little-known genre painter, resigned in 1850 as he struggled with his religious convictions, but Thomas Woolner, the sculptor and an accomplished artist, played an important role. Rossetti paid homage to Woolner in an intimate pencil study capturing something of the unease that led the sculptor to abandon his profession and country, leaving in 1852 to prospect for gold in Australia, an event commemorated in Brown's great modern-life painting, *The*

10 *Dante Gabriel Rossetti* 1847

13 *William Holman Hunt* 1853

16 *Frederic George Stephens* 1853

19 *Elizabeth Siddall*

11 *Ford Madox Brown* 1852

14 *Thomas Woolner* 1852

17 *John Everett Millais* c.1853

20 *William Morris* c.1856

12 *John Everett Millais* 1853

15 *William Michael Rossetti* 1853

18 *Christina Rossetti* 1857

21 *Simeon Solomon* 1859

Last of England (no.94). The departure of Woolner signalled the imminent dissolution of the Brotherhood. The other members of the group commemorated it by painting each others' portraits, before sending them to the absent sculptor. Hunt's dashing and dynamic portrait of Millais, dated 12 April 1853, is inscribed 'W.H.Hunt to his PRBrother Tom Woolner'. This marks the intensity of connection between the three men, a strong homosocial bond. Hunt's admiration for, and friendship with, Millais are evident in the work, and the gift to Woolner seems to indicate that the three will always remain 'brothers' despite the sculptor's emigration and the end of the PRB. Millais's tousled hair once again contrasts with his Olympian physiognomy in Munro's laudatory profile sculpture.

Both William Michael Rossetti, the younger brother of Dante Gabriel, and Frederic George Stephens, introduced to the group as a friend of Hunt, soon abandoned any aspirations towards an artistic career, Stephens going so far as to destroy almost all the paintings he had produced. As writers and critics, however, Stephens and William Michael Rossetti were essential in propagating the Brotherhood and its members in prose media. William Michael worked from 1845 to 1894 as a civil servant in the Excise Office, but found time to edit and manage the Pre-Raphaelite journal, *The Germ* (no.23) and to produce almost 400 often lengthy articles of art criticism in the periodical press between 1850 and 1878, many promoting Pre-Raphaelite ideals. Later in life he published voluminous editions of Pre-Raphaelite correspondence and memoirs. Stephens managed to make a living as a critic (writing for the influential periodical, the *Athenaeum*) and art historian, eventually modifying his staunchly pro-Pre-Raphaelite views. Millais's portrait of the young Stephens, his forehead thrown into the shadows, probably in the evening lamplight, is a display of the draughtsman's virtuosity that his Pre-Raphaelite Brothers could not quite match; this drawing, too, was posted to Woolner in April 1853.

Though the term 'brotherhood' implies an exclusively male membership, women played a crucial role in the Pre-Raphaelite circle. The poet Christina Rossetti, who sat to her elder brother as a model for *The Girlhood of Mary Virgin* (no.24) and *Ecce Ancilla Domini!* (no.87), developed a distinctive Pre-Raphaelite idiom in literature. In addition to her brother's many drawings of her, Christina Rossetti was portrayed in a highly original, though unfinished, oil painting on panel by the Pre-Raphaelite follower John Brett in 1857. This painting may result from an unfulfilled romantic attachment between the two, commemorated in her down-to-earth poem 'No, Thank you, John', which includes the lines:

I never said I loved you John:
Why will you teaze me day by day …[11]

The portrait, with the bizarre inclusion of an outsized feather against a rich ultramarine background, carries a high degree of emotional intensity and belongs to a different idiom to the intimate friendship portraits between equals produced by Millais, Hunt and Dante Gabriel Rossetti.[12]

Elizabeth Siddall was a significant visual artist in her own right, whose close association with Rossetti, as muse, model, lover and eventually wife, has been allowed to overshadow her fiercely original artistic contribution. Siddall's own work is seen elsewhere in the exhibition (see nos.49–52), and she is represented in this section by one of Rossetti's many intimate drawings of her in a domestic setting. The pose seems to prefigure that of his posthumous portrayal of Siddall in *Beata Beatrix* (no.124). The overwhelmingly homosocial atmosphere of the Brotherhood's early years was disrupted by Siddall's dual position as artist and model. Her features can be seen in some of the most celebrated of the Brotherhood's paintings, such as Millais's *Ophelia* (no.69), yet, like the male artists seen in the other portraits in this section, she was an active creative force as well as a passive subject of the gaze. Her work was purchased and encouraged by the most influential critic of the era, John Ruskin, and her early death in 1862 robbed what has been termed the Pre-Raphaelite Sisterhood of its most distinguished talent.

During the mid-1850s a group of younger artists, inspired by the Pre-Raphaelites and especially by the work of Rossetti and the writings of Ruskin, formed a second generation of Pre-Raphaelites, whose work would move beyond the work of the founders into the decorative arts and into more arcane and more controversial subject matter. Simeon Solomon, only a child when the PRB was founded, adopted a medievalising, Pre-Raphaelite idiom in his early self-portrait, aged nineteen, and took Rossetti's work of the 1860s as the starting point for his own creative project. His pictures explore his identity as homosexual and Jewish, in both regards standing in a relationship of alterity to the original Pre-Raphaelite group.

William Morris, scion of a wealthy family, went to Oxford University in 1853, destined for the church, but under the influence of Tennyson, Ruskin and Rossetti, whom he met in 1856, became a passionate medievalist. His self-portrait demonstrates his ineptitude with pictorial representation in the mid-1850s; he had already found a voice as a poet, however, and, in collaboration with his friend Edward Burne-Jones, would, with magisterial skill and vision, develop an unmistakable Pre-Raphaelite idiom in the decorative arts. TB

22
MICHEL DE ST CROIX (dates unknown)
View of the National Gallery, London 1839

Daguerreotype 11 x 17.2
The National Media Museum, Bradford

This work bears double significance for the history of Pre-Raphaelitism. The daguerreotype, the first form of photography to gain widespread acceptance, was named after the inventor Louis-Jacque-Mandé Daguerre who announced it to the public in Paris in January 1839. The daguerreotype is a direct positive image on a copper plate coated with a thin layer of light-sensitive silver. The process was soon being demonstrated in London. On 14 September 1839 *The Times* could announce: 'The first experiments made in this country with the instrument and process of M. Daguerre were exhibited yesterday by M. St Croix, who has just arrived from Paris, in the presence of a select number of scientific men and artists.'[13] The identity of St Croix remains a mystery, but he must have been connected to Daguerre, who had given the first public demonstration of his process in Paris less than two weeks earlier.

This image, incised on the back 'Londre 1839', is believed to be one of the very first photographs made in England. In addition to the novelty of a picture made by an automatic process, the unprecedented clarity and sharpness of the daguerreotype profoundly influenced perception and had a powerful impact on Pre-Raphaelite style.[14] The camera's uncanny ability to capture quotidian details such as the railings, street-lamps and vendors' carts in Victorian London deeply affected art-making in the next decades.

This preternaturally clear image represents the side of the church of St Martin-in-the-Fields and the National Gallery in Trafalgar Square, London. The early daguerreotype camera produced reversed images, a technical flaw remedied by later technological innovations. In this case, St Martin-in-the-Fields appears to the left of the National Gallery building, although it should be on the right. In 1839 John Everett Millais was a student at the Royal Academy Schools, then located in the same building as the National Gallery, which was designed by William Wilkins and opened in 1838. The RA was situated in the side of the building shown by St Croix. The collection was already rich in old masters from the sixteenth and seventeenth centuries, with a special emphasis on Italian painting of the time of Raphael and after.[15] The acquisitions of Jan van Eyck's *Arnolfini Portrait* (1434; fig.13) and other early works such as the wing panels from Lorenzo Monaco's *San Benedetto Altarpiece* (1407–9; acquired in 1848, no.27), however, were of fundamental importance for the Pre-Raphaelites, offering a precision and clarity of vision which seemed to parallel that found in the new technology of photography. TB

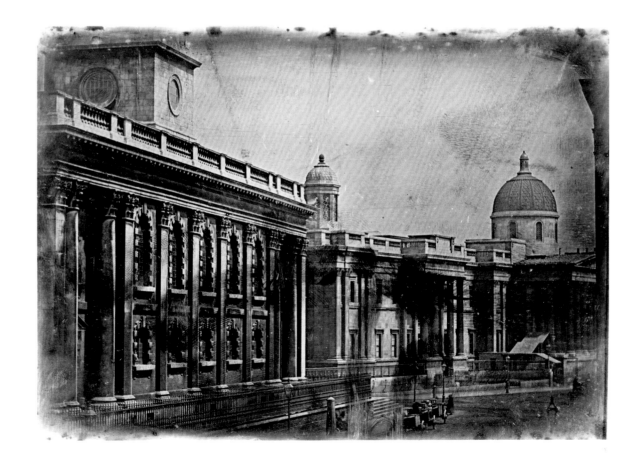

The Germ: Thoughts towards Nature in Poetry, Literature, and Art, no.1, January 1850: open at frontispiece, *My Beautiful Lady,* by William Holman Hunt

Pub. Aylott & Jones, 8 Paternoster Row, London

Printed journal 22.5 x 14.4
Victoria and Albert Museum. Donated by John Forster

The Germ was intended from the start to be a journal of Pre-Raphaelite art and literature, and in early discussions the title *P.R.B. Journal* was proposed. Its content included poetry, short stories, prose essays and engraved illustrations from drawings specially created for the purpose. The eventual list of contributors, however, extended well beyond the Pre-Raphaelite circle. The strongest influence over the short-lived periodical was that of Dante Gabriel Rossetti, whom Hunt remembered being 'indefatigable in beating up literary contributors to *The Germ*'.[16] Rossetti's important short story 'Hand and Soul', published in the first issue, offered a complex meditation on artistic identity, modern and medieval. Rossetti also contributed poetry, including 'The Blessed Damozel'. The practical duties of editing the magazine were almost all discharged by his younger brother William Michael Rossetti. The title of *The Germ* was changed after the first two numbers to the more Ruskinian *Art and Poetry: Being Thoughts towards Nature Conducted Principally by Artists*. Each issue contained an engraving after a work by a member of the Pre-Raphaelite circle.

The journal struggled to establish itself. The first number appeared on New Year's Day, 1850. An ambitious run of 700 copies was printed; a deluxe edition of fifty had etchings on India paper. Only seventy were sold. The figures were hardly better for the remaining three issues (February, March and May 1850), after which the journal was discontinued. The financial costs of its failure were borne by the printer, George Tupper, father of John Lucas Tupper, the aspiring sculptor, who was a member of the Pre-Raphaelite circle (fig.15). The younger Tupper contributed five articles anonymously to *The Germ*, including an important two-part discussion of 'The Subject in Art', which advocates painting from modern life. Brown, by contrast, submitted a careful article 'On the Mechanism of a Historical Picture', which clearly laid out the academic orthodoxies he had been taught in Belgium.

The typography was emphatically gothic, suggesting links between *The Germ* and Puseyite publications of the Oxford Movement and even with Pugin. William Dyce, too, had experimented with gothic typefaces in his High Anglican Order of Service.[17]

The journal was widely reviewed but never reached a large audience. It was, wrote Edward William Cox in *The Critic*, 'not *material* enough for the age'. Despite its ethereal character, however, Cox later added: '*The Germ* was not wantonly so entitled, for it abounded with the promise of a rich harvest.'[18] It made a distinct impact and, without offering a specific manifesto, indicated the breadth and ambition of the Pre-Raphaelite project.[19] TB

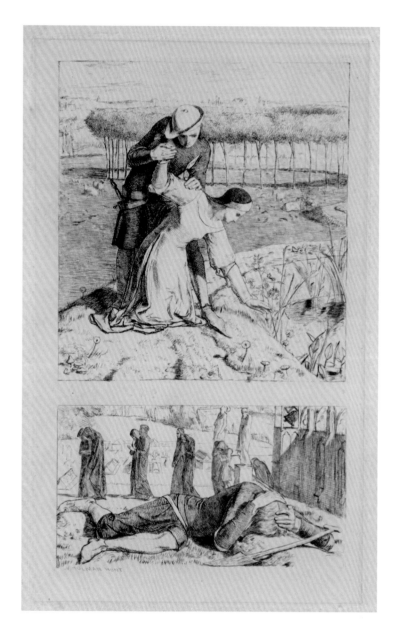

DANTE GABRIEL ROSSETTI 1828–82

The Girlhood of Mary Virgin 1848–9

Oil on canvas 83.2 × 65.4
Tate. Bequeathed by Lady Jekyll 1937

This was the first Pre-Raphaelite picture to appear in public, going on display from late March 1849 at the National Institution's 'Free Exhibition of Modern Art' held at the Chinese Gallery behind the Alexandra Hotel on Hyde Park Corner. Rossetti added the secretive initials 'P.R.B.' at the bottom with the date and his name in a script as careful as his overall brushwork. In choosing this venue, Rossetti followed his early mentor Brown, who had shown *Wycliffe* (no.9) there the previous spring. He also may have feared rejection at the RA or been wary of that prestigious public stage, despite his painterly Brothers' encouragement. Rossetti's picture represents a revivalist style that draws on early Renaissance paintings from Northern Europe and Italy, blended with a comprehensive religious symbolism expressed in a profusion of clearly observed details and natural forms, such as the lilies redolent of the Virgin Mary's purity and the lamp evoking piety. Also notable are its brilliant coloration, complex anti-perspectival construction beyond the immediate foreground, and modern realist technique evident especially in unidealised faces taken from family members: Rossetti's deeply religious mother Frances and sister Christina for Anne and Mary.[20] In this work and *Ecce Ancilla Domini!* (no.87), his submission to the National Institution the following year, Rossetti painted symbolic interpretations of New Testament themes that rejected inherited iconography. These images paralleled the growing interest in ritual spurred on by the Anglican Tractarian or High Church movement, a development his mother and sister supported.

Religious imagery is prevalent throughout the long history of Pre-Raphaelitism, but works such as this picture, Millais's *Christ in the House of His Parents* (no.85) or Hunt's *Light of the World* (no.92) depict novel scenes in the history of art. Mary embroiders a lily, studying it from nature. A small angel at left presages the inclusion of Gabriel in the succeeding scene in Mary's story of the Annunciation, a subject Rossetti painted the following year, and in the background the dove of the Holy Spirit sits on a grape trellis that is being trimmed by Joachim.

The picture set the stage for Pre-Raphaelite challenges to artistic orthodoxy. Rossetti inscribed a sonnet he wrote explaining the picture's theme and symbolism on the original frame, and included another in the exhibition catalogue.[21] This foreshadowed the links between image and poetry that he would pursue all his career. In the painting the sharpness of the forms, the emphasis on building composition through planes parallel to the surface of the picture, and the sense of measured movement and intricate glances reflect concerns in early Pre-Raphaelite drawings with their subjects from Italian literature or continental history (nos.28–9). In addition, the gilding in details such as the haloes and the lamp on the balustrade, which functions as an altar in the middle ground, was in response to early Italian art, as are the bright white ground and red underpainting in sections found in tempera pictures on panel. The firm linear perspective organisation of the foreground, with its vanishing

point just above the angel's right wing, turns the properly positioned viewer into a reflection of that heavenly witness to the scene. The picture was originally arched at the top in a link to early Italian altarpieces and as in Rossetti's contemporaneous drawing of *The First Anniversary of the Death of Beatrice* (no.28).

Rossetti's *Girlhood* was generally well received, with critics praising his high aims and depth of thought, referring to its 'old missal style' and overlooking the compositional difficulties he encountered in trying to unify the carefully constructed foreground with the condensed and flattened middle ground and distance.[22] To that end Rossetti employed such solutions as placing the symbolic red robe of Christ over the stone altar so that he would not have to elucidate the position, or scale, of Joachim's lower body. Rossetti either wilfully embraced or clumsily dealt with the same compositional shortcomings in *Ecce Ancilla Domini!*, with its similarly leftward vanishing point at the apex of Gabriel's head and a blue screen covering an unarticulated corner of a squat and truncated room. Critics were now less kind; he consequently ceased exhibiting oils and turned his creative energies to drawings and opulent, patterned and formally flattened, medievalising watercolours (nos.39, 46–8). JR

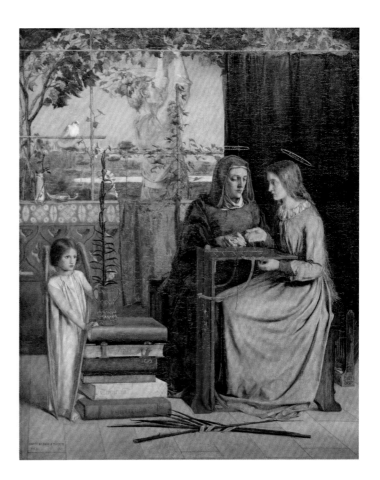

WILLIAM HOLMAN HUNT 1827–1910

Rienzi Vowing to Obtain Justice for the Death of his Young Brother, Slain in a Skirmish between the Colonna and Orsini Factions 1848–9

Oil on canvas 86.4 x 121.9
Private collection, England

Hunt showed *Rienzi*, Millais his *Isabella* (no.26) and Collinson his *Italian Image-Boys at a Roadside Alehouse* (fig.11) at the annual Royal Academy exhibition, which opened in early May 1849, two months after the Free Exhibition where Rossetti debuted his *Girlhood of Mary Virgin* (no.24).[23] *Rienzi* and *Isabella* were hung near one another in the preferred Middle Room, their frames seated on 'the line', a point 8 feet (2.4 metres) high on the wall and just above the prime position for best viewing. Pictures at the Academy at that time were displayed frame to frame, sometimes four high, and in choosing to employ vivid colours and distinctive compositions and subjects, the Pre-Raphaelites were seeking to attract notice in a crowded visual field. Critics responded positively, recognising the similarities between Hunt's and Millais's pictures, although they did not attempt to decode the three consonants that accompanied the artists' signatures. The meaning of 'PRB' and its members' names were revealed in the press the following year, when the artists were then suddenly perceived as revolutionary and a threat: exactly what they had been all along.

Both *Rienzi* and *Isabella* depict subjects from early Italian history derived from literature. Both feature bright colours and, like Rossetti's *Girlhood*, an absence of pervasive chiaroscuro, or dramatic contrasts of light and shade. Millais's work focuses on a psychologically and emotionally fraught moment, while *Rienzi* reprises countless scenes of fervent oath-taking from the previous century by Henry Fuseli, Gavin Hamilton, Jacques-Louis David and others. Hunt's subject was topical, channelling the pan-European fervour of revolutions across the continent in the year before and portraying a scene from Edward Bulwer-Lytton's novel of 1835 (recently reissued) *Rienzi, the Last of the Roman Tribunes*, set in the fourteenth century. It shows the future liberator of Rome, appropriately modelled by the British-Italian Rossetti, vowing to avenge his brother, slain in an incidence of what would now be called friendly fire in a fight alongside the Colonna against the Orsini. It is also a picture that deals with class difference, as Rienzi was a commoner and his brother was killed by a nobleman, of the rank of the knight, Adrian di Costello, to his right. Rienzi had appeared on the list of Pre-Raphaelite immortals that Hunt had composed with D.G. Rossetti in August 1848, reflecting the revolutionary ardour of the movement, a sentiment put into practice by Hunt in attending with

Millais the Chartist meeting on Kensington Common in April of that year (fig.10).[24] Hunt adhered closely to descriptions from the book, especially of costume and setting, although in a typical act of later repainting he changed the protagonist's cloak from dark grey to maroon: given the chance at some later date – in this case nearly four decades on – Hunt was not one to leave his pictures well enough alone.

Rienzi was the first Pre-Raphaelite work to be painted partially outdoors from nature, a process that would become an established Pre-Raphaelite practice and lead to a definite style in his and Millais's works of the coming years, as seen in the 'Nature' section below. He worked on Hampstead Heath and in Lambeth. The relatively straightforward composition and planar frontality, with figures crammed in a rectangular formation in the immediate foreground, would become a compositional device for his outdoor works (no.86). This reflected the need to leave a regularised and clear space in the centre of his canvases where figures would be added, painted not under full sunlight but in the studio. Following the developing practice of archaeological accuracy in Pre-Raphaelitism and inspired by Brown (see no.7), Hunt painted the weaponry at the Tower of London. The figure at the left bears W.M. Rossetti's features, though Millais had also posed for this character. The notable array of swords, poles and spears in the foreground that serve as orthogonals, diagonal lines perpendicular to the picture plane and leading into depth, have clear precedents across quattrocento art, especially in Paolo Uccello's work.[25]

Despite the existence of a small oil sketch, it is difficult to describe the original appearance of the painting; it was evidently much abraded and cracked by the mid-1860s. In substantially repainting the foreground and sky in 1886, Hunt perhaps enhanced the azure tones to harmonise better with Millais's early works, which he would have seen in abundance for the first time in decades at that artist's comprehensive Grosvenor Gallery show earlier the same year.

While *Rienzi*, rarely exhibited, is less familiar than other early Pre-Raphaelite works, it can claim special status in the history of avant-garde painting since a related drawing influenced the young Pablo Picasso during his Rose Period.[26] JR

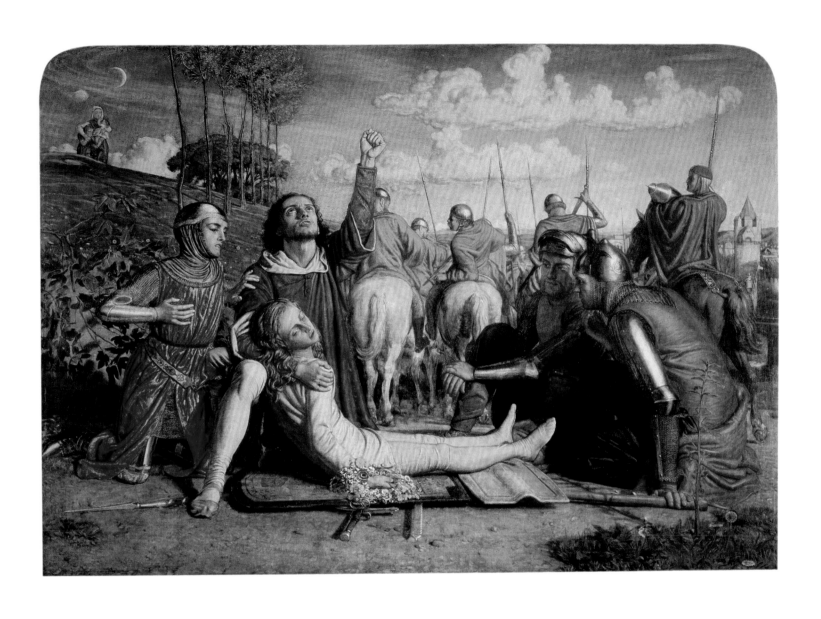

JOHN EVERETT MILLAIS 1829–96

Isabella 1848–9

Oil on canvas 103 x 142.8
National Museums Liverpool, Walker Art Gallery

Isabella was Millais's first painting completed after the formation of the Brotherhood, his only work at the RA of 1849, and part of that year's bold rollout of Pre-Raphaelite art in London.[27] He signed it at lower right with his name and twice with 'PRB'. Unlike Rossetti, Hunt and Millais abjured religious subject matter in their initial PRB statements (see no.24), instead searching vernacular literature for distinctive and compelling scenarios. This allowed them to test their radical pictorial ideas in subjects with few prior associations in the minds of their viewers – a goal of challenging familiarity they also had for their new style. And Hunt and Millais firmly set their sights on the Royal Academy as the venue for the opening move of their aesthetic gambit.

Isabella represents Pre-Raphaelite practice in terms of novelty of source, thorough research into costume and setting, sketching of carefully selected models, stylistically archaising manner and modern conceptualisation of narrative. The story is medieval, from Boccaccio, via a poem by the short-lived Romantic John Keats: 'Isabella; or, The Pot of Basil' (1818). On the left two brothers from a mercantile family in Florence discover across the table the covert love affair of their sister and Lorenzo, a clerk in their warehouse. They murder Lorenzo and bury him in a forest. A phantasm leads Isabella to the body. She digs him up, removes his head and plants it in a pot of basil. The brothers become suspicious of the endless time she lavishes on this pot, discover what it conceals and, shamed and guilt-stricken, flee Florence. Isabella perishes of a broken heart.

The remarkable advance that Millais achieved in this picture was to encapsulate the story's key elements in a single image, without resorting to the early Renaissance technique of simultaneous narrative, where sequential scenes from a story and multiple images of the same characters are contained in a single framed work. In this transcendent painting the intense ardour of a socially forbidden love is brazenly revealed in Lorenzo's spellbound features. Isabella demurely accepts his gaze and his macabre offer of a halved blood orange. The brothers simultaneously perceive the truth, and one crushes a nut to allude to Lorenzo's fate. On the window sill behind Isabella, positioned like the typologically symbolic instruments of the Passion in Millais's subsequent *Christ in the House of His Parents* (no.85), is a pot of herbs, presaging the resting place of Lorenzo's head. From but a few lines in Keats's long

poem, printed in the RA catalogue, Millais presented a seemingly singular, but actually compressed and pregnant moment, encompassing the past, present and future of the ill-fated lovers.

In conformity with Pre-Raphaelite practice, Millais used family members and Brothers as models, including D.G. Rossetti for the man draining his glass in the background and F.G. Stephens for the brother at the far left. He derived Isabella's outfit from Bonnard's lavish *Costumes historiques* (1829), which illustrated paintings of the general period. He laboured over each detail in the picture, from maiolica and stockings to the two dogs in the foreground. He evoked early Italian art in three ways. He based the forms of the four main protagonists on saints from the wings of Lorenzo Monaco's altarpiece just down the hall from the RA in the National Gallery (no.27). He backed the figures with a golden rear wall as in fifteenth-century religious panel paintings in tempera and gold leaf. And he disregarded traditional one-point perspective and balanced compositions bearing a single vanishing point, a structural advance not achieved until the generation after Lorenzo Monaco's time, in favour of a wilfully skewed table, with four seated at left and eight at right. This deceptively complex depiction of depth brings the key characters vividly to the forefront.

The faces in *Isabella* reveal much about Pre-Raphaelite practice and the avid pursuit of an optically exact realism. However, they owe more to contemporary daguerreotype portraits (no.31) and northern painting of the fifteenth century than early Italian art: Jan van Eyck's peerless *Arnolfini Portrait* (fig.13) entered the National Gallery collection in 1842 and influenced numerous PRB works (no.90). But unlike van Eyck, who conveyed a remarkably particularised individual in the face of the Italian merchant Giovanni di Nicolao Arnolfini but idealised Giovanna Cenami as a type based on traditional medieval images of saintly women, Millais opted for the pursuit of realism in producing personal images of both sexes, which would be a hallmark of his practice throughout his career as he evolved into Britain's most successful portraitist (no.118).

The *Art Journal* wrote that *Isabella* was 'perhaps, on the whole, the most remarkable of the whole collection; it cannot fail to establish the fame of the young painter'.[28] In his memoirs of 1905 Hunt himself called it 'the most wonderful picture that any youth under twenty years of age ever painted'.[29] JR

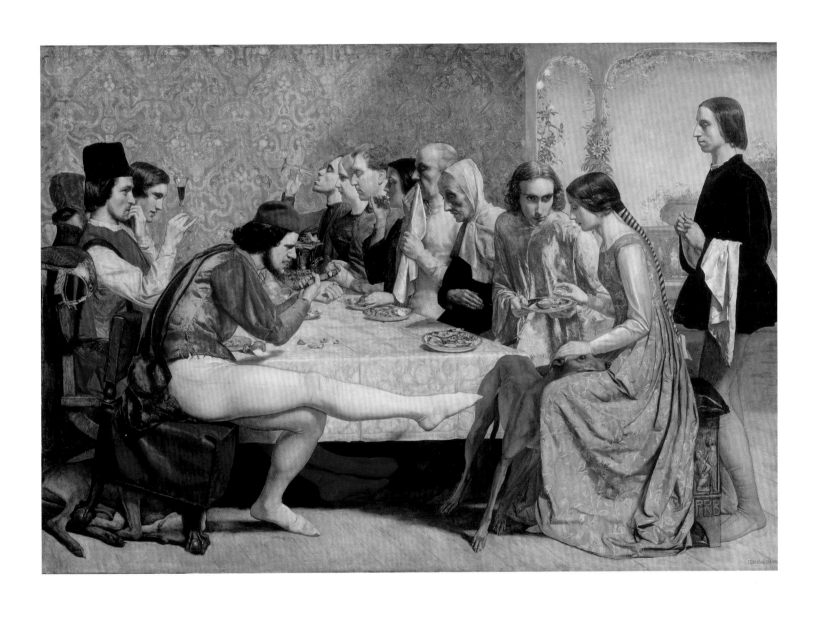

27

LORENZO MONACO, active 1399, died 1423/4

Adoring Saints, right main tier panel from the *San Benedetto Altarpiece* 1407–9

Egg tempera on wood 197.2 x 101.5
The National Gallery, London. Presented by William Coningham, 1848

Piero di Giovanni, known as Lorenzo the Monk, painted this wing panel for the Camaldolese monastery of San Benedetto fuori della Porta Pinti in Florence as part of the high altarpiece dedicated to the patron saint of the Benedictine order. William Coningham, former officer in the 1st Royal Dragoons and close friend of the painter John Linnell, who later served as a liberal MP for Brighton, gave both wings of the altarpiece to the National Gallery in July 1848, two months prior to the PRB's formation.[30] Then attributed to Taddeo Gaddi, they were the first Italian 'primitive' works to enter the collection and consequently had a distinct influence on the Pre-Raphaelites, in particular on Millais's *Isabella* (no.26). The central panel was acquired in 1902.

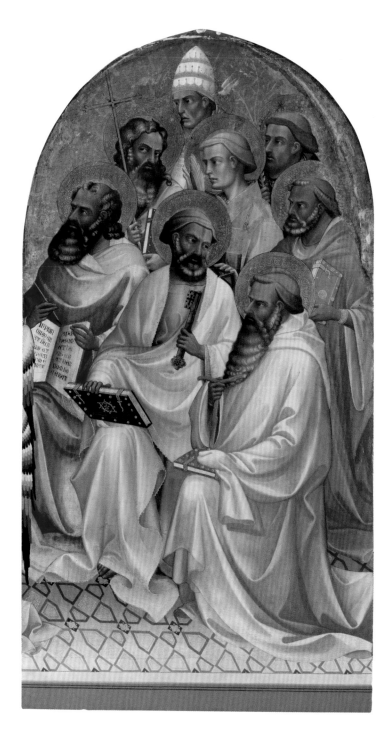

The right wing features eight saints in three rows in attendance at the Coronation of the Virgin Mary, imaged in the central panel. St Romuald (d.1027), the founder of the Camaldolese Order, occupies the prime position (in white) at the far end of the first row, opposite St Benedict on the left wing. He holds a book and a hermit's T-shaped staff: Isabella occupies his position in Millais's picture (no.26). To his right St Peter wields the gold key to heaven and turns towards Romuald, as Lorenzo does to Isabella. In the left panel the features of St Benedict have a severity in the eyes reflected in that of Isabella's foremost brother, and the image of St John the Baptist to the right of Benedict, with outstretched right arm, relates to the brother behind.

Despite an interest in early Italian art, Coningham had fairly conventional taste, even disapproving of the Nazarenes (no.1), and it is ironic that the wings of the *San Benedetto Altarpiece* would, through the brush and inventiveness of Millais, influence a wholesale revolution in British art. JR

28

DANTE GABRIEL ROSSETTI 1828–82

Dante Drawing an Angel on the First Anniversary of the Death of Beatrice 1848–9

Pen and black ink, inscriptions in brown ink 40 x 32
Birmingham Museums and Art Gallery. Purchased and presented by subscribers, 1903

29

JOHN EVERETT MILLAIS 1829–96

The Disentombment of Queen Matilda 1849

Pen and ink on paper 22.9 x 42.9
Tate. Purchased 1945

Artistic abilities varied widely among members of the Brotherhood, but their early drawings reveal stylistic unity. This had been nurtured in the Cyclographic Society sketching group, which was established in early 1848 and included all PRB members except W.M. Rossetti.[31] Through an affection for William Blake's works (no.2), illuminated manuscripts perused at the British Museum, the continued influence of John Flaxman's elegant line illustrations, contemporary German publications by Moritz Retzsch and the study of Lasinio's engravings (fig.12) the members of the group developed a distinctive style. As in their early paintings, they simplified form and emphasised outline, eliminated deep chiaroscuro and *sfumato* shading, and took advantage of the brightening and flattening qualities of exposing the blank sheet and embracing negative space. The resulting works share the angularity of form the artists saw in engravings and gothic sculpture, in addition to the clarity of natural detail and slow rhythmic movement typical of their art.

These two works were made in the first year of the Brotherhood's formation: Rossetti presented his to Millais; Millais gave him his elegant *My Beautiful Lady* (1848; Birmingham Museums and Art Gallery). They feature willowy and spiky figures in a gothic style in a rejection of the idealised musculature of the classical tradition, and closely observed period costume and detail. Moreover, they refrain from the deep shading and light-to-dark transitions in forms that were standard practice since the late Renaissance and Baroque eras. Rossetti's is a subject from his beloved Dante Alighieri's *Vita Nuova*, which he had translated in October 1848. The poet has been disturbed in his chamber while drawing an angel on the one-year anniversary of the death of Beatrice. The perspective of the room is awkward, as in his *Girlhood of Mary Virgin* (no.24), but the figures, in a frieze-like formation across the foreground of the image, demand attention. Rossetti shaded the wall on the left with upright parallel striations, as in an engraving, and anchored the work through a progression of vertical emphases in the cloaks and furniture. The pageboy on the right, who idly scratches his leg with the point of his shoe, is positioned like the servant on the right in Millais's *Isabella* (no.26) with figures in front of him similarly plunging back into space and facing left.

Millais's *Disentombment* takes as its subject a historical incident: the plunder of the eleventh-century royal tombs at Holy Trinity Abbey, Caen, France, in 1562.[32] Calvinists have rudely disinterred William the Conqueror's wife and stolen her jewels. This Reformation-era ransacking of an abbey's late-Romanesque and gothic tapestries, reredos, statues and tombs serves as a Pre-Raphaelite critique of contemporary taste. Millais approached the subject with gusto in one of his few early works to include scenes of action, as opposed to measured and deliberate movement, as in Rossetti's drawing.

Early Pre-Raphaelite drawings, as with the commensurate paintings in oils or watercolours, and the Brotherhood's production of *The Germ* (no.23), retain evidence of intense labour. This element of their approach would commend them to Ruskin and attract a younger generation of artists such as Morris and Burne-Jones, for whom process and effort were a means to authenticity. This was a paramount element in the Pre-Raphaelite manifesto, forcibly reflected in their draughtsmanship. JR

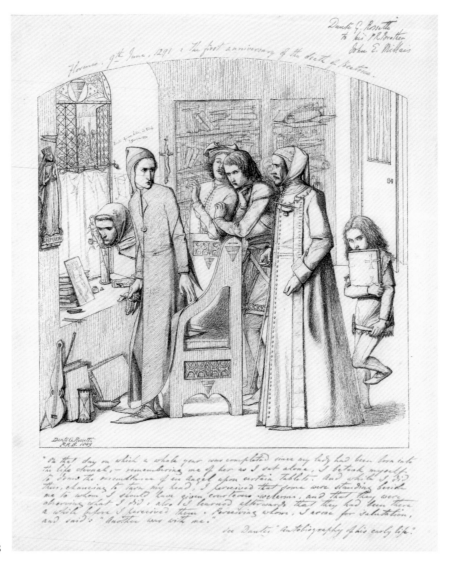

28

29

30

JOHN EVERETT MILLAIS 1829–96

Mrs James Wyatt Jr and her Daughter Sarah c.1850

Oil on mahogany panel 35.3 x 45.7
Tate. Purchased 1984

31

WILLIAM EDWARD KILBURN 1818–91

Portrait of a Man and Girl c.1848

Hand-coloured daguerreotype 13 x 10.5 (period leather case)
K. & J. Jacobson, UK

This portrait was one of Millais's earliest commissioned works, from a family that was generous and supportive of him in the first years of the PRB.[33] Eliza Wyatt was the daughter-in-law of James Wyatt, a printseller in Oxford who owned pictures by the artist, and Millais would stay with him over the summer months when he was painting in the environs. He produced a picture of James and his granddaughter Mary in 1849 (Lord Lloyd Webber), and then this picture, in which Eliza and her younger daughter pose somewhat stiffly on a sofa. It is a conceptual work, an essay in the new Pre-Raphaelite approach to the body in the unassuming poses of the sitters, the clarity of features and the crisp verticals and diagonals that define the composition in the arms, legs, furniture and framed prints. Millais contrasted the array of monochrome engravings after Raphael and Leonardo da Vinci on the wall behind (the latter's *Last Supper* flanked by two pictures of the Virgin Mary and the baby Jesus) with the modern flesh-and-blood mother-and-child image in the foreground.

The painting functions as a sly riposte to the High Renaissance and its perfection of mobile and credible bodies in illusionistic space. Millais denied this in the rigidity of his mother and daughter, more typical of the early Renaissance works of Antonio Pollaiuolo, Fra Filippo Lippi or Jan van Eyck. The figures do not interact and so bear a resemblance to period daguerreotype portraits such as William Kilburn's of an unidentified man and his daughter. Kilburn opened his studio in 1846 on Regent Street in London, where this example was probably taken. He is best known for his portraits of Queen Victoria and her family, and he also photographed the Chartist gathering in 1848 (fig.10). The formal stiffness was determined in part by exposure times.[34] Millais echoed this in his painting and produced a contemporary portrait but with more naturalistic colours than those in Kilburn's softly hand-tinted daguerreotype, an integrated brilliance of hues that at this time remained the province of painting alone. JR

30

31

3. HISTORY

The true distinction of these men is, that they are poets on canvass [sic], and paint mind, character, and feeling, while the most of our figure-painters – at least those who attempt anything beyond the delineation of humorous scenes – do little else than give a prosaic and literal representation of the action or person they profess to depict. In how many cases is the title of a picture a mere after-thought? How often is an historical piece nothing more than a collection of costumes? The rich colours, the minute and careful finish which mark the works of Millais and Hunt, give one the impression of being the natural result and accompaniment of the intense vividness of their conceptions, and not mere efforts of executive art; and these qualities are here but subordinate to the higher interest of expression which pervades the whole. In a word, these painters have touched a deeper chord than English art has hitherto known; and in no short space of time their merits will be clearly recognised as are now those of a Keats or a Beethoven, whose works, when first promulgated to the world, were pronounced strange, un-intelligible, and contrary to all rule.[1] (*The Guardian*, 1851)

The history category in painting and sculpture – the depiction of dramatic narratives from the Bible, classical mythology and culture, literature, or world history – had been the pre-eminent fine-art genre since the establishment of academies in the seventeenth century. The young Pre-Raphaelites were well aware of the developments since the 1780s, led in France by Jacques-Louis David and J.-A.-D. Ingres and in Germany by the Nazarenes, that had invigorated history painting in the Neoclassical and Romantic periods. They were also cognisant of the failure of British history painting at that same time to create either a national aesthetic or a robust market, despite the explicit goals of the Royal Academy and the efforts of its members from Sir Joshua Reynolds and Benjamin West to James Barry and Benjamin Robert Haydon.

Yet the PRB were determined to address literary and historical subjects. Employing their evolving hard-edged style and insisting on precise accuracy of dress and accoutrements, they developed modern forms of this genre, in which intimate personal relationships stood for broader currents of human experience. The results defied convention, provoked critics and entranced audiences; and they also appealed to new industrial and commercial patrons in the Victorian era.

This section explores works based on the writings of Shakespeare and Dante Alighieri, two of the Brotherhood's heroes, on narrative subjects of their own invention and on medieval tales.

The PRB were not interested in ripping action stories or idealised classical scenes inhabited by languid nudes. They rejected classical history and its attendant ideas of exemplary virtue, military might and monarchical achievement. As detailed in the 'Manifesto' section, they established their concerns from the outset: intimate scenes of religion in Rossetti's *The Girlhood of Mary Virgin* (no.24); literary and historical imagery that elevated the individual achievements of lesser-known personages in Hunt's *Rienzi* (no.25); and intensely poetic depictions of adolescent romance from the past in Millais's *Isabella* (no.26).

Seemingly unconcerned with commercial imperatives, the Pre-Raphaelites chose subjects based on what they were reading, the plays and opera productions they attended, the works of contemporary poets such as Coventry Patmore and Alfred Tennyson, and imaginative reconstructions of the medieval world taken from the remnants of the historical past visible to them throughout London. Religious subject matter is dealt with in the 'Salvation' section below.

The Pre-Raphaelites approached history painting with a different mindset from their elders. In particular, their transformations of material from Shakespeare or opera were realised in such a way that they do not recall staged productions with backdrops. Instead, by working so diligently at landscape backgrounds before inserting figures, the Pre-Raphaelites created a convincingly realistic setting for the action. This was a great shift from the tableau tradition of the previous century. Early works such as Deverell's *Twelfth Night* (no.32) and Millais's *Ferdinand Lured by Ariel* (no.33) demonstrate the artists' inventive reworking of themes from Shakespeare. Adopting a luminous palette, they stayed close to the source material, finding costumes and design ideas from illuminated manuscripts and reference books in order to reconstruct plausible and accurate settings. The features of each character were painstakingly painted from sitters in their circle, creating an effect of truthfulness. These strategies resulted in pictures that conveyed a precise optical realism married to a distinctive appearance, which contravened academic tradition. John Ruskin provided an eloquent summary of the radical aim of these works, brilliantly linking realism and revivalism, in his letters to *The Times* in 1851. The Pre-Raphaelites, he wrote,

> will draw either what they see, or what they suppose might have been the actual facts of the scene they desire to represent, irrespective of any conventional rules of picture making; and they have chosen their unfortunate though not inaccurate name because all artists did this before Raphael's time, and after Raphael's time did *not* this, but

sought to paint fair pictures rather than represent stern facts, of which the consequence has been that from Raphael's time to this day historical art has been in acknowledged decadence.[2]

The procedure of making such historical and literary compositions was also new and collaborative. In October 1850, when Hunt began to conceive *Valentine Rescuing Sylvia from Proteus* (no.34), the group including Stephens and Rossetti decided to decamp to Knole near Sevenoaks in Kent (an imprecise, though practical, substitute for the picture's Italian setting in *Two Gentlemen of Verona*), to bring their models with them, and to work, cavort and eat outside. This anticipates the type of communal activities of later painters and models on the continent that would become the hallmark of the avant-garde: Claude Monet, Édouard Manet and Pierre-Auguste Renoir at Argenteuil in 1874; the circle around Paul Gauguin and Émile Bernard in Brittany in the 1880s; Henri Matisse, André Derain and the Fauves at Collioure in 1905; or Pablo Picasso and Georges Braque at Céret in 1911. But the Pre-Raphaelites' desire to bring their models connects them to later artists such as the Brücke, whose utopian summer retreats in the Moritzburg lakes outside Dresden in 1907–11 were exercises in a free-spirited communality that translated into painterly style. Unluckily for the Pre-Raphaelites, Elizabeth Siddall, then a model and not yet an artist, refused to go, so the party was reduced to Rossetti, Hunt, Stephens and Annie Miller, and their choice of Kent in the autumn was unfortunate, as rain and cold impeded their progress.[3]

In the mid-1850s Rossetti, who had abandoned making exhibition pictures in oils, turned to the medium of watercolour to create a series of intensely coloured, intricate compositions loosely rooted in the tradition of medieval illumination. Many, such as *The Wedding of St George and the Princess Sabra* (no.46), explored themes of chivalric love. The heroines, tall, pale and slender, were often drawn from, or based on, the physique and features of Siddall, Rossetti's muse, mistress and, from May 1860 until her premature death in February 1862, his wife. Siddall's own works of this period, necessarily made on a small scale, indicate a distinctive artistic personality, influenced, but not dominated, by Rossetti. The sinuous, flattened figures in her work more closely resemble the stylisation of the body in gothic art, an effect sometimes attributed to Siddall's lack of formal training but one that was, rather, a function of her fierce artistic originality.

While Ruskin's writing on Turner and landscape had influenced Hunt and Millais in the 1840s, his essay on 'The Nature of Gothic' in *Stones of Venice* (1851–3) deeply impressed Rossetti, Edward Burne-Jones and William Morris. It laid out a powerful ethical, as well as aesthetic, argument in favour of medieval models of creativity and praised the free, 'grotesque' quality of the medieval imagination in *Modern Painters* in preference to the 'slavery' of modern factory labour and, by implication, academic art education.[4]

The imaginary world of Rossetti's watercolours of the mid-1850s was notable for richly decorated and colourful neo-medieval interior settings. By the end of the decade Rossetti's younger followers Burne-Jones and Morris would begin their transformation of Victorian interior design, making actual furniture, textiles and wallpaper in broadly similar schemes. Ford Madox Brown and Rossetti were also involved in the collaborative endeavour to decorate Red House in Bexleyheath, the new home Morris erected after his marriage to Jane Burden in 1859. Historical narrative played an important part in the decorative scheme of Red House. *The Prioress's Tale Wardrobe* (no.54), decorated by Burne-Jones, represents a dramatic innovation in history painting: not only are elaborate paintings applied to the surfaces of a functional object (as on Renaissance *cassoni*), but multiple narratives are juxtaposed with differences of scale and knowing distortions of perspective that refer back to medieval manuscript illumination.

The interchange of ideas and designs between this group of friends was the basis for the founding of 'the Firm', Morris, Marshall, Faulkner & Co., in 1861. Many of the Firm's productions incorporated historical narratives. Figurative stained glass, in particular, became a speciality, depicting with bold and original motifs both religious subjects and secular themes such as *King René's Honeymoon* (no.60), derived from Walter Scott's novel *Anne of Geierstein*.

Pre-Raphaelite sculpture of historical subjects lacks the visible newness manifest in the group's paintings, watercolours or even drawings. Initially, the strict adherence to the traditional materials of the medium – plaster, marble, limestone – in the works of Thomas Woolner, Alexander Munro and John Lucas Tupper (fig.15) did not represent a break with the past. The possibilities of a radical medievalising style combined with realism, parallel to that promoted in the early paintings of Hunt, Millais and Rossetti, were diluted. In their crispness of outline and sharpness of profile, Munro's *Paolo e Francesca* (no.38) and *Young Romilly* (no.83) verge on being three-dimensional equivalents to spiky and angular Pre-Raphaelite drawings, but do not rise to the level of chromatic brilliance in PRB painting. Only in his novel polychrome relief portraits (no.116) did Munro rival the early Pre-Raphaelite paintings in originality. He did not use colour in this way in his narrative work.

Pre-Raphaelite historical art invigorated the genre and then transformed it with their style and focus on particular subjects. After the break-up of the group in 1853 Hunt went to the Holy Land to pursue an authentic brand of religious history painting on Pre-Raphaelite principles, and Rossetti evolved an iconic style of depiction of female beauty, often based on literary sources, that spurred on the Aesthetic Movement. Morris and Burne-Jones established a poetic form of narrative art based on medieval precedents and melded into the multiplicity of applied art produced by the Firm, while Millais continued his investigation of human interactions in historical circumstances that propelled him to the forefront of European artistic culture. TB & JR

WALTER HOWELL DEVERELL 1827–54

Twelfth Night 1849–50

Oil on canvas 101.6 x 132.1
Private collection

Twelfth Night was painted during the autumn and winter of 1849 and exhibited the following spring at the National Institution in the same room as Rossetti's *Ecce Ancilla Domini!* (no.87). Although Deverell was never formally elected to the PRB, he was an integral part of the circle, sharing many of their goals and interests as can be seen in what the *Literary Gazette* described as his 'kaleidoscopically coloured' composition with its Shakespearean subject matter and playful adaptation of medieval and quattrocento sources.[5] In the painting these influences are shown in the bright costumes of the two pages in the bottom-right-hand corner, above which stands a black musician playing bells adapted from a fourteenth-century manuscript in the British Museum.[6] While the deliberately naive perspective and balustrade device recall no.24, the frozen triangular grouping of the three main figures bears a striking resemblance to the composition of Hunt's *Valentine Rescuing Sylvia from Proteus* (no.34), which in turn may have been influenced by the hieratic arrangement of figures in the Flemish painter Hans Memling's *Triptych of the Two Saints John* (1474–9), which Hunt had recently studied in Bruges. Deverell also adopts the Pre-Raphaelite practice of casting acquaintances according to role. Renowned for his good looks, Deverell painted himself as the lovelorn Duke Orsino, while D.G. Rossetti sat for the jester Feste and Elizabeth Siddall for Viola disguised as the page Cesario, her first appearance in a Pre-Raphaelite painting.

Deverell specialised in Shakespearean subjects, being a keen amateur actor. His painting of Act II, Scene iv, of *Twelfth Night* shows an in-depth understanding of the subtleties of plot and characterisation. Tormented by his unrequited love for Olivia, Orsino sits idly on a terrace serenaded on one side by his clown with the song, 'Come away, come away Death', and attended on the other by Viola in the guise of the duke's manservant Cesaro. The superficial harmony of the scene is disturbed by the expressions and postures of the protagonists, which, in deliberately eschewing the grand rhetorical gestures associated with theatrical representation, disclose their inner feelings and longings. Feste's attitude gently mocks that of his master, who assumes a melancholy pose as he pulls distractedly at a lock. As Orsino lolls his head to the side he avoids the ardent gaze of Viola who sits modestly, 'patience on a monument', totally absorbed by his presence. Her real feelings are hinted at by the rose she holds and the passion flower on the balustrade, as well as by the red of her hair and tunic, and the crimson patch glimmering on her thigh. She leans against a bench carved with a skull surrounded by a garland of roses, an allusion to the transience of love and physical beauty that forms the leitmotif of the play.

Although the scene is conceived as a stage set under a proscenium arch, the different elements of the design converge to confound the eye. The column against which Orsino leans is thus positioned in front of this arch, as if in the viewer's space. In the distance the wall abutting the steps is abruptly cut off by the foreground column, while the figures immediately behind Orsino and Feste appear rather large in scale, especially when set against the musicians on the left. The background thus occupies an ambivalent position as both a real space and a backdrop, an illusory foil to the tensions explored in the foreground. Probably the most eccentric feature of the composition, however, is the section with two pages standing on an unexplained level on the right. The boy nearest the spectator nonchantly swings a button on a thread in time to the music, a quirky touch that encapsulates the idea of a moment seized in time. AS

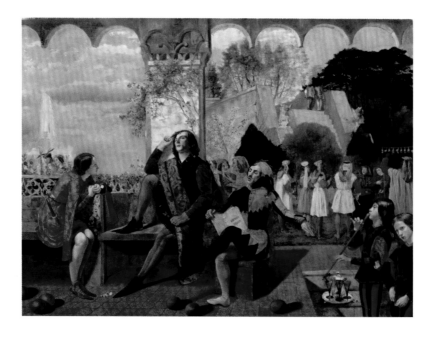

JOHN EVERETT MILLAIS 1829–96
Ferdinand Lured by Ariel 1849–50

Oil on panel, arched top 64.8 x 50.8
The Makins Collection

Millais's success with *Isabella* (no.26) established both his early promise in critical and artistic circles and his initial Pre-Raphaelite approach to making a painting. He continued in a novel literary mode with *Ferdinand*, while following the pioneering landscape procedure of Hunt's *Rienzi* (no.25).[7] He painted the background during the summer at Shotover Park outside Oxford. In October, as Hunt had done with *The Missionary* (no.86) the month before, Millais returned to London with the landscape in the foreground, sides and background nearly complete, and a bright white unpainted central section awaiting the inclusion of models. This inverted the traditional post-Renaissance manner of composing figures first and then adding the ancillary landscape.

The scene is from Shakespeare's *Tempest*, Act I. The shipwrecked Ferdinand, stockings still wet and clinging, hears bells and music and a disembodied voice in his ear falsely informing him: 'Full fathom five thy father lies.' The manipulative sprite Ariel, who caused the shipwreck and will wreak further mayhem, is invisible to Ferdinand and darts up from under his right arm to hover in the air, playing a stringed conch and lifting his cap to whisper falsehoods. The imaginative and humorous 'vegetable bats', as W.M. Rossetti called them,[8] ring the hem of Ariel's cape and relate to fairy painting traditions in British art and the grotesque in continental works, including Moritz Retzsch's works. F.G. Stephens sat for Ferdinand, as he had done previously in *Isabella*, but the figures are rivalled by the remarkable sunlit naturalistic features and various fauna, including a robin and lizards. This is history painting that appeals vividly to the senses: the clarity of detail is nearly tactile, the high colour key stimulates vision, and the musicality and noisy sprite and bats give it an aural quality.

Thomas Woolner, no stranger to fantastical Shakespearean subjects (no.5), owned the picture in the 1870s. JR

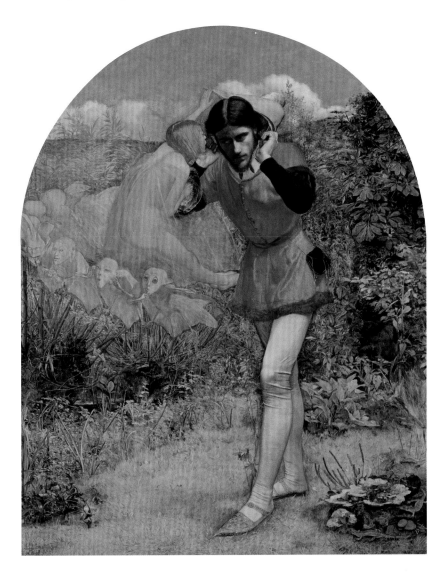

WILLIAM HOLMAN HUNT 1827–1910

Valentine Rescuing Sylvia from Proteus – Two Gentlemen of Verona (Act V, Scene iv) 1850–1

Oil on canvas, framed with arched top 98.5 x 133.3
Birmingham Museums and Art Gallery. Purchased 1887

Hunt's third large Pre-Raphaelite picture maintained the format of *Rienzi* (no.25) and the *Missionary* (no.86), with a grouping of figures arranged in a rectangular bulk at the immediate forefront of the composition, a high horizon line at head level, and a profusion of natural detail around and behind the figures painted outdoors.[9] *Valentine* continued Hunt's avant-garde experimental exploration of perception and form through focused-looking and collaged imagery. It was conceived in Sevenoaks, Kent, where Hunt went in the second week of October 1850 with F.G. Stephens and then D.G. Rossetti and Annie Miller to paint the autumnal landscape for a small panel sketch and this larger oil.[10] He worked out the composition on the panel and then on the canvas at Knole Park, returning to London in mid-November. He added the figures in his studio at 5 Prospect Place, Cheyne Walk, Chelsea, over the winter.

Roberson's, the artists' materials merchants, primed the canvas white and then Hunt added two additional layers of white, blended with amber or copal varnish, for a purer base. The resultant brilliancy was part of the PRB method for preserving vibrant colours and bolstering luminosity via light reflected through subtle glazes of pigment.[11] He sketched the pencil composition on top of that final white priming and then, immediately before painting, added a thin layer of translucent white on top of the drawn design with a palette knife, so that the lines remained visible. This is commensurate with the *intonaco*, or thin layer of wet plaster, in a fresco painting, under which the sepia guideline for the day's work would have been drawn. Elements of Hunt's and Millais's pictures could also be worked into wet white, an aspect of their technique still under investigation. In this picture the faces and hands appear to have been painted on a wet white upper layer to give them added intensity, something very difficult to perceive with the naked eye. But these techniques form part of the advanced nature of Pre-Raphaelite art. Inspired by the exquisite depth of tone and subtle light effects in van Eyck's *Arnolfini Portrait* (fig.13), and armed with their knowledge of the procedure for making radiant frescoes and tempera and gold leaf on panel paintings from the early Italian Renaissance, Hunt and Millais experimented with modern materials in the form of modern pigments, tube paints, small brushes and various varnishes to develop their still-startling surfaces. The next step would be to work more fully outdoors, which they did in the summer of 1851 as detailed in the 'Nature' section below.

Hunt's first-exhibited Shakespearean subject, *Valentine*, continued the Pre-Raphaelite preference for vernacular literature and the Italian Middle Ages or early Renaissance. Of special interest were themes of sexual tension and ideas of loyalty, with immobile foreground figures posed in tableaux. Valentine, standing, has rescued his beloved Silvia, at his feet, from the threatened sexual advances of his best friend and now chastened Proteus, who kneels submissively at right. The grass and leaves at their feet are crushed and crumpled as evidence of the scuffle that has taken place. On the left the cross-dressing Julia, in a page's costume, stares mesmerically at Proteus, the object of her adoration, while absent-mindedly turning the ring on her right hand that Proteus had given as a pledge. Simultaneously, Valentine offers Proteus forgiveness, Proteus professes shame and repentance and Silvia registers dazed resignation in her face that rests on her hand against Valentine's hip. Meanwhile, Julia is about to faint, at which her true identity will be revealed and Proteus will, in the manner of his mythological namesake, shift his affections again back to her. Silvia's father, the Duke of Milan, arrives in the background for the epic concluding confrontation. Through subtle gestures, positions and glances Hunt effectively conveyed the entire situation, in emulation of the complexities of narrative in Millais's *Isabella* (no.26). In what would become a common tactic, he included lines from the play around the frame to bolster comprehension.

The remarkable weaponry, armour and clothing derive from Bonnard's *Costumes historiques* (see no.26) and Hunt's own designs. Proteus's sword hilt, reflecting the reddish-pink of his pants, Silvia's dress and Julia's skirt are particularly noteworthy. Elizabeth Siddall initially posed for Silvia, but Ruskin described the figures' faces in general as being too common in his important first letter to *The Times* that May, and Hunt meekly changed her features.[12] Ruskin notably praised Hunt's 'absolutely inimitable execution'. Hunt signed the work 'W. HOLMAN HUNT 1851. Kent', his inclusion of the location showing the significance he accorded to having painted it outdoors.

The work was Hunt's only submission to the Royal Academy of 1851, and it shared the West Room with Millais's *Mariana* (no.35) and *The Return of the Dove to the Ark* (no.89); his *Woodman's Daughter* (no.66) was in the North Room. The picture subsequently won a prize at the Liverpool Academy and then sold, to the financially struggling Hunt's relief, to the Belfast cotton merchant Frances McCracken.[13] JR

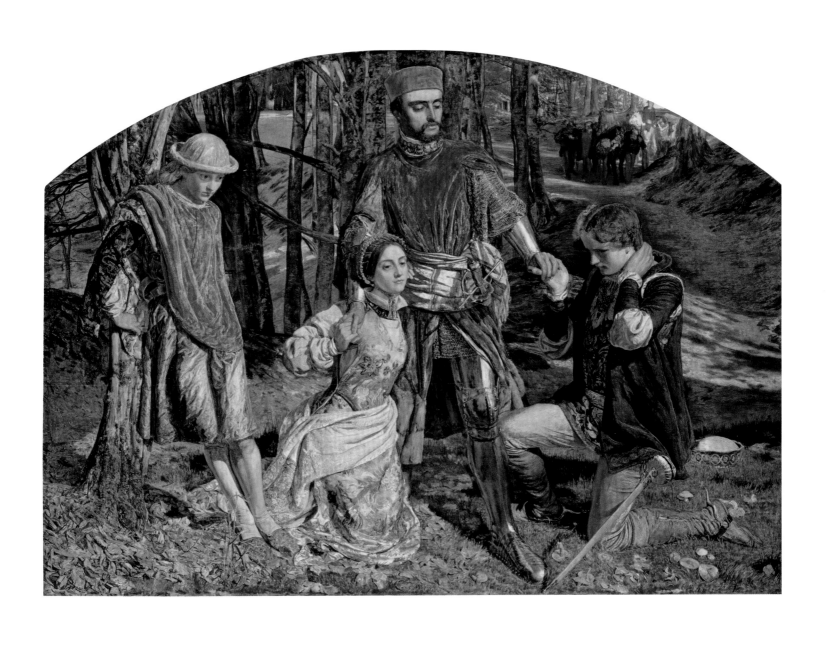

JOHN EVERETT MILLAIS 1829–96

Mariana 1850–1

Oil on mahogany panel 59.7 x 49.5
Tate. Accepted by HM Government in lieu of tax and allocated to the Tate Gallery 1999

Millais included lines from 'Mariana' by Alfred Tennyson, who had just been named poet laureate, in the RA catalogue of 1851:

> She only said, 'My life is dreary–
> He cometh not!' she said;
> She said, 'I am aweary, aweary–
> I would that I were dead!'

Both poem and painting were based on Shakespeare's *Measure for Measure*.[14] Mariana is dejected since her shallow intended, Angelo, the deputy governor in Renaissance Vienna, has exiled her, due to her dowry having been lost in the depths of the sea. Her pose mirrors the Virgin Mary in *Christ in the House of His Parents* (no.85), but she is hardly pure. Standing and arching her back after spending long hours at her embroidery, her opulent belt slips down her front while clinging to her hips and emphasising her buttocks. She leans her head back and twists her neck left to reveal her bodily and facial profiles. Mariana is eroticised, her sexuality treated frankly in a naturalistic pose, free from the idealised contrapposto perfection of the academic tradition. The sharp perspective of Mariana's room, the stained-glass panels of the Annunciation that serve as a transition from the interior space and work table to the scene of autumnal nature outside, and the use of glowing colours such as the cobalt blue in the dress – made possible through modern, commercially produced paints – bespeak Ruskin's definition of Pre-Raphaelitism in his first letter to *The Times* in the month it was exhibited (see p.52–3).[15] Thus Millais denied technical convention, drew from nature, reconstructed the past and embraced technological progress in materials.[16] Mariana herself is trapped within a space where nature is controlled and rendered artificial. She is framed by a textured golden wallpaper of vegetal arabesques and fauna, fronted by the embroidered floral pattern that she has been working on and that rests on a kind of natural altar, and caged by casement and stained-glass windows that afford a tantalising view of an enclosed garden. Behind her and deeper in the room is a devotional altar with a small religious triptych and a hanging votive candle above. In her confinement her true sexual nature is denied, and faith serves as no succour.

In Millais's treatment of this literary theme he did not condense the entirety of the narrative into one image, as he had with such complexity in *Isabella* (no.26), for Mariana's eventual salvation is not implied in the symbolism or through character action. Instead, he imagined a plausible scene from both literary sources, one not described in either text but instead invented and representative of a more suggestive mode in his art. *Mariana* has a Pre-Raphaelite descriptive urgency that conveys a specificity of time and place, but as in subsequent works such as *A Huguenot* (no.37), *The Order of Release, 1746* (no.40) and the elaborate masterpieces of his maturity, psychological complexity is pre-eminent.

Millais would later design an engraving for the Moxon Tennyson of the same subject, more illustrative, more claustrophobic in format and dependent on body language, not facial expression, to convey the void in Mariana's life.[17] Julia Margaret Cameron later took on the theme in one of her close-format female photographs (no.129). She employed the transformed Pre-Raphaelitism of the Aesthetic movement and dealt not with a sexually expressive body or claustral environs, but literally focused her lens on the melancholy sense of hopeless drift movingly conveyed in the model's face – in recognition of the element that was most advanced in Millais's painting. JR

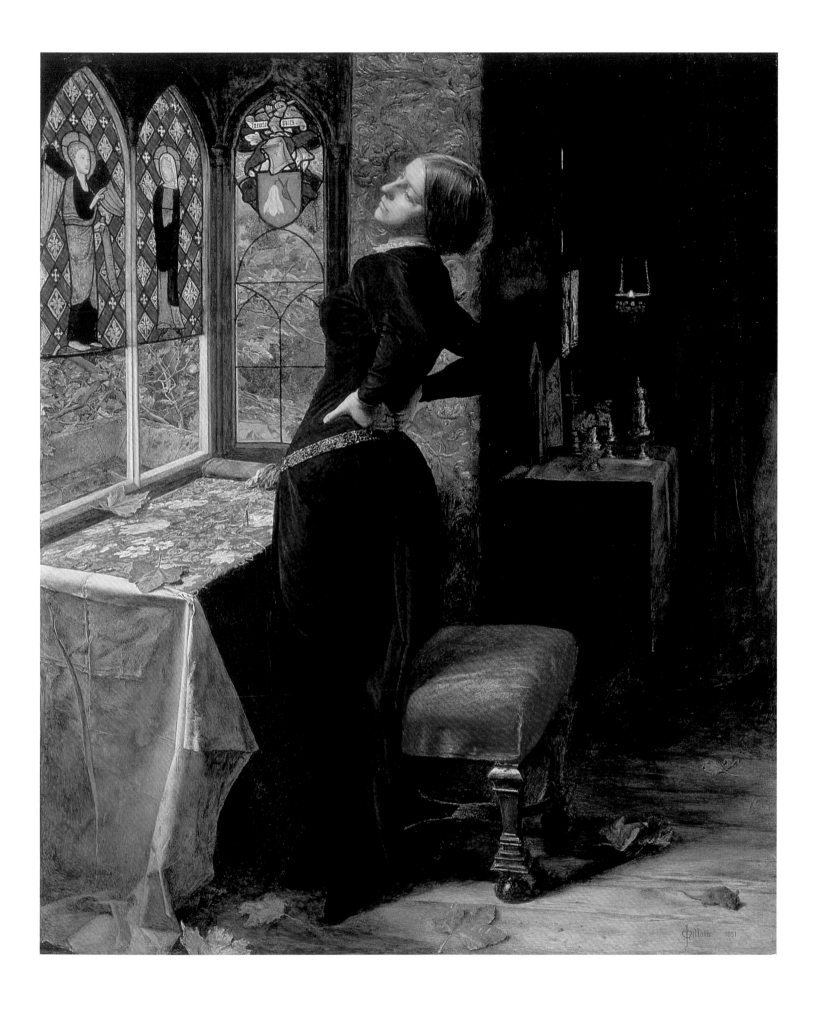

WILLIAM HOLMAN HUNT 1827–1910

Claudio and Isabella 1850–3, retouched 1879

Oil on mahogany panel 75.8 x 42.6
Tate. Presented by the Trustees of the Chantrey Bequest 1919

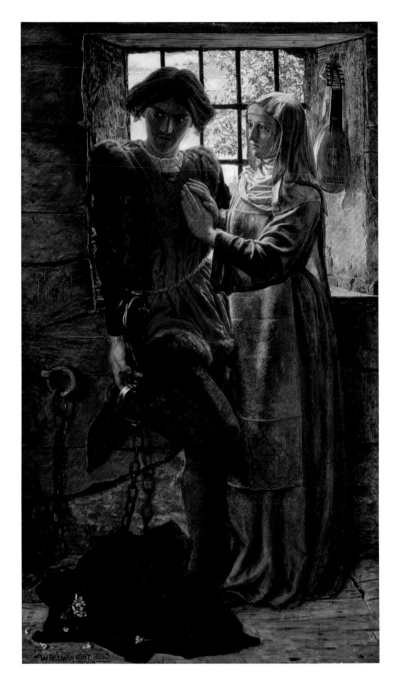

Hunt had probably intended to exhibit *Claudio and Isabella* at the Academy in 1851 with *Valentine* (no.34), where it would have nicely complemented Millais's three similarly upright full-figured works (nos.66, 89), but the large scale of *Valentine* and then his concentration on *The Hireling Shepherd* (no.70) and *The Light of the World* (no.92) in Surrey from the summer of 1851 to early 1852 meant he had to put off its completion. This was to the picture's benefit. For Hunt had grown as an artist in the intervening years. It is full of glistening, resonant colour, and the contre-jour faces of the siblings are exquisitely shaded and modelled and expressive: Claudio's eyes convey a level of bewilderment and desperation, and Isabella's are glassily imploring, finished with a touch beyond Hunt's capabilities of two years earlier.

As with Millais's *Mariana* (no.35), it is based on Shakespeare's *Measure for Measure*, forming another Italian subject from the Middle Ages. The characteristically convoluted plot involves Claudio, a young nobleman, and Juliet, his fiancée, whom he has already slept with. In doing that, he has roused the ire of Angelo, the temporary ruler of Vienna, who has condemned him to death. Angelo comes to desire Claudio's sister Isabella, a novice nun, and makes her a shocking offer: her brother will live if she gives him her virtue. Isabella refuses and tries to ease Claudio's acceptance of his fate. He implores her to yield, occasioning the lines included at the RA, 'Ay, but to die, and go not where; / * * * 'Tis too horrible!…', and on the top of the frame, 'Claudio. – Death is a fearful thing. / Isabella. – And shamed life a hateful.' With his left hand, Claudio pulls his sister's hand away from his heart.

Hunt painted the exquisite brickwork, plaster casement and stone wall in Lambeth Palace and added 'LONDON' to his signature.[18] JR

JOHN EVERETT MILLAIS 1829–96

A Huguenot, on St Bartholomew's Day, Refusing to Shield himself from Danger by Wearing the Roman Catholic Badge 1851–2

Oil on canvas, arched top 92.7 x 62.2
The Makins Collection

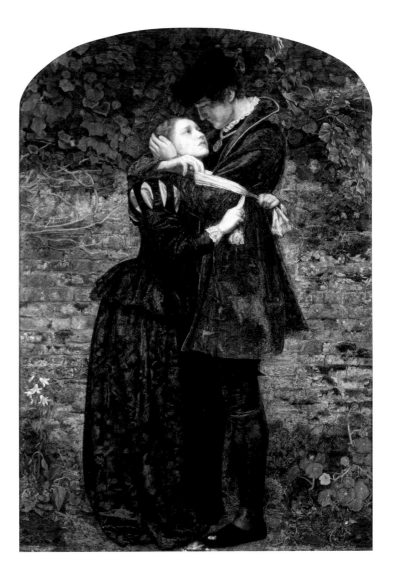

In the pivotal summer and autumn of 1851 Millais and Hunt worked in and around Ewell in Surrey, and transformed the idea of outdoor painting in Pre-Raphaelitism. While Millais's *Ophelia* (no.69) and Hunt's *Hireling Shepherd* (no.70) were the main productions of this fecund, collaborative period, each artist also began secondary works that have become signature images of religious and history painting in the movement. Hunt commenced *The Light of the World* (no.92), and Millais produced *A Huguenot*. There is no more traditionally romantic work in the period than the latter, and for Millais it spawned an entire genre in his art.[19] While superficially an image of lovers, in its intensity of gaze, interplay of linked bodies, exquisite natural detail and historical setting Millais produced a work that challenged conventional representations and effectively embraced an intense, quiet emotionalism.

Hunt may have suggested that Millais should expand the initial concept of a simple scene of two lovers into a historical drama. Millais accordingly developed the idea from Giacomo Meyerbeer's opera *Les Huguenots* (1836), which he had attended at Covent Garden. A French Protestant, or Huguenot, refuses to take up the white armband that would protect him by falsely identifying him as Catholic, so sealing his fate: three thousand of his fellows would be slaughtered over three days in Paris in late August 1572. Millais's theatrical tableau is a moving vision of unnamed lovers rent by historical circumstance.[20] The woman, who is a Catholic and urges him to take the armband, will lose her lover; her eyes register her impending loss. His face bears a serenity that reveals he is at peace with his decision. Impenetrable ivy suffocates the upper section of the delicately depicted brick wall, and Canterbury bell and nasturtium bloom at bottom. Hunt's in-progress *Claudio and Isabella* (no.36) may have inspired the interplay of two figures and hands, but Millais would perfect this intertwined complexity in subsequent popularly acclaimed works such as *The Order of Release, 1746* (no. 40), and *The Black Brunswicker* of 1859–60 (Lady Lever Art Gallery). JR

38
ALEXANDER MUNRO 1825–71
Paolo e Francesca 1851–2
Marble 66 x 67.5 x 53
Birmingham Museums and Art Gallery. Purchased 1960

39
DANTE GABRIEL ROSSETTI 1828–82
Paolo and Francesca da Rimini 1855
Watercolour on paper 25.4 x 44.9
Tate. Purchased with assistance from Sir Arthur Du Cros Bt and Sir Otto Beit KCMG through the Art Fund 1916

The subject of the doomed lovers Paolo and Francesca from Dante Alighieri's *Divina Commedia* (1308–21) was popular throughout nineteenth-century art, but the Pre-Raphaelites addressed it in multiple media and with an unprecedented intensity. Munro exhibited the original plaster of his group in the Great Exhibition in 1851.[21] The Liberal politician William Gladstone commissioned this reduced-size marble version, Munro's only submission to the Royal Academy of 1852, titled in Italian as above and with the translation below from Dante in the catalogue. In the second circle of hell the poet encounters carnal sinners and a parade of historical figures, then is moved by the piteous sight of Paolo and Francesca da Rimini. The latter relates their story, buckling him at the knees. Having been betrothed to Paolo's crippled brother Gianciotto, she came to love Paolo as they read together a book about Lancelot and Guinevere, whose illicit affair in King Arthur's Camelot mirrored her own:

> One day we read, for pastime and sweet cheer,
> Of Lancelot, how his love was tyrannous.
> We were alone, and without any fear
> Our eyes were drawn together, reading thus,
> Full oft, and still our cheeks would change and glow;
> But it was only one point conquered us.
> For when we read of that great lover, how
> He kissed the smile which he had longed to win,
> Then he whom nought may sever from me now
> For ever, kissed my mouth all trembling–
> A pander was the book, and he that writ–
> Upon that day, we read no more therein.[22]

The last line, 'Quel giorno più non vi leggemmo avante', is inscribed along the base.

The story of Paolo and Francesca's love blooming over a book held great weight for a post-Romantic movement so concerned with literature, writing, poetry and scripture, and comprising artists who often composed their own verse or inscribed lines on their frames. Munro, the most gifted sculptor to adopt a Pre-Raphaelite style, depicted them having read a passage detailing how Lancelot, struck by Guinevere's concession to smile, impulsively kisses her.[23] Possibly modelled by Arthur Hughes (no.43), Paolo, shaking with trepidation, leans in with slightly opened mouth to nuzzle and kiss Francesca's neck, his right hand falling on hers on top of the splayed open book, and his stockinged legs and sharp-booted feet in a twist betraying both his ardour and nervousness.

As he leans over her, Francesca's body language is noncommittal; she remains stoutly upright, but she bows and turns her head slightly to him to encourage his advance, feeling his left arm around her back pulling them together, her left hand gripping the book tightly and her right foot emerging from her gown to brace her frame.[24] They would read no more therein. Munro's image of youthful yearning makes no commentary on their illicit entanglement and, unlike early Pre-Raphaelite paintings such as Millais's *Isabella* (no.26) or Hunt's *Hireling Shepherd* (no.70), includes no peripheral narrative elements or symbols that allude to their final fate – to be discovered and killed by Paolo's brother. Munro's intense image essays a pair of lovers far more genteel than Hunt's sunburnt swain and heavy-lidded lass. It is an evocation, only, of youthful love, and the finely detailed and luminous marble conveys considerable romantic heat.

Munro appears to have been influenced by John Flaxman's line engraving of *The Lovers Surprised* of 1793 and William Dyce's dreamlike and more similarly posed depiction of the subject from 1837 (National Galleries of Scotland, Edinburgh), as well as drawings by Rossetti and in particular works by Theodor von Holst (no.3), whose sketchbook he possessed.[25] Dante Alighieri was a favourite writer of Rossetti, who would take up the theme many times over the course of his career, as in this medievalist watercolour that shows the subsequent kiss, Dante and Virgil, and then the embracing lovers perpetually floating against the patterned flames of hell.[26] Munro's own medieval style, evident in Paolo's hair and clothing and the delicate feather plume of his discarded hat, is related to the decorative sculpture he produced as a carver for the new Houses of Parliament. Yet such Pre-Raphaelite sculpture, despite its similar themes, costume and hairstyles to its cousin paintings, was hampered by a lamentable reliance on marble, a material connected to the traditions of classical and academic art. If the sculptors had truly wanted to match their painter associates in a radical form, they might have introduced colour to their three-dimensional work. However, if Munro had added colour, working perhaps in wood, a medium more agreeable to realism, his work would have moved perilously close to devotional art and thus elicited charges of expressing Catholic sympathies more severe than those levelled at Millais. This technique might also have resulted in works that veered perilously close to the popular type of sculpted human illusionism on view since 1831 at that venerable London institution, Madame Tussauds.[27] JR

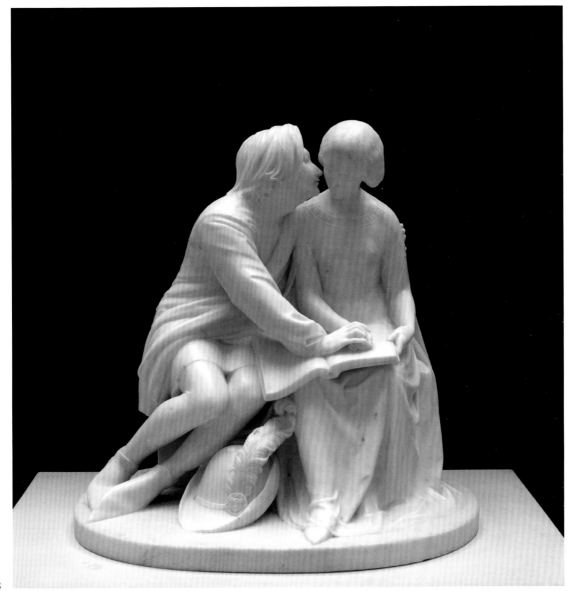

38

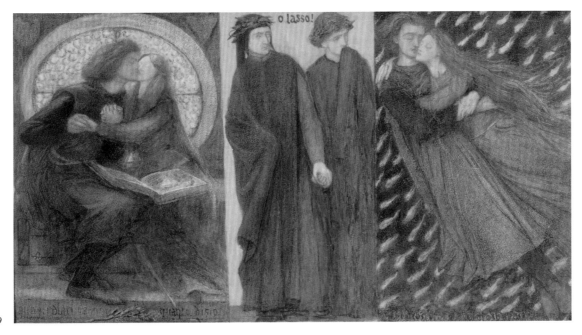

39

JOHN EVERETT MILLAIS 1829–96
The Order of Release, 1746 1852–3

Oil on canvas, arched top 102.9 x 73.7
Tate. Presented by Sir Henry Tate 1898

By including the date 1746 in the title of *The Order of Release*, Millais clearly alludes to the Battle of Culloden on 16 April that year, at which the English defeated the Jacobite army of Charles Stuart, known as Bonnie Prince Charlie. At Culloden forces loyal to George II, under the command of the Duke of Cumberland, thwarted the rebellion of 1745, which had aimed to return the Stuart dynasty to power. The figures in this historical genre painting are not named; the viewer must piece together the narrative. A guard wearing the uniform of a British redcoat receives the order of release identified in the title. A wounded Scottish highlander, a member of the defeated army, has walked out of the prison door and now embraces his wife and child.

Psychologically, the painting reverses the usual Victorian model of male heroism and female weakness. The strength and calmness expressed by this powerful Scottish wife make up the central element in the work. The unresolved narrative – how did this stoical, barefoot woman persuade the authorities to release her beloved husband? – accords it the status of a 'problem picture'. We are intended to scan her enigmatic physiognomy for clues as to whether she has paid for the order with her virtue. Hers is the only face fully revealed to us; the three male figures, for different reasons, shield their faces, a mark of weakness rather than strength.

The painting inaugurated Millais's lifelong love of Scotland, its literature and landscape. The Victorian taste for Scotland was led by Queen Victoria and Prince Albert, but among Highlanders memories of the harsh suppression of the rebellion of 1745 were still vivid a century later. The long and cruel process of Highland clearance, forced mass emigration, left a legacy of resentment of rule from London.

The Order of Release is also his first representation of Effie Ruskin, born Euphemia Chalmers Gray and twenty-four at the time Millais sketched her early in 1853. John Ruskin, Millais's most powerful critical champion, allowed the young artist to sketch his wife for the work, in opposition to the social conventions of the day, which would prohibit a respectable lady from taking on the role of an artist's model. The following year, Millais and Effie would fall in love, leading to her divorce from Ruskin and marriage to the painter in 1855. The subject of the painting appealed to Effie's strong sense of Scottish identity: it was, she wrote, 'quite Jacobite and after my own heart'.[28]

In this highly original composition Millais displayed his virtuosity as a figure and animal painter. The extremely complex interaction of forms in the central group exceeded the most challenging academic exercise. What appears at first to be an awkward positioning of figures repays close study. The exchange of affection through hands in the central group – the father's hand on the boy's back and the wife's firm grasp of the wounded soldier's right hand – contrast with the stern transaction enacted between the woman and the redcoat. The gaoler's keys hang from his right hand, symbolising the power of Hanoverian Britain over the beleaguered Jacobites. The pressure of the dog's paw on his master's belt adds another layer of emotion, one worthy of the work of Edwin Landseer, the foremost animal painter of the era and one of Millais's heroes.

The painting also represents a high point of Millais's quest to represent reality with the utmost fidelity. The dark and featureless setting allows details such as the primroses that have fallen to the floor from the child's hand, the folds and wrinkles in the white cloth of the soldier's sling and the child's curly ginger hair to be represented with preternatural clarity. Millais paid close attention to the textiles, representing each with consummate care. In the library of the British Museum he consulted the recently published, illustrated ethnography, *Highland Clans*, by James Logan and Robert McIan, and he carefully rendered two tartans, the Gordon (worn by the released soldier) and the Drummond, presumably his wife's clan, which is worn by the boy.[29] The Drummond clan was associated with Perth, Effie's home town, so perhaps this detail paid homage to her.

The painting was received with great popular enthusiasm at the Royal Academy exhibition of 1853, to the extent that the authorities placed a railing in front of it for protection. This notable step had not been needed since the rapturous reception of David Wilkie's *Chelsea Pensioners* (Apsley House, London) in 1822. According to the *Illustrated London News*, Millais had 'a larger crowd of admirers in his little corner in the Middle Room than all the academicians together'.[30] The painting was also shown at the Exposition Universelle of 1855, where it was admired by Théophile Gautier and by the Romantic painter Eugène Delacroix, who noted 'this child asleep in its mother's arms, whose silky baby hair and sleeping state are expressed with such remarkable observation and above all, with feeling'.[31]

The Order of Release became the first of Millais's paintings to be translated into the lucrative medium of mixed-method engraving. The publisher Henry Graves paid £300 for the copyright, and the eminent engraver Samuel Cousins produced a large-scale print of the work in 1856. TB

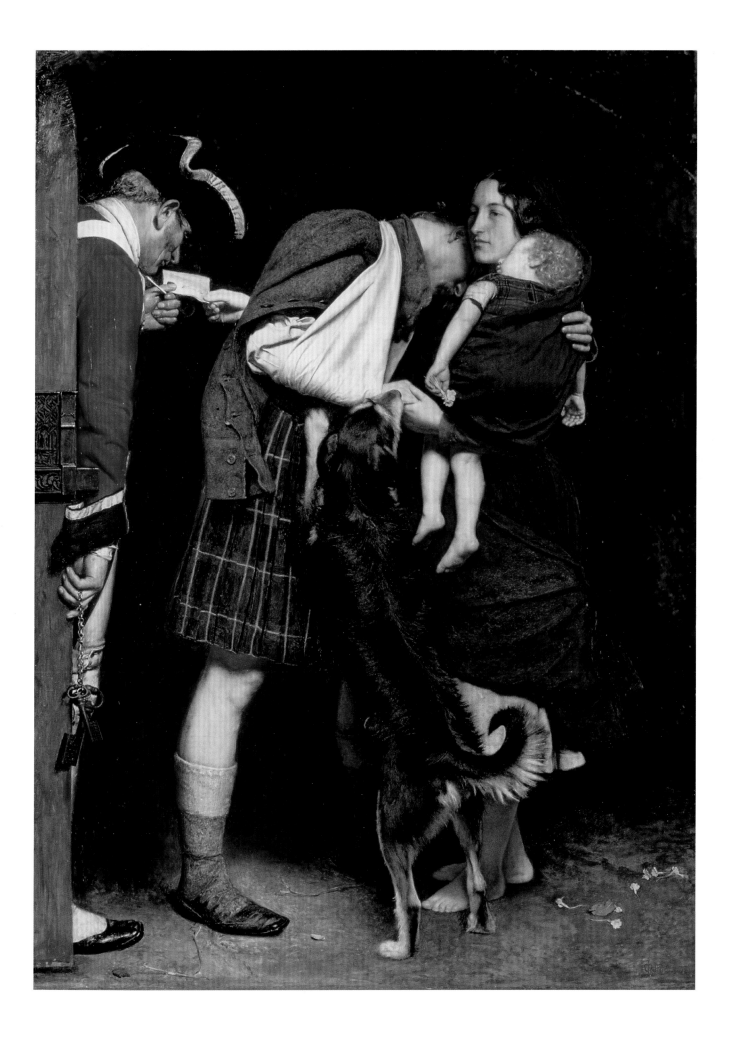

41
JOHN HANCOCK 1825–69
Beatrice c.1854

Bronze 60.5 x 22 x 26.5
Birmingham Museums and Art Gallery

The sculptor John Hancock was an early associate of the PRB. He became acquainted with D.G. Rossetti in 1846 and during the late 1840s occupied a studio next to Woolner's. It was through the latter that he felt encouraged to seek membership of the PRB although he never went through with the application. Hancock was also a member of the earlier Cyclographic Society and was briefly involved in setting up *The Germ* (no.23).

The sculptor's original plaster version of *Beatrice* (V&A) was shown at the RA in 1850 and at the Great Exhibition in 1851 where Munro exhibited his prime plaster version of *Paolo e Francesca* (no.38). This bronze is almost certainly the statuette exhibited at the RA in 1854. The original composition was accompanied by a sonnet entitled 'Of Beatrice de' Portinari, on All Saints' Day', which was written by Dante to accompany *La Vita Nuova*, and describes the poet's first meeting with Beatrice as she walks by the Arno in Florence, the moment represented in the sculpture.[32] This subject was likely to have been inspired by Rossetti, who had completed his translation of *La Vita Nuova* in 1848 and around this time was producing drawings on the theme of Dante and Beatrice (see no.28). Hancock's *Beatrice* is a figure of Ghibertian grace with gothic drapes and a halo-like garland in her hair (Lorenzo Ghiberti was one of the four sculptors acknowledged in the PRB's 'List of Immortals'[33]). She is presented strolling with her hands gently clasped and a pensive expression on her face in keeping with the lines from the sonnet: 'A flame burn'd forward through her steadfast eye, / As when in living fire a spirit dwells.' AS

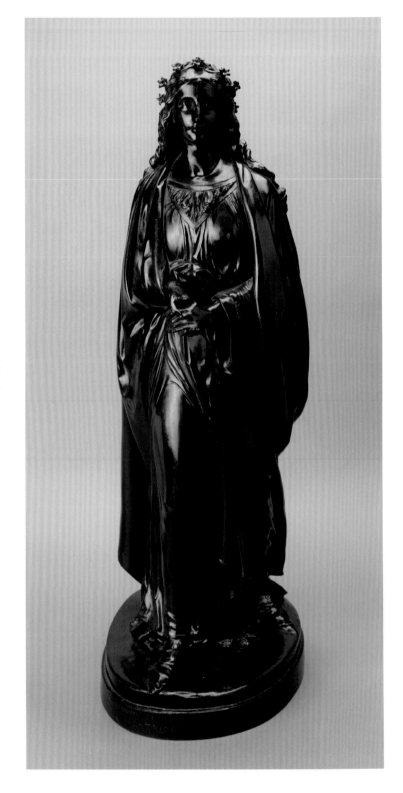

WILLIAM SHAKESPEARE BURTON 1824–1916
A Wounded Cavalier 1855–6

Oil on canvas 91.5 x 104.2
Guildhall Art Gallery, Corporation of London

A delightful one-off in the history of Pre-Raphaelitism, the still little-known Burton produced this masterful historical subject in the spirit of Millais's romantic historical couples, *A Huguenot* (no.37) and *The Proscribed Royalist, 1651* (1853; Lord Lloyd Webber). Unlike the tense uncertainty of Millais's successful formula, Burton showed the tragic conclusion to his invented tale set in the English Civil War. In it a Puritan woman cradles the pale and nearly stiff body of a Cavalier. She holds a cloth to his wounded shoulder as he lays his left hand on hers. A spectral male Puritan figure looks on, holding a large bible, a symbol of his rectitude, self-discipline and rule-following.[34] Burton's sympathies appear to lie with the vanquished Royalist, although some Victorian viewers would surely have identified with the severe rectitude of the Puritan onlookers. Brown's later portrayal of Oliver Cromwell (no.114) exemplifies Victorian sympathy for the Puritan voice in British history.

The *Athenaeum* cited this as the 'most remarkable Pre-Raphaelite picture in this year's Exhibition', revealing that the style had fully taken hold in artistic circles and been divorced from its earliest practitioners.[35] The critic noted that while replete with closely observed naturalistic details, it was painted with a broader execution than previously associated with the movement. This is con-sistent with Millais's evolution of his style in *Peace Concluded, 1856* (see pp.246–7), *The Blind Girl* (no.81) and *Autumn Leaves* (no.117), all exhibited in the same Academy of 1856.

Yet, like Arthur Hughes's *April Love* (no.43) also in the 1856 RA, Burton's painting is closer to a waxwork diorama than an evolving Aestheticism. Its frozen features fascinate and reveal the story: a mass of playing cards at the Cavalier's feet allude to a gambling dispute that proved fatal; the broken ferns and bramble in the foreground reveal the struggle that took place. Most extraordinary is his sword, which has found purchase not in his opponent, but in the beech tree's trunk. Its severed hilt lies at the Cavalier's side on an exactly parallel line to the above blade. It has just slipped from his hand. And a spider has already spun a web between it and the tree, while a butterfly 'emblem of life', according to *The Times*, and impeccably observed, has alit on the suspended metal.[36] The two main figures form a traditional image of the *pietà*, or dead body of Christ cradled by Mary. The pair resemble Michelangelo's *Pietà* (St Peter's Basilica, Rome) or the image of John the Evangelist and Jesus in Caravaggio's *Entombment* (1602–3; Vatican) with its similarly limp right arm. The precedents for this picture are notably from the Renaissance and later, appropriate to the seventeenth-century subject. JR

43
ARTHUR HUGHES 1832–1915

April Love 1855–6

Oil on canvas 88.9 x 49.5
Tate. Purchased 1909

Arthur Hughes became a student at the Royal Academy Schools in December 1848 and was an avid reader of the Pre-Raphaelite journal, *The Germ* (no.23), in the early months of 1850. Through the sculptor Alexander Munro he met Ford Madox Brown and D.G. Rossetti in 1851, and became a member of the Pre-Raphaelite circle, though not the Brotherhood itself.

April Love bears very clearly the imprint of Pre-Raphaelite influence. It was exhibited at the Royal Academy in 1856 with a quotation from Alfred, Lord Tennyson's 'The Miller's Daughter':

> Love is hurt with jar and fret.
> Love is made a vague regret.
> Eyes with idle tears are wet.
> Idle habit links us yet.
> What is love, for we forget:
> Ah, no! no!

Hughes does not illustrate the details of Tennyson's poem, but rather presents a contemporary, middle-class instance of a quarrel between young lovers, set in a garden bower overgrown with ivy.

Hughes employed the Pre-Raphaelite tactic of using members of his personal circle as models, perhaps thus including an autobiographical element in *April Love*. In November 1855, after a courtship of five years, Hughes had married Tryphena Foord at Maidstone in Kent. *April Love* was begun at Maidstone in the garden of the aptly named Robert Cutbush, her father's employer, with Tryphena modelling the figure. Although much of the landscape was painted in the open air, the work was completed in the studio in Pimlico that Hughes shared with Munro, who seems to have sat for the shadowy male figure.

John Ruskin admired *April Love* and recommended it for purchase by the Leeds collector Ellen Heaton, who, however, turned it down, disliking the facial expression of the main figure. The critic remonstrated that 'the girl is just between joy & pain – *of course* her face is unintelligible, all a-quiver, like an April sky when you do not know whether the dark art of it is blue – or a rain-cloud'.[37] Undoubtedly, Ruskin chiefly admired the careful painting from nature, inspired by earlier works of Millais and Hunt, and the interweaving of the female figure with floral imagery. *April Love* was bought from the Royal Academy by William Morris, still a student at Oxford. TB

44
ALEXANDER MUNRO 1825–71
Dante Alighieri 1856

Marble 59.5 x 31 x 25
The Mistress and Fellows of Girton College Cambridge

Alexander Munro was a close friend of Dante Gabriel Rossetti from 1847, and although he was never a member of the Pre-Raphaelite Brotherhood, his work was profoundly engaged with Pre-Raphaelite styles and ideas. Munro's affiliations were always with the poetic and literary, rather than the realist, aspirations of the Brotherhood, and by the mid-1850s he had begun to move away from the stylised medievalism of his pioneering essay in Pre-Raphaelite sculpture, *Paolo e Francesca* (no.38), towards a directly expressive style. Still a member of the Rossetti circle, by 1856 he was sharing a house in London with Arthur Hughes, which became a centre for a large group of artists and intellectuals. In the same period he taught at the Working Men's College, thus meeting Ford Madox Brown and John Ruskin.

The bust of Dante is part of a large group of works, including *Paolo e Francesca*, arising from the deep admiration for Dante's poetry shared by Munro and Rossetti. The austere physiognomy of the poet may derive from the famous death mask in the collections of Palazzo Vecchio in Florence, of which Gabriele Rossetti, father of Dante Gabriel and Christina, possessed a cast. The young Frederic Leighton had scored a spectacular success at the Royal Academy in 1855 with *Cimabue's Celebrated Madonna is Carried in Procession through the Streets of Florence* (Royal Collection), where the poet is presented in a similar characterisation and with similar headgear.

The Dante bust is contemporary with the life-size sculptural portraits of historical figures commissioned from Munro for the Oxford Museum, including *Galileo*, *Newton* and *Leibniz*. He particularly relished the challenge of rendering historical figures in a manner both historically accurate and vividly life-like and immediate. In these regards, his bust of Dante is one of his consummate successes. TB

HENRY WALLIS 1830–1916

Chatterton 1855–6

Oil on canvas 62.2 x 93.3
Tate. Bequeathed by Charles Gent Clement 1899

Henry Wallis's painting of the young poet Thomas Chatterton on his deathbed has become an icon not only of doomed literary genius but also of Pre-Raphaelite painting. Although Wallis was acquainted with the Pre-Raphaelite circle and had been a student at the Royal Academy Schools briefly in 1848–9, he was also trained in the atelier of M.G.C. Glèyre and at the Académie des Beaux-Arts in Paris, returning to England only in 1853. John Ruskin had high praise for *Chatterton* when it was exhibited at the Royal Academy in 1856: 'Faultless and wonderful: a most notable example of the great school. Examine it well inch by inch; it is one of the pictures which intend and accomplish the entire placing before your eyes an actual fact – and that a solemn one.'[38]

The facts, though solemn, are not altogether straightforward. Thomas Chatterton, born in modest circumstances in Bristol in 1752, rose to precocious fame through his celebrated works of literary forgery, among them the creation of the works of Thomas Rowley, a 'secular priest' of fifteenth-century Bristol. Chatterton produced elaborate fake manuscripts and texts in many genres. By seventeen, he had published thirty-one articles in seven different journals. In 1770, having embraced radical politics, he moved to London hoping for success and patronage as a writer. Struggling

to establish himself, Chatterton lived in a garret in Brooke Street, Holborn, above a bawdy house run by a Mrs Angell. It was there that, on the night of 24 August 1770 and still aged seventeen, he died. This was widely believed to have been a suicide, but recent biographers have argued that the death was accidental, perhaps deriving from mixing medical treatment for venereal disease with recreational opiates.

For the Victorians, however, Chatterton was, like Keats, a glorious boy, a literary martyr. No portrait of Chatterton survived, and Henry Wallis asked his friend, the author George Meredith, to model for the present work. It is not certain where the interior and view of dawn breaking over London were painted, but Wallis's picture conveys an astonishing impression of fidelity. A quotation from Christopher Marlowe's *Doctor Faustus*, 1604, was inscribed on the frame and in the Royal Academy catalogue when the work was exhibited in 1856: 'Cut is the branch that might have grown full straight / And burned is Apollo's laurel bough.' Victorian taste passed over Chatterton's career as a forger and lingered instead on the pathos of promise unfulfilled. Wallis's life was long and prosperous, but his later work never attained the heights reached in *Chatterton* and *The Stonebreaker* (no.103).　　　　TB

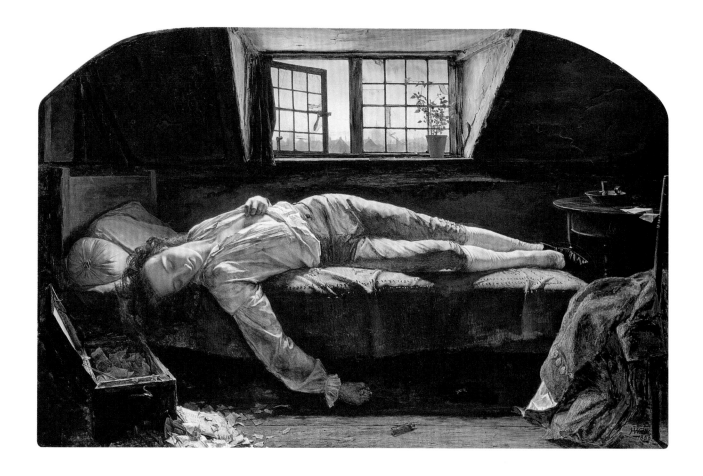

46
DANTE GABRIEL ROSSETTI 1828–82
The Wedding of St George and the Princess Sabra 1857
Watercolour on paper 36.5 x 36.5
Tate. Purchased with assistance from Sir Arthur Du Cros Bt and Sir Otto Beit KCMG through the Art Fund 1916

47
DANTE GABRIEL ROSSETTI
The Tune of Seven Towers 1857
Watercolour on paper 31.4 x 36.5
Tate. Purchased with assistance from Sir Arthur Du Cros Bt and Sir Otto Beit KCMG through the Art Fund 1916

48
DANTE GABRIEL ROSSETTI
The Blue Closet 1856–7
Watercolour on paper 35.4 x 26
Tate. Purchased with assistance from Sir Arthur Du Cros Bt and Sir Otto Beit KCMG through the Art Fund 1916

The year 1857 saw the final flowering of Rossetti's medievalism. At the moment when he and his 'round table' of young followers were working on the Oxford Union mural commission, Rossetti completed a group of watercolours that are among his finest achievements. Five of them were purchased by the young William Morris.[39]

John Ruskin, whose influence over Rossetti was at its height in 1857, was a keen collector of 'missals' and of single pages sold by dealers from illuminated manuscripts, and studied the British Museum's superlative collection.[40] Rossetti's *Wedding of St George and the Princess Sabra* refers directly to the early-fourteenth-century *Psalter of Queen Philippa* in the collection of the British Museum (now British Library), from which Rossetti quotes the distinctive carillon of bells seen in the background.

The subject of *The Wedding of St George* probably derives from a popular ballad collected by Thomas Percy and published in his *Reliques of Ancient English Poetry* in 1765. Percy had collected the story of St George and the Dragon from 'the old story-book of The Seven Champions of Christendome'. The elaborate tale relates that a fierce dragon terrorised Egypt and could be placated only by being fed a virgin every day, until finally only one – King Ptolemy's daughter, Sabra – remained. With self-effacing fortitude, attractive to Victorian readers, she offers to die for the greater good. The Christian St George rescues Sabra from the dragon; she falls in love with him, but their love is discovered and he is banished by the princess's pagan father. Finally, St George returns, claims Sabra and returns with her to England. Doubting her purity during his absence, he tested her: this may explain St George's distracted expression in Rossetti's watercolour. Sabra,

> sad and demure,
> There stood most like a virgin pure.
> Now when St. George did surely know
> This lady was a virgin true …
>
> And fortune did his nuptials grace:
> They many years of joy did see,
> And led their lives at Coventry.[41]

Rossetti represents an intimate moment rather than an actual wedding ceremony. St George's arrival has evidently interrupted the princess's toilette (a favourite Rossetti subject of the 1860s): a hairbrush and comb lie on a fanciful wicker chair to the left. Through a loop on the top of his bascinet helmet she has wound a lock of hair, an emblem of their marital bond, which prefigures the consummation to follow: the marital bed (dressed like that in van Eyck's *Arnolfini Portrait*, fig.13) is distantly seen in the room beyond. Sabra cuts her hair with a pair of modern scissors, an indication of Rossetti's lack of interest in historical accuracy. The dragon's scaly head is seen in a box at the lower right.

As so often, the models were members of Rossetti's circle. Valentine Cameron Prinsep, one of the Oxford muralists, sat for St George, and in the figure of Princess Sabra we see for the first time in Rossetti's art the flowing, dark hair of the seventeen-year-old Jane Burden, the future wife of William Morris. She was an ostler's daughter, whom Rossetti 'discovered' in Oxford in October 1857, and would become his muse and model from the mid-1860s until his death.[42]

The watercolour is a tour-de-force in which Rossetti overlaps and interlinks a plethora of patterns, heraldic and decorative, many of which (like the peacock-tail motif on the blue fabric of the chair on which St George sits) seem to prefigure Aesthetic design. The jewel-like colour scheme, imitative of medieval illumination, is carefully orchestrated to achieve an overall harmony: green, for example, can be seen in the stylised grass underfoot, in the dragon's skin, in the hedge by the wall and in the wings of the angels who play bells through a window behind. A complementary range of reds, pinks and purples marks out highlights in the draperies and the dragon's forked tongue. Rossetti abandons the hard-won illusionism of early works like *The Girlhood of Mary Virgin* (no.24) and self-consciously alludes to the flatness of the picture plane, notably in the square black-and-white motif formed by the ailette on the shoulder of St George and in the picture-within-a-picture containing the angels.[43]

The Tune of Seven Towers and *The Blue Closet* share many elements with *The Wedding of St George*, including the elaborate medievalising interiors and rich, chromatic colour schemes. The

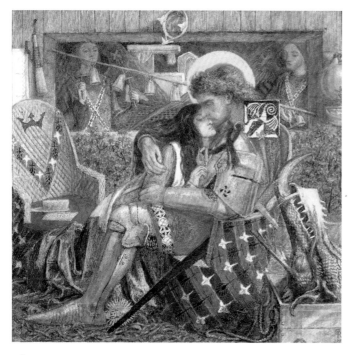

46

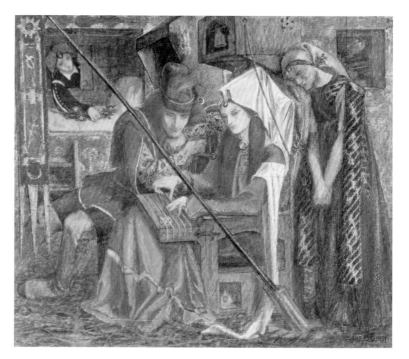

47

bold diagonal of the carillon in *St George* reappears here as the black staff bearing a pennant, which slashes this composition into two uneven parts. There is, however, no reference to an external narrative in either work. The title *The Tune of Seven Towers* is enigmatic: although the ancient Byzantine Fortress of the Seven Towers outside Istanbul was well known to Victorian readers, it has no apparent connection to this whimsical image. A young lover is enchanted by the playing of a strange instrument, flowers are laid on the virginal white sheets of the bed behind. We are left to imagine the identity of the lovers, to speculate about the misery of the blue-clad figure to the right and to wonder at the bizarre furniture with its many crevices and compartments. Morris, entranced by the work, took up the challenge and wrote a poem in 1858 exploring its meanings.

The Tune of Seven Towers echoes the composition of *St George*, but in this work we encounter a theme that would loom large in Pre-Raphaelite work of the 1860s: the mysterious, erotic power of music (compare *The Blue Bower*, 1865, no.126). This is also central to *The Blue Closet*, where, as in so much later painting, careful harmonies of colour and the balance of line and proportion in Rossetti's composition are linked to the music being played and sung by two queens and their attendants. Elizabeth Prettejohn has identified a source for this work in a Florentine School panel, then attributed to Taddeo Gaddi, *Four Musical Angels*, which Rossetti could have seen in the collection of Christ Church, Oxford, in 1857.[44] Referring, like his earliest paintings, to art before the time of Raphael, this pivotal composition also announces the major themes of Rossetti's work of the next two decades, connecting Pre-Raphaelite revivalism with the aspiration towards art for art's sake discussed in the 'Beauty' section below. TB

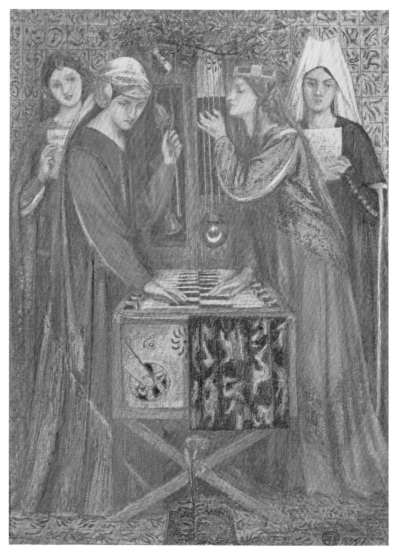

48

49

ELIZABETH ELEANOR SIDDALL 1829–62
The Lady of Shalott 1853

Pen, black ink, sepia ink and pencil 16.5 x 22.3
The Maas Gallery

50

ELIZABETH ELEANOR SIDDALL
Lady Clare c.1854–7

Watercolour on paper 33.8 x 25.4
Private collection

51

ELIZABETH ELEANOR SIDDALL
Lady Affixing Pennant to a Knight's Spear
c.1856

Watercolour on paper 13.7 x 13.7
Tate. Bequeathed by W.C. Alexander 1917

52

ELIZABETH ELEANOR SIDDALL
The Ladies' Lament from 'Sir Patrick Spens'
1856

Watercolour on paper 24.1 x 22.9
Tate. Purchased 1919

Siddall has recently been the subject of study that has productively exhumed her from under Rossetti's shadow and biography and cast her remarkable art and poetry in a new, more generous light.[45] Colin Cruise has described Rossetti's followers in the 1850s, Simeon Solomon, Edward Burne-Jones and Siddall, as 'all untrained or partially trained artists whose ambitions were not for amateur achievement but for the highest genre in modern art – imaginative subject painting'.[46] Siddall's evolution as an artist was hampered by her lack of training before meeting Rossetti, his in turn less than rigorous regimen, and her deficiency in resources and a proper place to work.[47] Nonetheless, and despite W.M. Rossetti's later disparagement of her work in his histories of the movement, she developed a remarkable body of images that pushed the boundaries of PRB practice and anticipated later trends in British art.

Siddall had been best known as a model for numerous artists of the PRB circle, in Deverell's *Twelfth Night* (no.32), Millais's *Ophelia* (no.69) and, most frequently, in the work of her lover and eventual husband, D.G. Rossetti, whose Beatrice Portinari at the lower right of *Dantis Amor* (no.58) bears her features. However, she explored similarly literary imagery in her opulent watercolours and distinctive drawings. Her early *Lady of Shalott* is her own take on a subject familiar in Pre-Raphaelitism and then throughout Victorian art. Millais made a sketch of it with the Lady in her boat (Art Gallery of South Australia) and Hunt would transform his drawing of 1850 into the spectacular Pre-Raphaelite statement of his late career (no.171). As Deborah Cherry has written, Siddall's imaginative illustration shows the Lady at her loom, at the moment that she turns her head to look outside at Lancelot, causing the coloured woven web to dissemble and the mirror on the left wall to crack, lifting the curse but bringing on her eventual death.[48] Unlike the elegantly curvaceous pose of the Lady in Hunt's drawing and the artificial dance-like positioning of her arms and hands, Siddall's heroine is seated, erect, working and dressed in a simple robe with an unsexualised body. Lancelot is visible in the reflection in the mirror, but not in the drawn reality of the landscape seen out of the window. That view of him is the privilege of the Lady alone, with all the havoc it entails. She has elected to decide her own fate. Stylistically, the parallel hatching of the right wall and truncated perspective are related to Rossetti's early drawings (no.28), but the chaotic threads bursting behind the loom and careening

cracks on the mirror are expressive elements that Siddall would consistently pursue.

The three watercolours similarly deal with female protagonists, presenting them not solely as objects of romantic infatuation or newly constructed ideals of beauty, but as people in psychologically challenging situations. With their delicate coloration these historical works demonstrate Siddall's interest in sylphlike women and spindly men, moments of quiet interaction, and emotional complexity on the faces of her female subjects. The comparatively large *Lady Clare* is intricate in its design, delicately delineated architecture, expressive poses and references to different artistic media – tiles, sculpture and stained glass.[49] Also drawn from Tennyson, the poem of the same title concerns a nurse who tells the noble Lady Clare on the eve of her wedding night to her cousin Lord Ronald that she is her own child and not of the same class as her intended. Siddall imagined the comprehension dawning in the Lady's wide-eyed features, as she pushes back her pleading mother and tries to get out to tell Ronald the truth:

> 'Nay now, what faith?' said Alice the nurse;
> 'The man will cleave unto his right.'
> 'And he shall have it,' the lady replied,
> 'Tho' I should die to-night.'

49

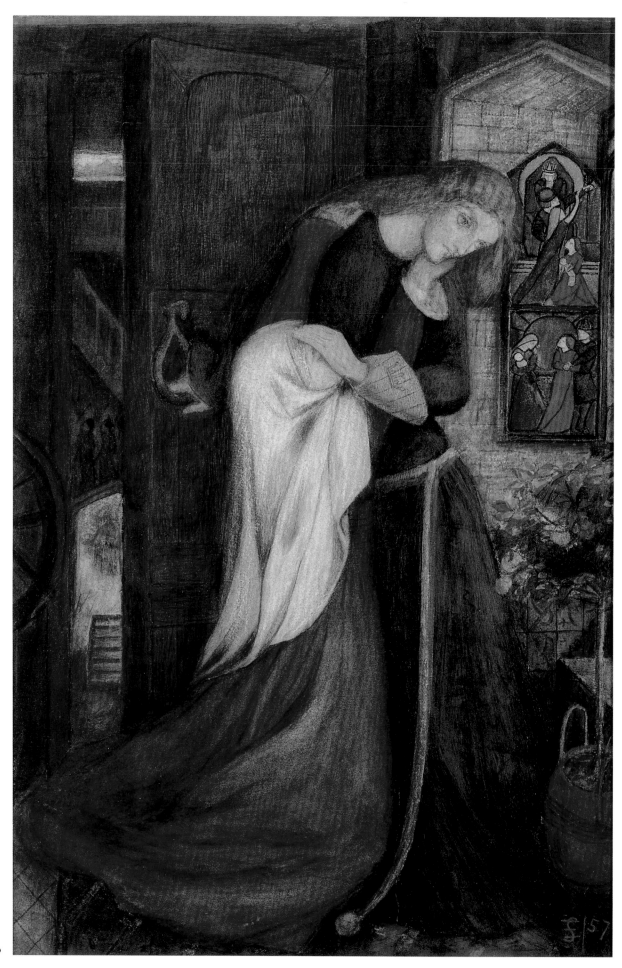

50

51

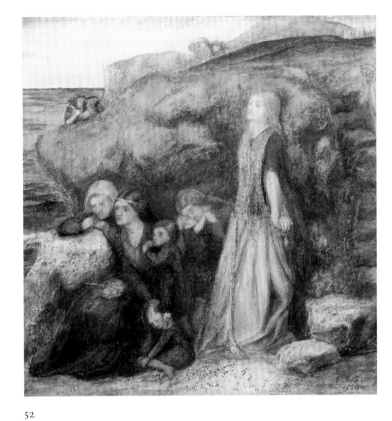

52

In conformity with Pre-Raphaelite practice, Siddall worked the picture up from pencil sketches and studied illuminated manuscripts at the British Museum showing the costume. The interplay of the two figures in opposing positions, with Lady Clare trying to open the door while the nurse seeks to halt her passage, is related to similar intertwined characters in Millais's art, such as in *A Huguenot* (no.37). Millais in turn would use a comparable confrontation and play of angular limbs, as well as a door, in *The Black Brunswicker* of 1859–60 (Lady Lever Art Gallery). In *Lady Clare* the women collectively form an elegant 's'-curve against the rigid perpendiculars of the architectural elements, reflected in the artist's monogram at lower right, and are flattened like the stained-glass depictions of the Judgement of Solomon on the right.

As opposed to the intense drama of *Lady Clare, Lady Affixing Pennant to a Knight's Spear*[50] and *The Ladies' Lament* represent moments of quiet fortitude in the dutiful lives of female protagonists. In the former the enveloping gesture of the house-bound woman, as her lover heads out to a confrontation, conveys a sense of joint acceptance of his possibly fatal calling, in an image refreshingly devoid of clutter and excessive detail. *The Ladies' Lament* is based on 'Sir Patrick Spens', one of the Scottish ballads that became so popular among artists in Rossetti's circle at this time, and can serve as a sequel to the previous work: women await the return of Spens and the Scottish king, but they would be lost at sea.[51] The amorphous and imagined east coast of Scotland reflects their internal anguish. The lengthy, elegant, jewel-toned garments and long, unrestricted hair reveal Siddall to have been as formative an influence on the style of the Aesthetic movement as any artist in the late-1850s. JR

53
La Belle Iseult 1857–8

Oil on canvas 71.8 x 50.2
Tate. Bequeathed by Miss May Morris 1939

La Belle Iseult, Morris's only known easel painting, was started in 1857 with Jane Burden posing for the princess, uncannily anticipating through this role her own eventual sense of entrapment within marriage. The background was largely painted in Morris's rooms in Red Lion Square where, according to Philip Webb, the bed that appears in the painting stood for months unmade.[52] Based on Malory's version of the Tristram and Iseult legend, the painting shows Iseult immured within her chamber, mourning her lover's absence following his exile from King Mark's court. As in Millais's *Mariana* (no.35), which also represents an abandoned woman, Iseult is shown standing dolefully by a table laden with symbolically suggestive objects. The girdle that she fits around her waist implies an enforced state of chastity, a point reinforced by Tristram's dog, or brachet (an archaic term for a female hound), which lies curled up in his place on the warm crumpled sheets of her bed. The mirror into which she vacantly gazes is inscribed 'DOLOURS' (sorrow),[53] and her crown contains sprigs of rosemary for remembrance combined with convolvulus for bonds or attachment, a reference perhaps to the lovers' hope of being reunited.

While the rich colours and decoration of the claustrophobic setting recall Rossetti's densely patterned watercolours on subjects from the fourteenth-century French historian Jean Froissart, which Morris admired, there is a stronger feeling for space in this work. Even though Morris was not such a proficient painter as Rossetti or Millais (hence the odd perspective and ellipses of vessels in the foreground), he was keen to attend to the material properties of objects and the role they played in an environment. The neat folds of the linen damask covering the altar frontal have thus been carefully observed, contrasting with the equally well-scrutinised dishevelled folds of the bed sheets. These in turn stand out against the heavy textures of the Turkish rug, Persian embroidered cover and blue stitched tapestry in the background, the last reminiscent of the experimental hangings Morris was producing at the time (see no.138). The illuminated manuscript, open at a page with a decorated initial, provides another instance of how Morris sought to both understand and revive the techniques of the medieval crafts he appreciated and collected.

The painting is one of several Pre-Raphaelite works that respond to van Eyck's *Arnolfini Portrait*, which entered the National Gallery in 1842 (fig.13). While the bed, carpet, oranges, dog and slippers might all have been prompted by features in this composition, Morris's real interest seems to be in van Eyck's use of a sheer single-point perspective for symbolic purposes. In *La Belle Iseult* the orthogonals of the dressing table and floorboards converge to a vanishing point high up in the picture at Iseult's head, accentuating perhaps her confinement and the burden of thoughts in her mind.

Recent technical analysis of the painting has confirmed that the red sleeve of Iseult's gown and red base of the bed were later over-paints, together with the reworked section of the dress on the upper right. According to Webb, Morris abandoned the painting, 'hating the brute', and 'Rossetti took it to finish, and then Madox Brown',[54] although whether they were responsible for the alterations is not altogether clear.[55] The painting was described as unfinished in 1874 when Morris gave it to Brown's son Oliver.[56] It was subsequently given to Rossetti and, following his death in 1882, passed from his brother to Jane Morris, who agreed to it being shown at the Morris memorial exhibition at the New Gallery in 1897 under the title *Queen Guenevere*. AS

Fig.13 Jan van Eyck, *The Arnolfini Portrait* 1434, oil on oak, 82.2 x 60. National Gallery, London

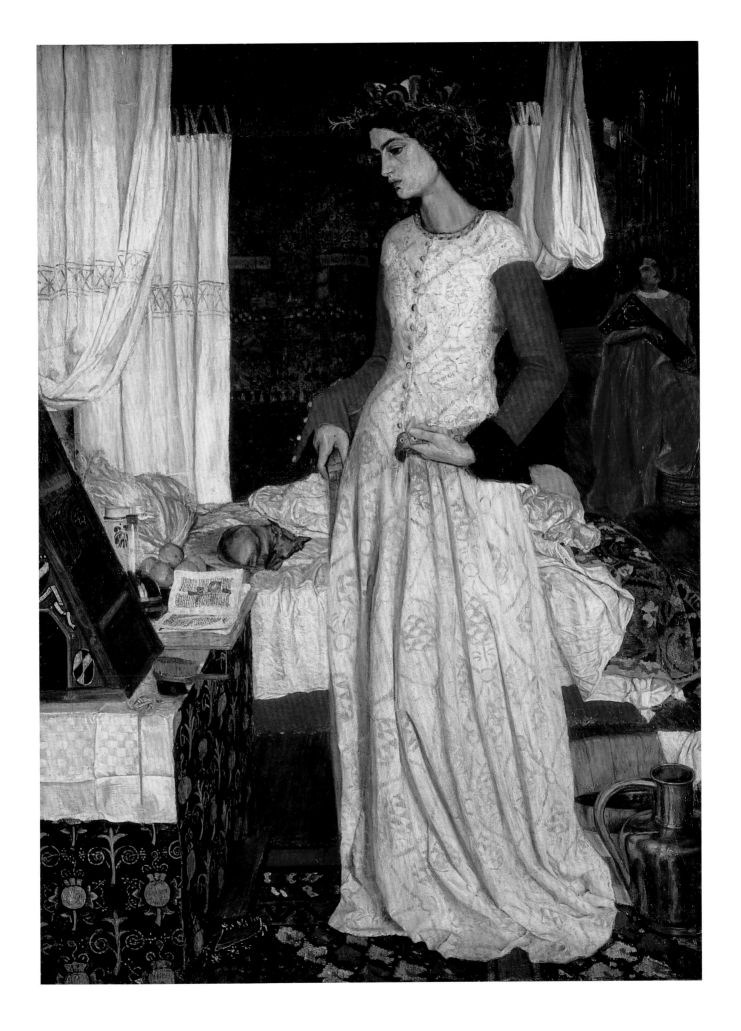

PHILIP WEBB 1831–1915 and EDWARD BURNE-JONES 1833–98
The Prioress's Tale Wardrobe 1857–8

Oil on pine and oak 219.71 x 157.48 x 53.7
The Ashmolean Museum, Oxford. Bequeathed by Miss May Morris 1939

This was Burne-Jones's first ambitious painting in oil and a piece that exemplifies the idea of 'storytelling' furniture peculiar to the artists and designers associated with the Pre-Raphaelite movement. The wardrobe itself was designed by Philip Webb and probably made by Henry Price, a carpenter in the employ of the cabinet-maker Tommy Baker of Hatton Garden.[57] Although the object is simply inscribed 'EBJ to WM [William Morris]', it was actually intended as a wedding present on the latter's marriage to Jane Burden in April 1859. It first stood in William and Jane Morris's bedroom in Red House, Bexley Heath, and was later transferred to the drawing room of Kelmscott House in Hammersmith as seen in a photograph of 1896 by Emery Walker (fig.14).

The disturbing anti-Semitic subject matter of the painting is taken from Geoffrey Chaucer's *The Prioress's Tale* in *The Canterbury Tales*. This describes how a Christian boy offended a group of Jews by singing a hymn to the Virgin Mary as he passed through their ghetto. They assassinate him by slitting his throat and throw his body into a cesspit but he continues to sing the Virgin's praises. The chorister's voice reveals the location of his corpse and he subsequently explains how the Virgin had placed a grain of corn on his tongue to enable him to continue singing after the murder. The guilty Jews are then killed and the boy accorded a martyr's burial. Although this macabre story seems an inappropriate choice for either a wardrobe or a wedding present, the subject may have been intended as a homage to Chaucer whose portrait, after Thomas Hoccleve's famous 'likeness' of the poet (also quoted in Ford Madox Brown's *Chaucer*, no.8), adorns the bottom-right-hand corner. Burne-Jones may also have been humorously acknowledging the prioress's euphemistic use of the word 'wardrobe' to describe a latrine as a pun on the intended location of the object in a bedroom. Beyond this, he was probably genuinely interested in the miraculous aspect of the story, later repeating the subject as a gouache (1865–98; Delaware Art Museum) for William Graham and as an engraving for the Kelmscott *Chaucer* (no.152). In her introduction to the collected works of her father, May Morris describes how as a child she would stand on a chair to follow the scenes of the narrative, conflating in her mind Chaucer's *Prioress's Tale* with the folk legend of 'Little Hugh of Lincoln' (an English boy believed to have been ritually sacrificed by Jews in the Middle Ages). This was the subject of a popular ballad likely to have been known by Burne-Jones, whose keen interest in oral culture informed many of his gruesome early works in watercolour.[58]

While the gothic form and decoration of the cabinet clearly relates to the work of the designers and architects associated with the Medieval Society, which had been established in 1857 to promote the study of antiquities from the Middle Ages, the emphasis on simple, even crude, construction anticipates the Arts and Crafts movement. However, rather than relating the painted scene to the function of a particular piece of furniture, as was the case with the colourfully painted works of William Burges, the decoration of the wardrobe conforms to Morris's practice at Red Lion Square of treating furniture primarily as a field for painted decoration irrespective of the object's purpose.[59]

The decorative scheme is divided into two parts, the largest of which runs across a hinged door so the narrative is not interrupted. In the centre of this panel the Virgin (a portrait of Jane) stands on a lawn holding a cornstalk in one hand while with the other she places a grain on the boy's tongue as he rises up from the tomb-like structure of the privy. Behind these figures, and on a smaller scale, is a turreted town packed with people relaying other scenes in the narrative; in May's words: 'the gaily dressed children going to school, the little boy at his lessons … the evil figures of the Jew and Jewess with their victim between them, the townspeople gathered at the well, the armed men riding through the town to take the ill-doers, and in the distance the dreadful gallows, dim and blurred'.[60] The red-brick wall of the privy lines the foreground, over which are painted symbolic poppies, daisies and a sunflower, as well as a cartouche with an inscription from Chaucer's text. In the panel to the right of the partition the Virgin (also based on Jane) appears again with an entourage of angels in Heaven listening to the boy singing. This section is more two-dimensional in appearance and easier to read than the complex scene on the left. While the compact, detailed surface is reminiscent of the richness of manuscript illumination, as a painting on oak and pine it also recalls early panel painting and the allegorical scenes adorning quattrocento *cassoni* (marriage chests). The wardrobe's status as both a domestic object and a work of art helps explain why it

Fig.14 The drawing room at Kelmscott House furnished with *The Prioress's Tale Wardrobe*, 1896, gelatin-silver print by Emery Walker, 23.3 x 29. Victoria and Albert Museum

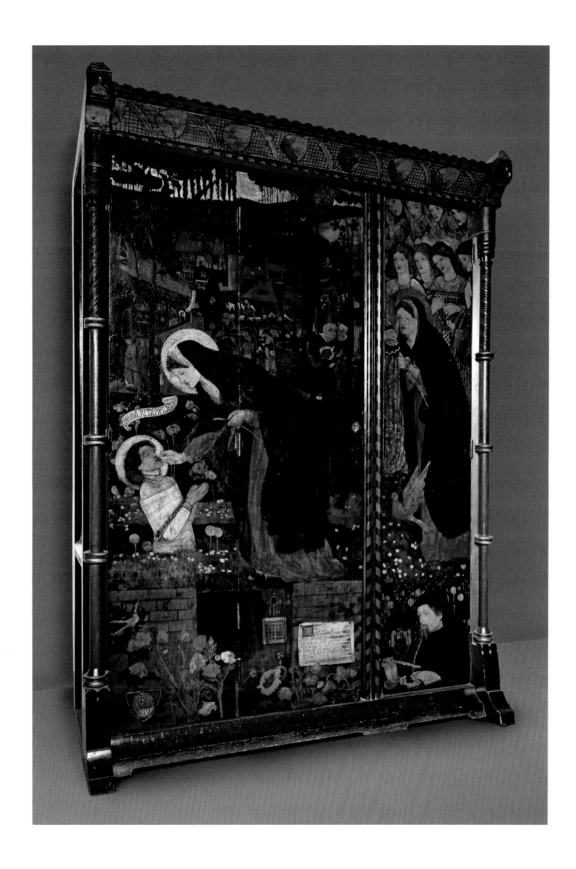

was selected in 1860 for exhibition at the Hogarth Club, which provided an arena for Pre-Raphaelite works in different media.[61]

In the interior of the wardrobe Morris himself went on to paint four panels of women in medieval dress engaged at their toilette, subjects more in keeping with the function of the object than the narrative on the exterior. These may have been intended as a personal gesture of praise to his wife, the pose of a figure loosening a girdle being similar to no.53 and the inscription next to it, a reference to the refrain in Morris's paean to Jane, 'Praise of my Lady', published in 1858 as part of his first volume of poems, *The Defence of Guenevere*. AS

55

EDWARD BURNE-JONES 1833–98

Clara von Bork 1560 1860

Watercolour and gouache on paper 34.2 x 17.9
Tate. Bequeathed by W. Graham Robertson 1948

56

EDWARD BURNE-JONES

Sidonia von Bork 1560 1860

Watercolour and gouache on paper 33.3 x 17.1
Tate. Bequeathed by W. Graham Robertson 1948

These companion pictures exemplify Burne-Jones's radical use of watercolour. By interlacing pigment with thin layers of gum arabic, he created a dense syrupy surface that suited the predatory nature of his subject. Both images derive from Johann Wilhelm Meinhold's 1847 gothic romance *Sidonia von Bork, die Klosterhexe*, translated into English by Jane Francesca Wilde (who preferred to be known as 'Speranza') as *Sidonia the Sorceress: The Supposed Destroyer of the Whole Reigning Ducal House of Pomerania* in 1849. This novel was much admired among the Rossetti circle for its wealth of visual detail and its combination of sensuality and malevolence that suited the group's interest in the idea of the alluring but destructive female. Burne-Jones presents the two women as polar opposites. Clara, the demure but courageous victim of Sidonia's machinations, cradles a cluster of baby doves in her hands, sheltering them from the devouring attention of the witch's black cat as she turns to face the spectator with a noble detached expression. By contrast, Sidonia looks at us with a sly sidelong glance as she tugs at a chain around her neck. Her malignant nature is suggested by the spider in the bottom right corner and what Algernon Swinburne described as a pattern of 'branching and knotted snakes' writhing across the surface of her dress.[62] Inspired by Giulio Romano's portrait then believed to be of *Isabella d'Este* at Hampton Court Palace (and formerly attributed to Parmigianino), these sinister configurations allude to the dark undercurrents of her thoughts and are echoed in reverse on the carpet on which Clara stands, hinting that she too will become ensnared in the sorceress's evil plans. In order to bring out the different physical characteristics of the two women, Burne-Jones used Rossetti's model and mistress Fanny Cornforth for Sidonia, her bold manners and thick blond hair matching his conception of the witch, while the figure of Clara was based on Georgiana Macdonald, the principled daughter of a Methodist minister whom Burne-Jones himself married in 1860, the year he completed both pictures.

The cloisonné-like patterns that characterise the paintings are also indicative of Burne-Jones's interest in working across media, which became a hallmark of his practice. Similar colour harmonies and a fascination with bold interlocking shapes also distinguish the artist's early painted furniture and stained-glass productions (no.137), examples of which are translated back into two-dimensional form as background features in both compositions. AS

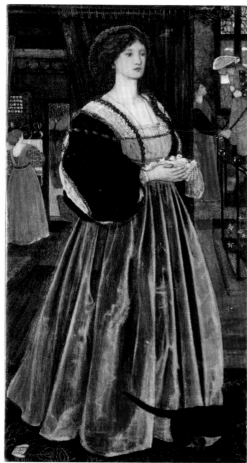

55

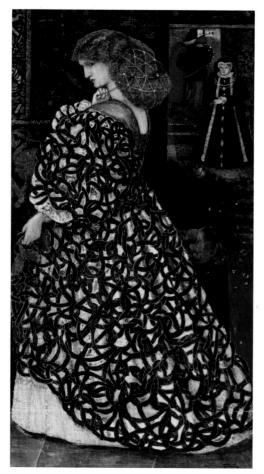

56

DANTE GABRIEL ROSSETTI 1828–82

The Salutation of Beatrice in Florence and *The Salutation in the Garden of Eden* 1859

Oil on wood, with gilded frame painted by Rossetti in 1863 101 x 202 x 10.9
National Gallery of Canada, Ottawa. Purchased 1957
[Washington only]

58
DANTE GABRIEL ROSSETTI

Dantis Amor 1860

Oil on mahogany 74.9 x 81.3
Tate. Presented by F. Treharne James 1920

These three panels were painted as a sequence on the cupboard doors of the upper part of a settle first commissioned for Red Lion Square. The settle was described by Henry Price, the furniture-maker, in his diary in its initial incarnation: 'Oak, Walnut, Pitch, Pine, Lime Tree and Mahogany all went into the job. A large Cabinet about 7ft high and as long, a seat forming a bunk, with arms each end Carv [sic] to represent Fishes. Three Cupboards The Doors with fantastic ironwork hinges, representing Birds, fishes and Flowers Bolted on, and gilt coloured.'[63] It was subsequently moved to Red House, the home in Kent designed by Philip Webb for Morris and his new bride, Jane. There a minstrels' gallery was added on top and the carving was removed.[64]

Rossetti completed the two panels now in the National Gallery of Canada in June of 1859, writing to Ford Madox Brown: 'I have done a whole picture in a week on one of Topsy's [a nickname for Morris] doors.'[65] As Douglas Schoenherr has suggested, these paintings were executed on the original doors of the settle, probably between their removal from Red Lion Square and reinstallation at Red House, and the iron hinges were subtracted, as evident from plugged holes in the wood.[66] Rossetti exhibited them separately at the Hogarth Club in March 1860.

They were probably placed back on the settle at Red House by December 1860, when Rossetti painted the third panel, *Dantis Amor*, or 'Dante's Love', which occupied the centre of the settle. He wrote to William Bell Scott: 'Lizzie [Elizabeth Siddall, Rossetti's wife] is gone for a few days to stay with the Morrises at their new house at Upton, where I join her tomorrow but shall probably return before her as I am full of things to do, & could not go there at all but that I have to paint a panel there.'[67] This was painted on a newer piece of wood: it lacks the plugged holes of the other two, indicating it was not one of the original doors.

All three panels were detached from the settle by early August 1863 and returned to Rossetti, who then framed the two Salutations together in their current frame, and sold them to the London dealer, Gambart. It is not clear, however, why the panels were removed from Red House, since it was a few years before the Morrises vacated and sold their home.

Rossetti was a long-time admirer of his namesake, Dante Alighieri, even changing the order of his given name to place Dante first. In his book *Early Italian Poets* (1861) he published his English translation of *La Vita Nuova*, from which the left-hand panel, Beatrice in Florence, takes its subject. It shows Dante passing by Beatrice, the middle figure modelled on the newly married Jane Morris, and two companions in Florence. The features of Fanny Cornforth, Rossetti's housekeeper, possible mistress and frequent model during these years, appears as the lady on the right, while 'Red Lion Mary', Morris and Burne-Jones's housekeeper at Red Lion Square, sat for the figure on the far left. The scene on the right-hand panel is from the *Divina Commedia*, when Dante meets Beatrice in Eden after her death. In this scene, according to William Michael Rossetti, Beatrice is modelled on Siddall.[68]

On the frame between the two panels, Rossetti painted a figure similar to the central panel, *Dantis Amor*, which he described as representing 'Love, holding the Sundial, with the shadow falling on the hour of 9 at which Beatrice died, as Dante tells us, on the 9th of June 1290, which date is above; and Love is extinguishing his Torch as a symbol of her death.'[69] In *Dantis Amor* the figure of Love appears at the centre of a diagonally divided composition, flanked by the sun's golden rays against a bright blue ground on the left and stars arrayed against dark blue on the right, visualising the final words of the *Divina Commedia*: 'Love which moves the sun and the other stars.' Rossetti includes Beatrice's face surrounded by the moon in the lower right, while in the upper left the figure of the sun with Christ's head enclosed bears the inscription from the last line of *Vita Nuova*, 'Qui est per omnia saecula benedictus' (who is eternally blessed). In its original placement between the two narrative panels, the strikingly flat decorative quality of the panel would have underlined their separation. Rossetti revisited the subject in his posthumous painting of Siddall as Beatrice, *Beata Beatrix* (no.124). DW

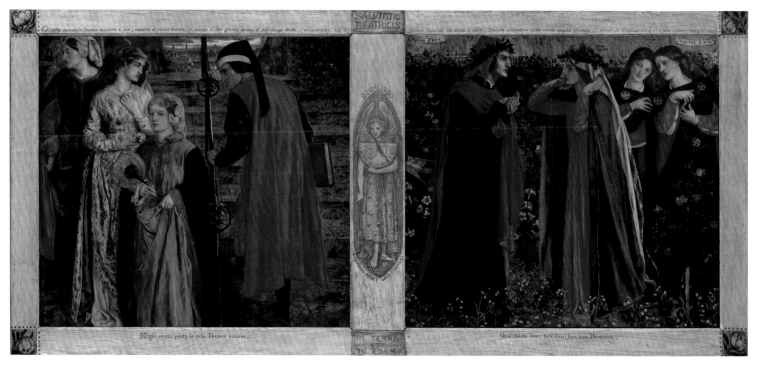

57

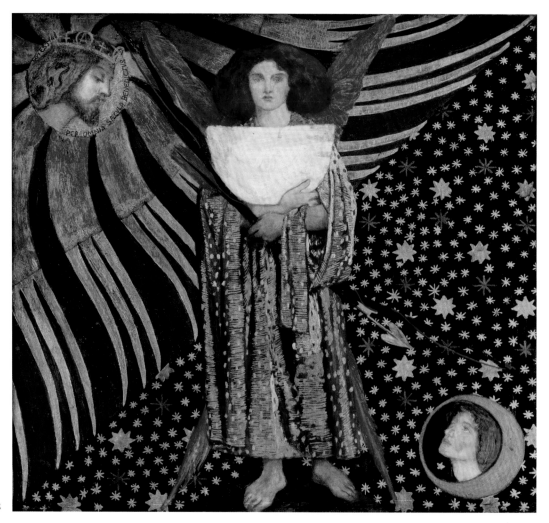

58

FLORENCE CLAXTON 1835–c.1889

The Choice of Paris: An Idyll 1860

Watercolour, heightened with gold paint and gum arabic 26.8 x 37.8
Victoria and Albert Museum

Claxton trained under her father, a painter, and worked in London producing engravings and drawings for the popular press.[70] In 1859 she signed a petition to allow women into the Royal Academy Schools and in 1861 she painted *Women's Work: A Medley*, a critique of Brown's *Work* (no.95).[71] Her career is representative of the effects of institutional opposition on the development of women artists: unless a woman came from an artistic family, like Claxton or Rosa Brett, or could receive training from a male artist and financial support, as Elizabeth Siddall did from Rossetti and Ruskin, advancement was nigh impossible in the period, and even then not assured.

The Choice of Paris was Claxton's candy-hued, but complex and erudite response to contemporary trends in Pre-Raphaelitism. She exhibited the original oil on panel (private collection) at the National Institution's Portland Gallery, Regent Street, in 1860. It was subsequently engraved, published and reviewed in the *Illustrated London News*. The inscription above this watercolour variant reads: 'As a cock was scratching in a farm-yard he came upon a jewel. "Oh", said he, "You're a very fine thing no doubt, but, give me a barley-corn before all the pearls in the world". Aesop.' Thus Claxton participated in the critical assault on the evolving and multiple streams of Pre-Raphaelite ideals of beauty, and accusations of vulgarity, and it is Millais, shown twice, who bears the brunt. Like the Trojan prince of the title, he chooses from three women: a Raphaelesque Madonna, a fiery-haired, full-lipped, long-necked and willowy aestheticised girl, and a prim woman of the 1850s. He holds one of Ruskin's publications in his left hand and offers the golden apple to the central figure. Claxton has mistaken him for Rossetti or Siddall, however, whose medievalising and proto-Aestheticist works traded in this type (nos.46–52, 119), while Millais developed an idea of beauty along realist lines (no.118). Caricatures from numerous Pre-Raphaelite works abound.[72] JR

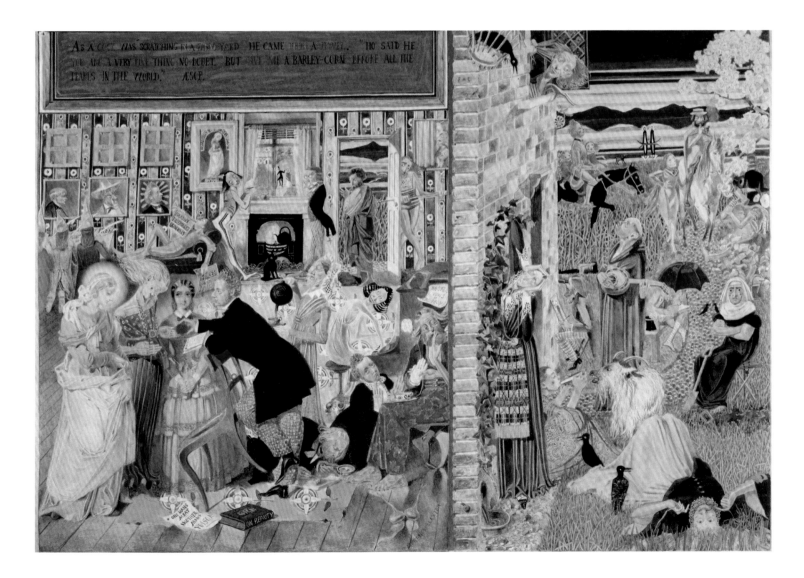

MORRIS, MARSHALL, FAULKNER & CO.

Four stained-glass panels depicting *King René's Honeymoon* c.1863

Victoria and Albert Museum

DANTE GABRIEL ROSSETTI 1828–82

Music

Stained and painted glass 63.5 x 54

EDWARD BURNE-JONES 1833–98

Painting

Stained and painted glass 63.7 x 54.3

EDWARD BURNE-JONES

Sculpture

Stained and painted glass 63.5 x 54

FORD MADOX BROWN 1821–93

Architecture

Stained and painted glass 63.7 x 54.3

The four stained-glass panels depicting *King René's Honeymoon* embody the collaborative work of the circle of artists involved at the inception of Morris, Marshall, Faulkner & Co. The designs originated in a commission in 1861 from the gothic-revival architect John Pollard Seddon to decorate a large oak chest for his own use. The elaborate inlaid decoration, it was agreed, would be executed by Seddon's father, a cabinet-maker. J.P. Seddon commissioned ten painted panels depicting the Fine and Applied Arts from Morris, Marshall, Faulkner & Co. He was personally connected to the Pre-Raphaelite circle through his elder brother, the landscape painter Thomas Seddon, a friend of Hunt and Brown.

Brown suggested a decorative scheme based on the character of the medieval René of Anjou (1409–80), King of Naples and of Aragon, a figure familiar in the nineteenth century through his appearance as an art-loving, but weak, old man in Sir Walter Scott's novel *Anne of Geierstein* (1829).[73] Brown suggested the subjects Architecture, Painting, Sculpture and Music and 'a series of imaginary incidents in the "Honeymoon" of King René by which to express them, that King having been skilled in all these arts'.[74]

The decorative scheme was a collaboration that reveals the distinct individual styles, as well as the overlapping themes and enthusiasms, of the Rossetti-Morris circle in the early 1860s. Brown designed the 'Architecture' panel, 'Painting' and 'Sculpture' were by Burne-Jones, while Rossetti was responsible for 'Music' and a smaller panel, 'Gardening'. Other small panels were by Val Prinsep, and Morris designed the decorative surrounds for each panel.

The cabinet was shown in the Medieval Court at the 1862 International Exhibition at South Kensington, and the South Kensington (later Victoria and Albert) Museum unsuccessfully attempted to purchase it, although it did later pass into the collection. Critics were less positive about the avant-garde character of the decoration: the *Building News* referred to the 'angular figures and wretched compositions which deface Mr Seddon's writing table'.[75]

In 1863 Morris, Marshall, Faulkner & Co. were commissioned to decorate the interior of The Hill, Witley, Surrey, home of the successful watercolourist, Myles Birket Foster. The four large panels from the doors of Seddon's cabinets were refashioned as designs for stained glass, a medium that was already in the throes of a major revival, but one that Morris and Burne-Jones would transform in the coming decades. 'The Firm' pioneered the introduction of stained glass, hitherto limited largely to ecclesiastical settings, into the domestic interior. These panels embellished Foster's library at Witley.

Small panels with stylised floral designs surround each of the King René scenes. The dramatic, graphic style employed by Brown and Rossetti for the Seddon cabinet translates vividly to the medium of stained glass. Each artist prepared a black-and-white design, recasting the composition for a rectangular format rather than the arched shape of the niches on Seddon's cabinet. Morris converted these into the medium of stained glass, with which the artists were relatively unfamiliar. Burne-Jones, for example, 'was not in the habit of inserting the lead-lines in his cartoons and … Madox Brown did so only occasionally'.[76] Morris's first biographer notes 'how much remained over and above for Morris and his assistants to do to adapt the designers' monochrome drawings for practical execution'.[77] Morris's skill can be seen in the complex variation of tone and texture in 'flashed ruby glass' employed in the receding floor tiles in the foreground of the *Architecture* panel and in the rich colours used in Rossetti's *Music* panel.[78]

Brown and Rossetti emphasised the sexual in their depictions of the medieval honeymooners. In the case of Architecture, the king experiences a dilemma, choosing between the charms of his pale, blonde wife and the allure of working on the gothic design (with echoes of Philip Webb's designs for Morris's Red House) before him. Brown's characteristic foreshortening of the face and emphasis of costume details such as the fancy, pointed shoes of the king reach back to his designs of the 1840s (no.7). Rossetti's panel makes explicit a connection between music and erotic delight suggested in his Tennyson illustration, *St Cecilia* (1856–7).[79] As in the earlier drawing and engraving, the composition is structured by a dramatic diagonal line formed by the pipes of a portative organ. Although Rossetti simplified the design from the elaborate original for Seddon's cabinet, Morris and his assistants had to stylise further the draperies for translation to the medium of stained glass. The side panel of the organ, however, retains its decoration, with complex patterns appearing in black on gold and the words 'Hierusalem/Sicilia/Neapolis/Cyprus' clearly legible, a reference to the 'Four Kingdoms' claimed by the Aragonese monarchy.

Burne-Jones's two frieze-like compositions, *Painting* and *Sculpture*, are less dramatic than those already discussed, but adapted well to the stained glass medium. *Painting* presents an allegory of Pre-Raphaelite practice: on the canvas appears a decorative,

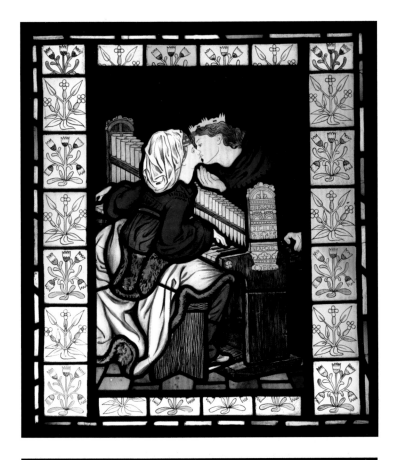

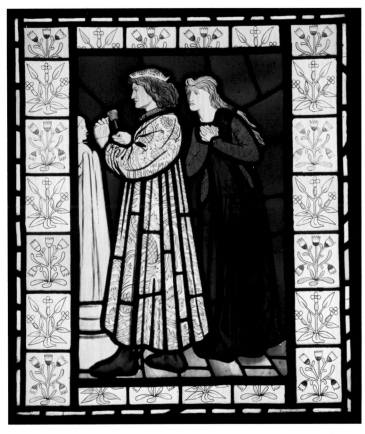

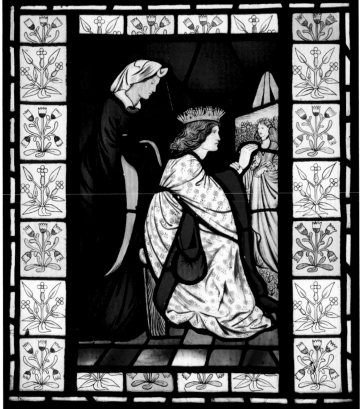

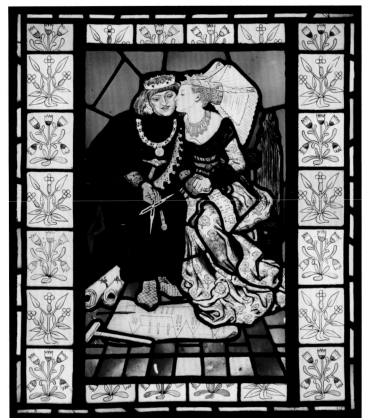

Aestheticist composition based on the appearance of King René's new queen in flowing gown and with floral background, just as Rossetti based his single-figure female compositions on the appearance of Elizabeth Siddall and Fanny Cornforth. In *Sculpture*

Burne-Jones explores a central theme in his work: the sculptor's eroticised fascination with his life-like creations. The two versions of his Ovidian *Pygmalion* cycle (1868–70) offer a full elaboration of the theme initiated here. TB

4. NATURE

The Pre-Raphaelite response to nature constitutes one of the most dramatically original aspects of the movement in terms of both artistic theory and style.[1] Partly inspired by the writings of John Ruskin, the artists successfully developed their own novel and precise method of transcribing the natural world in oils based on close looking and sustained engagement with the motif. These are works best known for their optically precise description, in which 'the world represented … is uncannily like the "real" world, yet it is clarified and concentrated', as Elizabeth Prettejohn has written.[2] With few exceptions, the Pre-Raphaelite vision of nature abjured the panoramic and collapsed the proximate and the distant into a single unit, every element seen in equally precise focus. There is little precedent in the history of art for the process of making these works, the newly available materials they used, the places where they were painted, or the way the resulting images appear to the viewer.[3] Vivid and precise natural imagery appears in Pre-Raphaelite subjects from Shakespeare and in imagined scenes of the past thrust into the optical present. Other works placed unfamiliar aspects of contemporary labour in landscape settings and engaged with modernity, as represented in an increasingly compromised natural environment around the expanding metropolis of London. And an understanding of process is essential to unlocking the striking contemporaneity of these pictures and the pervasive presence of nature across genres in Pre-Raphaelitism.

The young members of the PRB avidly read volumes one and two of *Modern Painters*, Ruskin's spirited defence of J.M.W. Turner and landscape painting published in 1843 and 1846. Ruskin was a key influence, and his simple directive to 'go to nature in all singleness of heart, and walk with her laboriously and trustingly, having no other thoughts but how best to penetrate her meaning, and remembering her instruction; rejecting nothing, selecting nothing and scorning nothing' has come to stand as a manifesto for the Brotherhood's wide-eyed approach to painting the exterior world.[4] To a degree, the PRB took this to heart; their works superficially seem to deliver an objective, unblinkered view of the environment.

Ruskin, in turn, promoted the PRB as simultaneously radical and part of an art-historical tradition; he recognised the movement's potential. He wrote approvingly in 1851: 'For the most part these pictures are rashly condemned, because the only light which we are accustomed to see represented is that which falls on the artist's model in his dim painting-room, not that of sunshine in the fields.'[5] But while through his words Ruskin may have inspired the artists to leave their studios and look closer, he had no personal role in the development of a Pre-Raphaelite landscape painting style, and in their formative years the Pre-Raphaelites were unfamiliar with Ruskin's own art apart from illustrations he produced for his books, although he was a fine artist in his own right (nos.61–2) and had a sharp eye for detail and a professional interest in geology. By the time Ruskin commissioned his portrait from Millais – a genuine collaboration between artist and critic (no.72) – Millais, Hunt, Collins, and Brown had already settled on their style. It formed as a result of their distinctive artistic processes, developed from 1849 to 1851, as detailed in catalogue entries below and in Alison Smith's essay (pp.18–23).[6]

Works by John Inchbold, John Brett (no.77) and Rosa Brett powerfully demonstrate the impact of Pre-Raphaelite philosophies on landscape painting during the second half of the nineteenth century. Inchbold's *At Bolton* (no.76), with its inspiration from English literature, close attention to natural detail, symbolic use of flora and fauna to signify religious meaning, and calculatedly decorative patterning and design draws together these four major strands of the exhibition. It demonstrates the sophistication with which artists younger than the Pre-Raphaelites adopted the various facets of the PRB enterprise. Brett's *Stone Breaker* (fig.16) would seem fully to encapsulate Ruskin's idea of 'sunshine in the fields'. There is little in art of the period to match the intense clarity of forms seen under local colour in the foreground, and fine depiction of detail in the far landscape, with its plainly visible railway embankment and distant hill. The *Stone Breaker* functions as landscape, genre and Realist image of labour that evokes comparison with the works of Gustave Courbet, while, as is typical of Brett, bearing a religious subtext. Truth to nature is something that many artists used as a rallying cry in the period, but closely observed nature is more than mere ancillary detail here: successful Pre-Raphaelite images of nature marry an intensity of vision and detailed description with an equally effective treatment of figures and complexity of theme, integrating every element into a coherent whole.

In this way, also, the artists continued to meet the challenge of photography, which both complemented Pre-Raphaelite images of nature (nos.63–5) and spurred the painters to intense representations in their paintings. Simultaneously, artists became fascinated, as Ruskin was, with developments in the natural sciences, something felt broadly in society in this period, as evidenced in Dyce's *Pegwell Bay* (no.82) with its amateur shell-gatherers in the foreground. William Henry Fox Talbot's *The Geologists* (no.63) of the mid-1840s brings both of these strands, photography and science, together. It reveals the gender-blind appeal of natural science, the pervasive presence of sites of

possible discovery, and the dramatically detailed possibilities of the new art form, here in a salted paper print from a paper negative, as opposed to the daguerreotypes that Ruskin had made for study in this period (no.73). Photography appeared to fix true nature, but its greatest drawback was that it was limited to monochrome.[7] The critic of the *Guardian* recognised this, writing of Charles Allston Collins's *Convent Thoughts* (no.88): 'As a piece of painting it is wonderful. We direct attention to the groups of gorgeous flowers in the garden and to the evergreens by the wall, which we conceive are executed somewhat as a daguerreotype would represent them, if it could convey colour as well as form to the plate.'[8] For the French critic Maxime du Camp, himself a photographer, the natural detail of hay and straw painted in Millais's *The Return of the Dove to the Ark* (no.89) represented 'not art, but coloured photography' and *Ophelia* merited comparison to 'an enamelled toy',[9] a critique that both denigrated photography and attempted to evict Pre-Raphaelitism from the realm of fine art. A similar disparaging link to contemporary concepts of mass production and the packaging of consumer goods was occasioned by the ambitious approach to nature in Collins's *May, in the Regent's Park* (no.68): one critic believed that 'the absurdity of the production is the more obvious from its being so misplaced – a tea-tray, not a picture frame, was its appropriate vehicle'.[10]

Unlike the nascent medium of photography, Pre-Raphaelite technique could more easily represent complicated narratives and emotions by integrating figures and landscape in complex compositions that enhanced the stories, elicited sentiment and conveyed a vivid sense of costume. In these terms, Pre-Raphaelite painting preserved its edge. Practitioners of photography such as Oscar Gustave Rejlander and Henry Peach Robinson adopted collage techniques in making more grandiose and pictorial photographs, marrying detailed grounds, figure and expression in a more pictorial way and, in a sense, mimicking the remarkable collage effects in Pre-Raphaelitism, as in *Ophelia* (no.69) and *The Hireling Shepherd* (no.70), where Millais and Hunt painted the backgrounds separately from the figures. But the joins in such photographs remain visible, no matter how subtle, the lighting effects are uneven and variances in scale are often evident. Photography, and the demands of a public increasingly familiar with rudimentary science and bearing an impressive grasp of the species of flora and fauna in Britain, inspired the artists to develop their process of making highly focused work in strong colours.

In Pre-Raphaelite sculpture the finest example that followed the naturalistic creed is John Lucas Tupper's *Linnaeus*, produced for the new Oxford University Museum (fig.15).[11] Tupper conceived the Swedish eighteenth-century botanist and taxonomist as enmeshed in a delicately carved full-length Lapland coat while he contemplates a sprig of flora held in his right hand. Under his arm the fingers of his left hand hold his place in a Bible along with another small stem. This sculpture was made just three years

before the publication of Charles Darwin's *On the Origin of Species*, and it anticipated the challenge of teaching modern science in an Anglican university.[12]

The extreme, sharp-focused approach to nature in Pre-Raphaelitism with its commitment to a convincing realism presented a problem for the development of landscape painting. Daniel Alexander Williamson's *Spring, Arnside Knot* (no.84) provides a kind of *terminus ante quem* for the style, with its migration of Pre-Raphaelite precision beyond London in the 1860s. By this time Millais had moved on to a very different approach to nature, one wedded to Aestheticist suggestiveness (no.117); Hunt, after his experiences in the Holy Land, used precise nature in a diminished role in his exhibition oils, although he continued to produce watercolour landscapes; Dyce had decided on a more spiritual approach to the environment (no.108), in pictures that are Pre-Raphaelite in appearance but were not painted outdoors; and artists like Inchbold and Brett, who had previously adhered to PRB painting processes, had broadened their styles along more conventional lines. The sheer expenditure of time on each canvas, the sizes of which were also getting larger, made the process untenable for artists in their maturity, reliant on the sale of work to support themselves and their families.

The commitment to represent nature survived in changed form in later phases of the movement: in the patterned naturalism of William Morris's designs for wallpapers, textiles, stained glass, ornamental manuscript illumination and book design, and in the Scottish landscapes painted by Millais until his death in 1896 (no.162). These late landscapes, broader in format, were still painted almost entirely on site and reveal a deep knowledge of the underlying truths of nature. JR

Fig.15 John Lucas Tupper, *Linnaeus* c.1866, limestone. Oxford University Museum of Natural History

61

JOHN RUSKIN 1819–1900

Mountains of Villeneuve c.1846

Pencil, brown ink and ink wash on heavy toned paper 27.8 x 45.5
Ruskin Foundation (Ruskin Library, Lancaster University)

62

JOHN RUSKIN

Mountain Rock and Alpine Rose 1844 or 1849

Pencil, ink, chalk, watercolour and bodycolour 29.8 x 41.4
Ruskin Foundation (Ruskin Library, Lancaster University)

John Ruskin is perhaps unique among the major thinkers of the nineteenth century in that his work in visual media, as a draughtsman and watercolourist, was an integral, indeed an essential, part of his intellectual practice. 'There is a strong instinct in me', he wrote to his father in 1852, 'which I cannot analyse, to draw and describe the things I love.'[13] He studied under various drawing masters, including Anthony Vandyke Copley Fielding and J.D. Harding, and recalls in his autobiography, *Praeterita*, the intensity of his visual experience of the natural world, even at an early age.[14]

In his *Modern Painters*, the first volume of which appeared in 1843, Ruskin laid out a critical and theoretical defence of the work of J.M.W. Turner that evolved into a five-volume treatise on landscape painting, illustrated by many of his own as well as Turner's works. Its influence on the young Pre-Raphaelites, especially William Holman Hunt, was formative.

Mountains of Villeneuve encapsulates many of Ruskin's primary concerns in *Modern Painters* and is reproduced and discussed in the fourth volume, which appeared in 1856. It provides a demonstration of his singular expertise as a draughtsman. While it offers a sweeping representation of the famously picturesque scenery of Switzerland near Lake Geneva, the primary function of the drawing is to reveal the underlying geological construction of the mountain range. The drawing is evidence of mountains with

> the high crest or wall of cliff on the top of their slopes, rising from the plain first in mounds of meadow-land, and bosses of rock, and studded softness of forest; the brown cottages peeping through grove above grove, until just where the deep shade of the pines becomes blue or purple in the haze of height, a red wall of upper precipice rises from the pasture land, and frets the sky with growing serration ... [This drawing] represents a mass of mountain just above Villeneuve, at the head of the Lake of Geneva, in which the type of the structure is shown with singular clearness.[15]

Ruskin's virtuoso prose descriptions were made possible by his close visual observation; as with Pre-Raphaelite landscape painting, the process of intense looking resulted in a novel and distinctively modern style.

The contours of the slopes in *Mountains of Villeneuve* have first been followed in pencil, and then dramatised by the application of grey wash in areas of shadow. Finally, firm strokes of the pen – the same pen and ink Ruskin used for writing – emphasise the strata of the mountainous scree, drawing attention to the region's turbulent geological history in which the earth's crust was violently disrupted. The stress on underlying structures does not preclude an attention to the quotidian details of the landscape. Tiny pencil lines at the upper limit of the mountains indicate forestation, each fir tree carefully delineated. Ruskin is less interested in the calmness of the valley bottom and impatiently indicates the deciduous woodlands with swift, calligraphic flourishes of the pen.

Mountain Rock and Alpine Rose demonstrates a different aspect of Ruskin's practice, the observation of the interaction of natural forms in close proximity, recorded here in a swift and energetic style eschewing a high level of finish. The sketch, very likely completed on the spot, represents a boulder, but here Ruskin is less interested in the details of its surface than in its massive bulk. Around it he has indicated a plethora of forms typical of Alpine woodland: fir trees; a small shed or shack, perhaps a herdsman's shelter, to the right; and the hint of a figure, slightly indicated, sheltering in a niche in the foreground. This might represent Ruskin's servant John Hobbs, who accompanied him on Alpine hikes, and on occasion carried and manipulated a large daguerreotype camera for his employer.[16] It is possible that the influence of photography can be detected in the sudden, brilliant attention paid by Ruskin to plants in the left foreground.

The alpine rose is picked out meticulously in bodycolour in the left foreground. In a letter to the artist George Richmond, Ruskin expressed the difficulty of drawing this plant with the paint or pencil: 'Infinity multiplied into infinity – what can white lead or black lead do with it?'[17] Typically for Ruskin, colour is used sparingly and the palette is limited, but patches of bright paint are applied boldly, even wildly. The mountains, however, appear only as white paper silhouettes against a pale blue sky in the upper right. This drawing is essentially a personal notation of a visual experience, rather than a finished work of art. The contrast with a finished Pre-Raphaelite painting such as John Brett's *Val d'Aosta* (no.77), painted under the influence of Ruskin's writing and later purchased by the critic, is striking. Ruskin's own works as an artist never truly conformed to the hyperrealistic Pre-Raphaelite style that he espoused, nor did he work in the Pre-Raphaelite medium of oil paint. TB

61

62

63
WILLIAM HENRY FOX TALBOT 1800–77
The Geologists c.1843

Salted paper print 8.4 x 9.5
The National Media Museum, Bradford

64
JOHN DILLWYN LLEWELYN 1810–82
Rabbit c.1852

Salted paper print 20.8 x 16
The Royal Photographic Society Collection at the National Media Museum, Bradford

65
ROGER FENTON 1819–69
Double Bridge on the Machno 1857

Albumen print, curved top 40 x 33.5
The Royal Photographic Society Collection at the National Media Museum, Bradford

When the Pre-Raphaelites first exhibited their paintings to the British public, their highly detailed style prompted the accusation that they copied from photographs, a charge that John Ruskin rushed to deny on their behalf.[18] Though the artists did not acknowledge photography as a source for their art, their paintings nevertheless show that they readily absorbed its unique and new ways of representing the world, drawing in particular on photography's precision of focus, flattening of forms, planar composition and radical cropping of the visual field. William Bell Scott witnessed Rossetti and Hunt working on *The Girlhood of Mary Virgin* (no.24) and *Rienzi* (no.25) and remarked:

> Every movement has its genesis, as every flower its seed; the seed of the flower of Pre-Raphaelism [sic] was photography. The seriousness and honesty of motive, the unerring fatalism of the sun's action, as well as the perfection of the impression on the eye, was what it aspired to. History, genre, mediaevalism, or any poetry or literality, were allowable as subject, but the execution was to be like the binocular representations of leaves that the stereoscope was then beginning to show. Such was my conclusion on thinking over that first visit to Hunt's studio – conclusion as to the execution, that is to say.[19]

Scott connects photography's reliance on the neutral agency of sunlight to make an image to the Pre-Raphaelite aim to make paintings that mirrored the world they saw around them.

In the 1840s the young Pre-Raphaelites would have most certainly seen examples of the daguerreotype, which had been introduced in France in 1839 and was available in England primarily through the establishment of commercial studios, where portraits, such as that by William Edward Kilburn (no.31), were offered. They were probably aware also of the burgeoning field of British photography utilising the positive-negative system invented by William Henry Fox Talbot. Talbot's process, which he named the calotype and introduced to the public in 1841, was initially not as widely adopted, due in part to Talbot's claim of patents on the process.[20] Yet Talbot, his circle of relatives and friends, and other amateurs were actively producing photographs and refining the photographic process. From 1844 to 1846 Talbot

also published *The Pencil of Nature*, which catalogues various potential uses of the young medium, from the documentation of plant specimens and art objects to architectural views and landscapes. Over time, many of the Pre-Raphaelite artists recorded encounters with photography, including variously sitting for portraits, visiting photography exhibitions, using photographs as aids for painting, and interacting with photographers.[21]

Talbot's *Geologists*, a salted paper print from a paper negative, demonstrates attributes characteristic of the medium at the time: stark contrasts between light and shadow and a planar composition with the rock face filling the frame to its edges. The two figures, serving as stand-ins for the viewer, are engaged in the empirical observation of the rock formations. Scrutiny of the visible world was a vital aspect of the developing science of geology, which studied the earth, revealing its age and how it changed over millions of years, thus altering the Victorian world view.

Similarly, John Dillwyn Llewelyn's salted paper print of a rabbit revels in the close observation of nature in its detailed study of grass, foliage and ferns. The son of a botanist, Llewelyn was married to Talbot's cousin Emma, and both he and his wife were active in photography, taking many photographs at Penllergare, the family home in Wales, where this photograph was probably made. Due to the difficulty of photographing animals with the extended exposure time then necessary, Llewelyn partially staged this woodland scene by placing a stuffed rabbit in the landscape.

Roger Fenton, who had trained as a painter and was a friend of Ford Madox Brown, became one of the most widely admired landscape photographers of the 1850s. He showed prints frequently at the exhibitions of the newly founded Photographic Society of London and other regional societies. Fenton's *Double Bridge on the Machno* employed the dominant photographic process in use by the mid-1850s, the wet collodion glass negative and the albumen print, which were capable of providing a sharp delineation of form and a rich range of tonal gradations. The photograph was among several Fenton produced of the landscape of Wales and captures the contrasting textures of rock, water, bark and foliage, as well as the play of dappled sunlight and shade on these surfaces. DW

63

65

64

JOHN EVERETT MILLAIS 1829–96
The Woodman's Daughter 1850–1

Oil on canvas 88.9 x 64.8
Guildhall Art Gallery, Corporation of London

Dating from Millais's third year of Pre-Raphaelite production, *The Woodman's Daughter* was his second *plein air* landscape after *Ferdinand Lured by Ariel* (no.33) and presents the most vivid sense of a deep natural setting in a PRB work to date. Complex and sophisticated, it also refers to old-master art, contemporary poetry and issues of social injustice.[22] The picture was painted in Wytham Woods near Botley, outside Oxford.[23] In this first large-scale work outdoors Millais expanded the process he would retain over the course of his career, and a style that followed from that approach. He would paint the backgrounds first, entirely, then return to London to his Gower Street studio, once the weather turned less agreeable, to finish the pictures from models in more temperate surroundings. The stiff and vertical poses of the figures reveal the continued influence of van Eyck's *Arnolfini Portrait* (fig.13), and the deep and rapid perspectival recession is innovative in the way it pushes their bodies even further forwards in the composition.

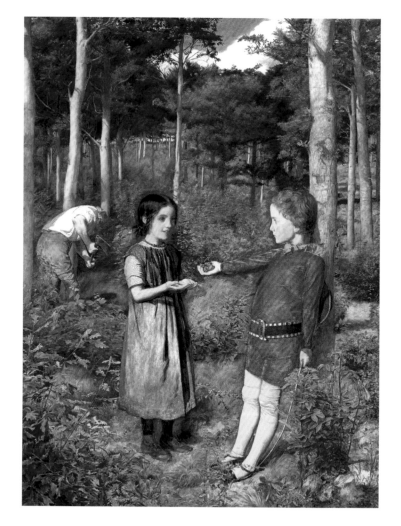

The subject is from Coventry Patmore's poem of the same title (1844). Reversing the gender and class roles in *Isabella* (no.26), the woodman's daughter Maud falls in love with the squire's son Merton. In adulthood the social gap between them precludes any public relationship. He deserts her. She drowns their love child and loses her mind. Millais depicted the early connection between the two, as the boy offers her strawberries, painted from fruit Millais procured at Covent Garden. He enlisted his friends, patrons and hosts in Oxford, Thomas and Martha Combe (see nos.86, 88, 89, 92), in this project, writing to ask them to go to Botley near Wytham Woods to procure a pair of old boots from a cottage girl he had met, and a suitable country dress. This they did, and the contrast between her simple yet iridescent costume and Merton's brilliant red finery and riding crop marks their disparate stations in life, increasingly a concern of Pre-Raphaelite modern-life subjects in the 1850s (nos.95–8).

The *Daily News* wrote that the Pre-Raphaelites in 1851 'have come out in strength, adhering to their tenets with the faith of martyrs, yet commanding respect by their fervid and devotional artistic principles'.[24] This was most evident in the vivid landscape elements, but also in the original freckled face of Maud, described in the *Guardian* as a 'female rustic'.[25] In 1886 Millais repainted her with a smoother complexion at the behest of the picture's owner, his half-brother Henry Hodgkinson, dulling the appearance of social disparity between the protagonists. JR

FORD MADOX BROWN 1821–93
'The Pretty Baa-Lambs' 1851–9

Oil on panel 61 x 76.2
Birmingham Museums and Art Gallery. Purchased 1956

Begun in April 1851, 'The Pretty Baa-Lambs' was the first Pre-Raphaelite painting to be produced outdoors in bright sunlight and with the figures similarly observed in the open air and not in the studio.[26] It represented an expansion of Brown's experiments with effects of natural light on sitters in his large *Chaucer* (1847–51; Art Gallery of New South Wales, Sydney), seen at the RA that same spring. It had an impact on Hunt and Millais, spurring them to spend the summer and autumn in Surrey engaged in similar pursuits in *The Hireling Shepherd* (no.70) and *Ophelia* (no.69). The revolutionary impact of the work has been noted since the late nineteenth century, when the critic R.A.M. Stevenson stated that 'the whole history of modern art begins with that picture. Corot, Manet, the Marises, all the Fontainebleau School, all the Impressionists, never did anything but imitate that picture.'[27]

Brown painted it in five months in the garden of his house in Stockwell and on Clapham Common, later adding the strip of seaside that extends the view into the background. His future wife Emma and five-month-old daughter Catherine posed in eighteenth-century dress for the figures, a strange concession to historical genre considering Brown's predilection for modern-life subjects. The use of a panel prepared with bright white gesso made it easier to work *in situ* and resulted in sharper colours and

drawing. There are remarkable formal touches in the mother's individually painted yellow eyelashes and visible teeth (a calling card of Brown's realism), the raised pink of the child's bonnet and the delicately described grasses that resemble gesso relief work in early-Italian panel paintings. By contrast, in some areas Brown used scratching out to denote grasses. The mother reaches out with empty fingers to attract the lamb, while holding her child tightly with her left hand, her wedding ring visible.

Despite the period costume and the woman's gentle words to the baby in the title, Brown considered the work subjectless, briefly titling it *Summer Heat* and emphasising what he saw as its most notable feature – the depiction of the unsparing specificity of a sun-splashed day. In the catalogue to his exhibition of 1865 he wrote: 'Pictures must be judged first as pictures … I should be much inclined to doubt the genuineness of that artist's ideas, who never painted from love of the mere look of things, whose mind was always on the stretch for a moral.'[28] In terms of thematics, Brown's approach could not be further from that of Hunt (no.70), although both are resolutely Pre-Raphaelite in their radical approach to painting finished exhibition pictures *en plein air*, over a decade before Impressionist artists made that integral to their practice in France. JR

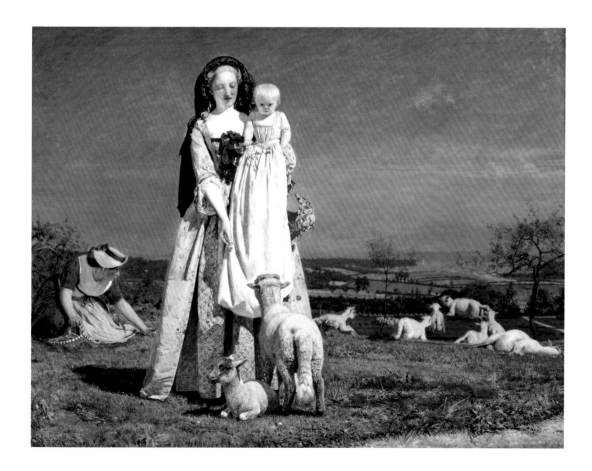

CHARLES ALLSTON COLLINS 1828–73

May, in the Regent's Park 1851

Oil on mahogany panel 44.5 x 69.2
Tate. Purchased 1980

Never a PRB member, Collins was close to Millais from the late 1840s. They met in the Royal Academy Schools around the time of the death of Collins's father William (1748–1847), the esteemed Academician and genre painter. Since August 1850 he and his elder brother Wilkie, then but a budding novelist, had lived at 17 Hanover Terrace, facing east-northeast, across Regent's Park with their doting mother Harriet, who became something of a second mother to Millais. Compared to the often overbearing and domineering Hunt, Collins was somewhat of an agreeable acolyte to Millais. They interacted socially in summers at Oxford, took long walks with Wilkie through the environs of north London, and Millais called him 'Fra Carlo', bringing him into the Brotherhood in an affectionate and casual rather than official sense.

Collins contributed a major work of Pre-Raphaelite religious genre with *Convent Thoughts* (no.88), his most impressive picture and one whose botanical detail earned him his Pre-Raphaelite credentials and elicited Ruskin's praise. Its background was begun in Botley in the summer of 1850 while Millais painted that of *The Woodman's Daughter* (no.66). While *Convent Thoughts* was on display at the RA in the spring of the following year, Collins painted the present, far less detailed, but no less vivid picture from his family's lodgings. It is the only pure Pre-Raphaelite landscape of a central London subject and is remarkable in its fidelity to nature, expression of Pre-Raphaelite principles and documentation of the particularities of this metropolitan park without any evident religious or social themes.

The title establishes a specificity of scene and time although it bears a veiled complexity.[29] 'May' refers to the month Collins began the painting, but also to the thick and lush 'double pink hawthorn' tree in the left foreground, the *Crataegus laevigata* 'Rosea Flore Pleno'. This seemingly straightforward view out of a window onto both private and public urban greenery is actually complex. Collins conflated the prospect from his upper-floor bedroom to the distant park across the Outer Circle – where a man and a young girl head north towards the upper reaches of the park and Portland Town – with that of the first-floor, more head-on perspective of the garden frontage. The foreground of the picture, with its hawthorn tree and other planting, lies in the private grounds of Hanover Terrace. Beyond the Circle and the iron fence are the park's lawn with sheep serving as mowers,

the boating lake with a solitary swan plying its placid waters, and a variety of deciduous trees. In the middle left distance, within the park, are the gothic peaks of St Katharine's Lodge, destroyed in World War II, but then part of a hospital complex of the same name. At the far right looms the barely perceptible bulk of Chester Terrace. Between the two, but invisible in the picture, lies Cumberland Terrace, the home of Mr Crooke who purchased the picture.

Ultimately, the picture is an escapist vision of a privileged view, something John Nash intended in his design of the park's terraces. The depopulated park, reduced to its manicured terrain and planting and ordered into rigid horizontals of parterre, path and road, fence, water and tree line, and into dark verticals of figures, fence palings and tree trunks, conforms to Collins's proprietary gaze. It presents a mid-day vista of an idyllic retreat in the midst of the sprawling metropolis, whose grime and industry are studiously avoided. The crowds that converged on London at this time for the Great Exhibition of the Works of Industry of All Nations in the Crystal Palace are not at all in evidence. It is a singularly Pre-Raphaelite painting that, brightly chromatic, works against the tradition of picturesque views of gardens out of windows. It lacks framing devices around the view such as elements of the window, tall foreground motifs at the sides that define space, or plunging lines that draw the eye back into depth. The *Art Journal* critic wrote that 'all kinds of inexorable straight lines are boldly and importunately brought forward, despite the useless and absurd rules of composition', inadvertently hitting on the picture's chief claim to distinctiveness.[30]

Hawthorn trees had recently engendered some controversy. Following the enactment of the British General Enclosures Acts beginning in 1845, the shrubs were used as hedgerows to demarcate now private lands due to their impenetrability and dissuasive thorns.[31] Here it serves to separate the broad and public park from the still-exclusive terrace. The picture presages similar subliminal reflections on the development of London and demarcations of space in Brown's view over Hampstead Heath (no.74), begun the year after *May* was exhibited at the RA, and his delicate and even more similar watercolour of *Hampstead from my Window* (1857; Delaware Art Museum).[32] JR

JOHN EVERETT MILLAIS 1829–96

Ophelia 1851–2

Oil on canvas 76.2 x 111.8
Tate. Presented by Sir Henry Tate 1894

Millais made a career out of representations of women in trying emotional circumstances; Hunt often preferred to show how they might have found themselves in such a position. The artists' two main submissions to the Academy in 1852 evince this dichotomy. Millais's *Ophelia* and Hunt's *Hireling Shepherd* (no.70) were begun in Ewell, Surrey, in June, with the artists working for months on the backgrounds of their canvases, painting them inch by inch in front of fields and streams. They returned to London in December, refreshed by the countryside and its freedom from social and artistic obligations, with canvases completed but for sections in the centre that remained as patches of brilliant white, awaiting the insertion of figures. These would be painted from models in their studios. Elizabeth Siddall sat for Millais. She was a cutlery-maker's daughter whom PRB associate Walter Deverell had discovered at her job in a milliner's.[33] Millais posed her in a bathtub on Gower Street, intending to produce an authentic image of Hamlet's drowning lover from Shakespeare's play. The resulting painting, with its opulent foliage painted at its peak and piteous heroine, is a paradigm of the Pre-Raphaelite approach to nature, psychology and storytelling.

The familiarity of *Ophelia* as an iconic image in Pre-Raphaelitism has not diminished its effect. Like the greatest works of art, it not only stands as an emblem of the age in which it was made but also continues to provide continuing inspiration for contemporary artists.[34] The picture fills every prescription of early Pre-Raphaelitism. Millais's imaginative visualisation of the fate of Hamlet's doomed lover captures the past in its late-sixteenth-century textual source, in the elements of invented dress and in the form of Ophelia herself. She is recumbent on her back, stiff as a gothic tomb effigy, buoyed yet enveloped in the water that will serve as her tomb, enmeshed in vegetation vibrantly in bloom and bedecked with multi-coloured blossoms that speak eloquently of the life she has rejected. It perpetuates the novel qualities of Pre-Raphaelite history painting in drawing from a vernacular subject and in treating the moment from a play as if it occurred in actuality. The lines Millais cited in the RA catalogue, intoned by Queen Gertrude in Act IV, form an image in the mind, a tableau hardly ever staged:

> There on the pendant boughs her coronet weeds
> Clamb'ring to hang, an envious sliver broke;
> When down her weedy trophies and herself
> Fell in the weeping brook. Her clothes spread wide;
> And mermaid like, awhile they bore her up;
> Which time she chanted snatches of old tunes,

> As one incapable of her own distress,
> Or like a creature native and indued
> Unto that element; but long it could not be,
> Till that her garments, heavy with their drink,
> Pull'd the poor wretch from her melodious lay
> To muddy death.

The nature in the image is both observed from life and manufactured for the scene. Just as Hunt had Kent stand for Verona (no.34), Millais substituted a topographically unrecognisable Surrey for Denmark. It was churlish for some, like Tennyson, to chide him for including varieties of flowers that do not bloom at the same time of year in the image. Instead, they function symbolically to enhance the story, along with the sensitivity in her portrayal. *Fraser's Magazine* offered praise, finding pathos in Ophelia's face within a picture where the 'poetical reality' of the natural surroundings was combined with the artist's 'wilfulness of taking Nature as she is, instead of *composing* her into a picture'.[35] It was seen as a novel description without artifice.

The botanical specificity and close-up view of vegetation painted with a magnified sense of detail make this painting the most remarkable fine-art exponent of growing popular trends in the study of natural history in the period.[36] Millais delivered a picture that functions like a diorama in a museum display, with the body of Ophelia set in a convincingly true space and including fauna such as a robin and, originally, a water-rat. This reflects, on a macroscopic level, the microscopic and domestic interests of naturalists, terraria and aquaria owners, fern collectors and amateur botanists in local societies that were a hallmark of accessible science in the period.

Ophelia and *The Hireling Shepherd* represent the consummation of Pre-Raphaelite landscape practice in the service of literary and moralising subjects. Most critics had little issue with Millais's conception of Shakespeare's scene, seeing it as following in a theatrical tradition in British art, but almost all writers were entranced by Millais's conception of nature and saw it as the defining stylistic element of the movement.

Millais's innovative process of working from nature took him out of London. The general location where Millais painted the background has been identified in a stretch of the Hogsmill River at Malden, not much changed today.[37] The picture is in fine condition but for some bluing of the distant leaves and retouching of fading gamboge yellow pigment in the foreground weeds and on her face, undertaken by the artist in 1873.[38] JR

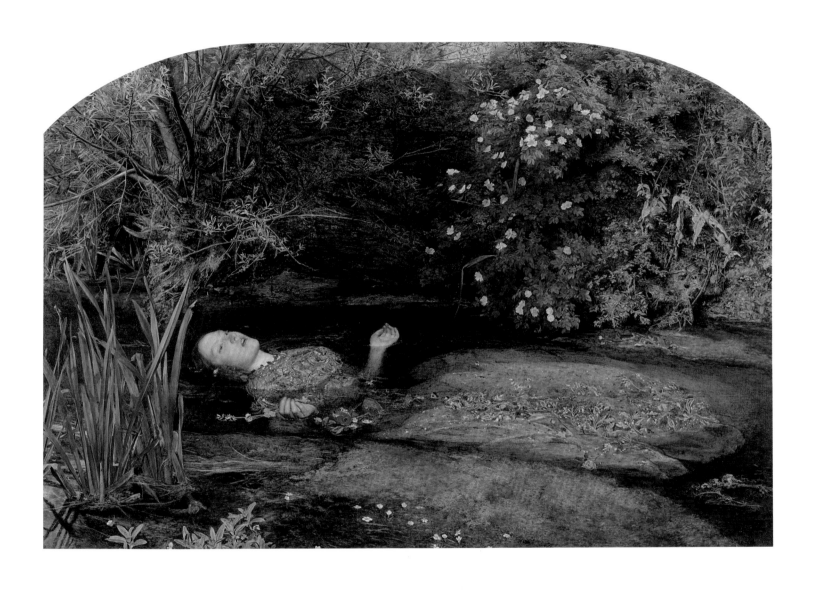

WILLIAM HOLMAN HUNT 1827–1910

The Hireling Shepherd 1851–2

Oil on canvas 76.4 x 109.5
Manchester City Galleries

Hunt's *Hireling Shepherd* abjures literary drama for social and religious criticism, while using nature to heighten visual sensation.[39] An idle shepherd, whose sheep have been left to roam unattended through the corn and consume unrestrictedly, cosies up to a welcoming shepherdess who leans into his frame. He is a 'hireling' shepherd, who is brought in from elsewhere, paid in cash and has no loyalty to his flock. Things are amiss in the countryside: the shepherdess has a lamb on her lap that eats unripe apples, she hangs precariously over a stream, and the neglectful shepherd teases her with a macabre death's-head moth. Hunt meant this as a commentary on a contemporary religious controversy concerning Anglican pastors neglecting their worshipping flocks, on which Ruskin had published a tract.[40] But as the religious relevance has dissipated over time, the treatment of vegetation and fauna with local colours, in direct sunlight, remains the most striking element of this picture.

Ruskin referred to this picture in a cautionary letter to John Brett, by comparison recommending works of Paul Veronese as being 'good for all complaints – especially of that ridiculous PreRaphaelite [sic] love of painting people with purple cheeks and red noses by way of being in the sun', and later referring to 'the blue cheek style'.[41] Ruskin objected to Hunt's frank portrayal of the rural working class. The critic of the *Athenaeum* noted with disgust that 'their faces, bursting with a plethora of health, and a trifle too flushed and rubicund, suggest their over-attention to the beer or cyder keg on the boor's back', implying that the imminent sexual encounter in the fields was fuelled by alcohol.[42] Other critics saw the complexions not necessarily as a fault, but an effective representation of the purported idleness and moral lassitude sweeping the countryside.[43]

Hunt worked in Ewell on the landscape and animals in the picture from late June to Halloween 1851. As in *Valentine* (no.34), he invented some of the clothing: as Judith Bronkhurst has pointed out, a typical field girl would not be sporting such a decorative chemise, whose stitching emphasised the swell of her breasts, thus giving her a possibly symbolic role as the tempting whore of Babylon.[44]

The ears of wheat and corn stooks on the original frame reflect the subject matter and detailed naturalism within, the first instance of Hunt using such a linked frame design.[45] Millais did the same for *Ophelia*.[46] The notable naturalist William James Broderip bought the picture, consequently inspiring his cousin Charles Maud to commission *Our English Coasts, 1852* (no.71).[47] JR

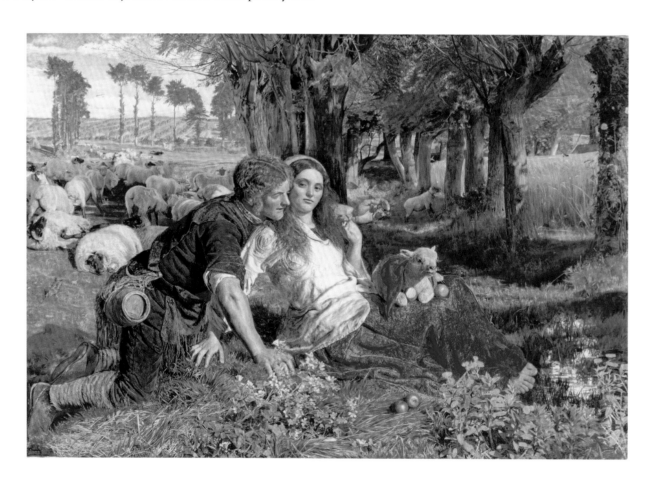

WILLIAM HOLMAN HUNT 1827–1910

Our English Coasts, 1852 (Strayed Sheep) 1852

Oil on canvas 43.5 x 58.4
Tate. Presented by the Art Fund 1946

Hunt painted this, his most startlingly pure and unpeopled Pre-Raphaelite landscape, outdoors at Fairlight near Hastings in the summer and autumn of 1852.[48] Unlike the year before, when he worked with Millais in Surrey, Hunt went alone to East Sussex to stay with the family of the Pre-Raphaelite associate, Robert Braithwaite Martineau. It was easy to get to the south coast via trains from London Bridge, and the area was swiftly becoming a tourist destination – the Pre-Raphaelites were early in adopting new modes of transport.[49] The view is of Covehurst Bay from near the Lovers' Seat. However, Hunt's title eschewed romantic associations in favour of a nod to military history, specifically the proximity to important locations associated with the Norman invasion and later conflicts with France. But Hunt, unlike J.M.W. Turner thirty years earlier, chose not to depict Battle, Senlac Field or Hastings Castle. Instead, he cast his panorama down the dramatic cliff and out to sea, where a solitary steamship moves slowly east, its smoke trailing in the wind, and the invisible coast of France lies beyond. Troops had been stationed at Fairlight during the Napoleonic wars, and Hunt played on the then current fear of invasion provoked by the unpredictable Napoleon III, who had seized imperial power in December 1851, establishing the Second Empire. The picture, a sequel to *The Hireling Shepherd* in its imaging of wayward, unmarked sheep, was a veiled critique of the undefended state of the Channel coast. Hunt subsequently exhibited it at the Exposition Universelle in Paris in 1855, where it 'truly amazed' Eugène Delacroix and was peaceably retitled *Strayed Sheep*. This also served to set it and its depicted ruminants in a religious light in which, untended, some sheep stray from the path of righteousness.

The lopsided composition, free from geometric rules of perspective, creates a vertiginous space and a sense of sublime peril as the landscape falls away at left. The sheep, insensibly grouped at the cliff's edge, mill about in the high bright sunlight, and graze or preen in the foreground. At left are two red admiral butterflies, not native to the scene but sent live by post in a perforated box from urban London. Nearby are various carefully observed flowers and thorny bushes, and Hunt's signature with the now characteristic location abbreviation, 'Fairlt', for Fairlight, serving as a fine description of the appealing luminescence represented. Other notable details are the visible ear capillaries on the furthest-right sheep in the foreground, brilliantly illuminated by the penetrative sun, this despite the fact that Millais claimed the preponderance of rainy weather Hunt experienced in the painting of this picture had convinced him to go to the Holy Land to further his art – as he would finally do in January 1854.[50] JR

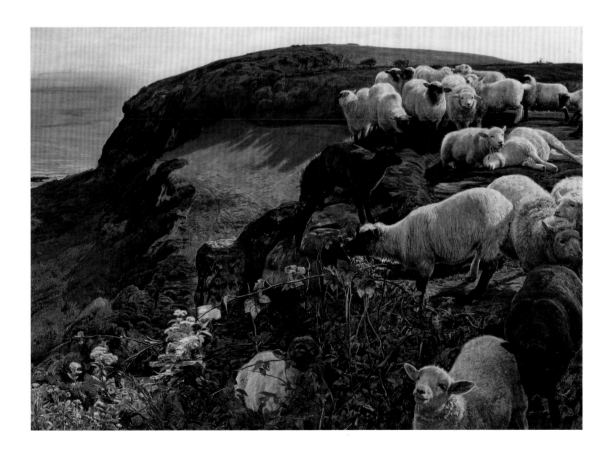

72
JOHN EVERETT MILLAIS 1829–96

John Ruskin 1853–4

Oil on canvas, arched top 78.7 x 68
On loan from a private collection, courtesy of the Ashmolean Museum, Oxford

73
JOHN RUSKIN 1819–1900

*Cascade du Dard, Chamonix c.*1854

Daguerreotype 16.1 x 12.2
K. & J. Jacobson, UK

This portrait, commissioned by John James Ruskin, father of the critic, was intended as a monument to Ruskin's mentorship of Millais, the artist whom he revered as a potential leader of the British school. It was also intended to exemplify Ruskin's theory of landscape painting, as laid out in *Modern Painters*.

The work was begun at Brig o'Turk at the mouth of Glenfinlas, a remote area of the Trossachs in Scotland, in the summer of 1853. Ruskin insisted that the rugged landscape should be painted on the spot, despite bad weather and swarming midges. 'Millais has fixed on his place', he wrote, 'a lovely piece of worn rock, with foaming water, and weeds, and moss, and a noble overhanging bank of dark crag.'[51] Following Ruskin's prescriptions, Millais explores not only the surface appearance, but also the underlying structure of this distinctive formation of gneiss rock.

In the presentation of the water Millais acknowledges the influence of the daguerreotype: the long exposure times meant that the movement of water created a distinctive blurring effect.[52] For Ruskin this was water 'such as was never painted before'.[53] The critic may have shown Millais daguerreotypes that he took, with the aid of his assistants John Hobbs and Frederick Crawley, in the Alps and in Italy and that include this effect. Ruskin was fascinated with photography as a means of capturing visual information from architecture and nature. The preternatural clarity of Millais's work of this period owes something to the razor-sharp daguerreotype image.

The figure of Ruskin was completed in Millais's Gower Street studio in early 1854, by which time relations between the two men had declined disastrously. Millais found it 'the most hateful task I have ever had to perform'.[54] On the trip to Scotland in 1853 Millais had fallen in love with Effie Ruskin, leading to the annulment of the marriage in 1854 and her marriage to Millais in the summer of 1855. TB

72

73

74
FORD MADOX BROWN 1821–93

An English Autumn Afternoon, Hampstead – Scenery in 1853 1852–5

Oil on canvas, oval 71.7 x 134.6
Birmingham Museums and Art Gallery. Presented by the Public Picture Gallery Fund, 1916

75
FORD MADOX BROWN

The Hayfield 1855–6

Oil on mahogany panel 24.1 x 33.3
Tate. Purchased 1974

Brown followed his experiment in painting high summer in 'The Pretty Baa-Lambs' (no.67) with landscapes offering different times of day or season in preferentially cooler working conditions. *An English Autumn Afternoon, Hampstead – Scenery in 1853* bears a specificity in its title like that of Collins's *May, in the Regent's Park* (no.68) but adds the time of day and year.[55] It is a grandiose statement of the possibilities of a Pre-Raphaelite approach to nature, transforming the prosaic into the compelling. It occasioned the famed anecdote of a perplexed and pestering Ruskin saying: '"Mr Brown will you tell me why you chose such a very ugly subject"… it was a pitty for there was some *nice* painting in it.' Brown's insouciant reply, 'because it lay out of a back window', both sealed his fate with the critic, who never supported him again, and demonstrated the novelty of Pre-Raphaelite landscapes, which rejected the picturesque, the artistically familiar, the historicist, the sublimely inclement and the far-flung locales of traditional landscape painting.[56]

Brown painted this oval canvas from his lodgings on the High Street, looking north and east over the Heath. In the foreground are a boy and girl, holding hands, accompanied by a dog and lying on a bank above the view, having opted not to sit on a nearby bench that is oriented south-east towards London. This choice replicates that of Brown, who turned his eye on this suburban prospect, instead of the metropolitan vista just off canvas to the right. The ideal viewer should stand at nearly the extreme left edge according to Brown's cloaked but fully resolved perspectival system. The subtle orthogonals line up perpendicular to the bottom of the picture on a vertical running through the small detail of a repositioned Kenwood House, visible at the upper left. This is characteristic of Brown's *plein air* pictures. The right-handed artist would situate his focus at the left edge, so that the landscape opens out into space at right, where he could extend his brush. Here this act is simulated in the gesture of the male pointer in the foreground, whose riding crop directs the eye towards the occluded city view, and lies along the angle of the properly positioned viewer of the picture. Dyce would similarly experiment with such concise perspectival constructions in his broader landscapes (no.82).

Brown referred to the work as a 'literal transcript', marked by details such as the 'upper portion of the sky [at 3 p.m. which] would be blue as seen reflected in the youth's hat'[57] and the number of people who labour in the landscape below the dawdling boy and girl: there are harvesters, and a woman and a child in a hen yard. From the artist's perspective, the purpose of the picture is characteristically to convey the commonplace. But recent writing on the work has stressed the rapid development of the northern suburbs in this period and the preservation of the Heath as a somewhat tamed natural space, framing Brown's choice of vista. In working at the various edges of the expanding metropolis, as Millais and Hunt had in Surrey in 1851, Brown engaged in the practice of urban mobility that was a presiding aspect of modern life in London in the 1850s, yet it is also true that in his landscape work Brown elided the moralising and social commentary so familiar in his major historical and modern-life subjects.

The panel of *The Hayfield* is one of a series of small and visually arresting works that Brown painted at Hendon, within walking distance of his subsequent lodgings further out at Finchley.[58] It is both landscape and self-portrait, the artist himself at left assuming the role of the middle-class viewers in *An English Autumn Afternoon*. Brown noted that the colours of the scene had been heightened by excessive rain, the grass greener than normal, and the waiting hay stacks turned pink and red in the twilight, an effect he unfortunately toned down due to criticism from his dealer, D.T. White.

Again, as in *English Autumn Afternoon*, the ideal position of the viewer is at far left so as to share the perspective of the artist who, exhausted from his labour, contemplates the view. The perspective and the banks of elements that block vision, such as the undulating rising and falling landscape in the middle and background, are radical in Brown's work. Millais and Hunt were uninterested in such design complexities, nor did they undertake such essays in experimental viewing overlaid with a poetic use of colour. However, *The Hayfield* appealed to the sharp-eyed young William Morris, who was the first owner of this jewel-like lunar work. JR

74

75

76

JOHN WILLIAM INCHBOLD 1830–88

At Bolton 1855

Oil on panel 68.6 x 50.8
Leeds Museums and Galleries

Born into a family of printers in Leeds, Inchbold was apprenticed under lithographer and watercolourist Louis Haghe in London. He was one of a number of artists who adopted a recognisably Pre-Raphaelite style and the artists' advanced approach to nature. He exhibited an earlier view of Bolton Priory, *The Chapel, Bolton* (Northampton Museums and Art Gallery), in the Academy of 1853 accompanied by lines from William Wordsworth's *The White Doe of Rylstone; or, the Fate of the Nortons* (1807, 1815), returning to the poem two years later with *At Bolton* and moving the scene inside the ruins. He showed it with *A Study, in March* (Ashmolean), bearing lines from Wordsworth's *Excursion*, and '*The Moorland*' – Tennyson (Tate). Inchbold intimately bound his brand of Pre-Raphaelite landscape to poetry, later publishing his own original verse.[59]

At Bolton illustrates Wordsworth's lines:

> And through yon gateway, where is found,
> Beneath the arch with ivy bound,
> Free entrance to the church-yard ground,
> comes gliding in with lovely gleam,
> Comes gliding in serene and slow,
> Soft and silent as a dream,
> A solitary *Doe!*

Inchbold remained deeply connected to Wharfedale in the Yorkshire Dales and particularly to 'Bolton's mouldering Priory', as Wordsworth described it, which was also the setting for Munro's *Romilly* (no.83) and provided the ideal background for the miraculous white doe that signifies Christ's redemptive suffering. Millais had admiringly noted the artist's work the year before, and Inchbold met W.M. Rossetti and Stephens around this time.[60] Ruskin supported him, and his impact is evident in this picture's transcriptive detail and declarative, locational title. Painted outdoors, it is remarkable for the transition through telescoping arches into a sharply observed middle ground. Inchbold integrated animate creatures with a vivid, static, daytime landscape. The image remains convincing despite pentimenti, the visible changes the artist made in the positions of the gliding doe's legs. The perspective coalesces just above the doe's downcast eye, reflecting the poem's Romantic theme of connectivity between nature and the past and underlining the symbolic importance of the deer. JR

JOHN BRETT 1831–1902
Val d'Aosta 1858

Oil on canvas 87.6 x 68
Collection: Lord Lloyd Webber

John Brett and his sister Rosa (nos.79–80) grew up near Maidstone. Both were artists from their youth and he had an early interest in science and scientific instruments. Brett began reading Ruskin in 1852, became acquainted with Thomas Woolner and enrolled in the Royal Academy Schools in 1853, leaving Rosa behind. He met Hunt later that year. Like Inchbold (no.76), Brett was an artist of the PRB generation who adopted the group's approach to nature without being an intimate member of its circle. Both were influenced by pictures at the Academy and by Ruskin's fourth volume of *Modern Painters* (1856). Its theme, 'Of Mountain Beauty', inspired them to travel, independently, to the Swiss Alps.[61] Inchbold spent time there with Ruskin and painted a picture that had a key impact on Brett: *Jungfrau, from the Wengern Alps* (1856; unlocated). They met in the mountains that summer of 1856. Brett had first exhibited in the Academy in the spring, showing three portraits, but the following year submitted a domestic genre picture and his watershed *Glacier of Rosenlaui* (1856; Tate).[62] In 1858 he showed his *Stone Breaker* (fig.16) and in 1859 submitted only *Val d'Aosta*.[63]

The Nonconformist Brett was a fervent Congregationalist, and a deep religious element is present in his *Glacier* and *Val d'Aosta* of two years later. *Val d'Aosta* is conventional in format, although it is higher than it is wide, but it delivers a satisfyingly comprehensive view of carefully depicted deep space. Brett painted it after exhibiting with the Pre-Raphaelites at the group show of May 1857 at Russell Place, Fitzroy Square, and completing his *Stone Breaker* the following year. The latter work, replete with Christian and social meaning and now too fragile to travel, was his first attempt at a broad sunlit landscape in oils and, as such, a warm-up for *Val d'Aosta*. Unlike the earlier *Glacier*, this spectacular view of the Aosta Valley abounds with human and animal presence, from the slumbering girl with a prominent cross on her chest on the rocks in the foreground to the goat framed by a boulder and the various houses and tilled fields that drift among the ridges of the landscape into the distance. The girl has been interpreted as representing the human soul awaiting religious guidance, while

the mountains, through the writings of the influential minister and poet Thomas Toke Lynch, stand for life's challenges.[64] At this time Brett was romantically involved with the equally religious Christina Rossetti, who, like Lynch, became known for her hymns. He began a delicate but ultimately unfinished portrait of her (no.18), a casualty of their failed relationship.

Ruskin's comment on Brett's *Stone Breaker* was an injunction: 'If he can paint so lovely a distance from the Surrey downs and railway traversed vales, what would he not make of the chestnut groves of the Val d'Aosta!'[65] Whether spurred on by this or not, Brett spent five months working in Italy, visiting Ruskin once in Turin. Christopher Newall has located the viewpoint as from the slope of Mont Torretta and painted on the spot.[66] The blue of the sky was worked with ultramarine blended with emerald and there is a remarkable range of hues in the middle section.[67] JR

Fig.16 John Brett, *The Stone Breaker* 1857–8, oil on canvas, 51.3 x 68.5. National Museums Liverpool, Walker Art Gallery

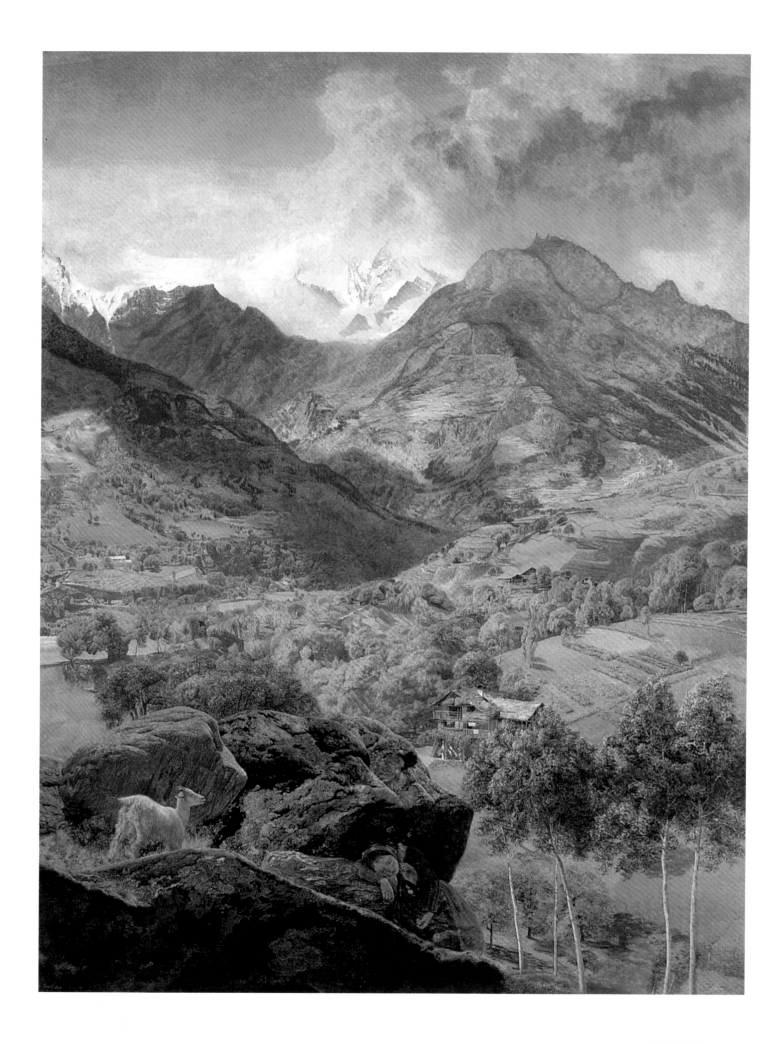

JOHN BRETT 1831–1902
The Hedger 1859–60

Oil on canvas 90 x 70
Private collection

Brett worked on *The Hedger* from April 1859 at his family home, Lynchfield House, Detling, near Maidstone in Kent, and exhibited it in 1860 along with lines from Coventry Patmore's *Angel in the House*: 'In dim recesses hyacinths drooped, / And breaths of primrose lit the air.'[68] Brett had painted Emily Patmore in watercolour in 1856 (Ashmolean), and although friendly with the poet, Brett had an antipathy for his behaviour. But Brett adored his wife, and the poem she had inspired.[69]

The picture represents a return to the subject matter of his *Stone Breaker* (fig.16), concurrent with other Pre-Raphaelite images of labour and morality by Brown (no.95) and Henry Wallis (no.103), or Millais's earlier image of a woodman, also related to one of Patmore's poems (no.66). It shows 'the common, highly skilled, rural occupation of hedge-laying, in which saplings are slashed and woven into the hedge, where they will continue to grow, thus making a very strong and thick hedge'.[70] The child holding a baby in the background evokes works by Arthur Hughes and George Elgar Hicks's *Sinews of Old England* (1857; Yale Center for British Art) with their emphatic association of labour with

family cohesion and duty. The hedger is rosy cheeked like the boy in Brett's *Stone Breaker*, but this is not a portrait of exhaustion and exasperation.

Brett still had sold neither the *Glacier*, nor *Val d'Aosta* (no.77), but had higher aspirations for this picture, writing in his diary:

> I hope it will be more felt than the Aosta: it is much more strongly painted, and is deeper in color: not half so delicate and refined perhaps, but I can't think how I ever got the Aosta done. I have worked at the hedger harder I think but there is nothing in it compared with the other nor anything like the difficulties.[71]

In choosing a more familiar subject, with an appealingly jewel-toned palette and a quotation from a popular poem, Brett was seeking a more amenable image of duty and toil. The important collector Benjamin Windus purchased *The Hedger* in 1863, after it had been shown at the London International Exhibition of 1862.

JR

ROSA BRETT 1829–82

The Artist's Garden 1859

Oil on board 15.6 x 14.2
Private collection

ROSA BRETT

Mouse in the Undergrowth 1859

Oil on canvas 20.5 x 15.5
Private collection

Rosa, the elder sister of John, was the only female among the five siblings in the Brett family. During the early 1850s she assisted her brother with his work in return for art tuition. However, while John Brett went on to establish a career as a painter, any ambition Rosa harboured for her art was kept in check by domestic and familial responsibilities as well as by bouts of ill health. The oils and watercolours she produced during her life are distinguished by what her brother termed a 'close child-like study of nature',[72] and feature humble plants and creatures, which she studied at close range with a Ruskinian attention to detail in the Kentish countryside where she lived with her parents. Although her meticulous rendition of ordinary objects accords with the Pre-Raphaelite interest in the familiar aspects of the natural world, it also conformed to the modest expectations of what a woman might achieve in the visual arts at a time when the campaign for female art education was beginning to gather momentum.

Brett's small, hallucinatory *Artist's Garden* was painted around the time when she first started exhibiting at the Royal Academy under the name Rosarius, an identity she adopted to prevent being confused with her brother and to avoid being discriminated against as a female artist. The picture is unfinished, as seen in the bare patch of priming in the foreground, and is an intensely observed depiction of a horse-chestnut tree in bloom in the garden of the Brett family home, Lynchfield House, at Detling near Maidstone.[73] Rather than locating the tree in the context of the garden, with surrounding atmospheric elements, the painting is focused on the variegated pattern of leaves that fill the uppermost part of

the picture and, like an intricately worked embroidery, blend with the shrubs in the background and the lilac bush overlapping the tree on the left. In the lower register of the composition areas of shaded and illuminated grass vie for the viewer's attention. While the cropping of the image and lack of modulation between forms invites comparison with the exactitude of photography, the type of peephole vision demonstrated in the work may have been prompted by John Brett's recommendation that his sister use a card with a small hole in the centre as a viewing device to establish the absolute identity of each individual hue when painting, a method upheld by Ruskin at the Working Men's College in London.[74]

In the year she painted *The Artist's Garden*, 1859, Brett also produced a picture of roughly the same size of a field mouse in its natural habitat, dwarfed, yet protected, by dry autumn leaves and ivy and enclosed by thorns, poppy heads and grasses.[75] As a close-up study of a creature frozen in an untamed as opposed to a domesticated setting, the picture bears comparison with J.D. Llewelyn's photograph of a rabbit illuminated against vegetation (no.64). However, whereas the latter appears to have been produced with the aid of a stuffed animal, Brett was known to have worked from living creatures and in 1867 made her fourth appearance at the RA, now under her own name, with a painting entitled *The Field-Mice at Home*, which, according to the *Athenaeum*, was 'a perfect gem in its way, and although comprising nothing more pretending than the little creatures and grass, has plenty of subject'.[76] AS

79

80

81
JOHN EVERETT MILLAIS 1829–96
The Blind Girl 1854–6

Oil on canvas 80.8 x 53.4
Birmingham Museums and Art Gallery. Presented by the Rt Hon William Kendrick, 1892

Millais showed *The Blind Girl* and *Autumn Leaves* (no.117) at the Royal Academy in 1856, signalling a permanent shift in his approach to landscape. He continued the poetic conflation of women and nature heralded in *Ophelia* (no.69), but eschewed the magnified detail of his early Pre-Raphaelite works in favour of a broader approach, looser brushwork, more subtle modulations of colour, and varied weather and times of day. The one constant in Millais's art of this period, which peaked with the pioneering Aestheticist works, *Spring* (1856–9; Lady Lever Art Gallery) and *The Vale of Rest* (1858; Tate), was that, in transforming his style of painting landscape elements, he still worked *en plein air*. The method was modified on the ground and not in the studio. This would hold true in his landscape work throughout his career (no.162).

The Blind Girl is characteristic of Pre-Raphaelitism in its carefully observed landscape backdrop, subtle religious symbolism, modern-life subject matter and emphasis on specificity of place and figures. The focus on illuminating social ills is characteristic of the group's art of the mid-1850s.[77] In this picture Millais brought out a quietude, a sense of solemnity of purpose evidenced in his themes and on the faces of his subjects, that is particular to his art. This is consistent with his other major pictures of the year: *Autumn Leaves* with its twilight meditation on nostalgia and the passage of time, its four young female sitters either engaged in their labour or absorbed in thought; *L'Enfant du Régiment* (1854–5; Yale Center for British Art) with its injured girl asleep on a medieval tomb in a clear connection with the composition and theme of *Ophelia*; and *Peace Concluded, 1856* (see pp.246–7) with its tempered demonstration of a family's relief at the cessation of hostilities in the Crimean War. Millais's figures turn their faces outwards, often seeming to establish eye contact with an implied viewer, and elicit sympathy, concern or emotion without action or bombast. This, along with a deeper range of coloration and a less mannered approach to composition, as against the perspectival dynamics of *Isabella* (no.26) or the flattened frontality of *Christ in the House of His Parents* (no.85), signified that his art, and Pre-Raphaelitism itself, had reached maturity.

In this respect, *The Blind Girl* is one of his most effective compositions. It was painted at Winchelsea, near Rye in Sussex, in the late summer and autumn of 1854, and finished at Perth during the following two years. The view, hardly changed today, is from the field by the Royal Military Canal east of the town, looking up towards the early-fourteenth-century Strand Gate in the centre, the ivy-capped eastern windows of the church of St Thomas the Martyr to the left, inside which he painted *L'Enfant*, and the great bulk of Barrack Square to the right. The sitters were Matilda Proudfoot and Isabella Nicol, the two Perth working-class girls in *Autumn Leaves*.

It is mid-day and a high blinding sun above has just emerged from the stormy cloudbank, which moves off to the west. The sightless girl lifts her face to it, eyes barely open – flecks of blue just visible beneath the soft, blond, individually painted lashes. The double rainbow, symbol of God's covenant with humankind, intersects the horizon above each of their heads. Behind them on the far bank of the glassy stream are six crows or rooks, a donkey on the left, sheep on the right (each dyed with a red '8'), a white horse in the centre, a gully with some cows and then the Strand Hill leading up to Winchelsea, brilliantly lit against a gunmetal grey sky. The tortoiseshell butterfly on the blind girl's shawl is a touch of *trompe-l'oeil* to fool the eye of the viewer.[78] 'I did not attach any poetry quotation to the "Blind Girl" but sent it with the above title', Millais wrote to his mother-in-law, Euphemia Gray.[79] It did not need it.

In its negation of the densely detailed and laboured surfaces of early Pre-Raphaelite pictures, with their pure white priming and carefully laid glazes, this picture represents a transitional phase in Millais's art. The weave of the canvas is evident beneath thin washes of yellows and greens in the middle ground. There are precisely observed elements in the grassy bank besides the figures, but they are rendered with flicks of paint and short brushstrokes – Millais was developing a more elegant painting style without sacrificing effective communication of natural truths. In subsequent works Millais's style became even freer, the landscape backgrounds broader, the compositions looser. In place of the stable atmospheric conditions of early Pre-Raphaelite landscapes, weather becomes changeable and emblematic of the vagaries of human existence, in explorations of emotionality that mark the later phases of the art of the Brotherhood. JR

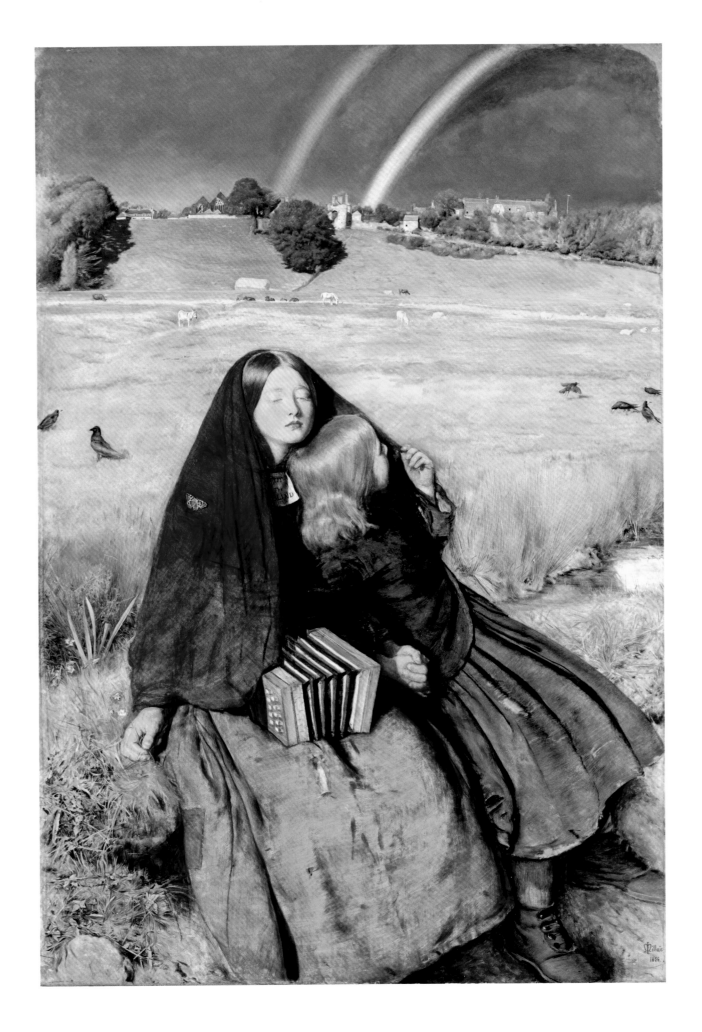

WILLIAM DYCE 1806–64

Pegwell Bay, Kent – a Recollection of October 5th, 1858 1858–60

Oil on canvas 63.5 x 88.9
Tate. Purchased 1894

While at work on the series of fresco paintings for the Houses of Parliament that would consume the last two decades of his life, Dyce quite separately evolved a style far removed from the Nazarene-inflected history painting represented by *King Joash Shooting 'the Arrow of Deliverance'* (no.4). This was largely due to the stylistic example of the Pre-Raphaelites. Dyce's work had given the young artists of the Brotherhood a starting point for their own transformation of historical imagery, but the landscapes of the Pre-Raphaelites in turn had a deep effect on Dyce's imagery of nature. *Pegwell Bay* is his most remarkable adoption of this aesthetic, one that he would also employ in a moving series of small religious pictures in the late 1850s (no.108).

Dyce commenced this work on a family vacation to Ramsgate and included his family in a frieze across the foreground: his son and wife bracket his two sisters and they are painted with the delicacy of miniature portraits.[80] They are bundled with scarves and layers to ward off the autumnal evening chill. Dyce depicted himself with painting materials in the right background. The foreground is full of details such as mollusc shells and distinctive skate egg casings, marking the extent of the tide. The view is essentially west-southwest, affording an unexpected image of sunset on the east coast, and putting the time at early evening, around half past five. Donati's comet with its rightward arching tail is clearly visible in the western sky in the upper centre of the picture, only five days before it would pass closest to the earth and sit directly between the planet and the sun.[81]

Dyce's larger theme is a meditation on temporality.[82] Geological time is denoted in the chalk cliffs of the middle ground, pitted at bottom with caves but anchored solidly to the earth. Astrological time is inherent in the trailing comet above, and the diurnal rhythm implied by the sunset. Human time is evidenced in the various ages and occupations of the people that pepper the scene, some engaged in seemingly timeless seaside labours, and others in the fashionable leisure activities of the middle class. Dyce gave special attention to his wife's garments, noting the red glare on her back from the sunset and her striped blue and white shawl, horizontally striated like the chalk cliffs in the background.

Donati's was the first comet to be photographed, only eight days earlier than the day Dyce painted it, by William Usherwood in

Dorking, a print sadly lost. Dyce's picture was purportedly based on a photograph, also unlocated, and it bears a generally monochromatic tonality related to that medium. However, there is a more richly hued watercolour preliminary study (1857; Aberdeen Art Gallery & Museums) with a view slightly to the east around the bay.[83] Such preliminary painted studies were not foreign to Pre-Raphaelite painting – Hunt made one for *Valentine* (no.34) and Brown made some for *Work* (no.95). The difference is that Dyce remained true to his academic training and techniques, producing the final picture in the studio, instead of on location as per Pre-Raphaelite practice. It is a picture that is nonetheless Pre-Raphaelite in its intensity of description, insistence on the actual facts of the location and temporal specificity, despite a more muted colour scheme than other such works of the late 1850s. This, as in Millais's portrait of Ruskin (no.72), is reflective of the particular location the artist has chosen. Nonetheless, the treatment of clouds and glimmers of fading pink light in the far left background may owe something to the twilight effects Millais had explored in *Autumn Leaves* (no.117) and *The Vale of Rest* (1858, Tate).

Pegwell Bay may appear at first glance to be a seaside view bordering on the picturesque. Yet it is actually a calculated work based on a rigid geometric armature, separated by internal elements into ten equal and parallel vertical strips, and anchored by a central vertical that runs down from the comet above, through a figure in the centre in contrapposto and holding a staff over his left shoulder, and down to the centre of the picture's lower edge. There is a science to Dyce's conception that orders the scene.

As Rebecca Bedell has pointed out, the two years over which Dyce painted the work saw the publication of Darwin's *On the Origin of Species* (1859) and a consequently virulent debate over its contents and the repercussions for faith.[84] The image of the artist staring at the wondrous comet in the right background would seem to militate against reading the studies of the amateur naturalists in the foreground as holding the key to understanding life on earth – microscopic Pre-Raphaelitism giving way to macroscopic Romanticism in the form of a hurtling mass of rock, ice and gas screaming its slow transit across what was, for the deeply religious Dyce, unquestionably God's heaven. JR

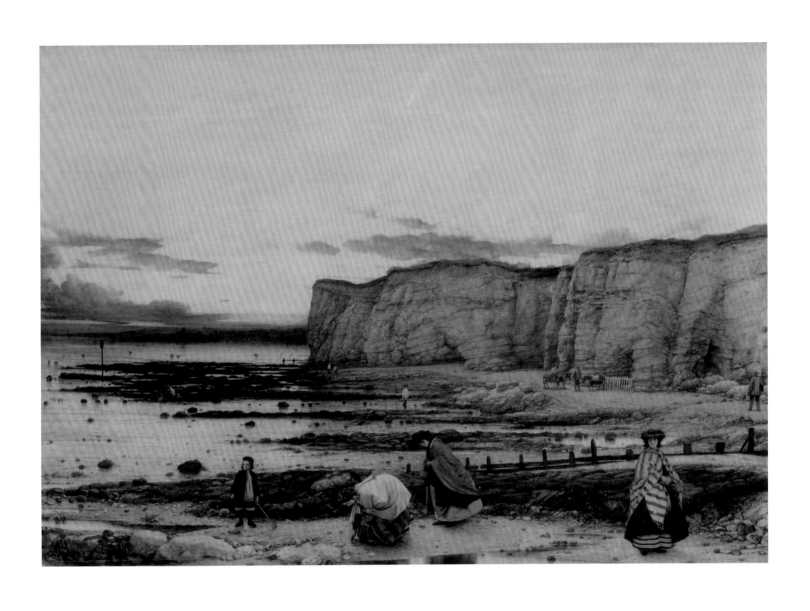

ALEXANDER MUNRO 1825–71
Young Romilly c.1863

Marble 97 x 35 x 60
Scottish National Gallery, Edinburgh. Purchased 1993

This group represents the pinnacle of the treatment of nature in Pre-Raphaelite sculpture. It conformed to conventional subject matter in the movement, based on William Wordsworth's 'The Force of Prayer' (1807) about the foundation of Bolton Priory, a site Inchbold had also depicted (no.76):[85]

> Young Romilly through Barden woods
> Is ranging high and low;
> And holds a greyhound in a leash,
> To let slip upon buck or doe.

William Egremont, known as Romilly, accompanied by his spirited hound, would fall and perish in the Strid, a deep cleft in the rocks filled with the waters of the River Wharfe. Little sense of impending peril is felt in this image, however, where the protagonists pose against a convincingly stiff wind, the dog rising into the face of it:

> He sprang in glee,–for what cared he
> That the river was strong, and the rocks were steep?–
> But the greyhound in the leash hung back,
> And checked him in his leap.

Momentum hampered, he failed the gap and drowned in 'the arms of Wharf'. His mother raised Bolton Priory nearby in his memory.

Munro's sculpture attempted something uncommon even in Pre-Raphaelite painted nature: weather. Working outdoors, the artists naturally preferred stable conditions. But the boldly conceived brow of Romilly, with the elevated stance of the dog, and the shine and blinding white of the marble surface, conveyed a sense of both marked airflow and suffusing sunlight. Added to that is the remarkable treatment of ferns in marble, employed as a strut for the elevated torso of the dog, but filling the lower half of the composition along with the carefully observed foliage and rocks that form the base. Detail notwithstanding, ultimately the key references in this dynamic work are post-Raphaelite and Baroque: Gianlorenzo Bernini's *David* (1623–4) for the striding and twisting pose of Romilly, and Bernini's Cerberus in *Pluto and Persephone* (1621–2) for the dog, both in the Borghese Collection in Rome, which Munro probably visited on his honeymoon in late 1861.

JR

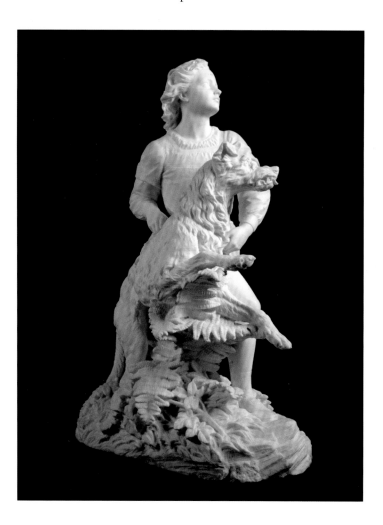

DANIEL ALEXANDER WILLIAMSON 1823–1903

Spring, Arnside Knot and Coniston Range of Hills from Warton Crag c.1863

Oil on canvas 28 x 41
National Museums Liverpool, Walker Art Gallery

Always a marginal figure in the Victorian art world, Daniel Alexander Williamson was born in Liverpool but moved to London to further his artistic career, exhibiting portraits at the Royal Academy between 1853 and 1858. He left London and went back to the north in 1861, where he turned to landscape painting. He specialised in precisely rendered, small-scale works representing the moorlands of north-west Lancashire near his home in Carnforth. *Spring* illustrates the undulating terrain just inland from Morecambe Bay, with the distinctive outline of Arnside Knot occupying the centre of the horizon. The lighter, purple area indicates the effects of quarrying, a man-made gash in an otherwise natural landscape. In 1864 Williamson moved to Broughton-in-Furness, bringing him closer to the Lake District, the region so revered by John Ruskin. In the present work the Coniston hills, deep in the Lake District, can be glimpsed in the distance to the far right, capped with a bursting storm cloud. Williamson exhibited mainly in Liverpool and his work appealed to collectors in the region such as James Smith of Blundellsands, north of the city, who owned *Spring*.

The influence of Ruskin's *Modern Painters* and of earlier Pre-Raphaelite landscape painting is clearly visible in Williamson's style in *Spring*, which places great emphasis on local colour and precision of detail. A rabbit, frozen in the foreground, is carefully depicted with minute strokes of the brush. There is a parallel with the effects achieved by photographers such as Roger Fenton and Robert Howlett in the 1850s, whose work combined precision of detail with depth of field (see no.65).[86] However, the strikingly chromatic colour scheme of *Spring* is highly original. Williamson offers a less analytical approach to geology, botany and meteorology than did Ruskin's most dedicated followers, John Brett and John William Inchbold. The heightened colour scheme emphasises the vividness of the artist's experience of nature but also moves towards an abstract patterning that was a hallmark of Aestheticist painting in the 1860s. TB

5. SALVATION

The young artists who came together to form the PRB in 1848 were well aware that they had been born into a culture that lacked a strong tradition of religious art. The Protestant Reformation of the sixteenth century had wiped out the rich culture of images that had been central to the Catholic faith of the Middle Ages and that still flourished on the continent. A new interest in the question of what should comprise religious art in modern Britain had been awakened by the highly self-conscious debates concerning the future identity of the British school, and of history painting in particular, which developed in the 1820s and 1830s in the aftermath of Waterloo. The challenge for Protestant artists lay in how to revive religious art without falling back on idealising Catholic conventions of representation. One innovative response was to travel in the spirit of an ethnographer to the places where Jesus had lived with the aim of painting authentic locations to be used in the depiction of religious scenes. Such was the strategy adopted by the Scottish painters David Roberts and David Wilkie who visited Jerusalem in 1838–9 and 1841 respectively. But Roberts only painted landscapes, and Wilkie died before he could fulfil his ambition. In the intervening years between the death of Wilkie in 1841 and the launch of the PRB in 1848, a dynamic public debate had opened up in Britain concerning the different forms of religious observance available at the time. The established Anglican Church was unsettled by competing Evangelical, Tractarian (or ritualistic High Church) and Broad Church (liberal) factions, and challenged from outside by the rise of the Nonconformist and revived Catholic movements. The most heated debates focused not so much on theological issues as on the material culture and paraphernalia of worship, for example architectural style, music, the use of vestments and the emotional and symbolic content of services. It was largely in response to these interests that the Pre-Raphaelites set out to make religious subjects an important part of their iconography. Pre-Raphaelite paintings were not intended for ecclesiastical environments. Even an overtly iconic image such as Hunt's *Light of the World* (no.92) was intended for public exhibition and private contemplation in the patron's home. The fact that it ended up in a side chapel in Keble College, Oxford, was not particularly welcomed by the artist, but the image reached a global audience in engraved form.[1]

Concomitant with a widespread fascination for the material forms of Christian worship, the 1840s also witnessed a growing public awareness of a history of art that extended back beyond the Renaissance to the Middle Ages. In the summer of 1848, not long before the launch of the PRB, the British Institution in London staged an exhibition of old-master painting that included examples of early Italian and Flemish art and the period *Wilton Diptych* (c.1395–9) now in the National Gallery. Meanwhile a growing interest in pre-Renaissance art was being stimulated by publications such as Lord Lindsay's *Sketches of the History of Christian Art* of 1847 and Anna Jameson's *Sacred and Religious Art* of 1848. The former was written with the aim of inspiring Protestant artists to emphasise moral subjects as a key agent of spiritual regeneration in Britain. Within the National Gallery the study and appreciation of early devotional art was encouraged by the acquisition of works such as the two side panels of an altarpiece, then attributed to Taddeo Gaddi, one of the first Italian 'Primitives' to enter the collection in 1848 (no.27). Under the leadership of Charles Eastlake (who served as Keeper from 1843 and Director from 1855) a dedicated policy of collecting early works developed at the National Gallery, culminating in the acquisition in 1857 of twenty-two early Italian pictures from the Lombardi-Baldi collection.[2] Such purchases underline the extent to which apparently crude images were now being offered to the public as works of historical, psychological and even aesthetic interest.

Confident that the public sphere was now ready for a new kind of 'pre-Raphaelite' art, Hunt, Millais and Rossetti set out to revive the forgotten typological and iconographic language of Christian painting, together with its didactic qualities, to create a vital visual idiom for secular spaces as opposed to a church context. Theirs was a self-consciously artistic strategy: they set out to embrace the symmetrical formats and symbol-laden codes of religious art forms that had been neglected since the Renaissance and to create meaningful subjects, because they knew their audience would understand the relevance of the radical new language they were presenting. Thus in paintings such as Rossetti's *Girlhood of Mary Virgin* and Collins's *Convent Thoughts* (nos.24, 88), paint is applied in small delicate strokes in deference to each iconographic detail, an approach aimed at encouraging the viewer to decode a picture's overall spiritual meaning bit-by-bit rather than suggesting the momentary reality of a particular event through the vivid, theatrical style of much admired High Renaissance and Mannerist painters like Veronese and Tintoretto.

Given that theirs was primarily a stylistic revolution, the early work of the Brotherhood was nevertheless perceived by some critics as disclosing a covert theological message: hence the erroneous assumption that they were acting as agents of a revived Catholicism within Britain. The accusations of wilful naivety and

deformity that surrounded the reception of the group's early exhibits were lent greater significance by the artists' preoccupation with unusual forms of symbol and sacrament, which gave rise to the suspicion that they harboured the invidious intention of promoting 'popery' under the guise of art. Since their first works coincided with intense anti-Catholic fervour following the re-establishment of dioceses in Britain by Pope Pius IX in 1850, the combination of ritualism and archaism was certainly suspect, as evidenced by Ruskin's initial reservations over the Brotherhood's intentions.[3] On the other hand, the material conviction that underpinned their enterprise, the concern to invest their subjects with a sense of historical validity, marked a continuation of the Protestant endeavour to promote an empirical, archaeological approach to religious subjects first articulated by Wilkie and the orientalists. The claim to present religious truth by insisting on factual data was to become especially significant in the context of Victorian debates about evolution and creation generated by the new natural history of the earth and its species, as seen in Hunt's determined mission to reconcile material fact with spiritual meaning in orientalist projects such as *The Scapegoat* or his novel conception of the young Jesus as a precocious rabbi in *The Finding of the Saviour in the Temple* (nos.101–2).

A separate question is the personal religious affiliations of the Pre-Raphaelites. Despite their interest in the symbolism and ritualism of early Catholic art, none of the artists was a practising Catholic with the exception of James Collinson, who became rather estranged from the Brotherhood following his resignation in 1850. After a brief flirtation with Anglo-Catholicism (probably encouraged by his association with the High Church Collins and Thomas Combe) Millais positioned himself as a middle-of-the-road Anglican, maintaining regular church observance while being open to new critical interpretations of the Bible (see no.113). Rossetti was more of an agnostic, while Brown was sympathetic to the Broad Church ideas of the Christian Socialist F.D. Maurice who sought to apply Christian principles to social problems of the time. None of these artists was especially interested in divulging the theological messages embedded in the subjects they represented, but rather approached the Bible as a source of human drama as well as for its literary and poetic meaning, as seen in Brown's focus on the psychodynamics of plot in *The Coat of Many Colours* and *Jesus Washing Peter's Feet* (nos.93, 111). Hunt was the most committed Christian of the group, an idiosyncratic religious intellectual who embraced evangelical, High Church and Broad Church ideas as part of his mission to bring science into harmony with scripture in order to uphold its revelatory and prophetic significance.

The representational traditions of Christian art could lend themselves, even in the case of atheists or agnostics such as Rossetti, to social and political ends. Rossetti's ironic adaptation of a traditional *noli me tangere* scene in *Found* (no.97) to convey the shame felt by a prostitute on being discovered by her former sweetheart, and Brown's novel updating of an early Renaissance Madonna and Child image to communicate the strength of a family bond in *'Take your Son, Sir'* and *The Last of England* (nos.90, 94) are just two instances of how Pre-Raphaelite artists sought to represent the lives of ordinary individuals in a distinct Pre-Raphaelite way to dramatise social and ethical themes such as prostitution and emigration.

In adopting the iconography of religious art, the Pre-Raphaelites sought to invest their genre pictures with a moral seriousness and to give them a particular edge by confronting provocative subjects from modern life. The juxtaposition of religious paintings with images of contemporary life in this section shows the extent to which the moral language traditionally associated with religion permeated all aspects of Victorian society, influencing artists' strategies of representation and the interpretative habits of their audience. Pre-Raphaelite pictures of the social scene tend to take the form of modern parables, being premised on an evangelical awareness of the fallen condition of man and a need for salvation, together with an emphasis on duty and self-help. It was this awareness that emboldened artists to tackle controversial subjects, as Hunt did with *The Awakening Conscience* (no.98). By pairing this picture with his vivid depiction of Christ as the 'Light of the World' (no.92), he made the problematic topic of the double standard (the idea that there should be different codes of sexual behaviour for men and women) a gripping one for his audience by illuminating the psychology of a kept woman poised on the brink of redemption.[4] Even politically motivated pictures such as Brown's *Work* and Wallis's *Stonebreaker* (nos.95, 103), which set out to question the dominant attitudes and conditions that devalued the poor in modern society, depended on the kind of religious values that came to view labour as sacred and invited respect for different types of work within the existing system – hence the use of biblical quotations inscribed on the slip of the frame of *Work* to reinforce its overall message.[5] These include: 'Neither did we eat any man's bread for nought; but wrought with labour and travail night and day' (2 Thessalonians 3: 8) and 'In the sweat of thy face shalt thou eat bread' (Genesis 3: 19).

In representing the theme of work, Christ thus came to typify the ideal of the hero-worker proposed by Thomas Carlyle in his lectures *On Heroes, Hero-Worship and the Heroic in History*.[6] In Brown's Carlylean concept of Christ in *Jesus Washing Peter's Feet* the emphasis is more on the Saviour's humility and humanity than his divine status. Likewise in Hunt's *Shadow of Death* he is projected as a democratic figure and a teacher who communicates across divisions of class and race in upholding the dignity and ethic of work as a cure to social unrest and poverty. Just as the Pre-Raphaelites had appropriated early Christian iconography to reform art at the onset of the movement, they now looked to Jesus Christ as a model for the making of dynamically relevant 'history' paintings. AS

JOHN EVERETT MILLAIS 1829–96

Christ in the House of His Parents (The Carpenter's Shop) 1849–50

Oil on canvas 86.4 x 139.7
Tate. Purchased with assistance from the Art Fund and various subscribers 1921

The most controversial picture in the early years of the Brotherhood, this was Millais's second major Pre-Raphaelite painting and his first biblical work at the Academy.[7] Along with Rossetti's *Girlhood of Mary Virgin* (no.24) of the previous year, it set the tone for the experiments that the members would pursue in depicting the Holy Family. Millais's combination of a symbolic imagined scene from the life of Christ, one not dictated by scripture, with realistic figures and environment elicited the opprobrium of many contemporary critics. And it presented an approach to religious subjects that was very different to Rossetti's imaginatively symbolic *Ecce Ancilla Domini!* (no.87), shown at the National Institution that same spring, or Hunt's historical tableau of ancient Britain in his *Missionary* (no.86), also seen at the Academy of 1850.

The original exhibited title in 1850 consisted of lines from the Book of Zechariah (13: 6): 'And one shall say unto him, What are these wounds in thine hands? Then he shall answer, Those with which I was wounded in the house of my friends.' The apparent disconnection between the painting of Jesus and biblical lines that refer to a false prophet can be explained as referring to a text by Edward Pusey, a leader of the Oxford movement.[8] Subsequently, it has been known by the two more prosaic titles above.

The young Jesus has cut his left palm on a nail protruding from a door that Joseph and his assistant across the room have been building in the shop. Mary has come over to comfort her wounded son, but seeing her excessive concern, Jesus offers a reassuring kiss to her left cheek. Mary's husband Joseph bends back Jesus's left hand to inspect the wound, moving it into a gesture of benediction and causing a drop of blood to fall on the boy's left foot. Behind, Mary's mother Anne reaches for pliers to remove the offending nail, and on the right John the Baptist comes towards his cousin bearing a bowl of water as a salve. Millais has evened out the composition in this work in comparison to that in *Isabella* (no.26), employing the broad side of the carpenter's work table as the central form and arranging the six figures symmetrically around it. The interior of the shop is expanded through views into the bright landscape on the left, filled with curious sheep painted from heads Millais bought from a butcher, and to the right down a storage hall with foliage seen through a lunette window at the end. The blood from his wound prefigures the injuries Jesus will endure at his Crucifixion, and further symbols of the Passion fill the background wall including the dove of the Holy Spirit, a ladder and carpentry tools referring to the building of crosses not doors. Millais used some of the same models who had sat for *Isabella* and spent a few nights in a carpenter's shop in Oxford Street to develop the picture's details.

For contemporary critics there were two fatal issues with the picture. From the standpoint of Charles Dickens, Millais had gone too far in pursuing what the novelist perceived to be an abject realism in depicting the members of the Holy Family. For other writers the issue was the ritualistic nature of the image that drew it perilously close to practices associated with Roman Catholic worship, an interpretation followed by some modern scholars.[9]

Christ in the House of His Parents challenged traditional religious imagery in its format and made vivid use of prefigurative (or 'typological') symbolism, whereby elements in scenes of Christ's youth anticipate his eventual sacrifice. By comparison, John Rogers Herbert's *Our Saviour, Subject to His Parents at Nazareth* (no.6) is an impressive Academy picture that preserves the ideal softly shaded faces and forms, a clear one-point perspective and atmospheric recession to the hazily rendered hills in the distance. Millais's unstintingly honest depiction of common workers assuming the roles of Holy Family members was a departure that incensed Dickens. In the middle of serialising *David Copperfield*, the novelist satirised the painting in *Household Words*, the journal he edited, in an essay entitled 'Old Lamps for New Ones', an ironic inversion of the tale of Aladdin's lamp that mocked the Pre-Raphaelites for their revival of early Italian painting. It depicted, he wrote,

> a hideous, wry-necked, blubbering, red-headed boy, in a bed-gown; who appears to have received a poke in the hand, from the stick of another boy with whom he has been playing in an adjacent gutter, and to be holding it up for the contemplation of a kneeling woman, so horrible in her ugliness, that (supposing it were possible for any human creature to exist for a moment with that dislocated throat) she would stand out from the rest of the company as a Monster, in the vilest cabaret in France, or the lowest ginshop in England … Wherever it is possible to express ugliness of feature, limb, or attitude, you have it expressed. Such men as the carpenters might be undressed in any hospital where dirty drunkards, in a high state of varicose veins, are received. Their very toes have walked out of St Giles's.[10]

Dickens seems to have been more offended by Millais's apparent pictorial blasphemy, presenting the Holy Family as real working-class people instead of Raphaelite ideal beings, than by any fear of a Catholic resurgence.[11]

Millais, open to a range of ecclesiastical practices, sought a truth beyond sectarianism, in a style that combined early Italian coloration and Netherlandish acuity. The dealer Henry Farrer sold it to the committed Leeds Nonconformist Thomas Plint, who saw no High Church leanings in the painting but relished the idea of the saviour as a working man.[12] Plint became a great supporter of the Pre-Raphaelites and commissioned Brown's *Work* (no.95) before his death in 1861 at the age of thirty-eight. The opulent Renaissance-style frame with its broken pediment is more associated with the Aesthetic movement and probably dates to the 1880s.[13] JR

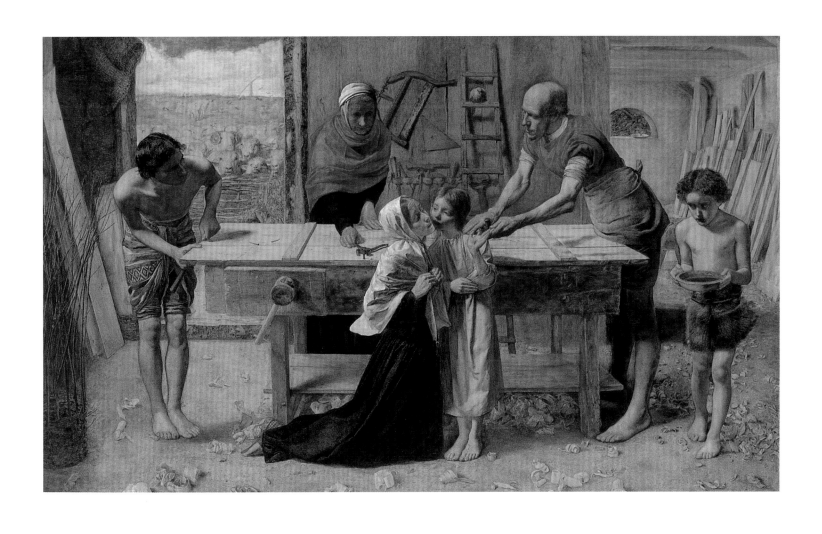

WILLIAM HOLMAN HUNT 1827–1910

A Converted British Family Sheltering a Christian Missionary from the Persecution of the Druids 1849–50

Oil on canvas 111 x 141
The Ashmolean Museum, Oxford. Bequeathed by Thomas Combe, 1893

Hunt's first major painting on a religious theme was exhibited at the RA in 1850 where it hung as a pendant to Millais's *Christ in the House of His Parents* (no.85).[14] The two works were compared by critics and are indeed strikingly similar in terms of their compressed treatment of space, high horizon and the layered symbolism that underscores the sacramental significance of both compositions – the last likely to have been encouraged by the High Church Thomas Combe, the first owner of no.86. Although it was the ritualistic overtones of the two works that made them controversial, especially in light of the Tractarian disputes and anti-Catholic sentiments of the time, Hunt's picture was in no way nearly as inflammatory as Millais's, the main difference being that his was an invented historical scene rather than a scriptural subject. As Hunt subsequently explained in a letter to Combe, his aim was to represent an event that might have occurred historically and that was on a symbolic level a fulfilment of the texts from St John 16: 2 and Romans 3: 15 inscribed on the frame.[15] Hunt was also aware that the advent of Christianity in England was traditionally associated with the arrival in AD 597 of St Augustine who had been dispatched by the pope in Rome. By explicitly setting his scene in the first century AD, Hunt sought to bring the story of the faith in Britain closer to the original Eastern Church (he himself described the missionary as 'Israelitist'), thereby demoting the role of the Roman Church in the history of Christianity in Britain.

The painting portrays an act of mercy in the context of Druidic persecution. In the left distance an Archdruid exhorts his pagan followers to seize a missionary at the right, who appears a conspicuous target in his brilliant red chasuble. Meanwhile the victim's undetected companion catches his breath in the sanctuary of a hut belonging to a group described by Hunt as 'an aboriginal family' who have been civilised by accepting the divine religion of the missionaries. Comprised of birchwood and stone interwoven with straw and vines, the converts' humble dwelling merges organically with the environment in contrast to the stark monoliths of the Druids, which stand out rather intrusively in the landscape. Hidden from the mob but exposed to the viewer, the converts tend the missionary as they anxiously listen out for approaching footsteps. The drama and tension of the moment are accentuated by the elision of foreground and distance as well as by the jarring dazzling colours and the jumble of limbs throughout the composition. There are glints of fear in the eyes of the protagonists while their taut awkward bodies and bare flesh betray a sense of vulnerability that does not however diminish their heroism. In keeping with Pre-Raphaelite practice, Hunt took great care in selecting the right models for his cast, from the red-haired Elizabeth Siddall, who posed for the woman holding a bowl, to the gypsies of 'proper brown colour'[16] for the Druids and the guardsmen he hired for the two stocky men guarding the door.[17]

Although the details of the painting would have been justified for their historical accuracy, they also demand to be read in symbolic terms. Thus the missionary and older woman painted in Marian blue combine to form a *pietà*, symbolically positioned in front of a crude altar (adapted from a Druidic standing stone) with a red cross illuminated by a lamp flickering beneath it. The converts surrounding this group hold symbols of the Passion, a thorn branch, sponge and grapes – objects that assume Eucharistic significance in relation to the altar and the invitation to view the missionary both as a type of Christ and as a consecrated priest. The sacrament of baptism is emphasised by the bowl of water in the left foreground and the river that forms an emblematic threshold through which one enters the picture into what is implied to be a sacred space. Such overt typological symbolism is balanced by a more subtle ambiguous Eyckian kind: for example, the net at the entrance of the hut, which could well have hung on such a door but also suggests Christ's injunction to his disciples to be fishers of men (as well as referencing the sacred significance of fish to the Druids); or the water that seeps into the dry earth, both a wonderful fresh piece of observation and a sign of the regenerative power of Christianity. AS

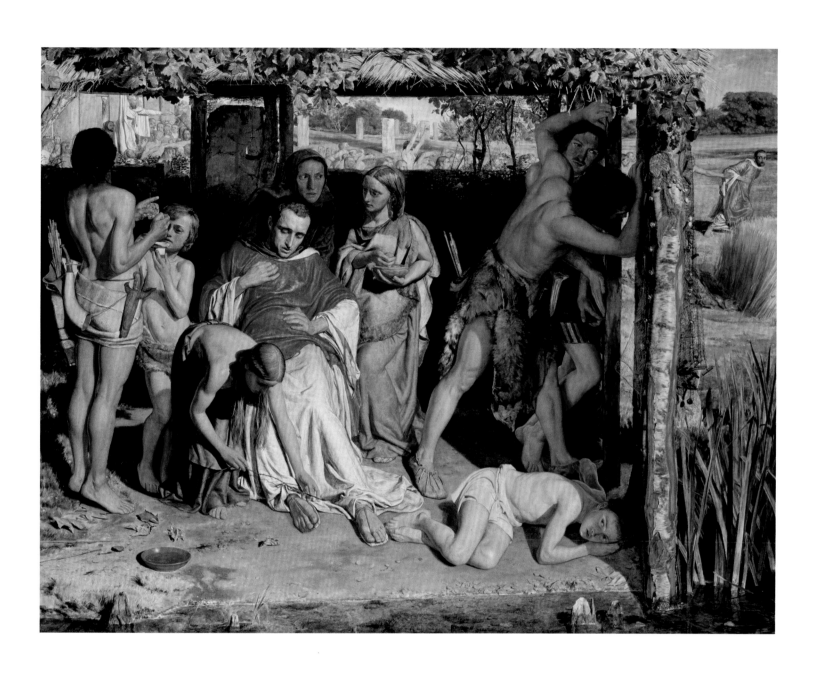

DANTE GABRIEL ROSSETTI 1828–82

Ecce Ancilla Domini! (The Annunciation) 1849–50

Oil on canvas 72.4 x 41.9
Tate. Purchased 1886

According to William Michael Rossetti, this painting was originally conceived as part of a diptych, the companion to a 'panel' representing the Virgin's death, which explains the unusual narrow shape of the canvas.[18] The picture depicts the Annunciation (following Luke 1: 28–38), but with the aim of venturing beyond the traditional iconography associated with the subject to create a modern and meaningful image at a time when the literal interpretation of the Bible was beginning to be questioned in Broad Church circles. The composition was established as early as November 1849 and respects the description of the event in the sonnet Rossetti wrote to accompany *The Girlhood* (no.24), as William Michael explained in the *Pre-Raphaelite Diaries*: 'The Virgin is to be in bed, but without any bedclothes on, an arrangement which may be justified in consideration of the hot climate, and the angel Gabriel is to be presenting a lily to her.' The setting is deliberately cell-like and ascetic, with details such as the frayed matting of the bed kept to a minimum, so as not to detract from the idea of how an inexperienced young woman might respond to such a portentous and improbable event.

In representing the sequel to *The Girlhood*, Rossetti used the same model, his devout sister Christina, for the Virgin and another family member, his brother William, for the angel Gabriel. The embroidery copied from three lilies in the earlier work is now shown to be completed and hangs over a frame suggesting that the Virgin has finished her early training and is ready to fulfil her destiny as the handmaid of the Lord. The three embroidered lilies are repeated as real blooms (with one still in bud) on the stem proffered by the wingless angel in a white shift, who angles the stalk at the girl's womb as he relays his message. The startling fact that we are witnessing the conception together with the Annunciation is made clear by the stunned expression of the girl, who is shown waking from a dream she can barely comprehend and drawing up her legs as if recoiling from a sexual advance. The recent hypothesis that this pose originated in a popular illustration of a 'match girl' would further testify to how Rossetti sought to realise the Virgin's response in terms of gritty social observation.[19]

Beyond the emphasis on expression, the psychological charge of the image owes much to the simple colour scheme and bold use of primaries. Although the colours have clear symbolic connotations (white representing the purity of the Virgin, and blue, her later role as Queen of Heaven; red, the Passion of Christ; and gold, divine status), the overall impression of white adds to the strangeness and vertiginous feel of the composition. In masking the transitional area between the floor and wall, the white tones create a sense of spatial ambiguity, giving the uncanny illusion of a real flesh and blood angel hovering in space.

The painting was first exhibited at the National Institution of Fine Arts at the Portland Gallery, Langham Place, in 1850 where it was singled out for its primitive qualities, *The Times* comparing it to 'a leaf torn out of a missal' and *The Examiner* describing it as 'A provokingly clever monstrosity in which the lean meagreness of the early painters is imitated as closely as if it were their excellence, not their defect'.[20] Such harsh criticisms discouraged Rossetti from attempting any further realistic portrayal of a religious event. Around the time he sold the painting to the Irish Pre-Raphaelite patron Francis McCracken in 1853, he changed the original Latin mottoes on the frame to English inscriptions and altered the title to *The Annunciation* 'to guard against the imputation of popery'.[21] At some point he also reworked the signature to erase the initials PRB, and when the painting re-entered his possession in 1874, he took the opportunity to play down the didactic overtones of the work by changing the original surround with the mottoes to a simpler aesthetic frame of the 1860s. AS

CHARLES ALLSTON COLLINS 1828–73
Convent Thoughts 1850–1

Oil on canvas 84 x 59
The Ashmolean Museum, Oxford. Bequeathed by Thomas Combe, 1893

Although Collins was not an official member of the PRB, his *Convent Thoughts* was immediately recognised as a Pre-Raphaelite image on account of its self-conscious adoption of the iconography and decorative motifs found in medieval illuminated manuscripts. It was produced in Oxford under Millais's guidance, the flowers painted direct from specimens in the garden of Thomas Combe in the quadrangle of the Clarendon Press, and it was largely through Millais's encouragement that the High Church Combe and his wife Martha purchased the painting as a pendant to Millais's *Return of the Dove to the Ark* (no.89).

The picture represents a nun in an enclosed garden contemplating the stamen of a passion flower, an emblem of the Crucifixion. This connection is suggested by the Book of Hours she holds in her left hand, which is shown open at a page emblazoned with an image of Christ on the cross surrounded on three sides by the Virgin, St John and Mary Magdalene. The page that she has actually been studying, which is marked by her index finger, discloses an image of the Annunciation. Ideas associated with this event are developed within the painting itself through the image of the lily, a standard attribute of the Virgin Mary. Through a sequence of registers of verisimilitude, the eye is led from the representation of the Annunciation in the book to the painted lilies in the garden and the three-dimensional blooms on the frame, which was designed like that of *The Return of the Dove* by Millais (no.89). The Latin inscription at the top, *Sicut lilium* ('As the lily', among thorns), taken from a passage in the Song of Solomon, reinforces the association between the nun and the Virgin and the former's vocation in a celibate cloistered existence. The theme of virginity would have been further acknowledged by the quotation from *A Mid-summer Night's Dream* that accompanied the painting when it was first shown at the RA in 1851: 'Thrice blessed they, that master so their blood / To undergo such maiden pilgrimage.'

The manuscript that Collins adapted from a missal in the Soane Museum would seem to provide the key to the composition.[22] What we see in miniature form on the open page – a bordered hieratic scene surrounded by a decorative margin – is reinterpreted in the main body of the composition in the image of a nun encased within her shapeless habit, isolated on a grassy island and hemmed in on either side by carefully aligned areas of brilliantly coloured foliage. Collins was known among the Pre-Raphaelites for his High Church sympathies, and the 'Catholic' elements of his picture would not have been lost on his audience at a time when the revival of secluded orders was the subject of intense debate within the established church. In his review of the painting the defiantly Protestant Ruskin chose to ignore the symbolic elements of the image, praising it instead as a 'botanical study' and singling out for attention Collins's depiction of the leaf of the water plantain, *Alisma plantago*, growing on the pond: 'I never saw it so thoroughly or so well drawn.'[23] In making this point, Ruskin deliberately played down the implicit Romanist aspects of the image in order to emphasise his own notion of 'nature-scripture', in which the shape and structure of particular types testified to a divine force driving creation. AS

89

JOHN EVERETT MILLAIS 1829–96
The Return of the Dove to the Ark 1851

Oil on canvas, arched top 88.2 x 54.9
The Ashmolean Museum, Oxford. Bequeathed by Mrs Thomas Combe, 1893

Millais's Oxford friends Thomas and Martha Combe bought this picture before its exhibition at the Academy in 1851.[24] They were affiliated with the High Church movement in that city, and were important early patrons of the Pre-Raphaelites. The picture was part of a grouping in the Combes' living room at the Clarendon Press, for which Thomas served as superintendent. It formed a triptych with Hunt's *Missionary* (no.86) and Collins's *Convent Thoughts* (no.88). Millais's Old Testament subject complemented the ancient and modern responses to faith in Hunt's and Collins's pictures. And Hunt's breathless tale of pursuit and persecution was in turn nicely bracketed by Millais's and Collins's introspective symbolic works.

In this gentle scene two young daughters-in-law of Noah comfort the dove, which has returned with an olive leaf signifying the abatement of the flood. Its breast is heaving from exertion, and its feathers are ruffled from its passage. One white plume has settled on the arm of the girl on the right, and another on the lower fringe of the girl's dress on the left. This was one of three pictures Millais submitted to the Academy, along with *The Woodman's Daughter* (no.66) and *Mariana* (no.35), and represents perhaps a more docile approach to a religious subject after the furore over *Christ in the House of His Parents* (no.85) the year before. Pressed for time before the Academy's opening, he also simplified the background, opting for a black that throws the figures into bright relief and saved him the trouble of producing a time-consuming landscape or archaeologically detailed backdrop. Millais designed the olive-leaf frame, as well as the frame for Collins's picture.

This is a deeply humanist response to the subject of salvation and God's covenant with Noah and his family. It is an image without pyrotechnics or demonstrable action, content to demonstrate its truths through the evolving brilliance of Millais's technique. This is best seen in the delicately stippled faces of the girls, produced through measured dabs of a small brush, and the iridescent garments set off by the brilliant white and sharp folds of the girl's cloak on the right. For the *Guardian* the colouring was 'rich and harmonious to a high degree, and has a very "killing" effect upon the surrounding pictures'.[25] Millais's talent for verisimilitude is most evident in the straw in the foreground, the part of the picture that would have been most easily seen by visitors to the Royal Academy exhibition. JR

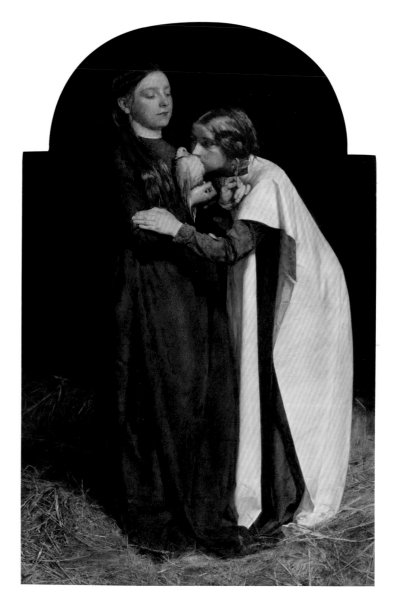

90

FORD MADOX BROWN 1821–93

'Take your Son, Sir' begun 1851–2, enlarged and reworked 1856–7

Oil on canvas 70.5 x 38.1
Tate. Presented by Miss Emily Sargent and Mrs Ormond in memory of their brother John S. Sargent 1929

91

FORD MADOX BROWN

Study of Arthur Gabriel Madox Brown for the Baby in 'Take your Son, Sir' 1856

Black chalk on paper 17.5 x 23.5
The Trustees of the British Museum, London

This painting, composed of seven pieces of joined canvas, was started in 1851–2 as a portrait of the artist's mistress Emma with her head back laughing.[26] With the enlargements of 1856 it was transformed into an image of triumphant motherhood. A woman stands in a homely parlour holding out a baby to a man with outstretched arms, who, imagined in the position of the viewer, is reflected in the convex mirror that encircles the woman's head like a halo, a format likely to have been suggested by van Eyck's *Arnolfini Portrait* in the National Gallery (fig.13). The words inscribed on the canvas, 'Take your Son, Sir', would suggest that she is actually speaking to the father, asking him to hold the boy so they can dress him in a nightshirt, while the maid just visible on the extreme right prepares the infant's cot. The features of the couple have been identified as those of Emma and Brown, who were married in 1853, and they appear to be celebrating the arrival of their third child, Arthur Gabriel, who was born on 16 September 1856 but died on 21 July 1857, an event that moved Brown greatly and resulted in him abandoning the painting. The infant Arthur also appears in Madox Brown's masterpiece, *Work*, completed long after the child's death, in 1863 (no.95). Against the white of the primed unfinished canvas the baby seems to emerge symbolically from a womb-like cavity, the edges of which are defined by the crisp outline of the shirt that encircles him.

Brown painted his son with the aid of a drawing of Arthur inscribed 'aged 10 weeks'. This carefully observed study enabled him to focus on the physicality of the baby with its unsteady head, sausage-like limbs and tightly clenched fists. By attending to a reflex peculiar to newborns, the raised big toe of the baby's left foot, Brown demonstrates an empirical grasp of a response that was not identified until later in the century as the Babinski sign. Emma's flushed complexion and weary eyes betray her exhaustion, as if Brown deliberately set out to subvert the idealised images of motherhood seen in old-master painting – which he alludes to in his picture by the hieratic disposition of the figure – as Millais had in his portrait of Eliza and Sarah Wyatt (no.30). By emphasising the realities of parenthood, he may also have been offering a corrective to the spiritualised views of women that were being advanced in writings such as Coventry Patmore's narrative poem *The Angel in the House*, first published in 1854, which Brown found 'deploringly tame and tiring'.[27] AS

90

91

WILLIAM HOLMAN HUNT 1827–1910
The Light of the World 1851–2

Oil and gold leaf on canvas, arched top 122 x 60.5
Warden, Fellows and Scholars of Keble College, Oxford

By virtue of his idiomatic interpretation of scripture, Hunt can justifiably be regarded as the successor to William Blake. However, in advancing a symbolic language that embraced rather than rejected the real material world, he came to command a much wider audience. *The Light of the World* was a pivotal work in this endeavour, a deeply personal image that came to be hailed as an icon of British Protestantism throughout the dominions of its empire and probably attained more widespread fame than any other Victorian picture.

The painting apparently developed from a religious epiphany Hunt experienced when reading the Bible, specifically a passage from the Book of Revelation (3: 20) that was subsequently incorporated into the frame: 'Behold, I stand at the door, and knock: if any man hear my voice, and open the door, I will come in to him, and will sup with him, and he with me.' The private nature of what Hunt later described as his 'emotional conversion' is borne out by the inscription, 'Me non praetermisso Domine!' (Don't pass me by, Lord), written by the artist on the spandrels hidden under the arched top of the frame, which would imply that he intended the words to remain secret. In the picture Hunt's own plea to the Saviour becomes that of the spectator who is entreated by Christ's intent gaze and steady knock to allow him to enter. The very directness of the encounter is premised on the evangelical belief, central to Hunt's thinking at this time, that mankind is inherently sinful and in desperate need of salvation, and that scriptural inspiration should be emphasised above any claim to authority on the part of the church or priesthood.

In devising an iconography based on symbols that emerge naturally from the scene, rather than relying on traditional emblems of the risen Lord, Hunt was concerned to transcend denominational divisions in presenting Christ as a human as well as a divine being. For the general scheme he appears to have followed the format used in Gottfried Rist's engraving of 1824 after Philip Veit's *Christ Knocking on the Door of the Soul*, which was in circulation around the time when Hunt's picture was in progress,[28] but chose to present the Saviour as a more regal figure with his halo, crown and elaborate priestly cope fastened by a jewelled tripartite clasp. The head was composed from a number of male and female models, which, together with the decidedly unanatomical body, lends the figure a mystical appearance, an effect enhanced by the hallucinatory nocturnal setting. However, in order to invest his apparition with a sense of real presence, Hunt made it his mission to render every detail of the picture according to Pre-Raphaelite principles. The door and a significant proportion of the background were thus painted by the light of a candle on location at Ewell at the time of the full moon. Back at his Chelsea studio in London, the artist constructed an imitation door and stood a lay figure by the window to achieve the pearly glow of the white robe illuminated by the moon and lamp.[29] Such an elaborate working procedure was directed to creating an effect of both real and eternal light, thereby enhancing the numinous presence of Christ in the mind of the beholder.

Although Hunt was concerned that his picture should appeal on aesthetic grounds, the actual meaning of the image depends on the intricate symbolism that permeates every aspect of the composition. Hunt set out the basis of his scheme in the pamphlet accompanying his 1865 exhibition:

> Physical light represented spiritual light – a lantern, the conservator of truth; rust, indicated the corrosion of the living faculties; weeds, the idle affection; a neglected orchard, the uncared for riches of God's garden; a bat, which loveth darkness, ignorance; a blossoming thorn, the glorification of suffering – a crown, kingly power; the sacerdotal vestment, the priestly office, & c.[30]

Despite the arcane nature of some of the symbols employed, the main emphasis is on the universal appeal of Christ and how in embodying light he dispels doubt and even the fear of death. The door thus functions as a symbolic threshold not only into the convert's soul but into the afterlife, hence the ghostly shadow of a skull cast by the eerie light of the lamp onto the door, like a question mark over the future. Hunt's adoption of a suggestive rather than an explicit symbolic scheme also explains why he discouraged Millais from painting a pendant in which the door would have been shown open and the penitent at the Saviour's feet. Instead, Hunt conceived of pairing the painting with what he termed the 'material interpretation of the idea' in *The Awakening Conscience* (no.98).[31] In representing a moment of private revelation in a real urban location, this daylight scene complements the nocturnal moment of spiritual illumination in the timeless setting of *The Light of the World*. As Michaela Giebelhausen has noted, it is only when the two works are read together that the transformative power of Christ's allegorical knock is translated into the conscience of a particular woman in contemporary society, an idea made manifest by the metaphoric play of light in both compositions.[32]

The picture's dual emphasis on real and visionary form did not pass without criticism. It received a lukewarm reception when first exhibited at the RA in 1854. The *Art Journal* and *Athenaeum* thought the subject matter too sublime for such literal interpretation,[33] while in a letter to *The Times* the eminent German art historian Dr Waagen contended that it broke the iconographic rules of religious art in confusing idealistic with realistic modes of representation.[34] It was only with Ruskin's defence of the picture, as both a work of art and a persuasive religious statement whose meaning depended on the typological exegesis provided by its symbolism, that *The Light of the World* gained greater currency.[35] This was abetted by the publication by Gambart in 1860 of W.H. Simmons's engraving of the work, to coincide with a tour of the

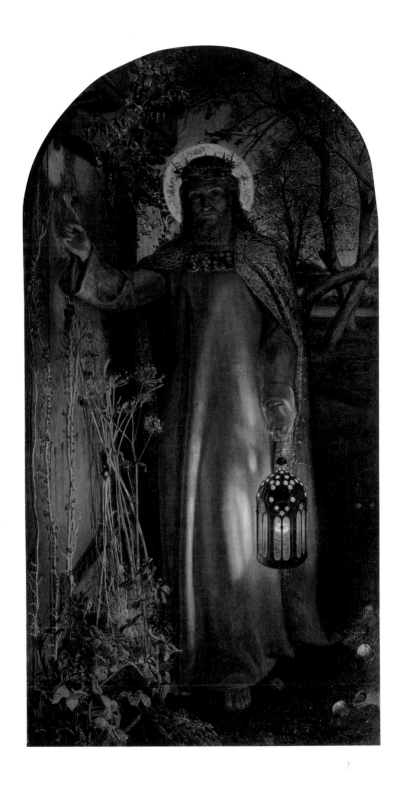

picture throughout the United Kingdom, which served to imprint the motif in the public conscience and in turn encouraged the return of the image to the written word in the form of numerous poems and hymns inspired by its message.

Hunt went on to produce two other versions of the picture, a smaller one now in Manchester (see pp.246–7) and a larger more 'muscular' painting that he commenced in 1899 out of pique that the original, having been gifted by its first owner Thomas Combe (who purchased the work in 1853) to Keble College in 1872, was poorly maintained and not easily accessible to visitors. The final version was purchased by the shipbuilder and sociologist Charles Booth, who funded a tour of the painting through the colonies of the British empire in 1905–7 to promote its ecumenical message of enlightenment that transcended denomination or even religious belief. The painting travelled to Canada, Australia, New Zealand and, finally, South Africa as a peace token in the aftermath of the Second Boer War.[36] Hunt's addition of a crescent moon to the lantern in this final version in acknowledgement of the Islamic faith would seem to confirm the 'all embracing' sentiment of the work. However, the success of the tour was such that it sealed the reputation of the picture as a sermon in paint, which may explain why Booth decided to give it to St Paul's cathedral as an object of veneration, rather than, as Hunt would have preferred, to the Tate Gallery as a work of art. AS

FORD MADOX BROWN 1821–93
Jesus Washing Peter's Feet 1852–6

Oil on canvas 116.8 x 133.3
Tate. Presented by subscribers 1893

In this picture it was Brown's intention to create a resolutely modern religious painting that was true to the source on which it was based (John 13: 4–5, 15) but also acknowledged the new historical interpretation of the Bible offered in contemporary critical scholarship. He wanted to emphasise the human relationships in the story: the humility of the naked Christ as he washed and dried his disciples' feet, and Peter's acquiescence in the ritual despite an acute sense of embarrassment in allowing his master to act as a servant. In the painting this is suggested by the tension in Peter's legs and by his left foot reluctantly touching the water. In focusing on the ablution itself, Brown was keen to stress the manliness of Jesus's endeavour as he grasps Peter's foot, in keeping with the Christian Socialist philosophy that he espoused and was to find full expression in *Work* (no.95).

An early study for the composition in the Tate collection limits the supporting cast to just the figure of St John, whereas in the finished painting seven disciples are squashed into the upper register of the canvas with the figure of Judas adjusting his sandal on the far left counterbalanced by the devout figure of John, 'whom Jesus loved', on the far right. By bringing out the different psychological responses of the cast, Brown was concerned to emphasise the individuality of the main characters in the narrative as 'warranted by modern research … the traditional youthfulness of John, curly grey hair of Peter, and red hair of Judas'.[37] As with Millais's *Isabella* (no.26), the careful selection of acquaintances to serve as models shows how Brown sought to invest his image with a strong sense of physical presence.[38]

It has been suggested that the composition derives from another ritualistic washing scene, Peter Paul Rubens's *Magdalene Bathing Christ's Feet with her Tears*, engraved in the *Art Journal* in 1851.[39] Following the general scheme of this composition, Brown adopts a low view point to emphasise the monumental form of the two main characters who, like the copper basin of water teetering on the edge of the step, threaten to invade the spectator's space. The horizontal bands of the composition that run from the foreground step to the far line of the table are interrupted by two diagonal lines that converge at the point where Jesus holds Peter's foot, fixing the eye on his act of humility. This compositional arrangement relates to the artist's interest in expressing the 'general truth' of the event by establishing its connection to the scene it follows in the biblical text, the Last Supper. For Anna Jameson this was generally the subject of an altarpiece in Protestant churches, where there was one, and a ubiquitous piece of iconography that needed revivifying.[40] In Brown's painting the table that faces the viewer on a raised platform symbolically doubles up as an altar against which Christ's haloed profile is silhouetted and which in Brown's words 'appeals <u>out</u> from the picture to the <u>beholder</u> – not to the other characters in the picture'.[41] His flesh-and-blood rendition of Christ's limbs thus carries Eucharistic significance, allowing the artist to concentrate on his humanity without having to depend on traditional symbols of the Passion.

The painting was poorly positioned near the ceiling when first exhibited at the RA in 1852 with the result that Brown never exhibited there again. It also received largely negative comments in the press, the majority of critics condemning the nudity of Christ as inappropriate for a divine subject, a failing they felt was exacerbated by the livid skin tints that gave the effect of flesh being violently scrubbed.[42] Disappointed that the work did not sell, Brown set about reworking it and clothed Christ in an Arab shirt he borrowed from Seddon.[43] Although the revisions may have imparted more decorum to the scene, Brown feared the draping imposed a modesty 'more in accordance with modern European notions' than the Bible.[44] To honour the simplicity of his original conception, he produced a watercolour replica in 1876 (Manchester City Galleries), the revised draped version having been purchased by Thomas Plint following its display at the Manchester Art Treasures exhibition in 1857. AS

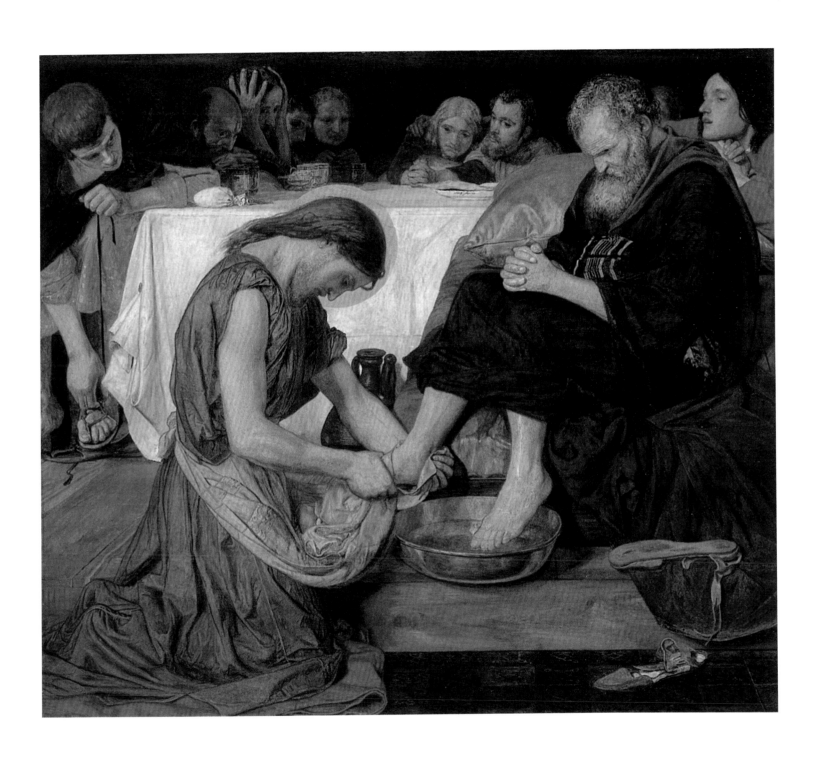

FORD MADOX BROWN 1821–93
The Last of England 1852–5

Oil on panel, oval 82.5 x 75
Birmingham Museums and Art Gallery. Purchased 1891

With the exception of *Work* (no.95), this is Brown's most politically motivated painting. In the artist's words, it 'treats of the great emigration movement which attained its culminating point in 1852'.[45] As public perceptions shifted in the mid-1850s, owing to the increasing prosperity of Australian colonists and, more immediately, to the gold rush that began in New South Wales in 1851, the Australian colonies came to be perceived less as a penal settlement and more as a land of possibility. Consequently, mass emigration was encouraged both as a means of alleviating poverty and as a solution to excessive population growth in mainland Britain. Middle-class figures, such as the couple seen in *The Last of England*, were encouraged to seek their fortune in the colonies.

However, rather than celebrating the exodus as Thomas Carlyle had done in his *Latter-Day Pamphlets* of 1850, Brown's painting exudes a feeling of stoicism combined with bitterness on the part of passengers 'thrust out' of their homeland and bracing themselves for the arduous four-month journey to their destination. The name of the ship, 'El Dorado', indicated by the inscription on the lifeboat in the distance – an ironic allusion to the fabled overseas city of wealth and opportunity – invites the spectator's sympathy for what Brown suggests may be a thwarted journey. The despondent mood of the picture relates to the hardship the artist experienced at a time when he was achieving little in the way of commercial success and was even contemplating emigration to India.[46] Thomas Woolner's embarkation for Australia in 1852, however, to try his hand at gold digging, provided the immediate catalyst for the choice of subject, and the feeling of frustration that led to his return in 1854 may further explain the strong sense of alienation and anger expressed by the men-folk in the picture.

In the catalogue to his 1865 exhibition Brown explained that the picture was 'in the strictest sense historical' and that it was his aim to give the personal narratives of ordinary people an epic dimension.[47] This would explain his adoption of a Raphaelesque tondo format and the reference to the Holy Family in the grouping of the principal couple with their newborn child, whose tiny extremities peep out from under the woman's shawl. He may also have been acknowledging the biblical theme of the Flight into Egypt, especially in relation to the contemporary promotion of emigration as a means of accommodating the aspirations of the rising generation. However, the idea of escape into safety suggested by such an association is undermined by the confusion of the composition itself with its dislocated and jumbled body parts. These fragments disrupt the rhythmic interplay of form epitomised by the Raphaelesque ideal and convey instead a feeling of apprehension fitting for the representation of a journey into the unknown. The vivid magenta line of the woman's scarf, which juts out like a child's paper whistle as it blows in the wind, is a quirky piece of observation that jars rather comically with the man's stony expression as if mocking his grumpiness.

The couple, modelled by Brown himself and his wife Emma, are, according to the artist, middle class – 'high enough, through education and refinement, to appreciate all they are now giving up, and yet depressed enough in means, to have put up with the discomforts and humiliations incident to a vessel "all of one class"'.[48] Nestled in the poop of the vessel and sheltered by an umbrella from the sight of the land from which they are retreating, they turn their backs to the jostling and crammed throng of eight others in the distance, among whom Brown describes an honest lower middle-class grocer and his family, a working-class cabin boy, and a criminal reprobate shouting obscenities at his native land and urged on by his drunken companion, while his mother reproves her son for his foul tongue. Despite the rather bathetic touch of the cabbages swinging from the foreground rope, the overall sentiment is one of pathos, and to engage the viewer's empathy, the artist paid meticulous attention to the various details of the composition, copying each discrete part from its counterpart in life, from the weave and fringe of the grey woollen shawl to the male protagonist's hat tied to a button on his coat and the drops of sea spray on the tarpaulin, ropes and umbrella. Moreover, to give the effect of what Brown describes as 'the peculiar look of light all round, which objects have on a dull day at sea',[49] he painted the bulk of the work in the open air on overcast days, reserving the flesh for particularly cold weather as can be seen in the pinched skin and red knuckles of the man. AS

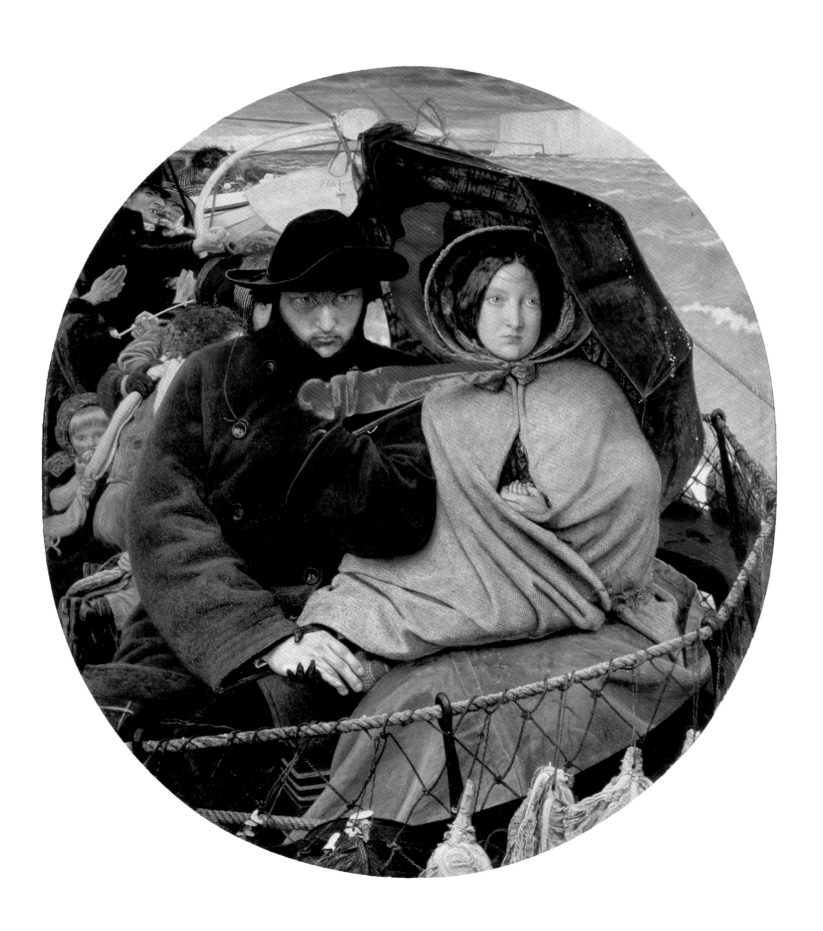

FORD MADOX BROWN 1821–93
Work 1852–63

Oil on canvas 137 x 197.3
Manchester City Galleries

Ford Madox Brown's allegory of labour in all its forms is the most ambitious Pre-Raphaelite painting of modern life and a consummate masterpiece of nineteenth-century realism.[50] Brown began the composition in Hampstead in 1852, alongside *The Last of England* and *An English Autumn Afternoon* (nos.94 and 74), but continued to elaborate it for another eleven years, finishing it in 1863 and exhibiting it in a one-man show in 1865.

The painting engages with mid-Victorian intellectual debates about the meaning and value of labour, in which religion played a central role. It is a visual treatise on labour and salvation. Brown portrayed two significant contemporary thinkers at the right of *Work*, the philosopher Thomas Carlyle (with the strange, satirical leer) and the beatific churchman Frederic Denison Maurice. They shared with Brown the then radical notion that work tests, and displays, the moral fibre of the individual and that the industrious man can earn a high place for himself in society, and can also determine his fate on the day of judgement. Brown inscribed the frame with biblical quotations relating to this theme:

> In the sweat of thy face shalt thou eat bread [Gen. 3 : 19].
> Neither did we eat any man's bread for naught but wrought with labour and travail night and day [2 Thess. 3 : 8].
> I must work while it is day for night cometh, when no man can work [John 9 : 4].
> Seest thou a man diligent in his business? He shall stand before Kings [Prov. 22 : 29].

Work, then, is a religious history painting for a secular age, which reflects the belief of Carlyle that 'there is a perennial nobleness, and even sacredness, in work'.[51] The nobility of labour, it is implied, are of greater value than those noble by blood. Although the 'gospel of labour' has been identified as a creed of the nineteenth-century middle class, it had radical implications by placing the 'working man' at the top, rather than the bottom, of society's hierarchy of value.

The heroes of this painting are the manual labourers whose bodies form a great pentagonal mass in the centre, brilliantly lit by the hot summer sun. They are navvies, men of formidable strength whose job was to dig trenches, in this case for the installation of new fresh-water pipes. Normally, such labourers would have been considered too vulgar to appear in a work of high art, but Brown took the opposite view. The pose of the central navvy who, Brown wrote, 'occupies the place of hero in this group', alludes to the Apollo Belvedere, a classical statue in the Vatican collection much reproduced as a plaster cast and long considered the epitome of male beauty.[52] The navvy improbably holds between his teeth a red carnation. To link the proletarian navvies with ideas of nobleness, beauty and moral value was a radical move on Brown's part.

The painting offers a range of figures for us to compare with the central group of navvies. Each character demands slow and careful interpretation, as in a Victorian novel. Behind the central group is an aristocrat mounted on horseback. He is thrown into the shadows, irrelevant. His expression suggests sympathetic interest in the social problems of the day, but he is too far from the action to make a difference.

By contrast, to the right, shaded on the bank, is a group of unemployed haymakers, who are dependent on the seasons and the vagaries of the farming industry, and bring their tools with them. We can sympathise with their plight. Brown applauds the efforts of a couple of young labourers to feed their small child: a young mother's yellow bonnet suggests a halo, linking this poorest of women with the Virgin Mary.

Perhaps the most striking figure is the social outcast at the extreme left of the painting, a barefoot seller of groundsel and chickweed, which wealthy Victorians used for flower-arranging and placed in birdcages. This stooped, shifty man combines pathos and menace, staring despairingly through the brow of his battered hat. Brown described him as 'the ragged wretch who has never been *taught* to *work*'.

Gender was central to ideas about labour, and in Brown's vision middle-class women do not work, or rather, should not be seen to work in public. A respectable and beautiful young woman, shading her face from the sun with a parasol, walks down the footpath to our left, oblivious to the spectacle of labour. Behind her a redoubtable lady in her middle years is engaging in philanthropy. Close examination of the painting reveals that the temperance tracts she is distributing are titled 'The Hodsman's Haven, or Drink for Thirsty Souls'. Brown laughs at this well-meaning character; his sympathies are with the hefty navvy downing a pint of beer at the apex of the composition, in an echo of the engraving *Beer Street* (1750) by William Hogarth, whom Brown greatly admired.

In the foreground we find a group of urchins whose mother has recently died (as we learn from the black band on the baby's arm). They play a raucous game, but even here there is a hint of Victorian domestic probity as the elder sister attempts to discipline her unruly brother. Yet this ginger-haired girl is wearing a battered, second-hand, red velvet dress, loosely laced at the back, which barely covers her body. It may hint at a future life of prostitution, the destiny of many Victorian women whose life began, as here, in poverty. Brown also chronicles the hardship meted out to women attempting to earn a living: an orange seller is moved on by the police at the extreme right of the painting. The fruit falling from her basket is frozen in mid-air, casting circular brown shadows on her skirt.

The policeman is one of many servants of the state in *Work* who maintain order with varying degrees of fairness. Between the horses at the back can be discerned the tiny figure of a postman

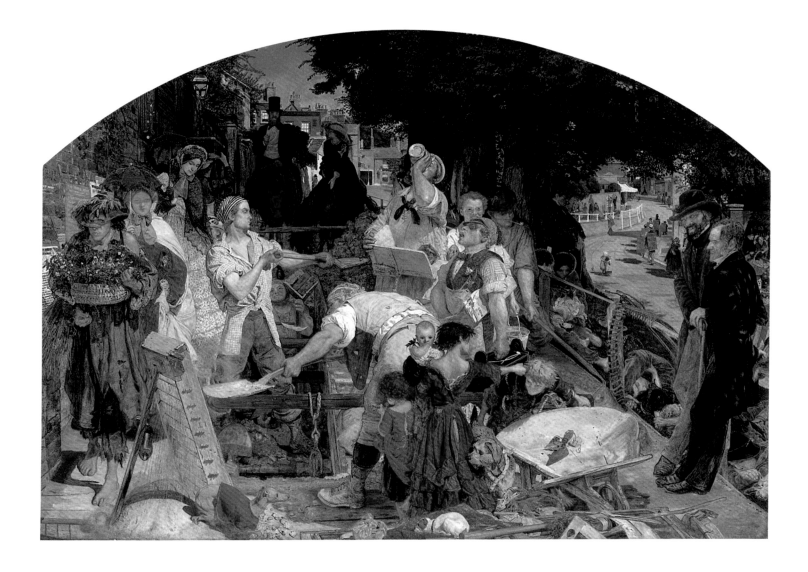

in a crimson coat silhouetted against a whitewashed wall; in the same distant register to the right are two off-duty volunteer soldiers on a raised footpath.

Politics, too, does not escape Brown's criticism. An election is underway with the name BOBUS inscribed on sandwich boards carried by a variety of grotesque characters in the right middle distance. Bobus Higgins was a character from Carlyle's writings, who made a fortune by selling horse-meat sausages.[53] Bobus appears in *Work* as a non-working, swindling capitalist who is attempting to buy himself a seat in Parliament.

The painting's endless elaboration and fanatically detailed finish meant that it consumed enormous amounts of Brown's time and energy. He laid it aside after sketching out the composition and painting the landscape background in 1852, turning to other projects that would sell more quickly. Eager to complete his masterpiece, he returned to it in 1855. On 9 November 1856 Thomas Edward Plint, an evangelical Leeds stockbroker and passionate art collector, visited Brown's studio, 'inveigled here by Gabriel Rossetti'.[54] Plint already owned Millais's *Christ in the House of His Parents* (no.85), and he would later purchase Brown's *Jesus Washing Peter's Feet* (no.93) and commission Holman Hunt's *The Finding of the Saviour in the Temple* (no.101), among other religious works. Perceiving the

moral seriousness of the painting, Plint commissioned Brown to complete *Work*, paying the artist the full amount in steady instalments. Plint's premature death in 1861 meant that he never saw it completed. While the full-size painting (now at Manchester) awaited completion, Brown made a smaller version, identical in almost every detail (now at Birmingham, see p.246–7), for the Newcastle lead manufacturer James Leathart, who asked that a portrait of his wife be included, replacing the carefree young woman in a red dress.

When *Work* was finally complete, Brown organised a privately funded, one-man exhibition at the Piccadilly Gallery in 1865, promoting it with 'advertisements inserted in newspapers and on the walls of railway stations'.[55] This modern strategy of promotion was appropriate to such a profound response to urban modernity. Critical response was favourable, with one critic noting that, having worked so hard to produce his masterpiece, Brown 'is well entitled to give his opinion of what constitutes hard work'.[56] The *Athenaeum*'s critic considered the painting to be 'brilliant, solid, sound, studied with extraordinary earnestness, elaborate and masterly'.[57] After more than a decade of struggle Brown declared in 1864 that the finished canvas embodied no less than 'the work of my life'.[58]

TB

96
DANTE GABRIEL ROSSETTI 1828–82
Found 1853

Pen and brown ink, heightened with white on paper 20.5 x 18.2
The Trustees of the British Museum. Bequeathed by Col William James Gillum 1910

97
DANTE GABRIEL ROSSETTI
Found begun 1859

Oil on canvas 88.9 x 76.2
Delaware Art Museum, Wilmington, DE. Samuel and Mary R. Bancroft Memorial. 1935

Found, Rossetti's one ambitious realist work, was to preoccupy him on and off from the early 1850s up to his death in 1882. The painting continues the subject of the fallen woman he had first explored in his poem 'Jenny' of c.1846–9 and in drawings representing repentant sinners such as Gretchen and Mary Magdalene. It is a modern subject, but unassertively so when compared with Hunt's very contemporary *Awakening Conscience* (no.98), and it unites city and country with the aim of addressing the controversial theme of prostitution. The finished drawing for the painting dated 1853 presents, in the artist's words,

> a London street at dawn, with the lamps still lighted along a bridge which forms the distant background. A drover has left his cart standing in the middle of the road … and has run a little way after a girl who has passed him, wandering into the streets. He had just come up with her and she, recognising him, has sunk under her shame upon her knees, against the wall of a raised churchyard in the foreground, while he stands holding her hands as he seized them, half in bewilderment and half guarding her from doing herself a hurt.[59]

In the drawing the honesty of the countryside, suggested by the man's white smock and the tethered calf he brings to market, vie with the degradation of city life indicated by the girl's black shawl and the sharp angle of the cemetery wall against which she is crushed. The motto inscribed at the bottom of the sheet, a quotation from Jeremiah 2: 2, reinforces the poignancy of the image by recalling the woman's innocent past: 'I remember thee: the kindness of thy youth, the love of thy betrothal' (the final word replaced the original 'espousals'). A discarded rose in the gutter alludes to lost love, while the pair of nesting birds gathering straw fallen from the cart represents a homely contrast to the solitary figures on the bridge, who further serve as reminders of the woman's alienated condition. The only hint of redemption lies in the inscription on the gravestone at the top left from Luke 15: 7, the Parable of the Lost Sheep, which introduces a note of ambiguity as to whether the girl will find salvation through repentance or whether she like the calf is doomed.

In 1854 Rossetti commenced a small painting of the subject (Carlisle City Art Gallery) according to the Pre-Raphaelite principle of working on location. Seeking a city wall, he alighted on a suitable structure in Chiswick, noting with approval that it was 'within earshot almost of Hogarth's grave – a good omen for one's modern picture'.[60] The cart and calf were painted on a farm in Finchley while Rossetti was staying with the Browns, the animal copied slowly 'like Albert Durer, hair by hair', as Brown noted in his diary.[61] The head of the woman is recognisably that of Fanny Cornforth, with whom Rossetti had established an intimate relationship by the end of 1858. After working intermittently on the picture during the 1850s, he returned to it again in 1859 when James Leathart expressed an interest in purchasing it as a commission. At this point Rossetti appears to have copied completed sections from the small painting to a larger canvas, which he then enlarged again when the commission passed to William Graham in 1869. A horizontal section was added to the bottom and a vertical strip to the right side of the wall in order to accommodate the figures, a not entirely satisfactory solution as the additions did not quite resolve the problem of relating the proportions of the figures to the rest of the design, hence Rossetti's difficulties in completing it.

In its unfinished state the painting strikes a bleaker note than the drawing, and the contrast between the prostitute's tawdry dress and the drover's rural costume is more pronounced with details such as the cowslips in his hat counterpointing the soiled and artificial floral decorations on her dress and shawl. The painting also displays greater psychological tension in the taut arrangement of hands in the centre and the sickly green pallor and pained expression of the woman as she resists the drover's attempt to prise her away from the wall. An isolated metal bollard hovering in the foreground area doubles up as a displaced phallic symbol, while the blue bridge and riverside fading in the distance seem to point up the gulf between the girl's past rural innocence and the hopelessness of her present situation. In January 1881 Rossetti wrote a sonnet to accompany the picture that concludes with the words, 'Leave me – I do not know you – go away', a bitter sentiment that supports F.G. Stephens's recollection that in the end Rossetti was 'thoroughly indisposed to ameliorate anybody's condition by means of pictures'.[62] AS

96

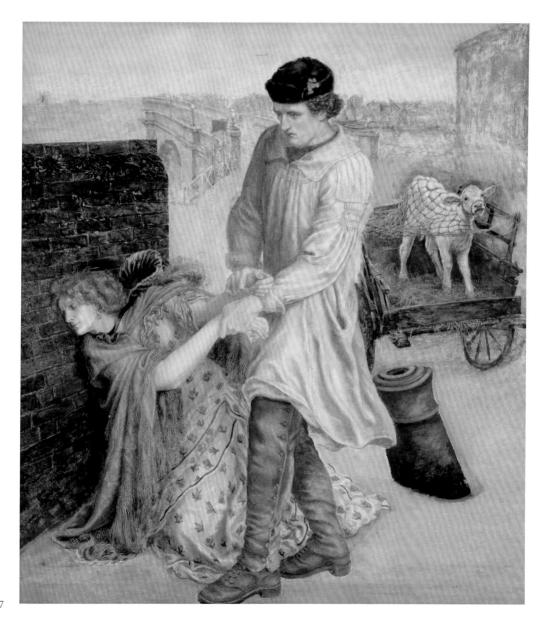

97

WILLIAM HOLMAN HUNT 1827–1910
The Awakening Conscience 1853–4

Oil on canvas 76.2 x 55.9
Tate. Presented by Sir Colin and Lady Anderson through the Friends of the Tate Gallery 1976

Hunt conceived *The Awakening Conscience* as a fulfilment of the promise of divine grace offered in *The Light of the World* (no.92). The light of salvation cast in the latter is both literally and metaphorically received by the woman in the present picture who looks out from the gloomy interior of her parlour to a sun-drenched garden, her face transfixed by what she sees and feels within. Adopting a scenario reminiscent of Hogarth's modern moral subjects, Hunt set out in this work to confront the topical and controversial subject of the kept mistress.

The *mise-en-scène* is a parlour that Hunt painted in Woodbine Villa, a 'courtesan's house' in the fashionable suburb of St John's Wood where a rich young swell is shown dallying with his lover in the vulgar residence he has procured for her. The man is modishly attired and his mistress sports rings on every visible finger except that customarily used for a wedding ring. She wears an odd assortment of garments, a loose blouse, petticoat and paisley shawl, a state of half-dress that complements her confused and transitional state of mind as she rises from the lap of her paramour, struck by the sentiment of the song he is singing – a setting of Thomas Moore's poem 'Oft in the Stilly Night', the score of which is displayed on the piano. This piece is seen to provide the catalyst for her enlightenment, evoking memories of a past innocence, an idea picked up elsewhere in the composition by the garden scene reflected in the mirror and the music sheet on the floor with Edward Lear's equally elegiac setting of Tennyson's poem 'Tears, Idle Tears'. As an ironic foil to the depicted moment of transformation, the lurid trappings of the room stand out with what Ruskin termed a 'fatal newness'.[63] The brightly coloured Turkey carpet, veneered rosewood piano, embroidered bell pull and luxuriously appointed pelmet above the window testify to the superficiality of the man's affections, while details such as the cat pawing a bird, the discarded glove and skeins of the girl's embroidery convey her captive status and the precariousness of her situation.

The frame Hunt designed for the painting reinforces its didactic and sermonising purpose with decorative bells and marigolds symbolising warning and sorrow, while the inscription from Proverbs 25: 2 communicates the overall burden of the scene: 'As he that taketh away a garment in cold weather, so is he that singeth songs to a heavy heart.' Passages from the Old Testament (Ecclesiastes 14: 18 and Isaiah 35: 3–4) were also inserted in the catalogue entry that accompanied the picture when it was first exhibited at the RA in 1854. Together with the star placed at the centre of the upper moulding of the frame, these invite the viewer to see the woman's faith as the key to her salvation, and in conceptually pairing the work with *The Light of the World*, Hunt was offering an alternative narrative to the downward trajectory through prostitution to the grave propagated in much of the contemporary literature surrounding the fallen woman. In devising his iconographic scheme, it would seem that Hunt was very much indebted to the ways in which novelists such as Dickens in *David Copperfield*

and Edward Bulwer-Lytton in *Ernest Maltravers* had tackled the theme of prostitution and the double standard of sexual morality in relations across social divisions. However, it was not only the plots of novels that interested Hunt but also the vivid and realistic descriptions used by writers to cast moral light on particular characters. He may have been struck by a novel by the Pre-Raphaelite associate Wilkie Collins entitled *Basil*. Published in 1852, it is a melodramatic tale of a rich young gentleman's marriage to a tradesman's daughter, and the passage in chapter 10 describing the drawing room of the girl's father's house could almost be taken as a description in prose of the interior in Hunt's painting:

> Everything was oppressively new … the paper on the walls, with its gaudy pattern of birds, trellis-work and flowers … the showy window curtain of white and sky blue, and the still showier carpet of red and yellow … the round rosewood table was in a painfully high state of polish … Never was a richly furnished room more thoroughly comfortless than this – the eye ached at looking round it.[64]

It would also seem that Hunt had a very personal motive for painting the subject, as he had formed a strong attachment with the working-class model Annie Miller, who posed as the kept woman. As with Brown and Emma Hill, it had been Hunt's intention to educate the illiterate Miller in order to take her on as his wife, an aspiration picked up in the painting itself with the detail of Henry Noel Humphrey's *The Origin and Progress of the Art of Writing* on the table by the man's elbow, which serves as a reminder of the education the girl has been receiving. The broderie anglaise flounce on the edge of her petticoat may be an ironic touch in this respect, alluding to the preparatory 'bottom drawer' work a woman would undertake for her marriage wardrobe.[65]

The interweaving of personal and literary narrative in *The Awakening Conscience* makes for a highly complex image, and the density of information provided helps explain why it was not easily comprehended when first presented before the public. Ignoring the underlying spiritual message, critics were deterred by its subject matter, the confusion of visual detail (compounded by the spatial confusion generated by the three mirrors in the composition) and the stunned expression on the woman's face, all of which threatened to disturb and agitate the spectator rather than elicit feelings of sympathy for her plight. In Hunt's defence Ruskin provided a detailed reading of the painting, treating each accessory as significant in elucidating the overall 'principle of the pathetic' expounded by the subject. Even so, the criticisms were enough to make the first owner of the painting, the Manchester industrialist Thomas Fairbairn (see no.110), uneasy about its content. On his request Hunt repainted the girl's face in 1856 and 1857, so her expression appeared less painful, and also changed the title to *Awakened Conscience* when the picture was next exhibited at the Birmingham Society of Artists in 1856. AS

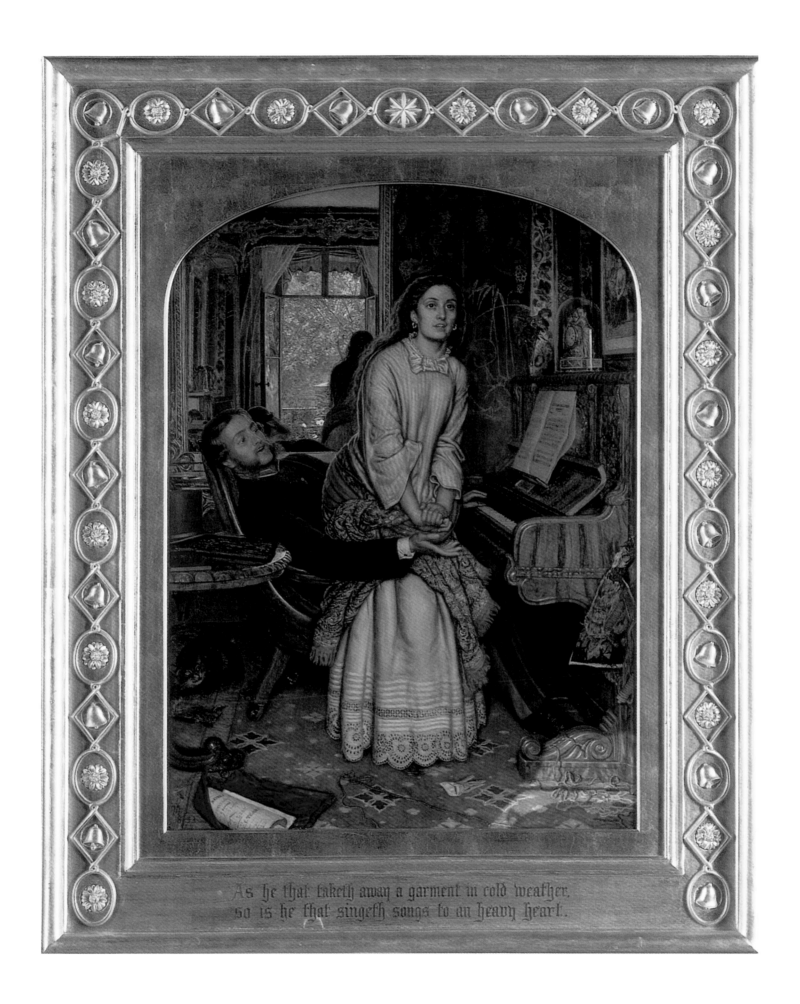

As he that taketh away a garment in cold weather, so is he that singeth songs to an heavy heart.

JOHN EVERETT MILLAIS 1829–96

The Race Meeting 1853

Pen and black ink with touches of sepia 24.8 x 17.6
The Ashmolean Museum, Oxford

From around 1852 Millais began to expand his range of subject matter in his drawings and produced a stream of absorbing images of modern urban life. While he was uninterested in depicting the fabric of London in his art, he was fascinated by the social interactions of its citizenry. This was spurred by his residency in the city for over a decade and his interaction with artists who produced imagery for the popular press, such as his close friend John Leech.

Just as Millais transformed the style of his paintings in the mid-1850s, his modern-life drawings also became markedly different from his earlier Pre-Raphaelite historical works. The earlier subjects are characterised by outlined form and spiky gothic designs (no.29). The modern-life subjects bear 'broken lines, hatching and cross-hatching' in a freeing up of his approach.[66]

As with Hunt's and Rossetti's modern-life subjects (nos.97–8), Millais created his own stories instead of illustrating literature: *The Race Meeting* was inspired by a trip to the Epsom Derby in 1853. And similar to Millais's and Hunt's other works of the early 1850s, this drawing indirectly represents the artists' exploration of London and its environs via the expanding railway network. Epsom became accessible by 1847 with transport through Ewell where the artists had worked in 1851. The composition resulted from a visit to the races in late May with Hunt and their friend the artist Mike Halliday. As he wrote to Charles Collins:

> In a very few minutes I came to the conclusion that the racing audience attend, principally, for the sake of gorging themselves with pigeon pie, and lobster salad, and who would severally (if not for civilisation) aspire to the Epicurean climax of the Roman Emperors, by fattening white bait upon Spitalfield weavers … Such tragic scenes I saw on the course. One mustachioed guardsman was hanging over the side of a carriage guilty of a performance only excusable on board a ship in a state of abject intoxication, with a white aristocratic hand dangling, as dead a lump, as the plaster casts of hands in painters studios, [his mistress] in the same carriage seated beside him endeavouring to look as though she was not cognisant of the beastly reality.[67]

In *The Race Meeting* Millais transformed the description above into a central male figure who has lost his stake yet continues to boast while his paramour hides her face in shame.[68] His spread-handed pose ironically mimics that of Christ on the cross, and the woman one of the weeping Marys at the Deposition.[69] Details of

clothing and foodstuffs abound, including carefully observed elements of the races in the background, as well as social disparities, with beggars to the right, attendants and the wealthy racing audience. Millais's affinity for capturing details of fashions, expressive gestures and faces, and compositional directness in carefully wrought works such as this one led him to become the most sought after and acclaimed illustrator in Britain for the next two decades, as he simplified his style and caricature in his images illustrating works by Anthony Trollope and others. JR

THOMAS SEDDON 1821–56

Jerusalem and the Valley of Jehoshaphat from the Hill of Evil Counsel 1854–5

Oil on canvas 67.3 x 83.2
Tate. Presented by subscribers 1857

Like Ford Madox Brown, Thomas Seddon was almost a decade older than the Pre-Raphaelites, but the advent of his career as an artist was forestalled by parental opposition and instead he joined his father's cabinet-making firm. By the late 1840s he was attending life classes at the studio of Charles Lucy in Mornington Crescent and met Brown, who became his mentor.

Seddon and Hunt shared deep religious convictions and travelled together to the Holy Land to see in person, and transcribe in painting, the locations associated with the life of Christ. The intention was a paradoxical one: by painting Palestine precisely as it appeared in 1854, the two painters believed they could create works that would function both documentarily and allegorically, revealing the ineradicable links between nature and religion, as well as the literal truth of the Bible. It was with a sense of awe that they arrived at Jerusalem on 3 June 1854. Seddon, a gifted linguist who, in a significant act of cultural cross-dressing, immediately adopted an Arab style of dress, camped at Aceldama, the 'Field of Blood' on the Hill of Evil Counsel, and spent almost five months working on Temple Mount, painting *Jerusalem and the Valley of Jehoshaphat from the Hill of Evil Counsel* directly from nature.

The location, to the east of the old city of Jerusalem, is charged with profound religious significance. In the distance to the right is the Mount of Olives where, according to scripture, Christ went to pray after the Last Supper. The Acts of the Apostles identified this as the site of the Ascension. Seddon's panorama also includes places of significance for Judaism and Islam, as Seddon accepted by featuring the al-Aqsa Mosque prominently at the left. The Mount of Olives also houses an ancient Jewish cemetery, marked by the so-called Tomb of Absalom shown in Seddon's image by its cone-shaped upper section visible near the centre of the composition and to the right of the shaded hillside. All three religious traditions identify the Mount of Olives as the place where the Last Judgement and the Resurrection of the Dead will take place.[70] This is truly a landscape of salvation, which links the biblical past with revelatory events of the future.

The figure of a slumbering Arab shepherd to the left is no mere example of picturesque staffage. Seddon recorded his sense of the decline of the Holy Land under Arab rule, claiming that the current inhabitants of the region lacked the work ethic that, in Jewish times, had made Jerusalem 'the garden of the whole earth'.[71] This Western orientalist trope of Arab degeneracy, discussed extensively by Edward Said, becomes more complex when Seddon's own appearance in Arab garments is considered.[72]

Following the manner of his mentor Brown, Seddon laboured fastidiously on the painting, working up to eleven hours a day for 120 days – affirming the difference between his identity as an English Protestant and that of the slumbering and negligent shepherd. This was artistic toil as religious observance: the act of looking and recording became one of faith. The intense, arid finish reveals a fervent desire to record the scene with a cartographic level of precision, to tell the truth pure and simple. The painting was not finished when Seddon left on 19 October 1854, and he used his own sketches and photographs by James Graham to complete it.

Seddon's sudden death in 1856 was felt as a great loss, and the painting was purchased by subscription and presented to the National Gallery in 1857, the first Pre-Raphaelite painting to enter a public collection. TB

WILLIAM HOLMAN HUNT 1827–1910

The Finding of the Saviour in the Temple 1854–60

Oil on canvas 85.7 x 141
Birmingham Museums and Art Gallery. Presented by Sir John T. Middlemore Bt, 1896

The Finding of the Saviour was Hunt's major project during his first residency in Jerusalem in 1854–6, undertaken with the aim of applying the Pre-Raphaelite principle of truth to the life of Christ by setting the scene in the places and culture in which he lived. In this Hunt was following the widespread assumption concerning the 'unchanging East', where, according to one commentator, 'tradition rules all things, and two thousand years make less difference in the externals of life than two centuries in the west'.[73] As with the *Light of the World* (no.92), there was a strong evangelical dimension to Hunt's mission, for in approaching his subject in the spirit of an ethnographer, he wanted to create a more authentic and British alternative to what he considered to be redundant Catholic modes of representation. Rejecting the blanket-like draperies and generalised settings found in old-master painting, every detail of the composition was scrupulously researched, from the history of the Temple to the ceremonies of Passover, with which the depicted scene is connected. In this Hunt's aim was to use material evidence to foreground divine truth, a deliberate reversal of the rules governing conventional religious art, which maintained that a picture should be made to look unearthly in order to exemplify divine meaning.

The picture represents the scene described in Luke (2: 45–51), in which Mary and Joseph return to Jerusalem to seek the young Jesus who has gone missing and find him discoursing with the priests in the Temple. In response to his parents' concern, Jesus rebukes them: 'How is it that ye sought me? Wist ye not that I must be about my Father's business?' Extracts from the text are inscribed on the ivory slip of the frame inviting the spectator to find in the picture visual confirmation of the scriptural citations. Although the image itself stands for the Disputation (Luke 2: 46–7), in which Jesus converses with the doctors, astonishing them with his understanding and knowledge, Hunt makes the scene more of a confrontation, where the old dispensation, represented by the rabbis seated indolently on the floor clinging to their accoutrements and instruments of law, is eclipsed by the new Testament, signalled by the dynamic figure of Christ tightening his belt in anticipation of his future role. The significance of the juxtaposition is underscored by the typological symbolism that runs through the composition, from the quotation from Malachi 3: 1 on the gate of the Temple to details such as the doves, ear of wheat and Pascal lamb in the distance, all of which presage Christ's future ministry and sacrifice.[74]

In presenting the rabbis as ritualistic and sacerdotal with their prominently displayed phylacteries, Hunt was also transferring to them the very qualities that Thomas Carlyle had condemned in *The Light of the World*. In his memoir of 1905 the artist reconstructed a long dialogue, in which Carlyle criticised Hunt's

conception of Christ in *The Light of the World* as 'mere papistical fantasy' and illustrated his point with reference to the painting in the National Gallery of *Christ among the Doctors* (c.1515–30), now attributed to Bernardino Luini, which he argued similarly represented the Lord as a 'puir, weak, girl-faced nonentity'.[75] In what has been described as a deferred response to Carlyle's criticism of *The Light of the World*,[76] Hunt set out to represent Christ as a simply garbed youth poised for duty, an imperative that had led him to Jerusalem in the first place.

However, as if to reinforce the viewer's acceptance of Jesus as the Messiah, Hunt shows, seated amid the rabbinical group, a young scholar looking up from his scroll and gazing intently at Christ as if in recognition of his preternatural qualities. This act of looking stands out against the blind servitude to scripture conveyed by the other figures, in particular the 'old half-imbecile blind man',[77] as Stephens describes him, hugging the Torah (an allusion to the blindfolded personification of Synagoga in medieval church art[78]). In the young scholar Hunt stresses the possibility of conversion through the evidence of the eye alone, a visual corrective perhaps to what he considered to be the failed British mission in Jerusalem, which had abandoned its directive of converting the local Jews.

In order to establish the authenticity of the scene, Hunt had determined to employ only Jewish models, an objective that proved difficult due to tensions between Jewish leaders and Protestant missionaries in the city, which made locals reluctant to participate in the artist's undertaking. Hunt disapproved of the official Protestant mission, which he found rather corrupt and non-committal, but worked closely with Anglo-Jewish philanthropists to secure sitters. Even so, the frustrations were enough to make him complete much of the painting in London in 1856, where it was easier to recruit appropriate models. The figure of Mary was thus based on Mary Ada Mocatta, wife of Frederic Mocatta, who had assisted Hunt in Jerusalem, while Jesus was composed from Jewish and Christian youths including the Eton schoolboy Cyril Flower (see no.168). Hunt also resolved the design for the Temple in London, basing it on Owen Jones's replica at the Crystal Palace at Sydenham of the late-fourteenth-century Moorish Alhambra at Granada. While such anachronisms would seem to compromise his quest for truth, Hunt himself was prepared to accept more than a degree of latitude in interpretation in order to accentuate the drama of the encounter and the underlying theme of conversion.

The artist's overall approach certainly paid off, as this was his first commercial hit and a picture that succeeded in introducing his new critical way of presenting the Bible to a broad public. It was paid for in instalments by Ernest Gambart for the unprecedented sum of 5,000 guineas, including copyright, and exhibited at the dealer's German Gallery on New Bond Street in 1860, accompanied

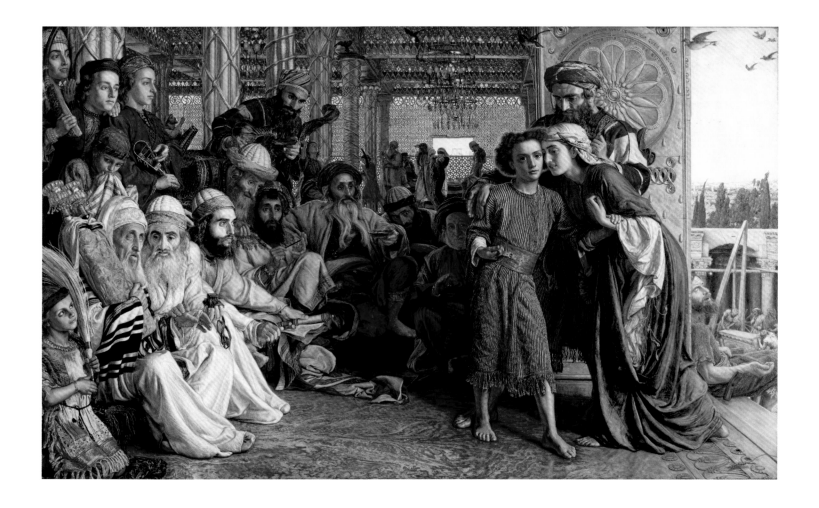

by a long pamphlet enumerating the complex details of the composition written by Stephens, apparently with Hunt's sanction.[79] Between 1863 and 1868 the picture toured the provinces, allowing Gambart to recoup his investment through exhibition fees, catalogue sales and the engraving, which came out in a large edition of 13,000 in 1867 together with the key plate devised by Hunt. By exhibiting outside the RA, the artist was thus able to control interpretation, especially as the majority of critics followed Stephens's lead in presenting the work as a singular endeavour in advancing a new rational kind of religious art. AS

WILLIAM HOLMAN HUNT 1827–1910
The Scapegoat 1854–6

Oil on canvas 86.5 x 139.9
National Museums Liverpool, Lady Lever Art Gallery

Hunt's extraordinary painting of *The Scapegoat* was undertaken with the aim of reconciling scientific realism with spiritual and prophetic meaning, in keeping with the artist's mission of affirming the continued presence of Christ throughout human history. Much of the background was painted in November 1854 on location in the desolate Sabkha or salt-incrusted shallows at the narrow end of the Dead Sea south of Jerusalem, which had recently been identified as the site of the ancient city of Sodom, a place cursed by God in the Bible for the abominable practices of its inhabitants. The rest of the composition was finished in Jerusalem, where Hunt posed a rare white species of goat in a tray filled with salt crystals and mud brought back from the region. The picture was first exhibited at the RA in 1856, accompanied by a long note in the catalogue making clear the artist's purpose of recasting a traditional Jewish theme as Christian allegory. Quoting Leviticus 16, this describes the annual rite of atonement performed on Yom Kippur, in which two goats were selected to expiate the transgressions of the Israelites. While one was sacrificed in the Temple, the other was cast into the wilderness bearing the sinful burden. According to the Talmud, a symbolic fillet of red wool was tied around its horns, and a portion of this retained by the high priest in the Temple in the belief that, were the propitiation accepted, the band would turn white in the heat of the sun, in fulfilment of the promise in Isaiah 1: 18: 'Though your sins be as scarlet, they shall be as white as snow: though they be red like crimson, they shall be as wool.'[80]

In Hunt's painting the goat, marked by a bloody handprint on its head, is shown expiring with the close of day as it staggers across the unforgiving salty terrain, its tongue parched and its eyes drooping with exhaustion. The red band (which has not yet turned white) symbolically doubles up as an emblem of the crown of thorns placed on the head of Christ before his death in atonement for the sins of those who rejected him. The fulfilment of prophecy suggested by this typological sign is reiterated on the frame Hunt designed to complement the picture with its two biblical inscriptions (from Isaiah 53: 4 and Leviticus 16: 22) making clear the parallel between the sacrifice of the goat and the Passion of Christ. Together with the decorative emblems carved into the frame (the seven stars, dove holding an olive branch, heartsease and seven-branched Menorah), these citations also relay the didactic message of the painting, which, as Hunt explained in a letter to Millais, was intended as 'a means of leading any reflecting Jews to see a reference to the Messiah as He was, and not (as they understand) a temporal king'.[81] As with the *Temple* picture (no.101), the theme of the conversion of the Jews to Christianity formed an important subtext to the painting, an idea that eventually led Hunt to embrace Restorationism – the belief that the return of the Jews to Palestine would coincide with the return of the Messiah – as a key tenet of his evangelicalism.[82]

The setting of the *Scapegoat* was central to Hunt's mission,

enabling him to affirm that, because the visible world was redolent with prophetic meaning, it was his religious duty to paint the world exactly as it appeared. The site of Oosdoom, inscribed on the bottom left of the picture as was Hunt's practice in earlier pictures, was thus selected by the artist as much for its unique geological features as for its biblical associations, allowing him to represent with verisimilitude the little efflorescences of crystallised salt that characterise the area, together with the patterns of horizontal banding on the mountain range of Edom in the distance. Cast in the lurid glow of sunlight, these details assume an eerie quality suggestive of torment or an apocalyptic landscape, ideas accentuated by the skeletal remains of other species surrounding the goat, which indicate its fate together with that of the inhabitants of the damned cities of the plain. In the reduced version of the composition (fig.17), commenced on Hunt's first visit to the Dead Sea in October 1854, the artist included a rainbow as a symbol of God's covenant with Noah but rejected this feature in the larger painting as introducing too optimistic a note into an otherwise barren scene.

When the larger version was exhibited back in London, the deeper meanings intended by Hunt's naturalistic symbolism were not easily apprehended by his audience. This was because the painting was most unusually representing an animal that also demanded to be taken seriously as a religious image. For many reviewers it seemed as if the artist was confusing the boundaries of history and animal painting, there being few precedents for this kind of image, apart from Bible illustrations. Moreover, the excessive realism of the setting was regarded as a barrier to interpretation, preventing the transformation of the goat into what it was supposed to signify: as the *Athenaeum* put it, 'the goat is but a goat, and we have no right to consider it an allegorical animal'.[83] Successive commentators have tended to abide by this point with the consequence that the painting has been noted more for its bizarre science-fiction qualities than admired for the prophetic readings that inspired its novel iconography.

Nevertheless, despite the work's challenging symbolic scheme, Hunt's audience was full of praise for his resolve in seeing through the creation of the work in challenging circumstances. This avowedly imperial dimension to his endeavour came to inform the artist's own subsequent narrative of how he completed the painting.[84] Repressing the anxieties he experienced on his travels, together with the strong feelings of sexual guilt and disgust set down in his diaries and letters of the time, Hunt projected the persona of a manly and intrepid explorer venturing into the unknown in his later autobiographical writings.[85] This image is epitomised in a photograph taken around 1895 that shows the artist re-enacting the painting of the *Scapegoat* in his back garden with paint brush in one hand and gun in the other (private collection). AS

Fig.17 William Holman Hunt, *The Scapegoat*, 1854–5, oil on canvas, 33.7 x 45.9. Manchester City Galleries [Washington only]

HENRY WALLIS 1830–1916
The Stonebreaker 1857

Oil on panel 69 x 82.2
Birmingham Museums and Art Gallery. Bequeathed by Charles Aitken, 1936

The Stonebreaker was possibly conceived as a pendant to Wallis's *Chatterton* (no.45), the theme of the artist in the past suffering through neglect complemented by the tragedy of the rural labourer in contemporary society. It was first exhibited at the RA in 1858 where John Brett coincidentally presented his picture of a young stonebreaker (fig.16) in a bright, mimetically detailed landscape. At this time the job of flint-knapping for the repair of roads in rural areas was regarded not so much as an occupation as a form of relief for paupers so desperate to receive workhouse food and shelter that they were prepared to take on what was widely perceived to be a dehumanising task. Despite criticisms of the Poor Law Amendment Act that sanctioned the employment of the destitute in this way (thereby discouraging other forms of relief), little had been done to ameliorate the situation since the legislation was first introduced in 1834.[86]

In adopting the subject, it is likely that both Wallis and Brett were aware of Gustave Courbet's controversial *Stonebreakers* (destroyed), exhibited at the Paris Salon in 1851 and then in the artist's 'Pavilion of Realism' at the *Exposition Universelle* in 1855, where it was seen by William Michael Rossetti. In a review of this exhibition in the *Spectator* Rossetti criticised Courbet for his defiant factual approach, setting it against the more inventive methods of the Pre-Raphaelites.[87] Inspired perhaps by Rossetti's words, Wallis exhibited his picture without a title but with the opening line of Tennyson's poem 'A Dirge' (1830) inscribed on the (original) frame: 'Now is done thy long day's work.' While this established the elegiac mood of the picture, the long quotation from Carlyle's *Sartor Resartus* (1833–4) that accompanied the painting in the Academy catalogue invited the viewer to read the image as a homage to the toil-worn labourer:

> Hardly-entreated Brother! For us thy back was so bent, for us were thy straight limbs and fingers so deformed: thou wert our Conscript, on whom the lot fell, and fighting our battles wert so marred. For in thee too lay a god-created Form, but it was not to be unfolded: encrusted must it stand with the thick adhesions and defacements of labour; and thy body, like thy soul was not to know freedom.

Against a glowing twilight landscape an adult male labourer is shown to have expired with the passing of day, as suggested by the quotation from Tennyson. His pick has dropped from his hands onto a pile of stones as his head slumps on his chest. Not even the movement of a stoat near his foot disturbs the figure's immobile form, which blends with the surrounding vegetation as the light fades from the scene, its final rays illuminating a patch of moss on a hillock. The man wears the smock of an agricultural labourer, which implies that he was once employed on a farm before being compelled to become a stonebreaker. However, the melancholy mood of the painting tempers the accusatory tone of Carlyle's text and its bitter condemnation of the waste of fully formed flesh through exploitative labour. In universalising the sentiment, it would seem that Wallis was eliciting sympathy from his largely middle-class audience rather than alienating them, as Rossetti felt Courbet had done with his rendition of the theme. The *Daily News* thus described the figure of the labourer as 'the model peasant, victim of social mistakes', while the *Morning Star* went so far as to suggest that the picture should be hung in the boardroom of a metropolitan workhouse.[88] Others, however, found the theme unduly provocative, and in marked comparison to the above comments, *The Times* complained that the subject was improbable at a time when more had been done to assist the poor than at any period of British history.[89] In his diary Edward Lear abruptly dismissed it with the words 'I do not like at all'.[90] AS

JOHN RODDAM SPENCER STANHOPE 1829–1908

Thoughts of the Past 1858–9

Oil on canvas 86.4 x 50.8
Tate. Presented by Mrs F. Evans 1918

Thoughts of the Past, exhibited at the RA in 1859, belongs to the early Pre-Raphaelite phase of Stanhope's career. It was painted in the studio he occupied on the ground floor below Rossetti's lodgings at 14 Chatham Place, Blackfriars, and was likely to have been influenced by the latter's *Found* as well as Hunt's *Awakening Conscience* (nos.97–8). In his diary for 21 June 1858 George Price Boyce recorded: 'Went into Stanhope's studio to see the picture[s] he is engaged with of an "unfortunate" in two different crises of her life'.[91] Another picture that Boyce probably refers to here is *Robins of Modern Times* of c.1857 (private collection), a rural scene symbolising seduction and loss of innocence.[92] Boyce also mentions seeing the present picture on a subsequent visit of 16 December that year: 'Called on Stanhope. He was painting on his picture of a gay woman in her room by side of Thames at her toilet. "Fanny" was sitting to him.' Rossetti took up with Fanny Cornforth in 1858 and used her as a model for the head of the woman in *Found*. Although the face of the prostitute in Stanhope's painting bears little resemblance to Cornforth's physiognomy (the pose and features actually share greater affinities with Rossetti's drawings of Elizabeth Siddall), there is no reason to doubt Boyce's account that Cornforth also sat for Stanhope at this time.

The painting shows a prostitute in a nightgown and wrapper standing forlornly by a window in her shabby lodgings by the Thames as she brushes her hair, the auburn colour of which invites association with Mary Magdalene, the archetypal remorseful harlot. On the wall hangs a man's Algerian cloak or burnous, overlaid with a crochet lace collar, the latter suggestive of a pretence of respectability on the woman's part.[93] The view looks upriver along the polluted Thames (1858 was the year of the Great Stench) to Waterloo and Hungerford Bridges, places that bring to mind Thomas Hood's tragic poem, 'The Bridge of Sighs', of 1844 and its motif of the fallen woman plunging to a muddy death. As with Hunt's *Awakening Conscience*, the room is filled with signs that convey the girl's predicament. Poverty and exploitation are communicated by the cracked window panes, the torn curtains and broken veneer of the table covered with her meagre possessions – scissors, an Indian rosary, a scarf and hair pins. The few coins on the table are presumably her derisory payment from a client whose impending departure is signalled by the man's glove and walking stick on the floor. Tucked in the frame of the mirror, which reflects a worn-out paisley shawl hanging from a bedpost, is a recently opened letter, a trigger perhaps for her present emotional state, which from the plants and scattered posy on the floor the viewer is invited to interpret in terms of early attachment (the thornless rose on the left), faithfulness (wilting violets) and sadness (primroses).

Although these various signs would seem to reinforce the standard view that the prostitute was in essence a social victim,[94] the absence of any scriptural backing leaves the image more open-ended than in Hunt's or Rossetti's pictures. Thus, while the painter's niece, A.M.W. Stirling, could write of a force of 'great despair' in the figure – 'even the strenuous grip of her hand upon the brush bespeaks the torment of remembrance'[95] – it is not entirely clear whether the prostitute is actually repentant or not, whether she will overcome her poverty and isolation or whether she is doomed to perish like the feeble plants struggling to reach the light at her side. A study for the painting in the Tate collection (fig.18) presents the woman turning more towards the window with her eyes raised as if in prayer or martyrdom. In the finished picture the expression is more ambiguous, suggesting willpower and determination as much as hopelessness and despair. AS

Fig.18 John Roddam Spencer Stanhope, *Study for Thoughts of the Past*, c.1859, pen and ink on paper, 61 x 31.8. Tate. Presented by Mrs Evelyn de Morgan 1917

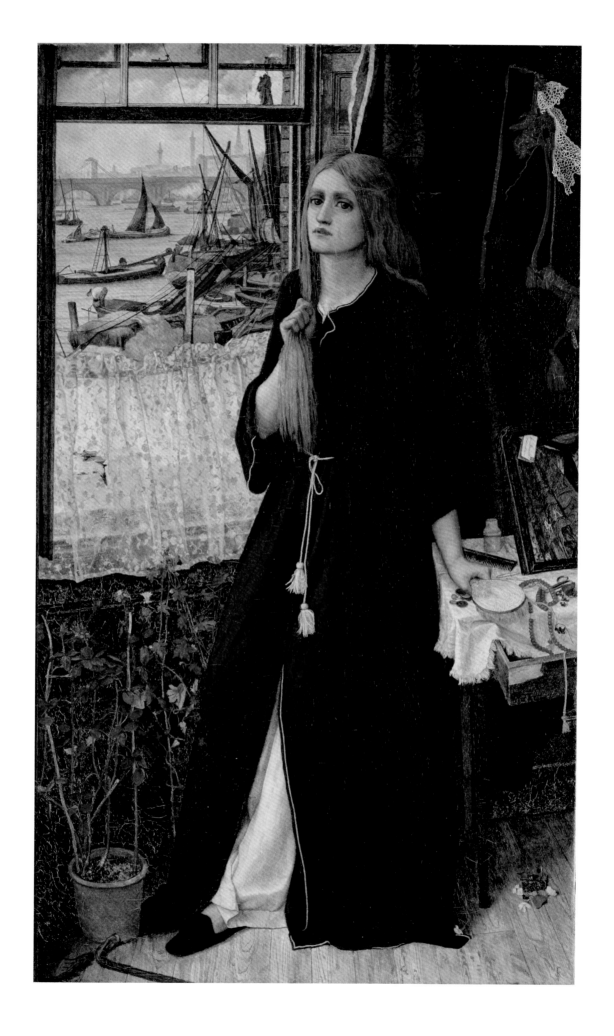

105

FORD MADOX BROWN 1821–93 (designer); MORRIS,
MARSHALL, FAULKNER & CO. (maker)

Washstand c.1860

Painted wood, originally stained 88 x 93 x 63
Society of Antiquaries of London. Kelmscott Manor Collections

106

FORD MADOX BROWN (designer); MORRIS,
MARSHALL, FAULKNER & CO. (maker)

Towel horse

Painted wood 106 x 92.5 x 71
Society of Antiquaries of London. Kelmscott Manor Collections

107

Lidded tankard

Grès de Flandres stoneware with pewter lid 22.5 (high)
Society of Antiquaries of London. Kelmscott Manor Collections

105

106

Brown was known to have experimented with furniture design before the establishment of the Firm in 1861, being an early advocate of the idea, which Morris was later to expound in *The Lesser Arts* of 1878, that the decorative arts should be equally ranked alongside fine-art production. Brown fell out with the Hogarth Club over this very issue when he was not allowed to display furniture at its 1859 exhibition. Although he went on to become a designer for the Firm, most of his pieces were made specifically for his own use or for that of friends, which explains why so few objects can be attributed to him today. The writer of an anonymous article in *The Artist* maintained that Brown was himself enough of a socialist to consider that 'what was good enough for an artisan's house was fit for his own',[96] which helps explain why the furniture he designed tended to be spartan and well constructed, typifying the artist's ideal of unpretentious artisan existence, as described by E.M. Tait in the *Clarion*:

> Madox Brown held that utility and simplicity were the two desiderata for domestic furniture, united with solidity of construction; Veneer, so beloved of the philistine in early Victorian days, was abhorrent to him. 'Let us be honest, let us be genuine, in furniture as in aught else' was his motto. 'If we must needs make our chairs and tables of cheap wood, do not let them masquerade as mahogany or rosewood; let the thing appear that which it is; it will not lack dignity; if it only be good of its kind and well made.'[97]

Although this washstand and towel horse exemplify Brown's notion of honest plebeian furniture, they were actually made for Red House, respecting the vernacular style of that building, before being transferred at a later date to Kelmscott Manor. A drawing by Hanslip Fletcher, dated 1899, shows the washstand in Morris's bedroom at Kelmscott by the window with a Grès de Flandres bowl and jug resting on its ledge. The addendum to May Morris's will of 17 June 1939 also suggests that Grès de Flandres (of which Morris was an avid collector, there being over thirty pieces at Kelmscott) would originally have been used with the washstand.[98] Indeed, the

simple bold design of this blue and grey stoneware would have suited both Brown's and Morris's conception of that for a traditional labourer's dwelling. The furniture itself has been described as being of a severe feudal type, 'boarded construction, mortise, tenon and halving joints, use of pegs and dowels, chamfering and heavy section wood'.[99]

The washstand has a wide boarded top with an opening for the basin and a splashback, and rests on a hinged cupboard with holes for ventilation supported by sturdy, slightly splayed legs. The rail horse also has splayed legs strengthened by a cross bar. At the top triangular side pieces are pierced to hold three rails, the uppermost extending to complement the wide board of the washstand. Both items are painted green, although according to the article in *The Artist*, they were originally stained in a green finish of Brown's own devising to disguise the grain of the wood employed in their construction.[100] In 1865, just a few years after the furniture was made, the Firm's new manager, Warrington Taylor, recommended that this practice be discontinued in favour of retaining a natural wood finish, due to difficulties in removing water marks from stained furniture. AS

107

WILLIAM DYCE 1806–64
The Man of Sorrows 1860

Oil on board 34.9 x 48.4
Scottish National Gallery, Edinburgh. Purchased with the aid of the National Heritage Purchase Grant (Scotland) 1981

Dyce exhibited this quietly sublime work at the RA in 1860 along with *Pegwell Bay* (no.82) and *St John Leading Home his Adopted Mother*, a picture of 1844 revised in 1851 (Tate). It illustrates lines included in the Academy catalogue from the poem, 'Ash Wednesday' (1827), by Dyce's friend, the Tractarian leader John Keble. The poem addresses the needs of Christians to be steadfast as they begin Lent and to resist temptation in their lives. The quoted lines are the only reference to Christ's experience in the poem:

As, when upon His drooping head
His Father's light was pour'd from heaven,
What time, unsheltered and unfed,
Far in the wild His steps were driven,
High thoughts were with Him in that hour,
Untold, unspeakable on earth.

Christ with bowed head endures with humility his forty-day and forty-night fast in the wilderness, a rocky expanse of Scottish scenery presented as a stand-in for the desert of Judea. In terms of the face and garments, Dyce offered a traditional image of Jesus, as opposed to the novel type promoted by Hunt and Millais. F.G. Stephens in his *Athenaeum* review took issue with such pictures, wondering why Dyce did not paint the Holy Land as the setting.[101] But, as Marcia Pointon has noted, Dyce, 'as an extremely active and articulate High-Churchman, believed in a contemporary Christ',

and his 'deliberate presentation of biblical characters as very human and as existing in a physical environment described in concrete detail is essential to his theological interpretation of his subject and is not a means of evoking the ethos of an earlier style of art'.[102] And, as Michaela Giebelhausen has explained, it differs greatly from Hunt's conception of Christ, as seen in *The Finding of the Saviour in the Temple* (no.101), which was on view at the German Gallery, New Bond Street, at the same time that Dyce's work was visible at the RA.[103] Ultimately, in Dyce's conception Christ's contemplation is innately connected to the British viewer through an expansive, explicated and familiar landscape – and this well reflects Keble's poem, whose focus is on the trials of worshippers.

Dyce's small biblical landscapes of this period represent a shift in style from more broadly painted natural scenes, with little figures, to works in which the characters play a larger role and the details have a Pre-Raphaelite intensity. Dyce had toured Arran in 1856 and 1859 and sketched out of doors, which seems to have had an effect on his approach, as did seeing the works of Millais, Hunt, Inchbold and Brett. The symbolic naturalism in his religious pictures of this period subsequently bounced back to influence a Pre-Raphaelite: Millais and his scenes for Dalziel's *Bible Gallery* (no.113) with their exquisite backgrounds based on Highland scenery. JR

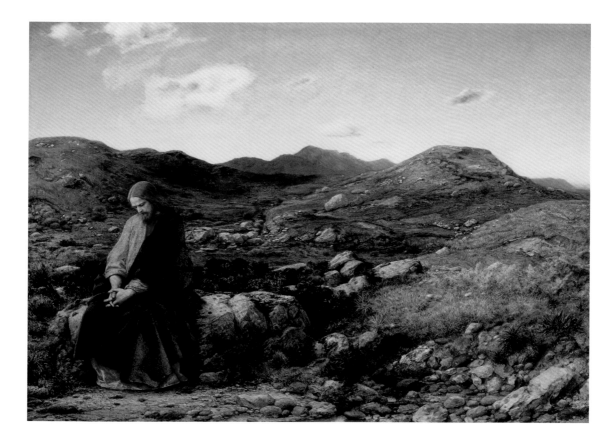

WILLIAM HOLMAN HUNT 1827–1910
The Children's Holiday 1864

Oil on canvas 210.2 x 146.1
Torre Abbey, Torquay

WILLIAM HOLMAN HUNT
Thomas Fairbairn Esq. 1873–4

Oil on canvas 121 x 98.7
Private collection

In these two works Holman Hunt exceeded portraiture's normal task of chronicling the appearance and character of individuals, choosing instead to represent an entire social class. He depicted the industrial bourgeoisie, the 'Captains of Industry' whom Thomas Carlyle had described as being 'almost Captains of the World'.[104]

Thomas Fairbairn owed his prominent position in the engineering industry to the extensive achievements of his father, Sir William Fairbairn. A distinguished collector of art, administrator of exhibitions and supporter of design reform, Thomas Fairbairn married Allison Callaway, the daughter of a surgeon, in March 1848.[105] Fairbairn had already made some tentative steps in art collecting when, at the Royal Academy exhibition of 1853, he noticed Holman Hunt's paintings, including *Our English Coasts, 1852* (no.71). An open commission followed, brokered by the Oxford patron Thomas Combe, and after some negotiation Fairbairn purchased Hunt's *Awakening Conscience* (no.98) in 1854. He also acquired *Valentine Rescuing Sylvia from Proteus* (no.34) in 1855 and lent it to the ground-breaking Manchester Art Treasures exhibition of 1857, of which he was the chairman. That exhibition, he believed, displayed 'the public spirit and earnestness of a single and a provincial community'.[106]

Fairbairn seems to have subscribed to social values and aesthetic tastes emblematic of his class and era. The two paintings he commissioned directly from Holman Hunt articulate brilliantly the 'separate spheres' accorded to women and men by the conventional ideology of the day. In 1861 Fairbairn and his family moved from Manchester to 23 Queen's Gate, London, near the growing South Kensington Museum, and acquired a country seat, Burton Park, a neo-classical pile in Sussex. If this suggested an attempt to emulate an aristocratic lifestyle, *The Children's Holiday*, which depicts the grounds at Burton Park and was probably destined to hang on its imposing staircase, is an emphatic statement of bourgeois values. The monumental figure of Allison Fairbairn is seen as the epicentre of domesticity; she is portrayed as a wife and mother, ruling over the home as John Ruskin elaborated in the second lecture, 'Of Queen's Gardens', in his *Sesame and Lilies*.[107] Such a figure is the very opposite of the idle, sensuous and aestheticised woman featured in Hunt's *Il Dolce far Niente* (no.121). Mrs Fairbairn is about her business, politely pouring tea. The opulent circumstances of the family are made very clear through Hunt's fastidious enumeration of the possessions, which have been carried out into the garden by the Fairbairns' servants. The heavy chair and table, the Russian samovar, and the tea service and china are newly purchased commodities in the latest style, objects of the kind that Thomas Fairbairn would have inspected as a juryman on the committees of the International Exhibitions of 1851 and 1862. Mrs Fairbairn's magnificent dress, with crinoline, gives every impression of awkwardness despite its opulent sheen. An Indian

shawl, admired for its colour values and fine workmanship, is wrapped protectively around her.

As Caroline Arscott has noted, this dress seems to insist on the purity and sanctity of her body – the guarantee of the family's wellbeing – in contrast to the loose undergarment worn by the kept woman in *The Awakening Conscience*, also owned by Fairbairn.[108] The two poles of Victorian womanhood, as understood in the advice books and journalism of the period – chaste wife and prostitute – were vividly characterised by the two works Hunt sold to Fairbairn.

Thomas Fairbairn is seen alone in the male sphere of work, not the labour of making money, but philanthropic, cultural endeavour. In a highly unusual portrait Fairbairn appears not in his home but in a public institution, the South Kensington Museum, with whose administration he was connected. He is seated in its North Court, one of the most spectacular museum spaces in Britain, designed by the military engineer Captain Francis Fowke and completed in 1862. It was an ingenious structure with large glass roofs, effective temperature controls, gas lighting and a huge space for the display of objects in specially designed cases.[109] In Fairbairn's portrait these contain the museum's outstanding collection of ceramics. The intention of the Director, Sir Henry Cole, was that the museum would serve as a resource for artisans and industrial designers, raising standards both of taste and profitability.[110] Fairbairn provided an essential link between the metropolitan design reformers and the northern industrialists. Believing that the display of great works of art from the past could improve the quality of design and production in the present, he collaborated with Cole in the acquisition of Jules Soulages' collection of medieval and renaissance decorative arts.[111]

Fairbairn is shown in this portrait not as a family man but as a public figure and benefactor of the nation. His looming, bulky pose, corpulent body and self-confident stare suggest both prosperity and a certain menace. And indeed, Fairbairn's wealth was not acquired without cost. In 1852 he had been the ringleader and, under the pen name 'Atticus', the public voice of a cartel of Manchester industrialists dedicated to the destruction of the fledgling union, the Amalgamated Society of Engineers. After a lockout lasting four months and involving 'every important engineering establishment in Lancashire and the Metropolis',[112] the exhausted union, its members starving, was shattered, with lasting social consequences. The workmen's journal *The Operative* simply noted that 'from this time forward the connection that has hitherto existed between us and our employers has been severed for ever'.[113]

Hunt's portraits of the captain of industry, and his wife and family, especially when triangulated with *The Awakening Conscience* and the commentaries of Fairbairn's employees, offer a strikingly candid and revealing image of the Victorian middle class. TB

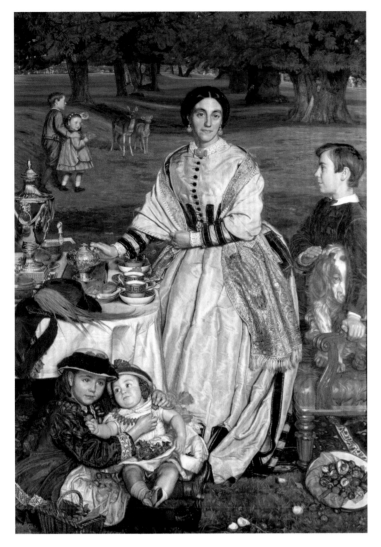

109

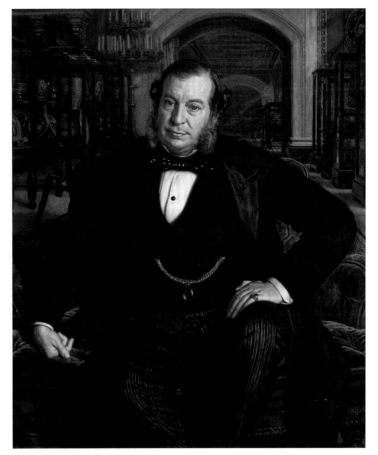

110

FORD MADOX BROWN 1821–93

The Coat of Many Colours (Jacob and Joseph's Coat) 1864–6

Oil on canvas 108 x 103.2
National Museums Liverpool, Walker Art Gallery

This picture derives from a design Brown devised in c.1863 for the *Dalziels' Bible Gallery* (published 1881). The artist had the idea of developing it into an oil painting and offered his proposal to George Rae, who agreed to underwrite the commission for the present picture in 1864. Brown went on to produce two other versions of the subject in watercolour (1867; Tate) and oil (1868–71; Museo de Arte de Ponce, Puerto Rico).

The subject is taken from Genesis 37: 32. Envious of their father Jacob's preference for Joseph and hating him for his self-aggrandising dreams, Joseph's brothers conspire to be rid of him. Having stripped him of the coat of many colours given to him by Jacob, they sell him to a company of Ishmaelites (Arabs whom the Book of Genesis describes as descending from Ishmael, the elder son of Abraham) travelling to Egypt. They then kill a young goat, dip the coat in its blood and present the soiled garment to Jacob saying: 'This have we found: know now whether it be thy son's or no.' In the painting the diagonal line of the tent serves to separate the guilty party from the innocent family members nestled under the protective shade of a fig tree. Exposed in the full light of the sun, the duplicitous nature of Joseph's brothers is made apparent to the viewer. Victorian viewers, familiar with ethnographic theories of race and phrenology's belief that the shape of the head revealed moral qualities of the individual, would have perceived that Levi's simian features and low forehead disclose his criminal nature as he addresses his father. Simeon stands stiffly upright clutching his straw sandals in his hands in pretence of deference to the patriarch, while Judah sneakily observes the impact of his brother's words and 'the fool [Issachar] sucks the head of his shepherd's crook and wonders at his father's despair'.[114] Elevated on a dais in a shadowy recess of the composition, Jacob rents his tunic out of grief as his youngest son Benjamin intently examines the evidence and his granddaughter gazes with hostility at her uncles, her suspicions confirmed by the sheepdog that sniffs

at the blood clearly recognising it as not being of human origin. The feet that dangle above Jacob's head on the step of a ladder – a reference to the dream he had of angels ascending and descending a ladder (Genesis 28: 12) – is both a naturalistic means of referencing this event and a way of inferring that Jacob has been deceived. In this sense he forms a parallel to Lear, who is similarly duped by his elder offspring as shown in *Cordelia's Portion* (1866–72; Lady Lever Art Gallery), a work Brown also offered to Rae in 1863.[115]

Unlike Hunt, who had advanced a complex symbolical form of religious painting, Brown regarded the Bible merely as a branch of literature or history. He thus did not deem it necessary to travel to the Holy Land but, in keeping with the recommendations set out in his essay 'The Mechanism of a Historical Picture' published in *The Germ* in February 1850, consulted books and objects in the British Museum in order to establish a sense of authenticity. He borrowed African robes from Rossetti and used Seddon's watercolour *The Well of Enrogel* (1854; Harris Museum and Art Gallery, Preston) as a model for the distant landscape.

The painting was first exhibited at Ernest Gambart's French Gallery on Pall Mall in 1866 where it met with a mixed response. The *Art Journal* described it as 'spasmodic and sensational' while praising its realism and deep-toned harmonies of colour.[116] F.G. Stephens meanwhile expressed his disgust at the 'horny yellowness' of colour, the 'ultra-grotesque' actions of the dog and the 'uncouthness' of the idea of the feet in the upper left corner.[117] Rae, the picture's first owner, was understandably more enthusiastic, describing the picture as the artist's greatest work to date and stating his hope that Brown would henceforth devote himself to biblical and Shakespearean subjects.[118] On his recommendation the artist carried out a number of revisions to the design including making the figure of Simeon appear more oriental with dark instead of blond hair. AS

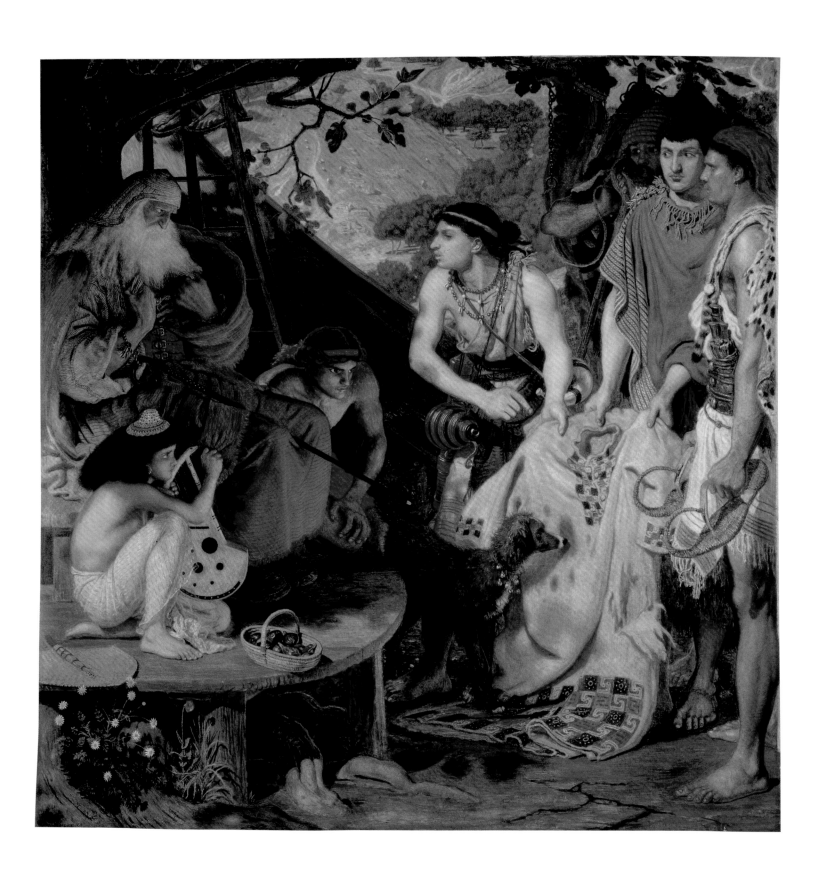

WILLIAM HOLMAN HUNT 1827–1910
The Shadow of Death 1870–3

Oil over tempera on canvas 214.2 x 168.2
Manchester City Galleries

In using a carpenter's workshop to stage a premonitory moment in the life of Christ, this painting is in many respects a reprise of Millais's *Christ in the House of His Parents* (no.85). However, Hunt took the Pre-Raphaelite quest for authenticity one step further by locating his scene in the actual places where Jesus had lived and worked, paying particular attention to capturing the poetic light effects peculiar to late afternoon. The subject was conceived in Italy in 1869 while the artist was reading Ernest Renan's *Vie de Jésus* (first published in 1863), and was largely executed in Bethlehem, Nazareth and Jerusalem in 1870–2. Although Renan's historical account of Christ, inspired by his sojourn in the East, had proved controversial in presenting Jesus as a historical rather than a divine figure, it had strengthened an emphatic vein of scepticism in Broad Church circles. Therefore, in stating that his picture was fitted 'for the Renan class of thinkers … with not a single fact of any kind in it of a supernatural nature',[119] Hunt was effectively asserting that the sober representation of material data was the valid and Protestant way of approaching God in modern times. However, mindful that he might be accused of blasphemy in daring to represent Christ merely as a carpenter, Hunt set out to bestow the mundane objects in his picture with divine significance through association with the Passion of Christ.

According to Renan, there was nothing humiliating in Jesus following the trade of his father, the Jewish custom requiring 'that a man devoted to intellectual work should learn a handicraft'.[120] Hunt appears to respect this idea by showing Christ stretching out his arms in prayer and fatigue at the end of a long day in the workshop. The cruciform pattern of his shadow is cast on a plank bearing tools on the wall, the red weight of a plumb line falling on the exact position of his heart in the shadow. This premonitory sign is recognised by Mary, who is shown kneeling with her back to the spectator and looking up at the wall from her position on the floor, where she is opening a casket laden with the gifts of the Magi. As if the chest were Pandora's Box, the act of opening it symbolically unleashes the horrific image of her son's death, an idea picked up elsewhere in the composition by the red band suggestive of the crown of thorns and the reeds on the left that allude to the flagellation. Elsewhere the triumph of resurrection is symbolised by the pomegranates on the shelf and the arch of the window, which also serves as a nimbus. In attempting to reconcile the temporal with the supernatural aspects of Christ's life, Hunt sets up a tension between the vulnerable elements of the figure – seen in Jesus's naked body – and the physical presence of the objects, which as real and shadowed forms threaten to lacerate his flesh. Jesus's body is also marked out in minute detail with dilated veins and tiny hairs, features that repelled a number of viewers for disturbing their mental conception of the Saviour as well as the visual coherence of the design. The Low Church Revd Francis Kilvert thus found the picture 'theatrical and detestable', while the poet and Jesuit novice Gerard Manley Hopkins thought it contained 'no inscape of composition whatever', by which he meant that the plethora of factual detail detracted from the unity and significance of the theme.[121]

In the descriptive leaflet that accompanied the painting Hunt declared that it had been his intention to present Jesus as a Carlylean hero-worker toiling in the heat of the sun, stating that his representation of Christ as a carpenter 'furnishes an example of the dignity of labour' relevant to an era concerned with 'the duty of the workman'.[122] The inclusion of modern tools not only brought the scene into the present but was a means of targeting a working-class audience as much as the historical detail was aimed at Broad Church liberals. While the representation of Christ's tanned skin was judged 'too brown' by some, it was praised by lay ministers and clergymen of various denominational persuasions for upholding the ecumenical dimensions of Christ's ministry and his identification with the ordinary man. The sheer muscularity of Hunt's own endeavour in producing such an elaborate picture on a vast scale further served to emphasise the gospel of work through the artist's identification with Christ as a labourer.

Following the strategy used for the *Temple* picture (no.101), Hunt promoted his painting through a commercial gallery. It was sold in 1873 to Agnew's, together with the oil sketch and copyright for the engraving, for the enormous sum of £10,500, which was paid in instalments. The publicity generated by the first exhibition of the work at the company's London gallery that year created a vast market for the engraving, which came out in an edition of 4,000 in 1878. The profits from print sales were so big as to encourage Agnew's to present the painting to Manchester Art Gallery in 1883, by which time it had been exhibited in London and the English provinces as well as New York and Boston, and celebrated worldwide as 'the greatest Christ that Protestant art has attained to'.[123] AS

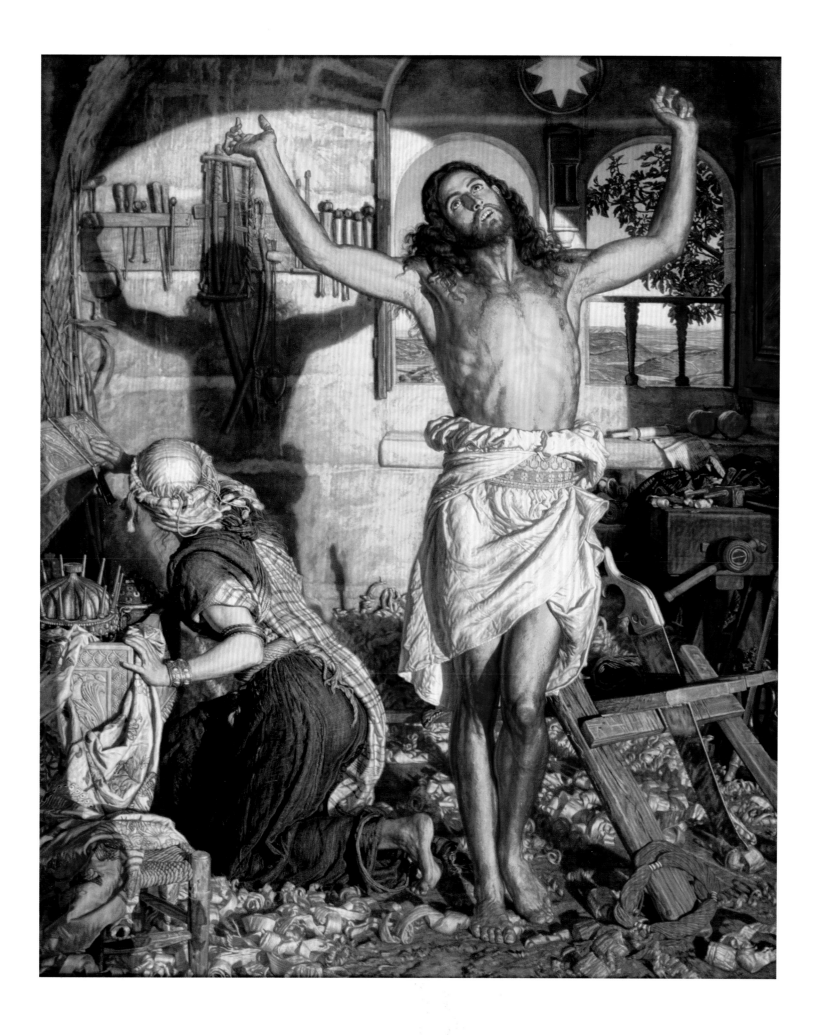

JOHN EVERETT MILLAIS 1829–96

The Prodigal Son, illustration from *The Parables of Our Lord and Saviour Jesus Christ* 1864

Pub. Routledge, London

Wood engraving by the Brothers Dalziel 14 x 10.8
Tate. Presented by Gilbert Dalziel 1924

In 1857 Millais accepted a commission from the Brothers Dalziel to produce thirty drawings to serve as the basis for engravings illustrating a book on the Parables of Jesus, which was to be published by Routledge the following year. Due to other pressures and commitments, Millais took a long time completing the designs and it was not until 1864 that the publication was issued with the twenty illustrations he was able to deliver. The book was priced at 1 guinea, which lifted it out of the popular market, and sales remained low in comparison to the single-sheet engravings after Hunt's religious works, which were priced so as to reach a broad demographic. However, early in 1863 twelve of the engravings had been published in monthly intervals in the popular journal *Good Words*, accompanying a series of articles entitled 'The Parables in Light of the Present Day' by the Revd Thomas Guthrie, which brought some of the images to a wide audience and lent them a topical dimension.

The Parables told by Jesus in the Gospels were simple word-pictures aimed at helping people understand, through the details of everyday life, the hidden nature of God. They were an important mainstay of Church teaching, often featuring in sermons to illustrate a moral or doctrinal point. In commissioning Millais, the Dalziels recognised that he both possessed the skills of narration necessary for elucidating the substance of the stories and could be relied on to treat each subject in an understated manner with clarity and dignity, avoiding the didactic overtones or idealising conventions of traditional biblical art. Eschewing the hidden meanings and ancient customs without which many of the Parables would have appeared obscure or even cruel to modern readers, Millais focused on the human appeal of each tale, paying close attention to psychology and characterisation. In his depiction of the Parable of the Prodigal Son (Luke 15: 11–32) the narrative is encapsulated in the moment when father and son embrace in forgiveness and repentance, the theme of unconditional love brought out by the tender play of hands and the heads of the two figures that nestle against each other. Unlike Hunt, who at this time was seeking authentic locations and models in the East for his biblical paintings, Millais opted to situate his scenes in the landscape that surrounded his wife's family home in Perth, hence the round cattle shelter and evergreens distinct to the region that slightly jar with the vaguely oriental dress of the protagonists. In so doing, he came close to Dyce in *The Man of Sorrows* (no.108) in advocating the accurate, albeit anachronistic, depiction of a familiar environment to underscore his theme. At the same time,

Millais drew on an image of the Deposition in Albrecht Dürer's *Small Passion* series (1511) that was consistent with the style of his earlier Pre-Raphaelite works.[124]

Reviewing the illustrations in *Good Words*, the *Athenaeum* felt that Millais had not been consistent either in adopting a strict historical naturalism throughout the series or in making the drawings appear uniformly modern in feeling.[125] Millais himself was aware of what he described as 'the difficulty of giving agreeable reality to sacred subjects', and subsequently came to regret that the emphasis on material data over inner truth in the modern world had deprived religious art of the poetry that had sustained it in the past.[126] He attempted to rectify this in a number of remarkable and mystical subjects that he painted at the end of his career. AS

FORD MADOX BROWN 1821–93

Cromwell on his Farm, St Ives, 1636 1874

Oil on canvas 143 x 104.3
National Museums Liverpool, Lady Lever Art Gallery

Oliver Cromwell loomed large in the Victorian imagination. Portrayed in the writings of Thomas Carlyle and others as a hero motivated to world-historical acts as a result of his heightened moral and religious conscience, Cromwell seemed to prefigure a particularly Victorian form of protestant masculinity. He epitomised principled, anti-establishment, avant-garde rebellion.

Ford Madox Brown chose to paint Cromwell in 1636 as a Huntingdonshire gentleman engaged in anguished self-questioning before his rise to national prominence. Brown surely identified with this phase of the Puritan leader's life, since the artist constantly adopted the position of an outsider in the art world, and his diary records his intense self-doubt.[127] The composition was begun as a drawing in 1853, a time of turbulent creativity and soul-searching for Brown, when he also produced *Work* (no.95) and *An English Autumn Afternoon* (no.74).

The frame is inscribed with two quotations that illuminate this theme. On the left the text is from Psalm 89: 'Lord, how long wilt thou hide thyself – forever? And shall thy wrath burn like fire.' On the right, a quotation from Cromwell himself, from a speech given on 12 September 1654, which Brown found in Carlyle's edition: 'Living neither in any considerable height, nor yet in obscurity, I did endeavor to discharge the duty of an honest man.'[128] Brown probably had in mind the following text from Carlyle, describing Cromwell's life at St Ives in 1636:

> A studious imagination may sufficiently construct the figure of his equable life in those years. Diligent grass-farming, mowing, milking, cattle-farming: add 'hypochondria,' fits of the blackness of darkness, with glances of the brightness of heaven: prayer, religious reading and meditation … we have a solid, substantial and inoffensive farmer of St Ives, hoping to walk with integrity and humble, devout diligence through this world … Much wider destinies than he anticipated were appointed him on earth.[129]

In 1856 Brown travelled to Huntingdon and St Ives, searching, as Carlyle had before him, for material evidence of Cromwell's life and times. There he made sketches for the current work. The composition remained as a drawing and it was not until 1873 that Brown received a commission, from William Brockbank of Manchester, to complete an oil version. Brown wrote to his friend, the radical artist Frederic Shields, that *Cromwell* was his finest work.[130]

In this dramatic composition, whose vertiginous upright format recalls that of an altarpiece, Cromwell meditates on the passage from the Psalm, his finger still holding open the page of the Bible. He holds an oak sapling: the oak tree is a symbol of strength, but here it is at a vulnerable, early stage of its development. So deep is his reverie that he ignores the chaos around him; a servant calls him, mimicked by the quacking of a duck. His horse and a lamb munch on roadside plants while a ginger-haired boy attempts to drive a herd of cows to milking and a sow and her piglets become comically entangled amid the horse's legs. Cromwell's abstracted concentration on the great questions of state ironically results in chaos. Meanwhile, three sensible working men continue their agricultural activities untroubled by abstract questions (this division between 'brainworkers' and manual labourers is also found in *Work*). The flames and smoke of the garden bonfire in the foreground form an analogy for the ferment in Cromwell's mind, which would eventually lead to the execution of Charles I, Civil War and the Protectorate, sweeping away (so many Victorian historians believed) papism and absolute monarchy, and paving the way for democracy. Carlyle and Brown were both interested in the role of the heroic individual in history, to be depicted 'warts and all'. Enlivened by Brown's idiosyncratic exaggerations and his characteristic enjoyment of the grotesque, *Cromwell* is the definitive Pre-Raphaelite history painting. Attentive to historical and local detail, it explores great moral and religious questions, combining past and present with Carlylean vigour. TB

6. BEAUTY

Millais surprised critics in 1856 by exhibiting at the Royal Academy a haunting, dark-toned painting without any obvious narrative or meaning. *Autumn Leaves* (no.117) was prophetic of artistic developments in the next two decades as the Pre-Raphaelites explored new forms of expression, turning away from literary narrative and the precise exegesis of nature, society and religion, to explore instead the purely aesthetic possibilities of picture-making. Much early Pre-Raphaelite painting engaged deeply with literature, but the 1860s would see a close relationship emerge between art and music, considered to be the most abstract and purely formal of the arts. By 1877 the critic Walter Pater, who admired Rossetti's work, could claim that 'all art constantly aspires to the condition of music'.[1] The PRB's vivid sense of art's campaigning and revelatory role in society gave way to a more reflective mood, encapsulated by the phrase 'art for art's sake'. Yet the art that emerged from new groupings of artists rooted in the Pre-Raphaelite movement was equally innovative. Newly self-conscious approaches to mood and atmosphere dominated the art of the mid-1860s, by which time Pre-Raphaelitism had metamorphosed into the Aesthetic movement.

Autumn Leaves is, as Effie Millais remarked, a work 'full of beauty and without subject'.[2] This solemn, elegiac painting represents four girls and a pile of fallen leaves, which they have collected to be burned. The sun has set over the hills, sharply silhouetting the trees, and the chill of the season contrasts with the healthy glow of the girls' faces. Some elements of the painting are wrought with the minute clarity of earlier Pre-Raphaelite painting, such as what Ruskin called 'the perfectly painted twilight' and 'valley mist', and the vibrantly coloured sycamore, beech and alder leaves spilling out into the foreground. Much of the canvas, however, verges on illegibility.[3] The smoke rising from the smouldering leaves obscures the grass to the left, though in the gloaming a distant, and troubling, figure of a man with a scythe can be discerned.

Yet *Autumn Leaves* resists the process of iconographic decoding, the search for signs and symbols essential to our under-standing of *Isabella* (no.26) or *The Girlhood of Mary Virgin* (no.24). Instead, it communicates on two levels. Firstly, it suggests associations with the viewer's own past experiences: distant recollections of crisp autumn evenings and of childhood itself. More important, it appeals as a formal arrangement of burnished colours and textures. The work is concerned, in theoretical as well as purely visual terms, with beauty itself.[4] The search for beauty, which Rossetti described as 'the only absolute aim' of

art, distinguishes the second decade of Pre-Raphaelite painting.[5]

Rossetti, too, was in pursuit of beauty, but his goal was the creation of beauty of a novel and radical variety. In 1859 Rossetti returned to oil painting with striking results. He created a work small in size but monumental in effect: a bust-length painting of a woman, sensuously modelled, lavishly dressed, adorned with jewellery and flowers, and placed very close to the picture plane. No perspectival space opens up behind her: rather, her figure is surrounded by a frieze of ornamental flowers and foliage. Titled *Bocca Baciata* (no.119), the work has only tangential links to any text. It is a celebration of a robust, sexualised form of female beauty. The luscious paint surface, applied in broad strokes with stout hogshair brushes, self-consciously emulates Venetian art of the sixteenth century and particularly the work of emphatically post-Raphaelite painters such as Titian and Veronese. Rich, deep greens, blues and dark reds replace the gothicising, stained-glass clarity of early Pre-Raphaelite colour. Critics recognised that, despite the web of connections with art of the past, this was unmistakably modern art: 'Even in a Rossetti, what an entire nineteenth-century spirit it is that prevails! The unrest, regret, the "questionings of self and outward things" which constitute the prevailing flavour of his art, have no analogy, as far as we are concerned, with the painting of former times.'[6] Despite its genealogy among the old masters, the work's explicitly sexual appeal was shocking to contemporaries, and even to Hunt who detected in it 'gross sensuality of a revolting kind, peculiar to foreign prints', a clear allusion to pornography.[7]

Rossetti's paintings of the 1860s contain an especially powerful autobiographical element. *Bocca Baciata*, for example, portrays the distinctive features of Fanny Cornforth, whose broad face, long neck, thick, pursed lips and luscious hair appear in many of Rossetti's works of the 1860s, culminating in the magisterial *Blue Bower* (1865; no.126). Cornforth, who was born Sarah Cox, daughter of a Sussex blacksmith, has often but wrongly been described as a prostitute. After encountering Rossetti on a visit to London, perhaps as early as 1856, she became first his model and muse, and then perhaps his mistress. Rossetti's wife, Elizabeth Siddall, whose features are so prominently represented in his works of the 1850s, died in February 1862, cutting short an artistic career of great promise. Rossetti's profound grief, heightened perhaps by guilt, found its eventual monument in the mystic *Beata Beatrix* (no.124). From late 1862 Cornforth lived, ostensibly as housekeeper, in an unorthodox ménage at Rossetti's home, Tudor House, 16 Cheyne Walk, in Chelsea. With Dante

Gabriel Rossetti and his brother William Michael, she can be seen in a photograph by William Downey of 1863, which also includes the diminutive figure of another Tudor House resident, the poet Algernon Swinburne (fig.19). Fanny's skill in self-fashioning can be seen in another photograph made at the same time, where her image is doubled in a bedroom mirror which has been carried out into the garden (no.127). As Rossetti's principal model of the early 1860s, she may be considered a collaborator in the production of some of his most ambitious and successful works, a role taken by Jane Morris in later years.

Hunt eventually modified his view of Rossetti's Aesthetic paintings and even produced his own idiosyncratic contribution to the genre, *Il Dolce far Niente* (no.121). Other critics, however, increasingly castigated Rossetti's painting and poetry as morally decadent. A public controversy flared in 1871 over Robert Buchanan's denunciation of Rossetti's circle as 'The Fleshly School'.[8] More challenging still was the work of Simeon Solomon, whose *Bacchus* (no.133) appropriated aspects of Rossetti's style and format for a homoerotic, androgynous portrayal of a male figure. An artist of great imaginative vision, Solomon was disowned by the Pre-Raphaelite circle after his arrest and conviction for sodomy in 1873.

One ardent admirer of paintings such as *Bocca Baciata* was the intellectually gifted and artistically ambitious Julia Margaret Cameron, who acquired a camera in 1863. Cameron found 'the deepest tenderness & beauty' in Rossetti's 'thoughts and designs' and adapted their idiom to photography, though it was Hunt's *Isabella and the Pot of Basil* (no.131) that provided the pose for her *Mariana* (no.129). Like Rossetti in the 1860s, Cameron eschewed the all-over precision of detail that early Pre-Raphaelite painting shared with photography. Instead, she allowed areas to appear out of focus, rendering clothing, drapery and hair in a smudged and indistinct style that conveys a painterly effect. Expanding the expressive range of the camera, she created a distinctive Aestheticist photography whose roots lay in Pre-Raphaelite art.

TB

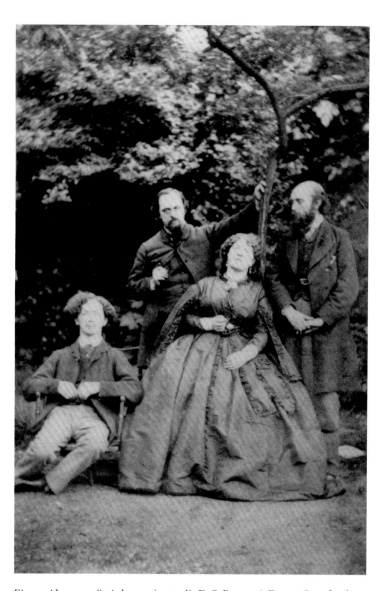

Fig.19 Algernon Swinburne (seated), D.G. Rossetti, Fanny Cornforth and W.M. Rossetti at Tudor House, Chelsea, c.1863, albumen print probably by William Downey. Photograph National Portrait Gallery, London, unknown collection

ALEXANDER MUNRO 1825–71
Josephine Butler 1855

Marble 69 x 46 x 27
The Mistress and Fellows of Girton College Cambridge

Alexander Munro produced two remarkable busts and a relief portrait of Josephine Butler, social reformer and advocate of women's rights, whom he met in Oxford.[9] Butler ranks among the most significant female figures in Victorian public culture. Her deep religious convictions, charismatic persona and rhetorical skill made her a compelling public speaker. She shared liberal but deeply Christian beliefs with George Butler, the clergyman whom she married in 1852 and who was secretary to the committee that selected Munro for a sculptural commission for the Oxford Museum. Josephine Butler signed the petition for women's suffrage presented to Parliament by John Stuart Mill in 1866, tirelessly advocated for women's access to higher education and vigorously opposed the Contagious Diseases Acts under whose provisions the police were empowered routinely to force suspected prostitutes to submit to invasive medical inspections for venereal disease.

Munro's sculptural portraits reveal contrasting aspects of this celebrated but controversial figure. The present bust represents the young Josephine, aged about twenty-six, her hair braided, but falling freely down her back. Woven into her locks are decorative jewelled stars, while her drapery – it is hardly conventional Victorian dress – reveals one bare shoulder. The unconventionally free and even eroticised presentation of her accoutrements, however, are countermanded by the powerful, kindly, but unsmiling face, dominated by what Woolner called her 'wonderful sad eyes'.[10] The facial expression suggests something of the intensely spiritual character that Josephine Butler's friends saw in her. Munro considered the treatment so unusual that the work would not be recog-nised as a portrait at all and that there would be 'a likely enough supposition that it is only an "ideal" subject'.[11]

A later bust (before 1872; Walker Art Gallery) presents Butler in relatively conventional form, her eyes demurely lowered and her hair modestly pinned. As in the present work, the sharply etched profile, reminiscent of that of Elizabeth Siddall, departs from Raphaelesque Victorian ideals of beauty. Though she was portrayed in pastel by the fashionable artist George Richmond and also sat for photographers on several occasions, Butler chose to represent herself by a photograph made after 1872 of the second Munro bust (fig.20), which she circulated as a carte-de-visite.[12]

Like the Pre-Raphaelites, Butler looked to historical examples to buttress her own radical reforms. Her publication, *Catherine of Siena* (1878), presents the fourteenth-century Sienese mystic and contemporary of painters admired by the Pre-Raphaelites as a pioneering feminist. If the present bust places her in the fervid Aesthetic world of Rossetti's Dante compositions, Munro's simpli-fication of Butler's figure in the later bust may reflect the sobering influence of Renaissance portrait sculpture by artists such as Desiderio da Settignano.
TB

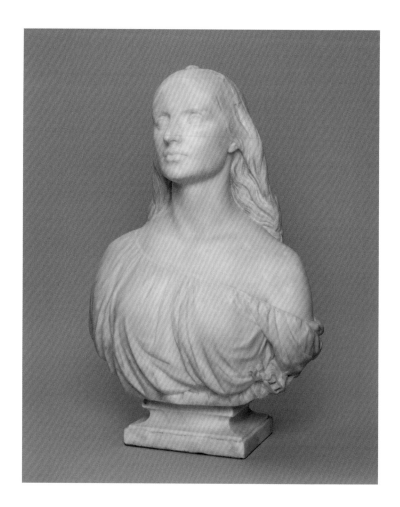

Fig.20 Signed photo-graph of the second bust of Josephine Butler by Alexander Munro taken by Vandyke and Brown of Bold Street, Liverpool, after 1872. Josephine Butler Collection, University of Liverpool Library

ALEXANDER MUNRO 1825–71

Elizabeth Smith (née Blakeway) 1859

White marble set in oak surround, faced with veined pink marble, in a marble frame 50.5 x 40.5
Scottish National Gallery, Edinburgh. Purchased 2007

Munro's sculpted portraits were innovative in their use of colour in surrounds of multi-hued stone, which served as frame and border for white marble faces in relief. His female portrait 'medallions' achieved excellent likenesses and correspond with contemporary developments in Pre-Raphaelite painted imagery. Like Pre-Raphaelite paintings of the late 1850s, they responded to evolving ideals of beauty that accompanied the rise of the Aesthetic movement.

Munro exhibited this portrait at the Academy in 1859, two years after Millais painted Sophie Gray (no.118) and the same year that Rossetti produced *Bocca Baciata* (no.119). Elizabeth Blakeway met the publisher George Murray Smith in April 1853 and they married in 1854; she was twenty-seven when the work was exhibited.[13] She was the daughter of a wine merchant who probably had business connections with Ruskin's father. Smith was Ruskin's and Charlotte Brontë's publisher and oversaw the first *Dictionary of National Biography*. Elizabeth was a great beauty, as Leonard Huxley described in *The House of Smith, Elder*: 'Her gifts of mind and character were no less gracious than her outward presence.'[14]

The Rossetti brothers and F.G. Stephens had all questioned whether a convincing likeness was possible in sculpture, and Munro in a letter of 1854 to the poet William Allingham had parried this assertion: 'There are times when sculpture speaks to us with infinitely greater power than painting can – in the twilight-evening – most suggestive hours – when paintings are really flat … at such times your bust may tell more effectively than all the painted eyes of pictures – at times when Æolian Harp influences touch us.'[15] Allingham described Munro's plaster bust of himself (1855; National Gallery of Ireland) as 'this white ideal of myself' that 'has the look of commemorating something'.[16] The challenge of balancing likeness with poetry, vitality against commemoration, was well met in the subtle Aestheticist harmonies of colour and texture in such refined, polychrome-rimmed high-relief medallions. As opposed to Woolner's preference for low-relief profiles, Munro developed a novel method of head-on faces that project

from the block. Elizabeth Smith's downward pensive gaze, delicate hand, wispy hair blown in a breeze, prominently exposed shoulder and details of modern dress and jewellery are characteristic of Munro's female busts. It resembles Rossetti's close-cropped female heads of the 1860s and bears a similarity to female subjects in works such as *April Love* (no.43) by Arthur Hughes, with whom Munro shared a studio until around 1858. JR

117

Autumn Leaves 1855–6

Oil on canvas 104.3 x 74
Manchester City Galleries

118

JOHN EVERETT MILLAIS

Sophie Gray 1857

Oil on paper laid on wood 30 x 23
Private collection c/o Christie's

In August 1855 Annat Lodge, Perth, Scotland, became the home of John Everett Millais. It was the first he shared with his new wife, Effie. She was born Euphemia Chalmers Gray in a house named Bowerswell, only yards from Annat Lodge, but, until the recent annulment of her first marriage, had been Mrs John Ruskin. The spacious garden of Annat Lodge, with fully grown deciduous trees and an orchard, commanded splendid views of the mountains known as the Arochar Alps. It is the setting for *Autumn Leaves*. Four girls have been raking fallen leaves and collecting them in a large wicker basket. Now they are setting them to burn. The models were Effie's young sisters (from the left) Alice and Sophie, who wear matching green velvet dresses, and two local working-class girls, Matilda Proudfoot (who studied at the local School of Industry) and Isabella Nicol, the daughter of a maid; the last two also posed for *The Blind Girl* (no.81). All are ruddy-cheeked and healthy; only Sophie verges on womanhood.

As noted in the introduction to this section, Millais intended to create an evocative, poignant image without any specific textual source or analogue. Nonetheless, he wrote to F.G. Stephens that he 'intended the picture to awaken by its solemnity the deepest religious reflection'.[17] At one time he considered using a subtitle from the Book of Psalms. There are hints of religion in the painting: the tower of St John's Church, Perth, can be discerned at the far left; the apple held by Isabella Proudfoot could allude to Eve the temptress; and the spectral man to the left with a scythe could portend death. None of this, however, amounts to a convincing iconographic scheme. The painting's message is eloquently conveyed by visual rather than semiotic means.

Although John Ruskin believed that *Autumn Leaves* and *Peace Concluded, 1856* (see pp.246–7) 'will rank in future among the world's best masterpieces', other critics at the Royal Academy of 1856 were nonplussed, as one wrote: 'We are curious to learn the mystic interpretation that will be put upon this composition.'[18] A perceptive response in the *Saturday Review* found *Autumn Leaves* most impressive 'not … from its depth of thought, but from its depth of feeling. He must have felt intensely the solemnity and gorgeousness of autumn twilight … There is no one thing that takes from the all-absorbing grandeur of the picture – it has the spell-binding power of nature.'[19]

Millais painted Sophie Gray again in 1857, this time in a striking head-and-shoulders portrait in which, at about fourteen years of age, she is seen entering adolescence.[20] Self-aware and pensive, with her chin lifted and her lips slightly pursed, the young Scotswoman is a commanding figure. It is an intimate portrait, reflecting Millais's fondness for his wife's younger sister. The composition is closely cropped, the head almost reaching the top of the image. The painting, achieved with supreme confidence by Millais, is an important precedent for *Bocca Baciata* (no.119) and Rossetti's series of female heads from the 1860s. George Price Boyce, water-colour painter and friend of Millais and Rossetti, purchased *Sophie Gray* in 1857 and commissioned *Bocca Baciata* in 1859. TB

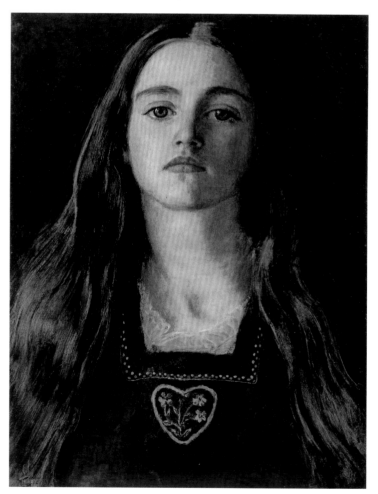

118

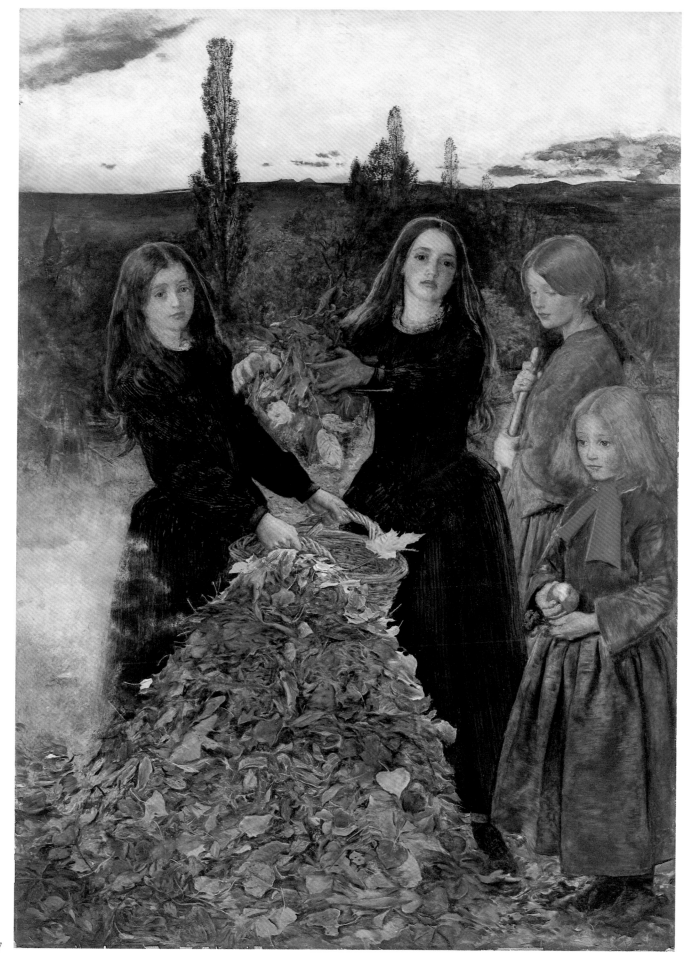

117

DANTE GABRIEL ROSSETTI 1828–82

Bocca Baciata 1859

Oil on panel 32.1 x 27
Museum of Fine Arts, Boston, gift of James Lawrence 1980.261
[Washington only]

Rossetti's return to oil painting in 1859 was heralded by this small panel, which he described in a letter to William Bell Scott as 'a little half-figure in oil' in which 'I have made an effort to avoid what I know to be a besetting sin of mine – & indeed rather common to PR [Pre-Raphaelite] painting – that of stipple in the flesh'.[21] In place of the tiny brushstrokes of his early work, Rossetti suggests that the painting is a technical exercise in a new painterly style with what he called 'a rather Venetian aspect'.[22] *Bocca Baciata* follows a format familiar in Venetian art of the sixteenth century, in which a single, half-length, female figure, lusciously modelled in oil paint, is positioned in a shallow space, often with draperies falling away with erotic effect. Titian, Veronese and Palma Vecchio all produced works of this type. Other British artists such as Theodore von Holst (see no.3) had explored this format, chastely avoiding the explicit sensuality of the originals.

Bocca Baciata, however, is more than an exercise. It announced an entirely new departure in Rossetti's art, which would dominate the rest of his career. The painting is dedicated, in both composition and style, to the celebration of beauty as an end in itself. The model in the present work is Fanny Cornforth, whom Rossetti had already known for some time; by 1859 he was probably her lover. Her distinctive features and voluptuous form appear in many of his works of this period. Here she is adorned with costume jewellery, probably kept in Rossetti's studio.[23]

In July 1859 George Price Boyce, a friend of Rossetti, commissioned the artist to complete the work for £40. Boyce and his sister had purchased from Millais in 1857 two head-and-shoulder-length portraits of Alice and Sophie Gray (see no.118) which form an important formal precedent for the present work. Frederic Leighton, too, had exhibited at the Royal Academy in 1859 a group of three subjectless studies of the famous Roman beauty, Nana Risi. In *Pavonia* (1859; private collection) the head of the inscrutable model, with what F.G. Stephens called a 'backward yet proud look', is relieved against an array of peacock feathers.[24]

The element of eroticism is far more explicit in *Bocca Baciata*. Its resonances for the original purchaser may well have been personal as well as purely aesthetic: Boyce was linked closely to Cornforth, possibly, like Rossetti, her lover, and called the work 'a portrait of Fanny'.[25] Arthur Hughes considered the painting 'so awfully lovely', noting that 'Boyce has bought it, and will I suspect kiss the dear thing's lips away'.[26] Fanny Cornforth was born Sarah Cox, on a farm in Sussex. Unlike the genteel, if impoverished, Elizabeth Siddall, Cornforth came from the rural working class. In a letter to Boyce Rossetti gently mocked her accent: '"Them be'inds merrygoes," as the fair original might say in her striking rendering of the word "marigolds".'[27] Marigolds signified grief and regret in the 'language of flowers', but despite the wistful gaze of the figure in *Bocca Baciata*, there is no implied narrative or moral commentary in this figure, who epitomises 'beauty for beauty's sake'. The prominent placing of an apple on the ledge in the foreground has suggested to some scholars that the image invokes the figure of Eve and the concept of original sin.[28] While Hunt found this work 'remarkable for gross sensuality of a revolting kind', the poet Algernon Swinburne considered it to be 'more stunning than can be decently expressed'.[29]

The title seems to have been added after the work was painted. The line, 'Bocca baciata non perde ventura, anzi rinnova comme fa la luna', appears in the *Decameron*, a collection of tales written in Florence by Giovanni Boccaccio in about 1350. The tale concerns Altiel, a woman of great beauty and sexual appeal who blissfully consummates eight relationships before finally marrying the King of Garbo. She 'went to bed with him like a virgin and made him think she was one'.[30] The line quoted on the reverse of Rossetti's panel translates as 'A kissed mouth loses no savour, but rather renews itself like the moon'.

The painting was exhibited at the Hogarth Club in 1860, in what the *Art Journal* referred to as 'an exhibition of Pre-Raffaelite pictures'. The Hogarth Club was a self-consciously avant-garde organisation run by artists in which Brown played a leading role. Although the Club's exhibitions were seen only by members and their guests, this was the first opportunity for a wide circle of artists and critics to see *Bocca Baciata*, the picture that established the major genre for Rossetti's later work.[31] TB

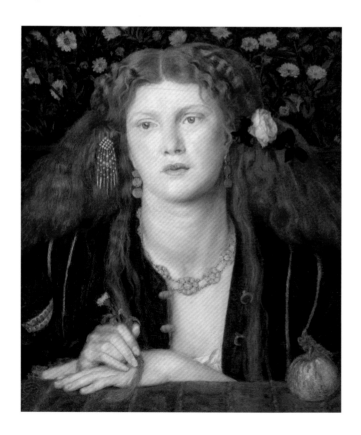

FREDERICK SANDYS 1829–1904
Mary Magdalene c.1859

Oil on wood panel 33.7 x 27.9
Delaware Art Museum, Wilmington, DE. Samuel and Mary R. Bancroft Memorial, 1935

The Norwich painter Frederick Sandys was of the same genera-tion as the Pre-Raphaelites and met Millais in 1847 when both were students. He spent most of the 1850s working as an illustrator and engraver in Norwich, however, and exhibited in London for the first time in 1860, when *Mary Magdalene* and another work, *Queen Eleanor* (1858; National Museum of Wales), were exhibited at the British Institution.[32] *Mary Magdalene* shows that Sandys was abreast of the new Aesthetic taste for single, sensuous female figures placed close to the picture plane. He had known Rossetti since at least 1857 and may have seen *Bocca Baciata* (no.119) in the latter's studio.

Although it is a character study rather than a history painting, *Mary Magdalene* does of course represent a biblical figure, and she is shown with the alabaster 'box' of ointment she used to anoint Christ's feet during the supper at Bethany. In Christian imagery there is a far smaller iconography of Mary Magdalene standing for the repentant, sexualised woman, than for the Virgin Mary, and Sandys does not seem to be referring to earlier representa-tions here. The period setting is uncertain, placing the figure in the medieval or Renaissance era rather than in biblical times. Behind her is a green brocade textile probably based on a late-medieval example, but also reminiscent of new wall-coverings designed by A.W.N. Pugin for the Palace of Westminster and seen in J.R. Herbert's portrait of Pugin (Palace of Westminster).

Sandys's style bears the imprint of Pre-Raphaelitism. The handling of paint, especially in the finely rendered details of the face, recalls Millais's work of the late 1850s; the emphasis on textiles suggests Hunt. The composition, however, has a Rosset-tian feeling, and this would be the cause of trouble between the two artists a decade later. In 1869 Rossetti accused Sandys of plagiarism, claiming that this figure derived from Rossetti's watercolour of 1857, *Mary Magdalene Leaving the House of Feasting* (Tate).[33] Though there is a distinct similarity in the orientation of the figures and in the sharp features of the chosen models, the two works are in truth extremely different; however, Sandys's adoption of the format and genre of *Bocca Baciata* (including the use of a small wood panel in preference to canvas) may have rankled with Rossetti. TB

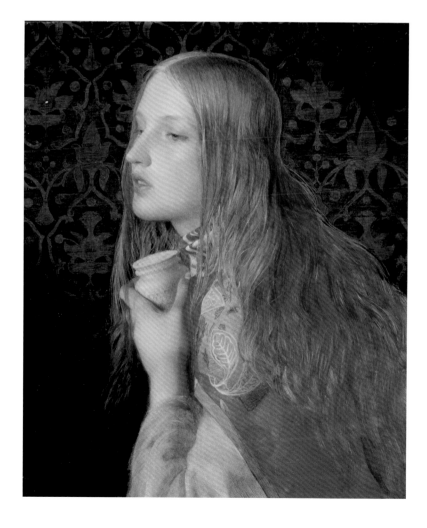

121

WILLIAM HOLMAN HUNT 1827–1910

Il Dolce far Niente 1859–66, retouched 1874–5

Oil on canvas 99 x 82.5
The Schaeffer Collection courtesy of Nevill Keating Pictures

122

WILLIAM HOLMAN HUNT

Egyptian chair c.1857

Mahogany and sycamore, inlaid with ebony and ivory 84 x 44 x 48
Birmingham Museums and Art Gallery. Presented by Gladys Holman Hunt, 1947

'I was glad of the opportunity of exercising myself in work which had not any didactic purpose', recalled Hunt of *Il Dolce far Niente*, which immediately followed the completion of his epic labours on *The Finding of the Saviour in the Temple* (no.101).[34] The title, the Italian phrase 'It is sweet to do nothing', confirms that this is a purely Aesthetic work, an unusually frank celebration of female beauty with no narrative content. The idea may have been suggested to Hunt when he saw Leighton's spectacular subjectless study in silver, *A Roman Lady (La Nanna)* (1858–9; Philadelphia Museum of Art), at the Royal Academy's exhibition in the early summer of 1859.[35] Rossetti was at work simultaneously on *Bocca Baciata*, a painting that later provoked Hunt to moralistic denunciation: 'Rossetti is advocating as a principle the mere gratification of the eye and if any passion at all – the animal passion to be the aim of art.'[36] Yet *Il Dolce far Niente* is itself sensuous, the composition oppressively replete with opulent textiles, fragrant blooms, loose, luxuriant hair and the glowing embers of a fire. In front of the mirror we can see small, white Parian-ware figures of Cupid and Psyche, made by Minton, emblematic of sexual desire. However,

Hunt added some iconographic details that might propose a more respectable reading: the woman wears an engagement ring, suggesting a conventional resolution to her life history, and the cosy glow of the fire indicates domestic virtue. The figure seems to have been reworked on several occasions: initially painted from a Miss Foster, it bears the likeness of Annie Miller (see p.134). Hunt's infatuation with Miller came to an unhappy end in 1859 and in 1865 he repainted the face from his fiancée, the highly respectable Fanny Waugh.

The lady of leisure is seated on an exotic Egyptian chair, one of a pair commissioned by Hunt from the London furniture makers Crace & Son for his own home. It dates from 1857, when he rented a modest terraced house, 1 Tor Villas, near Church Street, Kensington. Hunt designed the chair himself, basing it on a rare ancient Egyptian object known as the 'Thebes Stool' in the British Museum. The distinctive chair added an orientalist touch to two paintings at the Royal Academy's exhibition in 1867, *Il Dolce far Niente* and Millais's *Jephthah* (1867; National Museum Wales). TB

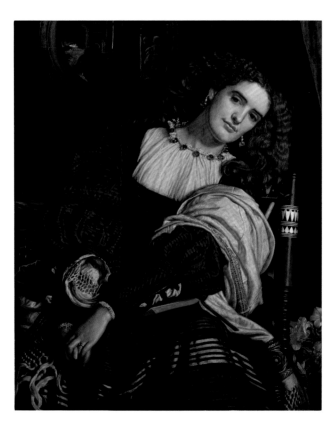

120

121

GEORGE FREDERIC WATTS 1817–1904

Portrait of Edith Villiers, Later the Countess of Lytton 1861–2

Oil on canvas 76.2 x 44.4
Private collection, courtesy of Sotheby's

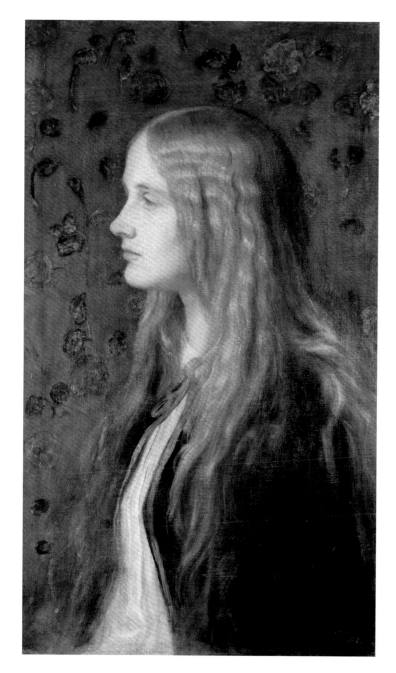

One of the most distinguished painters of the Victorian age, Watts was never closely associated with Pre-Raphaelitism, though he was on good terms with many members of the Pre-Raphaelite circle. His exquisite painterly touch identifies him as an admirer of Venetian painting. In the late 1850s he did adopt colour schemes in a higher key and painted some modern-life subjects with a Pre-Raphaelite crispness, such as *Jane Elizabeth Nassau Senior* (1857–8; Wightwick Manor, National Trust). With the *Portrait of Edith Villiers* his work came into close dialogue with Rossetti's Aesthetic studies of women. It is both a portrait and an Aesthetic experiment in subtly modulated colour, akin to Whistler's innovative works of the same period.

Edith Villiers later attained prominence as the Vicerene of India, wife of Robert, 1st Earl of Lytton. Watts, however, knew her from childhood as part of the cultured and aristocratic circle that gathered at Little Holland House in the 1850s. As Barbara Bryant notes, Edith and her twin sister Elizabeth 'came out' into London society in 1860; Elizabeth was the first to be married and Edith was 'feeling lonely and miserable' in May 1861 when sittings for the present work took place.[37] 'They pulled down my hair and made me sit to Mr Watts. It was such a *bore*', she recalled.[38] She was renowned for her tall and slender figure, which may explain the unusually narrow format of the portrait.

In this work Watts offered a virtuoso demonstration of painterly brushwork. Posing his melancholy adolescent sitter against a wallpaper influenced by Japanese patterning, he created a subtle interplay between her strawberry blonde hair and the deep greens of the wallpaper and her jacket. Her lips echo the deep pink roses in the wallpaper. A similar blend of tonalities can be found in *Choosing* (1864; National Portrait Gallery, London), Watts's portrait of the seventeen-year-old actress Ellen Terry wearing a Renaissance-style green velvet dress designed by Hunt, with whom Watts was friendly at this period. TB

DANTE GABRIEL ROSSETTI 1828–82

Beata Beatrix c.1864–70

Oil on canvas 86.4 x 66
Tate. Presented by Georgiana, Baroness Mount-Temple in memory of her husband, Francis, Baron Mount-Temple 1889

Rossetti's lifelong self-identification with the Florentine poet Dante Alighieri renders this a double work of art, representing both Dante's beloved Beata Beatrice, or 'blessed Beatrice', and Rossetti's own wife Elizabeth Siddall, whose distinctive features predominate. From the early 1850s Rossetti had conflated Siddall with Beatrice, and the parallel became all the more poignant when she died, tragically young, as Beatrice does in Dante's *Vita Nuova*. Rossetti used sketches made years earlier to complete this posthumous portrait of his wife as Beatrice.

The style of *Beata Beatrix* differs greatly from the sequence of opulent Venetian-inspired beauties inaugurated by *Bocca Baciata* (no.119). Ethereal and dimly lit, its dreamlike atmospherics and visionary intensity indicate the unique status of this work in Rossetti's canon. Rossetti insisted that *Beata Beatrix* was not a direct illustration of Dante's work, but a complex interpretation:

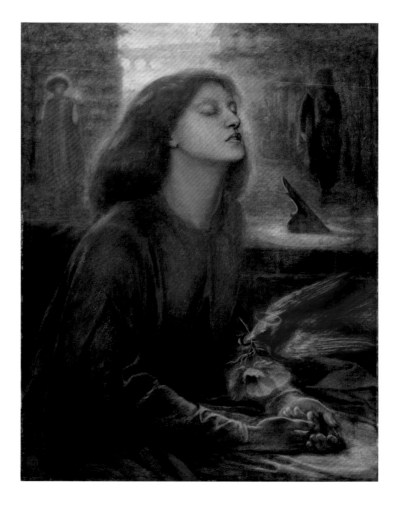

> The picture must of course be viewed not as a representation of the incident of the death of Beatrice, but as an ideal of the subject, symbolized by a trance or sudden spiritual transfiguration. Beatrice is rapt visibly into Heaven, seeing as it were through her shut lids (as Dante says at the close of the Vita Nuova): 'Him who is Blessed throughout all ages'.[39]

Beatrice/Siddall has her eyes closed, 'rapt' in a state either of religious or, perhaps, sexual ecstasy. The composition is enriched by many other symbols and references. The sundial points to 9, a number that attains great symbolic importance for Dante. As Rossetti explained, 'He meets her at nine years of age, she dies at nine o'clock on the 9th of June, 1290'.[40] A symbol of Rossetti's own making, a 'radiant bird, a messenger of death, drops the white poppy between her open hands', perhaps a reference to the fact that Siddall died of a self-administered overdose of laudanum. And in the background 'Dante himself is ... gazing towards the figure of Love opposite, in whose hand the waning life of his lady flickers as a flame'.[41] The Ponte Vecchio over the River Arno in Florence can be discerned behind the two figures – but here too there is a modern parallel: it could almost be Blackfriars Bridge, seen in *Found* (no.97).

Among several inscriptions Rossetti placed on the frame, the most significant is 'Love which moves the sun and the other stars', the last lines of Dante's *Divina Commedia*. *Beata Beatrix* is a heartfelt song of love and death, Rossetti's farewell to his muse and wife, and his consummate response to the literary figure whom he revered above all others. TB

DANTE GABRIEL ROSSETTI 1828–82
The Beloved ('The Bride') 1865–6

Oil on canvas 82.5 x 76.2

Tate. Purchased with assistance from Sir Arthur Du Cros Bt and Sir Otto Beit KCMG through the Art Fund 1916

The Beloved derives from the Song of Solomon in the Old Testament. On the frame are inscribed the following quotations:

> My Beloved is mine and I am his [Song of Solomon 2:16]
> Let him kiss me with the kisses of his mouth: for thy love is better than wine [Song of Solomon 1:2]
> She shall be brought unto the King in raiment of needlework: the virgins her companions that follow her shall be brought unto thee [Psalms 45:14]

These verses have often been read typologically as referring to the love of Christ by his flock, but Rossetti's point of departure in *The Beloved* is the sensuous language describing the unveiling of a woman before her future husband. For F.G. Stephens (doubtless following Rossetti) the work 'represents a bride with five attendants going to meet her groom'.[42]

This composition began as another depiction of Dante's Beatrice, but Rossetti decided that the healthy colouring of the professional model he used, Marie Ford, was not appropriate. Difference of skin colour is, however, a dominant presence in the final version. The 'bright' complexion of Marie Ford, blushing slightly as she unveils, lies at the centre of the composition,[43] but Stephens noticed the 'diverse tints' of the 'four maidens' arrayed around her providing 'so many foils to her beauty'.[44] Jan Marsh has suggested that Rossetti presented a hierarchy of racial types, with the 'gypsy' Kiomi Gray represented to the right and a darker-skinned woman behind. By gathering together a range of contrasting ethnic types, Rossetti may be alluding to the abundance of forms of human beauty, but the Caucasian figure undoubtedly occupies the place of honour.

Of the striking figure of the 'little negro girl' in the foreground, Stephens noted that 'black hair and tawny skin form an admirable contrast to the fairness of the bride'.[45] Rossetti suggested a purely formal rationale for this: 'I mean the colour of my picture to be like jewels and the *jet* would be invaluable.'[46] Marsh also makes the important observation that debates about slavery and the American Civil War would have informed perceptions of the child.[47] Although a girl was used for early sketches, the final sitter was an African-American boy. Rossetti spotted him in London travelling with his 'master' and made a superb pencil study (Birmingham Museums and Art Gallery).[48] Rossetti's inclusion of a black figure whose skin contrasted dramatically with a sexualised pale-skinned woman may be a response to Édouard Manet's

Olympia (1863; Musée d'Orsay, Paris), which Rossetti must have seen when he visited Manet's studio late in 1864.

As in *The Blue Bower* (no.126), Rossetti created a careful colour harmony, this time based on the different elements of an emerald-green Japanese kimono lent to him by George Price Boyce.[49] The flowers and foliage at the margins of the composition carefully echo those embroidered on the kimono. Other decorative elements emphasise the eclecticism of the composition: a Chinese feather-work jewel adorns the central figure, and the child's pendant in the foreground is of North African origin.[50] The overall composition is opulent almost to the point of claustrophobia, with a wealth of decorative elements flowing around the central point of stasis created by the pale physiognomy of the bride who confronts an imminent sexual awakening. TB

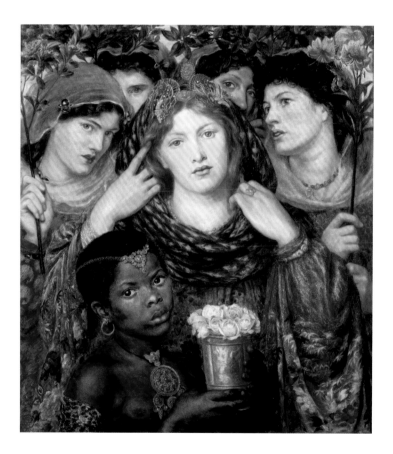

DANTE GABRIEL ROSSETTI 1828–82

The Blue Bower 1865

Oil on canvas 84 x 70.9
The Trustees of the Barber Institute of Fine Arts, University of Birmingham. Purchased 1959

127

W. & D. DOWNEY

Fanny Cornforth 1863

Albumen print 15.5 x 13.5
Watts Gallery, Rob Dickins Collection

'I've begun an oil picture all blue', Rossetti announced to Brown on Easter Monday 1865, 'to be called *The Blue Bower*'.[51] It embodies the concerns of his paintings of the 1860s and exemplifies British Aestheticism, in which art (in Walter Pater's later phrase) 'aspires to the condition of music'.[52] There is no narrative content, nor any meaningful signifier of date or place. The term 'bower' refers to a private space in a castle or garden associated with trysts, but this is no exercise in medievalism. The purely visual and sensual aspects of the work captivate the viewer. The luxuriant painterly style, more even than in *Bocca Baciata* (no.119), self-consciously refers to sixteenth-century Venetian precedents.

The arresting composition is based on colour harmonies far bolder than in *Bocca Baciata*. Both iconographically and formally, Rossetti explores the parallel between musical and visual harmonies, a theme already present in *The Blue Closet* (no.48). F.G. Stephens found 'melodious colouring' in *The Blue Bower*, mixing terminologies from the spheres of music and art:

> The music of the dulcimer passes out of the spectator's cognizance when the chromatic harmony takes its place in appealing to the eye. The blue of the wall finds its highest key-note in the superb corn-flowers that lie in front of the instrument … The green and chestnut-auburn, the pallid roses of the flesh, and the firmamental blue of the background, are as ineffable in variety of tint as in their delicious harmony.[53]

The instrument Stephens calls a dulcimer has been identified as a Japanese *koto*.[54] Rossetti shared with James McNeill Whistler the fashionable *Japonisme* of the era, but the *koto* is not being played correctly, suggesting that Rossetti purchased the object in a junk shop with no knowledge of its technique. A more explicit orientalist note is sounded by the blue and white tiles. Their hexagonal shape would suggest an Islamic origin, but the prunus motif probably derives from a Chinese export ceramic such as a tobacco jar. An allusion to the East, associated with sensuous delight and luxury, was more important to Rossetti than fidelity to any particular non-Western culture.

Rossetti punningly associated Fanny Cornforth, who modelled for the painting, with the blue cornflowers in the immediate foreground. The heavily scented passion flowers and convolvulus in the shallow space behind her perhaps allude to her passionate but tenuous relationship with Rossetti. *The Blue Bower* was purchased from Rossetti for 200 guineas by the celebrated dealer Ernest Gambart, who sold it to William Agnew for 500 guineas. The Manchester textile manufacturer Samuel Mendel purchased it in 1866.

Cornforth also appears in photographs made by William Downey at Tudor House, Chelsea, in the summer of 1863. For one a large bedroom mirror was carried into the garden and she assumed a pensive pose. The photograph may have influenced Whistler's *The Little White Girl*, later called *Symphony in White No. 2* (Tate), which was finished in 1864. Whistler was a frequent guest at Tudor House during the summer of 1863. There are also overtones of *The Lady of Shalott* (see no.171), whose life was experienced vicariously through reflections in a mirror. TB

127

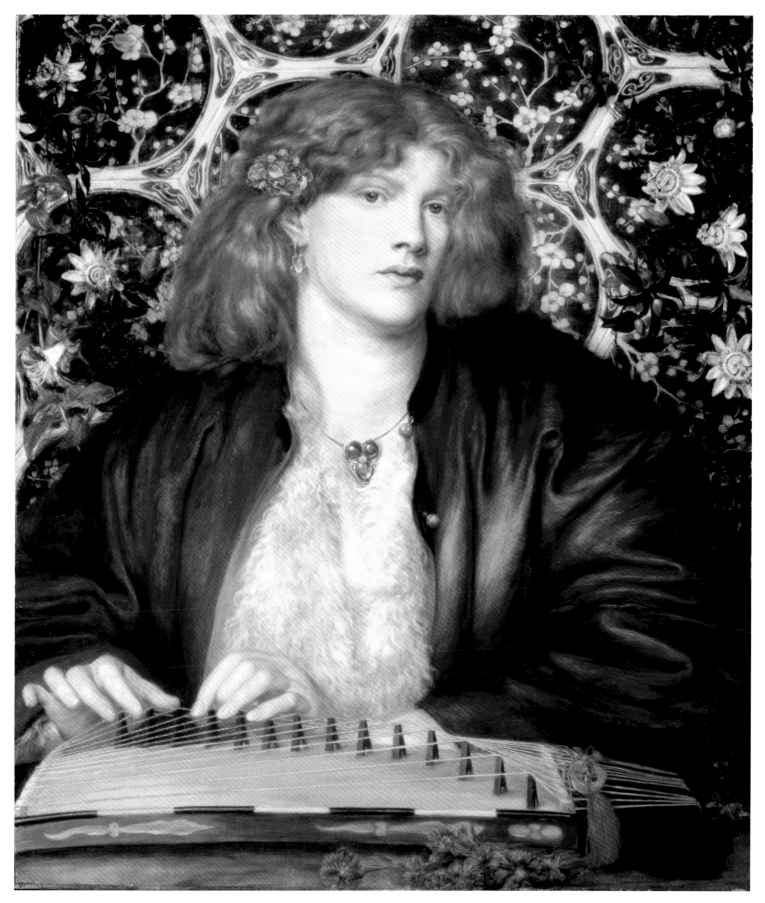

126

Hypatia 1868

Albumen print 29.5 x 24.3
Wilson Centre for Photography, London

Mariana 1874–5

Albumen print 45 x 35
Wilson Centre for Photography, London

Julia Margaret Cameron began photographing in 1864. Between then and her death in 1879, she produced a wide-ranging body of work unprecedented in its ambition and scope. By employing a variable focus and a shallow depth of field, she created a lush and evocative aesthetic style, which included almost life-size portraits in extreme close-up. She also adopted a broad range of subject matter, like the Pre-Raphaelites, using her models to embody characters and communicate narratives drawn from contemporary and historical literature, history and mythology.

Cameron grew up in India as one of the large family of Pattle sisters and married Charles Hay Cameron, who served as an administrator there and became a landowner in Ceylon. The Camerons left India and lived in England from 1848 to 1875, where they became an integral part of the social milieu of artists and writers, including many of the Pre-Raphaelites. She and her husband established a home on the Isle of Wight where they were neighbours to Alfred Tennyson and his family. From 1851 Cameron's sister, Sara Prinsep, served as hostess to a revolving group of artists and writers at her home in London, Little Holland House, where Cameron met many artists of the Pre-Raphaelite circle. William Michael Rossetti, William Holman Hunt and Val Prinsep (Cameron's nephew and associate of Rossetti, Burne-Jones and Morris) were all among her portrait subjects.

A woman of fervent enthusiasms, she especially admired Rossetti's art. As Joanne Lukitsh has shown, Cameron became acquainted with Rossetti and his brother William by 1857, according to surviving correspondence.[55] In 1858 Cameron wrote to William after seeing some of Rossetti's work, singling out *Found* (no.97) and *Mary Magdalene* (1857; Tate):

> [Rossetti's] thoughts & his designs are of the deepest tenderness & beauty and his painting is marvelously lovely – the nativity I think is adorable. The picture Found has a secret saving power in it – so has the Magdalen – Salvation is given by such hopes & deed so rendered. How beautiful & truly worthy of an Italian Poet is the feeling that inspired the 'Found' rather than Lost – So very many wd. have stopped at Lost & felt it to be more melodramatic but pity & Love are more profound.[56]

Praising Rossetti's work both for its beauty and its emotional and spiritual message, Cameron strove to achieve the same in her photographs when she herself began making pictures. As she wrote, she aimed 'to secure for [photography] the character and uses of High Art by combining the real and Ideal and sacrificing nothing of the Truth by all possible devotion to Poetry and beauty'.[57]

Cameron also sent dozens of prints to Rossetti as gifts: his estate sale listed forty-one Cameron photographs, of which eight are known today, including a print of *Hypatia*. Rossetti appreciatively responded to Cameron's gifts, writing to her in 1866:

> In my hurry this morning I actually forgot to thank you for the most beautiful photograph you kindly sent me. It is like a Lionardo. I looked over a set of your works at Colnaghi and really found them as endlessly delightful as if I had been going through an Italian Gallery. I cannot conceive how it is that no one ever turned photography to such good purpose before. You must have some most delightful models for one thing, but that is far from being all.[58]

Rossetti compared Cameron's work to that of Renaissance artist Leonardo da Vinci and praised her ability to expand the aesthetic vocabulary of the nascent medium of photography. Cameron's photographic style in her portraits and subject pictures was indeed unique within the developing conventions of photography in its earliest decades. Her images of women often place them in tightly cropped pictorial spaces positioned close against the picture plane and employ a variable focus and rich, tonal gradations to create a round, sculptural quality. These images display a striking correspondence with Rossetti's paintings of the 1860s, beginning with *Bocca Baciata* (no.119), though Cameron is more sparing in her use of background objects and accessories. The tonal variations of her prints serve as an analogue to the colour harmonies of Rossetti's work.

Hypatia, the fourth- to fifth-century-AD Neoplatonic mathematician and philosopher, was the subject of an 1853 novel by Charles Kingsley. Rossetti's letter noted Cameron's choice of models, and she was unusual in drawing many of them from among her social circle. The model for *Hypatia* is Marie Spartali, a member of the Anglo-Greek community, who provided important patronage for many of the Pre-Raphaelites. Spartali served as a model not only for Cameron but also for Rossetti and Ford Madox Brown. She became a painter in her own right, adopting a Pre-Raphaelite style, and married the photographer and writer William James Stillman.

Mariana is based on Tennyson's poem 'Mariana in the Moated Grange', taken in turn from Shakespeare's play, *Measure for Measure*. It was a subject already adopted by Millais in his 1850–1 painting, *Mariana* (no.35), and by Rossetti, using Jane Morris as his model, in 1870. Both Millais and Rossetti also contributed illustrations for the poem to the Moxon Tennyson. Cameron included this image in a series that she published in 1874–5 in two volumes, *Illustrations to Tennyson's 'Idylls of the King', and Other Poems*. An ambitious undertaking, this volume incorporated Cameron's most expansive narrative subjects. In *Mariana* she uses a claustrophobic tight focus on her subject and emphasises the uncomfortable body posture, as did Millais and Rossetti, to evoke Mariana's weary vigil for her feckless lover. DW

128

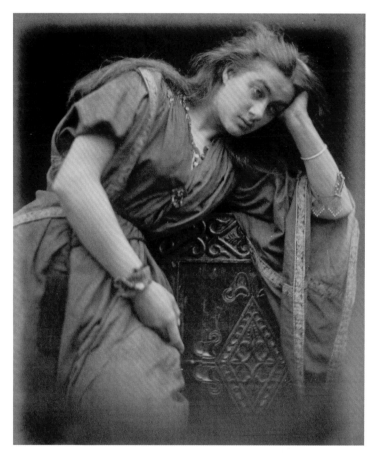

129

DANTE GABRIEL ROSSETTI 1828–82

Monna Vanna 1866

Oil on canvas 88.9 x 86.4

Tate. Purchased with assistance from Sir Arthur Du Cros Bt and Sir Otto Beit KCMG through the Art Fund 1916

Begun in 1864, the same year as *Beata Beatrix* (no.124), Rossetti's florid and self-consciously sensual *Monna Vanna* represents the antithesis of that interiorised visionary picture he dedicated to the memory of his wife, Elizabeth Siddall. Based on Alexa Wilding, a model for whom Rossetti developed no particular personal attachment, *Monna Vanna* presents a woman enveloped in a sumptuous white and gold embroidered robe (adapted from a shawl in his possession), gazing dispassionately out of the picture as she idly holds a fan of capercaillie feathers in one hand and, with the other, toys with the coils of the Indian coral necklace strung around her massive neck. Bold circular rhythms dominate the design, from the vast billowing sleeve that extends from the arch of the woman's shoulder, to details such as the curve of the armrest against which she inclines and the spiral-pearl hair ornament that adorns her auburn locks.

Although the composition is likely to have been inspired by Raphael's portrait of *Giovanna of Aragon* (c.1518) in the Louvre, which Rossetti saw on a visit to Paris in 1864, it was primarily intended to express 'the Venetian ideal of female beauty' in the artist's own words, hence the original title *Venus Veneta*. He described the painting as 'most effective as a room decoration',[59] which may explain why he later retitled it *Belcolore* as if to emphasise that it was essentially a decorative object rather than a portrait or character study. However, the definitive title he gave the painting following its completion, *Monna Vanna* (Vain Woman), taken from Dante's *Vita Nuova*, encouraged a reading of the woman herself, F.G. Stephens later describing the figure as 'a self-centered character … not warmed by inner passion, nor exalted by rapture of contemplation'.[60] Indeed, with her cold, deadpan expression the figure embodies desire in a rather vapid way, functioning more as a foil for the display of material wealth than allowing for the projection of intimate feeling. The accessories were painted from the antique trinkets and Eastern jewelled curiosities from the outer reaches of the British empire, which Rossetti collected as props to animate his compositions. These include a gold Burmese monster-head bracelet, an Indian green leaf ring and pendant earrings, and a magnificent heart-shaped crystal pendant hung tightly around the woman's neck. The painting shows how far Rossetti had exchanged early Pre-Raphaelite asceticism for a cold sensuous materialism. AS

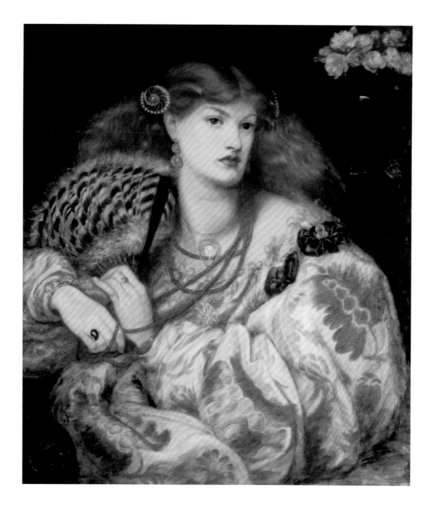

WILLIAM HOLMAN HUNT 1827–1910

Isabella and the Pot of Basil 1866–8, retouched 1886

Oil on canvas 187 x 116.5
Laing Art Gallery, Newcastle upon Tyne

In this work Hunt returned to the subject of Millais's ground-breaking *Isabella* of 1849 (no.26), John Keats's poem 'Isabella; or, The Pot of Basil', a reworking of a story from Boccaccio's *Decameron* of 1351–3. Isabella mourns her lover Lorenzo who has been killed by her brothers, two wealthy Florentine merchants. It drove them

> well nigh mad
> That he, the servant of their trade designs,
> Should in their sister's love be blithe and glad,
> When 'twas their plan to coax her by degrees
> To some high noble and his olive-trees.[61]

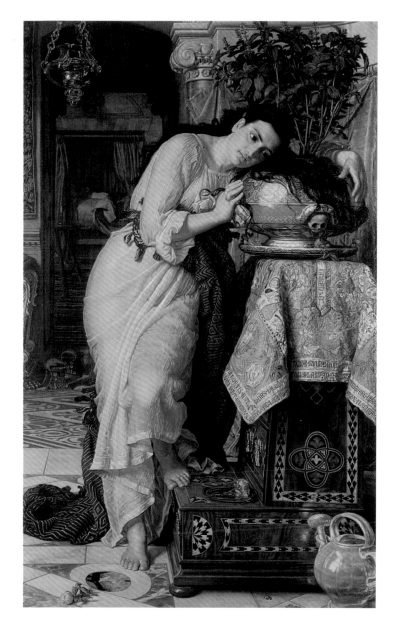

Although the brothers lied to her that Lorenzo was overseas, his ghost appears to Isabella and reveals the location of his body. With an old nurse she disinters it and severs the head, returning with it to her home, where she buries it in a pot, from which she grows basil, watered by her tears. Keats describes her fading away in pallor ('So sweet Isabel / By gradual decay from beauty fell'), but Hunt depicted a healthy young woman of Mediterranean type, clad in a clinging semi-transparent nightgown emphasising the unconsummated sexual rather than spiritual aspect of Lorenzo and Isabella's love. He justified this on common sense grounds: 'How they will pitch into me for making her strong and Etruscan … She could have cut his head off, you see, and the delicate sort of blonde, couldn't.'[62] However, Hunt's choice of figure and drapery forges links to sultry, Aestheticist studies such as Frederic Leighton's *Odalisque* (private collection), exhibited at the RA in 1862.

As in many Aesthetic movement paintings, the interior contains exotic elements as well as eclectic examples of European furniture. Hunt himself designed and decorated the maiolica vase with skulls on it, based on examples he had seen in Florence.[63] Isabella is depicted in the early hours of the morning, unable to sleep (see the disturbed sheets of the bed in the distant chamber). The painting was exhibited in a one-picture exhibition at the St James's showroom of the dealer Gambart in 1868 and received generally positive reviews. A stanza from Keats's poem was printed on the admission ticket, including the following lines:

> She had no knowledge when the day was done,
> And the new morn she saw not; but in peace
> Hung over her sweet Basil evermore.
> And moisten'd it with tears unto the core.[64]

TB

DANTE GABRIEL ROSSETTI 1828–82

Lady Lilith 1866–8, altered 1872–3

Oil on canvas 96.5 x 85.1
Delaware Art Museum, Wilmington, DE. Samuel and Mary R. Bancroft Memorial, 1935

Rossetti found a reference to Lady Lilith, the mythical first wife of Adam before he met Eve, in Goethe's *Faust*. These may have been the lines he had in mind:

> She excels
> All women in the magic of her locks;
> And when she winds them round a young man's neck
> She will not ever set him free again.[65]

The figure of Lilith, deriving from Talmudic and Kabbalistic sources, passed into Jewish folklore as the epitome of the femme fatale, a fantastical figure of violence, danger and allure. One characteristic, her refusal to obey Adam, resonated strongly within the complex sexual politics of Victorian England. A correspondent of Rossetti's found in Lilith an ancestor of Victorian feminism: 'Lillith was evidently the first strong-minded woman and the original advocate of human rights. At present she is a queen of the demons.'[66]

The work began, probably in 1864, as a scene close in spirit to *The Blue Bower* (no.126), showing a woman at her toilette modelled by Fanny Cornforth. In a letter of 1870 Rossetti explained that the painting 'represents a *Modern Lilith* combing out her abundant golden hair and gazing on herself in the glass with that complete self-absorption by whose fascination such natures draw others within their circle'.[67]

While working on the painting, Rossetti wrote a sonnet about Lilith, which he eventually titled 'Body's Beauty':

> Of Adam's first wife, Lilith, it is told
> (The witch he loved before the gift of Eve,)
> That, ere the snake's, her sweet tongue could deceive,
> And her enchanted hair was the first gold.
> And still she sits, young while the earth is old,
> And subtly of her herself contemplative,
> Draws men to watch the bright web she can weave,
> Till heart and body and life are in its hold.
>
> The rose and poppy are her flowers: for where
> Is he not found, O Lilith, whom shed scent
> And soft-shed kisses and soft sleep shall snare?
> Lo! as that youth's eyes burned at thine, so went
> Thy spell through him, and left his straight neck bent
> And round his heart one strangling golden hair.[68]

Rossetti's erotic fascination with luxuriant, 'enchanted' hair, here as in so many works, recalls Goethe's description of 'the magic of [Lilith's] locks'. Rossetti emphasises the tactile qualities of textiles and flowers across every inch of the canvas. As in Hunt's *Awakening*

Conscience (no.98), Lilith occupies a claustrophobic interior space that is contrasted with a reflection of sunlight through trees, in this case seen in her boudoir mirror. But Lilith's conscience will not awaken: she is absorbed in the sensuousness of her own body. The roses in the background, 'cluster after cluster of them', were picked in Ruskin's garden at Denmark Hill and laboriously painted in early Pre-Raphaelite realist fashion at Tudor House, 'until the whole space was filled up to the glorification of the design'.[69]

By 1868 Rossetti had paired *Lady Lilith* with another composition already on his easel, *Sibylla Palmifera* (1865–70; Lady Lever Art Gallery). In this new context *Lilith* represented 'Body's Beauty', and the palm-bearing *Sibylla Palmifera*, 'Soul's Beauty'. At the request of the purchaser F.R. Leyland, Rossetti repainted the face of *Lilith* in the early 1870s from the model Alexa Wilding, who also sat for *Sibylla Palmifera*, Cornforth's features now being considered 'too sensual and commonplace'.[70] This resulted in an unhappy disjuncture between the angular jawline and the voluptuous body. The difference between *Sibylla* and *Lilith* could be read as a replication of the conventional Victorian distinction between virgin and whore, between normative and deviant forms of sexuality, that pathologised sexual pleasure in women.[71] Lilith's pleasures, described by Stephens as 'passion without love, and languor without satiety', like those of Burne-Jones's later, but related work *Laus Veneris* (no.165), suggest not only vanity (the familiar symbol of the mirror) but also perhaps masturbation, a practice vehemently condemned by Victorian sexologists.[72]

Despite his apparent endorsement of spiritual over physical love, it is far from clear that Rossetti demonised Lilith in this conventional fashion. The painting's appeal lies precisely in its overwhelming appeal to the senses, its luxurious excess. Swinburne, for one, was happy to submit to Lilith's wiles: 'For this serene and sublime sorceress there is no life but of the body.'[73] Lilith herself offers a paradigm of aesthetic pleasure, tactile (her hand combing her hair) and visual (as she stares, rapt, into the mirror), which could be taken as a paradigm for viewing a work of art in the new Aestheticist climate of the mid-1860s. But she is also clad in traditionally virginal white. In this regard, the painting bears comparison with the early *Ecce Ancilla Domini!* (no.87), another exploration of the boundaries between spiritual and physical love. Rossetti himself wrily noted that *Ecce Ancilla Domini!* was a 'white painting' long before Whistler's three paintings bearing the title *Symphony in White* made that tonality a keynote of Aestheticism. Its ingenious exploration of white, cream and silver across the composition, as well as its fleshly and erotic suggestiveness, locate *Lady Lilith* at the very heart of British Aesthetic painting. TB

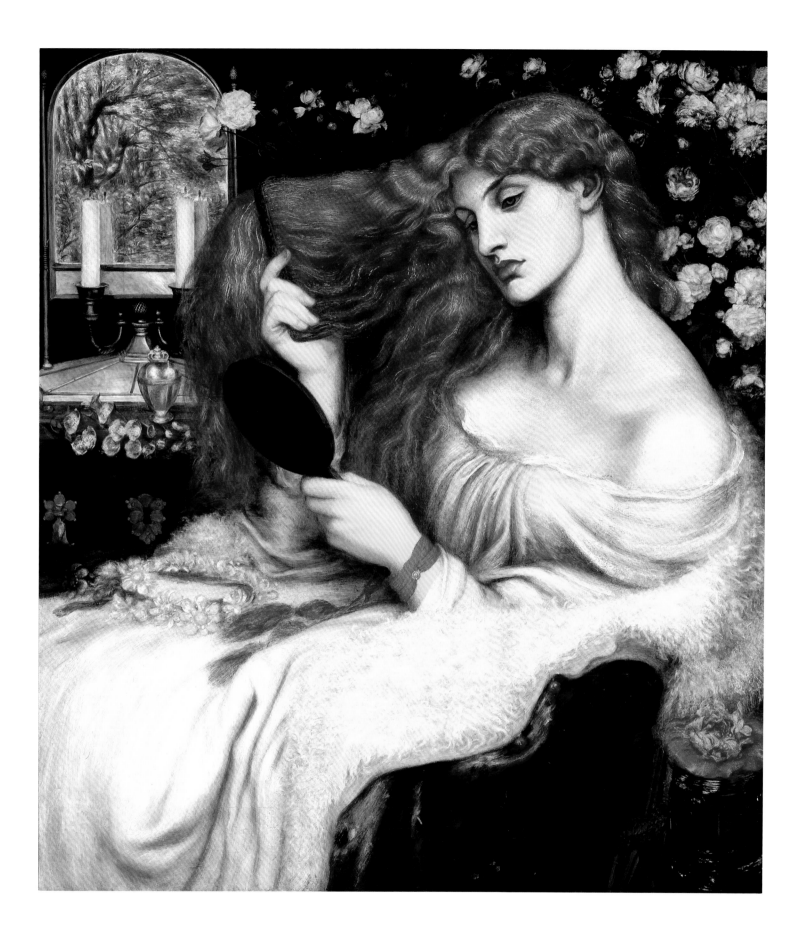

SIMEON SOLOMON 1840–1905

Bacchus 1867

Oil on paper laid on canvas 50.3 x 37.5
Birmingham Museums and Art Gallery. Bequeathed by Miss Katherine Elizabeth Lewis, 1961

Bacchus, the Roman name for the Greek Dionysos, god of wine and the grape harvest, was a troubling figure for respectable critics in Victorian England due to his associations with debauchery and also effeminacy.[74] Here, he is an androgynous youth with the traditional attributes of the fennel staff, or thyrsus, and the crown of vine leaves around his head. The painting is a brilliant appropriation of the genre of eroticised character studies perfected by Rossetti in the 1860s (see, for example, *Bocca Baciata*, no.119). Solomon eloquently demonstrated that the adolescent male body belongs in the canon of beauty, and offered a powerful, homoerotic contribution to British Aesthetic painting to contest the assertive hetero-sexuality of Rossetti's Aestheticism and the heteronormative assumptions underpinning most Pre-Raphaelite painting.

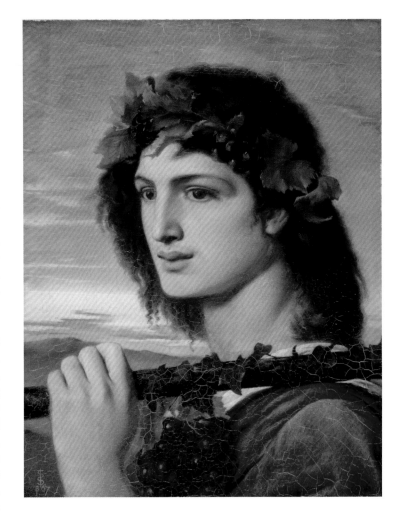

This *Bacchus* is also deeply rooted in the history of art. Solomon had admired a drawing in the Uffizi by the quattrocento painter Sodoma ('The Sodomite'), alleged to be a representation of his lover. However, the most powerful influence on Solomon's composition is that of the mysterious *sfumato* effects and androgynous, eroticised male figures of Leonardo da Vinci.[75]

The painting was exhibited at the Royal Academy in 1867, but was hardly mentioned in reviews. It did, however, make an impression on Walter Pater, the classicist and aesthetic theorist, who years later in 1876 recalled that 'in a "Bacchus" by a young Hebrew painter in the exhibition of the Royal Academy in 1868 [Pater remembered the date wrongly], there was a complete and very fascinating realisation … the god of the bitterness of wine, "of things too sweet"; the sea-water of the Lesbian grape become somewhat brackish in the cup.'[76] Pater detected in Solomon's painting a sense of the emptiness of purely sensuous pleasures. Algernon Swinburne, on the other hand, found that some works of Solomon, 'as the *Bacchus*, have about them a fleshly glory of godhead and bodily deity, which holds at once of earth and heaven … There is a mixture of utmost delicacy with fine cruelty in this face of fair feminine youth.'[77]

Solomon's name virtually disappears from art discourse after February 1873, when he was arrested for 'attempting to commit sodomy', ruining his career and condemning him to a life of poverty.[78] Despite technical shortcomings (the eyes of Bacchus, for example, are awkwardly rendered), Solomon can be numbered among the most original and compelling of the later Pre-Raphaelites. TB

EDWARD BURNE-JONES 1833–98
Maria Zambaco 1870

Bodycolour on paper 76.3 x 55
Clemens-Sels Museum, Neuss

Maria Zambaco was a member of the wealthy Greek mercantile community in London, the daughter of Demetrius Cassavetti and his wife Euphrosyne. She and two of her cousins, Aglaia Coronio and Marie Spartali, were admired for their striking appearance and became known as 'the Three Graces' in Aesthetic circles.

Zambaco began her artistic career as a painter and was probably a student of Burne-Jones, whom she met in 1866. Their passionate affair of 1868–9 had disastrous consequences for both parties.[79] 'She was born at the foot of Olympus and looked and was primeval', wrote Burne-Jones.[80] He was unwilling to leave his wife and children, however, and the affair came to a painful end when (in Rossetti's words) 'Ned … started for Rome suddenly, leaving the Greek damsel … howling like Cassandra'.[81] Later, she trained as a sculptor under Alphonse Legros, exhibiting successfully in London from 1886 and in Paris from 1888.

The present watercolour was made in 1870 for the sitter's mother, Burne-Jones's patron Euphrosyne Cassavetti. Exquisitely wrought in bodycolour, it is frankly confessional in content. The dolorous figure of Maria is seen with a tiny Cupid, whose arrow, on the ledge before her, bears Burne-Jones's signature. This places Maria in the role of Venus, Goddess of Love, and Burne-Jones as her victim. Her hands rest on an illuminated manuscript, which includes Burne-Jones's composition *Le Chant d'Amour* in the bodycolour version made in 1865 (Museum of Fine Arts, Boston). In it a medieval knight is helplessly entranced by a maiden playing music on an organ, whose bellows are worked by Cupid. The flower she holds is a dittany, which symbolises passion. The composition responds to a series of sensuous and eroticised female figures with Giorgionesque draperies by Rossetti, such as *The Blue Bower* (no.126). TB

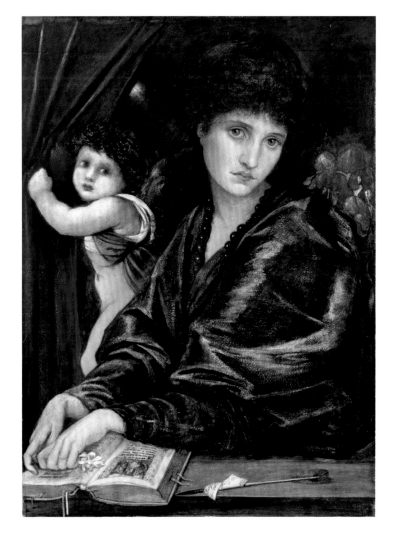

7. PARADISE

Many of the Pre-Raphaelites and their associates became deeply involved in the decorative arts in addition to painting or sculpture. Through the work of William Morris and the design firm he founded with Edward Burne-Jones, Dante Gabriel Rossetti and Ford Madox Brown, the applied arts had a profound impact on British and international design in the second half of the nineteenth century, influencing the course of British Aestheticism and leading to the Arts and Crafts movement. Morris and his collaborators wanted to elevate the status of design to equal that of the fine arts. Initially, they emphasised the collective and cooperative nature of artistic production in the decorative arts, modelled on an idealised view of the medieval workman.

Morris and Burne-Jones met while studying at Exeter College, Oxford, beginning a lifelong friendship and artistic collaboration (fig.21). As youthful students, they were excited by the most forward-looking contemporary art of the day and admired Rossetti's work. Burne-Jones recounted in 1854:

> I was working in my room when Morris ran in one morning bringing the newly published book [Ruskin's Edinburgh Lectures] with him: so everything was put aside until he read it all through to me. And there we first saw about the Pre-Raphaelites, and there I first saw the name of Rossetti. So for many a day after that we talked of little else but paintings which we had never seen.[1]

They first saw Rossetti's work in the collection of Thomas Combe in Oxford:

> Our greatest wonder and delight was reserved for a water-colour of Rossetti's, of Dante drawing the head of Beatrice and disturbed by people of importance. We had already fallen in with a copy of the Germ, containing Rossetti's poem of the Blessed Damozel, and at once he seemed to us the chief figure in the Pre-Raphaelite Brotherhood.[2]

The two young men met Rossetti not long after, and when both Morris and Burne-Jones moved to London, they eventually settled in the rooms at Red Lion Square that Rossetti had once occupied with Walter Deverell. Rossetti was effusive:

> Morris and Jones have now been some time settled in London, and are both, I find, wonders after their kind. Jones is doing designs (after doing the ingenuous & abject

so long) which quite put one to shame, so full are they of everything – *Aurora Leighs* of art. He will take the lead in no time … Morris' facility at poetizing puts one in a rage. He has been writing at all for little more than a year I believe, and has already poetry enough for a big book.[3]

In 1857 Rossetti organised a group of largely untested artists, including Morris and Burne-Jones, to paint frescoes based on the Arthurian legends in the newly constructed debating hall of the Oxford Union. During their time at Oxford Rossetti and Burne-Jones spotted Jane Burden, the daughter of an Oxford ostler, or stableman, while attending the theatre. She began modelling for Rossetti and for Morris (no.53), who fell in love with her and proposed marriage. They wed in 1859 and the young couple moved into Red House, the home in Kent that Morris commissioned from the architect Philip Webb.

Morris and his group of friends had set about decorating Morris and Burne-Jones's bachelor rooms at Red Lion Square, and subsequently the newly built Red House, with medieval-

Fig.21 Edward Burne-Jones (left) and William Morris (right) in the garden of Burne-Jones's home The Grange, Fulham, c.1890, platinum print by Frederick Hollyer. William Morris Gallery, London Borough of Waltham Forest [London and Washington]

inspired furniture and embroidery. These endeavours led to the founding of the decorative arts firm, Morris, Marshall, Faulkner & Co., in 1861. Though Morris was the primary force behind the Firm, as it was known, Burne-Jones, Rossetti, Webb and Brown were all original partners. It expanded over the years from its first premises in Red Lion Square in London, where it catered to a select artistic clientele, to a larger site in Queen Square and then to even larger workshops set up at Merton Abbey in Surrey and a shop on London's stylish Oxford Street, where its customers included the fashionable and rich. The partners' initial prospectus declared themselves 'Fine Art Workmen' who wished to provide 'work of a genuine and beautiful character'.[4] In 1875 the company was reorganised under Morris's sole direction as Morris & Co. with Rossetti and Brown ceasing to be partners. The Firm produced furnishings for both ecclesiastical and domestic interiors, beginning with tiles, embroidery, stained glass and furniture, such as *The Backgammon Players' Cabinet* (fig.22), and adding printed and woven textiles, carpets and, finally, tapestry. In many of these efforts Morris first taught himself how to make each kind of decorative art, often reviving older forms of production in protest against the cheap, mass-produced goods that dominated nineteenth-century manufacturing and had been made possible by the industrial revolution. Thus he mastered embroidery, weaving and dyeing, and through the Firm he revived the traditional techniques of block-printing wallpapers and textiles and medieval tapestry weaving. The Firm also drew on the nineteenth-century revival of medieval 'pot-metal' glass to produce brilliantly coloured windows for ecclesiastical and domestic decoration. Burne-Jones was the Firm's primary figure designer, and Morris the principal pattern designer. Together, they developed the Firm's distinctive compositions combining figure and background in tapestries and stained glass in the later years.

Morris sought unity between art and craftsmanship in all of his wide-ranging activities, and felt that the division of labour brought about by the industrial revolution had lost this ideal. His first-hand experience with manufacturing and production led him to embrace politics as integral to an aesthetic and creative life. He became a committed socialist and in the 1880s worked tirelessly as a political activist. He advocated that not only must the designer understand the medium and be true to its materials but also derive pleasure from the labour of producing the goods, as he believed had been the case during the medieval period.

Morris, like Rossetti, was also an accomplished and prolific poet, culminating in the publication of his cycle of poems, *The Earthly Paradise* (1868–70). He later turned to writing several prose romances, including *News from Nowhere*, which offered a utopian vision of a post-revolutionary future (no.151). He was a passionate reader and collector of rare books and manuscripts

and translated several ancient Icelandic sagas. As with the medieval crafts that he learned in order to further the aims of the Firm, Morris took up manuscript illumination and calligraphy in his spare time in the 1870s, producing a number of beautifully hand-illuminated books (no.145). After early experiences overseeing the publication of his poetry and his Icelandic translations, Morris devoted the last decade of his life to the art of the book, founding the Kelmscott Press in 1891. All features of the books were conceived by Morris, from the typography and ornamented initials and borders to the page layout, format and binding, and all the printing was done in a hand press on handmade paper. Burne-Jones provided woodcut illustrations for many Kelmscott Press books, including the masterful *Works of Geoffrey Chaucer* (no.152), which was issued shortly before Morris's death in 1896. DW

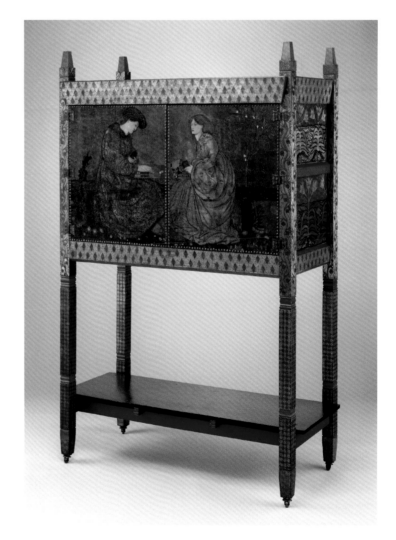

Fig.22 Philip Webb and Edward Burne-Jones, *The Backgammon Players' Cabinet*, made by Morris, Marshall, Faulkner & Co., 1861, painted pine, oil paint on leather, brass, copper, 185.4 × 114.3 × 53.3. Metropolitan Museum of Art, New York, Rogers Fund, 1926 [Washington only]

135

DANTE GABRIEL ROSSETTI 1828–82 and WILLIAM MORRIS 1834–96

The Arming of a Knight Chair 1856–7

Painted pine, leather and nails 141.3 x 47.6 x 49.5
Delaware Art Museum, Wilmington, DE. Acquired through the bequest of Doris Wright Anderson and through the F.V. du Pont Acquisition Fund, 1997
[Washington only]

136

EDWARD BURNE-JONES 1833–98

Self-Caricature in the Studio at 17 Red Lion Square 1856

Ink on paper 12 x 19.7
Mark Samuels Lasner Collection, on loan to the University of Delaware Library
[Washington only]

This chair is one of the few surviving pieces of furniture from Morris and Burne-Jones's bachelor days in London. Burne-Jones left Oxford in May 1856, taking rooms in Chelsea, and began seeing Rossetti often. Morris visited regularly while working for the architect George Edmund Street in Oxford. When Street relocated his office to London, Morris moved there and rented a small suite of rooms with Burne-Jones at 17 Red Lion Square, Holborn, which Rossetti had at one time occupied with Walter Deverell. They were settled there by December of that year, and John Ruskin became a frequent guest.

There are several accounts of the furnishings that Morris commissioned for the rooms. Georgiana Burne-Jones later wrote: 'Red Lion Square was dark and dirty … Morris and Edward had the first floor, on which there were three rooms; a large one in front with the middle window cut up to the ceiling for a painting light, a medium-size room behind this, which Edward had, and a further and smaller one, which was Morris'.[5] Burne-Jones, in a contemporary letter, portrayed the chaos of moving, which provides a glimpse of the collection of objects that the two men

gathered there: 'books, boxes, boots, bedding, baskets, coats, pictures, armour, hats, easels – tumble and rumble and jumble'.[6] In another letter Burne-Jones noted:

> We are quite settled here now. The rooms are so comfortable, not very furnished at present but they will be soon; when I have time I will make a rough drawing of the place and send it down. Topsy [a nickname for Morris] has had some furniture (chairs and table) made after his own design; they are as beautiful as mediaeval work, and when we have painted designs of knights and ladies upon them they will be perfect marvels.[7]

The drawing mentioned by Burne-Jones is the only image of the interior of the rooms and indeed shows a jumble of objects, including an easel, an artist's lay figure, clothing, candleholders and three images of medieval knights tacked on the walls. Though it was reproduced in Georgiana's memoir of her husband, the original has only recently come back to light. According to her, it shows 'a faithful record of the general aspect of the room, with

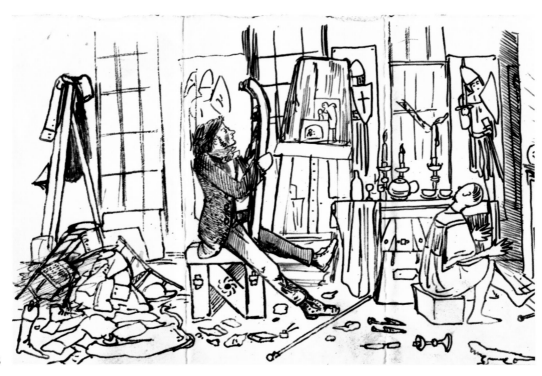

136

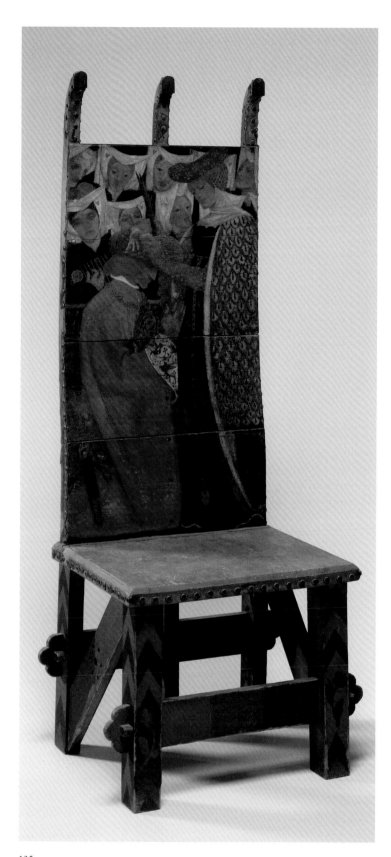

Edward himself, in caricature likeness, looking with devouring interest at a picture with which Rossetti had glorified one of the chairs that Morris designed'.[8] Two of these chairs are now in the collection of the Delaware Art Museum. The one exhibited here, *The Arming of a Knight*, was painted by Rossetti and Morris.

The furniture is thought to have been made by a local cabinet-maker, who recorded in his diary the 'orders for some very old fashioned Furniture in the Mideavel [sic] Style ... There were some tables and High backed chairs like what I have seen in Abeys [sic] and Cathedrals'.[9] Rossetti recounted that 'Morris is rather doing the magnificent there, and is having some intensely mediaeval furniture made – tables & chairs like incubi and succubi. He and I have painted the back of a chair with figures & inscriptions in gules & vert & azure, & we are all three going to cover a cabinet with pictures.'[10]

While Morris provided the abstract decoration on the legs of the chair, Rossetti painted the image of a lady bestowing her favour on a kneeling knight, though he is not wearing any arms. Behind the central pair are several women in white headdresses playing musical instruments. Rossetti and Morris adopted the bright colours and gilt characteristic of medieval manuscript illumination. The subject was identified as based on Morris's poem, 'Sir Galahad, A Christmas Mystery', though the incident pictured is not described as such in the poem.[11]

The chairs were subsequently moved to Red House in 1860 when Morris and Burne-Jones left Red Lion Square. They descended in the family of James A. Heathcote, who purchased Red House from Morris in 1866. DW

135

EDWARD BURNE-JONES 1833–98
Ladies and Animals Sideboard 1860

Pine with oil paint and gold and silver leaf 116.8 x 152.4 x 73.7
Victoria and Albert Museum, given by Mrs J.W. Mackail

In November 1856 Morris and Burne-Jones moved into rooms at Red Lion Square, for which Morris had furniture made to his own designs. Although this sideboard relates to what Rossetti called the 'intensely medieval' experimental furnishings that Morris and Burne-Jones produced in the years leading up to the establishment of the Firm,[12] it was a more conventional ready-made object than items such as no.54 and was described by Georgiana Burne-Jones as a 'plain deal sideboard' that the artist amused himself painting in the unsettled years before the couple's marriage in June 1860.[13] A watercolour by his studio assistant T.M. Rooke, executed in the year of Burne-Jones's death in 1898, shows the cabinet standing in the dining room of The Grange beneath a sumptuously painted *desco da parto*.[14] Unlike the artist's first example of painted furniture, *The Prioress's Tale Wardrobe* (no.54), the piece he simply titled 'Ladies and Animals' bears no ostensible narrative but depicts seven women in medieval dress engaged in both kind and abusive relationships with animals, a further instance of the dualism apparent in Burne-Jones's early, densely worked watercolours (no.56). On the front of the cupboard three ladies (possibly based on Georgiana and Jane) are shown attentively feeding pigs, parrots and fishes. These tranquil scenes are counterbalanced at each end by a painting of two women tormenting an owl and fishes on one side, while on the other side two further ladies recoil from a hideous newt and are attacked by a swarm of angry bees.

Figures are arranged to match the available spaces and to suit the different activities represented. Set against a dark background, the lady in the central panel stands upright on a red ground against a kimono stand, on which perch eight parrots. She is flanked on either side by two bending figures in landscape settings, with a gilded cloud and moon on the left door balanced by a sun on the right. The drawers above the two flanking figures, which determine their postures, are painted the same red as the floor in the central section and are enlivened with white clouds. The flatness, asymmetry and bold silhouettes of the front panels are echoed on the sides by the strong shapes formed by the gilded skies, which vie for attention against the patterned vegetation and banded decoration of the drapery. After Burne-Jones moved to Kensington in 1865, the sideboard was varnished to give it the warm glowing effect of lacquer, a decision possibly influenced by the Japanese artefacts on display at the International Exhibition of 1862 that so impressed the artists of the burgeoning Aesthetic movement. AS

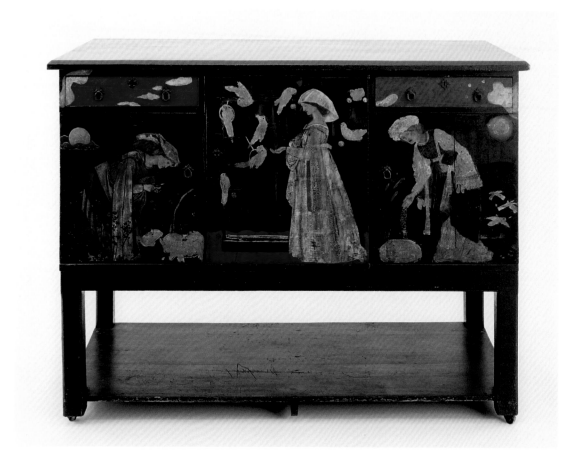

Qui bien aime tard oublie early 1860s

Linen ground embroidered with wool 184 x 68
William Morris Gallery, London Borough of Waltham Forest purchased with assistance from MGC/V&A Purchase Grant Fund, 1997

According to Jane Morris, her husband first became interested in embroidery during the mid-1850s, when he started to unpick antique examples to understand techniques and began experimenting using a wooden frame with worsted dyed to his own specification.[15] His earliest-known attempt was a wall hanging, crudely embroidered in natural dyed wools with a repeated tree and bird motif, and overarched with inscriptions of the motto, 'If I Can' (1856–7; Kelmscott Manor), which he took from Jan van Eyck's *Man with a Red Turban* (1433) in the National Gallery. While this panel was designed to reproduce the naive repeated patterns of the medieval embroideries that Morris had examined on his visit to France and the Low Countries in 1856, the actual motifs were adapted from wall hangings shown in two book illustrations, *The Dance of the Wodehouses* and *The King of France and the Duke of Brittany Meeting at Tours*, from the fifteenth-century manuscript of *Froissart's Chronicles* that he had studied in the British Museum. These details also served as the basis for the present work, a fragment from a larger section, which was made in the early 1860s, possibly for Red House, and was included on the Firm's stand at the 1862 International Exhibition before passing into the collection of Alice Boyd, mistress of William Bell Scott, for her home Penkill Castle, Ayrshire. Here it hung in a passageway in the old part of the building with another embroidered panel. These were collectively referred to by Rossetti in a letter to Boyd of November 1868 as 'the Topsaic tapestries', a pun on Morris's nickname 'Topsy'.[16] A variation of the design can be seen in the hanging adorning the background of Morris's painting *La Belle Iseult* (no.53).

The embroidery comprises a repeated design of fruit trees bounded with scrolls, decorated with grotesque chameleons and inscribed with the words *Qui bien aime tard oublie* (Who loves well forgets slowly) – a common proverb that also forms the title of a song in Chaucer's fourteenth-century poem the *Parlement of Foules*. Each tree grows from a triangular clump of earth scattered with daisies, and herons in flight move up the design in a vertical pattern. With a linen fabric of even weave serving as the support, the embroidery was produced in split and stem stitch in heavy wool threads of brown, green and ivory. Buff and red wools were twisted together for the ground, and stitches worked horizontally in what has been described as a 'brick' formation, an effect enhanced by the different dyes employed throughout the composition. In addition to natural dyes, it also incorporates a synthetic violet dye that only became available in the early 1860s, which would suggest that Morris was not totally averse to the use of aniline substances in his early embroidered prototypes.

Although Morris designed the hanging, it is not clear how much of the needlework he actually executed himself. Linda Parry has detected the work of at least three hands in the piece, all likely to be those of women in the artist's immediate circle: Jane Morris, her sister Bessie Burden and possibly Georgiana Burne-Jones.[17] While the involvement of women certainly attests to the collaborative nature of the Firm's ethos and Morris's belief that labour should be fulfilling for all involved irrespective of gender, it did not challenge the traditional association between women's craft and copying. This assumption only came to be questioned later in the century when craftswomen such as May Morris, Phoebe Traquair and Jessie Newbery began to establish reputations as designers as well as makers. AS

EDWARD BURNE-JONES 1833–98 and WILLIAM MORRIS 1834–96 (designers);
LUCY FAULKNER 1839–1910 (painter); MORRIS, MARSHALL, FAULKNER & CO. (maker)

Sleeping Beauty Tile Panel 1862–5

Hand-painted in various colours on tin-glazed earthenware Dutch blanks 76.2 x 120.6
Victoria and Albert Museum

Decorative tiles were among the earliest applied arts that Morris and his partners began producing after the formation of the Firm in 1861. Early tile painting was undertaken by Morris himself, Charles Faulkner and the women of Morris's circle, as well as the workmen he employed. Painted in enamels on tin-glazed earthenware blanks supplied by a Dutch manufacturer, the tiles were fired in the same kiln used for stained glass, first in the basement of Red Lion Square and later at Queen Square. The artist Myles Birket Foster, who ordered several tiles, stained glass and furnishings from the Firm, commissioned three panels illustrating fairy tales based on Sleeping Beauty, Beauty and the Beast (William Morris Gallery) and Cinderella (Walker Art Gallery) for his recently built home. The panels were intended as overmantels, to ornament the fireplace, which Morris called 'the chief object in the room'.[18] In 1864 Burne-Jones recorded payment for the Sleeping Beauty designs, noting humorously: 'To 10 designs of Sleeping Beauty at the mean and unremunerative price of 30/- each.'[19]

Burne-Jones's narrative scenes, which tell the story of Sleeping Beauty from her birth to her wedding with her princely rescuer, were surrounded by decorative tiles in the 'Swan' pattern, which Morris had created. At the bottom of the panel is the inscription: 'Of a certain Prince who delivered a King's daughter from a sleep of a hundred years, wherein she & all hers had been cast by enchantment.' All three of the tile panels for the scheme were painted by Charles Faulkner's sister, Lucy, who signed them with her initials.[20] The quaint charm of these works was characteristic of the Firm's early decorative ceramics and meant to evoke the simplicity of medieval decoration. DW

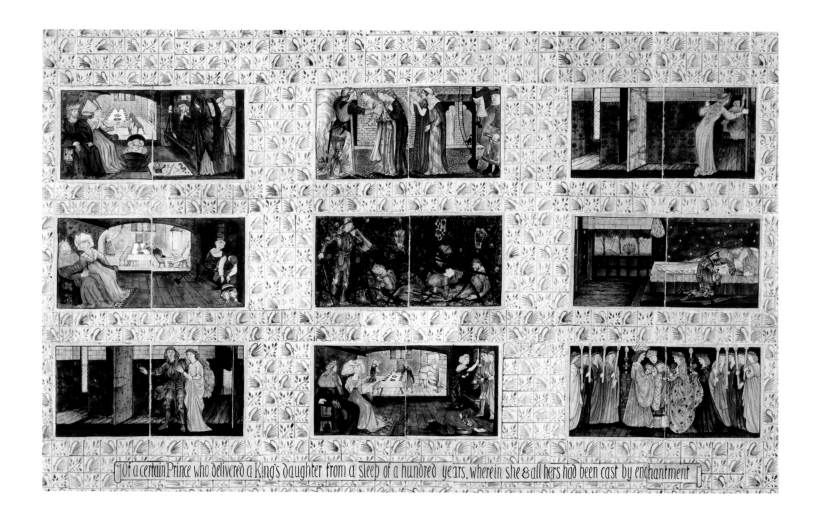

WILLIAM MORRIS 1834–96 and ELIZABETH BURDEN 1842–1924

Three-fold screen with embroidered panels depicting heroines c.1860

Wooden surround, woollen ground embroidered with wool and silk, each panel 135 x 71
From the Castle Howard Collection

These three appliqué embroidered panels, representing illustrious women from antiquity, were conceived as part of a set designed to form a narrative border around the walls of the dining room in Red House. Jane Morris described the scheme as comprising 'twelve large figures with a tree between each two, flowers at the feet and a pattern all over the background, seven of the figures were completed and some fixed on their background'.[21] Based loosely on Chaucer's late-fourteenth-century poem, 'The Legend of Good Women', the embroideries depict heroines, both sacred and pro-fane, from classical, religious and medieval sources. Not adhering strictly to the dramatis personae of Chaucer's text, Morris set out his own repertoire of virtuous women, bestowing on them long red tresses, sturdy draped bodies and solemn expressions to connote strength of mind and character. Rough sketches for the figures exist in a notebook of Morris's from the early 1860s,[22] and cartoons were made from these so that the designs could be transferred on to plain linen (a cartoon for the crowned right-hand figure of *Flamma Troiae* survives in the V&A collection[23]). The panels were embroidered in a traditional late-medieval technique before being cut out around the outline and applied to a woollen or serge backing, which had itself been worked in a simple coiling floral pattern in chain stitch.[24]

The overall scheme was, however, never completed, and when the Morris family moved out of Red House in 1865, the existing panels were shared out among those who had made them. The executants included Jane Morris, her sister Elizabeth (Bessie) Burden, Kate Faulkner (sister of the Firm's book-keeper), Georgiana Burne-Jones and possibly her sister Alice Macdonald.[25] This work has been attributed to Bessie, who went on to teach at the Royal School of Needlework in the 1870s. In 1888 she exhibited three panels at the Arts and Crafts exhibition, which have been identified with this piece. The following year the embroideries were sold to George Howard, 9th Earl of Carlisle, having been made into an oak-framed screen by Morris & Co., for which the Firm charged £20, and Burden was paid £80 for her work by the client.[26] From left to right the panels depict Lucretia with a sword, Hyppolyte holding a sword and a lance, and Helen of Troy with a torch. Displayed against an ornamental background, the three figures stand on a flower-strewn lawn behind a low brick wall, whose edge only the feet of Hyppolyte penetrate.

The panels display a variety of stitch work, which animates the rather static presentation of the figures. On the left the ivory robe of Lucretia was worked in wool in brick stitch and appliquéd onto a dark-blue wool ground embroidered with a tracery of chain-stitched foliage. The appliquéd warrior Hyppolyte in the central panel wears an olive wreath crown, and her body is encased in armour covered with a blue and ivory tabard embroidered with floral roundels and birds with outstretched wings. She holds a raised gilt-thread sword hilt and stands before a similarly worked background. In the final panel, *Flamma Troiae*, brick stitch has been used for the ivory and gold lattice robe, and silk floss and gilt thread for the peacock-feather-patterned sleeve linings. The frontal disposition of the figures, the diaper patterns and strong outlines of the draperies all invite comparison with the bold stained-glass designs produced by Morris & Co., especially the left-hand panel with its bright colours, the background of the other two having faded to pale blue. AS

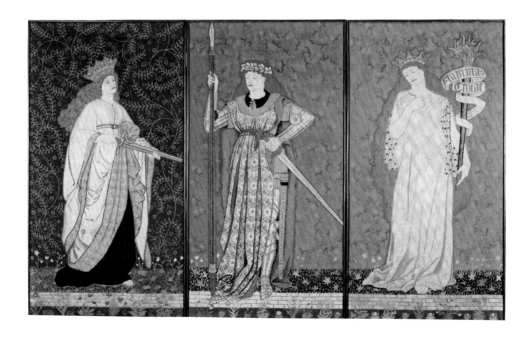

141
WILLIAM MORRIS 1834–96 (designer); MORRIS,
MARSHALL, FAULKNER & CO. (maker)
'Trellis' wallpaper, registered 1864
Block-printed in distemper colours by Jeffrey & Co. 80 x 60 (framed)
William Morris Gallery, London Borough of Waltham Forest

142
WILLIAM MORRIS
Design for 'Tulip and Willow' printed textile 1873
Watercolour over pencil on paper 114.2 x 95
Birmingham Museums and Art Gallery. Purchased from Morris & Co. through the
Friends of BMAG, 1940

143
WILLIAM MORRIS (designer); MORRIS & CO.
(maker)
'Cray' printed textile 1884
Block-printed cotton 362 x 93.5
William Morris Gallery, London Borough of Waltham Forest

'Whatever you have in your rooms think first of the walls, for they are that which makes your house and home', advocated Morris in an 1882 lecture.[27] He designed many patterns for wallpaper, beginning in the early 1860s shortly after the Firm's founding. His first wallpaper was the unusual pattern 'Trellis', which features climbing roses, perched birds and tiny butterflies, and was offered on both light and dark grounds. The printing of the wallpapers with woodblocks using distemper colours was contracted to the firm Jeffrey & Co.

During the 1870s Morris devoted considerable time to designing repeating patterns for wallpapers and textiles for use as wall decoration, curtains and upholstery. His designs drew on the forms of native British plants and flowers as well as his study of historical fabrics, and they ranged in colour and scale from subtle and quiet to bold and dynamic. As with wallpaper, Morris initially worked with other firms to dye embroidery yarns and produce printed and woven textiles. He rejected the technique of using engraved rollers to print textiles, which was widely adopted in commercial manufacturing by the mid-nineteenth century, because he believed the quality of the colour suffered in comparison with traditional block-printing. He first commissioned a Lancashire cotton printer, Thomas Clarkson, to produce printed textiles from woodblocks. His 1873 design for 'Tulip and Willow' was the second pattern put into production. Clusters of tulips punctuate a background pattern of compact willow leaves, which became a favoured motif in many of his early designs. Morris, however, disliked the chemical dyes that had come into use in the first half of the century. Clarkson's used synthetic dyes such as Prussian blue, and Morris was unhappy with the results.[28]

Morris soon immersed himself in reviving the art of dyeing with natural dyestuffs. From 1872 he conducted dyeing experiments at the Firm's premises in London's Queen Square. In 1875 he began collaborating with Thomas Wardle, the owner of a hand-dyeing and printing works in Leek, Staffordshire (and brother of George Wardle, the Firm's second manager). Some of his earliest patterns during this period reflect his earlier experience with wallpaper and, similar to 'Tulip and Willow', rely on wavy lines of flowers and leaves against dense vegetative backgrounds. Others show the influence of fashionable contemporary Indian textiles imported to England and the historic textiles he was studying at the South Kensington Museum. Morris, however, became increasingly dissatisfied with the quality of work from Wardle and his employees. In 1881 the Firm established workshops near Wimbledon at Merton Abbey, where Morris assumed full control of production by instituting his own dyeworks and printing facilities with the knowledge he had gained from working with Thomas Wardle. George Wardle saw Merton Abbey as the realisation of Morris's potential as a colourist:

> The peacock blues, rusty reds and olive greens of that period [the 1870s] were not by any means Mr. Morris's ideal, but the best he could get done. As soon as he was able to set up his own dyehouse he turned at once to the frank full hues of the permanent dyestuffs – indigo blue, madder red, the yellow of weld etc. etc., & with these he produced the beautiful Hammersmith carpets and the Merton tapestry & chintzes.[29]

Morris was pleased with the colours achieved by the Firm from the use of traditional natural dyes rather than the new dyes that produced 'hideous colours, crude, livid, and cheap'.[30] He gravitated to bright primary colours, and one of the Firm's signature offerings at Merton Abbey was cloth coloured by the traditional indigo-discharge method. Morris took great pains to revive this process, which produced a rich blue. The Firm also continued to produce woven fabrics to Morris's designs, which were again often inspired by his study of historical textiles.

'Cray' is among Morris's last designs for printed cottons and is one of a group named after tributaries of the River Thames. These elaborate patterns exploit strong diagonal lines and layers of botanical detail in several colours, conveying a masterful sense of complexity and depth. Using the indigo-discharge method at Merton Abbey, 'Cray' was printed in multiple colourways, such as this example with a red ground, green and blue leaves, and yellow and pink flowers. It required thirty-four printing blocks, the most of any of the Firm's printed cottons and thus the most expensive. DW

141

142

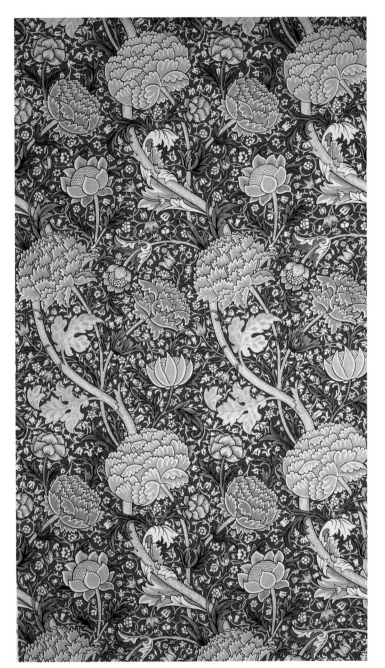

143

PHILIP WEBB 1831–1915 (designer); MORRIS & CO. (maker)
Sussex chair, designed c.1860–5, made 1870–90
Ebonised beech, with a rush seat 85 x 52 x 44
Victoria and Albert Museum

Warrington Taylor, who became the manager of Morris & Co. in 1865, encouraged Morris and his collaborators to design and commission lighter and more saleable furniture than the heavy, gothic forms designed by Philip Webb. There are various versions of the Sussex chair, which was based on examples of early nineteenth-century furniture found in farmhouses in Sussex. Webb was probably responsible for the first Sussex chair design, but Brown seems to have been involved in creating subsequent variants.

All the versions shared certain characteristics: slender, turned wooden legs and a back made from slim wooden elements and a wicker seat. If the wickerwork adds a slightly rustic appearance to this range of chairs, their general character is one of lightness and elegance. Indeed, its extreme simplification has allowed the Sussex chair to be seen as a precursor of modernist design, just as Morris himself was celebrated in Nicholas Pevsner's *Pioneers of Modern Design*. Morris's chairs, for Pevsner, 'tell of a deliberate return to the most primitive attitude in shaping domestic objects'.[31]

William and Jane Morris used Sussex chairs in their London home, Kelmscott House, Hammersmith; Burne-Jones also acquired four for The Grange at Fulham. Examples from Morris & Co.'s Sussex range were purchased to furnish students' rooms at Newnham College, Cambridge, and to provide respite for tired visitors to the galleries of the Fitzwilliam Museum, Cambridge. The chairs remained in production well into the twentieth century. TB

WILLIAM MORRIS 1834–96, EDWARD BURNE-JONES 1833–98 and CHARLES FAIRFAX MURRAY 1849–1919

The Rubáiyát of Omar Khayyám 1872: open at ff.9v–10

Ink, watercolour and gilding on vellum 13.5 x 23.5
The British Library, London

Morris first became interested in book production as a student in Oxford, when he and Burne-Jones visited the Bodleian Library to study medieval illuminated manuscripts. Here he would have encountered the earliest-known Persian manuscript of Omar Khayyám's *Rubáiyát*, dated 1460–1 and purchased by the library in 1844. Morris went on to develop a passion for the art of calligraphy, consulting early handwritten texts to master roman and italic scripts. For the twenty or so manuscripts he worked on between 1870 and 1875, he wrote out the text himself, an exacting task for such an impetuous and eager man, the actual decorative work being a collaborative enterprise involving Burne-Jones and the artist Charles Fairfax Murray.

Edward Fitzgerald's English translation of *The Rubáiyát of Omar Khayyám* became a cult book in Pre-Raphaelite circles. The original *Rubáiyát* by the twelfth-century astronomer, mathematician and poet, Omar Khayyám of Nisapur in Persia, was composed of 110 quatrains, or four-line stanzas, which the reclusive scholar Fitzgerald refashioned into a poem that treats universal themes through a persona who finds solace in material pleasures. Fitzgerald's anonymous translation was first published by the bookseller Bernard Quaritch in an edition of 200 copies in 1859, but attracted little notice until D.G. Rossetti and Algernon Swinburne discovered it, the latter presenting a copy to Burne-Jones who came to prize the poem for what he called its 'splendid blasphemies'.[32] It came out in the same year as Darwin's *On the Origin of Species*, and its epicurean agnosticism helped fuel the amoral 'art for art's' sake philosophy of the Aesthetic movement. As the poem became more widely known, Fitzgerald revised it three times, in 1868, 1872 and 1879.

A colophon provided by Morris for this volume, the first of altogether four copies he produced, states that it was completed on 16 October 1872, and according to a note dated 1908 that Georgiana Burne-Jones appended to the manuscript, Morris was then still not aware of the identity of the translator he so admired (Fitzgerald's authorship first being disclosed in 1873). In her memoir of 1904 she writes: 'Morris, to do the poem honour, had borrowed the copy that Swinburne gave to Edward, and glorified it by twice working out the whole in an exquisite hand upon fine vellum, illuminated with flowers and gold and colour fit for the words'.[33]

This manuscript was made specifically for Georgiana herself, as indicated by the capital 'G' that heads the five most densely ornamented pages. Morris provided the floral ornamentation and wrote out the verse in exquisite calligraphy in a minute roman script, most likely with the use of a crow-quill.[34] The opening of the book illustrated here illuminates a humorous section titled the 'Kuza Nama', or Book of Pots, in which animated clay vessels ponder the mysteries of their existence and then become quiet in anticipation of being filled with wine. Six full-length figures in soft muted tones (reminiscent of music-making angels by Fra

Angelico[35]) adorn the outer margins, playing, from top to bottom: an organetto, hand cymbals and a rebec on the left; and a psaltery, a shawm or flageolet, and hand cymbals on the right. According to Georgiana, these were all designed by Morris except possibly the top figure on the recto. The two seated angels playing Celtic harps beneath the verses on each page she attributed to Burne-Jones. However, as all the figures were actually executed by Fairfax Murray, the ascriptions are not all certain, as Georgiana admitted in her note. All figures are embedded within intercoiling foliage, the branches of which penetrate the area of the text itself. May Morris later claimed that each flower in the design was different and identifiable: 'I do not think there is a single conventional or nameless flower in the small slim volume … It is a flower garden turned into a book.'[36] Indeed, on close examination these appear to be whitethorn blossom and forget-me-nots on the verso and possibly creeping hydrangea and ash on the recto. A generic willow pattern interrupting the text on the verso provides a decorative foil to the title of the particular section. AS

EDWARD BURNE-JONES 1833–98 and WILLIAM MORRIS 1834–96
Love Leading the Pilgrim through the Briars, from *The Romance of the Rose* 1874–82

Linen embroidered with silks, wools and gold thread 88 x 582
William Morris Gallery, London Borough of Waltham Forest

In 1874 Morris and Burne-Jones received a commission from the metallurgist and industrialist Sir Isaac Lowthian Bell to design embroideries for the upper walls of the dining room of his house, Rounton Grange, at Northallerton in Yorkshire, which was being built by Philip Webb. Despite Morris's misgivings about having to minister to what his client overheard him call 'the swinish luxury of the rich', Bell, the leading iron manufacturer of the north-east, was to become an important patron of his firm, helping to establish its reputation in the north of England.[37] A contemporary photograph shows how the three main panels of the frieze ran above the wooden panelling on the southern, northern and western sides of the room, with the eastern aspect given over to a large bay window.[38]

The subject of the embroideries was based on the thirteenth-century French allegorical dream poem of courtly love, *Roman de la Rose*, by Guillaume de Lorris and Jean de Meun, known to Burne-Jones and Morris from a richly illuminated manuscript in the British Museum as well as Geoffrey Chaucer's translation, *The Romaunt of the Rose*.[39] In both versions of the poem the lover dreams of an encounter with the god of love, through whom he discovers a secret garden containing the rose that symbolises the attainment of his quest. Burne-Jones designed five panels for

the sequence: *The Pilgrim Studying Images of the Vices on the Exterior of the Garden of Idleness* (for the south wall); *The Pilgrim Greeted by Idleness at the Gate of the Garden* (original position unknown); *The Pilgrim in the Garden of Idleness* (north side); *Love Leading the Pilgrim through the Briars* (west side); and *The Pilgrim at the Heart of the Rose* (original position unknown). For each design he offered a free interpretation of the source, reflecting his and Morris's interest in how the oral tradition of repeating stories gradually led to them being altered over time, and explaining how an artist's choice of medium influenced interpretation.[40] In the present work the pilgrim is guided through a thicket of rose briars by the winged figure of love, who is crowned with roses and surrounded by birds. Embedded within the coiling branches lurk allegorical figures of Shame, lying asleep; naked, bearded Danger with his club and leopard skin; and hooded Wicked Tongue, girded at the waist with strands of thorns signifying slander. Burne-Jones went on to produce other versions of this scene in oil (1877–97; Tate), as designs for tapestry (1909; Birmingham Museums and Art Gallery – 1910; private collection) and as engravings for the Kelmscott *Chaucer* (no.152), adapting the composition in relation to the medium chosen for each design. In the embroidery the frieze-like disposition of the figures across the

composition and the dense patterns of verdure recall Botticelli's *Primavera* (c.1482; Uffizi, Florence), while the idea of enclosing figures within a continuous border of briars may owe something to the rose-hedge motif in the 'Tower of Jealousy' illumination in the British Museum manuscript mentioned above.[41] Morris was responsible for the decorative background of this panel, which tellingly recalls the wallpaper and fabrics he was designing at the time with their repeated patterns and compression of interlacing elements within a shallow surface.

The Rounton Grange commission is indicative of how the Morris Firm set out during the 1870s to disseminate the idea of art needlework in the form of kits to be completed at home. Once the composition had been decided on, Morris's business manager George Wardle prepared working drawings from Burne-Jones's designs (Birmingham Museums and Art Gallery), and these were traced onto the cream linen support in pencil and watercolour. The panels were then handed over to the client together with vegetable-dyed crewel wools and silks sourced from Thomas Wardle's silk-dye works in Leek, Staffordshire, to be worked in metre sections. The executants were Bell's wife Margaret (née Pattinson) and their daughter Florence, who each signed the embroidery on the reverse. Despite taking advice from Bessie

Burden about techniques and materials, these were two highly experienced and accomplished needlewomen, who spent eight years on the job, working 'with as much skill and patience as any two medieval ladies in a bower'.[42] Indeed, the quality of the embroidery is so high that it is impossible to discern where they started and finished each section.

To offset the monotonous task of executing the repeated patterns of the background, the Bell ladies adopted an experimental approach, using a combination of long and short stitch with satin and stem for the outlines. The stitch work respects each shape within the composition: leaves following veins, drapery following folds, and flesh composed of short vertical strokes. In order to dramatise the narrative, the figure of Love was made to stand out against the muted greens and russets, which serve to camouflage the other figures within the setting. For the wings, scarf, bow and arrow of Love, the women combined crewel wools with shiny silver floss and other metallic threads, and to lend texture and catch the light, the wings were couched with gold over string padding. These metal threads have since oxidised and turned black, somewhat muting the iridescent impact of the original design.[43] AS

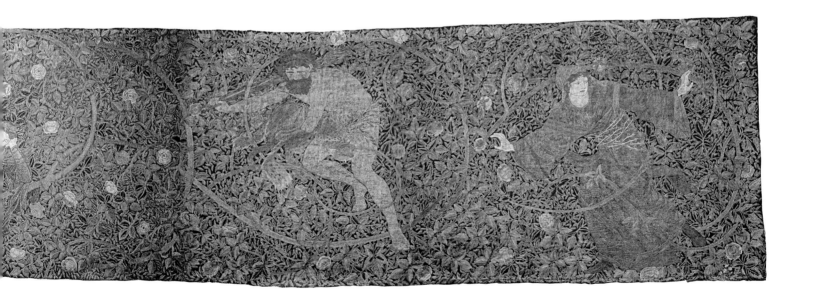

WILLIAM MORRIS 1834–96 (designer); MORRIS & CO. (maker)

Peacock and Bird Carpet 1885–90

Hand-knotted woollen pile on cotton warp 410 x 410
William Morris Gallery, London Borough of Waltham Forest

Morris had long been an admirer of Persian, Turkish and Chinese rugs and in 1877 began to experiment with carpet knotting with the aim of producing his own designs. The actual manufacture of hand-knotted carpets took place thereafter in the stables of his family house in Hammersmith until 1881, when production moved to the Merton Abbey works, which had space to accommodate larger looms. Here semi-skilled young women were employed as weavers, as Morris was of the view that only their small hands were suited to the intricate processes required for the job.

From the late 1870s London was the centre of an import trade in Persian carpets. Despite Morris's enthusiasm and deep knowledge of Eastern rugs (he advised the South Kensington Museum on its acquisition of the famous sixteenth-century Ardabil carpet from the shrine of Shaykh Safi al-Din Ardabili in Persia), he nevertheless aspired to make Britain independent of the East in the supply of hand-made carpets, an ambition he set out around the time of Morris & Co.'s first exhibition of rugs at its Oxford Street premises in 1880:

> It seems to us ... that ... we people of the West must make our own hand-made carpets ... and that these, while they should equal the Eastern ones as nearly as may be in materials and durability, should by no means imitate them in design, but show themselves obviously to be the outcome of modern and Western ideas, guided by those principles that underlie all architectural art in common.

In keeping with this claim, the carpets produced by the Firm used the relatively bulky Turkish or symmetrical knot to realise Morris's bold individual designs. This carpet thus has an average of 36 knots per square inch, a marked contrast to the very fine Ardabil carpet, which comprises an average of 304 knots covering the same area. According to the condition report commissioned by the William Morris Gallery (January 2010), the carpet is a knotted Axminster type with wool knots forming the pattern on cotton warps, the weft being cotton with jute used as a supplement. Hand-wrapped selvedges or borders mark either side, with the top and bottom edges knotted into macramé fringes.

Like other design reformers of the period such as Christopher Dresser, Morris discouraged the use of perspective and shading to create three-dimensional effects, choosing to compose with distinct blocks of colour, primarily his favourite combination of indigo blue and madder red. He was, however, wary of depending too much on geometrical forms, preferring organic shapes such as the floral decoration and peacock motif of the present work, which is tentatively dated 1885–90, the final period of Morris's career as a designer. It is not known who commissioned this vibrant and confident composition but the peacock motif suggests an aficionado of the Aesthetic movement. The carpet has an unusual square format and a directional centre panel, which would suggest that it was intended for an open space where it would not be obscured by furniture.

Although Morris often incorporated birds into textiles and wallpapers, he rarely used them in carpets (the Bullerswood example, V&A, made for the wool trader John Sanderson in 1889 being a notable exception). In the centre panel two peacocks are symmetrically arranged on scrolled foliage with open mouths, their tails just overlapping the border. Surmounting these are six unspecified birds fluttering among floral branches. The whole ensemble is set within an indigo-blue border with repeated abstracted tendril and lotus-head motifs. An outline design for the central section exists in the William Morris Gallery. All other preliminary designs would have been handed over to the Firm's draughtsmen for enlargement on point paper (each painted square representing one knot) to serve as a guide for the weavers at Merton Abbey.

In spite of his socialist principles, Morris was an astute businessman who catered to clients according to income. While his small rugs could be purchased direct from the Firm's shop, larger objects like this were generally made to order and often named after the grand houses for which they were intended. Morris & Co. also received orders from overseas, from places as far apart as Chicago and Adelaide, and in 1883 a selection of their hand-made carpets went on display at the International Fair in Boston. It is possible that this exhibition prompted the commission of Peacock and Bird, which passed down through several collections in the United States before being acquired for the William Morris Gallery in 2010. AS

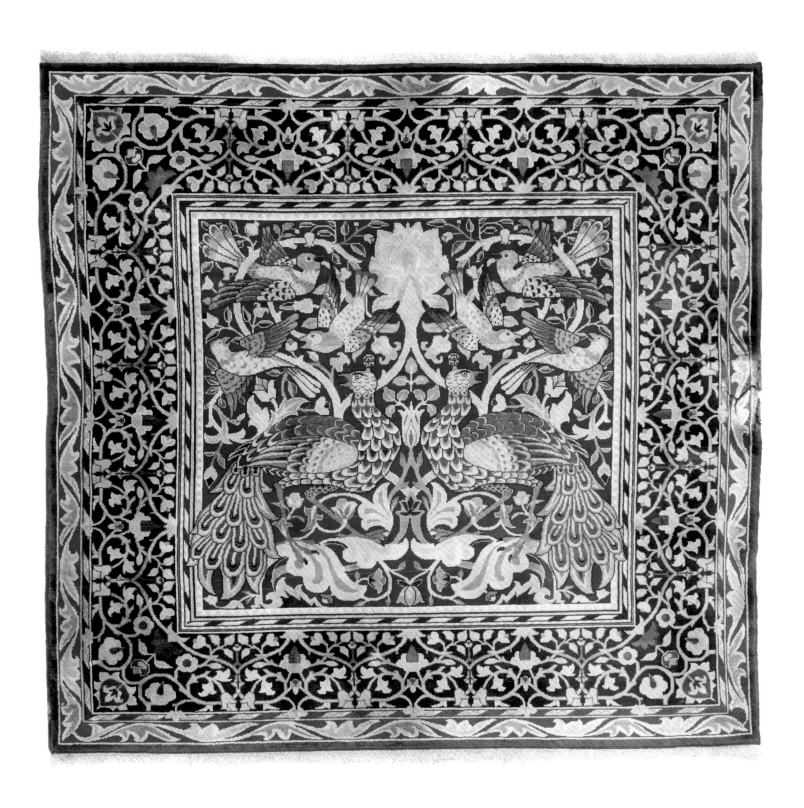

EDWARD BURNE-JONES 1833–98

Georgiana Burne-Jones begun 1883

Oil on canvas 73.7 x 53.3
Private collection

In 1879 Burne-Jones started a family portrait showing his wife Georgiana seated at a piano, flanked on either side by her children Philip and Margaret.[44] The solemn interiorised expression of Georgiana in this picture may have inspired the single portrait of her that Burne-Jones started in 1883 but was unable to resolve to his satisfaction. A label on the back describes the work as 'unfinished', a statement supported by the figure of Philip in the distance who on close inspection appears to be missing some limbs. The painting was never exhibited during the artist's lifetime, nor was it included in the large memorial exhibition at the New Gallery in 1898–9.

In marked contrast to E.J. Poynter's rather dainty watercolour of Georgiana that presents her as a demure society lady taking tea (c.1870; private collection), Burne-Jones's conception of his wife was more austere, reflecting the staunch Nonconformist upbringing and independence of character that distinguished the daughters of the Macdonald family.[45] Although as an adult Georgiana came to lose respect for organised religion, she retained a strong sense of moral integrity, channelling her energies into her marriage and the social and political causes that she espoused, encouraged by her long-standing friendship with William Morris. The painting was started when she was forty-three and in her twenty-third year of married life. Despite her sobriety of expression, which has been related to her stoicism as Burne-Jones's long-suffering wife, Georgiana's steady gaze conveys something of her strength of personality, a quality noted by the connoisseur W.G. Robertson, who on first meeting her was struck by the 'quiet in those wonderful eyes of clearest grey ... yet, beneath and beyond could be sensed an Energy, dominant, flame-like'.[46]

The composition respects the sitter's manner of self-presentation as seen in a photograph of Georgiana taken around the same time by Frederick Hollyer (V&A). This shows her seated, book in hand, in a similar upright manner, looking directly at the viewer and wearing a plain dark dress with lace trim, her hair parted in the centre and drawn back. In the painting Georgiana's arm rests on a parapet and she holds a copy of John Gerard's *Great Herbal or Generale Historie of Plantes* of 1597, a reference book favoured by Morris and Burne-Jones that the latter was consulting at the time in relation to a series of watercolours titled *The Flower Book*. The book is shown open at an illustration of a heartsease or pansy, against which rests an actual specimen of the plant. In the language of flowers this stands for thoughts and undying love, qualities that relate not only to the bond between husband and wife (Georgiana was later to place an offering of

purple pansies on her husband's grave[47]) but between Georgiana as a mother and her offspring, who appear in the illuminated room in the background – Philip the eldest seated at his easel with a maulstick, and Margaret standing reverently behind him. While the rectilinear alignments of the composition testify to the artist's interest in early Renaissance art, the abrupt jump to a distant room containing figures is reminiscent of the conventions of Mannerist and Baroque portraiture, one possible source being the painting then thought to be of Isabella d'Este at Hampton Court, which inspired the serpentine dress in no.56.[48] AS

149

WILLIAM MORRIS 1834–96

Chants for Socialists 1885

Pub. Socialist League Office, London

Printed pamphlet 22.4 x 14.6
William Morris Gallery, London Borough of Waltham Forest

150

WILLIAM MORRIS

Monopoly; or, How Labour is Robbed 1890

Pub. Hammersmith Socialist Society, London

Printed pamphlet 18.2 x 12.3
William Morris Gallery, London Borough of Waltham Forest

As undergraduates at Exeter College, Oxford, William Morris and Edward Burne-Jones encountered social and political radicalism at the same moment they became aware of Pre-Raphaelite painting. They were profoundly affected by 'The Nature of Gothic', the critique of capitalism in John Ruskin's recently published *Stones of Venice* (1851–3), which Morris considered to be 'one of the very few necessary and inevitable utterances of the century', adding that 'it seemed to point out a new road on which the world should travel'.[49]

It was only in the early 1880s, however, that Morris became involved with socialist politics. He joined the Democratic Federation, led by H.M. Hyndman, in 1883. That year he also read Karl Marx's *Das Kapital* in French, but his vision of social renewal was always more cultural and aesthetic in content than it was economic and ideological. His distinctive vision is best represented by the medievalising, English socialist Utopia he imagined in *News from Nowhere* (1890; see no.151). His carefully argued pamphlet, *Art and Socialism*, first delivered as a lecture in 1884, claims that 'popular art' (meaning the production of all the goods and objects that surround us) can only be beautiful if the workers who produce it are treated with respect, properly remunerated and able to enjoy their work.

Morris's political pamphlets are written in powerful, simple language. The tract *Monopoly*, 1890, centres around

> the simple statement of these few words: 'The workers are in an inferior position to that of the non-workers.' … [Morris imagines] the workman saying to himself, 'Here am I, a useful

person in the community, a carpenter, a smith, a compositor, a weaver, a miner, a ploughman … yet, as long as I work thus and am useful, I belong to the lower class, and am not respected like yonder squire or lord's son who does nothing.'

For Morris monopoly capitalism, simply a legalised form of cheating, lies at the heart of the system that perpetuates class difference.

Morris and his supporters left the Federation to found the Socialist League in 1884, to which he dedicated much energy in the final years of his life. Although he was interested in communal music-making and also in the revival of medieval music, Morris wrote socialist songs that were more perfunctory. In *Chants for Socialists* he provided fiery new words to well-known popular songs and hymns: accessibility and familiarity were more important than musical originality. These were sung at Socialist League meetings and form part of a larger tradition of socialist music-making that would also include Edward Carpenter's *Chants of Labour: A Song Book of the People, with Music* and the designer and architect C.R. Ashbee's *Essex House Song Book*.[50] *Chants for Socialists* was published by the Socialist League as a pamphlet in 1885, bearing a handsome emblem designed by Walter Crane, in which the league's aims, 'Agitate, Educate, Organize', were enshrined in a composition looking back to medieval design and forward to a post-revolutionary moment. Through Morris and his followers Pre-Raphaelitism was transformed from an artistic avant-garde to a revolutionary socialist movement. TB

149

150

151

WILLIAM MORRIS 1834–96

News from Nowhere, or an Epoch of rest: being some chapters from a Utopian romance 1892: open at frontispiece by C.M. Gere

Pub. Kelmscott Press, Hammersmith

Printed book, 21 x 15
Victoria and Albert Museum

152

WILLIAM MORRIS and
EDWARD BURNE-JONES 1833–98

The Works of Geoffrey Chaucer 1896: open at *The Romaunt of the Rose*, pp.252–3

Pub. Kelmscott Press, Hammersmith

Printed book, 44 x 32
The Blackburn Museum and Art Gallery

Morris founded the Kelmscott Press in 1891, with the aim of printing books that were 'visible works of art'.[51] He wrote: 'Let us say concerning the Book, that to cosset and hug it up as a material piece of goods, is surely natural to a man who cares about the ideas that lie betwixt its boards.'[52] Among the books issued by the Press until its closure in 1898, a year and a half after Morris's death, were Morris's own writings, English classics, Old English and medieval texts that he loved, and works by his friends and contemporaries, including Rossetti.

Morris began by designing a Roman typeface based on fifteenth-century Venetian fonts, particularly those by Nicolas Jenson, which came to be called the Golden type, after Caxton's *The Golden Legend*, the first book intended to be printed with it. Morris described: 'What I wanted was letter pure in form; severe, without needless excrescences; solid, without the thickening and thinning of the line, which is the essential fault of the ordinary modern type, and which makes it difficult to read; & not compressed laterally, as all later type has grown to be owing to commercial exigencies.'[53]

Among the works printed in the Golden type was a reprint of Morris's socialist prose romance, *News from Nowhere*, which was first published in 1890 in the socialist journal *Commonweal*. In the book Morris's narrator takes a journey on the Thames in twenty-second-century England where a revolution has led to a commonwealth of contented people living a simple, communal life. It creates a utopian vision of a future life imbued with Morris's love of the past. The frontispiece by Charles March Gere pictured Morris's beloved sixteenth-century country home, Kelmscott Manor, as the embodiment of the nostalgic ideal for the future. Morris leased the house from 1871 after leaving Red House in 1865. It lent its name both to Morris's London home in Hammersmith, Kelmscott House, and the Press, whose headquarters were set up nearby.

Other Kelmscott Press books were published in a larger size with more elaborate borders and illustrations, and set in Morris's second typeface, the Troy type, a gothic typeface based on German fifteenth-century examples and named after the Press's edition of William Caxton's translation of *The Recuyell of the Historyes of Troye* by Raoul Lefevre.

Morris's last, great achievement was also his final collaboration with Burne-Jones: the edition of Geoffrey Chaucer's work. Georgiana Burne-Jones describes the two men rereading Chaucer together in preparation for the volume: 'The friends sat down dutifully to read Chaucer over again before beginning their work, and infinitely funny it was when Morris occasionally professed to be taken prosaic and not to understand what the poet meant.'[54] Morris designed all of the borders, the full-page title page and twenty-six large initial words. It was set in the Chaucer type, a smaller version of the Troy type. Morris was adamant about designing for the open spread of pages rather than the single page, and in the Chaucer he achieved a full integration of text, ornament and image, even embedding the letters of the title and initial words into his ornate interleavings of vines and flowers. He also followed his rule, gleaned from medieval manuscripts, of varying the widths of the decorated borders around the block of type, with the inner margin the narrowest.

Burne-Jones produced over eighty wood-engraved illustrations and wrote to a friend: 'I have been calculating that the time I have given to the Chaucer work in the last two years and a half is exactly to an hour the time I should have spent in visits from Saturday to Monday at "houses," if I had been amiable and socia-ble – for I haven't let it invade the week's work, but have designed only on Sunday with very little exception.'[55] He drew on his own earlier illustrations, such as the image on *The Prioress's Tale Wardrobe* (no.54). During the process Burne-Jones wrote to another friend, humorously expressing his passion for the book and his collaboration with Morris:

> And so you don't like Chaucer – that is very sad – for I am beside myself with delight over it. I am making the designs as much to fit the ornament and printing as they are made to fit the little pictures – and I love to be snugly cased in the borders and buttressed up by the vast initials – and once or twice when I have no letter under me, I feel tottery and weak; if you drag me out of my encasings it will be like tearing a statue out of its niche and putting it into a museum – indeed when the book is done, if we live to finish it, it will be like a pocket cathedral – so full of design and I think Morris the greatest master of ornament in the world.[56]

Morris and Burne-Jones received the first two bound copies of the Chaucer in June 1896, a few months before Morris died in October of that year. The most ambitious book realised by the Kelmscott Press, it looked back to their youthful enthusiasm at Oxford for Chaucer and the medieval period. As Burne-Jones observed, 'When Morris and I were little chaps at Oxford, we should have just gone off our heads if such a book had come out then, but we have made at the end of our days the very thing we would have made then if we could.'[57] DW

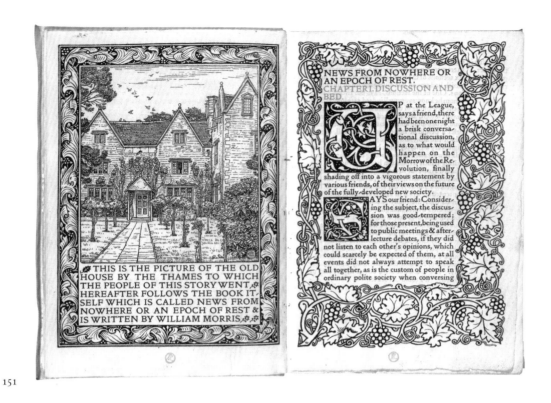

151

152

EDWARD BURNE-JONES 1833–98, WILLIAM MORRIS 1834–96 and
JOHN HENRY DEARLE 1860–1932 (designers); MORRIS & CO. (maker)

The Arming and Departure of the Knights of the Round Table on the Quest for the Holy Grail 1890–4
The Attainment: The Vision of the Holy Grail to Sir Galahad, Sir Bors and Sir Perceval 1890–4

Cotton warp, wool and silk weft tapestry 240 x 347; 245 x 749
Collection of Jimmy Page courtesy of Paul Reeves London

In the 1880s Morris was able to achieve his dream of weaving tapestries by hand as ambitious as those produced in the Middle Ages. As with other crafts, Morris first mastered the technique himself, adopting the *haute lisse*, or upright loom, and completed *Acanthus and Vine* in 1879, recording in a notebook the astounding 516 ½ hours he spent weaving it. Morris established a tapestry workshop with his first apprentice, John Henry Dearle, who would eventually succeed Morris as the chief designer of Morris & Co. after Morris's death. The silks and wools used in the tapestry were dyed from natural dyestuffs at Merton Abbey. Burne-Jones supplied drawings of the figural composition, which were then photographed and enlarged to full size. Morris and Dearle next added foreground and background detail. The weaver placed a tracing from the design against the warp and retraced the design onto it.

Morris loved tapestry from an early age, recalling in a lecture:

'How well I remember as a boy my first acquaintance with a room hung with faded greenery at Queen Elizabeth's Lodge, by Chingford Hatch, in Epping Forest (I wonder what has become of it now), and the impression of romance that it made upon me.'[58] He praised the art as the

> noblest of the weaving arts … in which there is nothing mechanical. It may be looked upon as a mosaic of pieces of colour made up of dyed threads … depth of tone, richness of colour, and exquisite gradation of tints are easily to be obtained in tapestry; and it also demands that crispness and abundance of beautiful detail which was the especial characteristic of fully developed Mediæval Art.[59]

The Holy Grail series, begun in 1890 as a commission for the dining room of Stanmore Hall, the home of wealthy financier and colonial

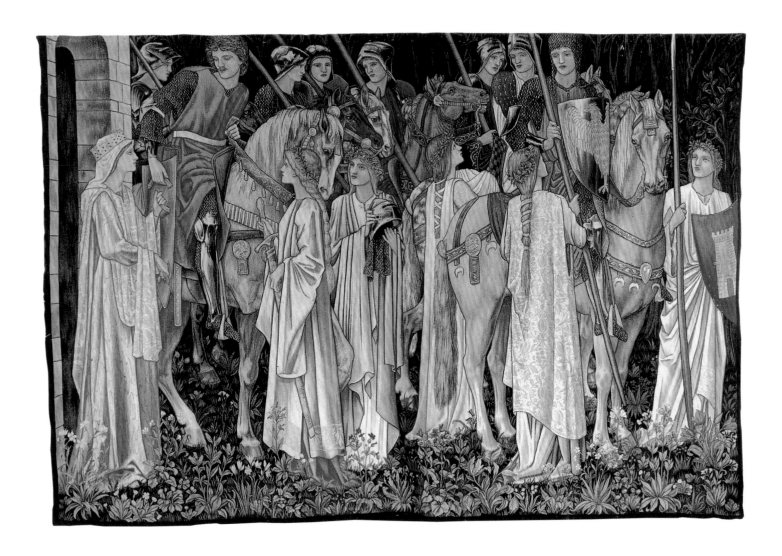

mining speculator William Knox D'Arcy, was the most creative and bold series undertaken by the Firm and the culmination of Morris's revival of medieval arts and crafts. Based on the Arthurian legends beloved of the Pre-Raphaelites, the tapestries were a collaboration between Burne-Jones, who designed the figures, and Morris, who, along with his assistant John Henry Dearle, designed the decorative detail and backgrounds. The series consisted of six narrative panels, hung high around the room and reaching 13 feet (4 metres) at the top, with six verdure panels hung below.

Morris was critical of the new architecture of Stanmore Hall, which he described as 'a house of a very rich – and such a wretched uncomfortable place! A sham Gothic house of fifty years ago now being added to by a young architect of the commercial type – men who are very bad. Fancy, in one of the rooms there was not a pane of glass that opened!'[60] Nevertheless, the commission was a lucrative one for Morris & Co., which also provided textiles and carpets for the house.

Thomas Malory's *Morte d'Arthur* had been a touchstone of Morris's and Burne-Jones's youth when they first discovered Robert Southey's edition, which they eagerly read aloud among their set of friends. Georgiana Burne-Jones later described:

Sometimes I think that the book never can have been loved as it was by those two men. With Edward it became literally a part of himself. Its strength and beauty, its mystical religion and noble chivalry of action, the world of lost history and romance in the names of people and places – it was his own birthright upon which he entered.[61]

They readily participated in Rossetti's scheme of decorating the Oxford Union Society Debating Hall with subjects drawn from the book, and Morris's first book of poetry, *The Defence of Guenevere*, relied on the same source. Burne-Jones produced early watercolours based on Malory and painted *The Beguiling of Merlin* in 1871 (Lady Lever Art Gallery). Even at the ends of their lives the book continued to move them: Morris had planned an edition of Malory for the Kelmscott Press on the same scale as *The Works of Geoffrey Chaucer* and Burne-Jones's final, uncompleted work was the massive canvas, *The Sleep of King Arthur in Avalon* (1881–98; Museo de Arte de Ponce, Puerto Rico).

The Arming and Departure of the Knights is the second narrative panel, described by Burne-Jones as 'the knights go forth, and it is good-bye all round. Guenevere is arming Launcelot.'[62] Designed to be seen across a right angle, as it was hung on a corner, the composition is divided into two distinct parts, with Guinevere handing a shield to Sir Lancelot at the far left and Sir Gawaine on the right side holding his shield with the double-headed eagle. The subject of the last panel, *The Attainment*, was also described by Burne-Jones:

And of all the hundred and fifty that went on the Quest, three only are chosen and may set foot on that shore, Bors, Percival, and Galahad. Of these Bors and Percival may see the Graal afar off – three big angels bar their way, and one holds the spear that bleeds; that is the spear that entered Christ's side, and it bleeds always. You know by its appearing that the Graal is near. And then comes Galahad who alone may see it – and to see it is death, for it is seeing the face of God.[63]

The cut-out in the lower right corner was due to the placement of a door in Stanmore Hall. Other partial sets were woven from the designs in later years, but the two exhibited here are from the original commission. The tapestries are a crowning achievement, combining Morris's rich colours, dense patterning on the fabrics and profusion of botanical detail with Burne-Jones's masterful litheness of line and expressive massing of figures. DW

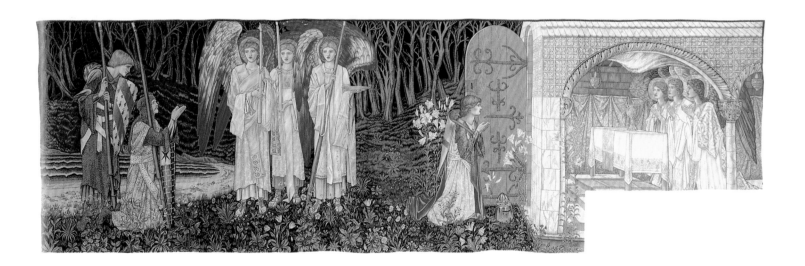

HENRY SCHEU after WALTER CRANE 1845–1915

The Triumph of Labour, published in *Building News,* 1 May 1891

Photolithograph printed by James Akerman, after Scheu's wood engraving after Crane's drawing 16.2 x 38.2
Collection of Tim Barringer

Walter Crane began his career as an engraver, apprenticed between 1859 and 1862 to the radical printmaker W.J. Linton, who was closely linked to the Chartist movement. While still in his teens, Crane also demonstrated his skills as a painter in the Pre-Raphaelite tradition, exhibiting a *Lady of Shalott* (1862; Yale Center for British Art) that referenced both the naturalism of Millais and the poetic painting of Rossetti and Arthur Hughes.

It was as an illustrator and a designer across a wide range of media in the decorative arts, however, that Crane achieved professional success. His children's book illustrations were enormously popular, and he designed wallpapers, tiles, printed textiles, posters, stained glass and embroideries, moving in the same social circles as Burne-Jones and Morris.[64]

Deeply rooted in the traditions of British radicalism and well read in French positivist philosophy and the works of Karl Marx, Crane turned to socialism in the 1880s. Like Morris, he joined the Social Democratic Federation (originally the Democratic Federation), under the leadership of H.H. Hyndman. Crane contributed illustrations to the party's journal, *Justice,* which combined the sharpness of political satire with an idealistic vision of the future articulated through references to historical styles. Though Crane remained loyal to Hyndman and the Social Democratic Federation, Morris transferred his allegiances to the Socialist League and thence to the Hammersmith Socialist Society, which Crane also joined in 1890. Unlike Morris, Crane embraced the challenge of creating a figurative iconography for the cause.

The Triumph of Labour is Crane's masterpiece, weaving together a late Pre-Raphaelite exploration of the art of the past with a clearly legible allegory including modern working figures.[65] Dedicated 'to the wage workers of all countries' on the 'International Labour Day', 1 May 1891, *The Triumph of Labour* envisions a procession led by the winged figure of Freedom, carrying the torch of liberty. At the centre of the image Lady Bountiful dispenses the cornucopia of plenty that, if shared equally, contains enough for all. A workman bears a banner inscribed 'Liberty, Equality, Fraternity', ideals of the French revolution, which had been adopted by the Chartists and by the British socialist movement. 'Labour is the source of wealth' reads another placard, attached to a navvy's shovel. Male and female labourers (modern equivalents of Atlas) hold up a globe girdled with the inscription, 'The International solidarity of Labour'. Crane also includes artists among the workers: he himself can be seen, palette in hand, at the far left, beneath the figure of a musician playing a fanciful curved instrument. Two other musicians – a female tambourinist and a man playing an oboe – stand in the centre foreground. The Aesthetic movement's concept of musical harmony as the ideal for all the arts is applied here to extend to social harmony between classes. Crane's vision includes a wealth of natural and agricultural imagery, from the oxen pulling a garlanded haywain, containing workers from all over the world, to the swallows flying overhead and the foliage, reminiscent of Morris's tapestries, in both foreground and background. While the Botticellian procession suggests Renaissance *trionfi,* it also alludes to the trades union processions and galas, often with banners made after Crane's design, which were an important element in working-class culture by the 1890s.

The Triumph of Labour was commissioned and engraved by a fellow socialist, the Swiss printmaker Henry Scheu, who worked for the periodical *The Graphic.* Crane's image appeared as a photolithograph with the magazine *Pall Mall Budget,* including a song of the same title written by the artist, but could also be purchased separately. It circulated internationally, being published with German, French and Italian captions, and remained popular with the union movement well into the twentieth century. TB

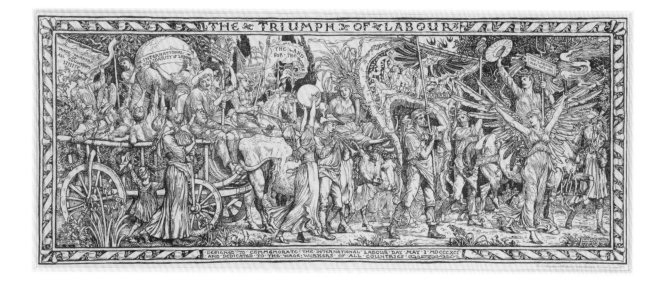

ARNOLD DOLMETSCH 1858–1940 and EDWARD BURNE-JONES 1833–98
Clavichord No.10 1897

Painted wood and ebony 12.3 x 144 x 42
Private collection, on long loan to Standen, National Trust

This clavichord was commissioned by the classicist, literary scholar and eventual Morris biographer, John William Mackail, for his wife Margaret, daughter of Burne-Jones, whom he married in 1888. It was made by the early-music revival pioneer Arnold Dolmetsch and is an example of how the medievalising tendencies present from the 1840s came to combine with the Aesthetic movement's insistence on the relationship between art and music. In making his first clavichord, Dolmetsch had apparently been encouraged by William Morris, who persuaded the musician to produce one for the Arts and Crafts exhibition of 1896.

A polygonal unfretted clavichord, with each key having its own set of three strings, the instrument is one of three constructed by the musician in the 1890s as a free 'aesthetic' interpretation of earlier prototypes. A letter from Dolmetsch to Mackail of 24 October 1897, acknowledging payment for the piece, indicates that he was willing to adapt the cover so that the instrument could be played either in its outer five-sided case with the top open or separately to show off its gilding. As an overture perhaps to his rather possessive father-in-law who had originally disapproved of the marriage, Mackail asked Burne-Jones to decorate the object, an idea that prompted Dolmetsch to express his hope that other instruments by him should be so adorned. Dolmetsch was presumably aware of existing painted keyboard instruments by Burne-Jones, including the artist's first attempt, a piano that was decorated with images of the 'Chant d'Amour' and the dance of death and was likewise for a domestic context.[66] Burne-Jones shared with Morris an abhorrence for the complex mechanised methods used in the production of contemporary pianos. The medieval-inspired instruments that inhabit their compositions are entirely in sympathy with the spirit of practical revivalism that informed Dolmetsch's work, as well as with the latter's sensitivity to the expressive qualities of early instruments, the clavichord in particular, which for Dolmetsch possessed a soul-like quality, reflecting every shade of the player's feelings.

For the red outer case Burne-Jones used a Latin inscription written by Mackail, which the scholar translated as: 'Into me, so that I might rejoice or mourn, the artificer put sound. Me the ancient flower of the muses, the muse arouses from Death. Once more therefore the disused voice sounds weeping, sounds joyfully, whenever Margaret opens the Clavichord.' Here Mackail appears to be playing on the association between his wife's name and that of St Margaret together with the marguerite or daisy flower, which in the language of flowers symbolises innocence and undying love.[67] These connections inform the decorations painted in an experimental oil or varnish medium on either side of the inscription. To its left is a foliate roundel decoration containing the pun devised by Margaret, *Clavis Cordium* (The Key of Hearts), and on the other side is an image of St Margaret daintily leading

her dragon on a leash surmounted by a clump of flowers resembling daisies. In keeping with the artist's rather crudely painted early furniture, this decoration is simple and flat. The figure group itself acknowledges Paolo Uccello's *St George and the Dragon* (c.1470; National Gallery, London), a work known to Burne-Jones around the time of its attribution, while the foliage motifs surrounding the pun and the flowers on the right recall respectively the fabrics and embroideries designed by Morris. On the instrument itself, as if to reinforce the sentiment of the decorations on the cover, Burne-Jones painted in soft watercolours a woman draped in white stooping to gather a white flower, while the remainder of the soundboard area is filled with the intertwining stems and blossoms of a pale rose. This pattern was intended to complement the actual decorated sound hole of the instrument, which doubles up as a large flower head. An inscription beneath the scene, prefaced by a floral motif, acknowledges Dolmetsch as maker and gives the place and date of execution, while on the underside of the base board of the outer case a hidden message sums up the interrelationships that underscore the whole enterprise: 'Jack gave this Clavichord to Margaret his wife, and made the verses that you read upon it; and her father painted it within and without for his children. London – Dec: 1897.'

Despite his professed admiration for Burne-Jones, Dolmetsch was somewhat disappointed by the outcome, disliking both the cracking caused by the paint application, and the disposition of the figures across the surface.[68] Margaret was, however, appreciative of the gift and played the clavichord to her father in the months leading up to his death in June 1898. AS

156
EDWARD BURNE-JONES 1833–98 (designer); MORRIS & CO. (maker)
Angel with Instrument 1890

Stained and painted glass, three panels 279.3 x 73.8 (overall dimensions)
The Whitworth Art Gallery, The University of Manchester

157
EDWARD BURNE-JONES 1833–98 (designer); MORRIS & CO. (maker)
Angel with Lute 1890

Stained and painted glass, three panels 280 x 74.3 (overall dimensions)
The Whitworth Art Gallery, The University of Manchester

Ecclesiastical stained glass was a mainstay of Morris & Co.'s business throughout its lifetime. Sparked by the gothic revival and the Anglican High Church movement, a boom in church building and restoration inspired a demand for stained glass, leading to the mid-nineteenth-century rediscovery of medieval techniques to produce colored 'pot-metal' glass, which contrasted with the surface-painted clear glass previously in use. The Firm never manufactured its own glass, but instead utilised coloured glass supplied by another company, Powell & Sons. By the time the Firm reorganised in 1875, Burne-Jones became the primary figure designer with Morris selecting glass colours and background details. Morris eventually delegated the backgrounds to his workmen, but he always chose the colours and reviewed completed windows.

By 1890, the year these two panels depicting angels playing musical instruments were created, Burne-Jones and Morris's windows had shifted away from the geometric medievalism that marked the Firm's production in the early decades (see no.60). The panels originally flanked a central window depicting the Good Shepherd at the church of St James, Westmoreland Street, in Marylebone, built in 1774. The rich variable-hued mosaics making up the azure sky, ruby angel wings, crimson, pink, green and gold drapery, and olive-green grass are characteristic of this period. As Morris wrote to Ruskin in 1883:

> In some of the pot-metals, notably the blues the difference between one part of a sheet [and] another is very great. This variety is very useful to us in getting a jewel-like quality … You will understand that we rely almost entirely for our colour on the *actual colour of the glass*; and the more the design will enable us to break up the pieces, and the more mosaic-like it is, the better we like it.[69]

The brilliant depths of colour and the dynamic, fluid compositions achieved by the Firm were unparalleled in Victorian stained glass.

While the depiction of music-playing angels had its origins in gothic and early Renaissance art, it also had contemporary resonances. High Anglican religion, as at St James's Westmoreland Street, placed a strong emphasis on music, often including the revival of medieval plainsong and Tudor choral anthems. Burne-Jones and Morris, both enthusiasts for plainsong since their undergraduate days at Oxford, were also participants in the Aesthetic movement, for whose devotees music provided the ideal art to which all others should aspire. DW & TB

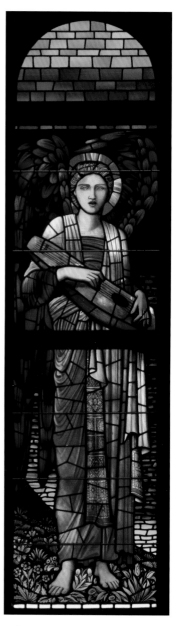

156

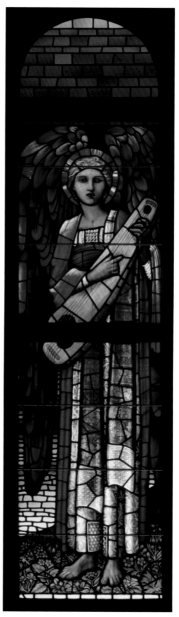

157

MAY MORRIS 1862–1938 and assistants

Bed pelmet 1891–3

Wool on linen 29 x 193 (longer sections), 29 x 139 (shorter section)
Kelmscott Manor Collection. By permission of the Society of Antiquaries of London

159

MAY MORRIS, assisted by LILY (SUSAN) YEATS, MAUDE DEACON and ELLEN WRIGHT

Bed curtains 1891–3

Wool and silk on linen 192 x 122
Kelmscott Manor Collection. By permission of the Society of Antiquaries of London

160

MAY MORRIS and JANE MORRIS 1839–1914

Bedspread 1910

Wool and silk on linen 261 x 212.5
Kelmscott Manor Collection. By permission of the Society of Antiquaries of London

In 1871 Morris and Rossetti took on joint tenancy of Kelmscott Manor, an Elizabethan house in Gloucestershire. While Kelmscott was a retreat for Rossetti, a place where he could indulge his passion for Jane, for Morris it represented the epitome of the ideal rural community he envisaged, where men and women could live in harmony with nature and experience labour as a pleasure rather than as a burden. He found particular solace in the small bedroom he occupied on the first floor dominated by an early-seventeenth-century oak four-poster bed that had passed down through the generations of the Turner family starting with Thomas Turner, the farmer who had built the property in the 1590s. Apparently, Morris so loved the bed that in the early 1870s he wrote a poem extolling its comforting warmth.

Some time later his youngest daughter May embroidered, in an undemonstrative Gothic script, the opening lines of this poem on the pelmet that she designed to hang around the crest of the bed:

> The wind's on the wold
> And the night is a-cold,
> And Thames runs chill
> Twixt mead and hill,
> But kind and dear
> Is the old house here,
> And my heart is warm
> Midst winter's harm.

May was one of the leading craftworkers of the era, having developed an aptitude for embroidery during her girlhood that she supplemented by studying the technique at the South Kensington School of Design. In 1885 she was considered proficient enough to be appointed Head of the Embroidery Department of Morris and Co., before going on to become a respected teacher and writer on the subject. Her book *Decorative Needlework* was published in 1893. In a letter to Eric Maclagen, Director of the V&A, written shortly after May's death, the companion of her later years, Mary Lobb, made the point that although Morris could design embroidery, he could not match May in the standard of her workmanship, while her mother Jane could embroider but not design: 'Miss

Morris could and did both design as well as William Morris and embroider as well [as] any one possibly could and [her] colour arrangements were unapproachable and original.'[70]

May certainly followed her father in taking inspiration from nature (in her case from common wayside plants and animals), but her work is generally more complex in terms of colour and composition, and less dependent on historical prototypes. It is characterised by clear structures with stylised natural features contained within geometrical frameworks. These qualities can be seen in the hangings May designed for the bed that she worked on in 1891–3 with the assistance of Lily (Susan) Yeats, sister of the poet William Butler Yeats, who was himself an acquaintance of William Morris through socialist connections, and two recruits from local schools in Hammersmith, Maude Deacon and Ellen Wright. Echoing the tapestries in the Musée Cluny (of which there are photographs among the May Morris papers in the Ashmolean Museum), the design comprises a central tree set against a trellis that is flanked by rosebushes and other plants with birds and rabbits in the foreground. These hangings were woven in wool and silk in a rich yet subtle combination of pinks, reds, blues and greens, and were exhibited at the Arts and Crafts exhibition at the New Gallery in 1893, where they were described by Aymer Vallance as typifying the 'hybrid Anglo-Dutch' style currently being advanced by designers within the Morris circle.[71]

A photograph by Frederick H. Evans, dated 1896, shows the bed in Morris's room draped with the valance and hangings, but not the present cover (fig.23). This was designed by May following her father's death and executed by Jane using crewel wools and silk in a variety of stitch work (stem, chain, split and back stitch with French knots for dots of colour). The bouquets of flowers were possibly influenced by Morris's Lily wallpaper that decorated his room at the time. It is a superb example of May's late work with its prominent network structure, stylised floral motifs and lively depiction of fauna along the edges. Like Morris, May respected the flatness of the fabric she employed but went further in using the unworked ground as a design element, influenced perhaps by examples of Elizabethan and Jacobean knotted strapwork. A design for the bedcover, which was acquired by the Society of

Antiquaries in 1994 and now hangs to the left of the bed at Kelmscott Manor, shows how the overall network structure allows the background to assume shape as well as providing the foil for each embroidered bouquet. To offset the formality of the main design, May incorporated into the top edge lines from Morris's poem, 'A Garden by the Sea', in his 1891 collection *Poems by the Way*:

> I know a little garden-close
> Set thick with lily and red rose,
> Where I would wander if I might
> From dewy dawn to dewy night,
> And have one with me wandering.

The idea of a formal garden brimming with life conjured by these lines is picked up by the eighteen small details of fish, birds and insects that animate the two side borders. These include a king-fisher, caterpillar, snail and owl. A wavy line in stem and chain stitch representing the Thames runs along the bottom edge, with a heron holding an eel in its beak marking the centre. On the extreme left Jane inserted a detail of Kelmscott Manor itself, balanced on the right by her signature surmounted by an inscription of the Morris family motto *Si je puis* (If I can) interlaced with a flower. Although May produced other variants of the main network design, including a bedcover for the Emery Walker house in Hammersmith, the Kelmscott embroidery is more intimate and personal, a testimony to the close working and familial relationships of those involved in its making.

A number of preparatory studies relating to the cover exist in the May Morris papers at the Ashmolean. Some of these are loose botanical sketches of flowers, dated 1905, including studies of a Melsetter sweet briar, a yellow-horn poppy, a rose and a tulip, all of which served as inspiration for the more stylised, scaled-up and perforated templates that were used as a guide for the needlework itself. Among the templates can be seen a tracing for the owl on the right, and for Jane's signature and motto. Marks of the transfers can still be detected on the fabric. AS

Fig. 23 Kelmscott Manor bedroom, platinum print by Frederick H. Evans, signed and dated 1896. William Morris Gallery, London Borough of Waltham Forest

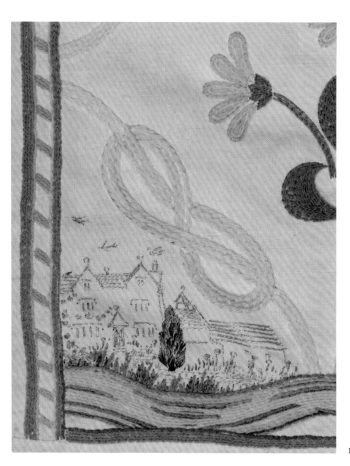

158

159

160

8. MYTHOLOGIES

By the 1870s the artists who comprised the Pre-Raphaelite Brotherhood had each developed an identity that represented an evolution of the original aims of the movement. The archaisms of composition and the delight in detail that had united the artists in their inaugural phase had given way to more diverse working practices making it difficult for audiences, then as now, to comprehend 'Pre-Raphaelitism' as a single concept.

Broadly speaking there were two main strands of development, which we might regard as the realist and the poetic (or proto-Symbolist); the latter came to dominate as the former retreated into a subsidiary course fated to remain on the periphery of mainstream modern art. In adhering fastidiously to the Pre-Raphaelite emphasis on mimesis and workmanship, Holman Hunt stood out as a singular figure, one whose work continued to mesmerise and baffle audiences on account of its professed verisimilitude and strident use of colour, despite changes in technique and scale. Millais and Brown also clung fast to the founding principles of the movement in abjuring academic conventions of history painting in favour of an uncompromising naturalism adopted to pursue an understanding of human psychology, albeit in grander and more idiosyncratic terms than before. But ultimately the legacy of the movement, both within Britain and beyond, derived more from Rossetti, whose distillation of the female figure in a drama above any overriding moral or literary message made a deep impression on Burne-Jones and through him on European Symbolism.

As the work of the key founder members took on distinct features, so each artist developed a public profile that matched his own particular conception of Pre-Raphaelitism. Rossetti had been unique among the group in refusing to exhibit in public and was in consequence partly perceived as a Blakean recluse eschewing the glare of publicity. The two memorial exhibitions held at the Royal Academy and Burlington Fine Arts Club in 1883 reinforced the perception of Rossetti as both the visionary leader of a 'poetic' vein within Pre-Raphaelitism and as a poet-painter combining different modes of artistic expression. In the meantime Millais had become the most famous and best loved of all the artists associated with the PRB with his emotive and inventive subjects from history and the elusive poetic quality of his late landscapes. The large retrospective exhibitions held in his honour in 1886 and 1898 confirmed his status among contemporaries as the greatest master of the nineteenth-century British school and a national treasure. Hunt's achievement was also celebrated in large-scale exhibitions staged in 1889 and 1906, while perhaps

because of his prickly personality and refusal to conform, Brown never achieved the celebrity that his work richly deserved.

As the Pre-Raphaelites attained 'old master' status in their later years, they embraced old-master traditions as part of a re-engagement with post-Renaissance art. While the early work of the movement had set out to proclaim a clear break with the past in refusing to defer to established conventions, the artists' various later productions display the influence of a greater variety of models. In continuing to advocate an anti-classical approach, Millais came to align himself with a painterly post-Renaissance manner as demonstrated in the panoramic sweep, broad brushwork and elemental slabs of composition that can be seen in his *Chill October* (no.162), a painting that acknowledges Dutch and British modes of landscape with its solitary mood and sombre tonality. Hunt's later work also reveals a rapprochement with post-Renaissance art. His elaborate frieze-like compositions and the prominence he accorded the human figure follow precedents set by Venetian painters such as Titian and Veronese. It was as a sign of 'old-masterliness' that the Pre-Raphaelites started to experiment with nude subjects (the nude in painting being a largely post-Renaissance invention), while venturing beyond the idealising parameters of the classical tradition in order to be faithful to the subject in hand. Brown's work comes close to that of Romantic painters such as Delacroix in this respect, as seen, for example, in *Don Juan* (no.163), where the limp figure of the hero functions as a visual equivalent to the metaphor of a lily adopted by Byron in his poem. Rossetti's late work fuses Venetian colouristic sensuousness with a Michelangelesque exaggeration of form in keeping with his mission to communicate the idea of the soul through the corporeal language of the flesh.

The way in which these artists had moved from a pre- to a post-Raphaelesque aesthetic almost suggests that they were, consciously or unconsciously, re-enacting the evolution of Italian art, famously described by Giorgio Vasari in his pioneering *Lives of the Artists* (1550) as an inevitable process leading from primitivism to the perfectionism of Raphael and Michelangelo. Perhaps once the Pre-Raphaelites had positioned themselves at a certain point in the early evolution of art history, it became impossible for them to avoid being swept along to the completion of its trajectory. But the main motor of development was a desire to communicate more broadly in big, bold narrative terms as the artists cast off their identity as rebels and embraced an audience beyond their immediate circle of acolytes and supporters. The production of large canvases developed in tandem with

the new strategies for marketing works that were available to artists in the late nineteenth century, whether in the carefully staged space of a dealer's gallery (as used by Hunt to launch no.169) or in the opulent settings of the new venues designed to pander to the tastes of the new industrial magnates of the day. Chief of the latter was the Grosvenor Gallery, the exhibiting society that opened in London in 1877 and provided a sanctum for the work of Burne-Jones, the main champion of the Pre-Raphaelite movement in its later phase.

A paradox within this development was that, whereas the early style of the Pre-Raphaelites spelt out exactly what was going on in a picture, the shift towards simpler compositions implied more ambiguous themes and an interest in the interior self that was to be the hallmark of the Symbolist movement. The subjects represented often focus on heightened psychological states, as in Hunt's elaborate *Lady of Shalott* (no.171), where the heroine is presented as a hysteric, abandoning any vestige of self-control as she twists amid the tangled threads of her embroidery, or in Rossetti's late visualisations of Jane Morris, who is presented less as a mortal than as a goddess or sibyl, one who, in the words of the French critic Théodore Duret, 'would crack your bones'.[1] Even Millais's late landscapes, painted as a sensual response to place, communicate a mood of intense introspection, as testified by the numerous poems inspired by the atmospheric yet enigmatic *Chill October*. The 'interior' aspect of much late Pre-Raphaelite art further explains its submerged 'watery' qualities or the distinct feeling that one is looking at a scene through the reflective surface of glass, as in the paintings in this section by Rossetti and Hunt where figures loom up at the spectator with large hypnotic eyes and highly defined prismatic surfaces (see especially nos.167, 171).

These tendencies are most apparent in the work of Burne-Jones, an artist who came to maturity holding to the assumption that a picture should be made mysteriously abstract through a refined and elaborate process of execution. In designing his works to appeal both as ornamental pieces that transform an environment and as imaginary worlds that entice the spectator, Burne-Jones aspired to collapse the boundaries between decorative and pictorial art. This duality of purpose lent his work a Symbolist dimension in that his pictures allowed different registers of experience to merge into one another, be it the aural into the olfactory and purely visual in *The Golden Stairs* or the suggested transition from tumult to stasis in *Love Among the Ruins* (nos.168, 175). In rejecting painting as the dominant mode of address, Burne-Jones went further than any other artist associated with the Pre-Raphaelite movement in his quest to revive and reference the decorative arts of the past within his

work and in seeking a translation of one medium into another, whether stained glass, embroidery or metalwork. This he did through his emphasis on the drawn line as the key element in fixing or crystallising an image in the mind of the spectator, an approach that harks back to the early work of the PRB and the primacy it accorded line in determining the look of a composition.

Although Burne-Jones's work could be seen to represent the purification of Pre-Raphaelite ideals, he was unique among the group in never having been a realist in the sense of engaging with subjects from contemporary life or in attempting a mimetic mode of representation. His mature pictures in oil were in this respect very much an extension of his early work in watercolour, being based on similar sources (traditional ballads for instance, or the poetry of Tennyson or Morris), and appear similarly opaque in terms of paint application and signification, with figures displaying no emotion but rather existing in an inert state so that any meaning remains obscure, as if hidden in the dense layers of paint work. As with Rossetti, Burne-Jones developed a visual language around the aura of the symbol, which in his work came to assume an authority independent of any nominal referent. This aura was paralleled in visual terms by evocative shapes that float free across the composition rather than being tied down to any presiding narrative or didactic content. Thus the window in *Laus Veneris* (no.165) through which the knight Tannhäuser encounters the subterranean realm of Venus's palace also doubles up as a mirror reflecting back at him his own ennui or isolation 'as a solitary prisoner in its own dream of the world' (to cite Walter Pater in the conclusion to his compilation of essays, *The Renaissance*, of 1873).[2] While tacitly referencing the fence/chancel screen device in Millais's *Christ in the House of His Parents* (no.85) to suggest the idea of a threshold through which Tannhäuser encounters his fate, the frame in *Laus Veneris* also exists as an object that serves no fixed iconographic purpose other than its own beautifully crafted presence within the composition.

By inviting his audience to simultaneously luxuriate in front of the painted object and to enter the imagined spaces of the composition, Burne-Jones was effectively offering up his art as an imaginative alternative to the extreme materialism of Victorian Britain and a non-doctrinaire means of glimpsing salvation in what he believed to be a degraded mechanistic age. In this his art was certainly utopian but in a distinctly abstract way. As he was quoted as saying: 'I'm a born rebel, and my politics are those of a thousand years hence – the politics of the millennium, and therefore of no account.'[3] AS

DANTE GABRIEL ROSSETTI 1828–82

La Pia 1868–81

Oil on canvas 104.8 x 120.6
Spencer Museum of Art, University of Kansas
[Washington only]

Rossetti began this depiction of La Pia, a subject from Dante Alighieri's *Purgatorio*, in 1868. The melancholy features of Jane Morris, who sat for the work in the spring of that year, dominate the composition. It was finished only in 1881, placing it among the last of Rossetti's completed works before his death in April 1882.

The tragic subject of *La Pia* appears in the fifth canto of Dante's *Purgatorio*. The young Sienese woman's name means 'pious', and her gospel and rosary are seen in the foreground; yet she was ill treated by her husband, whose love letters, from happier times, lie beneath the bible.

Although this work presents La Pia in life, pale and doleful, Dante encountered the soul of La Pia residing in purgatory because she 'died without absolution', the intervention of a priest with the last rites, which would have allowed her to pass to heaven. Although her death was not a suicide, the critic F.G. Stephens (in a text read and corrected by Rossetti himself) suggested that cruel captivity had stolen La Pia's will to live: 'On her features are no signs of animation, or hope, or care for existence, still less of a desire to do battle for life. Their melancholy is meditative and habitual.'[4] On the frame is a translation, most likely by Rossetti himself, of the relevant lines, spoken by La Pia's spirit:

> Ah! When on earth thy voice again is heard,
> And thou from the long road hast rested thee
> (After the second spirit said the third)
> Remember me who am La Pia; me
> Siena, me Maremma, made, unmade,

This in his inmost heart knoweth he
With whose fair jewel I was ringed and wed.[5]

Rossetti's La Pia fingers uneasily the extravagant ring given to her by her abusive, wealthy husband, who for no reason imprisoned her in a castle in the Maremma swamps, where she pined away to an early death. Thus the pile of lances draped over with a pennant to the left are surely a symbol of her inexplicably cruel and absent husband.

The grey twilight landscape with a flock of crows, predictive of later European Symbolist painting, adds a cheerless context for her suffering. Although by the end of his career Rossetti had decisively abandoned the precise realism of his early years, he made conspicuous attempts to achieve fidelity in this landscape, dispatching the painter and connoisseur Charles Fairfax Murray to make sketches of the unhealthy swamps of the Maremma (the sea-coast of south-western Tuscany). Rossetti also asked his friend Frederic Shields to 'bring any photograph or sketch of ivy growing on a wall, as I want it for the distant rampart of *La Pia*', an interesting acknowledgement of the incorporation of photography into Pre-Raphaelite practice.[6]

La Pia was purchased for 800 guineas by the great Aesthetic movement collector, Frederick Richards Leyland, in whose house at 49 Princes Gate, London, it occupied a place of honour alongside *Veronica Veronese* (1872; Delaware Art Museum) and *Lady Lilith* (no.132), among many others. *La Pia* came to public attention for the first time in the memorial exhibition for Rossetti at the Royal Academy in 1883. TB

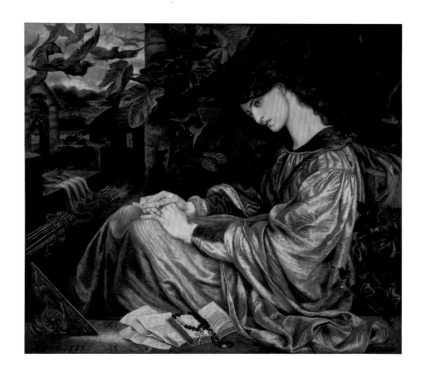

JOHN EVERETT MILLAIS 1829–96

Chill October 1870

Oil on canvas 141 x 186.7
Collection: Lord Lloyd Webber

In the last three decades of his life, in the maturity of his career, Millais bifurcated his practice. In London, in the spring and summer, he produced the most successful portraits of the age, while regularly exhibiting important historical pictures and, towards the end of his life, increasingly mystical religious works. In Scotland, during the autumn and winter, he created large-format, intensely observed, realistic landscapes freely painted outdoors, works bearing considerable force and energy. This series of twenty-one 6-foot high or wide works began with *Chill October*.[7] In it Millais returned to the punishing practice of the Ruskin portrait of over fifteen years before (no.72) and painted almost the entire picture on the shore of the River Tay, downstream from Perth, and in all manner of weather. But the figure has been eliminated, weather has been introduced and Millais has replaced the clarity of early Pre-Raphaelitism and photography with atmospheric drama conveyed through tone and an appeal to the senses.

Chill October had an effect on at least one artist associated with modernism: the young Vincent van Gogh. While working at his uncle's art firm in London in the 1870s, he wrote of the picture and of other works he saw by Millais. The sweep of the composition, the sudden plunge into depth, the depopulated appeal to the senses and emotions, and the activated painting surface, all of these attracted the Dutch artist. Millais's late work represents the development of an idiosyncratic vision that nonetheless preserved the Pre-Raphaelite mantra of his whole career: paint what you see. But in exploring landscapes as conveyances of psychological states ranging from autumnal melancholy to vitality, Millais's works anticipate and manifest an interest in interiority, the self and modern experience, which would become hallmarks of pan-European Symbolism in artists as varied as Edvard Munch, Arnold Böcklin and van Gogh himself. JR

FORD MADOX BROWN 1821–93

Don Juan and Haidee 1873

Oil on canvas 173.2 x 215.7
Birmingham Museums and Art Gallery. Presented by Mary Lucas, 1912

The subject of this painting is taken from Byron's 1818–19 mock-epic poem *Don Juan*, canto 2, stanzas 110–12:

> And like a wither'd lily, on the land
> His slender frame & pallid aspect lay
> As fair a thing as e'er was formed of clay

Juan, the sole survivor of a sea voyage, during which his ship is wrecked by a storm and the crew driven to cannibalism, is shown cast ashore on the Cyclades in the Aegean. Here the young Spaniard is discovered by Haidee, daughter of the corsair Lambro, and her maid Zoe, who tend him back to health in a cave near the beach. Even though they do not speak each other's language, Haidee and Juan fall in love, only to be separated following an assault by Lambro; distraught at her loss, Haidee eventually dies taking Juan's unborn child in her womb with her.

Brown had been enraptured by Byron since his youth, the poet's writings having inspired a number of works and the man himself venerated as one of the great 'fruits of English poetry' in no.7. This painting was the second of three versions – the first being a watercolour of 1869–70 (National Gallery of Victoria, Melbourne) and the third a smaller replica of the oil, which Brown finished in 1878 (Musée d'Orsay, Paris). *Don Juan* was first exhibited at the Royal Manchester Institution in 1875, where it attracted positive notices for capturing the emotion of the verse, even though some critics felt the figures were too individualised for such an ideal subject. The composition itself derives from a print of the subject for a set of illustrations that the artist produced together with his son Oliver for a popular edition of Byron's poems, edited by W.M. Rossetti and published by E. Moxon in 1870. In developing the illustration into a painting, it was Brown's ambition to produce a large-scale nude subject at a time when the genre was being revived in British art. Leighton, Watts, Millais and Burne-Jones had all made a mark with ambitious nude subjects involving lovers or couples and Brown wanted to follow suit. In a letter to James Leathart of 8 April 1869 Brown set down his latest thoughts on works he had in mind:

> One Haydee & her maid finding the naked & all but lifeless body of Juan on the beach after the shipwreck. Apelles sketching his Venus Anadyomene … from Phryne the beautiful Athenian Courtesan, naked on the sea shore with dishevelled hair – a most glorious subject. 3rd the Earl of Surrey to whom a wizard shows in a mirror his mistress the fair Geraldine – also naked.[8]

Despite the wide-ranging repertoire, these proposed subjects all concern human desire, and would therefore have been a compelling but potentially provocative gambit, as Burne-Jones discovered when his watercolour depicting a classical love chase, *Phyllis and Demophoön* (1870; Birmingham Museums and Art Gallery), created a furore at the Old Water Colour Society in 1870. Brown's *Don Juan and Haidee* parallels this work in placing the female in the role of seducer, as well as containing a hint of autobiography in his using the Greek Marie Spartali – the pupil for whom he developed an infatuation – as a model for Haidee, just as Burne-Jones had based the figure of Phyllis in his composition on his lover Maria Zambaco. Although Leathart had originally commissioned the work, Brown subsequently found a more congenial patron in Frederick Leyland, who purchased it in 1872 after Leathart withdrew his support. Leyland was significantly the owner of some of the most audacious nudes to appear at public exhibition around this time, including Burne-Jones's *Phyllis and Demophoön* and a number of works by Simeon Solomon, an artist renowned for his languid male figures (see no.133).

Using a Neapolitan youth as a model for the lithe body of Juan, Brown presents him lying insensible on the shore, his limp limbs still entwined around a piece of wreckage, in acknowledgment of Byron's words, 'his stretch'd hand / Droop'd dripping on the oar' – and the pose perhaps references the supine figure on the right of Théodore Géricault's initially infamous, but by the 1870s widely celebrated, canvas, *The Raft of the Medusa* (1819; Louvre). Juan's body rests on a white drape as if to reinforce the association with the lily in Byron's text, while against his pale flesh the darker hand of the kneeling Zoe feels for his heart beat. Standing slightly back from this group in Greek dress, as if abashed by the nakedness of the youth, Haidee gazes down on his frail body, the tender expression of her face and hands betraying feelings of love and compassion. The whole encounter is set in an opalescent landscape that combines observation of nature with atmospheric suggestiveness, the gaping cavities of the cliff face giving way to swirling mists in the distance. AS

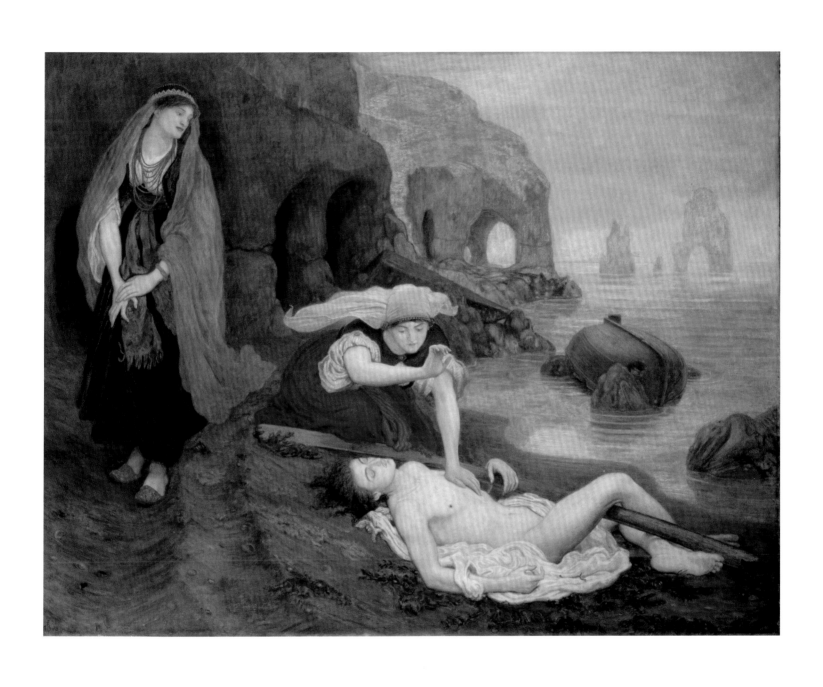

EDWARD BURNE-JONES 1833–98

Tristram and Iseult begun 1872

Oil on canvas 182.8 x 279.3
Private collection, England

This large unfinished oil painting was a product of the ferment of activity that followed Burne-Jones's third Italian journey of 1871, and brings together his fascination for the chivalric spirit of Thomas Malory's *Morte d'Arthur* (as re-told in Robert Southey's edition of 1817) with his appreciation of Italian art – the mysterious setting containing echoes of landscapes by Giorgione and Mantegna. The painting features in a long inventory of works on which the artist was engaged in 1872, as recorded by Georgiana: 'Began a large oil picture of "Merlin and Nimuë", and the large "Tristram and Yseult"'.[9] Years later Burne-Jones recalled that it was painted in Spencer Stanhope's studio at Campden Hill, Kensington, being too large for his room at The Grange.

The painting strings together various characters and incidents connected with the tragic story of the Cornish knight Tristram and the Irish princess Iseult in the Arthurian legends. This impassioned drama of love and betrayal appealed not only to Burne-Jones and Morris (see no.53) but also to the poets Alfred Tennyson, Matthew Arnold and Algernon Swinburne, the last's exaltation of the lovers' infatuation paralleling Burne-Jones's own preoccupation with the sinister erotic aspects of the story. A large preparatory drawing of c.1871 (fig.24) presents key and subsidiary characters from the tale in a frieze-like arrangement reminiscent of quattrocento low-relief sculpture. A note in one of his sketchbooks in the Fitzwilliam Museum (c.1871–2) identifies them as, from left to right: King Mark, la Belle Iseult's unsympathetic husband and the only fully clothed figure in the composition; Alisander le Orphelin, eventually to be killed by Mark; and la Belle Iseult, bearing a letter berating Tristram for his deceit in marrying Iseult of the White Hands, which she covertly gives to her faithful lady-in-waiting, Dame Bragwaine, who in turn reaches out her hand to receive it

so she can deliver it to Tristram deep in the wood kissing the other Iseult. Isolated on the right, the Saracen knight Palomides leans dejectedly against a well or fountain bemoaning his unrequited love for la Belle Iseult, while behind him can be glimpsed effigies of the two dead lovers shrouded with rose briars (a motif recycled from the artist's own design for a stained-glass window of the subject of 1862; Birmingham Museums and Art Gallery).

Dissatisfied perhaps by the rather monotonous disposition of the figures and the lack of spatial articulation in the Torre Abbey design, Burne-Jones adapted it to add greater depth and a sense of mystery. A rough pencil sketch on the right page of a sketchbook in the Fitzwilliam sets out the scheme for the present work with figures mutually proportioned as they are in the final composition.[10] To the right of the sketch are two sets of marks rather like musical notations or symbols designating poetic metre, which, as John Christian has explained, were probably made after the drawing to clarify the main accents of the design before it was transferred to canvas (the horizontal strokes corresponding to the figures). On the verso of the sketchbook page Burne-Jones drew a series of parallel lines diminishing in length from top to bottom, each inscribed with a name of a character in the composition: the more prominent the character, the longer the line. It would seem the artist was experimenting with how far he could take the idea of metric or musical interval in the composition of a picture in order to accentuate its formal qualities. Without this key it would be difficult to ascertain precisely what the scene represents, so unusual is the artist's treatment of the subject. Indeed, until very recently it was known under the erroneous title, *The Fountain of Youth*, the picture's true identity only being established through connection with the Fitzwilliam sketch.

Fig.24 Edward Burne-Jones, *Study for Tristram and Iseult*, c.1871, pencil on paper, 51.5 x 119.5. Torre Abbey, Torquay

Having transferred the design to canvas, Burne-Jones set about establishing the intervals between the characters adding a strip at some stage to the left to allow adequate space for Iseult 'to breathe'. Although each figure remains an isolated unit within the setting, the tableau-like arrangement enabled the artist to calibrate both the real and psychological space between the respective characters, the 'musical' elements of the composition being crucial to this endeavour in establishing variations in scale, spatial jumps and transitions, as well as accents and pauses through objects such as the ship in the distance, the tree stump and well. The overall oneiric mood is enhanced by echoes of other works by the artist that permeate the composition, notably the nude form of Bragwaine posed like Andromeda in *The Doom Fulfilled* (no.173), together with visual ambiguities such as the block on which Palomides leans, a fusion of the fountain and tomb structures in the Torre Abbey drawing.

In its unfinished state the picture provides insight into the artist's working process. The brown and ochre monochrome functions as a ground layer and the figures are painted nude in order to establish what the artist called the 'bones' of the composition before being draped.[11] Paint is laid on the canvas in thick dry patches for the light accents, but more loosely for dark areas and with rapid sketchy strokes for the foliage on the upper left. Touches of green at the top would suggest that Burne-Jones was just thinking about adding colour when he ceased work on the painting for reasons that are not altogether clear. He may have been undecided as to how to fill the open space in the left foreground, the tree stump near Bragwaine's foot not being an entirely satisfactory solution and the steep recession on the left contrasting rather abruptly with the dense thicket on the other side. Otherwise he simply abandoned the picture as other projects assumed precedence in his mind. AS

EDWARD BURNE-JONES 1833–98

Laus Veneris 1873–8

Oil on canvas 122 x 183
Laing Art Gallery, Newcastle upon Tyne

Opulent and sensuous in atmosphere, richly coloured and elaborately crafted, *Laus Veneris* is one of the most daring and powerful works in the Pre-Raphaelite canon. In this work Burne-Jones collapsed the boundaries between the fine and decorative arts, and offered a complex rumination on the relationship between art, music and love. His work engages with that of leading avant-garde figures in nineteenth-century poetry and opera.

The subject of *Laus Veneris* (literally 'the worship of Venus') derives from the German legend of Tannhäuser, the itinerant knight who, encountering the goddess of love in her home in the Venusberg, gives himself over to a life of sensuous delight. Remorseful, he travels to Rome to beg absolution, which the pope refuses, claiming that forgiveness of such sins is as likely as his papal staff bursting into blossom. After Tannhäuser leaves in despair, this miracle does indeed transpire, but too late: the knight cannot be found.

Burne-Jones represented the interior of the Venusberg with the languid figure of Venus clad in a vivid orange gown occupying the right, a lavish golden crown resting on her thighs. She runs one hand through her long, auburn hair. She is attended by a group of musicians from her court, who pause before beginning to play music from a gothic manuscript. It sits before them on a fantastical music stand supporting tiny bells played with a hammer. Behind Venus on the wall is an elaborate tapestry representing the goddess on a chariot accompanied by Cupid, who is about to fire an arrow from his bow. To the far left another tapestry represents the birth of Venus. Through an open window a group of knights can be seen in clear blue light – perhaps searching for the lost Tannhäuser. The overall effect is one of enervated luxury, as if Venus has tired of carnal delights.

The tale became well known in England in a version by the German Romantic writer Ludwig Tieck, *The Trusty Eckart*, translated by Thomas Carlyle as *German Romance*, 1827. The Tannhäuser narrative was the basis for William Morris's poem 'The Hill of Venus', part of his verse cycle *The Earthly Paradise*, for which Burne-Jones produced twenty illustrations in 1866.

Burne-Jones's sultry and erotic version of the subject was first conceived as a watercolour in 1861 (private collection). The composition bears close comparison with the poem 'Laus Veneris' by Algernon Swinburne, begun in 1862 and published in the controversial *Poems and Ballads* of 1866, a volume dedicated 'to my friend Edward Burne-Jones'. Swinburne may have seen the early version of *Laus Veneris*, and many aspects of his frankly erotic verse, written in the idiom later denounced as 'the fleshly school of poetry', enmesh with Burne-Jones's approach:

Her little chambers drip with flower-like red …

Her gateways smoke with fume of flowers and fires,
With loves burnt out and unassuaged desires;

Between her lips the steam of them is sweet,
The languor in her ears of many lyres.[12]

Though too sensuous for mainstream Victorian taste, Swinburne's work was at the forefront of European avant-garde writing, and he enjoyed a lively correspondence with the French poet and critic Charles Baudelaire, whose erotically charged and often melancholic poems *Les Fleurs du mal* (1857) Swinburne greatly admired. The Tannhäuser legend also became the subject of a major controversy when Wagner's opera on the subject, originally produced in 1845, was received with whistles and catcalls when offered at the Paris Opéra in March 1861. It was withdrawn by the composer, despite strong support in the press from Baudelaire, who forwarded a copy of his article to Swinburne. Burne-Jones, whose deep love of music extended to embrace the rich chromaticism of Wagner's operas, must have followed this controversy with interest.

Burne-Jones's original watercolour of 1861, in which the figure of Venus was modelled by Fanny Cornforth, indicates how much the young artist had learned from Rossetti's Aesthetic paintings of the 1860s such as *The Blue Bower* (see no.126). The watercolour version of *Laus Veneris* was purchased by William Graham, the most significant of Burne-Jones's patrons, who subsequently commissioned from the artist a large oil version. Burne-Jones began work on this in 1873, with periods of intensive labour in 1874 and 1875. Although Burne-Jones's inscription, in gold paint on the zither at the centre of the composition, states that the work was painted in '1873–5', it was in fact completed only in 1878, prior to being submitted to the Grosvenor Gallery.

The finished painting is remarkable for the sustained decorative elaboration of its surface. Each element of the interior – tapestries, draperies and costumes, furniture, metalwork – seems to echo designs produced by Burne-Jones for Morris & Co.; the tapestry of Venus and Cupid was originally designed as a ceramic tile in 1861. The painting itself is a decorative surface and employed unusual and archaic techniques, such as the use of a circular stamp in the gesso layer underneath Venus's shimmering orange garment, creating a distinctive surface texture.

Burne-Jones deliberately compressed the spaces of the composition to give the impression of flat planes of colour and design. Henry James complained that 'Mr Burne-Jones's figures … are too flat, that they exist too exclusively in surface. Extremely studied and filled in outline, they often strike one as vague in modeling – wanting in relief and the power to detach themselves'.[13] This, of course, was an avant-garde gambit. Rejecting academic perspectival conventions, Burne-Jones created an elaborate artwork that embraced the flatness of the decorative media he was exploring in his works with Morris & Co., but that also pushed to the boundaries of acceptable taste the erotic poetics he had developed in dialogue

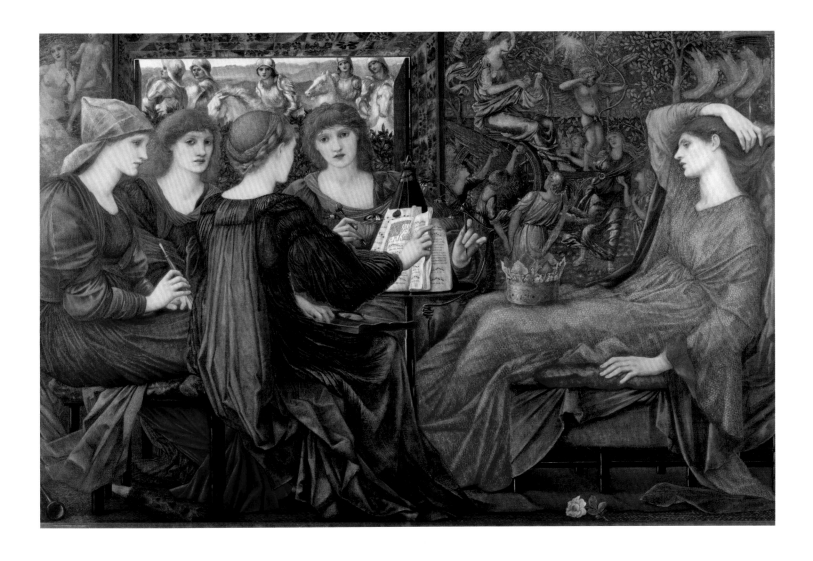

with Swinburne. It was here that the modernity of *Laus Veneris* ultimately lay, in figures 'so wan and death-like, so stricken with disease of the soul', according to the critic of *Temple Bar*.[14] James was doubtless correct in observing that Venus 'has had what the French call an "intimate" acquaintance with life': as the penitent Tannhäuser recalls in Swinburne's poem:

Behold, my Venus, my soul's body, lies
With my love laid upon her garment-wise,
 Feeling my love in all her limbs and hair …[15]

In his frank presentation of the melancholy aftermath of satiated sexual desire, Burne-Jones anticipated a central theme in decadent art of fin-de-siècle Europe. TB

DANTE GABRIEL ROSSETTI 1828–82

Astarte Syriaca 1877

Oil on canvas 185 x 109
Manchester City Galleries

Commissioned by the photographer Clarence Fry for £2,000, the largest sum Rossetti had ever commanded for a painting, *Astarte Syriaca* was regarded by the artist as his 'most exalted performance', a work that harmonised 'abstract sentiment' with 'physical grandeur'.[16] The picture, 6 feet in height, represents the ancient Syrian goddess of love Astarte looming large in the centre, flanked by two winged acolytes bearing flaming torches trailing branches of jasmine. Compressed into the shallow space of the design and illuminated by the sun as it eclipses the moon, the goddess looks imperiously down on the viewer who is placed before her like a worshipper in submission. In adopting an iconic format and in using blazing cosmic imagery, Rossetti also superimposed on his proto-Venus the image of 'the woman clothed with the sun' from the Book of Revelation 12: 1 to underscore both the goddess's elemental power and her enduring presence.

Despite the superhuman aspects of the figure with its heavy elongated limbs, abundant mass of hair and 'love-freighted lips', the features are recognisably those of Jane Morris, the subject of many of Rossetti's idealised female portraits from the late 1860s. She was not only an intimate of the artist but had collaborated closely with him in fashioning a distinct unconventional type of beauty based on her limp, sinuous posture and dark 'Eastern' features (as seen in the photograph of Jane in loose Aesthetic dress by John R. Parsons that Rossetti had staged in his garden at Cheyne Walk back in 1865: fig.25). Drawing on the salient aspects of Jane's physique and persona, Rossetti transforms her into an altogether more mysterious being in keeping with his description of Astarte as 'Amulet, talisman, and oracle' in the sonnet he wrote to accompany the painting, a practice of unifying image and text he had followed since his first exhibited oil, *The Girlhood of Mary Virgin* (no.24).

The figure is presented in a classical Venus Pudica pose with her

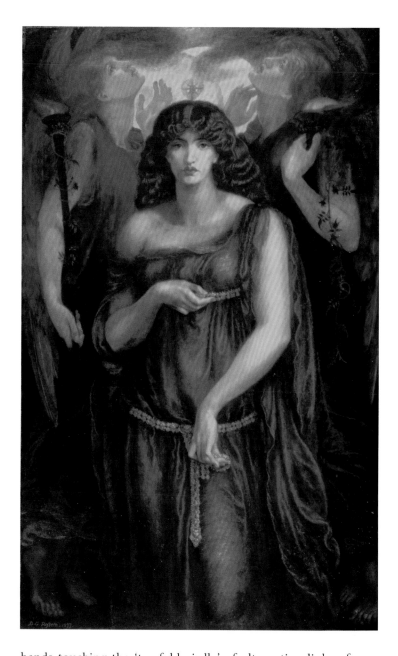

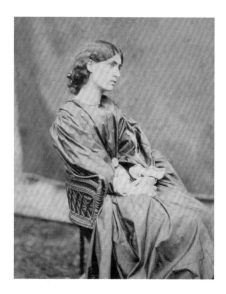

Fig. 25 Jane Morris, 1865, albumen print by John Robert Parsons, 21 X 15.6. Watts Gallery [London and Washington]

hands touching the 'twofold girdle' of alternating links of rose and pomegranate (adapted from a silver belt owned by Jane) that covers her erogenous parts. According to the sonnet, this girdle excites a kind of cosmic ecstasy. Yet in order to invest the sexually charged figure with a sense of monumental stature, Rossetti made the goddess into a figure of Michelangelesque proportion, with her masculine shoulders, small breasts and long tapering fingers. Such mannerisms are complemented by the green-blue tonality of the painting and the dry, textured handling of paint, features that distinguish the artist's late productions, replacing the more glossy use of oil in his earlier 'sensuous' female portraits. AS

DANTE GABRIEL ROSSETTI 1828–82
A Vision of Fiammetta 1878

Oil on canvas 146 x 88.9
Collection: Lord Lloyd Webber

This painting represents Maria d'Aquino, the beloved of the fourteenth-century Italian poet Giovanni Boccaccio and known to him as Fiammetta, meaning 'Little Flame'. She was venerated by the poet for her beauty of mind and person but died before the couple could fulfil their love. Boccaccio's grief was only broken when Fiammetta appeared to him in a vision, inspiring him to write a sonnet describing his last sight of his lady. This is inscribed along the top of the frame Rossetti designed for the picture; at the bottom is the artist's translation of it, accompanied by his own original sonnet in English, in which Fiammetta is presented as a vision brimming with life in defiance of death:

> Her garments beat the air:
> The angel circling round her aureole
> Shimmers in flight against the tree's grey bole:
> While she, with reassuring eyes most fair,
> A presage and a promise stands; as 'twere
> On Death's dark storm the rainbow of the Soul.

As if to reinforce the transcendent message of the sonnets within the painting itself, Rossetti depicts Fiammetta as a magnificent being, draped in a flame-coloured oriental robe as she parts the bloom-laden boughs of an apple tree to emerge from a gloomy twilight symbolic of the threshold between life and death. Azure butterflies, emblematic of the soul, flutter among the blossoms, and in the halo enshrining her head an angel hovers as if to receive her soul into the afterlife. Surmounting the composition is a blood-red bird, which, like the red dove in *Beata Beatrix* (no.124), appears as a harbinger of death.

For the figure of Fiammetta, Rossetti used Marie Spartali Stillman, an Anglo-Greek renowned in Pre-Raphaelite circles for her beauty who had also modelled for Madox Brown, Burne-Jones and Julia Margaret Cameron (see no.128). Spartali was an artist in her own right, having studied with Brown since 1864, and known as a painter of poetic subjects. These include *The Last Sight of Fiammetta*, of 1876, and *Fiammetta Singing*, of 1879, both of which had been inspired by Rossetti's translation of Boccaccio's sonnet first published in his *Early Italian Poets* of 1861. Spartali's own renditions of Fiammetta may well have suggested the theme to Rossetti, who in casting Spartali as Fiammetta herself, was perhaps recognising her own association with the subject.[17]

In order to accentuate the idea of a woman pulsating with life as she approaches death, Rossetti was concerned to make the apple blossoms in the picture appear as real as possible, to which end he sought the help of the artist Frederic Shields in sourcing what he termed 'a full-coloured red and white blossom, of the tufted,

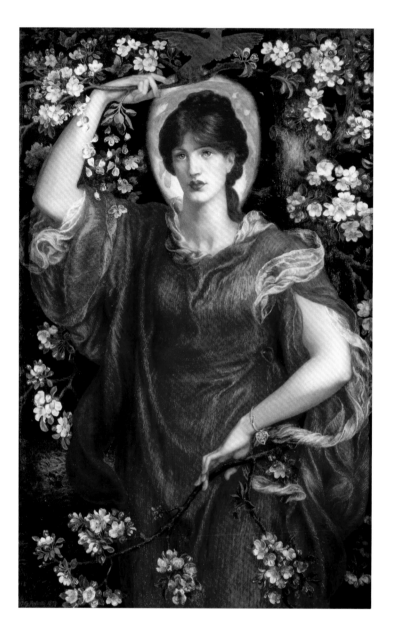

rich kind'.[18] Rossetti was clearly pleased with the result and in July 1878 wrote to the critic and poet Theodore Watts-Dunton: 'I want you to see *Fiammetta framed*; it looks a *ripper*.'[19]

The painting was acquired by the Manchester collector W.A. Turner, who agreed to it being exhibited at the Manchester Royal Institute in 1882 and at the Royal Academy in 1883. It was sold at Christie's in 1888 along with other works by Rossetti in Turner's possession, fetching the extremely high price of £1,207.[20] AS

EDWARD BURNE-JONES 1833–98

The Golden Stairs 1876–80

Oil on canvas 269.2 x 116.8
Tate. Bequeathed by Lord Battersea 1924

Started in 1876 and exhibited at the Grosvenor Gallery in 1880, *The Golden Stairs* was widely regarded as Burne-Jones's greatest work to date. It established his reputation internationally as a leading exponent of the Aesthetic movement. As in *Tristram and Iseult* (no.164), this was a picture in which rhythm and interval took precedence over narrative, the subject being described by the artist as simply 'a procession of girls coming down a flight of stairs' in his list of works for 1872. It was later known as *The King's Wedding* and *Music on the Stairs*, before the final title was chosen.[21] A company of eighteen young women holding a variety of instruments including cymbals, tambourines and long trumpets are shown descending a winding flight of steps; above, through an open roof, can be glimpsed a clear blue sky, and below, an open doorway leads to a golden Egyptian chamber lined with columns adorned with lotus capitals. The whole design conveys an impression of endless movement. To achieve this effect, the artist divided the composition into two groups at the viewer's eye level, and then adjusted the foreshortening of the architecture to accentuate the frontal plane on which the musicians process, the subtle variations of their fluted drapes, expressions and postures offsetting the geometric rhythms of the stonework. The overall somnambulistic mood is enhanced by the narrow colour harmonies of silver-gold, which coalesce with darker accents provided by the laurel tree and the shadowed recess of the ceiling and arch to create a sense of refinement and a trance-like state of being. Although *The Golden Stairs* invites comparison with the Aesthetic compositions of James McNeill Whistler and Albert Moore in its subtle colour harmonies and leitmotif of classically draped, self-contained figures playing musical instruments, there is a particular debt to Italian Renaissance art and uncompromising craftsmanship in this picture. With its elaborate surface patterns and overall suppression of emotion, it comes close to pure decoration. Indeed, comparisons have been made between stained glass and the tall, narrow format and arrangement of figures on the picture surface, and between Morris's fabric designs and the descending flow of sinuous ribboning lines.[22]

Despite the picture's rejection of narrative and characterisation, there are tantalizing invitations to interpretation that lend the work a Symbolist dimension. It is thus not clear why the glances and expressions of the more animate figures on the upper stairs gesturing to their immediate neighbours are not reciprocated, nor why in the bottom register a mirroring or doppelgänger effect is introduced with pairs of figures gazing simultaneously at and away from one another, imparting a mysterious impression where it is not altogether certain whether the space into which they are being led is real or illusory. The sprigs of rosemary on the steps, and strands of laurel and jasmine adorning the figures are also ambiguous, carrying symbolic connotations of marriage, victory and grace, as well as introducing smell to the multi-sensory appeal of the work with its opulent reflective surfaces and musical references. The picture certainly caused some confusion when it first appeared in public. Georgiana recalled the artist's own exasperation at being unable to respond adequately to the letters he received requiring an explanation of the picture:

> It was to this that he refers in a letter written in one of his wearied hours. 'If you had to paint pictures now, what would you do? Should you feel as bewildered as I do, who sit and stare at them and wonder why I began them and what I meant? I feel inclined to write to Mr. Burne-Jones and apologise for troubling him, but should be so grateful if he would tell me the hidden meaning of these pictures.'[23]

Given such reservations, the painting was nevertheless acclaimed for its Aesthetic 'musical' properties, which critics defined in terms of rhythm, colour harmony and resistance to any form of narrative. The girls' graceful wet-fold muslin gowns also struck a contemporary chord, implicitly acknowledging the dress reform movement of the period. Moreover, in basing many of the heads on the faces of young women in his family and immediate circle (including his daughter Margaret, May Morris and intimate friends Frances Graham and Mary Gladstone), the artist was in effect offering a celebration of the *jeunesse dorée* of fashionable London society. The painting was purchased by the aesthete Cyril Flower shortly after his marriage to Constance Rothschild, a close friend of Blanche Lindsay, wife of Sir Coutts Lindsay, proprietor of the Grosvenor Gallery. In 1880, the year he acquired *The Golden Stairs*, Flower entered parliament as a Liberal MP, and the picture went on display at the couple's lavish residence, Surrey House in Oxford Street, where it was seen by the great and good of the day. Its reputation outside the United Kingdom was largely due to the etching made after it in 1894 by Feliks Jasiński, whose highly refined and exacting technique matched the labour and care Burne-Jones invested in his own productions. AS

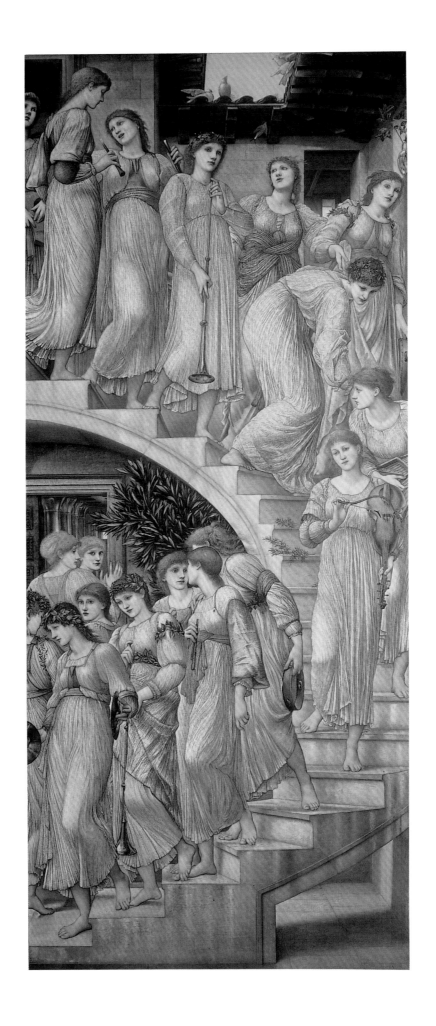

WILLIAM HOLMAN HUNT 1827–1910

The Triumph of the Innocents 1883–4, retouched until 1897

Oil on canvas 156.2 x 254
Tate. Presented by Sir John Middlemore, Bt, 1918

The Triumph of the Innocents exists in two main versions – one, started in 1876 (Walker Art Gallery), and this replica, commenced in 1883. The subject was first conceived in Florence in 1868 following the loss of Hunt's first wife Fanny, who left him with a baby son, but did not become a major project until he returned to Jerusalem with his second wife Edith in 1876. Hunt's progress on the first painting was impeded by physical and psychological difficulties that help explain the extraordinary, visionary nature of the work. He had to contend with the anxiety generated by the dangerous political situation in Jerusalem following Russia's declaration of war against Turkey in 1877, which led him to evacuate his family to Jaffa to escape what he feared would be a massacre of Christians in the area. Hunt also faced technical problems caused by the uneven surface of the cotton he had purchased in Jerusalem as the support for his picture. Despite having restoration work carried out on the canvas following his return to London in 1878, the problem of applying pigment to the twisted support persisted, leading Hunt to suspect that demonic interference was preventing the picture's completion. This culminated in an uncanny psychic event when Hunt was working on the painting at his studio in London on Christmas Day 1879, as he explained in a letter to his friend William Bell Scott: 'I hung back to look at my picture. I felt assured that I should succeed. I said to myself half aloud, "I think I have beaten the devil!" and stepped down, when the whole building shook with a convulsion, seemingly immediately behind the easel, as if a great creature were shaking itself and running between me and the door.'[24] But ultimately finding the first version impossible to salvage, Hunt embarked on the Tate replica in 1883.

The subject is taken from St Matthew 2: 13–18 and represents Mary, Joseph and the Infant Jesus on the road to Gaza as they flee Bethlehem at night to seek sanctuary in Egypt. They are accompanied by spirits of the infants slaughtered by King Herod, bearing signs of their suffering and martyrdom as they awaken to a new spiritual existence. It is to their luminous presence that the Christ Child attempts to draw his mother's attention as Joseph looks away, oblivious to the spirits and distracted by a pair of dogs scavenging for prey by a watermill.

Although the painting was inspired by old-master representations of the Flight into Egypt, Hunt explicitly rejected Baroque conventions of conveying transcendent meaning through effects such as billowing clouds and radiant shafts of light. Instead, he attended to the specifics of the location in Gaza believed to be the actual route taken by the Holy Family, as well as to details of Palestinian costume, to lend a sense of authenticity. However, in order to express the underlying metaphysical significance of the scene and a sense of the otherworldly in an otherwise mundane landscape, he blended natural with supernatural light. Three types of light illuminate the scene: the natural moonlight that reveals the landscape in the distance, lamplights from surrounding dwellings and the supernatural 'rainbow' light that irradiates both the Innocents and the ectoplasmic spheres on which they glide. The painting can thus be read as both a true and a fantastical vision. While Hunt invites us to share the Christ Child's encounter with the supernatural spectacle of the resurrected infants, he also gives us reason to doubt the Innocents' real presence through the prominence accorded to Mary, who is shown to be only dimly prescient of their existence, and Joseph, who is altogether unaware of them, absorbed as he is in the task of ensuring his family's safety. The different perceptions of the protagonists serve to confound the audience's sense of which realm the event takes place in – the real or imagined – resulting in a strangeness of vision that accords with the artist's mission to fuse matter and spirit into prophetic meaning.

In the exegesis he offered in the pamphlet published to accompany the painting when it was first exhibited at the Fine Art Society in 1885, Hunt outlines the complex eschatological symbolism of the image. He emphasises the three main visionary aspects of the picture: the spirits of the martyred children, the sacred light that encircles them and the globes that rise from 'the streams of eternal life'.[25] The most complex iconographic feature, Hunt explains, comprises the large 'magnified globes' that hover in the spaces surrounding St Joseph. The largest of these miniaturised compositions contains typological imagery from Genesis 28: 12 and Revelation 22: 2 (Jacob's dream and the Adoration of the Lamb), symbolising the union of the heavenly and earthly spheres, the Jewish belief in the Millennium and the return of the Messiah.[26]

In order to dramatise the revelatory import of the painting, Hunt had it encased in a magnificent gilt frame carved with pomegranate motifs emblematic of the Resurrection, reinforcing the overall message of the triumph of the spirit over death. He also arranged to have the picture displayed at the Fine Art Society in a room 'arranged with graduated benches, like a theatre, and the darkness secured by heavy dark draperies [which] make the light falling on the picture, and the picture itself, extremely brilliant'.[27] While some critics found the mixture of the real and unreal in the painting confusing for the modern rational mind, others were won over by the sublimity of Hunt's conception, Ruskin hailing it as the most important work of Hunt's career and 'the greatest religious painting of our time'.[28] AS

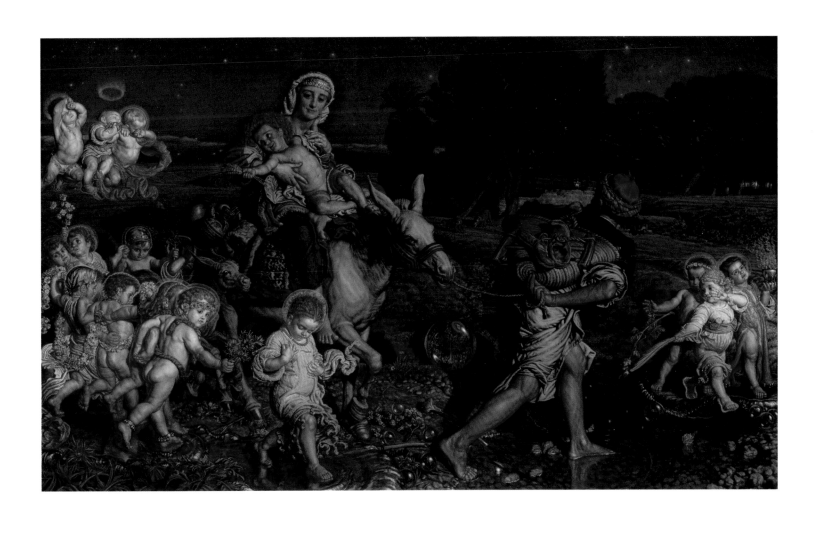

EDWARD BURNE-JONES 1833–98

King Cophetua and the Beggar Maid 1880–4

Oil on canvas 293.4 x 135.9
Tate. Presented by subscribers 1900

Like the *Golden Stairs* (no.168), this painting has a vertical format with figures arranged in a vertiginous architectural space, the reflective patterns and compactness of which are alleviated by touches of foliage and glimpses through to a natural world beyond the artificial richness of the interior. Burne-Jones first approached the subject in an unfinished oil painting of 1862 (Tate). Although the present picture was conceived around 1875, he did not start work on it in earnest until after 1880 with most of the painting completed in 1883–4. The theme of male enthralment to female beauty was a consistent one in Burne-Jones's *oeuvre* (and would be a presiding motif in pan-European Symbolism). In this case it derives from two sources: Richard Johnson's 1612 ballad 'A Song of a Beggar and a King', reprinted in Thomas Percy's *Reliques of Ancient English Poetry* of 1842, which itself inspired the second source for the painting, Tennyson's poem 'The Beggar Maid' of the same year. The former tells the legend of an African king who disdained ladies but fell in love at first sight with Penelophon, 'a beggar maid all in grey', while the latter is more of a dream vision in which the reader is imaginatively placed as Cophetua mesmerised by his prize.

In order to present Penelophon as the focus of both the king's and the viewer's attention rather than the material possessions that surround her, Burne-Jones situates her off-centre at the apex of an ascending succession of steps in Cophetua's palace. As she gazes enigmatically out of the picture, the king looks reverently up at her, having put aside the trappings of his power and wealth, his crown and shield, in deference to her beauty. The delicacy of the maid's pale bare skin is accentuated by the strand of hair that caresses her right shoulder and the touch of her toes on the cool metallic surface of the step, while the hint of a nipple beneath her meagre bodice reinforces the icy self-containment of the figure, suggesting that perhaps his is an unattainable vision – a point reinforced by the anemones in her hand – a symbol of rejected love. The whole encounter is set in a richly decorated mausoleum-like structure that the eye enters over an open cavity in the foreground, an allusion perhaps to the tomb in which both king and Penelophon were interred following their demise in the original ballad, and beyond this, to a moment of perfection frozen in time.

The composition developed with the aid of numerous figure studies as well as metalwork models for the shield and crown made to the artist's specifications by W.A.S. Benson. The image itself is a subtle compound of a number of sources, notably Andrea Mantegna's *Madonna della Vittoria* of 1495–6 in the Louvre with its motif of the kneeling duke gazing up at the Virgin, of which the artist owned a reproduction, and Carlo Crivelli's *Annunciation* of 1496 in the National Gallery with its elaborate ornamentation and steep receding perspective.[29] The maiden's skimpy vest was likely to have been suggested by the low-cut tunic worn by St John the Baptist in the altarpiece by Mantegna acquired by the National Gallery in 1855, with its appropriate connotations of holy poverty, while the puffed sash may allude to a similar one on the standing figure on the right of Mantegna's *Madonna della Vittoria*.[30] Meanwhile, the pairs of deer and drinking birds were adapted from pieces of decorated silk found in the grave of the Emperor Henry VI of Sicily in Palermo Cathedral, a fragment of which is in the British Museum. The other plates adorning the gilded chamber are decorated with a bewildering assortment of reflected patterns: circular interlace, classical key, lotus and meander, as well as pseudo-Arabic Kufic inscriptions and animal frieze decorations. Amalgamated from Roman, Arabic and Persian sources, these combine to create the heady atmosphere of an ancient palace, while details such as the ears of wheat and Coptic textiles help locate the scene in Africa, the imagined setting of the poem. The sheer weight and opulence of the materials are conveyed by shifting lights and reflections together with the layering and dryness of the paint surface, the application of pigment following the shape of each object, lending it volume and a sense of having been carefully crafted.

King Cophetua was first exhibited at the Grosvenor Gallery in 1884 to great acclaim and then at the 1889 Exposition Universelle in Paris, which marked the centenary of the French Revolution. Here it hung in the British pavilion, flanked on either side by G.F. Watts's equally anti-materialist *Hope* and *Mammon* (both Tate), which helped reinforce perceptions that the painting contained an abstract political message, symbolising, in the words of the French critic, Robert de la Sizeranne, the scorn of wealth seen elsewhere in the exhibition, 'the Apotheosis of Poverty' and the 'revenge of art on life'.[31] Due to the impact the painting made in Paris, Burne-Jones was awarded the Légion d'honneur by the French government and the picture attained iconic status throughout Europe, a development abetted by the dissemination of the image through Franz Hanfstaengl's photogravure, published by Colnaghi in 1893.

According to Georgiana, Burne-Jones's work on the painting took place at a time when he and Morris diverged in their views on socialism.[32] Morris's despair at social inequality had led him to abandon Liberalism to embrace a more radical form of politics when he joined the Democratic Federation in 1883. But Burne-Jones clung steadfast to the dream Morris had expounded in his 1877 essay, *The Decorative Arts*, that the making of 'decorative, noble, popular art' could itself be the route to social equality, offering pleasure in labour and the promise of fulfilment to all who encountered it.[33] For Burne-Jones the crafting of a beautiful object offered pleasure to both the maker and to those who encountered it, irrespective of rank or status, whereas political activism carried no guaranteed social benefit.

In the immediate term the artist's utopian vision was dependent on private capital, as the painting had been commissioned by the

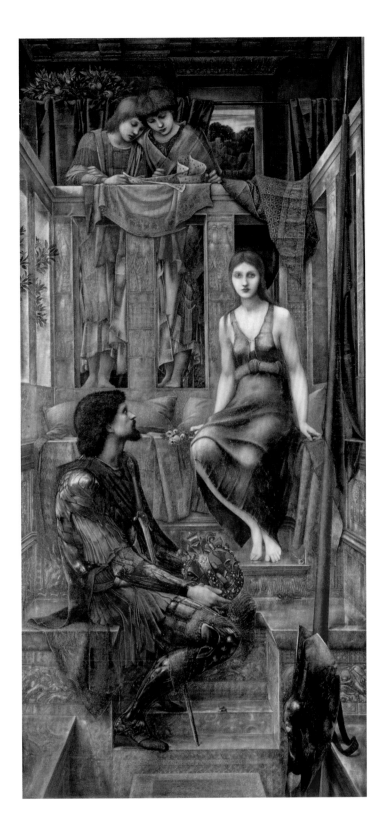

wealthy aristocratic landowner and Chairman of the Great Central Railway, the Earl of Wharncliffe, for £1,000. Through the intervention of Burne-Jones's devoted patron William Graham, who owned the full-scale gouache and chalk cartoon for the painting (1883; Birmingham Museums and Art Gallery), this was increased to £3,000. Following Wharncliffe's death, the painting came to command a wider audience when in 1900 it was purchased for the nation by public subscription. After being placed in the National Gallery, it was transferred after six months to the Tate Gallery at Millbank, where its rich decoration and anti-materialist subtext took on a special resonance in a museum built specifically with the aim of bringing art to the people. For the current exhibition the Renaissance-style frame, made by the Vacani family, has been repaired to return it to its original state after it was altered around the time it entered the Tate collection. The restoration includes the reinstatement of a single putto at the centre of the base. AS

WILLIAM HOLMAN HUNT 1827–1910, with the assistance of EDWARD ROBERT HUGHES 1851–1914

The Lady of Shalott c.1888–1905

Oil on canvas 188 x 146.1

Wadsworth Atheneum Museum of Art, Hartford, CT. The Ella Gallup Sumner and Mary Catlin Sumner Collection Fund

Hunt's fascination with Alfred, Lord Tennyson's poem 'The Lady of Shalott' reaches back to the very origins of Pre-Raphaelitism. The Pre-Raphaelites held Tennyson in high esteem, including him in their 'List of Immortals', and in 1849 the poet sat to Thomas Woolner for a portrait medallion.[34] Hunt and Millais both turned to Tennyson's works for subjects in 1850, the year that Tennyson became Poet Laureate. Hunt's pen and ink drawing, which contains the rudiments of the present composition, was completed by 29 May 1850.[35] While Millais's *Mariana* was transformed speedily into a painting exhibited in 1851 (no.35), it would be more than half a century before Hunt completed the oil version of *The Lady of Shalott*.

Tennyson's poem was first published in 1832.[36] Set in Arthurian times, it tells of a lady condemned by a curse to live alone in a tower weaving scenes that represent a world she must only look at through a mirror. All of Hunt's visual representations of the poem concentrate on the central moment of crisis when, seeing in her mirror the irresistibly appealing figure of Sir Lancelot on the road to Camelot beneath her tower, the lady defies the curse:

> She left the web, she left the loom,
> She made three paces thro' the room,
> She saw the water-lily bloom,
> She saw the helmet and the plume,
> > She looked down to Camelot.
> Out flew the web and floated wide;
> The mirror crack'd from side to side;
> 'The curse is come upon me,' cried
> > The Lady of Shalott.

Hunt's first drawing, completed in 1850 (National Gallery of Victoria, Melbourne), depicts the lady in a plain chamber with a large, convex mirror, clearly cracked, on the wall. Following Jan van Eyck's *Arnolfini Portrait* (fig.13), where events from the life of Christ are shown in roundels in the frame of a mirror, Hunt added scenes from the rest of the poem illustrating the full narrative.

The central concern of both Tennyson and Hunt was the agency and behaviour of women. Feminist critics have noted that the curse placed on the lady bears many similarities to the highly restrictive codes of behaviour for respectable Victorian women laid out in texts such as Sarah Stickney Ellis's *Women of England* of 1839.[37] The frank expression of the lady's sexual desire for Lancelot contravened the powerful ideological demand that women's sexuality should be passive and related solely to reproduction. By contravening that directive, the rebellious lady – like any Victorian woman who transgressed – is driven from society. However, Tennyson's text seems to offer a more sympathetic account of the lady's dilemma, even as it condemned her to suicide as a result of her actions. Deborah Cherry has noted that while Hunt's image pathologises the lady's act of rebellion, a drawing of the same scene

by Elizabeth Siddall (see no.49) celebrates her moment of power.[38]

Hunt continued to experiment with *Lady of Shalott* compositions throughout the early 1850s,[39] but in 1857 a commission to produce an illustration for Edward Moxon's lavish collection of Tennyson's poems brought forth what was to become his definitive composition. The mirror now has only two large roundels beside it, one containing a crucifixion. The lady's body is surrounded by an arabesque of threads from the tapestry that imprisons her, even as her hair flares wildly across the composition emphasising the movement of her bowed head. Tennyson disliked both of these aspects, complaining that the hair – 'wildly tossed about as if by a tornado' – and the threads 'wound round and round her like threads of a cocoon' had no basis in his poem.[40] This is no mere illustration, but a complex response to the poem. Its compressed energy and complex geometry display Hunt's mastery of the medium.

Probably in 1888 Hunt took up the composition again, determined to create from it a painting on a grand scale. In addition to the central figure and her accoutrements, Hunt included elaborate new elements. The tapestry now has a visible subject: Sir Galahad offering the Holy Grail to King Arthur, providing a virtuous alternative to the adulterous Lancelot. The interior has become more complex, including eclectic elements such as the Russian samovar and the pseudo-classical tessellated floor. The two large roundels on either side of the mirror are now shown as relief sculptures and Hunt went so far as to design and have an assistant, E.B. Bromfield, make three-dimensional plaster bas-reliefs, which Hunt then painted into the composition. The most elaborate depicts Hercules in the Garden of the Hesperides. The

Fig.26
William Holman Hunt, *The Lady of Shalott*, 1857, engraved by J. Thompson, relief print on paper, 9.5 × 7.9. Tate. Presented by Harold Hartley 1925

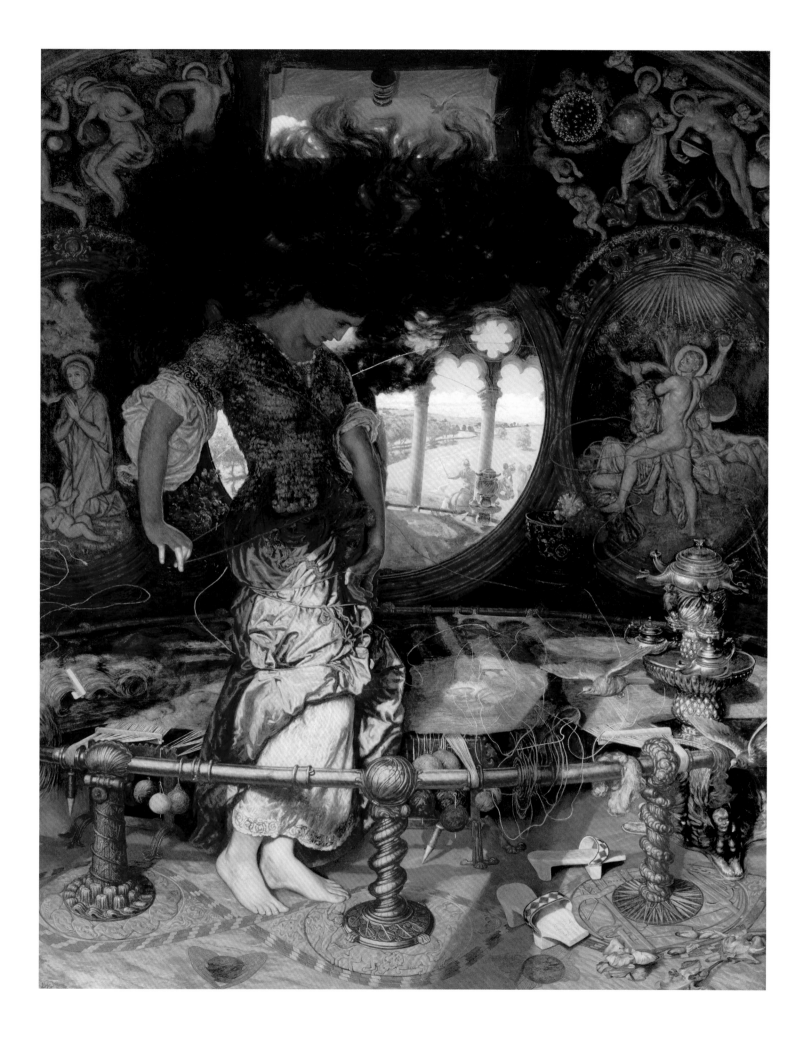

style of the reliefs owes something to the works of the della Robbia family, Florentine Renaissance sculptors and ceramicists much admired by the Victorians and collected by Hunt. The rich colour scheme, however, also acknowledges reliefs exhibited by Edward Burne-Jones and even by younger artists such as Robert Anning Bell and George Frampton at the Arts and Crafts Exhibition Society. Thus an image that began in the earliest days of the Pre-Raphaelites ended as an artefact of the Arts and Crafts Movement.[41] The finished painting is a palimpsest of seemingly incompatible artistic media: drawing, illustration, painting and the decorative arts.

In the final work familiar elements from the drawing of 1850 are still present: the tapestry; the cracked mirror; the figure of Lancelot; and the river down which the lady will soon float, dying, towards Camelot. Additions to the iconography allowed Hunt to elaborate more complex meanings for the work. The two bas-reliefs represent, respectively, the humility of the Virgin Mary (to the left of the lady) in accepting her fate and the heroism of Hercules in doing his duty despite the dangers, two moral exemplars whom the lady fails to emulate. The head of Hercules is encircled by a halo, indicating that he is typologically linked to Christ, whom he replaces in Hunt's final composition.

Far more arcane are the figures of the Fates who appear in the frieze above, classical draped nudes carrying orbs. Hunt only partially explained his intentions:

> When I abolished the Christ in glory to the left, and put instead a Virgin kneeling to her babe … there remained no consolation for the pain of endurance – no balancing one – till Heaven granted me this idea: a procession of the planets – Mercury, the Earth, Mars, the Planutoids, Jupiter and Saturn – guarded by feminine forms floating but without wings going from right to left of the picture as if rising from the Crucifixion in an arch.[42]

Here Hunt references the story of Er from Plato's *Republic*. Er, a warrior who dies in battle, passes into the afterlife but mysteriously returns to life. His tales of the other world reveal, in essence, that dutiful conduct in life is rewarded in the life to come. Pictured in the lady's chamber, Hunt explained in 1897, this narrative would 'incite her to patient service'.[43] The story of Er includes an exegesis of the arcane Platonic concept of the 'Spindle of Necessity', an

explanation of the orbiting of the planets. These dutiful figures, returning every night to their proper place in the cosmos like layers of thread on a spindle, appear in the upper register of Hunt's picture. Their cautionary presence suggests that disaster will result if one steps out of one's appointed orbit or role.

In 1901 Hunt wrote an introduction to the poem, revealing his definitive interpretation, which defined the lady as 'a Soul entrusted with an artistic gift destined to bring about a great end, who, failing in constancy, is overwhelmed by the ruin of her life's ideal'.[44] The lady is understood here as an artist who has failed to remain constant to her vision, preferring to satisfy her personal desires. Hunt believed himself to be the only member of the Pre-Raphaelite Brotherhood to have retained the purity of the movement's origins. While *The Lady of Shalott* does bear the imprint of the Aesthetic movement and Arts and Crafts influences, it is nonetheless the last great Pre-Raphaelite painting. Hunt transformed his masterpiece from a cautionary tale about female sexuality to a moralistic fable of artistic integrity in the face of resistance, a final statement of the Pre-Raphaelite narrative.

As the work was approaching completion, Hunt, in old age, was losing his sight, and his studio assistant, the fine and imaginative painter Edward Robert Hughes, assisted him in completing the work. The work's massive, aedicular frame – with pilasters and a pediment in the Mannerist style suggesting the outline of a classical temple – was designed by Hunt in collaboration with the radical Manchester artist Frederic Shields, a friend of Ford Madox Brown. It includes, in the centre of the pediment, a relief carving of Pandora's Box with a casket inscribed 'SPES' (hope).[45] Pandora's curiosity, like the lady's, was the cause of catastrophe, but in the case of Pandora there is a redeeming presence of hope, while the Lady of Shalott was condemned to death.

Uncompromising and overpowering, mannered and overwrought, the painting was already out of fashion by the time of its completion in 1905. Hunt identified the *The Lady of Shalott* as his final statement by positioning it as the frontispiece of his book *Pre-Raphaelitism and the Pre-Raphaelite Brotherhood*. Attempts to raise funds to purchase it for the nation when it was exhibited in 1906 were unsuccessful, however, and only with its acquisition in 1961 by the Wadsworth Atheneum did the painting attain the prominence it deserves. It has not been exhibited publicly in Great Britain since 1951. TB

172
EDWARD BURNE-JONES 1833–98
The Rock of Doom 1885–8

Oil on canvas 155 x 130
Staatsgalerie Stuttgart

173
EDWARD BURNE-JONES
The Doom Fulfilled 1885–8

Oil on canvas 155 x 140.5
Staatsgalerie Stuttgart

174
EDWARD BURNE-JONES
The Baleful Head 1885–7

Oil on canvas 155 x 130.5
Staatsgalerie Stuttgart

The Perseus cycle had its origins in Burne-Jones's introduction in 1875 to the twenty-six-year-old aesthete and newly appointed Conservative MP, Arthur Balfour, who had recently taken up residence at 4 Carlton Gardens, London. Balfour asked the artist to design a series of pictures for his principal drawing room, deferring to him in choice of subject matter, and Burne-Jones obliged by proposing the Perseus legend based on 'The Doom of King Acrisius' from William Morris's verse epic, *The Earthly Paradise* (1868–70), but also known to him through his reading of Ovid and other classical writers. This story relates Perseus's quest for and destruction of the Gorgon Medusa, whose very expression turned men to stone, his subsequent rescue of Andromeda, daughter of Cepheus, King of Joppa, his return home with his conquest, and his marriage to Andromeda.

From the onset Burne-Jones wanted the series to develop in an organic relationship with its intended setting, to which end he advised his patron that the entire room 'should be in harmony, and the whole should look as if nothing was an afterthought but all had naturally grown together'.[46] Accordingly, he requested that the windows be re-glazed with coloured glass and the lower walls panelled in oak, so that the finished paintings could run above in a frieze around the room. After a rush of preparatory activity in 1875–6 Burne-Jones presented Balfour with three intricately worked coloured designs (all Tate) that set out the disposition of the ten pictures within the interior. These proposed to alternate the paintings with panels decorated with gesso relief against an acanthus-pattern background of gilded ornamental raised plaster to be designed by William Morris. The designs appear very much as an extension of the pictorial and decorative work Burne-Jones was producing in collaboration with Morris in the form of illuminated manuscripts, tapestry and embroidery (see nos.145, 153). The artist then went on to make numerous sketches for each constituent part of the scheme, from nude studies to elaborate three-dimensional models for the armour, which he constructed from tin and cardboard with the assistance of W.A.S. Benson, the aim being, as Georgiana explained, to lift them out of association with any historical period.[47] The actual evolution of the series seems to have preoccupied Burne-Jones more than its completion, for after producing full-scale cartoons in watercolour and gouache between 1876 and 1885 (Southampton Art Gallery), only four of the ten canvases were completed, three of which are shown here: *The Baleful Head*, exhibited at the Grosvenor Gallery in 1887; and

The Rock of Doom and *The Doom Fulfilled*, both of which were shown at the New Gallery the following year.

Taking the pictures in narrative order, *The Rock of Doom* shows Perseus touching the water as he swoops down to reveal himself to Andromeda by removing Hades' Cap of Invisibility. Standing in elegant contrapposto, like an antique statue, Andromeda (for whom Benson's sister Margaret posed as model) turns somewhat apprehensively to face the hero across a vertical projection of rock. Set against the elaborately wrought configurations of Perseus's dark carapaced body, her form appears seamless and inert, with soft transitions of flesh and an apparently impenetrable pudenda, a contrast that brings to mind a remark the artist made about the appropriate pictorial treatment for male and female figures: 'A woman's shape is best in repose, but the fine thing about a man is that he is such a splendid machine, so you can put him in motion, and make as many knobs and joints and muscles about him as you please.'[48] However, as Caroline Arscott has recently argued, Perseus's encased form is no impregnable automaton. Rather it appears as agitated as the waves that surround him as he glances nervously at Andromeda, his close-fitting, multi-plate armour metamorphosing into flesh, inviting comparison with the exoskeleton of an insect or even the peeled rind of a desiccated vegetable.[49] Moreover, as Perseus approaches Andromeda, the wallet strung over his arm containing the fateful head of Medusa opens to reveal coils of the Gorgon's hair. In a Freudian reading (the founder of psychoanalysis himself was known to have been fascinated by the Medusa legend) this detail might stand as the fetishistic counterpoint to Andromeda's distinct lack of sex, while the sword across Perseus's thigh could be interpreted as arousing fears of castration, undermining the confidence projected by his masculine endeavour.

The subliminal aspects of the image become more pronounced in *The Doom Fulfilled* where the now helmeted Perseus slays the sea monster, his reversed 'invisible' state mirrored by Andromeda still present in the same position but this time from behind. Intertwined in the rubbery coils of the monster, Perseus's body takes on the characteristics of his foe, the sharp decorative elements of his armour echoing its jagged outer edge. Hemmed in by walls of rock, this group has a hard ossified look, or as *The Times* expressed, it is 'not so much action as the spirit of action, action made statuesque and robbed of its violence'.[50] Burne-Jones's comment that the series' development was 'as slow as granite hills' is apposite here,[51]

given the threat of petrification that permeates each painting in the cycle and culminates in the final image, *The Baleful Head*. Having now married Andromeda, here Perseus shows her his prize as he holds the head of Medusa aloft, allowing her safely to gaze at its reflection in the still waters of an octagonal well. The frozen expressions of the mirrored faces appear more vivid than their real counterparts, as if encapsulating the moment of being turned into stone they are otherwise presented as avoiding, and harmonising the themes of dismemberment, repulsion and desire that run through the series at a moment of stasis. Set in the lush surrounds of a *hortus conclusus* replete with ripe apple trees, the scene invites association with the biblical story of the Temptation and Fall to further impress on the spectator the division between the sexes and the dark undercurrents of the human psyche.

It was not until Burne-Jones's death in 1898 that the paintings finally entered Balfour's possession. After hanging for a number of years at Carlton Gardens, they came to adorn the state dining room of 10 Downing St during the term Balfour served as Prime Minister between 1902 and 1906. In this context the ideas of armament, possession and violence explored in the series might have been considered apt for a man who was given the nickname 'Bloody Balfour' for his implacability over the issue of Home Rule in Ireland. AS

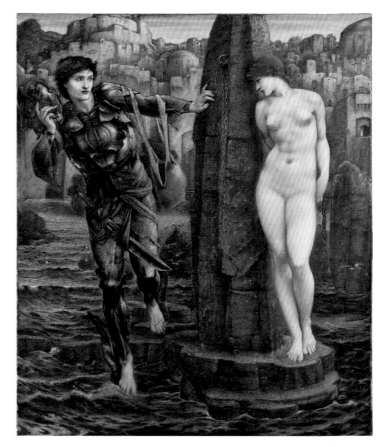

172

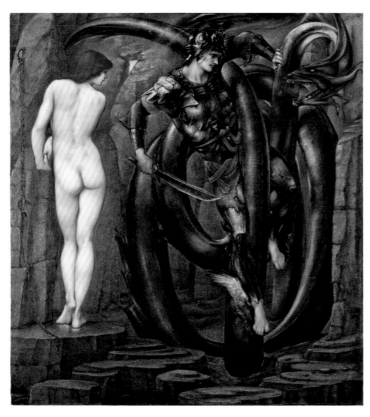

173

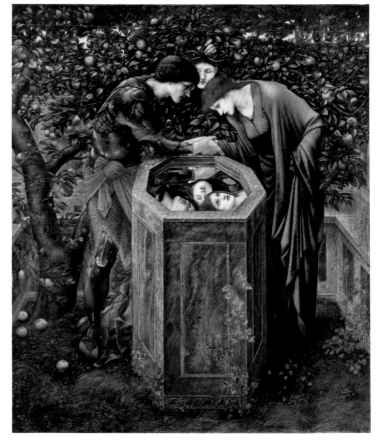

174

EDWARD BURNE-JONES 1833–98
Love among the Ruins 1893–4

Oil on canvas 96.5 x 160
Wightwick Manor, The National Trust

This composition originated in 1870 as a painting in gouache (private collection) begun at the height of Burne-Jones's relationship with Maria Zambaco. He then worked on it intensely throughout 1872 in the studio he borrowed from Spencer Stanhope at Campden Hill, where he also painted *Tristram and Iseult* (no.164). In the process of execution it was transformed into a more impersonal meditation on the eternal nature of love, and Burne-Jones went on to adapt it as the basis for a miniature for one of Morris's illuminated manuscripts of Edward Fitzgerald's translation of *The Rubáiyát of Omar Khayyám* in 1872, where it was used to illustrate verses contemplating the preciousness of the present moment in the light of 'past regrets and future fears'. While this version of the image was intended as a private gift (for Frances Graham), the original gouache was exhibited at the Dudley Gallery in 1873 and then at the *Exposition Universelle* in Paris in 1878, the first work by the artist to be shown overseas, and one of the pictures that established Burne-Jones's reputation outside Britain. It was sent to Paris again in 1893 but was accidentally damaged when being prepared for photogravure reproduction in Goupil's studio.[52] Believing the work to be literally a ruin and irreparable (in fact it was later restored), Burne-Jones immediately embarked on this larger replica in oil, which he exhibited the following year at the New Gallery and in 1895 at the Cercle d'Art and at the Exposition des Beaux-Arts in Brussels. It then passed into the ownership of Evelyn Benson (daughter of the collector Sir George Holford) and her husband Robert Henry, before entering the collection of the Scottish mining millionaire George McCulloch.

The title of the painting derives from Robert Browning's poem 'Love among the Ruins' in his compilation *Men and Women*, written in Italy and published in 1855, which elevates the pure and everlasting nature of love above material wealth and glory. Although Burne-Jones's image was by no means intended as an illustration, it picks up on the idea of an internal monologue presented in Browning's verse through the voice of a shepherd who ruminates on the passing of a once glorious city, to open up reflections on the general theme of ruination. Two monumental figures (based on the Italian model Gaetano Meo and probably Bessie Keene, who also posed for *The Golden Stairs*, no.168) dominate the foreground of the composition, the angular folds of their timeless drapes echoing the hard-edged architectural fragments that surround them. Amid the stillness of the ruins they comprise a self-enclosed entity, the man having put aside his instruments (a psaltery and a pen or stylus, which suggest human creativity in the form of music, literature and design) to tenderly embrace his companion, who gazes apprehensively out of the picture, suspended between a lost past and an unknown future. The spectator is invited to view the setting in terms of what might have prompted the couple's emotional condition, the column drums and architectural fragments indicating either a sudden disaster, such as war, or else a slow process of attrition – the implication being that their love is threatened by the same sense of decay that permeates the surroundings. Meanwhile, doorways and apertures in the distance suggest passages through time, while the frozen putti on the entablature of the portal, and the rose briars and harebells in the foreground, connote youth and regeneration on one hand, and unruly nature triumphing over the ruins of a past civilisation on the other. Although it is tempting to read the image in allegorical terms, perhaps as an indictment of industrialisation, the mood is neither condemnatory nor morbid. If anything, it projects the idea of love as a fragile yet pure value against a background of human attainment and loss, an idea expressed by George Eliot after seeing the first version in 1873:

> And I want in gratitude to tell you that your work makes life larger and more beautiful to me – I mean that historical life of all the world in which our little personal share often seems a mere standing room from which we can look all round, and chiefly backward. Perhaps the work has a strain of special sadness in it – perhaps a deeper sense of the tremendous outer forces which urge them of the inner impulse towards heroic struggle and achievement.[53]

AS

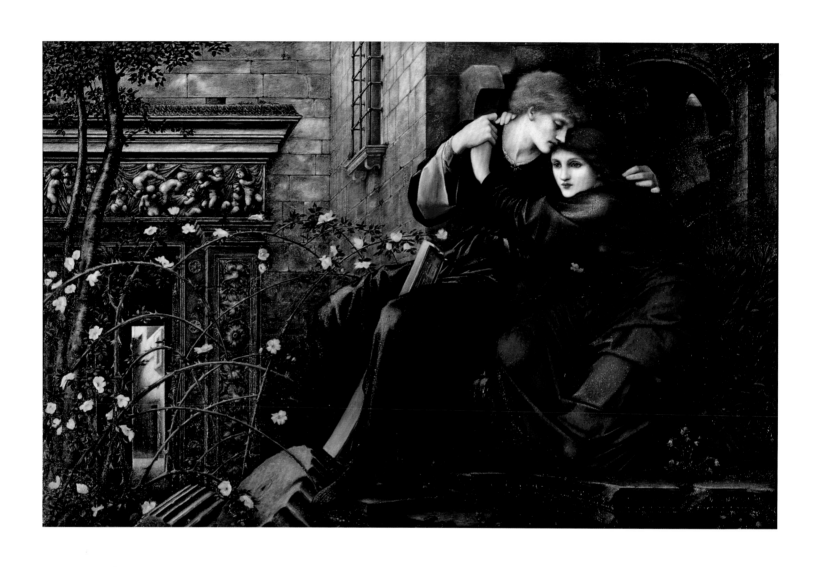

THE PRE-RAPHAELITE LEGACY

Elizabeth Prettejohn

I doubt if any Englishman – at least, any Englishman still so near to them – can approach [the Pre-Raphaelite] artists with the freshness and freedom that Salvador Dali, for example, brings to their revaluation.[1]

(Herbert Read, 1936)

These words of a great twentieth-century critic may come as a surprise, for they contradict some of the commonest received ideas about the Pre-Raphaelites: the myths of their English insularity, of their fall to oblivion after the end of Queen Victoria's reign, of their irrelevance to twentieth-century art. Each of those myths attempts to deny the Pre-Raphaelites a historical role in the lineage of modernist avant-garde movements, and in one way they have been successful. The story of the Pre-Raphaelites' fall from critical favour has become one of the most familiar anecdotes about the movement – as familiar as the story of Elizabeth Siddall catching cold in the bath while modelling for Millais's *Ophelia*, or Ruskin's non-consummated marriage and the flight of his wife to Millais, or the 'wet white ground' on which the Brothers supposedly painted.[2] These are like the anecdotes about the old masters in Giorgio Vasari's sixteenth-century *Lives of the Artists*: they parallel Vasari's stories of Raphael's death from too much lovemaking, for example, or the nun who ran away with Fra Filippo Lippi, or the invention of oil painting in the studio of the van Eycks.[3] And the most persistent of them all is the story of the precipitous decline in the Pre-Raphaelites' reputation at the end of the nineteenth century, followed by a revival in more recent years. That story survives even so relentlessly demystifying an account as the introduction to Marcia Pointon's *Pre-Raphaelites Re-Viewed*, which refers blithely to the '1960s rediscovery of the Pre-Raphaelites' as though it were a historical fact.[4]

It is a historical fact, on the contrary, that the Pre-Raphaelites have never been out of the public eye. At times they may have seemed embarrassing, objectionable or even hackneyed (as they apparently did to Read's 'Englishman'), but they were never inconspicuous. Unlike some of their contemporaries in both France and England – Paul Delaroche, for example, or George Frederic Watts, famous in their lifetimes but forgotten for decades after their deaths – the Pre-Raphaelites have been granted exhibitions in major museums, and publications by prominent authors, in every decade since their lifetimes. A random selection of highlights (and low points) from this history might begin in the 1890s with the first survey exhibition

of Pre-Raphaelite art at the new City of Birmingham Art Gallery and the chapter denouncing the group in Max Nordau's notorious *Degeneration* (first published in Berlin in 1892 as *Entartung*, in ominous anticipation of the Nazi denigration of avant-garde art as *entartete kunst*). In that decade the Pre-Raphaelites were at least as famous abroad as at home; they featured in monographs or surveys of modern art published by Richard Muther in Munich, Robert de la Sizeranne in Paris, O.G. Destrée in Brussels and Hugo von Hofmannsthal (most famous as Richard Strauss's librettist) in Vienna.[5] In 1895 they were a principal focus of attention at the first Venice Biennale.[6]

In the first decade of the twentieth century battle lines were already being drawn between different histories of Pre-Raphaelitism. William Holman Hunt's magisterially tendentious autobiography, *Pre-Raphaelitism and the Pre-Raphaelite Brotherhood*, appeared in 1905 and was answered the next year by what may already be called a reassessment, *The Pre-Raphaelite Brotherhood: A Critical Monograph* by Ford Madox Hueffer. Hueffer redressed the balance of Hunt's account, to emphasise the role of his grandfather Ford Madox Brown (after World War I Hueffer changed his name to the less German – and more Pre-Raphaelite – Ford Madox Ford, the name under which his modernist novels are still best known). In 1911 Wassily Kandinsky's *Über das Geistige in der Kunst* (*Concerning the Spiritual in Art*) identified Dante Gabriel Rossetti, Edward Burne-Jones and their followers as one of three artistic groups who had initiated the search for abstraction in modern art, while the new National Gallery of British Art (later renamed the Tate Gallery) devoted one of its first loan exhibitions to *English Pre-Raphaelite Painters*.[7]

In the 1920s the Pre-Raphaelites continued to attract attention in literary circles. Evelyn Waugh's first (albeit very short) book was *PRB: An Essay on the Pre-Raphaelite Brotherhood, 1847–1854*, privately printed in 1926. Three years later W.B. Yeats, on a visit to Ezra Pound in Rapallo, Italy, was reading William Morris's early poems 'with great wonder'.[8] Meanwhile, the scathing remarks in Clive Bell's *Landmarks in Nineteenth-Century Painting* and R.H. Wilenski's *The Modern Movement in Art* – both of 1927 – might be called a backhanded acknowledgement of the pictures' power (for Wilenski, indeed, Rossetti was a painter of genuine originality).[9] By the 1930s Surrealism had created an alternative modernist perspective; Herbert Read's comment, quoted above, took the occasion of the International Surrealist Exhibition in London to cite the Pre-Raphaelites as the most relevant British parallel to the surrealists.[10] In that decade,

too, there were exhibitions to mark the centenaries of the births of Burne-Jones (at the Tate) and Morris (at the Victoria and Albert).

By the 1930s, then, the Pre-Raphaelites could be welcomed as precursors by some modernist artists and writers (particularly those favourable to Surrealism) and violently repudiated by others (particularly those associated with Bloomsbury), but for neither side was the Pre-Raphaelite legacy a matter of indifference. Nor did interest from abroad die out. In 1935 Ford Madox Ford cautioned his teenage daughter against expressing fashionable disdain for the Pre-Raphaelites, 'the only English artists who cut any ice at all outside England'.[11] In 1946 a pioneering exhibition of Pre-Raphaelite art was held in the USA, at the Fogg Art Museum of Harvard University.[12] The centenary in 1948 of the formation of the PRB led to a host of exhibitions and a broadcast by the eminent literary critic Humphry House on BBC radio, 'Pre-Raphaelite Poetry'. In the 1950s the University of Kansas Museum of Art held an enterprising exhibition that included decorative art alongside Pre-Raphaelite painting, and the Gazette des Beaux-Arts published a study of the Pre-Raphaelites' impact in France.[13]

All of these events – and many more – predate the much-vaunted '1960s rediscovery of the Pre-Raphaelites'. If the Pre-Raphaelites were never out of view, then logically there ought to have been no special need to revive them. Yet in every decade there is some claim to 'rediscover' or 'revive' a movement whose moribund tendencies come in the process to seem strangely contradicted by its longevity. Thus in 1926 Waugh confidently declared that 'there is perhaps no artistic movement so little understood' (with the clear implication that his study will make good the deficiency).[14] For Read, a decade later, Surrealism created the stimulus for 'a reconsideration of the Pre-Raphaelites'.[15] In the 1950s the Pre-Raphaelites could be seen as an antidote to the sway of Abstract Expressionism and the purist version of modernism promoted by the American critic Clement Greenberg. In the 1960s mind-altering drugs and rock-and-roll could make the Pre-Raphaelites seem freshly relevant (as in Ken Russell's film about Rossetti and Siddall, Dante's Inferno, of 1967). Alternatively, the revival could be traced to rising prices on the art market, a view particularly prevalent in politicised or Marxist texts of the 1980s (including the important collection by Pointon already noted).[16] In recent accounts credit for the revival has been given, with bewildering variety, to William Gaunt's racy and anecdotal book, The Pre-Raphaelite Tragedy, first printed to 'War Economy Standard' in 1942; to Robin Ironside and John Gere's more scholarly assessment of 1948, The Pre-Raphaelite Painters; to Mary Bennett's series of monographic exhibitions in Liverpool and Manchester in the 1960s; and to the Tate Pre-Raphaelite exhibition of 1984. All of these made important contributions to Pre-Raphaelite studies,

but their claims to 'rediscover' the movement cancel one another out, so thick and fast do they come.

There is, then, little if any historical evidence for the persistent claim that the Pre-Raphaelites fell into oblivion at some (usually vague) date, or for the related claim that they were revived or resuscitated at some later (though often equally vague) date. The claims would appear to be ideological rather than factual. But if so, what is at stake in maintaining them, against the evidence? Why has the motif of decline and resurrection attained such prominence amid the host of stories and anecdotes about the Pre-Raphaelites? What motivates the myth-making process that contradicts itself every time it makes the (reassuringly familiar) claim that the Pre-Raphaelites were, at some date, out of fashion?

An intense self-consciousness about their place in the history of art is characteristic of the Pre-Raphaelites from the start. This is, indeed, implicit in the very name 'Pre-Raphaelite', so precisely oriented, not to the period before Raphael himself, but rather to that before his example ossified in the work of his followers, the 'Raphaelites'. Perhaps there is nothing coincidental or strange, after all, about the tendency of the Pre-Raphaelite anecdotes to resemble those in Vasari's Lives: it was the art-historical mindedness of the age that gave birth both to the revivalist tendency, encapsulated in the label 'Pre-Raphaelite', and to the PRB's determination to situate their own avant-garde project in the history of art. The process of writing the movement into the history of art intensified in the 1880s, following the first death among the original seven Brothers, that of Dante Gabriel Rossetti in 1882. Retrospective views began inevitably to emerge, at first in the memorial exhibitions given to Rossetti the next winter and then in the large exhibition accorded to the still-living Millais at the Grosvenor Gallery in 1886. These were pioneering examples of something we now take for granted, the retrospective exhibition of a single artist's work. Simultaneously with the last of the Impressionist group exhibitions (coincidentally held in 1882 and 1886), the Pre-Raphaelite avant-garde was already being inscribed into history with these retrospective exhibitions.

The surprise, for the audiences of those first retrospectives, was to see afresh the early work of the PRB, as vivid and startling in colour and detail as in the first exhibitions of 1849 and 1850. This led, in Millais's case, to a stark demonstration of just how much his style had changed from the painstaking, labour-intensive early days of the PRB (some critics were already speaking of Millais 'selling out'). Here we have another of the stock Pre-Raphaelite anecdotes – according to a story first told by Holman Hunt, Millais himself broke down and cried.[17] Millais's son does not tell that story in his biography of his father, but he does include a happier version: on seeing A Huguenot (no.37) for the first time in thirty years Millais 'laughed with

pleasure'. As reported by F.G. Stephens, 'He was especially delighted because the panel [was] perfectly unchanged in all respects. "I used," he said, "such a colour for this, and such for that. It was risky, perhaps; but there, you see, it's all right now."'[18] This is self-mythologising, and it follows again the Vasarian pattern – the magical freshness of Millais's old painting is like the survival of the early paintings by van Eyck, such as the *Arnolfini Portrait* (fig.13), whose miraculous state of preservation when it entered the National Gallery in 1842 had been one catalyst for the early style and technique of the PRB.

One story of the Millais retrospective in 1886, then, is that of tragic decline, but another is that of startling revelation – the revelation of how fresh and novel the paintings of the early Pre-Raphaelite period still looked. Two years later, John William Waterhouse exhibited *The Lady of Shalott* (fig.27), surely a tribute to the powerful impact Millais's *Ophelia* still had, or had again. Waterhouse's painting can be called derivative, but perhaps its mode of 'imitation' is more interesting: a revival of a revival that is at the same time a new exploration of the modernity of the original painting, reconceived in the terms of the 1880s. An 'impressionistic' brushstroke replaces the precision of the Pre-Raphaelite touch, and the colours are softer and duskier – one might call them nostalgic, as if the early Pre-Raphaelite style were recollected in a dream. The subject matter is also retrospective: Waterhouse chooses a poem by Tennyson that had been a favourite of the original Pre-Raphaelite Brotherhood. Perhaps the roundels of the tapestry even allude to the round tapestries

in Holman Hunt's first drawing of *The Lady of Shalott*, made in 1850, and in his illustration for the Moxon edition of Tennyson's poetry published in 1857. Yet Waterhouse also demonstrates something else about the subject when he repeats aspects of Millais's composition – the strange affinity between the two stories of a woman's death by drowning, Shakespeare's Ophelia and the Lady of Shalott of Arthurian legend. In making this connection, Waterhouse is responding to the interests of his own generation in comparative folklore or mythology; the classic study in comparative religion by James Frazer, *The Golden Bough*, would begin publication in 1890. In 1896 Waterhouse extended the idea by reconfiguring the archetypal story yet again as *Hylas and the Nymphs* (fig.28), with an intriguing reversal of gender roles: this time it is the beautiful boy who succumbs to a watery death. The same clump of reeds appears, in the same position on the lower left, in each of the three pictures in turn – *Ophelia*, *The Lady of Shalott*, *Hylas* – as if to call attention to the 'quotation' of each picture by the next. The botanical detail that is a quintessential sign of Pre-Raphaelite 'realism' metamorphoses, through this series, into an uncanny double or dream recollection – already we have taken a step towards Surrealism.

The Rossetti retrospectives in 1883 were just as startling in different ways. For the first time ever, Rossetti's works were given space at the Royal Academy, in a revisionist move that caused some controversy. Was Rossetti's 'avant-garde' practice being recuperated for the Academy, or did the limited showing (one small gallery, increased to two after press complaints)

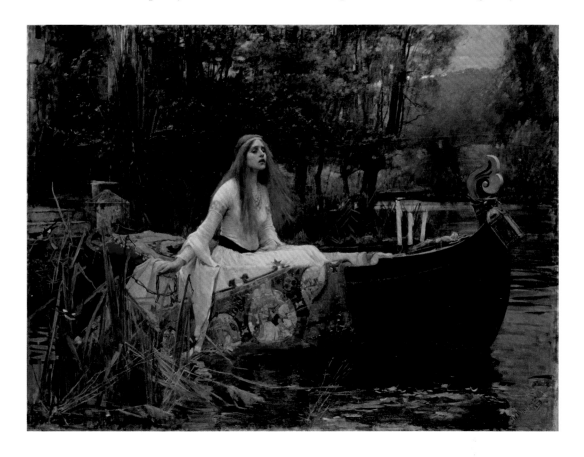

Fig. 27 John William Waterhouse, *The Lady of Shalott*, 1888, oil on canvas, 153 × 200. Tate; presented by Sir Henry Tate 1894

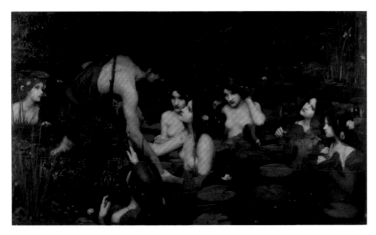

Fig. 28 John William Waterhouse, *Hylas and the Nymphs*, 1896, oil on canvas, 98.2 x 163.3. Manchester City Galleries

Fig.29 Fernand Khnopff, *I Lock my Door upon Myself*, 1891, oil on canvas, 72 x 140. Neue Pinakothek, Munich, Bayerischen Staatsgemäldesammlungen

indicate some half-heartedness on the Academy's part? The debate in the press inevitably stimulated interest in the show and in the supplementary exhibition at the Burlington Fine Arts Club. This was the first time since the early days of the PRB that Rossetti's works had appeared at public exhibition, and the very first time that a number of them had been displayed together. The mystique that had grown up around the painter-poet during the years of his seclusion raised expectations to an intense pitch, and the exhibitions were reviewed at length in the continental as well as the English press.

As in the case of the Millais retrospective a few years later, critics were able to marvel at the detail and precision of the early Pre-Raphaelite works. But the real revelation was Rossetti's more recent work, hitherto unseen except by Rossetti's own friends and patrons, with its striking new vision of the female figure (no.166). It is this that dominated the criticism of Rossetti in England and abroad, from the essay 'Rossetti and the Religion of Beauty' by the classicist and student of paranormal phenomena, F.W.H. Myers, to the French art critic Théodore Duret's account in the *Gazette des Beaux-Arts* of 'the woman imagined by Rossetti … a colossal being'.[19]

The legacy of Rossetti's powerful female figures may be traced throughout the diverse art forms we now associate with the term 'Symbolism', from Poland and Russia to Scandinavia and America – so much so that some writers began to distinguish 'Rossettism' from 'Pre-Raphaelitism' proper.[20] A typically complex example is *I Lock my Door upon Myself*, 1891, by the Belgian painter Fernand Khnopff (fig.29). The painting not only displays a revised version of the familiar Rossettian composition – a half-length female figure, mesmerising in her appeal to the viewer and placed amid a panoply of symbolic accessories that seem to allude to meanings too recondite to be decoded. It also draws on a personal identification between Khnopff himself and Rossetti that recapitulates Rossetti's own fascination with his namesake Dante; like Waterhouse, Khnopff is engaging in a

revival of a revival. The title is drawn from a poem by D.G. Rossetti's sister, Christina, and the figure in the painting is easily recognised as Khnopff's own sister, Marguerite. The orange lily that erupts into the solitary figure's space is a quotation from Rossetti's watercolour of 1857, *The Blue Closet* (no.48), another picture of a hermetically sealed space, like the Lady of Shalott's tower or the 'Palace of Art' in another of Tennyson's poems, also illustrated by Rossetti (see pp.246–7). Khnopff's background includes a scene of Bruges, his home town, and a version of the classical head of Hypnos, the god of sleep, with its extended wing; this might be a reference to the craving for sleep that led to Rossetti's addiction and death, as well as to the dream imagery characteristic of Symbolism and then of Surrealism.

Rossetti's example looms enormous over the artistic production, throughout continental Europe, of the last decade of the nineteenth century and into the twentieth. So does that of his follower Burne-Jones, whose obituary Khnopff wrote as 'a tribute from Belgium'. Like countless other continental artists, Khnopff had made the pilgrimage to meet Burne-Jones in his studio, and we have seen that Kandinsky, in 1911, gave a crucial role to Rossetti and Burne-Jones in the prehistory of modernist abstraction.[21] The female figures of Picasso's Blue and Rose periods surely bear traces of Burne-Jones, much admired in Picasso's Barcelona circle of the 1890s.[22]

Among English artists of the turn of the twentieth century, there was a notable phase of Pre-Raphaelite revival in the work of such artists as Eleanor Fortescue Brickdale, Frank Cadogan Cowper and John Byam Liston Shaw – artists who are themselves due for a revival after decades of neglect. Byam Shaw's *Boer War, 1900* (fig.30) returns once again to Millais's *Ophelia* in the tangled foliage and the vibrant colour of the riverbank, and also to the social concerns of early Pre-Raphaelitism: the woman in modern dress must be in mourning for a husband, lover or friend fallen in the war, and the lush English countryside reads as a poignant contrast to the thought of the dusty South African veldt.[23]

We seem to have two artistic legacies stemming from Pre-Raphaelitism, just as Pre-Raphaelitism itself is often said to have two sides: the 'realist' legacy, which could lead to such literal imitations as Byam Shaw's *Boer War, 1900*, and the 'romantic' legacy leading to 'Symbolist' works such as Khnopff's *I Lock my Door upon Myself*. In broad terms the first of these stems from Millais and Hunt, the second from Rossetti and Burne-Jones. And perhaps it is the case that the first is more 'English', with a later legacy that leads through Stanley Spencer to Lucian Freud, whereas the second is more cosmopolitan, with responses in places as far-flung as Picasso's Barcelona, Khnopff's Bruges, Edvard Munch's Oslo, Franz von Stuck's Munich and Gustav Klimt's Vienna. [24]

And yet the binary division is not so clear-cut, as so often in Pre-Raphaelitism. If Khnopff quotes Christina Rossetti to haunting effect, so too does Byam Shaw. When first exhibited at the Royal Academy in 1901, *Boer War, 1900* was accompanied by two lines from Christina Rossetti's poem, 'A Bird Song':

> Oh last summer green things were greener,
> Brambles fewer, the blue sky bluer![25]

Perhaps Byam Shaw's realism is tempered with something of the enigmatic quality of Khnopff's dreamlike space; and Khnopff, in turn, paints his interior with a precision worthy of Millais or Hunt. Frank Cadogan Cowper's *St Agnes in Prison* of 1905 (fig.31) manages to combine an allusion to the mystical encounter of angel and human woman in Rossetti's *Ecce Ancilla Domini!* (no.87) with realist details borrowed from Millais's *The Return of the Dove to the Ark* (no.89), as if to reconcile the two halves of the original Pre-Raphaelite project, half a century on. An article of 1936 by Salvador Dalí in the Surrealist journal *Minotaure* is entitled 'Le Surréalisme spectral de l'Éternel Féminin préraphaélite' and dwells (like so many of the continental responses) on the Rossettian female type. Yet Dalí illustrates Millais's *Ophelia* and Hunt's *Hireling Shepherd* (including a detail of the death's head moth) as well as Rossetti's *Beata Beatrix*.[26] And the hyper-real or (in Herbert Read's phrase) 'superreal' aspects of Pre-Raphaelite landscape are surely important to Dalinian Surrealism.[27] The parallel between Pre-Raphaelitism and Surrealism recurs as a structuring device in a major article on the latter movement by Clement Greenberg – yet another surprise, coming from the modernist critic who had notoriously derided the Pre-Raphaelites as 'literary' and 'academic' in an important theoretical article of 1940.[28]

This introduces another binary division: the Pre-Raphaelite legacy is contested in modernism, between a Surrealist fascination and a repudiation on the part of the mainstream modernist movements centred more exclusively on Paris. Perhaps, then, it was not the irrelevance of Pre-Raphaelitism to the twentieth-century movements, but rather the difficulty of pinpointing or

Fig.30 John Byam Liston Shaw, *Boer War, 1900*, 1901, oil on canvas, 100 × 74.9. Birmingham Museums and Art Gallery

categorising its art-historical legacy, that created the myth of its obsolescence. In his comprehensive four-volume survey of the development of modern art, published in the 1890s, the German art historian Richard Muther had no reservations about citing a cosmopolitan trio of realist paintings, which he saw as major statements about modern social conditions: Ford Madox Brown's *Work* (no.95), Gustave Courbet's *Stonebreakers* (1850; formerly Gemäldegalerie, Dresden, destroyed in World War II) and Adolph Menzel's *Iron Rolling Mill* (1872–5; Nationalgalerie, Berlin). But in the next decade Julius Meier-Graefe, author of a new German history of modern art, moved to an entirely Franco-centric version, with Courbet in unchallenged supremacy and slighting accounts of both Brown and Menzel.[29] Meier-Graefe's version, admired by Roger Fry, proved highly influential on the historiography of modernism in the earlier twentieth century. Thus the battle lines were drawn between a Francocentric modernism and any alternative version that might include the Pre-Raphaelites. A reason for the stridency of some twentieth-century attacks on the Pre-Raphaelites could be a sense that the abrupt segregation of French and non-French modernisms is indefensible.

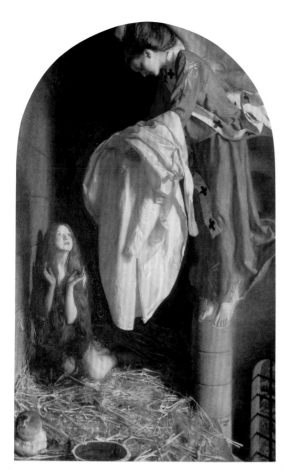

Fig.31 Frank Cadogan Cowper, *St Agnes in Prison Receiving from Heaven the 'Shining White Garment'*, 1905, oil on canvas, 74.3 × 45.1. Tate; presented by the Trustees of the Chantrey Bequest 1905

Dalí understood this tendentious binary very well, and his *Minotaure* article deconstructs it most powerfully, when he contrasts the 'inedible' apples of Cézanne with the exaggerated Adam's apples of the androgynous Rossettian female figures – a brilliant verbal play that upsets all our received ideas.[30] Twenty years later, the American art historian Robert Rosenblum also understood the binary, and was able to subject it to a probing critique in a notice for the *Partisan Review* of an exhibition on the past 150 years of British art, held – in another shock to our received ideas – at the Museum of Modern Art, New York, in 1957 at the height of Abstract Expressionism. Under the title 'British Painting vs. Paris' Rosenblum writes:

> The Museum, to be sure, has occasionally ventured into pre-Cézannesque territory in order to make a point about the ancestry of a contemporary attitude, but here were pictures which controverted, in part or in full, the very premises of the twentieth-century galleries below.[31]

It is the Pre-Raphaelites, above all, who challenge viewers' preconceptions:

With only seven canvases, they assaulted contemporary attitudes and visual sensibilities with unparalleled violence and, as such, comprised the major revelation of the show. It was no accident that their gallery was invariably more crowded than the others. This was not only a question of the close scrutiny their work demanded … It was rather that by flagrantly and passionately denying every premise of the twentieth-century aesthetic, the Pre-Raphaelites provoked spectators into looking and thinking.

For Rosenblum in 1957, then, the Pre-Raphaelites have become avant-garde *again*, as a challenge to the standard orthodoxies of MoMA and Francocentric modernism. At the same time they are open to new interpretation in the light of more recent artistic developments. Rosenblum gives a bravura account of Hunt's *Awakening Conscience* (no.98):

> Most paradoxically, the incredibly crowded two-dimensional pattern, which offered a multiplicity of pictorial incident rarely equaled in the history of art, could even begin to provide those values of a labyrinthine, over-all surface activity which the investigations of a Tobey or a Pollock have taught us to enjoy.[32]

Rosenblum's article shows that the art of the Pre-Raphaelites was as challenging and difficult in the New York of 1957 as it had been in the London of 1849. Whether or not the 'wet white ground' was actually employed, the vivid colour and superreal detail of the paintings still appear as startling as when they were new; they can give today's viewer some sense of the excitement of van Eyck's *Arnolfini Portrait*, when it entered the National Gallery in 1842. A crucial part of the Pre-Raphaelite legacy, indeed, is the revaluation of the art of the past implicit in its revivalist project. If we now take it for granted that the Netherlandish and Italian painters of the centuries before 1500 deserve a place in the history of art, that is in part because the Pre-Raphaelite painters demonstrated their aesthetic merit.

Perhaps, then, those ubiquitous anecdotes, so reminiscent of the ones in Vasari, should not be despised or discredited. Whether they are true or not, they are signs that the Pre-Raphaelites, like Vasari's artists, have become old masters, of a kind. Of a kind, for they may still be controversial: unlike so much of the art of twentieth-century modernism, they still do not look at home in the boardroom. They have not been tamed or made into comfortable viewing, and arguably *The Awakening Conscience* retains the avant-garde shock value that a Courbet or a Jackson Pollock lost long ago. Perhaps it is that stubborn refusal to be assimilated into the modernist mainstream that accounts for the vexations and contradictions of the Pre-Raphaelite legacy, as well as its sheer persistence.

NOTES

VICTORIAN AVANT-GARDE (pp.9–17)

1 This interpretation was hinted at in the introduction to the catalogue of the previous extensive Pre-Raphaelite survey exhibition of this kind, at the Tate Gallery in 1984; see Parris 1984. Elizabeth Prettejohn fully enunciated the claim in her magisterial *Art of the Pre-Raphaelites* (London and Princeton 2000), which explored the comparison between English and French avant-gardes. Her essay here expands on this theme (see pp.231–6).

2 Classic discussions of the term 'avant-garde' include Renato Poggioli, *The Theory of the Avant-Garde*, trans. Gerald Fitzgerald, Cambridge, MA 1981, and Peter Bürger, *Theory of the Avant-Garde*, trans. Michael Shaw, Minneapolis 1984. The long and complex history of the term incorporates both artistic and political meanings. For a useful introduction to the French context for the term see Linda Nochlin, 'The Invention of the Avant-Garde', in *The Politics of Vision: Essays on Nineteenth-Century Art and Society*, New York 1989, pp.1–19. For a discussion of the legacy of these ideas in England see Michael T. Saler, 'Modernism, the avant-garde and England', in *The Avant-Garde in Interwar England*, Oxford 1999, pp.4–24.

3 See Prettejohn 2000, pp.63–5.

4 Ernst Gombrich, 'Style', 1968, reprinted in Donald Preziosi (ed.), *The Art of Art History: A Critical Anthology*, Oxford 1998, p.160.

5 Carlyle 1912.

6 John Ruskin, 'The Nature of Gothic', *The Stones of Venice*, in Ruskin 1903–12, X, pp.180–269.

7 Nos.26–7 exhibited in London only.

8 John Ruskin, letter to *The Times*, 25 May 1854, Ruskin 1903–12, XII, p.334.

9 [Frank Stone], 'Royal Academy Exhibition Notice', *Athenaeum*, no.1179 (1 June 1850), p.591. See Jorge L. Contreras, 'Frank Stone and the Pre-Raphaelite Brotherhood', *The Victorian Web*, http://www.victorianweb.org/art/illustration/fstone/contreras1.html.

10 Charles Dickens, 'Old Lamps for New Ones', *Household Words*, vol.1, no.12 (15 June 1850), pp.265–6.

11 See Michaela Giebelhausen's excellent *Painting the Bible: Representation and Belief in Mid-Victorian Britain*, Aldershot 2006, especially pp.111–26; and also Éva Péteri, *Victorian Approaches to Religion as Reflected in the Art of the Pre-Raphaelites*, Budapest 2003.

12 Ruskin 1903–12, XII, p.330.

13 On prostitution and 'deviance' see Nead 1988.

14 On the links between empire and 'ethnology' in Victorian Britain, see George W. Stocking, Jr., *Victorian Anthropology*, New York 1987.

15 *Athenaeum*, 21 April 1860. See Mary Bennett, *William Holman Hunt*, Liverpool 1969, p.40, and Michaela Giebelhausen, 'Academic Orthodoxy versus Pre-Raphaelite Heresy: Debating Religious Painting at the Royal Academy', in Colin Trodd and Rafael Cardoso Denis (eds.), *Art and the Academy in the Nineteenth Century*, Manchester 2000, pp.164–78.

16 Carlyle 1912, p.189.

17 Rosenfeld 2000.

18 See the drawing by Dante Gabriel Rossetti, *Caricature of John Everett Millais*, 1851–3, Birmingham Museums and Art Gallery, in which Millais is given a speech bubble with the word 'Slosh!'.

19 Sources including engravings by Lasinio after Italian frescoes, contemporary German engravings by Moritz Retzsch (which themselves echoed the style of Northern Renaissance woodcuts) and, surprisingly, the classical outline drawings of John Flaxman. For an excellent study of Pre-Raphaelite drawing see Cruise 2011, especially 'The Outline Style', pp.47–57.

20 See Marsh 1991. In this publication we have chosen to use the original form of her name, 'Siddall'. Her reasons for changing the name to 'Siddal' in 1853 are unknown; some speculate that this 'seems to indicate a new consciousness of artistic identity' (Marsh 1991, p.19), but there is good reason to believe that 'the final "l" in her surname was discarded to please Rossetti' (Virginia Surtees, 'Siddal, Elizabeth Eleanor (1829–1862)', *Oxford Dictionary of National Biography*, Oxford 2004). Speculative, but replete with new material on the artist, is Hawksley 2006.

21 May Morris, *Decorative Needlework*, London 1893.

22 Anne Drewery, Juliana Moore and Christopher Whittick, 'Representing Fanny Cornforth: The makings of an historical identity', *British Art Journal*, 2.3, Spring/Summer 2001, pp.3–15; and Kirsty Stonnell Walker's extensive but speculative *Stunner: The Rise and Fall of Fanny Cornforth*, Raleigh, NC 2006.

23 Malcolm Warner, 'Millais in Reproduction', in Giebelhausen & Barringer 2009, pp.218–19.

24 Carlyle 1912, p.261.

25 Stephens 1860, p.56, quoted in Dianne Sachko Macleod, *Art and the Victorian Middle Class: Money and the Making of Cultural Identity*, Cambridge 1996, p.159.

26 Thomas Plint to Ford Madox Brown,

17 November 1856, quoted in Barringer 2005, p.65.

27 John Foster, *Class Struggle and the Industrial Revolution: Early Industrial Capitalism in Three English Towns*, London 1974, 227. See Barringer 2005, ch.3.

28 Ford Madox Brown, 'The Exhibition of Work', in Bendiner 1998, p.153.

29 See Linda S. Ferber and William H. Gerdts, *The New Path: Ruskin and the American Pre-Raphaelites*, Brooklyn, NY 1985, which includes Susan Casteras's study, 'The 1857–58 Exhibition of English Art in America and Critical Responses to Pre-Raphaelitism', pp.109–33.

30 For Central Europe see Thomas J. Tobin (ed.), *Worldwide Pre-Raphaelitism*, Albany, NY 2005. For Poland and Pre-Raphaelitism see Smith 2009.

31 Letter to William Bell Scott dated 14 April [1856], Roger W. Peattie (ed.), *Selected Letters of William Michael Rossetti*, University Park, PA, and London 1990, p.65.

32 William Holman Hunt to Thomas Combe, 12 February 1860, quoted Surtees 1971, p.69.

33 See 'Introduction', Giebelhausen & Barringer 2009, pp.1–16.

34 Dated Draycott Lodge Fulham / March 28th 1895, Millais Papers, Morgan Library, New York, MA.1485, K.415.

35 See Deborah Cherry, 'In a Word: Pre-Raphaelite, Pre-Raphaelites, Pre-Raphaelitism', in Giebelhausen & Barringer 2009, pp.17–51.

36 See Institute of Contemporary Arts, *William Morris Today*, London 1984. The exhibition ran from 1 March to 29 April, and the Tate's *Pre-Raphaelites* show was on view from 7 March to 28 May.

37 Cherry & Pollock 1984b; see also Cherry & Pollock 1984a.

38 Pointon 1989.

MEDIUM AND METHOD IN PRE-RAPHAELITE PAINTING (pp.18–23)

1 Charles Lock Eastlake, *Goethe's Theory of Colours; Translated from the German*, London 1840.

2 John Gage, *George Field and his Circle: From Romanticism to the Pre-Raphaelite Brotherhood*, exh. cat., Fitzwilliam Museum, Cambridge 1989, p.213; Mary Philadephia Merrifield (trans.), *A Treatise on Painting, Written by Cennino Cennini in the Year 1437 …*, London 1844, and *Original treatises, dating from the XIIth to XVIIIth centuries, on the arts

of painting in oil, miniature, mosaic, and on glass; of gilding, dyeing, and the preparation of colours and artificial gems; preceded by a general introd., with translations, prefaces, and notes*, London 1849.

3 Rossetti 1895, I, pp.142–3.

4 Townsend et al. 2004, p.57; Hunt 1905, II, p.276.

5 Townsend et al. 2004, Appendix. When they first used zinc white, the Pre-Raphaelites would not have known that it would take on the same appearance as lead white within a few years.

6 Hueffer 1896, p.77.

7 Joyce Townsend and Jacqueline Ridge, 'Tate Conservation Record', 29 July 2003.

8 Information provided by Joyce Townsend.

9 Hunt 1875, p.46.

10 Hunt 1905, I, pp.276–7.

11 Surtees 1981, p.76 (diary entry, 16 Aug. 1854).

12 Chevreul's *Principles of Harmony and Contrast of Colours* was first published in English in 1854 and discussed by John Sweetlove in 'The Natural Philosophy of Art', *Art Journal*, January 1852, p.7. The detail of the mouth is reproduced in Townsend et al. 2004, p. 130.

13 William Holman Hunt, 'The Present System of Obtaining Materials in the use by Artist Painters as Compared with that of the Old Masters', *Journal of the Society of Arts*, 23 April 1880, pp.485–99.

14 Jacobi 2006, p.130; Hunt 1875, p.45.

15 Diary entry, 11 Feb. 1868, quoted Melissa R. Katz, 'Holman Hunt on Himself: Textual Evidence in Aid of Textual Analysis', in Erma Hermens (ed.), *In Looking through Paintings – The Study of Painting Techniques and Materials in Support of Art Historical Research*, Leiden 1998, pp.415–44: p.436.

16 Tate Gallery, 'Conservation Report', Oct. 1993.

17 Natasha Walker, 'Tate Condition Report', May 2012; Morgan Library, Millais Papers, MA.1485, K.415, Hunt to Millais, dated 'March 28th 1895'.

18 Robertson 1931, p.87 (the painting described was possibly the artist's *Vision of Fiammetta*, no.167).

19 Ruskin, Lecture 2: 'Mythic Schools of Painting: E. Burne-Jones & G.F. Watts', *The Art of England* (1883), in Ruskin 1903–12, XXXIII, p.301.

20 I am grateful to Annika Erikson for this information.

21 Martin Hardie, *Watercolour Painting in Britain: The Victorian Period*, London 1968, pp.117–18.

22 Robertson 1931, p.83.

23 Robertson 1931, p.82.

1 . ORIGINS (pp.24–35)

1 See Malcolm Chase, *Chartism: A New History*, Manchester 2007, for a recent account of the Chartist movement.
2 Hunt 1905, I, pp.130–1.
3 John Ruskin, *Stones of Venice*, vol.2, in Ruskin 1903–12, X, p.193.
4 The National Gallery was founded in 1823 and moved into the building designed by William Wilkins in 1838. See Saumarez Smith 2009, pp.43–50.
5 See Tim Barringer, 'Ford Madox Brown', in E. Prettejohn (ed.), *The Cambridge Companion to the Pre-Raphaelites*, Cambridge, forthcoming 2013.
6 On the Nazarenes see Grewe 2009.
7 Grewe 2009, 20.
8 Hunt 1905, I, pp.50, 316.
9 Ruskin 1903–12, XV, p.223.
10 Irene Langridge, *William Blake: A Study of His Life and Work*, London 1904, p.157.
11 See Browne 2010, App.II.
12 Alexander Gilchrist, *Life of William Blake*, 2 vols., London 1863, I, p.379.
13 Charles West Cope, *Reminiscences of Charles West Cope*, London 1891, p.167, quoted Babington et al. 2009, p.98.
14 F.G. Stephens, 'Thomas Woolner RA', *Art Journal*, March 1894, pp.80–6, esp. p.82.
15 Amy Woolner, *Thomas Woolner RA, Sculptor and Poet: His Life in Letters*, London 1917, p.7.
16 Charles Darwin, *The Descent of Man*, 2 vols., London 1871, I, p.22.
17 William Vaughan, *German Romanticism and English Art*, London 1979, p.189.
18 George Dunlop Leslie, *The Inner Life of the Royal Academy*, London 1914, p.176.
19 Nicholas Wiseman, 'Art.X. – 1. *Sketches of the History of Christian Art*, by Lord Lindsay', *Dublin Review*, no.22, 1847, p.505, quoted Giebelhausen 2006, pp.6–7.
20 Quoted Giebelhausen 2006, p.64.
21 For a full and stimulating discussion see Wright 2007.
22 Thomas Babington Macaulay, *The History of England from the Accession of James the Second*, 5 vols., London 1849–61, vol.1, pp.13–14, quoted Wright 2007.
23 David Hume, *History of England: From the Invasion of Julius Caesar to the Revolution in 1688* (1778), London 1823, I, p.61.
24 Bennett 2010, I, p.26.
25 Sir James Mackintosh, William Wallace and Robert Bell, *The History of England*, London 1830, vol.1, pp.285–314.
26 Surtees 1981, p.1. The diary entry was written retrospectively on 4 September 1847.
27 Ford Madox Brown, *The Exhibition of WORK and Other Paintings by Ford Madox Brown at the Gallery, 191 Piccadilly*, London 1865, quoted Bendiner 1998, pp.132–3.
28 Rossetti, au fait with the latest literary trends, argued – 'growing quite warm' with anger (Hunt 1905, I, p.126) – that Pope and Burns were now deemed old-fashioned and that Shelley and Keats, key Romantic figures, should replace them. Brown stuck to 'my never-faithless Burns, Byron, Spencer

and Shakespear' (Surtees 1981, p.2). See also Bendiner 1998, p.132.
29 Hunt 1905, I, p.126.
30 Bendiner 1998, p.32.
31 William Michael Rossetti, 'The Royal Academy', *Spectator*, 10 May 1851, p.452, quoted Bennett 2010, I, p.56.
32 Bendiner 1998, p.132: my italics.
33 *People's Journal*, 1848, p.71, reviewing the Open Exhibition, 1848, quoted Bennett 2010, I, p.94.
34 John Lingard, *The History of England*, London 1823, vol.4, p.267.
35 Arthur C. Lane, *Illustrated Notes on English Church History* (1886), London 1890, vol.1, p.236.
36 *Foxe's Book of Martyrs*, edited and abridged by G.A. Williamson, Boston 1965, p.1. The full title of the work was *Acts and Monuments of matters most Special and Memorable happening in the Church, especially in the Realm of England*. Brown would have had easy access to any number of editions of this ubiquitous Protestant text and could have consulted early editions of it in the library of the British Museum on the many visits he made to research costume and furniture for this painting.
37 David Meara, 'The Catholic Context', in Paul Atterbury (ed.), *Pugin: Master of the Gothic Revival*, New Haven 1996, pp.45–62.
38 *Athenaeum*, 9 Sept. 1848, p.11.
39 Bendiner 1998, p.133.
40 Ibid. The portrait in question appears in a manuscript by Thomas Hoccleve, 'The Regiment of Princes' (1412), British Library, Harley 4866, f.88. See Jeanne E. Krochalis, 'Hoccleve's Chaucer Portrait', *The Chaucer Review*, vol.21, no.2, Fall 1986, pp.234–45.
41 Surtees 1981, p.35.
42 *Art Union*, May 1848, p.144.
43 Surtees 1981, p.125.

2 . MANIFESTO (pp.36–51)

1 Rosenfeld 2000.
2 Prettejohn 2000, esp. pp.23–45 and 63–5.
3 See Werner 2005, esp. pp.58–73; also Cherry & Pollock 1984b, pp.480–95, for a denial of an avant-garde status.
4 Fredeman 1975.
5 http://www.leicestergalleries.com/19th-20th-century-paintings/d/james-collinson/12714. On Collinson see Ronald Parkinson, 'James Collinson', in Parris 1984, pp.61–75.
6 William M. Rossetti, 'The Pre-Raphaelite Brotherhood', *The Magazine of Art*, 1881, p.436.
7 A.B.R. [Angus B. Reach], 'Town Talk and Table Talk', *Illustrated London News*, no.16 (4 May 1850), p.306.
8 Warner 1992.
9 Ruskin 1851.
10 Ruskin 1851.
11 Christina Rossetti, 'No Thank You, John', in Christina Rossetti, *Goblin Market and Other Poems*, Teddington 2007, 52.
12 See Payne & Brett 2010, p.43.
13 *The Times*, 14 Sept. 1839, quoted R. Derek Wood, 'Ste Croix in London, 1839', *History of Photography*, Spring 1993, no.17, p.101.

14 For further discussion and references see Waggoner 2010.
15 See Saumarez Smith 2009, pp.31–8.
16 Hunt 1905, I, p.208.
17 William Dyce, *The Order of Daily Service, the Litany, and Order of the Administration of the Holy Communion, with Plain-tune*, London 1843.
18 Edward William Cox, *The Critic*, no.9, 15 Feb. and 1 June 1850, quoted David Peters Corbett, '"A Soul of the Age": Rossetti's Words and Images, 1848–73', in Giebelhausen & Barringer 2009, p.81.
19 It is available in modern paperback editions and on line at www.rossettiarchive.org/docs/ap4.g415.1.1.rad.html.
20 See Parris 1984, pp.64–5; Barringer 1998, pp.7–8; Prettejohn 1997, pp.12–14; Treuherz et al. 2003, pp.146–7; Townsend et al. 2004, pp.79–84.
21 The present frame dates to 1864 and incorporates both pieces of verse. Townsend et al. 2004, p.195.
22 'The Free Exhibition of Modern Art', *The Literary Gazette and Journal of the Belles Lettres*, 31 March 1849, p.239: www.engl.duq.edu/servus/PR_Critic/LG31mar49.html
23 Bronkhurst 2006, I, pp.131–3, and II, pp.17–21.
24 Fredeman 1975, App. 2, pp.106–7, and Hunt 1905, I, pp.157–60.
25 The National Gallery's version of Uccello's *Battle of San Romano* (1438–40) was bought in 1857 from the Lombardi-Baldi collection, and his *Hunt in a Forest* (c.1470) at the Ashmolean Museum was in the Fox-Strangways collection and accessioned in 1850.
26 See Sotheby's, *The Eye of a Collector: Works from the Collection of Stanley J. Seeger*, London 2001, p.70; Bronkhurst 2006, I, pp.39, 131, and II, p.20. This is the second time *Rienzi* has been on public display since 1972.
27 See Rosenfeld 2012, pp.30–6; Rosenfeld & Smith 2007, p.34; Townsend et al. 2004, pp.84–7.
28 'The Royal Academy. The Eighty-First Exhibition – 1849', *Art Journal*, 1 June 1849, p.171.
29 Hunt 1905, I, p.178.
30 Dillian Gordon, *The Fifteenth Century Italian Paintings*, London 2003, vol.1, pp.xxviii, 162–87; Francis Haskell, 'William Coningham and His Collection of Old Masters', *Burlington Magazine*, vol.133, no.1063 (Oct. 1991), pp.676–81; Warner 1992.
31 See Rossetti 1895, vol.1, p.121.
32 For this drawing see Warner 1979, pp.20–1; Warner's entry in Parris 1984, p.247; Robert Upstone, *The Pre-Raphaelite Dream: Paintings and Drawings from the Tate Collection*, London 2003, pp.36–7; Rosenfeld 2012, pp.28–30; Rosenfeld & Smith 2007, p.39.
33 Rosenfeld & Smith 2007, p.60; Rosenfeld 2012, pp.39–41.
34 David A. Wooters, 'Daguerreotype Portraits by William E. Kilburn', *Image*, no.33 (Fall 1990), pp.21–9.

3 . HISTORY (pp.52–85)

1 'Fine Arts. Royal Academy', *Guardian*, Supplement 6 (14 May 1851), p.354.
2 Ruskin 1851, p.8.
3 Hawksley 2006, pp.40–1.
4 John Ruskin, *Stones of Venice*, vol.2, in Ruskin 1903–12, X, pp.193–4.
5 Literary Gazette, 4 May 1850, p.312.
6 Treuherz 1984, p.162.
7 See Rosenfeld 2012, pp.36–9; Rosenfeld & Smith 2007, p.40; Parris 1984, pp.74–5.
8 [William Michael Rossetti] 'Art. The Royal Academy. [Fourth Notice.]', *The Critic*, no.9 (15 July 1850), p.360.
9 Bronkhurst 2006, I, pp.143–6; Parris 1984, pp.90–2.
10 Hawksley 2006, pp.40–1.
11 Bronkhurst 2006, I, pp.24–9, 146; Townsend et al. 2004, pp.112–18.
12 Ruskin 1851.
13 Gail S. Weinberg, '"An Irish Maniac": Ruskin, Rossetti, and Francis McCracken', *Burlington Magazine*, vol.143, no.1181 (Aug. 2001), pp.491–3.
14 Rosenfeld 2012, pp.56–9; Rosenfeld & Smith 2007, p.52; Prettejohn 2000, pp.11–13; Townsend et al. 2004, pp.118–20.
15 Leslie Carlyle, 'Contemporary Painting Materials', in Townsend et al. 2004, pp.39–49.
16 Ruskin 1851.
17 See Rosenfeld 2012, pp.116–18; Parris 1984, pp.89–90.
18 Bronkhurst 2006, I, pp.140–2; Townsend et al. 2004, pp.108–11.
19 Rosenfeld 2012, p.68; Rosenfeld & Smith 2007, p.94; Parris 1984, pp.98–9.
20 See Hunt 1905, I, pp.284–6, 289–93; and Malcolm Warner, 'Notes on Millais' Use of Subjects from the Opera, 1851–4', *The Pre-Raphaelite Review*, no. 2 (May 1979), pp.73–6.
21 Now at Wallington, Northumberland, National Trust: nationaltrustimages.org.uk/image/158745. See Parris 1984, p.102, for details of studies and related works; also Read & Barnes 1991, pp.111–12; Colin Harrison and Christopher Newall, *The Pre-Raphaelites and Italy*, Oxford 2010, p.46.
22 Dante Alighieri, *Inferno*, canto v. This may have been translated by Munro, perhaps with Rossetti's assistance, as it is in part close to his later translation of 1862. See Paget Toynbee, 'Dante in English Art: A Chronological Record of Representations by English Artists …', *Annual Report of the Dante Society*, no.38, Boston 1921, p.50 (via googlebooks).
23 Macdonald 1991.
24 In the plaster model she is less reactive to his advance – her head remains erect and chin lifted, as she turns slightly. Both are inscribed 'Quel giorno più non vi leggemmo avante'.
25 See Browne 2010, pp.26–7 and illustration 15v on p.62.
26 Parris 1984, p.278.
27 A charge Edmund About levelled at Hunt's pictures when they were exhibited in Paris; see William Hauptman, 'The Pre-Raphaelites, Modernism, and Fin-de-Siècle France', in *Twenty-First-Century Perspectives on Nineteenth-Century Art: Essays in Honor of Gabriel P. Weisberg*, ed. Petra ten-Doesschate Chu and Laurinda S. Dixon,

Cranbury, NJ 2009, pp.249 and 253 n. 7.

28 Lutyens 1967, pp.37–9.

29 James Logan and Robert Ronald McIan, *The clans of the Scottish Highland, illustrated by appropriate figures, displaying their dress, tartans, arms, armorial insignia, and social occupations, from original sketches*, London 1845–7. Arthur Hughes recalled Millais seeking out this book. See Malcolm Warner, 'The Order of Release', in Parris 1984, p.108.

30 *Illustrated London News*, 7 May 1853. See Malcolm Warner, 'The Order of Release', in Parris 1984, p.109.

31 Hubert Wellington (ed.), *The Journal of Eugène Delacroix*, trans. Lucy Norton, Ithaca 1980, p.280. See Rosenfeld & Smith 2007, 76.

32 Read & Barnes 1991, p.106.

33 Fredeman 1975, p.107.

34 Parris 1984, pp.136–7.

35 'Fine Arts: Royal Academy', *Athenaeum*, 10 May 1856, pp.589–90.

36 'Exhibition of the Royal Academy – Private View', *The Times*, 3 May 1856, pp.9–10.

37 Virginia Surtees, *Sublime & Instructive: Letters from John Ruskin to Louisa, Marchioness of Waterford, Anna Blunden and Ellen Heaton*, London 1972, 177.

38 Ruskin 1903–12, XIV, p.60.

39 Banham & Harris 1984, p.100.

40 See Treuherz 1984.

41 Thomas Percy, *Percy's Reliques of Ancient Poetry* (London 1765), 2 vols. London 1906, vol.2, p.336.

42 Jan Marsh, *Dante Gabriel Rossetti: Painter and Poet*, London 2005, p.184.

43 Ailettes protected the shoulder in armour made between about 1290 and 1325. Square or oblong pieces of leather or wood, they were fixed to the shoulders with silk or leather cords and decorated with heraldic designs.

44 Prettejohn 2007, p.23. See also James Byam Shaw, *Paintings by Old Masters at Christ Church, Oxford*, London 1967, pp.31–2. The work was given to the college in 1828.

45 See Jan Marsh, *The Legend of Elizabeth Siddal*, London 2010; Hawksley 2006; Marsh 1991; Prettejohn 2000, ch. 2.

46 Cruise 2011, p.136.

47 Cruise 2011, p.138; Marsh 1991.

48 Parris 1984, p.266; Prettejohn 2000, pp.223–31.

49 Prettejohn 2000, pp.74–7; Marsh & Nunn 1997, p.116; Parris 1984, p.283.

50 Prettejohn 2000, pp.102–5.

51 Wilton & Upstone 1997, p.124.

52 Lethaby 1935, p.34.

53 Parry 1996a, p.102.

54 Lethaby 1935, p.34.

55 See Jan Marsh, 'La Belle Iseult', *Journal of the William Morris Society*, vol.XIX, no.2, Summer 2011, pp.9–19.

56 Fredeman 2002–10, I, letter no.74, p.86.

57 Kirkham 1981, p.27.

58 Allison Stielau, 'Habits of Encounter: The Prioress's Tale Cabinet', MA thesis, Bard Graduate Center for Studies in the Decorative Arts, Design and Culture, Bard College, Annandale-on-Hudson, NY 2009, pp.59–60.

59 Alistair Grieve, *The Art of Dante Gabriel Rossetti: The Decade 1848–1858*, Norwich 2010, p.465.

60 Morris 1973, II, p.402.

61 Cherry 1980, p.242.

62 *Fortnightly Review*, 1868, p.25.

63 Quoted Kirkham 1981, p.26.

64 The settle is still *in situ* at Red House today.

65 Dante Gabriel Rossetti to Ford Madox Brown, 22 June 1859, Fredeman 2002–10, II, p.259.

66 Katharine A. Lochnan et al. (eds.), *The Earthly Paradise Arts and Crafts by William Morris and his Circle from Canadian Collections*, exh. cat., Art Gallery of Ontario, Toronto 1993, pp.104–7.

67 Dante Gabriel Rossetti to William Bell Scott, 7 Dec. 1860, Fredeman 2002–10, II, p.335.

68 William Michael Rossetti, 'Notes on Rossetti and His Works', *Art Journal*, 1884, p.167.

69 Dante Gabriel Rossetti to Ernest Gambart, 8 Aug. 1863, Fredeman 2002–10, III, pp.72–3.

70 Catherine King, 'Claxton, Florence (Anne)', *Dictionary of Women Artists*, ed. Delia Gaze, London and Chicago 1997, vol.1, pp.404–6.

71 Deborah Cherry, *Beyond the Frame: Feminism and Visual Culture, Britain 1850–1900*, London and New York 2000, pp.37–40.

72 William E. Fredeman, 'Pre-Raphaelites in Caricature: *The Choice of Paris: An Idyll* by Florence Claxton', *Burlington Magazine*, vol.102, no.693 (Dec. 1960), pp.523–9.

73 Walter Scott, *Anne of Geierstein: or, The Maiden of the Mist*, Edinburgh 1829. The novel makes no mention of King René's honeymoon, as the king is eighty years old at the time of the action, but his lavish patronage of the arts is an important theme.

74 *Century Guild Hobby Horse*, Oct. 1888, quoted Vallance 1897, p.61.

75 *Building News*, 1862, quoted Bennett 2010, II, p.453.

76 Vallance 1897, p.65.

77 Ibid.

78 Parry 1996a, p.123.

79 Treuherz et al. 2003, p.177.

4. NATURE (pp.86–113)

1 For substantial studies on the subject see Rosenfeld 1999, Prettejohn 2000, esp. ch.5, Staley 2001 and Staley & Newall 2004.

2 Prettejohn 2000, p.171.

3 For studies of materials see pp.18–23 and Townsend et al. 2004.

4 From *Modern Painters*, vol.1, 1843, quoted Barringer 1998, p.60.

5 Ruskin 1851.

6 'Style is imbedded in process. That's where the rubber meets the road in painting.' Quote from Chuck Close in *Picasso and Braque Go to the Movies*, dir. Arne Glimcher, Cubists, USA 2008.

7 This was only partly offset by pale hand coloration of prints. For more on the interconnections between Pre-Raphaelitsm and photography see Tim Barringer, 'An Antidote to Mechanical Poison: John Ruskin, Photography, and Early Pre-Raphaelite Painting', in Waggoner 2010, pp.18–31.

8 'Fine Arts. Royal Academy', *Guardian*, Supplement 6 (14 May 1851), p.355.

9 'French Criticism on British Art. M. Maxime du Camp', *Art Journal*, no.18, 1 March 1856, pp.77–9.

10 *Illustrated London News*, 22 May 1852, p.407.

11 See Rosenfeld 1999, pp.273–9, and Prettejohn 2000, p.252.

12 Joanna Barnes and Alexander Kader, 'The Sculpture of John Lucas Tupper: "The Extremest Edge of P.R.Bism"', in Read & Barnes 1991, pp.66–70.

13 Ruskin 1903–12, I, p.126.

14 'Herne Hill Almond Blossoms', *Praeterita*, Ruskin 1903–12, XXXV, pp.34–50.

15 Ruskin 1903–12, VI, pp.300–1.

16 See Michael Harvey, 'Ruskin and Photography', *Oxford Art Journal*, vol. 7, no.2, 1984, pp.25–33. Hobbs was often called George to distinguish him from the two Ruskins, father and son.

17 Ruskin 1903–12, XXXVI, p.39.

18 John Ruskin, *Pre-Raphaelitism*, in Ruskin 1903–12, XII, p.157.

19 Scott 1892, I, p.251.

20 See Roger Taylor, *Impressed by Light: British Photographs from Paper Negatives, 1840–1860*, exh. cat., Metropolitan Museum of Art, New York 2007, for a history of the use of the salted paper print from paper negatives and the impact that Talbot's patents had on its adoption.

21 See Waggoner 2010 for further information on the connections between the Pre-Raphaelites and photography.

22 Parris 1984, pp.86–7; Robert M. Polhemus, 'John Millais's Children: Faith and Erotics: *The Woodman's Daughter* (1851)', in Carol T. Christ and John O. Jordan (eds.), *Victorian Literature and the Victorian Visual Imagination*, Berkeley, CA 1995, pp.289–312; Rosenfeld & Smith 2007, pp.48, 50; Rosenfeld 2012, pp.54–6.

23 Staley 2001, p.15.

24 Fredeman 1975, p.244.

25 'Fine Arts. Royal Academy', *Guardian*, Supplement 6 (14 May 1851), p.354.

26 Treuherz 2011, pp.162–3; Bennett 2010, I, pp.121–5; Townsend et al. 2004, pp.128–33; Rosenfeld 1999, pp.147–55; Parris 1984, pp.93–4.

27 Quoted Bennett 2010, I, p.123.

28 [F.M. Brown] *Mr. Madox Brown's Exhibition*, London 1865, p.7.

29 See Rosenfeld 1999, pp.69–124. Also Staley & Newall 2004, p.69; Staley 2001, pp.106–8.

30 *Art Journal*, no.4, June 1852, p.166.

31 Ian Whyte, 'Wild, Barren and Frightful' – Parliamentary Enclosure in an Upland County: Westmorland 1767–1890', *Rural History*, no.14 (2003), pp.21–38.

32 Rosenfeld 1999, pp.72–3.

33 Parris 1984, pp.96–8; Warner 1997, pp.68–70; Staley 2001, pp.23–9, 27–9; Staley & Newall 2004, pp.33–4; Barlow 2005, pp. 32–9; Rosenfeld & Smith 2007, p.68; Rosenfeld 2012, pp.63–8.

34 See the exhibition *Me, Ophelia* that accompanied the *Millais* retrospective at the Van Gogh Museum, Amsterdam: Katja Rodenburg, *ik, Ophelia*, Harderwijk 2008.

35 'Art and the Royal Academy', *Fraser's Magazine*, no.46 (Aug. 1852), p.234.

36 See Rosenfeld 1999, pp.172–208.

37 See Rosenfeld 1999, pp.124–47; Barbara C.L. Webb, *Millais and the Hogsmill River*, New Malden, Surrey 1997.

38 Payne & Brett 2010, p.51; Townsend et al. 2004, pp.134–8.

39 Bronkhurst 2006, I, pp.147–50; Parris 1984, pp.94–5; Townsend et al. 2004, pp.139–42.

40 'Notes on the Construction of Sheepfolds', Ruskin 1903–12, XII, pp.509–12.

41 Payne & Brett 2010, p.47.

42 *Athenaeum*, 22 May 1852, p.581.

43 Bronkhurst 2006, I, p.147.

44 Bronkhurst 2006, I, pp.147–9.

45 Bronkhurst 2006, II, p.300.

46 The present frame, however, may not be original. See Townsend et al. 2004, p.138.

47 On Broderip and Maud see Rosenfeld 1999, pp.200–3.

48 Bronkhurst 2006, I, pp.156–8; Parris 1984, pp.106–8; Townsend et al. 2004, pp.157–60.

49 The Tunbridge Wells-to-Hastings railway had opened on 1 February 1852, thus providing easy access to the expanding town and coastal resort, then fourth largest in the nation. John K. Walton, *The English Seaside Resort: A Social History 1750–1914*, Leicester 1983, pp.53, 58.

50 Allingham & Williams 1911, p.225.

51 Letter of 6 July 1853: Lutyens 1967, p.60.

52 For a fuller discussion, see Tim Barringer, 'An Antidote to Mechanical Poison: Ruskin, Photography and Early Pre-Raphaelite Painting', in Waggoner 2010, pp.18–31.

53 Lutyens 1967, p.150. See also Jason Rosenfeld, catalogue entry for *John Ruskin*, in Rosenfeld & Smith 2007, p.75.

54 Lutyens 1967, p.150.

55 Treuherz 2011, pp.164–5; Bennett 2010, I, pp.160–2; Staley & Newall 2004, pp.70–1; Alastair Ian Wright, 'Suburban Prospects: Vision and Possession in Ford Madox Brown's *An English Autumn Afternoon*', in Watson 1997, pp.185–97.

56 Surtees 1981, p.144.

57 Quoted Bronkhurst 2006, I, p.162.

58 See Bennett's entry on this picture and the labour involved in its creation: Bennett 2010, I, pp.181–2; Treuherz 2011, p.170.

59 Newall 1993, pp.8, 51–2.

60 Newall 1993, p.50.

61 See Newall 1993, pp.13–15.

62 Payne & Brett 2010, chs.2 and 3.

63 See Parris 1984, pp.147, 174–5; Staley & Newall 2004, pp. 138–42, 152–3; Payne & Brett 2010, chs.3 and 4.

64 Payne & Brett 2010, pp.39–40, 47.

65 Quoted Payne & Brett 2010, pp.45 and 190–1 for his lengthy review of *Val d'Aosta*.

66 Christopher Newall, '"Val d'Aosta": John Brett and John Ruskin in the Alps, 1858', *Burlington Magazine*, vol.149, no.1248 (March 2007), pp.165–72.

67 Although the use of fugitive yellow may have caused the furthest-right trees to turn bluish. Payne & Brett 2010, pp.48, 51.

68 Parris 1984, pp.183–4; Staley & Newall 2004, p.186; Payne & Brett 2010, pp.54–6, 59–63.

69 Payne & Brett 2010, pp.26, 30.

70 Payne & Brett 2010, p.59.
71 Quoted Payne & Brett 2010, p.60.
72 Quoted Payne & Brett 2010, p.26.
73 Marsh & Nunn 1997, p.106.
74 Timothy Hilton, *The Pre-Raphaelites*, London 1970, p.136; Michael Bartram, *The Pre-Raphaelite Camera: Aspects of Victorian Photography*, London 1985, p.62.
75 Listed in Pamela Gerrish Nunn, 'Rosa Brett, Pre-Raphaelite', *Burlington Magazine*, vol.126, no.979 (Oct. 1984), pp.630–4, esp. p.634.
76 *Athenaeum*, 1 June 1867, p.732.
77 Parris 1984, pp.134–6; Warner 1997, pp.71–2; Rosenfeld & Smith 2007, p.102; Rosenfeld 2012, pp.86–8.
78 The butterfly was used by the Pre-Raphaelites almost in the same way that Italian Renaissance artists such as Carlo Crivelli used a fly to show the veracity of their represented vision. Butterflies are found on the tree in Millais's *Proscribed Royalist, 1651* (Lord Lloyd-Webber), in the left corner of Hunt's *Our English Coasts, 1852 (Strayed Sheep)* (no.71) and later in Burton's *Wounded Cavalier* (no.42). George Landow has written of the butterfly as a traditional emblem of the soul: 'The Rainbow: A Problematic Image', in U.C. Knoepflmacher and G.B. Tennyson (eds.), *Nature and the Victorian Imagination*, Berkeley, CA 1977, pp.341–69.
79 Millais to Mr Gray, dated 'Langham Chambers, / Langham Place / April 11. 56', Pierpont Morgan Library, New York, Bowerswell Papers, PML, MA.1338, C.2.
80 Pointon 1979, pp.169–74; Parris 1984, pp.182–3; Staley 2001, pp.234–7; Staley & Newall 2004, p.188; Donald & Munro 2009, pp.62–4.
81 http://ssd.jpl.nasa.gov/sbdb.cgi?sstr=C/1858+L1;orb=1;view=Far
82 Pointon 1979, pp.171–3.
83 Babington et al. 2006, pp.166–7.
84 Rebecca Bedell, 'The History of the Earth: Darwin, Geology and Landscape Art', in Donald & Munro 2009, pp.63–4.
85 Read & Barnes 1991, p.127.
86 See Waggoner 2010, pp.84–6.

5. SALVATION (pp.114–55)

1 See Giebelhausen 2006.
2 Susannah Avery-Quash and Julie Sheldon, *Art for the Nation: The Eastlakes and the Victorian Art World*, New Haven and London 2011.
3 See Ruskin 1851.
4 For an extended discussion of the double standard in Victorian sexual mores, see Nead 1988.
5 See Barringer 2005.
6 Thomas Carlyle, *On Heroes, Hero-Worship, and the Heroic in History* (1840), introduction by Michael K. Goldberg, text established by Michael K. Goldberg, Joel J. Brattin and Mark Engel, Berkeley, CA 1993.
7 Rosenfeld 2012, pp.41–9; Rosenfeld & Smith 2007, pp.46–7; Warner 1997, pp.65–6; Parris 1984, pp.77–9; Townsend et al. 2004, pp.96–9.
8 See Alison Smith's interpretation in

Rosenfeld & Smith 2007, p.46.
9 Alastair Grieve, 'The Pre-Raphaelite Brotherhood and the Anglican High Church', *Burlington Magazine*, vol.111, no.794 (May 1969), pp.294–5.
10 Charles Dickens, 'Old Lamps for New Ones', *Household Words*, no.12 (15 June 1850), pp.265–6.
11 Giebelhausen 2006, pp.111–26.
12 Barringer 2005, pp.59–66.
13 Parris 2004, p.99.
14 Hunt 1905, I, p.203.
15 Combe papers, Ashmolean Museum, Oxford.
16 Fredeman 1975, p.66.
17 Bronkhurst 2006, p.134.
18 Rossetti 1900, p.218.
19 Werner 2005, p.153.
20 *The Times*, 15 April 1850, p.5; *The Examiner*, 20 April 1850, p.246.
21 Rossetti 1900, p.309.
22 Treuherz 1984, p.157.
23 Letter to *The Times*, 13 May 1851, quoted Ruskin 1903–12, XII, p.321.
24 Rosenfeld 2012, pp.58–60; Rosenfeld & Smith 2007, p.54; Parris 1984, pp.88–9; Townsend et al. 2004, pp.124–8.
25 'Fine Arts. Royal Academy', *Guardian*, no.6 (7 May 1851), p.331.
26 Diary entry, 16 Aug. 1854, in Surtees 1981, p.78.
27 Diary entry, 1 Nov. 1854, in Surtees 1981, p.105.
28 Maas 1984, pp.2–4.
29 Hunt 1886, pt.2, p.749.
30 Holman Hunt, 'An Apology for the Symbolism of "The Light of the World"', 1865, p.2, cited in Parris 1984, p.119.
31 Hunt 1886, pt.3, p.825.
32 Giebelhausen 2006, p.147.
33 *Art Journal*, June 1854, p.169; *Athenaeum*, 6 May 1854, p.561.
34 *The Times*, 13 July 1854, p.7.
35 *The Times*, 5 May 1854, p.9.
36 See Jonathan Mane-Wheoki, 'The Light of the World: Mission and Message', in *Holman Hunt and the Pre-Raphaelite Vision*, ed. Katharine Lochnan and Carol Jacobi, exh. cat., Art Gallery of Ontario, Canada 2008, pp.113–32, esp. pp.127–8; Maas 1984.
37 Ford Madox Brown, *The Exhibition of WORK and Other Paintings by Ford Madox Brown at the Gallery, 191 Piccadilly*, London 1865, cited in Bennett 2010, I, p. 129.
38 For a list of models see Bennett 2010, I, p.127.
39 Lucy Rabin, *Ford Madox Brown and the Pre-Raphaelite History Picture*, New York and London 1978, p.219.
40 Anna Jameson, *Sacred and Legendary Art*, 2 vols., London 1848, I, p.241.
41 Ford Madox Brown, *The Exhibition of WORK and Other Paintings by Ford Madox Brown at the Gallery, 191 Piccadilly*, London 1865, cited in Bennett 2010, I, p. 129.
42 *Illustrated London News*, 22 May 1852, p.407.
43 Diary entry, 30 July–5 Aug. 1856, in Surtees 1981, pp.184–5.
44 Brown quoted Bennett 2010, I, p.132.
45 Ford Madox Brown, *The Exhibition of WORK and Other Paintings by Ford Madox Brown at the Gallery, 191 Piccadilly*, London 1865, cited in Bennett 2010, I, p.168.
46 See diary entry, 31 Aug. 1855, in Surtees

1981, p.151.
47 Bennett 2010, I, p.168.
48 Ibid.
49 Ibid.
50 For fuller commentary see Barringer 2005, pp.21–81; John A. Walker, *Work: Ford Madox Brown's Painting and Victorian Life*, London 2006; and Bennett 2010, I, pp.136–59.
51 Carlyle 1912, p.189.
52 This and all quotations from Brown not otherwise referenced are taken from Ford Madox Brown, *The Exhibition of WORK and Other Paintings by Ford Madox Brown at the Gallery, 191 Piccadilly* (London 1865), quoted Bendiner 1998, p.156.
53 See Thomas Carlyle, 'Hudson's Statues', in *Latter-Day Pamphlets*, London 1898, ch.7, p.270.
54 Surtees 1981, p.192 (entry for 9 Nov. 1856).
55 Hueffer 1896, p.209.
56 *The Builder*, 18 March 1865, p.186.
57 *Athenaeum*, 11 March 1865, p.353.
58 Ford Madox Brown to George Rae, 1864 (letter no.29; Walker Art Gallery, Liverpool), quoted Mary Bennett, 'The Price of Work', in Parris 1984, pp.143–52, quotation on p.151.
59 Letter to Hunt, 30 Jan. 1855, in Surtees 1971, I, p.28.
60 Fredeman 2002–10, I, p.388.
61 12 November 1854, Surtees 1981, p.106.
62 Stephens 1894, p.3.
63 Ruskin, letter to *The Times*, 25 May 1854, in Ruskin 1903–12, XII, p.334.
64 Wilkie Collins, *Basil*, London 1852, p.61.
65 I am grateful to Charlotte Gere for this information.
66 Warner 1979, p.8. See also Annette Wickham, *The Gifted Hand: Drawings by John Everett Millais from the Royal Academy's Collection*, exh. cat., Royal Academy Library Print Room, London 2003.
67 Morgan Library, New York, Bowerswell Papers, MA.1338 R.25, dated 'Waddon, Croydon, 31st May 1853'.
68 Parris 1984, p.262; Rosenfeld & Smith 2007, p.90; Warner 1979, pp.10, 11, 22.
69 See Rosenfeld & Smith 2007, p.90.
70 See Nicholas Tromans, 'The Holy City', in N. Tromans (ed.), *The Lure of the East: British Orientalist Painting*, London 2008, pp.162–97.
71 Thomas Seddon, quoted Staley & Newall 2004, p.110.
72 Edward Said, *Orientalism*, New York 1978.
73 *The Critic*, 5 May 1860, quoted Stephens 1860, p. 105.
74 Bronkhurst 2006, p.176.
75 Hunt 1913, I, p.262.
76 Giebelhausen 2006, p.167.
77 Stephens 1860, p.105.
78 Tromans 2008, p.151.
79 Stephens 1860.
80 Hunt 1913, II, p.82.
81 Millais 1899, I, p.236.
82 Tromans 2008.
83 *Athenaeum*, 10 May 1856, p.589.
84 William Holman Hunt, 'Painting the Scapegoat', *Contemporary Review*, vol.52, July 1887, pp.21–38, and Aug. 1887, pp.206–20.
85 Marcia Pointon, 'The artist as ethnographer: Holman Hunt and the Holy Land', in Pointon 1989, pp.22–44; Jacobi 2006, pp.53–4; Bronkhurst 2006,

p.180.
86 Ann Bermingham, *Landscape and Ideology: The English Rustic Tradition, 1740–1860*, 1987, pp.189–90; Barringer 2005, pp.94–5
87 *Spectator*, 13 Oct. 1855, p.1063.
88 *Daily News*, 10 May 1858; see Parris 1984, pp.167–8.
89 *The Times*, 22 May 1858, p.9.
90 Lear diary, 10 Sept. 1858: http://www.nonsenselit.org/diaries/2008/11/11/friday-10-september-1858
91 Surtees 1980, p.25.
92 See Simon Poë, 'Robins of Modern Times: A Modern Girl in a Pre-Raphaelite Landscape', *British Art Journal*, vol.4, no.2, 2003, pp.45–8.
93 I am grateful to Charlotte Gere for this information.
94 See Nead 1988, p.139.
95 A.M.W. Stirling, *A Painter of Dreams and other Biographical Studies*, London 1916, p.311.
96 *Artist* 1898.
97 *Clarion*, 19 Nov. 1892, p.100.
98 A.R. Dufty, 'William Morris and the Kelmscott Estate', *The Antiquaries Journal*, vol.XLIII, 1963, pp. 97–115, esp. p.111.
99 Design Council, *William Morris and Kelmscott*, London 1981, p.155.
100 *Artist* 1898.
101 Pointon 1979, p.161; Parris 1984, pp.186–7; Staley & Newall 2004, p.122; Giebelhausen 2004; Emily Hope Thomson, 'The Religious Landscapes of William Dyce', in Babington et al. 2006, pp.47–53, 174.
102 Pointon 1979, p.162.
103 Giebelhausen 2004, pp.185–91.
104 Carlyle 1912, p.261.
105 Bronkhurst 1983. See also Judith Bronkhurst, 'Fairbairn, Sir Thomas, second baronet (1823–1891)', in *Oxford Dictionary of National Biography*, online edn, ed. Lawrence Goldman, Oxford, www.oxforddnb.com/view/article/62808 (accessed 20 Nov. 2011).
106 *The Times*, 15 Aug. 1856, p.10, quoted Bronkhurst 1983, p.591.
107 John Ruskin, 'Of Queen's Gardens', *Sesame and Lilies* (1865), in Ruskin 1903–12, XVIII, pp.109–44.
108 Caroline Arscott, 'Employer, Husband, Spectator: Thomas Fairbairn's Commission of *The Awakening Conscience*', in Janet Wolff and John Seed (eds.), *The Culture of Capital: Art, Power and the Nineteenth-Century Middle Class*, Manchester 1988, p.162.
109 John Physick, *The Victoria and Albert Museum: A History of the Building*, Oxford 1982, pp.47–51.
110 See Barringer 2005, ch.4.
111 John Charles Robinson, *Catalogue of the Soulages collection …; now, by permission of the committee of privy council for trade, exhibited to the public*, London 1856. The collection was shown at the 1857 Art Treasures Exhibition organised by Fairbairn. See also Bronkhurst 1983.
112 Sidney and Beatrice Webb, *History of Trade Unionism*, London 1896, p.196.
113 'Our Trade; or the Principles and Practice of Smithwork (by a Member of the Amalgamated Society)', *The Operative*, 24 April 1852, p.383.
114 Brown describing the treatment of his illustration in Ford Madox Brown, *The Exhibition of WORK and Other Paintings*

by Ford Madox Brown at the Gallery, 191 Piccadilly, London 1865, cited in Parris 1884, p.206.

115 Bennett 2010, I, p.216.

116 Art Journal, Dec. 1866, pp.374–5.

117 Athenaeum, 10 Nov. 1866, p.612.

118 Letter dated 1 May 1866, cited in Bennett 2010, I, p.218.

119 Letter of c.1872, quoted Bronkhurst 2006, p.226.

120 Ernest Renan, Life of Jesus, translated with an introduction by William G. Hutchison, London and Felling-on-Tyne 1921, p.47.

121 R.K.R. Thornton, All My Eyes See: The Visual World of Gerard Manley Hopkins, exh.cat., Sunderland Arts Centre, Sunderland 1975, pp.93–5.

122 [William Holman Hunt] 'Mr. Holman Hunt's Picture, "The Shadow of Death"', 1883, quoted Bronkhurst 2006, p.225; see Barringer 2005, pp.61–2.

123 P.T. Forsyth, Religion in Recent Art, London 1889, p.217.

124 Rosenfeld 2012, pp.118–19.

125 Athenaeum, 26 Dec. 1863, pp.881–2.

126 Walter Armstrong, 'Sir J.E. Millais, Bart., RA: His Life and Work', Art Journal, Art Annual Series, 1885, p.25.

127 Surtees 1981, passim.

128 Oliver Cromwell, 'Speech given at the Painted Chamber in Westminster on 12 September 1654', in Thomas Carlyle, Oliver Cromwell's Letters and Speeches: With Elucidations by Thomas Carlyle, London 1845, vol.2, pp.110–11.

129 Thomas Carlyle, Cromwell, Boston 1877, p.19. The text originally appeared in 1845.

130 Mary Bennett, 'St Ives, An. Dom. 1636', in Parris 1984, p.257.

6. BEAUTY (pp.156–77)

1 Walter Pater, 'The School of Giorgione', in Lawrence Evans (ed.), The Renaissance, Chicago 1978, p.139.

2 Effie Millais, quoted Malcolm Warner, 'John Everett Millais's Autumn Leaves: "A picture full of beauty and without subject"', in Parris 1984, p.126.

3 Ruskin 1903–12, XIV, p.67.

4 For a full discussion of this question see Elizabeth Prettejohn, 'Two early Aesthetic pictures', in Prettejohn 2007, pp.11–21.

5 Quoted Rossetti 1895, p.417.

6 'Pre-Raphaelitism', Spectator, LIX, 10 April 1886, p.484, quoted Dianne Sachko Macleod, 'Dante Gabriel Rossetti: A Critical Analysis of the Late Works, 1859–1882', PhD Dissertation, University of California, Berkeley 1981, p.6.

7 William Holman Hunt to Thomas Combe, 12 Feb. 1860, quoted Surtees 1971, I, p.69.

8 Robert Buchanan (pseudonym Thomas Maitland), 'The Fleshly School of Poetry: Mr D.G. Rossetti', Contemporary Review, no.18 (Oct. 1871), pp.334–50.

9 See Read & Barnes 1991, pp.113–14.

10 Thomas Woolner to Pauline Trevelyan, early 1857, quoted Mary Bennett, Artists of the Pre-Raphaelite Circle: The First Generation, London 1988, p.166.

11 Alexander Munro to George Butler (c.1855), Fawcett Library, quoted Macdonald 1991, p.59.

12 See 'Josephine Butler portraits', University of Liverpool Library, http://sca.lib.liv.ac.uk/collections/colldescs/butlerports.html (accessed 23 March 2012).

13 http://records.ancestry.com/Elizabeth_Blakeway_records.ashx?pid=94223139; http://en.wikisource.org/wiki/Dictionary_of_National_Biography,_1885-1900/Memoir_of_George_Smith

14 Leonard Huxley, The House of Smith, Elder, London 1923, p.82; http://scans.library.utoronto.ca/pdf/2/24/houseofsmitheldeoohuxluoft/houseofsmitheldeoohuxluoft.pdf

15 Allingham & Williams 1911, pp.236–7.

16 Allingham & Williams 1911, p.240.

17 J.E. Millais to F.G. Stephens, quoted Malcolm Warner, 'John Everett Millais's Autumn Leaves: "A picture full of beauty and without subject"', in Parris 1984, p.127.

18 'The Royal Academy', Art Journal, 1 June 1856, p.171, quoted Prettejohn 2007, p.14.

19 'The Royal Academy', Saturday Review, 10 May 1856.

20 Rosenfeld & Smith 2007, p.134.

21 Fredeman 2002–10, II, p.276.

22 Fredeman 2002–10, II, p.269.

23 Charlotte Gere and Judy Rudoe, Jewellery in the Age of Queen Victoria: A Mirror to the World, London 2010.

24 F.G. Stephens, 'Fine Arts: Royal Academy', Athenaeum, 1859, p.617.

25 Surtees 1980, p.27.

26 Fredeman 2002–10, II, p.271.

27 Dante Gabriel Rossetti to George Price Boyce, 5 September 1859, in ibid.

28 See Sarah Phelps Smith, 'Dante Gabriel Rossetti's Flower Imagery and the Meaning of his Paintings', PhD dissertation, University of Pittsburgh, 1978, reprinted University of Michigan Press, 1993.

29 William Holman Hunt to Thomas Combe, 12 February 1860, quoted Surtees 1971, I, p.69; Surtees 1980, p.89.

30 Giovanni Boccaccio, The Decameron: The First Five Days, trans. Richard Aldington, London 1954, vol.1, p.146.

31 See Cherry 1980.

32 Betty Elzea, Frederick Sandys: A Catalogue Raisonné, Woodbridge 2001, pp.120–1.

33 See Surtees 1971, I, p.50, no.88. See also Dante Gabriel Rossetti to Frederick Sandys, 10 May 1869, Fredeman 2002–10, IV, pp.180–1.

34 Hunt 1905, II, p.203.

35 For an excellent full discussion of Il Dolce far Niente see Bronkhurst 2006, I, pp.187–8.

36 William Holman Hunt to Thomas Combe, 12 Feb. 1860, quoted Surtees 1971, I, p.69.

37 Bryant 2004, p.40.

38 Quotes from her diary in Mary Lutyens, Edward and Elizabeth, privately printed, not paginated, quoted Bryant 2004, p.124.

39 Rossetti to William Graham, 11 March 1873, Fredeman 2002–10, VI, pp.88–9.

40 Dante Gabriel Rossetti to Ellen Heaton, 19 May 1863, Fredeman 2002–10, III, p.51.

41 Rossetti to William Graham, 11 March 1873, Fredeman 2002–10, VI, p.89.

42 Stephens 1865.

43 Letter to Ellen Heaton, 2 July 1863, Fredeman 2002–10, III, p.61.

44 Stephens 1865.

45 Ibid.

46 Quoted Surtees 1971, I, p.105.

47 Jan Marsh, '"For the wolf or the babe he is seeking to devour?" The hidden impact of the American Civil War on British Art', in Ellen Harding (ed.), Re-Framing the Pre-Raphaelites: Historical and Theoretical Essays, Aldershot 1995, pp.115–26.

48 Rossetti 1903, p.175.

49 Surtees 1980, p.42.

50 Shirley Bury, 'Rossetti and his Jewellery', Burlington Magazine, vol.118, no.875 (Feb. 1976), pp.94–102.

51 Dante Gabriel Rossetti to Ford Madox Brown, 18 April 1865, Fredeman 2002–10, III, p.285.

52 Walter Pater, 'The School of Giorgione', ed. Lawrence Evans, Chicago 1978, reprinted from The New Library Edition of the Work of Walter Pater, London 1922, p.139.

53 Stephens 1865.

54 Paul Spencer Longhurst, The Blue Bower: Rossetti in the 1860s, Birmingham 2000, pp.11–12.

55 See Joanne Lukitsh, '"Like a Lionardo": Exchanges between Julia Margaret Cameron and the Rossetti Brothers', in Waggoner 2010, pp.134–45.

56 Quoted Waggoner 2010, pp.135–6.

57 Julia Margaret Cameron to John Herschel, 31 Dec. 1864, Heinz Archive and Library, National Portrait Gallery, London, quoted Julian Cox and Colin Ford, Julia Margaret Cameron: The Complete Photographs, Los Angeles 2003, p.41.

58 Dante Gabriel Rossetti to Julia Margaret Cameron, mid-Jan. 1866, Fredeman 2002–10, III, pp.375–6.

59 Doughty and Wahl 1965–7, II, p.606.

60 Stephens 1894, p.70.

61 John Keats, 'Isabella; or, The Pot of Basil', lines 164–8.

62 Quoted Bronkhurst 2006, I, p.208.

63 See Bronkhurst 2006, II, p.288.

64 John Keats, 'Isabella; or, The Pot of Basil', lines 421–4.

65 Translation by Samuel Taylor Coleridge, quoted Prettejohn 1997, p.30.

66 Rossetti 1903, p.483.

67 Dante Gabriel Rossetti to Thomas Gordon Hake, 21 April 1870, Fredeman 2002–10, IV, p.449. See also Virginia M. Allen, '"One Strangling Golden Hair": Dante Gabriel Rossetti's Lady Lilith', Art Bulletin, 66.2, June 1984, pp.285–94.

68 Clive Wilmer (ed.), Dante Gabriel Rossetti: Selected Poems and Translations, London and Manchester 1991, p.37.

69 H.T. Dunn papers, quoted Surtees 1971, I, p.117.

70 Barbara Bryant, 'Rossetti, Lady Lilith', in Wilton & Upstone 1997, p.102.

71 See Nead 1988.

72 Stephens 1894, pp.68–9, quoted Surtees 1971, I, p.117. On Victorian sexology see Jeffrey Weeks, Sex, Politics and Society (1981), 2nd edn, London 1989.

73 William Michael Rossetti and Algernon Swinburne, Notes on the Royal Academy Exhibition, 1868, quoted Prettejohn 1997, p.30.

74 See Walter F. Otto, Dionysus: Myth and Cult, Bloomington, Indiana 1965.

75 Prettejohn 2007, pp.93–5.

76 Walter Pater, 'A Study of Dionysus', Fortnightly Review, 1 Dec. 1876, pp.752–72.

77 Algernon Charles Swinburne, 'Simeon Solomon: Notes on his "Vision of Love" and other studies', The Dark Blue, 1, July 1871, pp.568–77, quoted Simon Reynolds, The Vision of Simeon Solomon, Stroud 1984, p.35.

78 For a reassessment see Colin Cruise, Love Revealed: Simeon Solomon and the Pre-Raphaelites, London and New York, 2005.

79 MacCarthy 2011, pp.199–215.

80 Penelope Fitzgerald, Edward Burne-Jones: A Biography, London 1975, p.150.

81 Dante Gabriel Rossetti to Ford Madox Brown, 23 January 1869, in Fredeman 2002–10, IV, p.147.

7. PARADISE (pp.178–205)

1 Burne-Jones 1904, I, p.99.

2 Burne-Jones 1904, I, p.110.

3 Dante Gabriel Rossetti to William Allingham, 18 Dec. 1856, Fredeman 2002–10, II, pp.146–47.

4 William Michael Rossetti, Ruskin: Rossetti: Preraphaelitism: Papers 1854 to 1862, London 1899, pp.268–70.

5 Burne-Jones 1904, I, p.146.

6 Burne-Jones 1904, I, p.147.

7 Ibid.

8 Burne-Jones 1904, I, pp.147–9.

9 Quoted Kirkham 1981, p.26.

10 Dante Gabriel Rossetti to William Allingham, 18 Dec. 1856, Fredeman 2002–10, II, p.147.

11 See Denis Mackail, The Life of William Morris, London 1899, vol.1, p.114. Also see Jan Marsh's catalogue entry in Stephen Wildman (ed.), Waking Dreams: The Art of the Pre-Raphaelites from the Delaware Art Museum, Alexandria, VA 2004, pp.336–8.

12 Fredeman 2002–10, II, p.147.

13 Burne-Jones 1904, I, p.206.

14 Illustrated Burne-Jones 1904, II, p.286.

15 Dufty 1985, p.7.

16 Doughty and Wahl 1965–7, II, pp.675–6.

17 Parry 1996a, p. 235.

18 William Morris, 'The Beauty of Life, delivered before the Birmingham Society of Arts and School of Design, February 19, 1880', Hopes and Fears for Art, in Morris 1910–15, XXII (1914), p.77.

19 Quoted in Parry 1996a, cat. K.10, p.189.

20 See Emma Ferry, 'Lucy Faulkner and the "ghastly grin"', Journal of William Morris Studies, 18.1 (Winter 2008), p.81, n.15.

21 Dufty 1985, p.8.

22 Joanna Banham and Jennifer Harris, William Morris and the Middle Ages, exh. cat., Whitworth Art Gallery, Manchester 1984, p.216.

23 Illustrated Dufty 1985, p.39.

24 Barbara Morris, Victorian Embroidery, London 1962, p.96.

25 Parry 1996a, p. 237.

26 Dufty 1985, pp.16, 48.

27 William Morris, 'The Lesser Arts of Life', Lectures in Art and Industry, in Morris 1910–15, XXII (1914), p.262.

28 See Parry 1996a, pp.254–255, for a

sample of 'Tulip and Willow' printed by Clarkson's with Prussian blue dye.

29 George Wardle, 'Memorials of William Morris', in Charles Harvey and Jon Press, *Art, Enterprise and Ethics: The Life and Works of William Morris*, London 1996, pp.91–3.
30 Morris 1888.
31 Nikolaus Pevsner, *Pioneers of Modern Design: From William Morris to Gropius* (1936), London 1991, p.49.
32 Burne-Jones 1904, I, p.234, and II, p.135.
33 Burne-Jones 1904, II, pp.33–4.
34 Parry 1996a, p.305.
35 See Michaela Braesel, 'William Morris, Edward Burne-Jones and "The Rubáiyát of Omar Khayyám"', *Apollo*, Feb. 2004, pp.47–56, esp. p.50.
36 Morris 1973, p.256.
37 Lethaby 1935, pp.94–5.
38 Lawrence Weaver, 'Rounton Grange, Yorkshire', *Country Life*, 26 June 1915, pp.906–12, esp. p.909.
39 See Surtees 1980, pp.29–30.
40 Esmé Whittaker, *William Morris: Story, Memory, Myth*, exh. cat., 2 Temple Place, London 2011, p.20.
41 Illustrated in Alison Smith (ed.), *Watercolour*, exh. cat., Tate Britain, London 2011, p.42.
42 Philip Henderson, *William Morris: His Life, Works and Friends*, London 1967, p.156.
43 I am grateful to Margaret Dier at the Royal School of Needlework for this information.
44 Illustrated in Burne-Jones 1904, II, p.106.
45 See Judith Flanders, *A Circle of Sisters: Alice Kipling, Georgiana Burne-Jones, Agnes Poynter and Louisa Baldwin*, London 2001.
46 W.Graham Robertson, *Time Was*, 1931, p.75.
47 MacCarthy 2011, p.506.
48 Stephen Wildman and John Christian, *Edward Burne-Jones: Victorian Artist Dreamer*, exh. cat., Metropolitan Museum of Art, New York 1998, p.260.
49 See E.T. Cook, 'Introduction', in Ruskin 1903–12, X, p.lix.
50 Edward Carpenter, *Chants of Labour: A Song Book of the People, with Music*, illustrated by Walter Crane, London 1888; Janet Ashbee (ed.), *The Essex House Song Book, Being the Collection of Songs Formed for the Singers of the Guild of Handicraft*, London 1903–5.
51 Peterson 1982, p.37: 'The Woodcuts of Gothic Books'.
52 Peterson 1982, p.1: 'Some Thoughts on the Ornamented Manuscripts of the Middle Ages: A Fragmentary Essay Never Published by Morris'.
53 Peterson 1982, pp.75–6: 'A Note by William Morris on His Aims in Founding the Kelmscott Press'.
54 Burne-Jones 1904, II, p.217.
55 Burne-Jones 1904, II, p.259.
56 Letter to Charles Eliot Norton, 8 Dec. 1894, quoted Martin Harrison and Bill Waters, *Burne-Jones*, London 1973, p.164.
57 Burne-Jones 1904, II, p.278.
58 William Morris, 'The Lesser Arts of Life', *Lectures in Art and Industry*, in Morris 1910–15, XXII (1914), p.254.
59 Morris 1888.
60 William Morris to Georgiana Burne-Jones, 10 June 1890, in Norman Kelvin (ed.), *The Collected Letters of William Morris*, Princeton 1996, vol.3, p.164.
61 Burne-Jones 1904, I, p.116.
62 Burne-Jones 1904, II, p.208.
63 Burne-Jones 1904, II, p.209.
64 On Crane see Morna O'Neill, *Walter Crane: The Arts and Crafts, Painting, and Politics*, New Haven and London, 2010.
65 This account of the work relies on Morna O'Neill's catalogue entry in her exhibition catalogue, *'Art and Labour's Cause is One': Walter Crane and Manchester, 1880–1915*, exh. cat., Whitworth Art Gallery, Manchester 2008.
66 Burne-Jones 1904, I, p.207.
67 For the suggestion that the flowers represent marigolds see Stutchbury 2011, pp.36–7.
68 See Christopher Nobbs, 'Clavichord by Arnold Dolmetsch, London, 1897, No.10', restoration and conservation report, National Trust, 2006; Stutchbury 2011.
69 William Morris to John Ruskin, 15 April 1883, in Norman Levin (ed.), *Collected Letters of William Morris*, 4 vols., Princeton NJ 1984–96, II, p.186.
70 Parry 1996b, p.59. I am grateful to Linda Parry, Julia Dudkiewicz (Collection Manager at the Society of Antiquaries), and Rebecca and Marylyn Lewin for their help in compiling this entry.
71 *The Studio*, no.2, 1894, p.20.

8. MYTHOLOGIES
(pp.206–30)

1 Théodore Duret, 'Les Expositions de Londres: Dante Gabriel Rossetti', *Gazette des Beaux-Arts*, 1 July 1883, p.54. See Elizabeth Prettejohn's essay '"Beautiful women with floral adjuncts": Rossetti's new style', in Treuherz et al. 2003, pp.51–108.
2 Walter Pater, *The Renaissance*, ed. Adam Phillips, Oxford 1986, p.151.
3 M.H. Spielmann, 'Sir Edward Burne-Jones, Bt.', *Magazine of Art*, 1898, p. 528.
4 F.G. Stephens in *Athenaeum*, 26 Feb. 1881.
5 For the original Italian text see Surtees 1971, I, p.119.
6 Ernestine Mills, *The Life and Letters of Frederic Shields, 1833–1911*, London 1912, p.262.
7 Rosenfeld & Smith 2007, pp.218–20.
8 Bennett 2010, I, p. 248.
9 Burne-Jones 1904, II, p.30.
10 John Christian, 'Burne-Jones's "Tristram and Iseult" rediscovered', *Burlington Magazine*, vol. 154, no.1313 (August 2012), pp.555–63, which illustrates the Fitzwilliam sketchbook.
11 Burne-Jones 1904, II, p.323.
12 'Laus Veneris', Swinburne 1866, p.18.
13 John L. Sweeney (ed.), *Henry James: The Painter's Eye*, London 1956, p.164.
14 Frederick Wedmore, 'Some Tendencies in Recent Painting', *Temple Bar*, no. 53 (July 1878), p.339, quoted John Christian, 'Laus Veneris', in Stephen Wildman and John Christian (eds.), *Burne-Jones: Victorian Artist Dreamer*, exh. cat., Metropolitan Museum of Art, New York 1998, p.169.
15 Swinburne 1866, p.14.
16 Rossetti 1889, p.98.
17 Jan Marsh and Pamela Gerrish Nunn, *Women Artists and the Pre-Raphaelite Movement*, London 1989, pp.103–4.
18 Doughty and Wahl 1965–7, IV (1967), p.1564.
19 Ibid., p.1574.
20 Rossetti 1889, p.103.
21 Burne-Jones 1904, II, p.30.
22 Prettejohn 2007, p.244.
23 Burne-Jones 1904, I, p.297.
24 Scott 1892, II, pp.230–1.
25 Hunt 1913, II, p.412.
26 Hunt 1913, II, p.417.
27 *Nation*, 2 April 1885, quoted Bronkhurst 2006, p.256.
28 Ruskin 1903–12, XXXIII, p.277.
29 W.S. Taylor, 'King Cophetua and the Beggar Maid', *Apollo*, Feb. 1973, pp.148–55, esp. p.151.
30 Gail S. Weinberg, '"Looking backward": opportunities for the Pre-Raphaelites to see "Pre-Raphaelite" art', in Watson 1997, p.57.
31 Robert de la Sizeranne, 'In Memoriam, Sir Edward Burne-Jones: A Tribute from France', *Magazine of Art*, 1898, p.515.
32 Burne-Jones 1904, II, p.139.
33 May Morris (ed.), *The Collected Works of William Morris*, 24 vols., London 1910–15, XXII, p.26.
34 Fredeman 1975, App. 2: List of Immortals, pp.106–7.
35 Bronkhurst 2006, D46, pp.28–9. The drawing is now in the National Gallery of Victoria, Melbourne.
36 'The Lady of Shalott' appeared in Tennyson's *Poems* (London, Dec. 1832; the title page is dated 1833) and was revised in 1842.
37 Sarah Stickney Ellis, *Women of England*, London, 1839.
38 Cherry & Pollock 1984a.
39 Bronkhurst 2006, II, D151–61, pp.87–91.
40 Hunt 1905, II, pp.124–5.
41 See Bronkhurst 2006, II, App. C9, p.290.
42 Quoted Bronkhurst 2006, I, p.271.
43 Ibid.
44 William Holman Hunt, *An Introduction to Some Poems by Alfred Tennyson*, London 1901, pp.xx–xxi.
45 Bronkhurst 2006, II, p.344.
46 MacCarthy 2011, p.272.
47 Burne-Jones 1904, II, pp.145–6; Hilary Morgan, *Burne-Jones, the Pre-Raphaelites and their Century*, 2 vols., exh. cat., Peter Nahum Leicester Galleries, London 1989, I, p.77.
48 Burne-Jones 1904, II, p.269.
49 Caroline Arscott, *William Morris and Edward Burne-Jones: Interlacings*, New Haven and London 2008, p. 71. See also Caroline Arscott, 'Mutability and Deformity: Models of the Body and the Art of Edward Burne-Jones', *Interdisciplinary Studies in the Long Nineteenth Century*, No.7, London 2008 (www.19.bbk.ac.uk).
50 *The Times*, 8 May 1888, p.10.
51 MacCarthy 2011, p.274.
52 Burne-Jones 1904, II, p.237.
53 Burne-Jones 1904, II, p.31.

THE PRE-RAPHAELITE LEGACY (pp.231–6)

1 'Introduction', Read 1936, p.59.
2 On the 'wet white ground' as a key feature of the Pre-Raphaelites' group identity see Ford Madox Hueffer (later called Ford Madox Ford), *The Pre-Raphaelite Brotherhood: A Critical Monograph*, London 1920 (first published 1906), pp.142–50.
3 I am grateful to Sian White for suggesting this idea. On the 'invention of oil painting' see Jenny Graham, *Inventing Van Eyck: The Remaking of an Artist for a Modern Age*, Oxford and New York 2007, pp.41–2 and passim.
4 Pointon 1989, p.2.
5 Richard Muther, *Geschichte der Malerei im 19. Jahrhundert*, 3 vols. (Munich 1893–4), vol.II, pp.480–518; vol.III, pp.461–521; Robert de la Sizeranne, *La peinture anglaise contemporaine*, Paris 1895; Olivier Georges Destrée, *Les Préraphaélites: Notes sur l'art décoratif et la peinture en Angleterre*, Brussels 1894; Steve Rizza, *Rudolf Kassner und Hugo von Hofmannsthal: Criticism as Art: The Reception of Pre-Raphaelitism in Fin de Siècle Vienna*, Frankfurt am Main 1997.
6 See Giuliana Pieri, 'The Critical Reception of Pre-Raphaelitism in Italy, 1878–1910', *Modern Language Review* 99, April 2004, pp.374–5; Sandra Berresford, 'The Pre-Raphaelites and their Followers at the International Exhibitions of Art in Venice from 1895 to 1905', in Sophie Bowness and Clive Phillpot (eds.), *Britain at the Venice Biennale 1895–1995*, London 1995, pp.37–49.
7 Wassily Kandinsky, *Concerning the Spiritual in Art*, London 2006, p.36 (reprint, with an introduction by Adrian Glew and supporting material, of the first English translation, by Michael T.H. Sadler, published in 1914 as *The Art of Spiritual Harmony*); The National Gallery, British Art, *Illustrated Catalogue of Works by English Pre-Raphaelite Painters: Lent by The Art Gallery Committee of the Birmingham Corporation*, exh. cat., National Gallery of British Art (later called Tate Gallery), London 1912 (exhibition held December 1911–March 1912).
8 William Butler Yeats to Olivia Shakespear, 2 March 1929, *The Letters of W.B. Yeats*, ed. Allan Wade, London 1954, p.759: 'I have come to fear the world's last great poetic period is over'.
9 Clive Bell, *Landmarks in Nineteenth-Century Painting*, London 1927, pp.111–12; R.H. Wilenski, *The Modern Movement in Art*, London 1957 (first published 1927), pp.95, 113–17.
10 Read 1936, pp.59–60.
11 Ford Madox Ford to his daughter Julie (later Julia Madox Loewe), 11 September 1935, in Sondra J. Stang and Karen Cochran (eds.), *The Correspondence of Ford Madox Ford and Stella Bowen*, Bloomington and Indianapolis 1993, p.441.
12 *Paintings and Drawings of the Pre-Raphaelites and their Circle*, exh. cat., Fogg Art Museum, Harvard University, Cambridge, Mass. 1946.
13 *Dante Gabriel Rossetti and His Circle: A Loan Exhibition of Paintings, Drawings and Decorative Objects by the Pre-Raphaelites and Their Friends*, exh. cat., University of Kansas Museum of Art, Lawrence, Kansas 1958; Jacques

Lethève, 'La connaissance des peintres préraphaélites anglais en France (1855–1900)', *Gazette des Beaux-Arts*, May–June 1959, pp.315–28.

14 Evelyn Waugh, *PRB: An Essay on the Pre-Raphaelite Brotherhood 1847–54* (privately printed by Alastair Graham, 1926), reprinted Westerham, Kent 1982, p.13.

15 Read 1936, p.59.

16 This approach was initiated with polemical brilliance in Cherry & Pollock 1984b.

17 See Barlow 2005, pp.168–9, 216 n.48.

18 Quoted Millais 1899, vol.2, pp.195–6.

19 F.W.H. Myers, 'Rossetti and the Religion of Beauty', *Essays Modern* (vol.2 of *Essays Classical and Modern*), London 1883, pp.312–34; Théodore Duret, 'Les Expositions de Londres: Dante Gabriel Rossetti', *Gazette des Beaux-Arts*, 1 July 1883, p.54.

20 See Wilton & Upstone 1997.

21 Fernand Khnopff, 'In Memoriam: Sir Edward Burne-Jones, Bart.: A Tribute from Belgium', *Magazine of Art*, no.22, 1898, pp.520–6; MacCarthy 2011, pp.454–5.

22 See Anthony Blunt and Phoebe Pool, *Picasso: The Formative Years: A Study of his Sources*, London 1962, pp.8–10; Richard Shone, *The Art of Bloomsbury: Roger Fry, Vanessa Bell and Duncan Grant*, exh. cat., Tate Gallery, London 1999, p.19.

23 See Tim Barringer, '"Not a 'modern' as the word is now understood"? Byam Shaw, imperialism and the poetics of professional society', in David Peters Corbett and Lara Perry (eds.), *English Art 1860–1914: Modern Artists and Identity*, Manchester 2000, pp.76–83.

24 See for example Lynne Pudles, 'Fernand Khnopff, Georges Rodenbach, and Bruges, the Dead City', *Art Bulletin* 74, December 1992, pp.637–53; Edith Hoffmann, 'Some Sources for Munch's Symbolism', *Apollo* 81, February 1965, pp.87–93; Edwin Becker, 'Sensual eroticism or empty tranquillity: Rossetti's reputation around 1900', in Treuherz et al. 2003, pp.111–29. For the Pre-Raphaelite legacy in Central Europe see Smith 2009; Andrzej Szczerski, *Wzorce tożsamości. Recepcja sztuki brytyjskiej w Europie Środkowej okolo roku 1900*, Kraków 2002 (English Summary, 'Patterns of Identity: The Reception of British Art in Central Europe c.1900', pp.389–407). Further research is urgently needed into the international dissemination of Pre-Raphaelite art, which now extends to Japan and Eastern Asia.

25 *The Poetical Works of Christina Georgina Rossetti*, ed. William Michael Rossetti, London 1904, p.388 (the lines are slightly misquoted in the Royal Academy catalogue).

26 Dalí 1936.

27 Read 1936, pp.21–2.

28 'Surrealist Painting' (*The Nation*, 12 and 19 August 1944; *Horizon*, January 1945), reprinted in Clement Greenberg, *The Collected Essays and Criticism*, ed. John O'Brian, 4 vols., Chicago and London, 1986–93, vol.1, pp.225–31. For Greenberg's earlier denunciation see 'Towards a Newer Laocoon' (1940), reprinted in ibid., vol.1, p.27.

29 Richard Muther, *The History of Modern Painting*, rev. edn, London and New York 1907, vol.3, p.46; Julius Meier-Graefe, *Modern Art: Being a Contribution to a New System of Aesthetics*, trans. Florence Simmonds and George W. Chrystal, London and New York 1908, vol.2, p.188 and passim.

30 Dalí 1936, p.46.

31 Robert Rosenblum, 'British Painting vs. Paris', *Partisan Review* 24, Winter 1957, p.95.

32 Ibid., p.97.

SELECT BIBLIOGRAPHY

Allingham, Helen Patterson, and Williams, E. Baumer, *Letters to William Allingham*, London 1911

The Artist, 'Madox Brown's Designs for Furniture', May 1898, pp.44–51

Babington, Caroline, et al., *William Dyce and the Pre-Raphaelite Vision*, Aberdeen 2006

Barlow, Paul, *Time Present and Time Past: The Art of John Everett Millais*, Aldershot 2005

Barringer, Tim, *The Pre-Raphaelites: Reading the Image*, London 1998

Barringer, Tim, *Men at Work: Art and Labour in Victorian Britain*, New Haven and London 2005

Bendiner, Kenneth, *The Art of Ford Madox Brown*, University Park, PA 1998

Bennett, Mary, *Ford Madox Brown: A Catalogue Raisonné*, 2 vols., New Haven and London 2010

Bronkhurst, Judith, 'Fruits of a Connoisseur's Friendship: Sir Thomas Fairbairn and William Holman Hunt', *Burlington Magazine*, vol.125, no.967, Oct. 1983, pp.586–95

Bronkhurst, Judith, *William Holman Hunt: A Catalogue Raisonné*, 2 vols, New Haven and London, 2006

Browne, Max, *Theodor von Holst: His Art and the Pre-Raphaelites*, exh. cat., Holst Birthday Museum, Cheltenham 2010

Bryant, Barbara, *G.F. Watts Portraits: Fame & Beauty in Victorian Society*, exh. cat., National Portrait Gallery, London 2004

Bullen, J.B., *Rossetti: Painter and Poet*, London 2011

Burne-Jones, Georgiana, *Memorials of Edward Burne-Jones*, 2 vols., London 1904

Carlyle, Thomas, *Past and Present* (1843), London 1912

Cherry, Deborah, 'The Hogarth Club: 1858–1861', *The Burlington Magazine*, vol. 122, no. 925 (April 1980), pp.237–44

Cherry, Deborah, and Pollock, Griselda, 'Woman as sign in Pre-Raphaelite Literature: a study of the representation of Elizabeth Siddall', *Art History*, no.7 (June 1984a), pp.206–27

Cherry, Deborah, and Pollock, Griselda, 'Patriarchal Power and the Pre-Raphaelites', *Art History*, no.7 (Dec. 1984b), pp.480–95

Cruise, Colin, *Pre-Raphaelite Drawing*, exh. cat., Birmingham Museum and Art Gallery 2011

Donald, Diana, and Munro, Jane (eds.), *Endless Forms: Charles Darwin, Natural Science and the Visual Arts*, exh. cat., Yale Center for British Art, New Haven, CT 2009

Doughty, Oswald, and Wahl, J.R., *The Letters of Dante Gabriel Rossetti*, 4 vols., 1965–7

Dufty, A.R., *Morris Embroideries: The Prototypes*, Society of Antiquaries, London 1985

Fredeman, William E. (ed.), *The P.R.B. Journal, William Michael Rossetti's Diary of the Pre-Raphaelite Brotherhood, 1849–1853*, Oxford 1975

Fredeman, W.E., *The Correspondence of Dante Gabriel Rossetti*, 9 vols., Cambridge 2002–10

Giebelhausen, Michaela, 'Holman Hunt, William Dyce and the Image of Christ', in Nicola Bown, Carolyn Burdett and Pamela Thurschwell (eds.), *The Victorian Supernatural*, Cambridge 2004, pp.173–94

Giebelhausen, Michaela, *Painting the Bible: Representation and Belief in Mid-Victorian Britain*, Aldershot 2006

Giebelhausen, Michaela, and Barringer, Tim (eds.), *Writing the Pre-Raphaelites: Text, Subtext, Context*, Farnham 2009

Goldman, Paul, *Beyond Decoration: The Illustrations of John Everett Millais*, London and New Castle, DE 2005

Grewe, Cordula, *Painting the Sacred in the Age of Romanticism*, Aldershot 2009

Hawksley, Lucinda, *Lizzie Siddal: Face of the Pre-Raphaelites*, New York 2006

Hueffer, Ford Madox, *Ford Madox Brown: A Record of his Life and Work*, London 1896

Hunt, William Holman, 'Technical Notes', *The Portfolio*, vol.VI, 1875, pp.45–8

Hunt, William Holman, 'The Pre-Raphaelite Brotherhood: A Fight for Art', *Contemporary Review*, 1886, 3 parts: pt.1, April, pp. 471–88; pt.2, May, pp.737–50; pt.3, June, pp.820–33

Hunt, William Holman, *Pre-Raphaelitism and the Pre-Raphaelite Brotherhood*, 2 vols., London 1905 or 1913 (2nd edn)

Jacobi, Carol, *William Holman Hunt: Painter, Painting, Paint*, Manchester 2006

Kirkham, Pat, 'William Morris's Early Furniture', *Journal of William Morris Studies* 4.3 (Summer 1981), pp.25–8

Lethaby, W.R., *Philip Webb and his Work*, London 1935

Lutyens, Mary, *Millais and the Ruskins*, London 1967

Maas, Jeremy, *Holman Hunt and The Light of the World*, London and Berkeley, 1984

MacCarthy, Fiona, *William Morris: A Life for our Time*, London 2010

MacCarthy, Fiona, *The Last Pre-Raphaelite: Edward Burne-Jones and the Victorian Imagination*, London 2011

Macdonald, Katharine, 'Alexander Munro: Pre-Raphaelite Associate', in Read & Barnes 1991, pp.46–65

McGann, Jerome, *Dante Gabriel Rossetti and the Game That Must be Lost*, New Haven and London 2000

Marsh, Jan, *Elizabeth Siddal: Pre-Raphaelite Artist, 1829–62*, exh. cat., Ruskin Gallery, Sheffield 1991

Marsh, Jan, and Nunn, Pamela Gerrish, *Pre-Raphaelite Women Artists*, exh. cat. Manchester City Art Gallery 1997

Millais, John Guille, *The Life and Letters of Sir John Everett Millais*, 2 vols., London 1899

Morris, William, 'Textiles', *Journal of the Society of Arts*, 19 Oct. 1888, no.1874, vol.36, p.1133

Morris, William, *The Collected Works of William Morris*, 24 vols., London 1910–15

Nead, Lynda, *Myths of Sexuality: Representations of Women in Victorian Britain*, Oxford 1988

Newall, Christopher, *John William Inchbold: Pre-Raphaelite Landscape Artist*, Leeds 1993

Parris, Leslie (ed.) *The Pre-Raphaelites*, exh. cat., Tate Gallery, London 1984

Parry, Linda (ed.), *William Morris*, exh. cat., Victoria and Albert Museum, London 1996a

Parry, Linda (ed.), *Art and Kelmscott*, London 1996b

Payne, Christiana, and Brett, Charles, *John Brett: Pre-Raphaelite Landscape Painter*, New Haven and London 2010

Peterson, William S. (ed.), *The Ideal Book: Essays and Lectures on the Arts of the Book by William Morris*, Berkeley and Los Angeles 1982

Pointon, Marcia, *William Dyce 1806–1864: A Critical Biography*, Oxford 1979

Pointon, Marcia (ed.), *Pre-Raphaelites Re-Viewed*, Manchester 1989

Prettejohn, Elizabeth, *Rossetti and his Circle*, London 1997

Prettejohn, Elizabeth, *The Art of the Pre-Raphaelites*, London and Princeton 2000

Prettejohn, Elizabeth, *Art for Art's Sake: Aestheticism in Victorian Painting*, New Haven and London 2007

Read, Benedict, and Barnes, Joanna (eds.), *Pre-Raphaelite Sculpture: Nature and Imagination in British Sculpture 1848–1914*, exh. cat., Matthiesen Gallery, London, and Birmingham Museums and Art Gallery, 1991

Robertson, W. Graham, *Time Was*, London 1931

Rosenfeld, Jason, 'New Languages of Nature in Victorian England: The Pre-Raphaelite Landscape, Natural History and Modern Architecture in the 1850s', PhD Dissertation, Institute of Fine Arts, New York University 1999

Rosenfeld, Jason, 'The Pre-Raphaelite "Other"hood and Group Identity in Victorian Britain', in *Artistic Brotherhoods in the Nineteenth Century*, ed. Laura Morowitz and William Vaughan, Aldershot 2000, pp.67–81

Rosenfeld, Jason, *John Everett Millais*, London 2012

Rosenfeld, Jason, and Smith, Alison, *Millais*, London 2007

Rossetti, William Michael, *Dante Gabriel Rossetti as a Designer and Writer*, London 1889

Rossetti, William Michael, *Dante Gabriel Rossetti: His Family Letters with a Memoir*, 2 vols., London 1895

Rossetti, William Michael, *Pre-Raphaelite Diaries and Letters*, London 1900

Rossetti, William Michael, *Rossetti Papers 1862 to 1870: A Compilation*, London 1903

Ruskin, John, 'The Pre-Raffaellites [sic]', Letter to the Editor, *The Times*, 13 May 1851, pp.8–9

Ruskin, John, *Library Edition of the Collected Works of John Ruskin*, ed. E.T. Cook and A. Wedderburn, 39 vols., London 1903–12

Scott, William Bell, *Autobiographical Notes of the Life of William Bell Scott*, 2 vols., ed. William Minto, London and New York 1892

Smith, Alison (ed.), *Symbolist Art in Poland: Poland and Britain c.1900*, exh. cat., Tate Britain, London 2009

Smith, Charles Saumarez, *The National Gallery: A Short History*, London 2009

Staley, Allen, *The New Painting of the 1860s: Between the Pre-Raphaelites and the Aesthetic Movement*, New Haven and London 2011

Staley, Allen, *The Pre-Raphaelite Landscape*, New Haven and London 2001

Staley, Allen, and Newall, Christopher, *Pre-Raphaelite Vision: Truth to Nature*, exh. cat., Tate Britain, London 2004

Stephens, F.G., *William Holman Hunt and his Works: A Memoir of the Artist's Life, with Descriptions of his Pictures*, London 1860

Stephens, F.G., 'Mr Rossetti's Pictures', *Athenaeum*, no.1982, 21 October 1865, p.545

Stephens, F.G., 'Dante Gabriel Rossetti', *Portfolio* monograph, May 1894

Stutchbury, Anne F., 'Instruments of femininity: The Arnold Dolmetsch clavichords of 1897, Nos. 8 and 10', MA thesis, University of Sussex, Brighton 2011

Surtees, Virginia, *The Paintings and Drawings of Dante Gabriel Rossetti (1828–1882): A Catalogue Raisonné*, 2 vols., Oxford 1971

Surtees, Virginia (ed.), *The Diaries of George Price Boyce*, Norwich 1980

Surtees, Virginia (ed.), *The Diary of Ford Madox Brown*, New Haven and London, 1981

Swinburne, Algernon, *Poems and Ballads*, London 1866

Townsend, Joyce H., Ridge, Jacqueline, and Hackney, Stephen (eds.), *Pre-Raphaelite Painting Techniques*, London 2004

Treuherz, Julian, 'The Pre-Raphaelites and Medieval Illuminated Manuscripts', in Parris 1984, pp.153–70

Treuherz, Julian, *Ford Madox Brown: Pre-Raphaelite Pioneer*, exh. cat., Manchester Art Gallery 2011

Treuherz, Julian, Prettejohn, Elizabeth, and Becker, Edwin, *Dante Gabriel Rossetti*, exh. cat., Walker Art Gallery, Liverpool 2003

Tromans, Nicholas, 'Palestine: Picture of Prophecy', in Katharine Lochnan and Carol Jacobi (eds.), *Holman Hunt and the Pre-Raphaelite Vision*, exh. cat., Manchester City Art Gallery and AGO Toronto 2008, pp.135–58

Vallance, Aymer, *William Morris: His Art, his Writings, and his Public Life*, London 1897

Waggoner, Diane (ed.), *The Pre-Raphaelite Lens: British Photography and Painting, 1848–1875*, exh. cat., National Gallery of Art, Washington DC 2010

Warner, Malcolm, *The Drawings of John Everett Millais*, London 1979

Warner, Malcolm, 'The Pre-Raphaelites and the National Gallery', in *The Pre-Raphaelites in Context*, San Marino, CA 1992, pp.1–11

Warner, Malcolm, *The Victorians: British Painting 1837–1901*, exh. cat., National Gallery of Art, Washington, DC 1997

Watson, Margaretta Frederick (ed.), *Collecting the Pre-Raphaelites: The Anglo-American Enchantment*, Aldershot 1997

Werner, Marcia, *Pre-Raphaelite Painting and Nineteenth-Century Realism*, Cambridge 2005

Wilton, Andrew, and Upstone, Robert (eds.), *The Age of Rossetti, Burne-Jones & Watts: Symbolism in Britain 1860–1910*, exh. cat., Tate Gallery, London 1997

Wright, Alastair, 'Ford Madox Brown's *The Body of Harold*: Representing England at Mid-Century', *Nineteenth Century Art Worldwide*, vol.6, no.2, Autumn 2007 (www.19thc-artworldwide.org)

CHECKLIST OF WORKS
EXHIBITED IN WASHINGTON

Short listings (artist, title, date, and catalogue number) are provided in catalogue order for works with entries in the catalogue. Full listings are provided for works not given entries in the catalogue but shown in the exhibition. The latter are ordered alphabetically by artist under the heading 'Also Exhibited in Washington'; a cross-reference to a related catalogue entry is also included when relevant.

Ford Madox Brown
The Seeds and Fruits of English Poetry 1845-53
no. 7

Ford Madox Brown
Geoffrey Chaucer Reading the 'Legend of Custance' to Edward III and his Court, at the Palace of Sheen, on the Anniversary of the Black Prince's Forty-Fifth Birthday (Chaucer at the Court of Edward III) 1850-68
no. 8

Ford Madox Brown
The First Translation of the Bible into English: Wycliffe Reading his Translation of the New Testament to his Protector, John of Gaunt, Duke of Lancaster, in the Presence of Chaucer and Gower, his Retainers 1847-8, reworked 1859-60
no. 9

Dante Gabriel Rossetti
Self-Portrait 1847
no. 10

Dante Gabriel Rossetti
Ford Madox Brown 1852
no. 11

William Holman Hunt
John Everett Millais 1853
no. 12

John Everett Millais
William Holman Hunt 1853
no. 13

Dante Gabriel Rossetti
Thomas Woolner 1852
no. 14

Dante Gabriel Rossetti
William Michael Rossetti 1853
no. 15

John Everett Millais
Frederic George Stephens 1853
no. 16

Dante Gabriel Rossetti
Elizabeth Siddall Plaiting her Hair (undated)
no. 19

William Morris
Self-Portrait c.1856
no. 20

Michel de St Croix
View of the National Gallery, London 1839
no. 22

John Everett Millais
Mrs James Wyatt Jr and her Daughter Sarah c.1850
no. 30

William Edward Kilburn
Portrait of a Man and Girl c.1848
no. 31

Walter Howell Deverell
Twelfth Night 1849-50
no. 32

John Everett Millais
Ferdinand Lured by Ariel 1849-50
no. 33

William Holman Hunt
Valentine Rescuing Sylvia from Proteus – Two Gentlemen of Verona (Act V, Scene iv) 1850-1
no. 34

John Everett Millais
Mariana 1850-1
no. 35

William Holman Hunt
Claudio and Isabella 1850-3, retouched 1879
no. 36

John Everett Millais
A Huguenot, on Saint Bartholomew's Day, Refusing to Shield Himself from Danger by Wearing the Roman Catholic Badge 1851-2
no. 37

Alexander Munro
Paolo e Francesca 1851-2
no. 38

John Everett Millais
The Order of Release, 1746 1852-3
no. 40

William Shakespeare Burton
A Wounded Cavalier 1855-6
no. 42

Arthur Hughes
April Love 1855-6
no. 43

Alexander Munro
Dante Alighieri 1856
no. 44

Henry Wallis
Chatterton 1855-6
no. 45

Dante Gabriel Rossetti
The Wedding of St George and the Princess Sabra 1857
no. 46

Dante Gabriel Rossetti
The Tune of Seven Towers 1857
no. 47

Elizabeth Eleanor Siddall
The Lady of Shalott 1853
no. 49

Elizabeth Eleanor Siddall
Lady Affixing Pennant to a Knight's Spear c.1856
no. 51

William Morris
La Belle Iseult 1857-8
no. 53

Edward Burne-Jones
Clara von Bork 1560 1860
no. 55

Edward Burne-Jones
Sidonia von Bork 1560 1860
no. 56

Dante Gabriel Rossetti
The Salutation of Beatrice in Florence and *The Salutation in the Garden of Eden* 1859
no. 57

Dante Gabriel Rossetti
Dantis Amor 1860
no. 58

Florence Claxton
The Choice of Paris: An Idyll 1860
no. 59

Morris, Marshall, Faulkner & Co.
Four stained-glass panels depicting King Rene's Honeymoon c.1863
no. 60

John Ruskin
Mountain Rock and Alpine Rose 1844 or 1849
no. 62

William Henry Fox Talbot
The Geologists c.1843
no. 63

John Everett Millais
Ophelia 1851-2
no. 69

John Ruskin
Cascade du Dard, Chamonix c.1854
no. 73

Ford Madox Brown
An English Autumn Afternoon, Hampstead – Scenery in 1853 1852-5
no. 74

Ford Madox Brown
The Hayfield 1855-6
no. 75

John William Inchbold
At Bolton 1855
no. 76

John Brett
The Hedger 1859-60
no. 78

Rosa Brett
The Artist's Garden 1859
no. 79

Rosa Brett
Mouse in the Undergrowth 1859
no. 80

John Everett Millais
The Blind Girl 1854-6
no. 81

William Dyce
Pegwell Bay, Kent – a Recollection of October 5th, 1858 1858-60
no. 82

Alexander Munro
Young Romilly c.1863
no. 83

Daniel Alexander Williamson
Spring, Arnside Knot and Coniston Range of Hills from Warton Crag c.1863
no. 84

John Everett Millais
Christ in the House of His Parents (The Carpenter's Shop) 1849-50
no. 85

Dante Gabriel Rossetti
Ecce Ancilla Domini! (The Annunciation) 1849-50
no. 87

Ford Madox Brown
'Take your Son, Sir' 1851-2, enlarged and re-worked 1856-7
no. 90

Ford Madox Brown
Jesus Washing Peter's Feet 1852-6
no. 93

Dante Gabriel Rossetti
Found begun 1859
no. 97

William Holman Hunt
The Awakening Conscience 1853-4
no. 98

Thomas Seddon
Jerusalem and the Valley of Jehoshaphat from the Hill of Evil Counsel 1854-5
no. 100

William Holman Hunt
The Finding of the Saviour in the Temple 1854-60
no. 101

Henry Wallis
The Stonebreaker 1857
no. 103

John Roddam Spencer Stanhope
Thoughts of the Past 1858-9
no. 104

William Dyce
The Man of Sorrows 1860
no. 108

William Holman Hunt
The Children's Holiday 1864
no. 109

William Holman Hunt
The Shadow of Death 1870-3
no. 112

Alexander Munro
Josephine Butler 1855
no. 115

Alexander Munro
Elizabeth Smith (née Blakeway) 1859
no. 116

John Everett Millais
Sophie Gray 1857
no. 118

Dante Gabriel Rossetti
Bocca Baciata 1859
no. 119

Frederick Sandys
Mary Magdalene c.1859
no. 120

William Holman Hunt
Il Dolce far Niente 1859-66, retouched 1874-5
no. 121

Dante Gabriel Rossetti
Beata Beatrix c.1864-70
no. 124

Dante Gabriel Rossetti
The Beloved ('The Bride') 1865-6
no. 125

W. & D. Downey
Fanny Cornforth 1863
no. 127

Julia Margaret Cameron
Hypatia 1868
no. 128

Julia Margaret Cameron
Mariana 1874-5
no. 129

Dante Gabriel Rossetti
Monna Vanna 1866
no. 130

William Holman Hunt
Isabella and the Pot of Basil 1866-8, retouched 1886
no. 131

Dante Gabriel Rossetti
Lady Lilith, 1866-8, altered 1872-3
no. 132

Dante Gabriel Rossetti and William Morris
The Arming of a Knight Chair 1856-7
no. 135

Edward Burne-Jones
*Self-Caricature in the Studio at 17 Red Lion
Square* 1856
no. 136

Edward Burne-Jones
Ladies and Animals Sideboard 1860
no. 137

William Morris
Qui bien aime tard oublie early 1860s
no. 138

William Morris and Elizabeth Burden
*Three-fold screen with embroidered panels de-
picting heroines* c.1860
no. 140

Morris, Marshall, Faulkner & Co., designed
by William Morris
'Trellis' wallpaper, registered 1864
no. 141

William Morris
Design for 'Tulip and Willow' printed textile
1873
no. 142

William Morris, Edward Burne-Jones and
Charles Fairfax Murray
The Rubáiyát of Omar Khayyám 1872: open at
ff.9v-10
no. 145

Edward Burne-Jones and William Morris
Love Leading the Pilgrim through the Briars,
from *The Romance of the Rose* 1874-82
no. 146

Morris & Co., designed by Edward Burne-
Jones, William Morris and John Henry Dearle
*The Arming and Departure of the Knights of
the Round Table on the Quest for the Holy Grail*
1890-4
no. 153

Morris & Co., designed by Edward Burne-
Jones, William Morris and John Henry Dearle
*The Attainment: The Vision of the Holy Grail to
Sir Galahad, Sir Bors and Sir Perceval* 1890-4
no. 153

Morris & Co., designed by Edward Burne-
Jones
Angel with Instrument 1890
no. 156

Morris & Co., designed by Edward Burne-
Jones
Angel with Lute 1890
no. 157

Dante Gabriel Rossetti
La Pia 1868-81
no. 161

Edward Burne-Jones
Laus Veneris 1873-78
no. 165

Dante Gabriel Rossetti
Astarte Syriaca 1877
no. 166

William Holman Hunt
The Lady of Shalott c.1888-1905
no. 171

Edward Burne-Jones
The Rock of Doom 1885-8
no. 172

Edward Burne-Jones
The Doom Fulfilled 1885-8
no. 173

Edward Burne-Jones
The Baleful Head 1885-7
no. 174

Unknown photographer
Elizabeth Eleanor Siddall c.1850s
fig. 2

William Holman Hunt
The Scapegoat 1854-5
fig. 17
see no. 102

Frederick Hollyer
*Edward Burne-Jones and William Morris in
the garden of Burne-Jones's home The Grange,
Fulham* c.1890
fig. 21

Philip Webb and Edward Burne-Jones
The Backgammon Players' Cabinet 1861
fig. 22

John Robert Parsons
Jane Morris 1865
fig. 25

Also Exhibited in Washington

John Brett 1831-1902
Glacier of Rosenlaui 1856
Oil on canvas, 44.5 x 41.9
Tate. Purchased 1946

Ford Madox Brown 1821-93
Work 1863
Oil on canvas, 68.4 x 99
Birmingham Museums and Art Gallery. Bequeathed by
James Richardson Holliday, 1927
see no. 95

Julia Margaret Cameron 1815-79
The Mountain Nymph, Sweet Liberty 1866
Albumen print, 36.1 x 26.7
National Gallery of Art, Washington, New Century
Fund

Geoffrey Chaucer
The Works of Geoffrey Chaucer: open at the last
page of *The Romaunt of the Rose* and the first
page of *The Parlement of Foules*
Kelmscott Press, Hammersmith 1896
Designed by William Morris with illustrations by
Edward Burne-Jones
Rare Book and Special Collection Division, The
Library of Congress
see no. 152

Geoffrey Chaucer
The Works of Geoffrey Chaucer: open at
title-page
Kelmscott Press, Hammersmith 1896
Designed by William Morris with illustrations by
Edward Burne-Jones
Rosenwald Collection, Rare Book and Special Collec-
tion Division, The Library of Congress
see no. 152

William Holman Hunt 1827-1910
The Light of the World 1851-6
Oil on canvas, 49.8 x 21.6
Manchester City Galleries
see no. 92

William Holman Hunt 1827-1910
Portrait of Henry Wentworth Monk 1858-9
Oil on canvas, 53.34 x 67.31
National Gallery of Canada, Ottawa. Purchased 1911

William Holman Hunt 1827-1910
*The Flight of Madeline and Porphyro during the
Drunkenness Attending the Revelry (The Eve of
St. Agnes)* 1848
Oil on canvas, 77.5 x 113
Guildhall Art Gallery, Corporation of London

John Everett Millais 1829-96
Peace Concluded, 1856 1856
Oil on canvas, 116.8 x 91.4
Minneapolis Institute of Arts, The Putnam Dana
McMillan Fund

William Morris 1834-96
Chants for Socialists
Socialist League Office, London 1885
Mark Samuels Lasner Collection, on loan to the University of Delaware Library
see no. 149

William Morris 1834-96
News from Nowhere, or an Epoch of rest: being some chapters from a Utopian romance
Kelmscott Press, Hammersmith 1892
Designed by William Morris with a frontispiece by C.M. Gere
Mark Samuels Lasner Collection, on loan to the University of Delaware Library
see no. 151

William Morris 1834-96
The Life and Death of Jason, a poem: open to title page
Kelmscott Press, Hammersmith 1895
Designed by William Morris with illustrations by Edward Burne-Jones
Inscribed 'to Kate Faulkner from William Morris June 29th 1895'
Mark Samuels Lasner Collection, on loan to the University of Delaware Library

William Morris 1834-96
A Dream of John Ball, and, A King's lesson: open to 'When Adam Delved'
Kelmscott Press, Hammersmith 1892
Designed by William Morris with a frontispiece by Edward Burne-Jones
Inscribed 'to Eirikur Magnusson from William Morris Oct 1st 1892'
Mark Samuels Lasner Collection, on loan to the University of Delaware Library

William Morris 1834-96
The Story of the Glittering Plain: which has been also called the Land of Living Man or the Acre of the Undying: open to title page
Kelmscott Press, Hammersmith 1894
Designed by William Morris with illustrations by Walter Crane
Inscribed 'to William Harcourt Hooper from William Morris April 23rd 1894'
Mark Samuels Lasner Collection, on loan to the University of Delaware Library

Morris, Marshall, Faulkner & Co.
Designed by Edward Burne-Jones and painted by Lucy Faulkner
Cinderella Tile Panel, 1862-5
Overglaze polychrome decoration on tin-glazed Dutch earthenware blanks in ebonized oak frame, 71.8 x 141.6 x 6
The Huntington Library, Art Collections, and Botanical Gardens, San Marino, California
see no. 139

Morris & Co.
Designed by William Morris
'Peacock and Dragon' woven textile, registered 1878
Wool, 223.5 x 172.7
Baltimore Museum of Art, Gift of Dena S. Katzenberg, Baltimore

Morris & Co.
Designed by William Morris
'Strawberry Thief' printed textile, registered 1883
Indigo-discharge and block-printed cotton, 68.6 x 101.6
Mark Samuels Lasner Collection, on loan to the University of Delaware Library

Morris & Co.
Designed by William Morris
'Cray' printed textile, 1884
Block-printed cotton, printed between 1884 and 1917, 362.6 x 173.7
The Baltimore Museum of Art: The Jane and Worth B. Daniels, Jr. Fund
see no. 143

Dante Gabriel Rossetti 1828-82
Proserpine 1874
Oil on canvas 125.1 x 61
Tate. Presented by W. Graham Robertson 1940

The Germ: Thoughts Toward Nature in Poetry, Literature and Art, no.1, January 1850: open at frontispiece, *My Beautiful Lady*, by William Holman Hunt
Aylott & Jones, London
Mark Samuels Lasner Collection, on loan to the University of Delaware Library
see no. 23

LIST OF LENDERS

The organisers of the exhibition wish to thank the following public and private lenders:

The Ashmolean Museum
The Baltimore Museum of Art
Barber Institute of Fine Arts
Tim Barringer
Birmingham Museum and Art Gallery
Blackburn Museum and Art Gallery
Bradford Museums and Galleries
The British Library, London
British Museum, London
Stephen Calloway
Clemens-Sels Museum, Neuss
Delaware Art Museum
Girton College, Cambridge
Guildhall Art Gallery, London
Hamburger Kunsthalle
Hon. Simon Howard, Castle Howard Collection
The Huntington Library, Art Collections, and

Botanical Gardens
K. & J. Jacobson
Keble College, Oxford
Laing Art Gallery
Mark Samuels Lasner, on loan to the University of
Delaware Library
Leeds Museums and Galleries
Library of Congress
Lord Lloyd Webber
Wendy Makins
The Maas Gallery, London
Manchester City Galleries
The Metropolitan Museum of Art
The Minneapolis Institute of Arts
Museum of Fine Arts, Boston
National Gallery of Canada
The National Gallery, London
The National Media Museum, Bradford
National Museums Liverpool
National Portrait Gallery, London

Jimmy Page
Ruskin Library, Lancaster University
John Schaeffer
Scottish National Gallery
Society of Antiquaries of London
Spencer Museum of Art, The University of Kansas
Staatliche Museen, Berlin
Staatsgalerie, Stuttgart
Torre Abbey, Torquay
Victoria and Albert Museum, London
Wadsworth Atheneum Museum of Art, Hartford
The Walters Art Museum
Watts Gallery
Whitworth Art Gallery
William Morris Gallery, London Borough of
Waltham Forest
Wightwick Manor, National Trust
Wilson Centre for Photography, London

And all those who wish to remain anonymous

ACKNOWLEDGEMENTS

This exhibition, five years in the making, has been a close collaboration between Tate Britain and its partner venues: the National Gallery of Art, Washington DC, the State Pushkin Museum of Fine Arts, Moscow, and the Mori Arts Center, Tokyo. We are grateful to our colleagues at these institutions for their help in steering the project through each stage of its development. At the National Gallery of Art: Earl A. Powell III, Director; Franklin Kelly, Deputy Director; D. Dodge Thompson, Director of Exhibitions; Diane Waggoner, Associate Curator; and Jennifer Cipriano, Exhibition Officer. At the Pushkin Museum: Irina Antonova, Director; Anna Poznanskaya, Curator; as well as Anna Genina and Claire DeBraekeleer, Head of Art at the British Council in Moscow. In Japan: Yoko Obuchi, Deputy Manager, Cultural Projects Department at the Asahi Shimbun. At Tate Britain we are especially indebted to Kiko Noda for arranging indemnity and transport and to the dedication of the three assistant curators who worked on the project at different stages of its development: Philippa Simpson, Rebecca Lewin and most recently Anna Moore. We would also like to thank Stephen Deuchar for his critical early support of the project. The catalogue has been overseen by Alice Chasey and copy-edited by Colin Grant, with picture research by Miriam Perez and production by Bill Jones. We would like to thank them all, together with Susan Wightman, who has produced the elegant catalogue design.

In the twenty-eight years that have passed since the last major survey exhibition on the Pre-Raphaelites in 1984, scholarship in this field has expanded dramatically with the consequence that Pre-Raphaelitism is now recognised to be a defining phenomenon in both British and European art. In curating the present exhibition, we would therefore like to express our indebtedness to scholars past and present who have worked in various ways to promote a broader understanding of the movement. We would like to thank Elizabeth Prettejohn for her valued contribution to the catalogue, and Nicholas Tromans and Joyce Townsend for commenting on various aspects of the text. Expert advice in particular areas was offered by Charlotte Gere, John Christian and Linda Parry, as well as by Julia Dudkiewicz at the Society of Antiquaries and Anna Mason at the William Morris Gallery.

We would also like to extend our gratitude to all those individuals and institutions that have supported the exhibition with loans from their collections. Among those who have offered advice and assisted the project in various ways, we would like to acknowledge: Kirsty Anson, Sir Jack Baer, Christopher Baker, Jennifer Batchelor, Martin Beisly, Mark Bills, Ulrich Birkmaier, Charles Brett, Jo Briggs, Judith Bronkhurst, Peter Brown, Max Browne, Stephen Calloway, Caroline Campbell, Simon Cane, Andrea Clarke, Frances Collard, Peter Cormack, Ben Dale, Daniel De Simone, Hamish Dewar, Margaret Dier, Susan Earle, Olga Ferguson, Polly Fleury, Margaretta Frederick, Ann French, Peter Funnell, Frances Gandy, Hugh Gibson, Michaela Giebelhausen, Dillian Gordon, Karen Gottlieb, Desna Greenhow, Christopher Gridley, Alastair Grieve, Stephen Hackney, Saralyn Reece Hardy, Colin Harrison, Ruth Hibbard, Sara Holdsworth, Carol Jacobi, Ken and Jenny Jacobson, Alastair Johnson, Anita Jones, Rica Jones, Selina Jones, the late Vivien Knight, Carien Kremer, Mark Samuels Lasner, Marylyn Lewin, Brian Liddy, Trish Long, Rupert Maas, Melinda McCurdy, Rebecca McGinnis, Rita Mclean, Elinor McMonagle, Wendy Makins, Amelia Marietta, Jan Marsh, Anna Louisa Mason, Marc Mayer, Geoffroy Millais, Sarah Miller, Julie Milne, Peter and Renate Nahum, Angela Nevill, Jenny Newall, Christopher Nobbs, Patrick Noon, Rachel Oberter, Morna O'Neill, Victoria Osborne, Gustav Percivall, Aphrodite Phillipson, Elizabeth Pye, Andrea Wolk Rager, Paul Reeves, Christopher Ridgway, George Shackelford, the late Tessa Sidey, Andrew Sisson, Sonia Solicari, Anne Stutchbury, Ann Sumner, Virginia Surtees, Susan Talbott, Serena Thirkell, Simon Toll, Julian Treuherz, Peter Trippi, Natasha Walker, Amanda Wallace, Malcolm Warner, Alicia Weisberg-Roberts, Marta Weiss, Esmé Whittaker and Stephen Wildman. Thanks also to Marymount Manhattan College for giving Jason time off from teaching to work on the exhibition and catalogue.

Alan Farlie of RFK Architects assisted with the exhibition design, with graphics by Philip Miles. We are grateful to the Pre-Raphaelite Exhibition Supporters Group and Tate Patrons for their generous support of the exhibition, which was made possible by the provision of insurance through the Government Indemnity Scheme. Tate Britain would like to thank HM Government for providing Government Indemnity, and the Department for Culture, Media and Sport and Arts Council England for arranging this indemnity.

Finally we would like to extend our appreciation to all those at Tate and the National Gallery of Art who have been involved with this project in various ways and have helped see it through to completion.

AS, TB & JR

PHOTOGRAPHIC CREDITS

INDEX